# CHINESE GLAZES

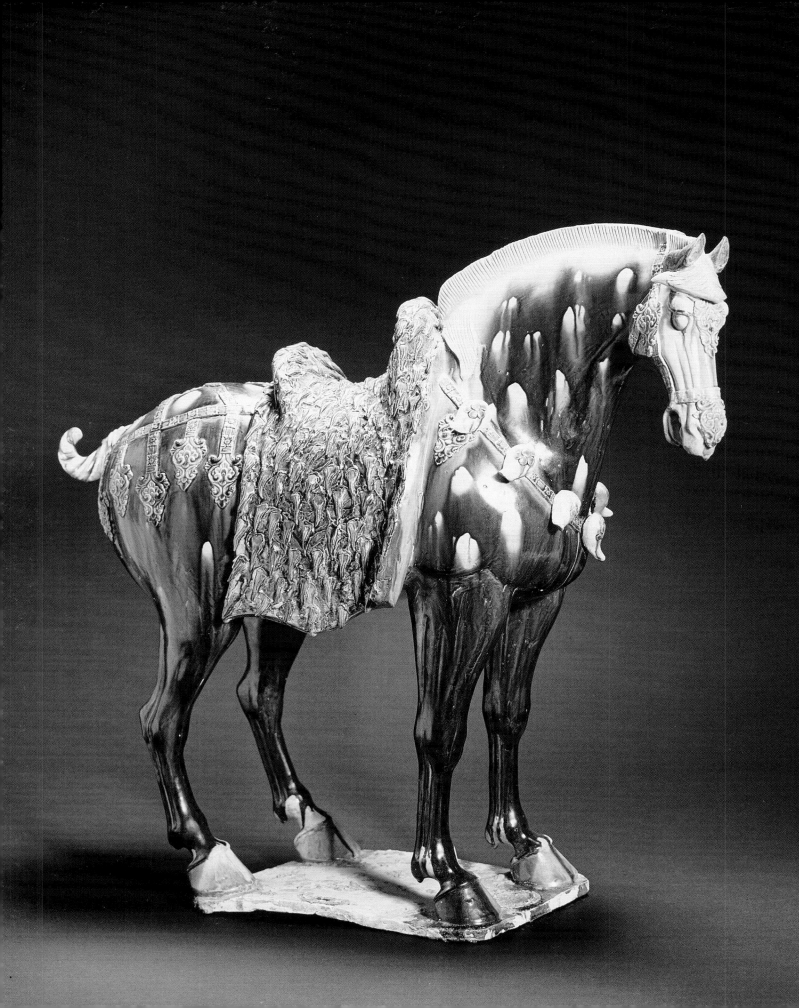

# CHINESE GLAZES

*Their Origins, Chemistry and Recreation*

Nigel Wood

A & C Black • London
University of Pennsylvania Press • Philadelphia

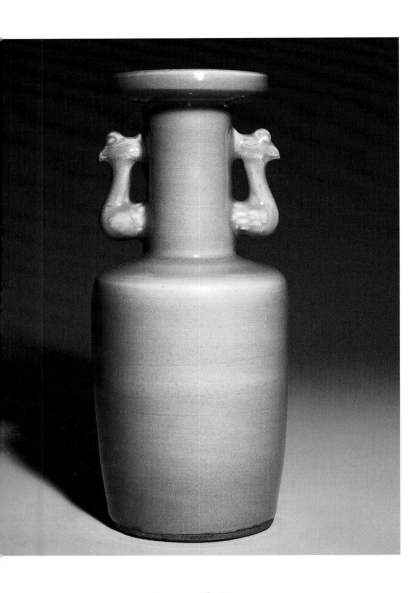

*To my wife Dee*

First published in Great Britain 1999
A & C Black (Publishers) Limited
35 Bedford Row, London WC1R 4JH

ISBN 0 7136 3837 0

A CIP catalogue record for this book is available
from the British Library.

Copyright © 1999 Nigel Wood

First published in USA by the University of Pennsylvania Press,
4200 Pine Street, Philadelphia, PA 19104

ISBN 0 8122 3476 6

**Library of Congress Cataloging-in-Publication Data**
Wood, Nigel.
Chinese glazes: their origins, chemistry, and recreation/Nigel Wood
    p. cm.
  Includes bibliographical references and index.
  ISBN 0-8122-3476-6
  1. Glazes 2. Pottery, Oriental. I. Title.
TP812.W65 1999
738. 1'27'0951 – dc21       98.8799
                     .CIP

Design: Janet Jamieson

*Cover photographs:*
Front:
*Right:* Dish, Ru ware, late 11th to early 12th century AD, British
Museum. *Left:* Black glazed vase, northern stoneware, 12th
century AD, British Museum. *Centre:* Porcelain jar with dragon
design in yellow, red and black overglaze enamels. Jingdezhen kilns,
Jiajing period, 16th century AD, British Museum.

Back:
*From left to right:* Porcelain ewer with low-firing turquoise glaze,
Jingdezhen, early 18th century AD, British Museum; Porcelain
bowl with low-firing lemon-yellow glaze, Jingdezhen, early 19th
century AD, British Museum; Porcelain covered jar with iron-red
turquoise glaze, Jingdezhen, early 19th century AD, British
Museum; Porcelain bowl with low-firing lime-green glaze,
Yongzhenz period, Jingdezhen, 1723–35 AD, British Museum.

*Frontispiece:* Large press-moulded earthenware horse with *sancai*
lead glazes, Tang dynasty, first half of the 8th century AD. Sotheby's.
*Left:* Southern Song dynasty Longquan celadon vase of *kinuta*
(mallet) form. Christie's.

Printed and bound in Hong Kong by Imago

# Contents

# Introduction

In this completely new edition of his valuable study on Chinese glazes, Nigel Wood takes us behind the beautiful surfaces of Chinese ceramics. These are categories of glaze that westerners were, until recently, completely unable to make, so different was the ceramic tradition in China from the work of potters in other parts of the world. Chinese vases and bowls imported into Europe from perhaps as early as the fifteenth century were prized possessions among the treasures of the Medici family in Florence or at the court of Augustus the Strong at Dresden. Not only in Florence and Dresden, but also in Mexico and India and in South-east Asia, Chinese wares added to the convenience and luxury of daily and court life. Such ceramics were so valued that they were mounted in special gold and silver fittings to emphasise their beauty and worth. Initially, the ceramics were probably sought after for their brilliant colours under shiny glazes. They were probably also desired because large sets could be commissioned by the aristocrats of Western Europe. To produce both the brilliant colours and the large numbers great technical skill was required. The Chinese had very early mastered glazing techniques. In addition, their highly organised industry and effective use of mass production made it possible to sell large matched sets for tea, for dinner services and for the great tureens and dishes on which European banquets were served. But these were the ceramics of the 16th and 17th centuries and later.

Long before this time, the Chinese had perfected another category of ceramics: that is, ceramics with fine, smooth shapes, sometimes with relatively thick bodies, covered in wonderful unctuous glazes in dark brown, green and pale lavender, to say nothing of white. It is for the ceramics of the Tang (AD 618–906) and the Song periods (AD 960–1279) that China is really famous among potters today. These glazes made Chinese renowned because they were not only beautiful to the eye, but also beautiful to the touch. Indeed, the customers and scholars of the Far East valued ceramics for the fine feeling when held in the hand for drinking tea or eating rice. While westerners have stored up great services of white porcelain coloured with the coats of arms of major houses to astonish the admiring visitor, to the Chinese the celebration of tactile qualities has had priority. This book discusses the ceramics of this second category, those that are beautiful to the eye and to the touch. Such ceramics were highly influential in the Far East, being developed and copied also in Japan and Korea, where entirely new and original varieties were developed. This large ceramic universe had, in turn, its own impact on the West through the work of what we today regard as 'studio potters' led, among others, by Bernard Leach.

Although such ceramics have been collected and admired for many decades, if not centuries, their compositions and the techniques by which glaze effects were achieved have been little understood before the last ten or twenty years or so. This unique book provides a window into this important area of research. Nigel Wood, long expert in this field, here makes available to the English-speaking world the secrets of this astonishing craft. One of the fundamental features of this tradition was that it was developed empirically. Few text books or manuals were ever written on the subject. Instead, in different parts of China, potters and their assistants sought out clays, developed kilns and discovered recipes for the glazes that they admired. This was a slow process taking place over two thousand years or more. In this volume Nigel Wood explains the technical complexities of these glazes and discusses how they came to be developed to such a sophisticated way. This is a work of utmost importance both to the student of China and its arts and to the potter or craftsman who wishes to explore the extraordinary glazes that the Chinese achieved.

Jessica Rawson

# Author's Note

Chinese ceramics is a large subject, and there are many ways to approach it. The methods adopted in this book are largely technological – that is, the ceramics of China are examined through the natures of the clays and glazes used to make them.

My interest in this subject sprang first from my work as a potter in the 1970s – and from a wish to bring to my own ceramics some of the extraordinary qualities that I found in early Chinese stonewares and porcelains. To these ends I scoured the very sparse technical literature that existed on Chinese ceramics at the time, and also developed (or rather rediscovered) a glaze and clay calculation system that was capable of dealing with chemical analyses expressed as oxides by weight. My initial work on these lines was published in a small handbook for potters called *Oriental Glazes*.

Since *Oriental Glazes* appeared in 1978 there has been an avalanche of information on the technology of Chinese ceramics, particularly through the five large international conferences on the subject, held in China in 1982, 1985, 1989, 1992 and 1995. Until now much of this valuable research has existed only in limited edition conference proceedings, and one motive in writing this book has been to make this important work accessible to a wider audience.

In addition to all this new knowledge, gained from China itself, I have also been fortunate, since 1982, to have been involved in a series of research projects on Chinese ceramics – first with scientists and art historians at Oxford, and then at the British Museum and the Victoria and Albert Museum in London. Much of what appears in the following chapters is the result of this research and my gratitude to the many scholars with whom I have worked over the last 15 years, is profound and long-lasting.

This book has been a long time in writing, and some chapters have already been published in other forms and in other places. However, now that they are combined in one volume, I hope that a certain amount of self-plagiarism is forgivable for the sake of completeness. Although this is a large book, it is inevitably still only an introduction to the subject – but I hope that it will go some way towards explaining why Chinese ceramics look as they do, and also towards demonstrating the essential principles that have helped to carry Chinese glazes forward, with such distinction, and with such boundless variety, over a production history of more than three millennia.

# *Acknowledgements*

I am very grateful indeed to the many friends and colleagues who have helped me in the preparation of this book, particularly to Ian Freestone, Rose Kerr, Jessica Harrison-Hall, Rosemary Scott and Shelagh Vainker for reading various drafts of the manuscript over the years. Any errors or inaccuracies that remain must be entirely my own. I also owe a great debt to Mary Tregear for first involving me in scientific research into Chinese ceramics at the Ashmolean Museum, Oxford, in 1982, and also to Jessica Rawson and Rose Kerr for their subsequent invitations to help with research projects at the British Museum and Victoria and Albert Museum, respectively. I am also very grateful to Dr. Rawson for providing an introduction to this volume.

I owe special thanks to the University of Westminster, for granting me a sabbatical to finish this book, amongst other projects. I am also most grateful to Professor Michael Tite, for generously providing me with working space at the Research Laboratory for Archaeology and the History of Art, at Oxford, where I was able to complete this manuscript. I must also pay special appreciation to my editors, Linda Lambert and Emilie Nangle, for their great patience, good humour and practical advice, during the production of this book.

Anyone working in the field must also be deeply aware of the debt that they owe to research scientists in China – both for their exhaustive work on this subject, and also for organising the many international conferences on the technology of Chinese ceramics that have been held in Shanghai and Beijing since 1982. I am particularly grateful in this regard to Professors Li Jiazhi, Chen Xianqiu, Zhang Fukang and Guo Yanyi, of the Shanghai Institute of Ceramics, Academia Sinica – all leading scholars in this field since the late 1950s, and still actively contributing to it.

I must also thank the Chinese art departments of Sotheby's, Christie's and Carter Fine Art for their generosity in providing pictures for this volume.

Finally I would like to thank my wife and children, for bearing with me while I wrote this book

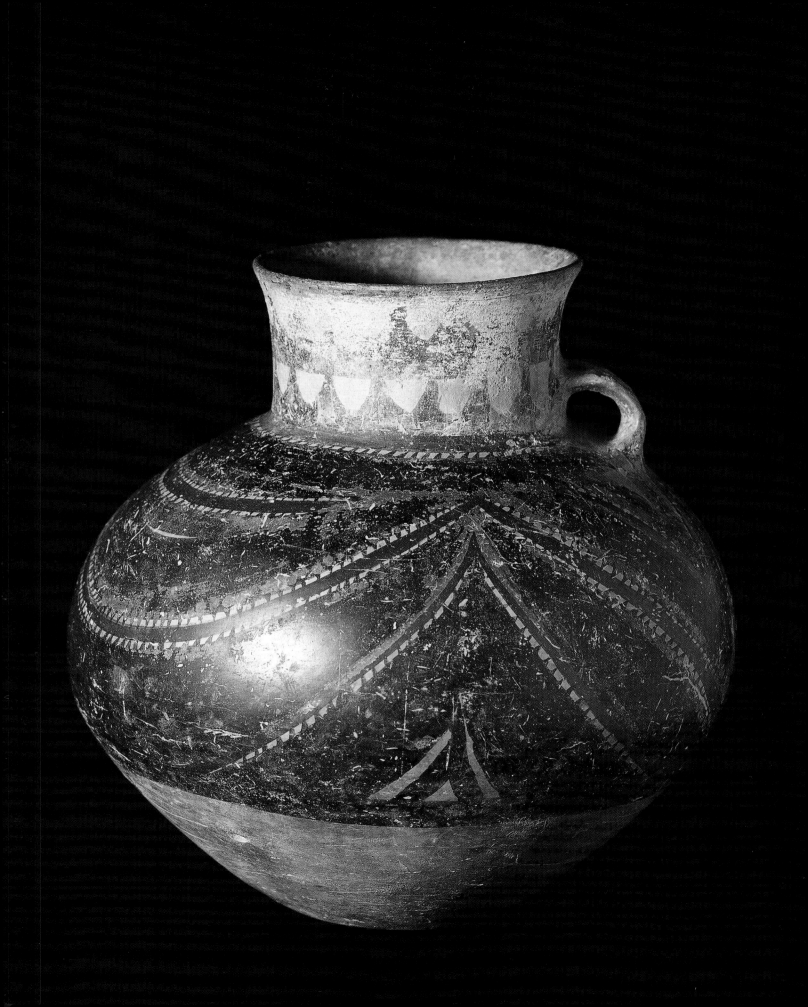

## Chapter 1

# NEOLITHIC AND BRONZE AGE CERAMICS

### *China's earliest ceramics*

Looking back to the very dawn of world ceramics we tend to assume that the very earliest fired clay objects must have been vessels of some kind. However recent excavations in both Central Europe and Northern Asia have shown that small ceramic sculptures of both humans and animals, and fired to perhaps only 600-800°C, may have been the earliest fired-clay objects made by man. A number of such finds have been made at Upper Palaeolithic (later Old Stone Age) sites in the former Czechoslovakia and Siberia that are dated to about 23000-13000BC. The use of naturally coloured clays for cave painting was also a feature of Upper Palaeolithic life – and early man and woman may well have used similar clays and ochres to paint their bodies. Red ochre has been found scattered around bones at an Upper Palaeolithic site near Beijing, and the material features in a number of Palaeolithic and Neolithic burials in Central Asia. In the later Stone Age (*c.*10000BC) ceramics advanced into the realm of fired pottery vessels, and eventually iron-rich clays, already long familiar as pigments for paints, and for use in burial rituals, proved ideal for creating permanent fired designs on hand-built pots.

Very few Upper Palaeolithic sites have so far been studied in China, so any similar figurines-to-pots evolution has yet to be proved or disproved for the country. The earliest ceramics yet found in China are still pottery vessels – such as those excavated from a cave in Wannian County, Jiangxi Province, in the south-central area, and carbon-14 dated to about 7000-6000BC. A single shape was used at the Wannian site for cooking, storing, eating and drinking. Pottery fragments of a slightly later date, and suggesting a greater variety of vessel form, have been found at Zhengpi Cliff in the far southern province of Guangxi. Huge quantities of small snail shells have been found in the Guangxi

caves inhabited by Stone Age man, together with masses of splintered elephant bone.

Life in Neolithic China developed rapidly with its later stages being marked by advanced social organisation and by an unusual skill in the applied arts. In fact, few peoples in the world can claim such enduring links with their Neolithic past as can the modern Chinese. The Chinese Neolithic age saw the beginnings of the country's great agricultural civilisation, as well as the emergence of such vital features of Chinese life as the weaving of silk, the carving of jade, and the use of lacquer. Designs on some Neolithic ceramics also supply evidence for China's first experiments with writing, which was to become the single most important unifying principle of Chinese cultural life – and buried deep within many modern Chinese written characters, are images taken from everyday Neolithic existence. A similar persistence of form can also be traced in ceramics, to the extent that it is not unusual in remote areas of China to see pottery vessels still in use that have exact parallels with local Neolithic styles.

Recent archaeological work in China has also demonstrated that Chinese Neolithic clay-workers were responsible for more than just pottery vessels. At one Neolithic site, near to the modern city of Zhengzhou in north China, part of an elaborate ceramic drainage system, constructed from interconnecting pottery pipes, has been found – while at another Neolithic village, to the northeast of Beijing, hollow clay figures, some more than three feet in height, and with eyes of inlaid turquoise, were unearthed. Discoveries such as these look forward to the complex imperial and civil engineering projects involving ceramics, and the huge armies of terracotta figures that became such important features of China's later ceramic history.

Gansu pottery oviform jar with iron and manganese-rich slip painting. Machang phase of Majiayao culture (*c.* 2300-2000BC). Gulbenkian collection, Durham.

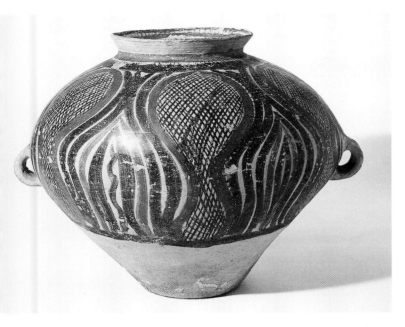

Gansu earthenware oviform jar, coil-built, beaten, scraped and burnished, then painted with black and red slips, Banshan phase of the Gansu Yangshao culture, 3rd-2nd millennium BC. British Museum. H. 11.8 in., 30.5 cm

## Banshan Yangshao ceramics

These aspects of Chinese Neolithic ceramics are still some-what unfamiliar to us in the West, where our image of Neolithic Chinese pottery tends to be based on the superb Neolithic burial jars made from the 4th to the 3rd millennia BC in the northwestern province of Gansu and known as Banshan Yangshao wares (from the Banshan phase of the Yangshao culture). These large and thinly-made pots were coiled, beaten, scraped and lightly burnished – and then painted with powerful whorls, circles and chequers of black and maroon slip. These Gansu jars are surprisingly light when handled, and this sense of fragility makes their survival for nearly 6000 years seem all the more extra-ordinary. In fact, these northwestern Neolithic wares are of such fine quality, and display such accomplished decoration that, if the Chinese had made no other ceramics in their entire history, they would still be counted among the world's greatest potters.

The physical lightness of the Banshan Yangshao jars comes partly from the hand-building skills of the Banshan potters (which show up well with modern x-ray techniques such as xeroradiography) but also from the kind of silty, lime-containing clays typical of the loess-lands of north-western China. Earthenwares of this type, fired in slight reduction, tend to burn more buff than red, due to the bleaching effect of calcium oxide on the iron oxides in the clays. Much of the impact of the Banshan painted designs derives from the Neolithic potters' skilful exploitation of the pale background colours of their clays as positive elements in their painted designs. Chemical analysis of these painted designs have shown that the black slips used to decorate these vessels were often natural umbers (that is, clays rich in iron and manganese oxides), while the maroon slips were probably ochres (clays with unusually high contents of iron oxides).

Chinese Neolithic wares from Gansu also display something that is harder to define, but which is fundamental to Chinese ceramics in general. It is an aspect well expressed by Michael Sullivan in 1967 when he wrote that:

'The forms of Chinese art are… in the widest and deepest sense harmonious… we can appreciate them because we too feel their rhythms all around in nature, and instinctively respond to them.'

Another important Chinese quality, evident in these large Gansu jars, is an obvious efficiency in production. Chinese potters tended to make their wares in large numbers, and this evidence of skilful dispatch in making, combined with a powerful sense of intended use, is another element in the lasting vitality of Chinese ceramics.

## Other Chinese Neolithic wares

Gansu Yangshao jars have come to be the main Chinese Neolithic wares on show in Western museums as hundreds of examples were collected from Gansu villagers in the 1920s and shipped to the West by the Swedish archaeologist Gunnar Anderson – unfortunately at some cost to the original site. However, the museums of China demonstrate clearly that these fine Gansu jars were simply one aspect of the enormous richness of Chinese Neolithic ceramic art. Quite different in spirit, but equally impressive, are the thin, black, carbonised earthenwares made by the slightly later Neolithic Longshan-culture potters of northeastern China. These wares can show an almost metallic precision in their making, and may well have been ceramic copies of beaten-metal vessels – although metal prototypes for these vessels have yet to be found. The extreme thinness (typically 1-3 mm) achieved by the Longshan blackware potters owed a great deal to skilful throwing and turning in order to maximise the precision of their profiles, and to create the finest practical sections.

Chinese Neolithic vessels were also made in human and animal forms, while in the northeastern province of Shandong the Longshan-culture wares show complex and ambitious designs with dramatic handles, full udder-like legs, and long, curved, beak-shaped spouts. Handled mugs, and jugs with well-fitted lids, both of surprisingly modern style, also feature among the Shandong potters' work – although many of these advanced shapes disappear entirely from the repertoire of Chinese ceramics with the end of the Neolithic age.

## Reduction and carbonising

Blackwares and greywares became important ceramics in China in the later Neolithic period, despite the fact that the firing processes used to create them tended to bring all the surface colours of the vessels to the same grey or black tones. The adoption of blackwares and greywares all but obliterated the impact of painted designs on Chinese Neolithic wares, and caused a rapid decline in the Neolithic slip-painting technique. This was a great loss to Chinese Neolithic art as the abstract slip-painted designs on the earlier wares were endlessly inventive, and included many powerful and rhythmic images that seem to have been refined from semi-realistic paintings of fishes, frogs and pigs, as well as from human faces and figures.

From the technical point of view, there seem to be important differences between how these grey and black clay colours were achieved. The greywares were usually made from iron-rich clays that were fired and cooled in a reducing atmosphere – that is, the kiln gases were rich in carbon monoxide and hydrogen. The potters achieved this state by cutting down the amount of air burning the fuel. The gases produced by this inefficient combustion 'reduced' any red iron oxide ($Fe_2O_3$) in the clay to its lower oxide state – black iron oxide (FeO) – giving the fired wares ashy-grey colours. This method was probably evolved to make the wares tougher as black iron oxide works as an efficient body-flux at temperatures above about 900°C. The

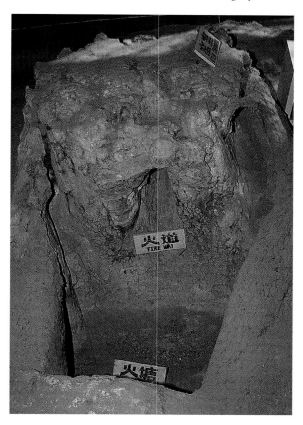

Foundations of a Yangshao culture Neolithic updraught kiln, Banpo Neolithic village, Shaanxi province, *c.* 4500BC. The roof to the firebox has collapsed, but the way that the fire was divided by slotted channels, before it entered the kiln chamber, can still be seen. Above this level a low circular wall probably contained the wares. In many simple updraught kilns of this type the wares were merely covered with shards, so a domed roof was not necessarily present.

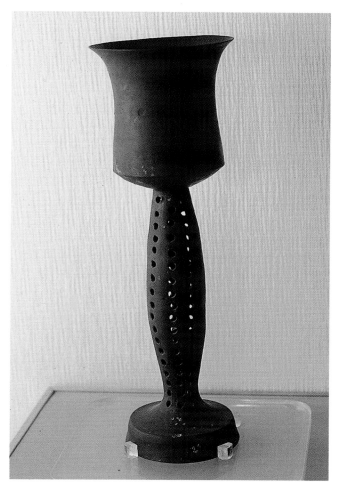

Fine black pottery cup with a tall perforated stem, Late Neolithic period (2800-2500BC), Late Dawenkou culture, Shandong province, north China. The intense black colour of the cup's clay seems to have come from the deliberate carbonising of the wares in the kiln. This could have been achieved through the production of black smoke at the end of the firing, perhaps by stacking the kiln with fuel and then clamming-up. The form shows a combination of fine throwing and fine turning, together with a careful joining of the thrown elements. Tall cups like these may have been used for drinking wine. Shanghai Museum. H. 7.5 in., 19 cm.

resulting iron silicate body-glasses helped to improve the strength of these wares in everyday use.

Neolithic blackwares seem to have been made using a different approach: their initial firings could have been either oxidising or reducing, and the clays they were made from were not necessarily rich in iron. However, at some stage during their cooling, the pots were exposed to smoke, which consists mainly of extremely fine carbon particles. This could have been managed either by filling the kiln's firebox with fuel, and then closing all the air-ways, or the pots themselves could have been surrounded with fuel and nearly all the air excluded. The intense black smoke thus generated penetrated deep into the hot porous ceramics, turning them to a fine black colour – a process known as carbonising. If the ceramics had been burnished before firing the result was a deep and glossy black.

From the evidence of the Chinese grey and black ceramics themselves, the greywares appear to have been generally utilitarian, while the more elaborate burnished blackwares seem to have been designed with some ceremonial purpose in mind. The fashion for blackwares declined somewhat in the Bronze Age, but unglazed grey ceramics persisted in China for at least another 2000 years and, in the form of grey bricks and tiles they remain a common sight in China today.

Perhaps as an indirect result of these new techniques, fired-on painting on Chinese ceramics went into abeyance for thousands of years, and did not reappear in any quantity until about the 8th century AD – when it was revived for glazed stonewares at the Tongguan and Qionglai stoneware kilns in south-central China.

### Bronze Age Chinese ceramics

Ceramics from China's early Bronze Age (the Shang Dynasty, *c.* 1600-1100BC) are generally regarded as inferior, both in design and finish, to the Neolithic ceramics that preceded them – indeed, Shang ceramics overall present a rather grim impression. The richness of ceramic invention, and the high status that Chinese ceramics enjoyed in the Neolithic age, seem to have waned early in the Shang dynasty, when cast bronze vessels began to replace ceramics for important ritual and burial uses.

Even so, what was lost to ceramics was more than gained by bronze. Not only are Shang ritual bronze vessels decorated with surface designs that are of quite amazing fineness and complexity, but their forms also include some of the most ambitious and powerful experiments in three-dimensional design in the whole history of art. Paradoxically, it was the very skill of Chinese clay-workers that allowed Chinese bronze casting to develop to such a pitch, particularly through a range of clay-based bronze-casting techniques that seem to have been unique to China.

Chinese bronze casting was a largely ceramic process until the last few seconds when the molten metal was poured into the mould.

### Chinese ceramics and bronze casting

Molten bronze alloy has no form of its own, so all the shapes (and almost all the decoration) seen in Shang bronzes had to be present in the original models from which the bronze-casting moulds were taken. These models were first made in dense and smooth clays, and

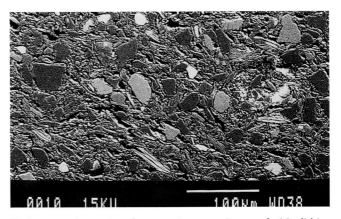

Back scattered scanning electron microscope image of a Neolithic earthenware shard from Banpo, Shaanxi province. Like the Gansu earthenware jars in the figure on page 12, many vessels at Banpo appear to have been made from the fine wind-blown rock dust known as loess that covers vast areas of north China. This is a fine, silty material of low plasticity, but very suitable for coiling and beating processes. By courtesy of the Department of Scientific Research, British Museum.

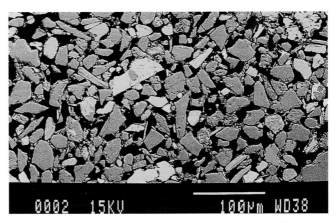

Back scattered scanning electron microscope image of a Shang casting mould from north China, also made from low-fired loess. Shang bronze-casting moulds seems to have used the same kind of raw material as the shard from Banpo (see above), but the finer fractions have been removed from the loess, probably to lessen its shrinkage in drying, and also to help gas absorption from the liquid metal during casting. By courtesy of the Department of Scientific Research, British Museum.

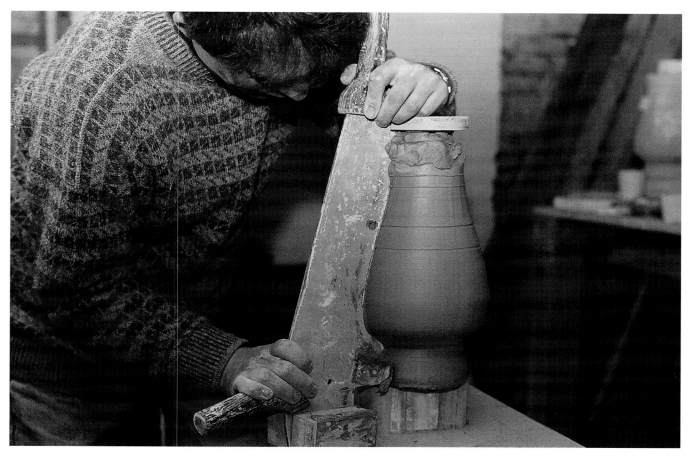

A 'running profile' technique was probably used to create the solid clay originals, from which Chinese bronze-casting moulds were taken, and the method is demonstrated here by the author. Profiles such as these were not suitable for refining the shapes of ordinary hollow clay vessels because friction would have buckled the soft clay forms. Nonetheless, the technique was eventually used successfully by Chinese potters for making solid models, from which press-moulds could be taken. For later Chinese stonewares and porcelains this was a popular method for creating formal vase shapes, often derived from ancient bronze forms.

then allowed to stiffen to the hard-leatherhard state – at which point they could be decorated with a combination of engraving, modelling, sprigging and carving. Once the solid model of the bronze was complete a fine-grained, low shrinking, silty clay called loess was applied to the model to produce a series of bronze-casting mould sections. These loess sections were easily removed from the solid clay models for drying and firing, and were designed so that they later fitted together perfectly – using simple joints, similar to those seen on modern slipcasting moulds made from plaster.

After a light biscuit firing, the various pieces of the ceramic casting moulds were set into place around suitable porous ceramic cores, and the whole assemblage tightly bound to contain the molten metal. Molten bronze could then be poured into the mould through channels left by the mould maker. The liquid metal (mainly copper and tin, but with a small percentage of lead to make it more fluid) filled the gap between outer moulds and core to make the hollow

vessel. Once the casting had cooled somewhat, the outer moulds were knocked away, the soft and porous cores were broken out, and the new bronze vessel was fettled and cleaned.

From the evidence of the Shang vessels themselves, and the thousands of Bronze Age mould fragments that have survived in China, these clay models and fired-loess casting moulds were disposable masterpieces of ceramic design and engineering – and far more accomplished in their making techniques than anything attempted by Shang potters producing pottery vessels.

### Shang model-making techniques with clay

The sophistication and precision seen in Shang bronze forms seems to have depended on the discovery of a model-making technique that used rigid formers, cut to the intended profiles of the bronze vessels. These profiles were swept around solid masses of plastic clay that had been packed around short vertical posts. At the tops and bottoms of the posts were attached rigid horizontal sections, cut to

the same cross-sections as the intended vessels. These guided the profiles as they were pulled around the solid clay models and ensured that correct cross-sections were maintained throughout the vessels' forms.

These techniques resulted in solid clay models of round, oval, square or rectangular section that showed remarkable mathematical subtlety and precision. When decorated with fine carving, and further embellished with applied clay details, they became the solid originals from which the ceramic bronze-casting moulds were taken.

Unfortunately for Shang potters, this was not a method that lent itself easily to hollow vessel-making: if applied to coil-built forms, the friction from the rigid profiles would have caused the thin pots to crumple and collapse as the profiles were swept around the soft vessel shapes. Also, the idea for using the hollow bronze-casting moulds for press-moulding ceramic forms using thin clay slabs does not seem to have occurred to Chinese potters until quite late in the Bronze Age – although, once discovered, the technique was used regularly for making inexpensive pottery copies of bronzes for burial use. Much later, these same model and mould-taking techniques were adopted by Chinese potters for the production of impressive glazed ceramics of non-round section. These were usually made in stoneware or porcelain and intended for display in palaces or temples.

These new and sophisticated clay-working techniques therefore remained largely the province of the Shang bronze mouldmakers, while Shang potters continued with their familiar Neolithic techniques of coiling, followed by smoothing, then beating with a 'paddle and anvil', and then sometimes finishing on a slow wheel. Shang ceramics that have obviously been thrown on a fast wheel are less abundant.

## Shang high-fired glazes

Although forming techniques for Shang ceramics remained fairly static throughout the dynasty, it was still a time for important advances in kiln design and firing methods, and these soon resulted in the production of the world's first glazed stonewares. Some of the earliest examples so far found of Chinese glazed stoneware were uncovered in the mid-1980s at an early Shang (late Erligang period) site called Yuanqu in south Shanxi province in northern China. The site dates to the fourteenth century BC, and amongst a mass of rather ordinary grey and black Shang wares were found a few shards of tough, high-fired ceramic, with hard, thin, greenish glazes. These are among the earliest high-fired glazed ceramics so far discovered in

Shang ash-glazed vessel, Shanghai Museum.

China, and also in the world. Similar but slightly later wares have been excavated at many Shang sites in China over the last 25 years, and about half a dozen complete Shang glazed stoneware vessels have now been found, or have been rebuilt from broken pieces.

Some idea of the enormous lead that China holds with its experience of high-fired glazes comes from realising that these Bronze Age glazed stonewares were made nearly 3500 years ago – some 2000 years before the first glazed stonewares appeared in Japan and Korea, and more than 3000 years before high-fired glazes were produced in the West. By the time low-fired earthenware glazes came to be used on Chinese ceramics, the high-fired stoneware tradition in China was already at least 1000 years old.

These northern finds are therefore very significant in their own right – but what is proving particularly puzzling to archaeologists and to ceramic scientists in China is that the body compositions of these very early glazed stonewares found in north China seem far more closely related to southern Chinese clays than to any stoneware clays so far found in the north.

At the time of writing, it is generally believed that these very early examples of Chinese glazed stonewares were actually made in the south of the country, and then transported hundreds of miles to the developing fortified cities

Late Shang bronze *hu* vessel from north China, probably a wine container, 13th to 12th century BC. The precision of form, the oval cross-section, and the raised and sunken lines on the vessel's surface, all suggest use of the model-forming technique illustrated in the figure on page 15. H. 12.2 in., 32 cm. British Museum, OA 1983.3–18.1.

Two ash-glazed stoneware vessels, Western Zhou period (11th century–770BC); excavated in Luoyang but probably made in south China. Luoyang Museum, W. 8.7 in., 22 cm.

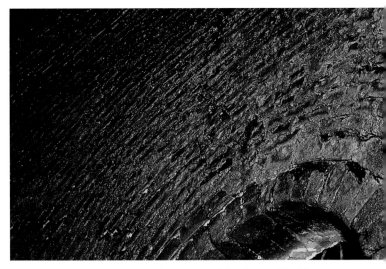

Natural ash glazing on the inside of a wood-fired porcelain kiln at Jingdezhen. The fluxes present in white-hot wood ash (mainly calcium and potassium oxides) are carried through the kiln by the draught of the fire, where they react with clay in the kiln's bricks to make a stoneware glaze. Observation of this effect may have lead to China's first experiments with applied glazes in the early Bronze Age.

in the Yellow River area. What is odder still, is that no Shang glazed stonewares so far excavated in north China seem of undeniably northern composition – despite the wealth of high-firing clays that can be found in north China, and which were later used so successfully for northern glazed stonewares, from about the late 5th century AD to the present day.

One possible explanation for the slow development of glazed stoneware in north China might be that the fusible clays commonly used for Shang everyday wares in the north would have melted if fired to low stoneware temperatures. In south China, by contrast, many Shang 'earthenware' clays were simply underfired siliceous stonewares, fired in reduction to exploit the greater strengths that are possible from the fluxing effects of black iron oxide.

Greater heat in firing (intended to render these southern wares tougher still) would have transformed many of them into stonewares, and would also have resulted in areas of natural ash-glaze developing, both on the pots themselves and on the insides of the kiln walls. From here onwards it would have been a short step to the deliberate glazing of ceramics with wood ash/clay mixtures.

However, this neat scenario does not quite explain why Shang potters in the north tended to ignore their abundant reserves of natural stoneware clays – using them only on a small scale to make a few whitewares in the late Neolithic age, and also for some unglazed hand-built Shang vessels ornamented with complex carving and engraving. Possible reasons for this very limited use of northern stoneware clays include their relative geological inaccessibility (due to their much greater age of deposition), and their poor fired-strength at traditional earthenware temperatures (about 1000°C in the north).

The unglazed Shang whitewares, mentioned above, are the only Shang dynasty wares from north China so far discovered that are made from true stoneware materials, and fired to anything approaching true stoneware temperatures (1150°C in one case). The exact status of Shang whiteware is discussed more fully in Chapter Five, but some scholars believe that they may have been copies of Shang carved marble vessels.

The evidence suggests therefore that south China was the birthplace of glazed stoneware in China, with the first glazes apparently based on wood ash. It seems very likely that the first use of ash in glazes developed from Chinese potters' observations of the natural glazes that built up on pots, kiln walls and fire-pits, when wood-burning kilns began to be fired to higher and higher temperatures (e.g. 1150-1250°C) in the early Bronze Age.

## Shang glazes

Examples of these very early, accidentally ash-glazed wares have yet to be found in China. What have been excavated so far are pots that show the second stage in glaze development whereby wood ash (either by itself or mixed with clay) has been carefully applied to the pots by brushing, dipping or pouring – usually on both the inside and outside surfaces of the vessels.

### Compositions of Shang stoneware glazes

As might be expected from glazes based on materials as variable as wood ash, Shang stoneware glazes cover a wide

Table 1 *Compositions of Shang stoneware glazes*

|  | $SiO_2$ | $Al_2O_3$ | $TiO_2$ | $Fe_2O_3$ | CaO | MgO | $K_2O$ | $Na_2O$ | MnO | $P_2O_5$ |
|---|---|---|---|---|---|---|---|---|---|---|
| Shang glaze | 54.6 | 14.5 | 1.4 | 2.6 | 19.3 | 2.7 | 3.5 | 0.8 | 0.3 | 1.8 |
| Shang glaze | 57.7 | 14.0 | 2.9 | 0.7 | 15.4 | 2.5 | 3.9 | 0.8 | 0.3 | 1.4 |
| Shang glaze | 60.8 | 16.7 | 0.9 | 4.4 | 10.6 | 2.1 | 2.4 | 0.2 | 0.4 | -.-★ |
| Shang glaze | 58.9 | 15.5 | 0.6 | 1.7 | 13.0 | 2.0 | 4.7 | 1.1 | 0.4 | -.- |

Table 2 *Compositions of typical mixed wood ashes from Chinese sources*

|  | $SiO_2$ | $Al_2O_3$ | $TiO_2$ | $Fe_2O_3$ | CaO | MgO | $K_2O$ | $Na_2O$ | MnO | $P_2O_5$ |
|---|---|---|---|---|---|---|---|---|---|---|
| Wood ash | 39.8 | 15.1 | -.- | 3.6 | 23.5 | 4.1 | 5.8 | 1.5 | 4.3 | 2.3 |
| Wood ash | 57.8 | 12.2 | 1.0 | 2.9 | 11.4 | 3.9 | 6.8 | 0.2 | 1.9 | -.- |
| Wood ash | 38.7 | 7.8 | 0.5 | 2.0 | 21.2 | 1.6 | 1.7 | 0.8 | 0.1 | -.- |
| Wood ash | 39.4 | 11.3 | -.- | 3.8 | 28.5 | 4.2 | 4.9 | 3.0 | 1.6 | 2.4 |
| Wood ash | 57.1 | 14.75 | -.- | 6.1 | 8.0 | 2.3 | 5.3 | 0.4 | 2.2 | 1.7 |

compositional spread – from high-alkali versions to those that are rich in calcium oxide. Glaze types that are both low and high in iron oxides were also in use at this time (see Table 1).

These glaze compositions may be compared with typical wood-ash analyses (see Table 2).

Many of these glazes are yellow-green, while others are dark amber or brown. Sites in southern China so far identified as production centres for Shang glazed stonwares are mainly in Jiangxi province (including villages such as Taishan, Wucheng and Jiaoshan), and at various districts in Jiangsu province, particularly near the lake-side city of Yixing.

## Later Bronze Age ash-glazed stonewares

Chinese glazed stonewares from the second millennium BC are still very scarce, but rather more abundant in recent finds are stonewares from the period 1000-500BC, and these may include a few genuine examples of northern high-fired glazed wares. However, the great majority of early glazed stonewares excavated in north China still seem to be of southern origin – and this suggests that an increasingly efficient high-fired ceramic industry was operating in the south, particularly in the provinces of southern Jiangsu, Jiangxi and northern Zhejiang – all areas that were later famous as producers of grey-green glazed stonewares, particularly in the period from about 200BC to AD1100.

Chinese glazed stonewares from about 1000 to 500BC can be impressive in scale and include some barrel-shaped jars with high domed lids. These are carefully glazed both inside and out with thick green-grey ash glazes, with their outer surfaces decorated by stamping, engraving, sprigging, rouletting and wavy combing – as well as by the more ancient technique of beating with a cord-wound paddle.

Later Bronze Age ash-glazed ceramics from the Spring and Autumn period (771–481BC). The jar was made by coiling and the footed dish by throwing. Forms similar to the jar were still being made in China in the 1980s by hand-building (see figure on page 20).

Table 3 *Compositions of typical Western Zhou stoneware glazes*

|  | $SiO_2$ | $Al_2O_3$ | $TiO_2$ | $Fe_2O_3$ | CaO | MgO | $K_2O$ | $Na_2O$ | MnO | $P_2O_5$ |
|---|---|---|---|---|---|---|---|---|---|---|
| W. Zhou glaze | 50.0 | 12.1 | 0.5 | 1.7 | 25.2 | 3.52 | 3.2 | 0.5 | 0.7 | 2.0 |
| W. Zhou glaze | 54.3 | 21.4 | 0.7 | 2.2 | 13.8 | 2.1 | 3.7 | 0.6 | 0.4 | -.- |
| W. Zhou glaze | 56.1 | 13.9 | 0.7 | 1.7 | 18.9 | 3.4 | 2.4 | 0.5 | 0.5 | 1.4 |

★Note: '-.-' means either that the oxide was not looked for in analysis – or that it was sought but not found. (The analyses used in this book come many different sources, and not all analysts make this distinction – hence the adoption of this convention. More complete analyses in the same table will usually give some idea of the percentage ranges that the missing figures should fall into.)

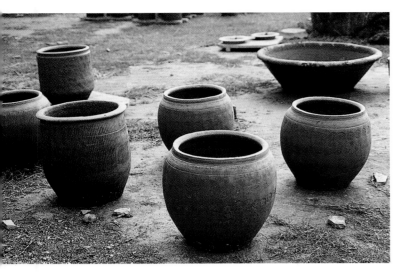

Coiled, beaten and stamped jars photographed in 1982 at a country workshop some 18.5 miles (30 km) south of Jingdezhen, in Jiangxi province. Northern Jiangxi was an important site for glazed stoneware production in the Bronze Age, and local pottery forms still echo the ancient styles.

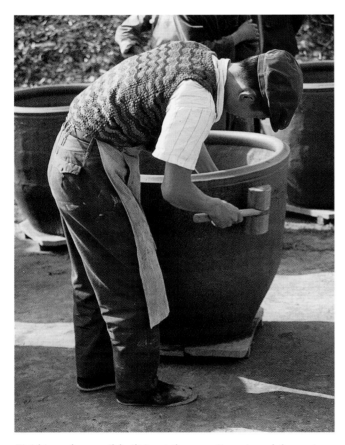

Finishing a large coil-built jar at the same Jiangxi workshop using a wooden paddle outside and a rounded fired-clay 'anvil' inside the form. Coiling in China tends to be a dynamic process with coils of soft clay, as thick as the potter's arm, being pulled up rapidly with the fingertips. The final consolidation, and much of the shape, is achieved by beating.

Most examples show signs of being coil-built and finished on a slow wheel, but a few of the later and smaller pieces appear to have been thrown direct. Evidence for the use of a fast wheel can be seen in their closely-spaced throwing ridges, and in the fine horizontal combed lines used to decorate them. The great majority of these wares derive from southern sites, or show typically southern Chinese body compositions.

### Warring States glazed stonewares

Some of the most accomplished examples of glazed stoneware from China's late Bronze Age are dated to late in the Warring States period (475-221BC). For the most part they are small, neat and simplified copies of bronze originals, often showing applied, engraved and stamped details taken from contemporary bronze ornament. Small bronze vessels with round cross-sections served as the models for these wares, as these forms could easily be copied by throwing. Warring States ceramics are made from fine siliceous stoneware clays with yellowish, greeny-grey or dark brown glazes, and they show body compositions typical of southern Chinese ceramics.

These stoneware imitations of bronze vessels (apparently made for burial use) firmly established Chinese ceramics as a material in which low-cost copies of expensive objects could be made – with bronze and lacquer vessels supplying the usual models. Once this principle had been established, Chinese ceramics only rarely regained the high status that they had enjoyed in the Neolithic age. When bronze casting eventually declined in China, beaten silver and gold plates, bowls, dishes and ewers, and fine lacquer vessels replaced cast bronze vessels as models for the finest Chinese stonewares and porcelains.

Ceramics copied from beaten metal and lacquer objects became particularly common in China during the Song dynasties (AD960-1279) – although these borrowings are not always so obvious as they are with cast bronze. Paradoxically, the making methods of metalsmiths and lacquer-workers tended to produce more 'plastic' forms than the solid, severe and rather massive shapes favoured by Chinese bronze casters – and this makes the origins of many later Chinese ceramic designs less immediately obvious to the viewer. Chinese lacquer and beaten-metal vessels have also survived in far fewer numbers than the ceramics they inspired, and this has also helped to obscure the vital roles that they have played as prototypes for so many familiar Chinese ceramic shapes.

Nonetheless, the fact that so many ceramic forms and designs in China were borrowed from more expensive materials in no way detracts from their undoubted qualities as works of art – it simply places ceramics within the general hierarchy of materials used in China. The qualities

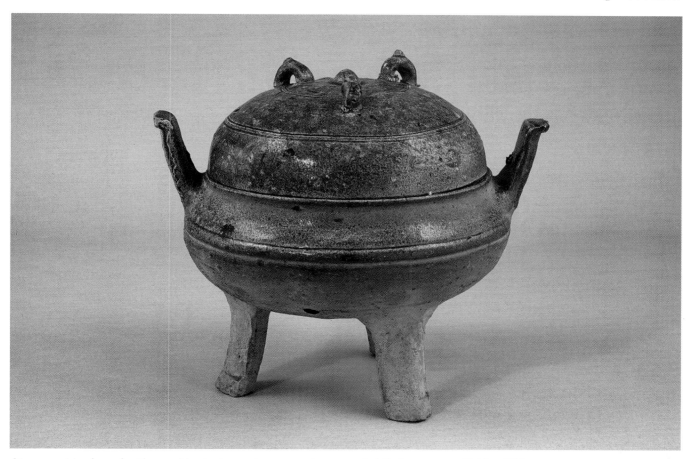

Stoneware tripod vessel with greenish ash glaze and cover, southern type, 3rd–2nd century BC. H. 7in., 17.7 cm. Ashmolean Museum, Oxford, 1956.932.

of Chinese high-fired clays and glazes (particularly those used later for Song stonewares and porcelains) were often superior to the metal and lacquer materials that they imitated, and a further aid to ceramic expression is the degree of subtlety that throwing can give to pottery forms – rather as life is imparted to calligraphy through slight nuances of brushwork.

## Protoporcelain wares

Despite their importance in ceramic history, only a small proportion of the high-fired ceramics that were made in southern China during the Bronze Age were actually glazed: the standard southern stoneware material at this time was a grey 'stamped ware' – unglazed, reduction-fired and decorated by textile impressions, by beating with cord-wound paddles, or by stamping with repeating designs. These greyish unglazed stonewares saw widespread use in southern China, and similar-looking wares, made from common earthenware materials, provided the typical ceramics of the north.

Amongst these more ordinary wares the rare glazed stonewares described above supplied an important, if rather tenuous, continuity for the principles of high-temperature

glazing in south China – and this technology began to consolidate and expand in about the 3rd century BC, when some cast bronze-derived vessels, once known in the West as 'protoporcelain' wares, began to be made. These owe their name to the early 20th-century scholar Berthold Laufer who found some genuine compositional similarities between these wares and the later porcelains of southern China. The term protoporcelain is more popular in China than it is in the West as the Chinese word *ci* (porcelain) embraces wares that are dense and resonant, as well as those that are obviously white and translucent.

These lively protoporcelain wares were made from about 300BC to AD200, and are mostly large jars, either almost globular in shape with slightly flattened and thickened rims, or rather leaner in form with tall flaring necks. Also included in this group are some large round, covered boxes of lacquer style – although these latter wares are less common in Western collections.

The green or brown ash glazes used on protoporcelain wares are largely confined to the tops and shoulders of the vessels, below which the glazes fade away beneath the fullness of the forms. These slightly mottled ash glazes also tend to thin, and then to disappear entirely, under flaring

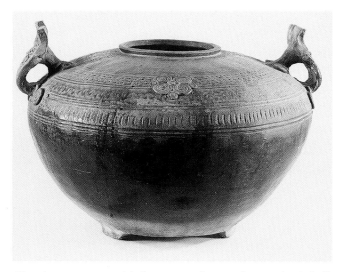

Glazed stoneware vessel in bronze *pou* form, perhaps with a 'sifted' or 'sprinkled' ash glaze, Western Han dynasty, 2nd century BC and probably from northern Zhejiang province, south China. H. 10.5 in., 26.5 cm. Gemeentemuseum, The Hague.

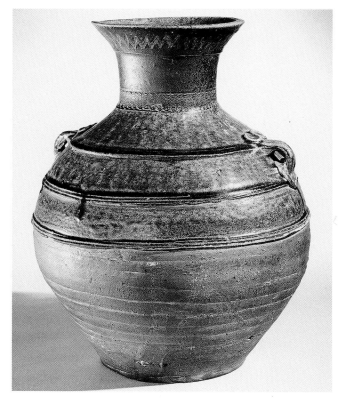

Greenish ash-glazed jar from south China with red-brown stoneware body, 1st century BC to 1st century AD. The distribution of this glaze suggests that it was probably achieved by sifting ash or a clay-ash mixture over the raw clay (the glaze is also heavier inside the flaring rim and at the bottom of the jar, inside). Although fired in reduction, the exposed clay has re-oxidised strongly in cooling to give a reddish brown surface. The ridges prevented the molten glaze from running at full heat, while at the same time evoking a general cast-bronze style. H. 13.5 in., 33.8 cm. British Museum, OA1973.7–26

rims, and also beneath the flat, strap-like handles that are often applied to the shoulders of these vessels – another feature borrowed from earlier cast-bronze designs. Round patches of glaze are often found inside these wares, at the very bottom of the vessels, and with the same diameter as the vessel's rim.

This very curious distribution of glaze has long puzzled historians of Chinese ceramics, and it was thought until quite recently that these glazes were either natural, and due to ash carried through the kiln by the draught of the fire, or that they were applied by some primitive form of spraying. However another possibility – proposed by the author on the basis of similar techniques used for English medieval lead-glazed wares – is that these stonewares were deliberately glazed by sifting ashes (or ash-clay mixtures) directly over the pots before firing – with the powdered glaze materials only resting on the semi-horizontal surfaces. In English medieval wares the pots were first brushed with a flour-water paste to encourage the dusted glaze materials to stick, and a similar technique may have been used in China, perhaps using rice-gruel (congee) as a glue. During firing the wood ashes (or wood ash/clay mixtures) would have reacted with the clay bodies to give lime-rich stoneware glazes. This 'sifted glaze' idea is still only a theory,

but it may explain the curious ways in which these glazes are distributed.

Han protoporcelain wares can be magnificently thrown, with their full but well controlled forms displaying unusual power and presence. These large Han jars seem to have been utilitarian rather than strictly burial vessels, and may have been important in the transport of food or the brewing and storage of wine. They seem to have been traded to north China, where they occasionally feature in burials. A similar style of ware was also made in the far south of China, in what is now Guangdong province and northern

Table 4 *Protoporcelain glazes of the Eastern Han dynasty (AD25-220)*

| Province | $SiO_2$ | $Al_2O_3$ | $TiO_2$ | $Fe_2O_3$ | CaO | MgO | $K_2O$ | $Na_2O$ | MnO | $P_2O_5$ |
|---|---|---|---|---|---|---|---|---|---|---|
| Hunan | 59.2 | 14.5 | 0.7 | 1.5 | 17.7 | 1.8 | 2.7 | 0.2 | 0.3 | 1.3 |
| Hunan | 58.8 | 13.1 | 0.6 | 2.2 | 18.3 | 1.8 | 3.0 | 0.7 | 0.4 | 1.0 |
| Zhejiang | 61.6 | 13.7 | 0.6 | 2.4 | 14.2 | 1.5 | 1.9 | 0.8 | 0.5 | 0.7 |
| Zhejiang | 58.9 | 12.7 | 0.6 | 1.5 | 19.1 | 1.9 | 1.8 | 0.7 | 0.4 | 0.9 |

(The Hunan glazes are from the Qingzhusi kiln, the Zhejiang glazes are from the Shanglinhu kiln.)

Vietnam. The stonewares seem softer here and the ash glazes used with them have often flaked away with time but, once again, the making skills of the local potters were outstanding.

### Splashed protoporcelain

A number of Han protoporcelain wares (particularly in Chinese museums) show splashes of a whitish or bluish opalescent glaze on their shoulders. Some of these splashes must have occurred when glassy, ash-rich drops fell from the roofs of the wood-burning kilns during firing – an effect known in China as 'kiln sweat' In present-day China the insides of well-used, wood-burning kilns are often hung with thousands of small stalactites of ash-rich slag, and these can drip glaze onto the wares at the height of the firing. However, in some cases, the regular placing of these bluish or milky areas suggests that the splashes may have been added before firing – perhaps using a thick ash-rich mixture applied with a brush.

Han protoporcelain wares share with the Banshan Yangshao earthenwares an enormous accomplishment (not to say relish) in the control of extreme clay forms – but in their bodies and glazes they look forward to the achievements of the countless stoneware kilns that were to develop throughout southern China over the next thousand years. These kilns established the famous southern green-ware tradition upon which Song potters were able to base their celebrated achievements with monochrome glazed stoneware. Southern greenwares relied for their success on the Shang discovery that clay plus ash equalled glaze, and they saw their most important development in the areas that manufactured the best of these protoporcelain wares – the northern part of Zhejiang province and the southern areas of Jiangsu.

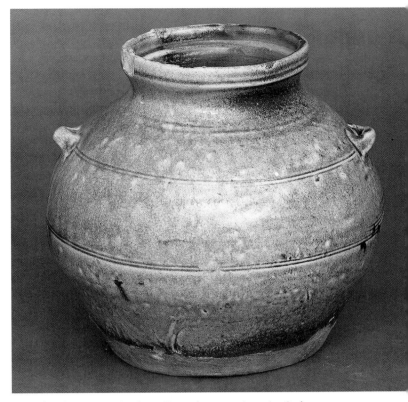

Ash-glazed stoneware jar from Guangdong province, 1st-2nd century AD. In the far south of China many stoneware clays are rather refractory, perhaps as a result of tropical weathering. These soft-looking ash-glazed stonewares are characteristic of this area and period, and they tend to have glazes that cover more than just the upper halves of the vessels. H. 6 in., 15 cm. British Museum.

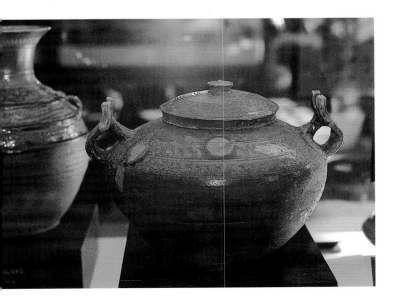

Stoneware covered vessel of bronze *pou* form, with 'sifted' ash glaze, and thicker ash-glaze splashes, in the Museum of Chinese History, Beijing. Thicker glaze on the vessel's handles suggests that some 'splashes' may have been added deliberately. Early 3rd or late 2nd century BC.

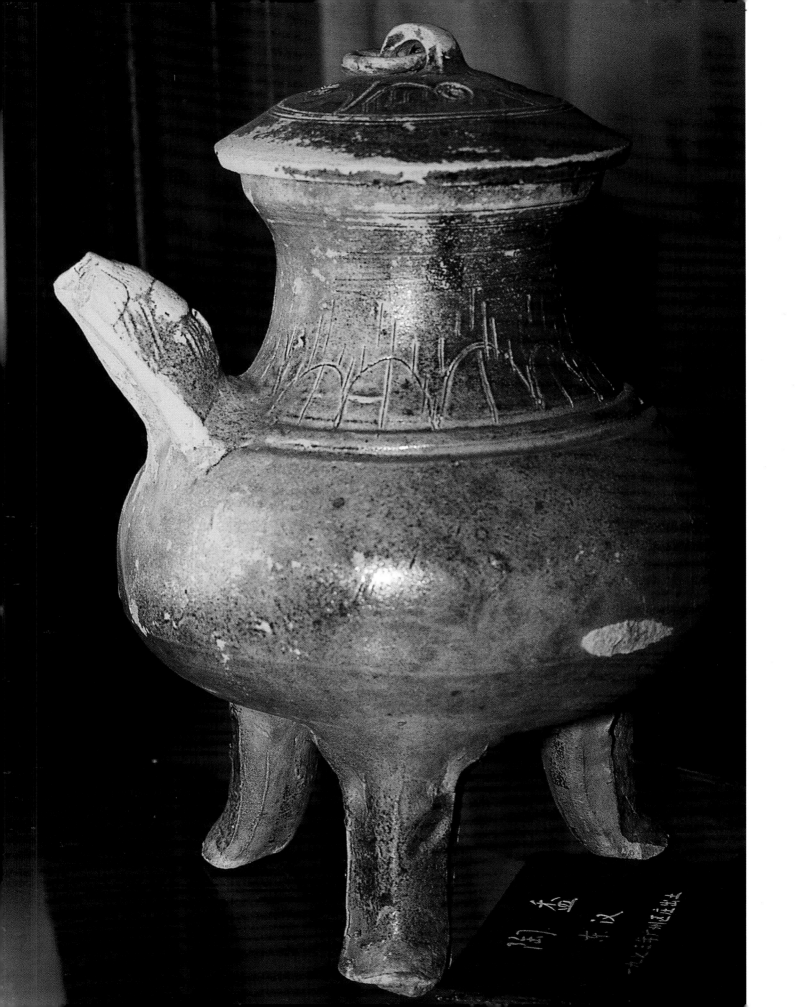

## FURTHER READING

*BOOKS AND EXHIBITION CATALOGUES*

Department of Archaeology at Peking University, *Treasures from a Swallow Garden – Inaugural Exhibit of the Arthur M. Sackler Museum of Art and Archaeology at Peking University*, Cultural Relics Publishing House, Beijing, 1992

Institute of Archaeology (Chinese Academy of Social Sciences), *Select Archaeological Finds*, Science Press, Beijing, 1993

Shelagh Vainker, *Chinese Pottery and Porcelain*, British Museum Press, London, 1991, pp 12-37

*PAPERS AND ARTICLES*

Pamela Vandiver, 'Technical Studies of Ancient Chinese Ceramics', *New Perspectives on the Art of Ceramics in China*, (George Kuwayama, ed.), Los Angeles County Museum of Art, 1992, pp 116-40

Nigel Wood, 'Chinese puzzles from China's Bronze Age', *New Scientist*, no. 1652, London, 1989, pp 50-53

Yang Gen, Zhang Xiqiu and Shao Wengu, *The Ceramics of China – the Yangshao culture to the Song Dynasty*, Science Press, Beijing and Methuen, London, 1985, pp 1-44

Zhang Fukang, 'The origin of high-fired glazes in China', *Scientific and Technological Insights on Ancient Chinese Pottery and Porcelain*, Science Press, Beijing, 1986, pp 40-45

Stoneware spouted vessel with three legs and a cover, Eastern Han dynasty, 1st century AD, perhaps from Hunan or Guangdong province, south China. Softer clays and flaky glazes typify Han stonewares from the far south of China.

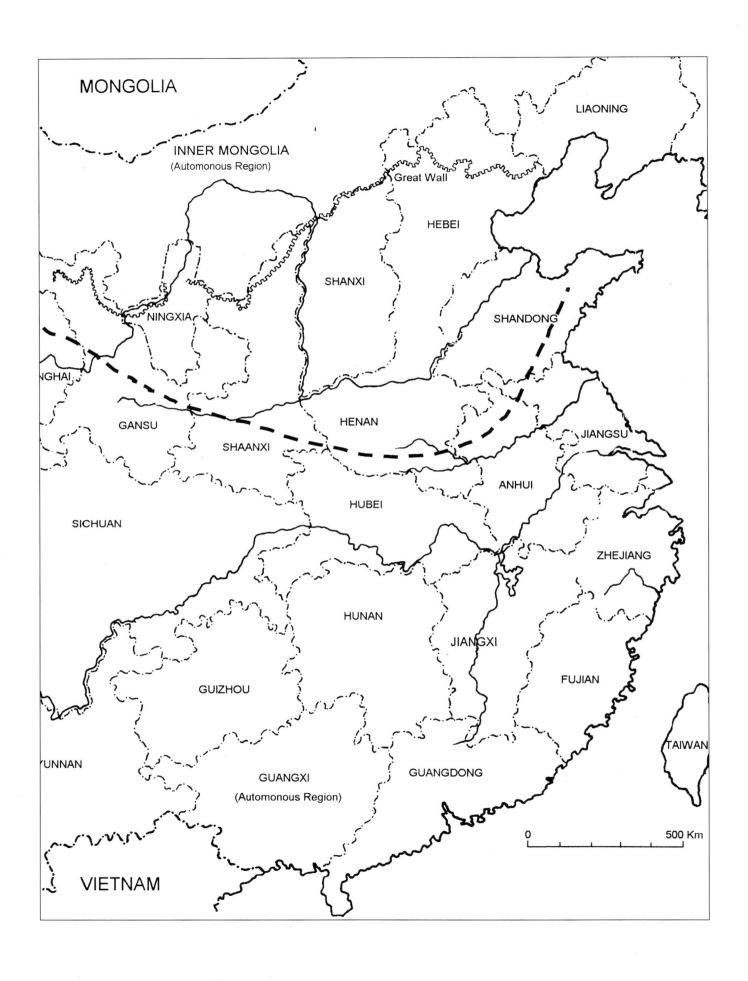

# Chapter 2

# SOUTH CHINA'S EARLY LIME GLAZES

## South China

South China is a cultural and geographical entity that takes in most of the area south of a line known as the Nanshan-Qinling divide. This imaginary line follows the Nanshan and Qinling hill systems that cross China from west to east, then runs north of the Huai river (see map). The Nanshan-Qinling divide broadly separates the wheat-and-millet lands of northern China from the mainly rice-growing provinces of the south. It also marks a southern boundary to north China's dusty but highly fertile loess lands – sometimes known as the 'Loess plateau' and the 'Great Central Plain'. This division also represents an important climatic change, with average winter temperatures falling below freezing north of the divide, and above freezing below it.

So important are these differences that the Nanshan-Qinling axis has often featured in Chinese history as a true line of demarcation. For example, when China was divided after the Jurchen Tartar invasion of AD1127, the frontier between the Tartars and the Southern Song tended to follow this general course. The concepts of North and South, so fundamental to China's own view of its history, also divide on this line – with the heart of north China being considered as the provinces around the Yellow River area (particularly Shaanxi, Henan, Shanxi and Hebei), and the traditional south as the main provinces around the Yangzi delta, but also including Zhejiang. These were the two ancient 'nuclear areas' of Chinese civilisation, and the most active contributors to its early history. In reality the centres of these two areas are only some 400 miles apart, while the modern extremes of northern and southern China are divided by a distance of nearly 3400 miles.

It can be seen from the above that there is some scope for confusion regarding the traditional view of the north and south of China, and the true extent of China today.

This ambiguity is an issue that has been faced squarely by the ceramics historian Yutaka Mino who, for his own writings, has renamed the traditional south as the 'east-central region' – reserving the term 'south' for the truly southern provinces of Guangdong, Guangxi, southern Jiangxi and Fujian.

While Yutaka Mino's new classifications are entirely logical, the older sense of north and south China has been retained for the present book, in conformity with most modern Chinese writing on ceramic history. The reason for this is mainly technological, in that the Nanshan-Qinling divide also marks a profound change in the types of raw materials that have been used to make ceramics in China. This is a difference that holds true for China as a whole, with wares from Inner Mongolia being as much a part of the northern technical tradition as the wares from Henan. Equally, Chinese ceramics from the far southern provinces of Yunnan and Guangdong are related closely in their raw materials to the 'classic' southern wares from Jiangxi and Zhejiang provinces.

The existence of this important compositional change, dividing ceramics made above and below the Nanshan-Qinling axis, is probably the single most important discovery concerning the technology of Chinese ceramics that has been made over the last half century. In retrospect we can see that this difference has had a profound effect on the ways that high-fired ceramics have developed in China, as well as on the types of glazes that have been used with them. A further influence of this important division is seen in the very different ways that kiln designs and firing temperatures evolved in the north and the south of China respectively – as these were developed to deal both with local raw materials and with the types of fuel available in these very different geological areas.

Map of China showing the main cities and kiln sites and the course of the Nanshan-Qinling divide, marking the division of north China from south China (dotted line). Above the divide, stoneware and porcelain raw materials are rich in clay minerals while stoneware and porcelain 'clays' south of the divide tend to be rock based and rich in fine quartz and micas.

## Raw materials for Chinese ceramics

The contrast between the essential natures of northern and southern raw materials, just described, seems to have depended more on differences in surface geology than on particular preferences on the part of the Chinese potters. Northern high-fired ceramics are (and were) made from materials unusually rich in true clay minerals – with most of these materials deriving from sedimentary geologies, that is, the settling out of wind-borne or water-borne particles into beds of rock or clay. South Chinese ceramics by contrast were often made from igneous rocky materials that were originally molten rock (magma). These southern materials contain relatively small amounts of true clay, but a great deal of fine quartz and secondary potassium mica. This makes the ceramics of south China low in aluminium oxide (a major component of clay minerals), and high in silicon and potassium oxides, from their quartz and mica

contents respectively. North Chinese ceramics, however, tend to be rich in alumina, from their high clay contents, and low in potassium, from their low mica contents.

Because of these differences the words 'aluminous' and 'siliceous' are often used by ceramic technologists to describe the high-fired wares of north and south China respectively – and it is the very consistency of this clay-rich/quartz-rich divide that has made Chinese scientists so certain that the Shang glazed stonewares that have been excavated in north China were actually made by potters in the south of the country.

## Materials for high-fired ceramics in south China

As indicated above, a great many southern wares appear to have been made from raw materials that were closer in nature to rocks than to clays – in particular to the kinds of altered and weathered igneous rocks from which most clays derive. Much of this material dates from a period of violent volcanic activity that occurred throughout southern China some 140 million years ago, during the change from the Jurassic to the Cretaceous periods, with many of these southern raw materials deriving from compacted volcanic dusts. Strictly speaking some of these rocks may be sedimentary too, as they result from the settling of ash clouds – but their fiery origins distinguish them from the water-borne clay-rich sediments of the north, and the oxide compositions of these compacted volcanic ashes are often indistinguishable from true igneous rocks.

By taking their raw materials direct from these prime sources Chinese potters often managed to 'short circuit' the more usual approach to clay collection – that is the mining of clays that have been washed by rain from weathered rock millions of years ago, and laid down in clay strata that were once ancient lake beds, river flood-plains or marine estuaries.

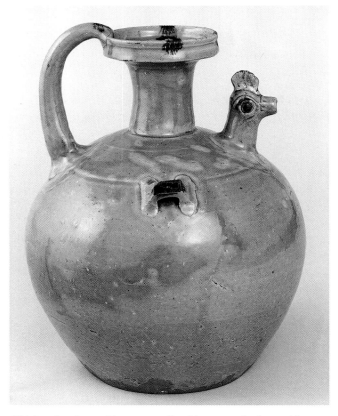

Chicken-head ewer, Yue ware; yellowish green ash glaze with iron-brown details, Eastern Jin dynasty (AD317–420). This popular ewer form occurs over much of southern China during this period, although Jiangsu and Zhejiang were the main producing provinces. The hollow handle was probably made by folding a thin slab of clay around a tapering core – and this was also the usual spout-making technique in China. Clay and ash glazes, of essentially eutectic mixture composition, were used for glazing Yue-type wares for many hundreds of years. H. 9 in., 23 cm. British Museum, OA 1972.1–26.1.

These weathered and 'rotten' igneous rocks, used so directly, and so widely, by potters in south China for both stoneware and porcelain, were (and still are) often crushed by water-powered trip hammers operated by the mountain streams that flow through the hilly landscapes typical of the ceramics-producing areas of southern China. Only a certain amount of this crushed rock could be used in the clay bodies, with much of the coarser grit (mostly large quartz, mica and feldspar crystals) being discarded. However, from about the 10th century onwards, even this waste material was exploited, particularly as a 'filler' in saggars, kiln-setters and kiln-bricks.

Igneous raw materials of this type remain popular ingredients for ceramics in southern China. They are naturally low in true clay, but can still be surprisingly plastic, with much of their plasticity deriving from their high content of hydromica or sericite (secondary potassium mica) – often supplemented by small amounts of super-

plastic clay-like minerals of the smectite group. In fact, so abundant are micaceous minerals in southern porcelain stones that many of these rocks consist of little more than quartz and mica (in about 3:2 proportions), with only minor amounts of primary clay and feldspar.

## Hydromica

The fact that some of the world's most successful and productive ceramic traditions came to be based on raw materials that often contained virtually no clay may seem extraordinary, but the fine secondary mica, so abundant in southern stoneware and porcelain, more than made up for this lack of true clay substance. Hydromicas are produced from the alteration and weathering of feldspars through a process known as sericitisation and they have minute, flat, platy crystals, similar in their appearance and behaviour to clays. This platy structure supplied the necessary plasticity to the materials but where hydromicas differ from clays is in their high potassium oxide content, which can vary from about 6–10% $K_2O$.

During firing the potassium oxide, supplied by the mica, melts some of the fine silica in the clay body into a stiff glass. When cold this body-glass acts as a cement in the stoneware or porcelain material, providing much of the remarkable toughness typical of southern Chinese ceramics. It was the high fired-strength of southern wares that encouraged and sustained the huge export trades that developed in southern ceramics from about the 8th century AD to the present day.

## *Early stonewares*

One of the problems facing researchers studying how stonewares developed in southern China comes from deciding at what stage the early potters were exploiting the silty downwash from these altered rocks (that is, true sedimentary clays, dug from flood-plains and ancient lakes), and when they began to use the weathered igneous rocks themselves – mimicking nature by processing the weathered rock with suitable crushing and 'washing' techniques.

It seems likely that most ceramics made in south China during the Neolithic and Bronze Ages were made from the more easily collected and processed sedimentary materials but, with the gradual rise of glazed stoneware in south China, the potters began to make greater and more direct use of the weathered rocks themselves. These primary materials were often lower in iron than the sedimentary clays, and therefore better able to stand the relatively high temperatures needed to mature the early stoneware glazes (1170–1240°C).

## Southern stoneware glazes

The nature of these unusual southern stoneware and porcelain 'clays' has been discussed at some length in this preamble because it seems likely that these body materials were also the main ingredients in the glazes used with them – a principle that appears fundamental to the southern Chinese approach to glaze-making. The other prime ingredient in these early glazes appears to have been wood ash, perhaps supplemented occasionally with limestone or, more rarely, by crushed shell. All three materials have the capacity to melt high-silica clays into true glazes, and wood ash was easily prepared by burning brushwood from the hillsides local to the kilns. However, before describing these southern Chinese ash glazes in greater detail a common misconception about Chinese glazes needs to be addressed – and that is their description in many Western writings as being of 'feldspathic' composition.

## Feldspathic vs. lime glazes

For some reason, early Chinese glazes have come to be known as 'feldspathic' – suggesting that the bulk of their glaze recipes was provided by feldspars. Potassium and sodium feldspars both melt into stiff white glasses at stoneware temperatures, giving surface qualities that are reminiscent of many classic Chinese porcelain glazes. With a little extra flux (e.g. some 10% of wood ash or limestone) and about 1–2% of iron oxide, feldspars will give glazes that closely resemble many southern and northern Chinese celadons. The strong superficial similarity of these feldspar-rich compositions to classic Chinese glazes led many writers earlier this century to assume that Chinese glazes were of a true feldspathic style. Eventually the term 'feldspathic' became synonymous with 'high-fired' when discussing classic Chinese glazes in general, and the term was also extended by some writers to include the greenish ash glazes of China's Bronze Age.

Feldspar, however, is by no means an indispensable ingredient in high-fired glazes, and the hundreds of

*Table 5* Compositions of southern stoneware clays

| | $SiO_2$ | $Al_2O_3$ | $TiO_2$ | $Fe_2O_3$ | CaO | MgO | $K_2O$ | $Na_2O$ | MnO | $P_2O_5$ |
|---|---|---|---|---|---|---|---|---|---|---|
| 1. E. Han Yue | 75.4 | 17.7 | 0.8 | 2.4 | 0.3 | 0.6 | 3.0 | 0.5 | 0.03 | –.– |
| 2. Tang Wenzhou | 74.4 | 18.3 | 0.7 | 2.1 | 0.4 | 0.3 | 3.7 | 0.3 | 0.02 | –.– |
| 3. Tang Yixing | 76.4 | 16.2 | 1.0 | 3.4 | 0.3 | 0.5 | 2.6 | 0.8 | 0.01 | 0.04 |
| 4. Han Qingzhusi | 76.6 | 17.5 | 1.0 | 1.4 | 0.01 | 0.6 | 2.6 | –.– | –.– | 0.03 |

(1. Shangyu, N. Zhejiang province, 2. Wenzhou, S. Zhejiang, 3. Yixing, Jiangsu, 4. Qingzhusi, Hunan)

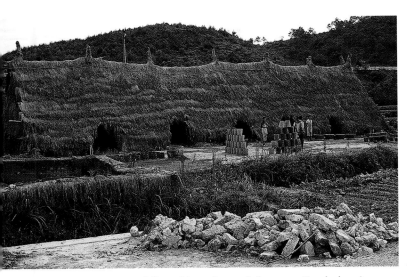

Country roof tile and large jar workshop near Jingdezhen in 1982. South Chinese stoneware potters must have worked in similar structures for centuries, with the large roofs to their workshops thatched with rice-straw.

chemical analyses of early Chinese glazes that have now been published show beyond doubt that feldspathic glazes are extremely rare in Chinese ceramic history (although they are quite common in Japan). Most early Chinese glazes belong instead to another important family of high-temperature glazes that are known as 'calcareous' or 'lime' glazes. Lime glazes are fluxed by calcium oxide (informally known as lime) – usually provided by wood ashes, or by crushed or burned limestone, marble, chalk or shell. The fine calcium carbonate that is present in all these materials breaks down during firing at about 800°C, liberating carbon dioxide and converting to calcium oxide (CaO) – one of the most useful and versatile of all glaze fluxes.

### The character of lime glazes

The good points about lime glazes are the ease with which they may be made from very ordinary rocks, clays and ashes, and their physical toughness and chemical stability after firing. Lime glazes also have relatively low maturing temperatures – typically 1200–1240°C, compared with some later Chinese lime-alkali glazes that mature in the 1240–1300°C range. Being rich in clay, lime glazes also made useful suspensions for applying glazes to unfired wares in the half-dry state, a technique known as 'raw glazing'. Lime glazes are at their best when enhancing decoration carried out on the surface of the clay itself, whether through fine carving, combing, rouletting, stamping or sprigging – all popular techniques for embellishing early Chinese stonewares.

In terms of colour, early Chinese lime glazes tend to be yellowish-brown, yellowy-green or grey-green, depending on how well they have been reduced in the kiln. Their colours derived mainly from the small amounts of iron and titanium oxides that they contain, and these colouring oxides were largely supplied by the 'clay' components of the glaze recipes. The surface qualities of Chinese lime glazes tend to be either glassy or somewhat dull – and both effects are typical of glazes high in calcium oxide. The glassier glazes have usually been high-fired and cooled quickly, while the duller examples are either under-fired, or have been fully fired and then allowed to cool slowly.

The main reason for dullness in lime glazes is a haze of fine crystals of lime-rich minerals that have grown in the glaze thickness during cooling. This happens most often in under-fired glazes as particles of unmelted batch material can then act as 'seeds' for the developing micro-crystals of lime feldspar and wollastonite.

Another – and more dramatic – type of high lime glaze is produced when the molten glaze forms a complex pattern of streaks and wandering rivulets of thick glaze on a thinner background, giving an effect reminiscent of heavy rain on a window pane. Sometimes this spontaneous patterning appears on a large scale, but it can also occur as a simple overall mottling, not unlike salt glaze. These effects tend to occur in glazes that are particularly high in lime and low in silica. Glazes of this type are often unstable and, where this natural patterning appears, the pots were often made with raised or deeply incised lines around them, to arrest the flowing glazes.

### The chemistry of lime glazes

The chemistry of lime glazes is extremely simple, and good stoneware glazes of this kind can be made from only three oxides: silicon dioxide ($SiO_2$, silica), calcium oxide ($CaO$, calcia or 'lime') and aluminium oxide ($Al_2O_3$, alumina). Silica provides the glassy substance of a glaze, calcia melts the silica, while alumina stiffens the resulting glaze to such an extent that it will not run off the pots at the height of the firing.

Individually silica, calcia and alumina are some of the most infusible compounds known (melting at 1713°C, 2572°C and 2050°C respectively) but, when combined in the right proportions, the melting point of the mixture drops sharply to about 1170°C. However, because it would take many hours of constant heat to bring about a total melt at 1170°C, it is more effective and economical for the potters to fire quickly to some 30°C higher then the melting point of the mixture – that is to about 1200°C and above.

This 'ideal', low-melting, oxide mixture is as follows (oxides by % Wt.):

| SILICA | ALUMINA | CALCIA |
|---|---|---|
| $SiO_2$ | $Al_2O_3$ | $CaO$ |
| 62 | 14.75 | 23.25 |

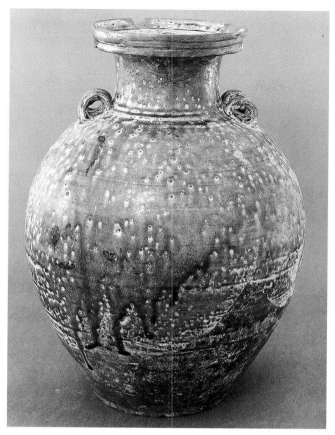

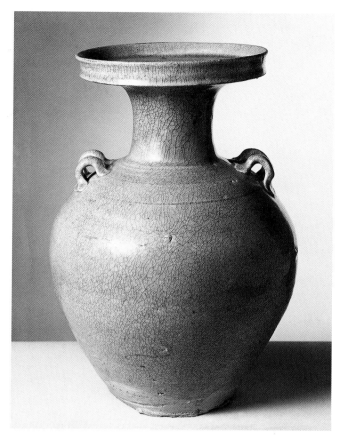

Large ash-glazed stoneware jar with four lugs, *c.* 5th C. AD, perhaps from Fujian province. The patterned and streaky surfaces seen on many clay-and-ash glazes may be relics of fine cracks that had developed in the glazes early in firing, which then became filled with melting glaze as the temperatures rose. (Lime glazes have low viscosity so are rather fluid). H 14 in., 36.5 cm. The British Museum

Stoneware jar with four lugs, and a finely crazed greenish glaze, Yue ware, perhaps from Jiangsu province, south China, 6th–7th century AD. H. 9.5 in., 24 cm. Victoria and Albert Museum, Circ.51–1927.

Combinations of materials that have especially low melting points, compared with other mixtures made from the same ingredients, are known technically as 'eutectic mixtures' (from the Greek, meaning 'ideal melting').

Not only are eutectic mixtures useful for the ways in which they save on fuel but, for some reason, they also result in glazes that are technically and aesthetically of a high standard. A further advantage of eutectic mixtures is that they often have wide firing ranges – that is, they provide successful glazes over a relatively wide spread of kiln temperatures. To some extent this can make up for shortcomings in kiln designs and in firing techniques.

Given this range of economic, practical and aesthetic advantages, it is perhaps not surprising to find that so many early glazes worldwide approximate to eutectic mixtures – with potters' having discovered these ideal blends through centuries of practical experiment. Analysis shows that eutectic mixtures not only provided the basic chemistry for many early Chinese lime glazes, but that they also represent the underlying structures of many Chinese lead glazes.

Eutectic mixtures also seem to have supplied the essential chemistry for many Chinese alkaline earthenware glazes. These differ from their Middle-Eastern equivalents in being fluxed with potassium oxide, rather than sodium oxide, and are discussed in more detail in Chapter Eleven.

**Achieving the eutectic balance**

Silica exists naturally and abundantly as quartz sand and flint. Calcia makes up some 56% of the common rock limestone (calcium carbonate, $CaCO_3$) with the difference being lost during firing as carbon dioxide ($CO_2$). Alumina though is very rare in nature as a single pure oxide, where it occurs mainly in the form of precious stones, such as rubies, sapphires and oriental emeralds. However, in chemical combination with silica, alumina is enormously abundant – being present in all clays and in all igneous rocks. This often means that the silica and alumina needed for a glaze may easily be provided by a single raw material, such as a siliceous rock or clay.

Test bar by the author showing the effects of blending a high-calcium wood ash with a siliceous clay (from 100% clay to 100% wood ash). The best melt (the eutectic mixture) can be seen as about 60% siliceous clay and 40% mixed wood ash – the same recipe proposed for most Yue-type glazes. The firing temperature used for this bar was about 1200°C and the kiln's atmosphere was reducing. Chinese potters may have used similar tests to establish the best clay-and-ash mixtures for their stoneware glazes.

Fortunately for Chinese potters, the rocky raw materials used to make most southern stonewares and porcelains contained silica and alumina in about the right proportions (4:1) to meet the demands of the 'lime eutectic'. All that was needed to turn these siliceous 'clays' into glazes was some concentrated source of calcium oxide. This was provided either by wood ash or by a pulverised or burned calcium carbonate rock, which in southern China, was usually limestone.

Analyses of early Chinese glazes suggest that wood ash was the favoured flux from about 1500BC to AD900 but, from about the 10th century AD onwards, potters at many important Chinese kilns began to substitute limestone for wood ash – although it is also likely that mixtures of wood ash and limestone were used together in Chinese glazes, at a number of southern kilns, both before and after this time. Some indications as to whether wood ash or limestone was the dominant flux in a particular glaze can come from studying the levels of magnesia (MgO), manganous oxide (MnO) and phosphorous oxides ($P_2O_5$) in the glaze analyses. If the levels of these three oxides were high, wood ash was

probably the dominant flux – if low or absent, limestone was more likely to have been the main source of calcia.

What constitutes 'high' and 'low' in this case can be seen by comparing an ash-rich lime glaze (a Yue ware glaze of the 10th century AD) with a slightly later lime glaze from Jingdezhen that was probably fluxed with a limestone-based glaze material known as 'glaze ash'.

Armed with both approaches – the basic chemistry provided by the 1170°C lime eutectic, and recognition of the typical 'wood ash oxides' – the following analyses of early southern Chinese lime glazes become more understandable:

The relatively high levels of $P_2O_5$, MnO and MgO in the glazes in Table 6 suggest that wood ashes were important ingredients in their original recipes, as ashes tend to be rich in these oxides, while stoneware clays are not – although whether wood ashes were the sole suppliers of calcia to these glazes is still rather difficult to establish.

**The 'lime or ash?' problem**

What remains slightly puzzling about all these analyses are their generally low alkali contents (1.7-2.9% $K_2O+Na_2O$). These levels are what one might expect from the use of about 60% body-clay in the original glaze recipes (see Table 5). However, wood ash (presumably the other 40% of the recipe) can also be a fairly alkali-rich material, and this means that the total alkalis ($K_2O+Na_2O$) supplied by mixtures of ash and clay should really be higher than they appear in the figures above – as indeed they are in the Shang ash glazes already quoted (see Table 1). Either the wood ashes concerned have been 'washed' so thoroughly that their alkali contents have been virtually eliminated (not too difficult to do in practice), or fairly large amounts of limestone (a material that contains virtually no potassium or sodium oxides) may have been intermixed with the wood ashes in the original recipes.

Table 6 Comparison between wood ash and limestone glazes

|  | SiO$_2$ | Al$_2$O$_3$ | TiO$_2$ | Fe$_2$O$_3$ | CaO | MgO | K$_2$O | Na$_2$O | MnO | P$_2$O$_5$ |
|---|---|---|---|---|---|---|---|---|---|---|
| Yue glaze | 61 | 12.1 | 0.7 | 2.1 | 16.5 | 3.0 | 1.4 | 0.4 | 0.4 | 1.6 |
| *Yingqing* glaze | 64 | 13.7 | –.– | 0.7 | 18.5 | 0.6 | 1.1 | 0.5 | –.– | 0.3 |
| Eutectic glaze | 62 | 14.75 | –.– | –.– | 23.25 | –.– | –.– | –.– | –.– | –.– |

Table 7 Analyses of typical southern lime glazes

| Dynasty | SiO$_2$ | Al$_2$O$_3$ | TiO$_2$ | Fe$_2$O$_3$ | CaO | MgO | K$_2$O | Na$_2$O | MnO | P$_2$O$_5$ |
|---|---|---|---|---|---|---|---|---|---|---|
| 1. Han | 57.9 | 13.7 | 0.6 | 1.7 | 19.7 | 2.4 | 2.0 | 0.7 | 0.9 | 0.9 |
| 2. W.Jin | 61.3 | 11.3 | 1.0 | 1.9 | 18.0 | 2.0 | 1.2 | 0.5 | 0.3 | 1.1 |
| 3. E.Han | 59.2 | 14.5 | 0.7 | 1.5 | 17.7 | 1.8 | 2.7 | 0.2 | 0.3 | 1.3 |
| 4. Tang | 57.0 | 12.0 | 0.75 | 1.8 | 20.3 | 3.5 | 2.0 | 0.2 | 0.3 | 2.3 |

(1. Yue ware; 2. Yixing Yue-type ware; 3. Hunan Yue-type ware; and 4. Sichuan Yue-type ware)

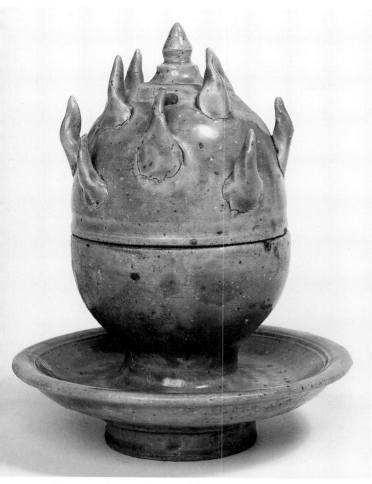

Stoneware incense burner with cover, Yue ware, probably Fujian province, late 5th to early 6th century AD. H. 9.8 in., 14.5 cm. Victoria & Albert Museum, C 921 A–1935.

Greenware shards from southern provinces. Among the kilns represented here are: Jingdezhen (Jiangxi), Yixing (Jiangsu) and Shangyu (Zhejiang). The use of reduction-firing, very similar body compositions, and clay-and-ash glazes, supplied a strong family likeness to early southern stonewares. Collection of Zhang Pushen, China.

With regard to the washing, it is certainly the case in Japan that stoneware potters often obtained their wood ash from textile workers, who had already extracted the soluble alkalis from the wood ash by steeping it in water, then pouring off the alkali-rich solution, which they used in dyeing. It may be that southern potters obtained their wood ashes from similar sources. However, it is also true that stoneware potters often follow this washing process anyway as it makes the prepared glazes less caustic to handle, and also more predictable in use.

One way to resolve this 'ash versus limestone' problem might be to study some of the badly under-fired examples of early Chinese lime glazes that abound at Chinese kiln sites. The true nature of the unreacted lime in the glazes might then be established by scanning electron microprobe techniques, which can show both the forms and compositions of the glaze-batch particles, and therefore distinguish between limestone and ash.

**Southern lime glazes**

Whatever the truth about their original recipes, lime glazes were made at stoneware kilns in most of the major provinces in south China, and the above analyses illustrate the extraordinary consistency in southern glaze-making technology that operated from about 1000BC to AD1000. These grey-green glazed stonewares were made in such huge quantities, over such a large area, and for such an extended period, that they are often described as the 'backbone' of Chinese ceramics. Not only do their glaze compositions hardly differ from province to province, but their body analyses also demonstrate just how widely distributed were the siliceous stoneware 'clays' from which they were made (see Table 5).

**Dragon kilns**

Abundant stoneware raw materials and a simple and effective approach to glaze-making were both essential for the development of glazed stoneware in south China – but a third element was also important for the growth of southern stoneware, and this was an efficient type of high-temperature kiln. South Chinese potters were particularly successful in this regard with their 'dragon' kiln design – developed in the Warring States period (475–221BC), and refined and enlarged over succeeding centuries.

The concept of the *long* or dragon kiln (*long* means dragon in Chinese) is simple but extremely effective. It is essentially a tunnel built on a gentle slope. The fuel burns in a large firebox at the foot of the tunnel and the kiln narrows somewhat at its higher end to act as an exit-flue. The wares are set on the floor of the tunnel, which is sometimes stepped, but more usually covered with a layer of sand or coarse quartz grit. By making the kiln gases travel

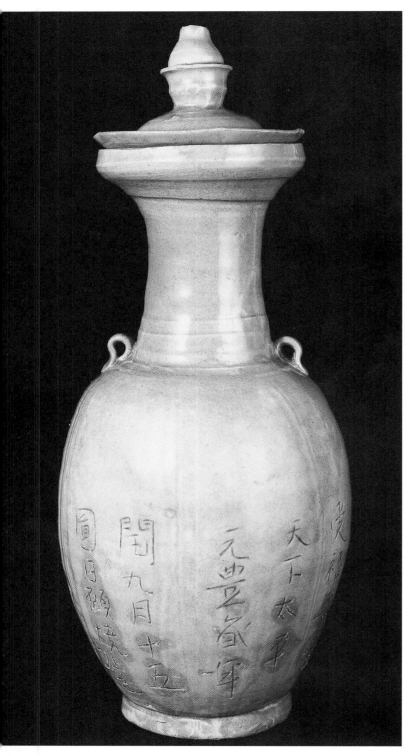

Yue ware funerary wine jar and cover with an inscription
incised under a degraded olive-green glaze, dated AD1080.
H. 14.75 in., 37 cm.
By courtesy of the Percival David Foundation of Chinese Art.

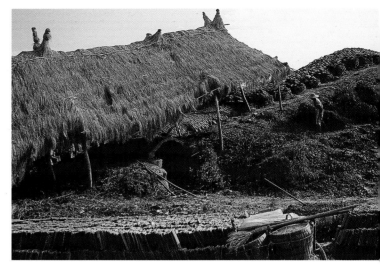

Countryside dragon kiln outside Jingdezhen. The kiln is thatched
over its lower half, while the rest of the kiln is tiled. The firemen
push brushwood amongst the pots through stoking holes in the
tiled section, gradually moving the full heat up the sloping
length of the tunnel. So efficient is the dragon kiln design that
the weight of fuel used sometimes equals the weight of ware
being fired.

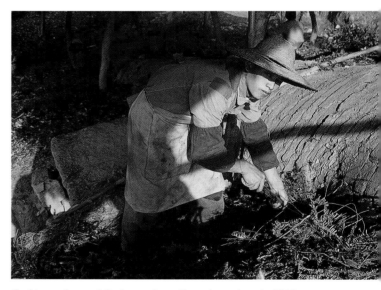

Stoking a dragon kiln in northern Jiangxi province in 1982.
Freshly-cut brushwood was used at this stage, but tinder-dry fuel
was kept near the kiln, presumably for achieving the final heat.

semi-horizontally their flame-speed is much reduced and
more efficient use is made of the energy that they contain.

Early Chinese dragon kilns were only about six metres
long, and were substantially cooler towards their chimney
ends. Soon after their development, side-stoking ports
began to be added to their cooler parts, and this allowed
fuel to be pushed in amongst the pots themselves, thereby
boosting the heat in the upper area, furthest from the
main firebox. Soon a firing system was devised whereby

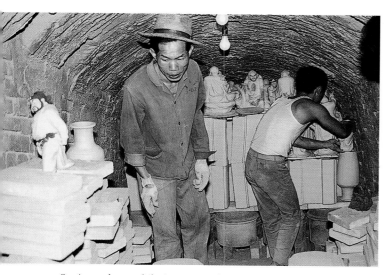

Setting a dragon kiln in present-day Guangzhou (Canton). Dragon kilns tend to be cooler near to their floors, so the wares are raised up, both to encourage more flame to travel at the lower level, and also to avoid underfiring ceramics in the lower part of the setting.

the lower part of the kiln was brought to full heat by the main firebox, which was then bricked up. Stoking then continued through the side ports, and the intense heat gradually moved up the kiln's length, until it reached the top – after which side-stoking ceased, all ports were sealed and the kiln was allowed to cool.

A great advantage of the dragon kiln system lay in the way that the air burning the fuel was admitted into the kiln some way before the current stoking port. The combustion air was therefore forced to pass over the cooling, but still red-hot pots, and this pre-heated air enormously increased the efficiency with which the side-stoked fuel burned. With this refinement, side-stoked dragon kilns could be built to any length. They averaged 10 metres in the 1st century AD but, by the late 13th century, some examples were approaching 140 metres in length, and were capable of firing hundreds of thousands of vessels in a single setting.

## Yue wares

Perhaps the most celebrated examples of siliceous stonewares, fired in dragon kilns, and glazed with wood ash/clay recipes, are the Yue wares of northern Zhejiang province. Yue wares are held in particular regard by students of Chinese ceramics as they seem to mark the emancipation of southern stoneware from its rather utilitarian roots, and its acceptance in China as a material capable of a high level of artistic expression.

The name for this ware dates from the Spring and Autumn period (770–476BC) when the area around Hangzhou and Shaoxing in northern Zhejiang province

was known as the state of Yue – an area with a rich history that rivalled that of the Yellow River region for its influence on Chinese culture. The finest Yue wares were made in northern Zhejiang, which is still a wealthy agricultural district, famous for its ancient towns, fertile valleys, plains and paddy fields. The area is criss-crossed with waterways, and interspersed with rocky hills of both limestone and granite.

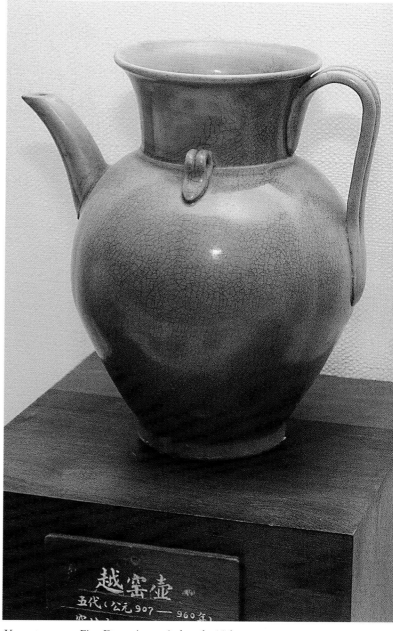

Yue ware ewer, Five Dynasties period, early 10th century AD. This fine stoneware ewer represents a high point in a very ancient tradition. By the time that it was made, glazed stonewares, based on similar clays and wood ashes, had been in production for some 2500 years in southeastern China.

35

Yue ceramics were sent as tribute wares to the imperial court in north China in the 9th century AD, and the most convincing evidence for their high status at this time is their presence in China's most sacred shrine, the Famen Temple in Shaanxi province. In a vault beneath the Famen pagoda was housed a single finger-bone of the Guatama Buddha (plus a number of 'shadow' bones, kept to be destroyed in case of religious persecution). The Famen shrine was sealed in AD874 and only re-opened in 1987 when the pagoda collapsed. Now rebuilt, the site is a major tourist attraction and an important place of pilgrimage. In addition to its priceless reliquaries, and its collections of gold, silver, glass, rock crystal and silk, the shrine also contains 14 pieces of the finest Yue ware.

**Bi-se Yue wares**

The top-quality Yue wares, found recently at the Famen Temple, are known as *bi-se* wares – meaning 'reserved' or of 'mysterious' quality. Although the term is a familiar one in the literature on Chinese ceramics, it was difficult, before the Famen finds, to identify all aspects of the style. One suggested example of *bi-se* Yue ware had been a thinly-made 9th–10th century bowl, with a slightly bluish grey-green glaze, now in the Percival David Foundation Collection in London. Another candidate had been a large, and very elaborately decorated, Yue ware dish in the Metropolitan Museum of Art in New York. However, in the event, neither style matched the pieces found at the Famen shrine exactly as these *bi-se* wares proved to be relatively thickly made, totally undecorated, but with unusually smooth and fine glazes.

The 14 examples of *bi-se* ware, found at the Famen temple, include some large dishes, bowls and bottles of considerable presence. Their novel shapes differ from contemporary Yue wares, and their style seems closer to northern whiteware. The bowls also have something of the character of turned marble, while the *bi-se* ware bottles are reminiscent of thick glass. Their bodies are lighter in colour than the usual Yue ware material, and their smooth, plain and rather thick glazes vary from a yellowish-green on some examples to a more bluish-green on others. At least one example of this 9th-century ware (now in the provincial museum in Xi'an) could be mistaken for fine Longquan celadon of the 12th century, in the smoothness and the semi-opacity of its glaze. These Famen *bi-se* pieces raise many questions, including who designed them, what the true models were for these unusual forms, and why this highly successful style of body and glaze was not developed further at the Yue ware kilns.

More ordinary Yue wares from the same period have greyer bodies and more grey-green glazes of a duller character. They were made in vast quantities, at one time (8th–11th century AD) representing a large part of the Chinese ceramics that were exported to countries as widely spread as Korea, Japan, the Philippines, Sri Lanka, Iraq, Egypt and East Africa.

**Origins of Yue wares**

As seen in the previous chapter, the historical and technological roots of Yue wares are extremely deep, reaching back into the early Bronze Age. Their essential glaze and clay compositions had been established in south China as early as the Warring States period, when yellowish-green stonewares were used for copying ritual bronzes for burial purposes. Since that time, the gradual development of these southern stonewares had been largely a matter of design and improved firing techniques. A combination of bigger kilns, a greatly increased range of forms, a wealth of engraved, carved, stamped and applied ornament, and better reduction-control in firing, all combined to make Yue ware one of the most successful and influential of all south Chinese ceramic types.

In their shapes Yue wares owe a good deal to contemporary beaten metal vessels and to fine lacquer wares, but many examples also display a vivid sense of the natural world. During the Six Dynasties period in particular

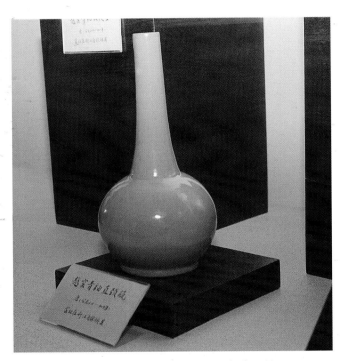

Yue ware vase of *bi-se* quality, Tang dynasty. The best Tang dynasty Yue wares, from northern Zhejiang province, anticipated qualities of form and glaze that saw their full expression in Song monochrome stonewares. This particular bottle form also appears in Korean celadon wares of the 12th–13th century and it may owe its origins to imported Syrian glass of the 8th–9th centuries. Palace Museum, Beijing.

*South China's Early Lime Glazes*

(AD220-589) lamps, candlesticks, water-droppers, and ewers were produced in the forms of animals, such as rams, toads, bears and lions. Amongst the lightly-drawn patterns seen on later Yue wares (9th-12th century AD) are lively sketches of parrots, turtles and fish – all familiar sights to the Yue people. Equally vivid in their drawing and carving are the dragons and phoenixes of Chinese mythology.

For many hundreds of years the Shanglinhu (Shanglin Lake) area of northern Zhejiang province was the largest centre for the production of Yue wares in China. Huge quantities of these grey-green stonewares were exported from the nearby port of Ningbo, to countries as distant as Egypt, Iraq, East Africa, Sri Lanka, Korea and Japan. Much of the Shanglin lake shore is littered with shards, setting spurs and broken saggars.

Two Yue ware covered vases, N. Zhejiang, Northern Song Dynasty. Towards the end of the Yue ware tradition in south China, thrown forms became more elaborate, with much use made of fine detail, sometimes combined with ambitious carved decoration. These ideas were also used by the northern celadon potters, but the style died out in the south – probably discouraged by the development of thick semi-opaque lime-alkali glazes of the Longquan celadon type, which tended to smother fine detail. Sotheby's. H.14.5 in., 36.8 cm.

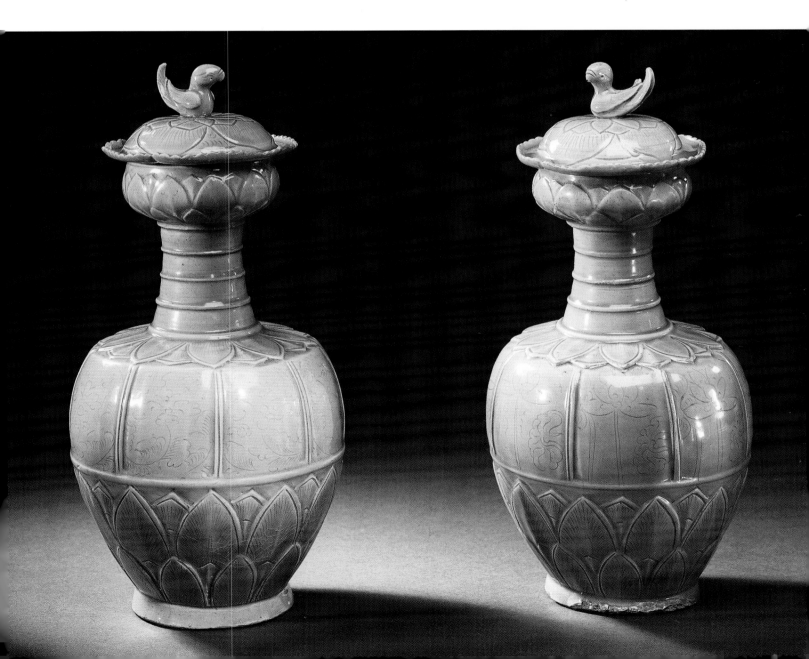

### Shanglinhu

The largest kiln-complex for the manufacture of Yue wares operated in northern Zhejiang province around Shanglin lake (Shanglinhu), about 40 miles inland from the major export port of Ningbo. This very beautiful area of northern Zhejiang province has something of the character of England's Lake District, and traces of some 196 huge dragon kilns are still visible today, running up the lightly wooded slopes around Shanglin Lake. The lake's shore is thick with broken saggars, setting pads, shards of grey-green stoneware and coarse grit discarded during clay preparation. A boat trip to different parts of the lake's perimeter provides an image of Yue ware development from the early 3rd to the 11th centuries AD. Rocky outcrops around the lake have often weathered to the crumbly state that may have been exploited in the manufacture of the Yue stoneware body itself.

### Yue ware technology

Mixtures of about three parts by weight of the dry Yue body material, with about two parts by weight of well-washed wood ash, would explain most of the analyses of Yue-type glazes that have been published to date – and glazes made with this recipe tend to fall within typical Yue ware compositions. As already mentioned, the unusually low alkali percentages in Yue glaze analyses may mean that the wood ash was sometimes supplemented with small amounts of limestone, which is a common rock in this part of northern Zhejiang.

The firing temperatures used for Yue wares are still under discussion. Imitations of Yue-type glazes, made from the 3:2 siliceous clays/wood ash recipe described above, tend to melt just above 1190°C, which seems understandable in view of their close similarities to the 1170°C lime eutectic. If applied thinly these glazes will fire to as high as 1240°C – and this wide firing range is another useful characteristic of eutectic-based compositions. Even so, firing temperatures for Shanglinhu Yue wares, averaging 1100°C are often cited in Chinese reports. While it is true that good reduction, longer firings and ample water vapour in a kiln can lower the melting point of glazes to some extent, 1100°C still seems rather low for true stoneware glazes.

### *Korean celadons*

Curiously enough, the ultimate development of the 'Yue-ware' approach to stoneware production – that is greyish stoneware bodies with lime-eutectic glazes – happened in Korea, rather than in China. Even in their own time (mid-11th century onwards) Korean celadons were compared favourably by the Chinese to Yue wares of the *bi-se* type, and the bluish-green celadon glazes developed by Korean potters in the Koryo Dynasty (AD918–1392) were certainly of exceptional quality.

Korean potters established their celadon industry under the influence of Chinese Yue wares, and Korean Koryo celadons are closely related, compositionally, stylistically and historically to the southern Chinese material. Indeed, the underlying geology of northern Zhejiang disappears under the East China and Yellow Seas to reappear some 500 miles to the north east of Zhejiang as the landscape of South Korea, where the main Korean celadon kilns were sited. This shared geology probably explains why the body compositions of Koryo celadons and Yue wares are so strikingly similar (see Table 8a).

In contrast to the similarity in body compositions, Koryo glazes show distinct differences, being noticeably bluer than Yue glazes. Indeed, chemical analysis shows that Korean potters used low-iron and low-titania lime glazes that produced watery bluish-green colours when applied over their grey-firing stoneware clays. To achieve this effect Korean potters seem to have combined porcelain stones, rather than body clays, with wood ashes, to produce glaze compositions that are even nearer to the 'eutectic ideal' than the Yue glazes themselves.

Korean bottle, early 12th century. Like Yue glaze, Korean celadons are high-lime compositions, but their fine blue-green colours seem to have come from the Korean potters' mixing porcelain stone rather than body clay with wood ashes. The low titania contents of Korean porcelain stone allowed the natural colours of dissolved and reduced iron oxide to dominate in the glazes. British Museum. H. 7.5 in., 19 cm.

*Table 8a* Chinese Yue wares and Korean Koryo celadons compared: bodies

| Bodies | $SiO_2$ | $Al_2O_3$ | $TiO_2$ | $Fe_2O_3$ | CaO | MgO | $K_2O$ | $Na_2O$ | MnO |
|---|---|---|---|---|---|---|---|---|---|
| Yue ware | 75.4 | 17.7 | 0.8 | 2.4 | 0.3 | 0.6 | 3.0 | 0.5 | 0.03 |
| Yue ware | 77.0 | 15.8 | 1.0 | 3.2 | 0.3 | 0.6 | 2.6 | 1.0 | 0.03 |
| Yue ware | 76.6 | 16.1 | 0.9 | 1.6 | 0.2 | 0.5 | 3.0 | 0.9 | 0.01 |
| Koryo celadon | 76.0 | 17.0 | 0.8 | 2.1 | 0.3 | 0.5 | 2.5 | 0.7 | –.– |
| Koryo celadon | 73.0 | 17.5 | 0.9 | 2.8 | 0.2 | 0.7 | 2.6 | 0.8 | –.– |
| Koryo celadon | 73.0 | 18.0 | 1.2 | 2.5 | 0.5 | 0.5 | 3.4 | 0.9 | –.– |

Table 8b Chinese Yue wares and Korean Koryo celadons compared: glazes

| Glazes | SiO$_2$ | Al$_2$O$_3$ | TiO$_2$ | Fe$_2$O$_3$ | CaO | MgO | K$_2$O | Na$_2$O | MnO | P$_2$O$_5$ |
|---|---|---|---|---|---|---|---|---|---|---|
| Yue | 60.9 | 12.1 | 0.7 | 3.0 | 16.5 | 3.0 | 1.4 | 0.8 | 0.4 | 1.6 |
| Yue | 57.9 | 13.7 | 0.6 | 1.7 | 19.7 | 2.4 | 2.0 | 0.7 | 0.9 | 0.9 |
| Yue | 57.4 | 12.5 | 0.8 | 1.8 | 20.3 | 3.0 | 1.3 | 0.9 | 0.4 | 1.5 |
| Koryo | 57.6 | 12.4 | 0.1 | 2.1 | 17.7 | 4.2 | 2.8 | 0.7 | 0.3 | 0.2 |
| Koryo | 58.1 | 13.9 | 0.2 | 1.4 | 19.9 | 1.8 | 2.9 | 0.5 | 0.4 | 0.9 |
| Koryo | 59.6 | 14.1 | 0.1 | 1.4 | 16.0 | 2.7 | 3.8 | 0.8 | 0.4 | 0.7 |

Table 9 Shouzhou yellow wares of the Tang Dynasty – bodies & glazes

| | SiO$_2$ | Al$_2$O$_3$ | TiO$_2$ | Fe$_2$O$_3$ | CaO | MgO | K$_2$O | Na$_2$O | MnO | P$_2$O$_5$ |
|---|---|---|---|---|---|---|---|---|---|---|
| Glaze 1 | 61.2 | 14.4 | 0.2 | 3.6 | 14.5 | 1.9 | 1.9 | 0.6 | 0.2 | 1.3 |
| Glaze 2 | 59.2 | 14.1 | 0.8 | 2.8 | 15.1 | 2.9 | 2.8 | 0.5 | 0.3 | 1.3 |
| Glaze 3 | 59.4 | 15.5 | 0.8 | 3.1 | 13.3 | 3.4 | 2.3 | 0.4 | 0.5 | 1.0 |
| Body 1 | 66.5 | 25.2 | 0.9 | 3.5 | 0.5 | 0.4 | 1.9 | 0.6 | 0.04 | –.– |
| Body 2 | 68.3 | 24.4 | 1.0 | 3.2 | 0.5 | 0.2 | 1.9 | 0.3 | 0.04 | –.– |
| Body 3 | 62.1 | 32.1 | 1.1 | 2.5 | 0.3 | 0.3 | 1.6 | 0.2 | 0.02 | –.– |

Although the qualities of Yue glazes never quite matched Korean celadons, Yue wares still enjoyed enormous fame and prestige within China itself, and the grey-green stonewares of Zhejiang and Jiangsu were imitated at greenware sites throughout southern China as well as providing inspiration for some of the earliest northern celadons. Among the important southern kilns that copied northern Zhejiang Yue wares were those at Yixing in Jiangsu province, and Jingdezhen in Jiangxi province. Lesser kilns making Yue-type wares in south China were active in provinces as various as Guangxi, Guangdong, Anhui and Fujian.

### *Anhui lime glazes*

The lime glazes of southern Anhui are of interest, not least for their great antiquity – with a number of examples surviving from the late Western Zhou period (1000–770 BC). Unlike many southern wares of the same date, which were made by coiling and beating, Anhui glazed stonewares seem to have been thrown direct on a fast potter's wheel. They are functional in spirit and suggest that a well-established stoneware tradition existed in Anhui as early as the 9th century BC.

Anhui is a poor province and its pioneering stonewares were soon overtaken by the more sophisticated wares of Jiangsu and northern Zhejiang. However, in the Tang dynasty, the mid Anhui kilns at Shouzhou did make some unusual amber-yellow glazed stonewares, using high-lime glazes that were coloured with iron and fired in oxidising atmospheres. At first glance these appear to be lead-glazed wares, but a closer look shows the yellow Anhui glazes to be duller and harder than those used on Tang earthenwares, and to be true stoneware glazes of the high-lime type.

These yellowish Shouzhou wares were unusual enough to be traded as tea wares, although they feature second from last in the celebrated 'league table' of Tang teabowl kilns, drawn up by the Tang writer Lu Yu: 'For [tea] bowls Yuezhou is best followed by Dingzhou, then Wuzhou, Yozhou, Shouzhou and Hongzhou.'

Tang dynasty stonewares from the Shouzhou kilns of northern Anhui province. The oxidised lime glazes of Shouzhou show a superficial resemblance to lead glazes, but their harder surfaces and duller colours identify them as true high-temperature compositions.

Recent analyses of these yellowish Anhui stonewares have shown that their body compositions are high in alumina, and therefore of the clay-rich northern type. This makes the Shouzhou clays something of an anomaly as the kiln site is well below the Nanshan-Qinling divide.

## The development of lime glazes in south China

Despite the ease with which lime glazes may be made, applied and fired, they still have some drawbacks, including their tendency to run if applied too thickly, their general unsuitability for underglaze decoration with concentrated oxide pigments (which tend to diffuse into the surrounding glazes), and a certain ordinariness about their surface qualities.

Even so, there were instances in China when lime-rich stoneware glazes were cleverly adapted to overcome these limitations – with oxidised firings proving particularly useful in this regard. Two examples of kiln complexes that used these 'developed' lime glazes are the Tongguan kilns, near Changsha in Hunan province, and the Qionglai kilns

in Sechuan province. Both kilns flourished in the 9th to 10th centuries, and both had declined sharply by the 12th century AD.

## Tongguan and Qionglai wares

The wares from the Tongguan (Changsha) and Qionglai kilns are so similar, despite being made at least 500 miles apart, that they are often considered together by historians of Chinese ceramics. The Tongguan stonewares are better made than the darker-bodied Qionglai wares, and also the better known outside China as they were exported in huge numbers in the late Tang Dynasty. They do not rate highly

Tongguan (Changsha) bird ewer with diagonal copper-green splashes on a light ground, W. 4.7 in., 12 cm, and a taller Changsha ewer with iron-brown 'windows' on a light ground, H. 7 in., 18 cm. A few examples of Tang Yue ware show rather blurred iron-brown painting, but the Changsha and Qionglai kilns made a more successful use of painted decoration, particularly through the use of coloured lime-glazes and oxidised firings. 9th–10th century. Christie's, London.

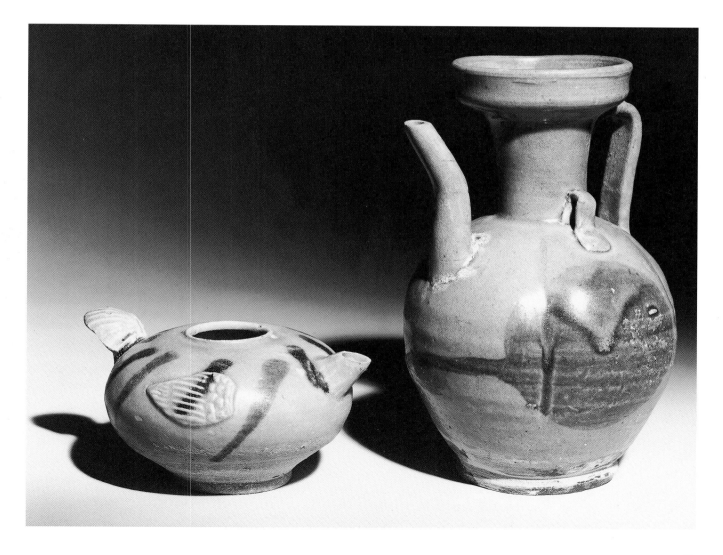

on the traditional status scale of Chinese ceramics (that is they were barely mentioned by poets, literati and connoisseurs) but they still command enormous appeal as country stonewares. Tongguan and Qionglai wares have a generous, sturdy quality, and they show an inventive handling of clays, glazes and slips that gives them an immediate appeal to potters. Wares from both kiln sites also show a lively influence from Tang lead-glazed earthenwares – particularly

Tongguan stoneware jar decorated with a dotted design using coloured glazes, late Tang dynasty, Changsha, Hunan province. Lime glazes coloured with copper (bluish-green) and a manganese-iron mixture (purple-brown) have been applied in a dotted pattern to an oxidised lime glaze, probably a body clay-wood ash mixture. A combination of high phosphorus levels and low alumina contents in the copper glaze have produced bluish-green tones that were once believed to have been caused by cobalt. Shanghai Museum, China.

through their use of green, brown and amber glazes and through the application of moulded relief.

The potters of Tongguan and Qionglai were particularly successful in exploiting the old Chinese lime-glaze techniques to produce high-temperature polychrome effects. They achieved these by firing their wares in an oxidising-to-neutral atmosphere, and colouring their glazes green with copper, dark amber-brown with iron, and purple-brown with a manganese-iron pigment. These new coloured glazes were splashed, trailed, brushed and dipped over and under transparent straw-coloured lime glazes which were essentially oxidised versions of the old southern greenware type.

In addition to these colours, both kilns also made use of milky-white lime glazes, rich in oxides of phosphorus and low in alumina, that separated in cooling into immiscible glasses. These 'glass-in-glass' emulsions scattered white light, and gave the glazes a milky cast. When overfired the white glazes could sometimes develop true

opal blues — although this latter effect was little used by the potters as lime glazes tend to run badly with excessive heat.

The white and creamy glazes of Tongguan and Qionglai made excellent light-coloured grounds for decoration in trailed green, brown and purple-brown. Some of the broad and loopy Tongguan trailed-glaze designs can also be seen on contemporary Egyptian and Mesopotamian tin-glazed earthenwares — perhaps as a result of the important two-way trade in ceramics that existed between China and the Middle East in late Tang times. Another discovery was that, by adding copper oxides to their milky-white emulsion glazes, blue-green glazes of a curious mouldy hue could be produced. With enough heat these blue-green glazes could show almost turquoise tones, as their optical-blues combined with their copper-green colours. The compositions of the various Tongguan and Qionglai bodies and glazes (probably firing to about 1220°C) can be seen in Tables 10 and 11.

*Table 10* Analyses of Tongguan bodies and glazes (late Tang to Five Dynasties)

| Tongguan bodies | $SiO_2$ | $Al_2O_3$ | $TiO_2$ | $Fe_2O_3$ | CaO | MgO | $K_2O$ | $Na_2O$ | MnO | $P_2O_5$ | | |
|---|---|---|---|---|---|---|---|---|---|---|---|---|
| Tongguan 1 | 70.9 | 20.5 | 0.9 | 2.3 | 0.2 | 0.7 | 2.9 | 0.1 | –.– | –.– | | |
| Tonguan 2 | 71.7 | 20.9 | 0.4 | 1.6 | 0.1 | 0.6 | 3.0 | 0.1 | 0.01 | 0.1 | | |
| Tongguan 3 | 71.8 | 20.4 | 0.9 | 1.7 | 0.2 | 0.6 | 2.7 | 0.1 | –.– | –.– | | |
| Tongguan 4 | 67.0 | 26.0 | 0.5 | 2.0 | 0.3 | 0.6 | 2.7 | 0.1 | 0.01 | 0.08 | | |
| Tongguan glazes | $SiO_2$ | $Al_2O_3$ | $TiO_2$ | $Fe_2O_3$ | CaO | MgO | $K_2O$ | $Na_2O$ | MnO | $P_2O_5$ | CuO | $SnO_2$ |
| Off-white | 59.9 | 9.2 | 0.8 | 0.8 | 16.9 | 3.4 | 2.1 | 0.2 | 0.7 | 3.0 | –.– | –.– |
| Opaque-white | 57.4 | 8.7 | 0.6 | 0.9 | 18.5 | 2.6 | 1.8 | 0.2 | 0.7 | 2.3 | –.– | –.– |
| Brown | 57.0 | 12.0 | 0.9 | 5.1 | 15.7 | 2.4 | 1.7 | 0.2 | 3.3 | –.– | –.– | –.– |
| Yellow–White | 62.1 | 12.3 | 0.9 | 1.4 | 15.0 | 2.2 | 2.0 | 0.1 | 0.5 | 1.3 | –.– | –.– |
| Green | 57.8 | 8.1 | 0.7 | 1.2 | 18.8 | 2.8 | 2.2 | 0.3 | 0.5 | 2.3 | 3.0 | 0.6 |
| Green | 59.2 | 8.7 | 0.8 | 1.9 | 18.3 | 2.7 | 1.8 | 0.2 | 0.5 | 1.6 | 3.0 | 0.7 |

*Table 11* Analyses of Qionglai bodies and glazes

| Qionglai bodies | $SiO_2$ | $Al_2O_3$ | $TiO_2$ | $Fe_2O_3$ | CaO | MgO | $K_2O$ | $Na_2O$ | MnO | $P_2O_5$ | |
|---|---|---|---|---|---|---|---|---|---|---|---|
| Qiong. 1 | 74.7 | 14.2 | 0.9 | 4.1 | 0.3 | 1.0 | 2.0 | 0.4 | 0.01 | 0.03 | |
| Qiong. 2 | 78.4 | 14.1 | 0.9 | 3.0 | 0.2 | 0.7 | 1.9 | 0.2 | 0.01 | 0.02 | |
| Qiong. 3 | 77.4 | 14.0 | 1.0 | 3.2 | 0.3 | 0.8 | 2.0 | 0.4 | 0.01 | 0.05 | |
| Qionglai Glazes | $SiO_2$ | $Al_2O_3$ | $TiO_2$ | $Fe_2O_3$ | CaO | MgO | $K_2O$ | $Na_2O$ | MnO | $P_2O_5$ | CuO |
| Opaque-turquoise | 56.8 | 10.1 | 0.7 | 2.5 | 17.5 | 4.3 | 1.5 | 0.3 | 0.5 | 1.9 | 1.5 |
| Yellow-transp. | 59.9 | 10.7 | 0.7 | 2.9 | 16.5 | 4.5 | 1.4 | 0.4 | 0.4 | 2.3 | 0.1 |
| Brown-green | 59.9 | 10.1 | 0.7 | 2.6 | 17.5 | 4.2 | 1.5 | 0.3 | 0.5 | 1.5 | 1.9 |

In addition to these broadly decorated wares, the Tongguan potters also devised a more detailed illustrative style using coloured glazes to show children playing, birds among boughs and, occasionally, simple calligraphy. The painted and trailed lines tend to appear blurred, where the coloured glazes have spread into the transparent lime glazes, but this diffused quality is very much part of the Tongguan and Qionglai characters.

A few examples of painted designs on Tongguan stonewares have copper-red details, and this seems to be the earliest use of this colour in China. In some cases these copper-red effects are the result of accidental reduction of copper-green glazes but, in other examples, the copper-red glaze appears to have been quite deliberate – particularly on the rare type of Tongguan ware where copper-green and copper-red stripes were applied alternately. These unusual Tongguan copper-reds are described in greater detail in Chapter Nine.

Apart from this pioneering use of copper-red, what makes the Tongguan and Qionglai kilns so important in the history of Chinese ceramics is their successful revival of painted and polychrome decoration on ceramics. The use of reduction and carbonising techniques by late Neolithic and Shang potters had dealt an early blow to painting on Chinese ceramics. A second setback came from the poor performance of painted designs (usually iron oxide) with the universally adopted, reduction-fired lime glazes. However, a combination of oxidised firing, and the use of coloured glazes rather than concentrated oxide pigments, allowed the Tongguan potters to achieve successful painted designs while still working within the old Chinese lime-glazing tradition.

Late Yue ware ewer, 10th century. Very few examples of deep relief carving on Yue wares are known, but the technique appears during the later stages of Yue ware production. H. 7.9 in., 20.2 cm. Sotheby's.

Given the high status accorded to painting and calligraphy in late Tang China, it seems surprising that painted decoration on ceramics remained essentially a folk technique from the 9th to the early 14th centuries AD, and that the technical discoveries made at Tongguan and Qionglai had little impact on other Chinese stoneware kilns. The main creative effort at the leading stoneware sites over this period was directed towards improving monochrome stoneware glazes – particularly for designing glazes that evoked the surface qualities of silver, lacquer and, most importantly, jade. The simple and austere characters of lime glazes were not well-suited for these purposes, and a more advanced type of composition, known as the 'lime-alkali' glaze, had to be developed in China before these more sophisticated qualities could be realised.

The greatest boost to the development of the southern lime-alkali glaze in the 10th–14th centuries came from the discovery of true porcelain materials in southern China. This significant find, which eventually led to the growth of the huge south Chinese porcelain industries, seems to have happened more or less simultaneously at a number of southern kiln sites where greenwares were made, sometime early in the 10th century AD. The important southern kiln complex of Jingdezhen was among the first in China to exploit this important new material.

## FURTHER READING

### BOOKS AND EXHIBITION CATALOGUES

Nils Sundius and Walter Steger, 'The constitution and manufacture of Chinese ceramics from Sung and earlier times', in Nils Palmgren (ed.), *Sung Sherds*, section 2, Stockholm, 1963, pp 374–505

Yutaka Mino and Katherine R. Tsiang, *Ice and Green Clouds – Traditions of Chinese Celadon*, Indianapolis Museum of Art, 1987

### PAPERS AND ARTICLES

Guo Yanyi, 'Raw materials for making porcelain and the characteristics of porcelain wares in north and south China in ancient times', *Archaeometry*, Oxford, Vol. 29, part 1, pp 3–19

Li Jiazhi et al., 'Study on ancient Yue ware body, glaze and firing technique of Shanglinhu', *Proceedings of the 1989 International Symposium on Ancient Ceramics*, (Li Jiazhi and Chen Xianqiu eds), Shanghai, 1989, pp 365–71

Zhang Fukang, 'Technical studies of Changsha ceramics', *Archeomaterials*, 2, 1987, pp 83–92

Zhang Fukang, 'Technical studies on Qionglai ware', *Proceedings of the 1989 International Symposium on Ancient Ceramics*, (Li Jiazhi and Chen Xianqiu eds), Shanghai, 1989, pp 267–71

Nigel Wood, 'Technological parallels between Chinese Yue wares and Korean celadons', *Papers of the British Association for Korean Studies (BAKS Papers)*, (Gina L. Barnes and Beth McKillop eds) Vol. 5, London, 1994, pp 39–64

# Chapter 3

# THE PORCELAIN GLAZES OF SOUTHERN CHINA

Despite the substantial lead that south China held over north China in stoneware production, the area was surprisingly slow to develop its own porcelain industries. By the time true porcelains first appeared in the south, in the early 10th century AD, white porcelains had already been manufactured in north China for more than 300 years. As described later, in Chapter Five, the kilns of north China made very high-fired, clay-rich porcelains, with their productions peaking in quantity and quality in the 11th and 12th centuries. However, because of their exposed situations in the northern provinces, northern porcelain kilns suffered from repeated attacks by invading tribes. The Ding kilns, for example, were raided by the Khitans in AD945 and later destroyed by the Jurchen Tartar invasion of 1127, which also caused the Northern Song court to flee south and establish its new capital in Hangzhou. The Ding kilns were operating at a reduced level when they were hit again by the Mongol re-invasion of 1234. After this catastrophe the northern porcelain industry went into a decline from which it has never recovered. Following these reversals south Chinese porcelain kilns took up the torch of porcelain production, eventually developing truly colossal domestic and export industries – to the extent that the very name China eventually became synonymous with porcelain in the English-speaking world.

From the evidence of their compositions, the first porcelains made in south China were quite different from any made in the north, proving instead to be near relations to existing southern stonewares. Early southern porcelains were essentially quartz-mica mixtures, and very low in the true clay minerals that made up the bulk of the raw materials used in northern Chinese porcelain manufacture.

The main differences between these new southern porcelains and the grey-bodied stonewares that they came to replace at many kiln sites in south China, were that the southern porcelain wares were lower in the colouring oxides of iron and titanium, and also somewhat richer in the flux-rich mineral, hydromica. These small but vital differences made the southern porcelains white-firing and translucent, while the old southern stonewares were greyish and opaque.

Suitable raw materials for making porcelain, virtually 'as found' had therefore existed in south China for millions of years, often in association with the same rocks as supplied the ancient southern stoneware industry. Once deposits of pure porcelain stones had been identified by the potters, white porcelain production sprang up at many kilns throughout south China in the 10th and 11th centuries, in provinces as widely spread as Anhui, Jiangxi, Fujian, Guangdong and Guangxi.

## Jingdezhen porcelain and Five Dynasties whiteware

A particularly early site for porcelain making in southern China was Jingdezhen in Jiangxi province – later to become the 'porcelain capital' of both China and the world. One of the most rewarding experiences for anyone studying Chinese ceramics is to explore the 1000 year old kiln sites that are set amongst the low rocky hills surrounding Jingdezhen, and to pick up and examine shards of some of the earliest white porcelain made in the area.

These rare 10th century porcelains are known in the West as 'Five Dynasties whitewares' and only a few complete pieces are held in Western collections. The material is

Porcelain bottle vase with underglaze copper-red decoration, probably from Jingdezhen, 14th century AD. Rather fugitive effects from the pigments and glazes used at this time, combined with lively brushwork, give great character to these early red and white wares. H. 11.75 in., 30 cm. Sotheby's.

Yue-type stonewares and the earliest style of south Chinese porcelain intermixed at the Yangmeiting kiln site, near Jingdezhen, Jiangxi province, early 10th century AD. This kiln site seems to mark the actual transition from Yue-type greenwares to true white porcelains in southern China. The slightly bluish cast, seen in the Jingdezhen Yue-type glazes, may have come from the use of porcelain stone, rather than from body clay, in the stoneware glaze recipes. Whether such a glazing approach actually led to the discovery of white porcelain in south China, though, is an open question, as the stoneware and porcelain shards at this site are obviously contemporary.

found at a number of sites around Jingdezhen, such as Yangmeiting and Hutian – intermixed at the kiln spoil-heaps with Yue-type grey-bodied stonewares with slightly bluish grey-green glazes. These very early white Jingdezhen porcelains are the forerunners of virtually all porcelains made since in south China, Korea and Japan, making Five Dynasties whitewares ceramics of substantial historical importance. Indeed, these early whiteware sites around Jingdezhen seem to mark the actual transition from stoneware to porcelain in south China in the early 10th century AD.

Most of these early porcelain shards found at Jingdezhen are of shallow bowls with rolled rims, and handled and spouted ewers. A certain amount of light carving is seen on some ewer fragments, but in general this magnificent material is allowed to speak for itself. Although the glazes and bodies of the Five Dynasties whitewares seem of high technical quality, the bases of the broken pieces strewn on the waster-heaps are usually badly flawed, with most having been fired on small pads of sandy clay that have left rusty 'scorch marks' on the white porcelain material. The pads have also caused some distortion to the wares in firing by sinking into the softening porcelain at full heat. This suggests that the setting arrangements for the new material were borrowed from the old greenware tradition, but were not ideal for these whiter and more flux-rich bodies.

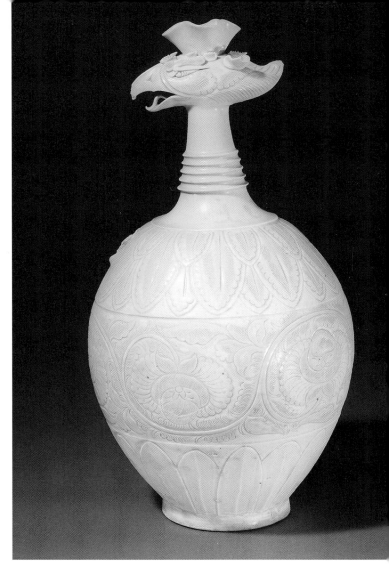

White porcelain ewer. This is regarded as one of the most important examples of early Chinese white porcelain to have survived, although its provenance has long been debated, with sites as various as Jizhou and Xicun in south China, and Longquanwucun in the far north, having been proposed. Xicun, in Guangdong province, is the current favourite, but it is still hard to find examples of equivalent quality. (The ewer's spout is missing, and the vessel would have been poured by grasping its neck.) 10th–11th century. H. 15.75 in., 39.5 cm. British Museum, OA 1936. 10–12.206.

## The nature of the material

The body materials used for Jingdezhen Five Dynasties whitewares are believed to have been single porcelain stones without added kaolin. The original rocks appear to have been natural mixtures of quartz, hydromica and primary clays, with only minor amounts of soda feldspar. Their natural clay contents seem to have ranged from about 10–20%, and the weathered quartz/mica porcelain rock would have been crushed and levigated to prepare it for making. Similar rocks, examined by Russian scientists at Jingdezhen in the 1950s, proved to have been compacted

*Table 12* Analyses of Five Dynasties whiteware glazes and bodies

|  | $SiO_2$ | $Al_2O_3$ | $TiO_2$ | $Fe_2O_3$ | CaO | MgO | $K_2O$ | $Na_2O$ |
|---|---|---|---|---|---|---|---|---|
| whiteware body | 77.5 | 16.9 | –.– | 0.8 | 0.8 | 0.5 | 2.6 | 0.35 |
| whiteware glaze | 68.7 | 15.5 | –.– | 0.7 | 10.9 | 1.16 | 2.6 | 0.2 |

*Table 13* Jingdezhen Five Dynasties whiteware glazes – actual and predicted

|  | $SiO_2$ | $Al_2O_3$ | $TiO_2$ | $Fe_2O_3$ | CaO | MgO | $K_2O$ | $Na_2O$ |
|---|---|---|---|---|---|---|---|---|
| Actual glaze | 68.7 | 15.5 | –.– | 0.7 | 10.9 | 1.16 | 2.6 | 0.2 |
| Predicted glaze | 69.0 | 15.5 | –.– | 0.8 | 10.1 | 0.7 | 2.4 | 0.3 |

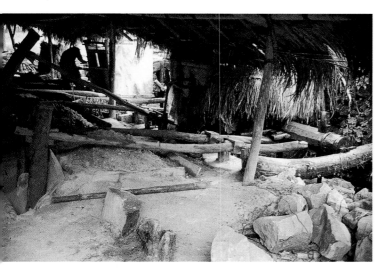

Water-powered trip hammers crushing porcelain stone at Jingdezhen in 1982. Water wheels have been used to operate trip hammers at Jingdezhen for many hundreds of years. Once pulverised, the stone is stirred in water and the finest fraction, which forms a scum on the surface, is skimmed off, dried somewhat, and then made into bricks. These are stamped with the name of the mill before being sent to the Jingdezhen porcelain factories, where they often undergo further refining. The coarser material is either returned for re-crushing, or is discarded.

Bricks of porcelain stone drying on racks, Jingdezhen, 1982. The term *petuntse* (bai tunzi) or 'little white bricks' is often used to describe Chinese porcelain stone, and this refers to the form in which the stone was processed for transport to the porcelain workshops. In China the material is also known as *cishi* (literally 'porcelain stone').

volcanic ashes, and the bedded rock was mined in large open-cast and terraced quarries. In common with most south Chinese porcelains made from the 10th century to the present day, these very early Jingdezhen porcelains seem to have been made from essentially micaceous, rather than feldspathic materials.

**Five Dynasties whiteware glazes**
When the glaze and body compositions of these pioneering Jingdezhen porcelains are studied in depth, two technical advances stand out clearly. The first is that limestone rather than wood ash appears to have been their main glaze-flux. The second is that the glazes on these 10th-century porcelains were not lime glazes (as were used on

contemporary Yue-like stonewares) but were of the more advanced 'lime-alkali' type.

The glaze above was probably made by mixing the porcelain body material with burned and crushed limestone – a raw material known to Chinese potters as 'glaze ash'. This kind of glaze recipe would therefore have been a slight adaptation of the old body-clay+wood ash principle that operated for Yue wares. This idea can be tested by assuming a body-clay/glaze ash mixture in proportions of about 82:18; the similarities between this suggested glaze, and the analysed porcelain glaze, are then striking (see Table 13).

The firing temperature for early Jingdezhen whiteware was probably about 1220-1260°C, using a neutral-to-reducing atmosphere that maximised the whiteness of the

material. These porcelains were almost certainly fired in kilns of the traditional 'dragon' design – universal in south China at the time, and still seen in the Jingdezhen area where they are used for firing stoneware roof tiles and large stoneware field-jars.

### Lime-alkali glazes

The second important characteristic of this very early Jingdezhen porcelain was its lime–alkali composition. This is shown by a lower than average content of calcium oxide (10.9%), and a slightly above average alkali content (nearly 3%). The silica level is also higher than that found in typical lime glazes (see Table 7) – and slightly elevated silica contents are another lime-alkali characteristic.

Very early type of white Jingdezhen porcelain, made in a northern whiteware style. Early 10th century AD. Wares such as these have been excavated in the Middle East, where they were also copied with local earthenware clays and glazes. D. 6.3 in., 16 cm. Ashmolean Museum; Oxford, 1978.1233.

The practical effects of all these changes were to create glazes with smoother, richer and more unctuous characters. They were less likely to develop the glassiness or dullness typical of lime glazes and were also less prone to run at high temperatures, so they could be applied more generously to the wares than lime glazes. When used to a good thickness, and slightly underfired, lime-alkali glazes can look remarkably like jade.

Given the many advantages of the lime-alkali composition it seems odd that these advanced glazes were abandoned at Jingdezhen so soon after they were developed, being replaced in the late 10th century AD by watery blue lime glazes, designed to show carving and, later, moulding of the new porcelain body to the best effect. Analysis suggests that these Jingdezhen *yingqing* (shadowy-blue) glazes were also made by mixing limestone with the porcelain body material, but in greater quantities than in the Five Dynasties recipes (typically 25–30% glaze-ash). Once established these *yingqing* glazes remained in fashion at Jingdezhen from the late 10th century until well into the Yuan dynasty (AD1279–1368).

Jingdezhen *yingqing* porcelains can be superbly translucent with icy, bluish glazes and clay bodies that can re-oxidise to warm orange tones that act as a perfect foil to the cool glaze colours. So exceptional are the *yingqing* material and its glaze, particularly when used for silver-derived forms, such as wine ewers and shallow bowls, that scholars have searched the Chinese literature for contemporary references to the ware. The difficulty here has been that *yingqing* was essentially a folk porcelain, and not highly rated by the taste-makers of the Northern and Southern Song. However, it has been found that, at the time that it was made, Jingdezhen *yingqing* was known locally as *Raoyu* ware (literally 'the jade of Rao') – Rao being the old name for the Jingdezhen district and white jade being the premier type to Chinese taste. This term, *Raoyu* is no longer current and the modern dealers' names of *yingqing*, and its alternative *chingbai* (a Song term meaning 'blue white'), are now used universally for wares of this type. These 'shadow-blue' porcelains were manufactured at many south Chinese kiln sites, besides Jingdezhen, from about the 10th to the 14th centuries AD.

A few of the later Jingdezhen *yingqing* glazes can approach the lime-alkali range in composition but in general *yingqing* glazes are particularly pure examples of the lime glaze type. Lime-alkali glazes were not used again at Jingdezhen in any quantity until the third decade of the 14th century, when they proved ideal for use with underglaze-blue painting. Once this was discovered the lime-alkali

*Yingqing* bowl with a tall foot. The rather sugary texture of the *yingqing* material can be sensed in this example. Numerous provinces in south China produced these porcelains from weathered volcanic rocks and, at some kiln sites, wood ash rather than limestone was the preferred glaze-flux. 10th–11th century. H. 3.75 in., 9 cm. Gemeentemuseum, The Hague, OCVO 12–35.

glaze became the standard type for Jingdezhen underglaze-blue wares, from the 14th century to the present day, and the old lime-glaze formulations (which had their distant origins in China's early Bronze Age) were gradually abandoned for most porcelain uses.

Where all these new porcelain glazes differed radically from the great mass of stoneware glazes, made so far in southern China, was in their exceptionally low titania contents – apparently made possible by the use of the low-titania material, 'porcelain stone', in the glaze recipes. This allowed the faint blueness of reduced and dissolved iron oxide to dominate in the glaze's colour – rather than the iron-titania grey-greens, typical of the Yue-type stoneware tradition.

Table 14 Analyses of Jingdezhen *yingqing* bodies and glazes

| Bodies | $SiO_2$ | $Al_2O_3$ | $TiO_2$ | $Fe_2O_3$ | CaO | MgO | $K_2O$ | $Na_2O$ | MnO | $P_2O_5$ |
|---|---|---|---|---|---|---|---|---|---|---|
| Jingdezhen *yingqing* 1 | 76.2 | 17.5 | 0.06 | 0.6 | 1.3 | 0.1 | 2.7 | 1.0 | 0.03 | –.– |
| Jingdezhen *yingqing* 2 | 75.5 | 18.4 | 0.1 | 0.9 | 0.6 | 0.03 | 2.6 | 1.2 | 0.03 | 0.02 |
| Jingdezhen *yingqing* 3 | 74.7 | 18.4 | 0.08 | 0.8 | 0.6 | 0.2 | 2.9 | 1.0 | 0.06 | 0.03 |
| Glazes | | | | | | | | | | |
| Jingdezhen *yingqing* 1 | 66.7 | 14.3 | –.– | 1.0 | 14.9 | 0.26 | 2.1 | 1.2 | 0.1 | –.– |
| Jingdezhen *yingqing* 2 | 66.7 | 15.2 | 0.07 | 1.1 | 13.9 | 0.4 | 1.5 | 0.6 | 0.06 | 0.08 |
| Jingdezhen *yingqing* 3 | 65.4 | 14.0 | 0.05 | 1.1 | 15.4 | 0.6 | 2.0 | 1.0 | 0.1 | 0.07 |

## Southern *yingqing* glazes

These new Jingdezhen *yingqing* wares were so popular that production of *yingqing*-style porcelains spread throughout south China in the Northern Song dynasty (AD960–1127), with the qualities of the local porcelain stones strongly influencing the various characters of the local wares. Southern provinces making *yingqing* at this time included Jiangxi (its apparent birthplace), Anhui to the north of Jiangxi, Fujian to the east, Guangdong to the south and Guangxi to the west of Guangdong. In many cases Jingdezhen *yingqing* wares seem to have provided the models for these widely scattered porcelain sites.

In virtually all *yingqing* glazes the iron oxide colourants were natural impurities in the raw materials used to make the glazes, while their relatively high calcium oxide content encouraged a pronounced iron-blueness to develop when the glazes were fired in strong reduction. Porcelain glazes less rich in calcia, but with similar amounts of iron to the *yingqing* glazes (about 0.9% iron oxide), tend to fire to cool, faintly bluish white colours under similar reducing conditions.

Saggar and *yingqing* shards, Jingdezhen, Northern Song dynasty. Earlier *yingqing* bowls were fired one-to-a-saggar. A button of sandy clay separated bowl from saggar base.

Microstructure of *yingqing* porcelain. By the time *yingqing* porcelain has been fired (typically to 1230°–1260°C in reduction) it consists largely of quartz, mullite and glass. Some large quartz crystals bedded in glass and mullite can be seen in this sample. The quartz and glass provide translucency, while the mullite gives extra strength. Optical microscopy – by courtesy of the Department of Scientific Research, British Museum.

Opposite page: *Yingqing* cup with tall foot, early 14th century AD. The *Yingqing* body is essentially a refused quartz-mica rock and the glaze was made from a similar rock with added limestone. Firing temperatures were modest by porcelain standards (typically 1220–1260°C.) and the bluish glaze-colour derived from reduction-firing and from iron naturally present in the raw materials. Interaction between the lime-rich glaze and the highly siliceous body added to the material's translucency. H. 4in., 10 cm. Christies.

Overfired *yingqing* bowls, melted into a solid mass, Southern Song dynasty. Later *yingqing* porcelains were often fired by the *fushao* (upside-down) technique, with the bowls' rims resting on step-setters (see left of picture) a technique borrowed from the Ding kilns in north China. At Jingdezhen the setters were made largely from coarser fractions of porcelain stone, discarded at the stamping mills. This ensured that the setters (used only once) shrank in step with the bowls they were supporting. Rice-husk ash (almost pure silica) was sometimes used to prevent the porcelain rims from sticking to the setters at full heat.

### *Rongxian copper-green glazes*

Iron oxide in reduction and in solution was the prime *yingqing* glaze colourant, but there was one remarkable exception to this principle in the Northern Song dynasty, and this was a bright green *yingqing*-style porcelain made at a little-known kiln site called Rongxian, in Guangxi province. In these unusual porcelain glazes copper oxide was the main glaze colourant, and oxidising atmospheres were used to fire the wares. The main product of Rongxian were ordinary *yingqing* wares of the Jingdezhen style, but the Rongxian potters also used their copper-green glazes on forms that were apparently designed to imitate northern Yaozhou celadons – an unusually early influence of a northern stoneware on the style of a southern Chinese material.

The Rongxian kilns have only recently been excavated and were first described fully in Shanghai in 1992. So far, only broken pieces of these remarkable copper-green wares are known, but their description has prompted re-examination of museum stores worldwide to see if any complete examples of this interesting ware have survived.

Perhaps even more extraordinary than the Rongxian greens, are a few shards of copper-red glazed porcelain, also dating from the Northern Song dynasty, and also from Rongxian. So far, these are the earliest copper-red glazed porcelains discovered anywhere in the world (the Tong-guan copper-red glazes, although slightly earlier in date, were applied to stonewares rather than porcelains). The levels of copper oxide in some Rongxian red glazes have proved to be much lower than in the copper-green glazes, and this suggests that they were true copper-red compositions, rather than simply misfired copper-greens – a low copper content being typical of a deliberate copper-red effect.

*Yingqing* wares made at Rongxian look less accomplished than the Jingdezhen originals, probably because the Rongxian potters used wood ash, rather than the more 'modern' material, limestone, as their main glaze-flux. Wood ashes contain both phosphorous and manganese

Shards of Nothern Song Rongxian porcelain with oxidised copper-green porcelain glazes (left), compared with Northern Song Yaozhou wares (right), excavated from the same site. The Rongxian kilns in the far south of China, in Guangxi province, copied Yaozhou stonewares in oxidised porcelain – a rare and early influence of a north Chinese stoneware on southern porcelain manufacture.

oxides and these give both a misting of fine bubbles and a slight greyness to fine porcelain glazes.

## Reduction firing and Jingdezhen *yingqing*

Reduction firings were essential for most *yingqing* wares, and the Jingdezhen *yingqing* materials, in particular, were too high in iron (at nearly 1% FeO in both glaze and body) to be oxidised successfully. Jingdezhen *yingqing* fired to an unattractive yellowish tone if not properly reduced and we know from an important text, first published in AD 1270, that accidentally oxidised wares were sold at a discount, often to customers outside Jiangxi province: '... the native dealers sell them under the name of *huang diao* or "yellow stuff" because the colour of the glaze is inferior and the ware is only fit to be thrown away.'

Table 15 Northern Song Rongxian *yingqing,* copper-green and copper-red compositions

| Glazes | SiO$_2$ | Al$_2$O$_3$ | TiO$_2$ | Fe$_2$O$_3$ | CaO | MgO | K$_2$O | Na$_2$O | MnO | P$_2$O$_5$ | CuO |
|---|---|---|---|---|---|---|---|---|---|---|---|
| Rongxian *yingqing* | 66.3 | 14.3 | 0.05 | 1.0 | 15.3 | 1.45 | 3.5 | 0.07 | 0.3 | –.– | –.– |
| Rongxian Green | 58.7 | 14.1 | 0.07 | 1.3 | 15.4 | 1.9 | 3.6 | 0.2 | 0.5 | 1.2 | 2.9 |
| Rongxian Red | 64.0 | 14.3 | 0.1 | 1.2 | 12.2 | 2.0 | 3.7 | 0.4 | 0.1 | 0.5 | 0.7 |

| Bodies | SiO$_2$ | Al$_2$O$_3$ | TiO$_2$ | Fe$_2$O$_3$ | CaO | MgO | K$_2$O | Na$_2$O | MnO | P$_2$O$_5$ | |
|---|---|---|---|---|---|---|---|---|---|---|---|
| Rongxian *yingqing* | 70.1 | 22.2 | 0.03 | 1.2 | 0.5 | 0.7 | 5.0 | 0.12 | 0.14 | 0.07 | |
| Rongxian Green | 69.9 | 23.7 | 0.02 | 1.1 | 0.1 | 0.6 | 4.9 | 0.12 | 0.14 | 0.05 | |
| Rongxian Red | | (not analysed) | | | | | | | | | |

Shards of *yingqing* porcelain, Northern Song dynasty, 11th century AD, at a kiln site outside Jingdezhen. Both well-reduced (bluish) and oxidised (cream-coloured) *yingqing* wares can be seen on this spoil heap. At the time that they were made, oxidised *yingqing* porcelains were valued less than the bluish wares, and priced accordingly.

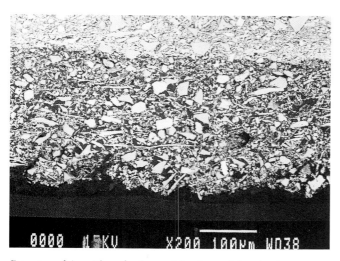

Raw porcelain with unfired porcelain glaze of the *yingqing* type, made from a mixture of the porcelain body with re-burned slaked lime in 3:1 body/limestone proportions (the finer particles are calcium carbonate, the longer crystals are white micas). Scanning electron microscopy, x 200. By courtesy of the Department of Scientific Research, British Museum.

The author of this text was Jiang Qi, a contributor to the official gazetteer of Fouliang – the county in Jiangxi province where the Jingdezhen kiln complex was sited.

## Jingdezhen 'glaze ash'

The use of limestone in Jingdezhen glazes can be deduced from the analyses of the glazes themselves, but there is also a valuable account by Jiang Qi indicating how the material was prepared:

'The porcelain earth prepared from Jin Keng stone is used in the fabrication of the finest porcelain… the rocks produced at Hu Keng, Lingpei and Jietian being of the second class… It is in the hills of Yu-shan that the mountain brushwood is collected to make the ashes used in the preparation of the glaze. The method adopted is to pile the lime from the stone in alternate layers with this brushwood mixed with persimmon [Diospyros] wood, and to burn the two together to ashes. These ashes must then be combined with the 'glaze earth' brought from Lingpei before they can be used.'

This shows that the Jingdezhen limestone was prepared by burning, which gave a fine powder ideal for glazes. Burning limestone (calcium carbonate, $CaCO_3$) initially gives quicklime (CaO), which is an extremely caustic material. Quicklime slowly rehydrates in air to give slaked lime (calcium hydroxide, $Ca(OH)_2$)) which is still mildly caustic. Rapid rehydration can also come from sprinkling water onto fresh quicklime – a process that develops considerable heat and steam. In both types of rehydration the burned rock expands and crumbles into a white mass about double the volume of the original rock.

However, a study of genuine Jingdezhen 'glaze ash' (burned limestone), made at Sèvres in the 1890s, showed that the material was mostly calcium carbonate, rather than the expected calcium hydroxide. The explanation for this seems to be that slaked lime will gradually revert to calcium carbonate (a much safer material than slaked lime for the potters to handle) after long weathering. This conversion to calcium carbonate can also be accelerated by re-burning the slaked lime to a low temperature, and this seems to be the process described by Jiang Qi in the text above. According to one modern account of glaze ash preparation this process might be repeated as many as five times. These various burnings saved crushing the limestone rock, and gave a smooth, rather slimy and mildly adhesive material of fine particle size, ideal for use in glazes. In addition to re-burning, the chemical conversion of calcium hydroxide to calcium carbonate at Jingdezhen was often encouraged by treatment with urine.

Despite these numerous re-burnings, the wood ash content of Jingdezhen glaze ash would have still been fairly low, probably because wood ash only accounts for about 2% of the original mass of most firewood. A tonne of limestone would have needed at least two and, more likely, about four tonnes of brushwood to burn it to glaze ash, so one would expect the end result to be roughly 92% calcium carbonate and about 8% wood ash – itself a good illustration of the relative efficiency of these two approaches to providing lime for glazes. Typical analyses of modern Jingdezhen glaze ashes seem to conform to these principle.

Table 16 Analyses of Jingdezhen glaze ash

| Analysts 5 | $SiO_2$ | $Al_2O_3$ | $Fe_2O_3$ | CaO | MgO | KNaO | Loss |
|---|---|---|---|---|---|---|---|
| Budnikov & Barakovsky | 6.35 | 2.3 | 0.6 | 49.8 | 1.36 | 0.3 | 38.1 |
| Georges Vogt | 1.3 | 0.6 | –.– | 53.7 | 0.75 | –.– | 42.8 |
| Ebelman & Salvetat | 2.6 | 0.6 | –.– | 52.6 | –.– | –.– | 44.2 |
| Li Guozhen & Ye Hongming | 3.1 | 1.03 | –.– | 52.5 | 0.7 | –.– | 43.4 |
| Average: | 3.07 | 1.03 | | 52.5 | 0.7 | | 42.1 |

Slaked and re-burned lime for glaze making at Jingdezhen. This process returns limestone to its carbonate state, but with a usefully fine particle size. The material is also slightly adhesive.

Porcelain stones with markings 'like cyprus leaves' have long been prized at Jingdezhen for use in glazes. The patterns come from intergrown manganese minerals which, in small quantities, are useful de-colourisers in glazes and glasses.

Whether the use of limestone as a glaze-flux was a 10th century innovation, or whether it had already been practised for some time by both southern and northern potters in China is still difficult to assess. As mentioned in the previous chapter, it is not impossible that Chinese potters had already learned to augment their supplies of wood ash with limestone in some early stoneware glazes. What is certain though, is that from the 10th-11th centuries onwards, burned or crushed limestone became the most widely used glaze-flux at the three giant south Chinese kiln complexes of Jingdezhen, Longquan and Dehua. From this time onwards the use of wood ash in south Chinese glazes declined markedly – although use of the material survived (and still survives) at some of the smaller country kilns.

### Porcelain stone/glaze ash mixtures

This simple technology – where porcelain stone was mixed with glaze ash (calcium carbonate) – proved to be extraordinarily versatile. Every mixture between about 5% glaze ash and 95% glaze stone, and 40% glaze ash and 60% glaze stone, gave Jingdezhen porcelain glazes of high quality. As less glaze ash was used in the recipes, the porcelain glazes became progressively whiter, stiffer and more opaque. The recipes lowest in glaze ash could be fired to as high as

1320°C and made excellent white grounds for later painting with coloured overglaze enamels. Mixtures somewhat richer in glaze ash matured between about 1220° and 1250°C and were more usually used with underglaze-blue painting. Thus differences in firing temperature, and degrees of whiteness and transparency, could all be managed by simply varying the proportions of glaze stone to glaze ash in the original recipes.

### Glaze stone

Analyses of earlier Jingdezhen *yingqing* bodies and glazes often show that the porcelain bodies themselves (or weathered micaceous rocks very similar to them) were used as their main glaze ingredients. In later *yingqing* porcelains (13th and 14th centuries AD) the principle does not hold so well, and this suggests that specific 'glaze stones', of rather different composition to the porcelain bodies themselves,

Opposite: Carved *yingqing* porcelain stem cup of exceptional quality, early 14th century. The production of *yingqing* porcelain at Jingdezhen lasted from the late 10th to the 14th century AD. This stem cup is a late and fine example of the ware. By this time that this cup was produced, special glaze stones were used in *yingqing* glazes, rather than the porcelain bodies themselves. D 6.3in., 16 cm. Carter Fine Art, London.

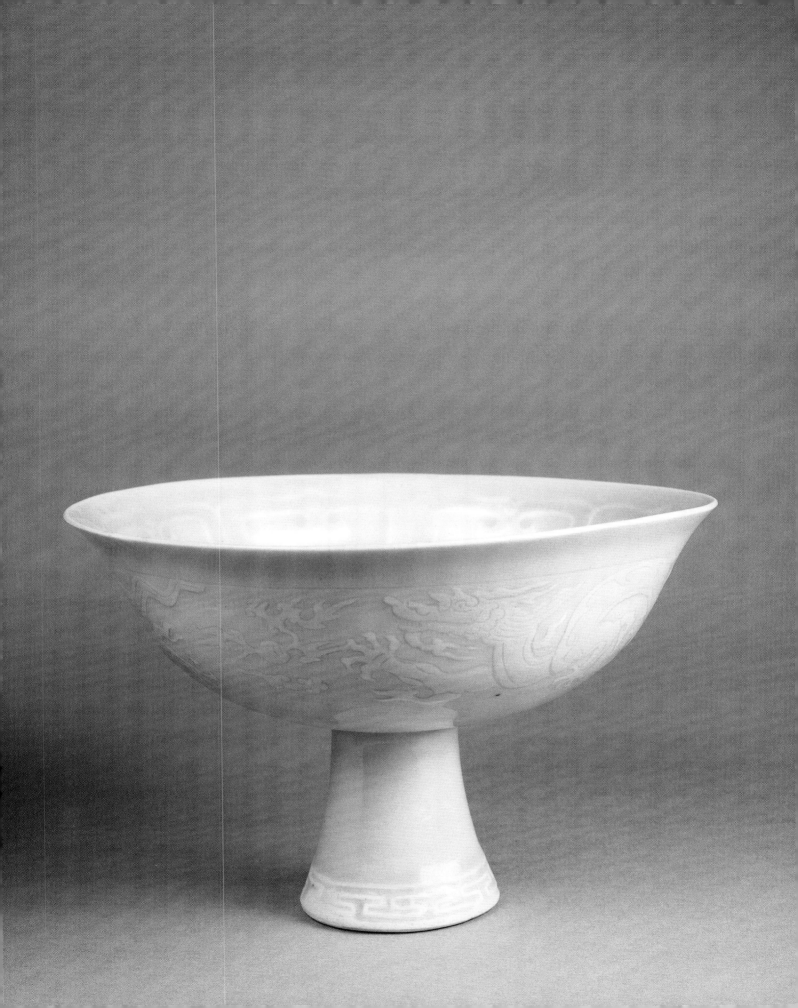

*Gaoling* (kaolin) at a Jingdezhen porcelain factory. Chinese kaolin was often prepared from highly kaolinised igneous rocks at crushing plants similar to those used for processing porcelain stone – the difference being that, with kaolin, a much greater proportion of crushed rock is discarded in the refining process. The introduction of kaolin as a body material seems to have occurred at Jingdezhen sometime in the late 13th or early 14th century, since when it has been a key material in Jingdezhen porcelain recipes. (The name *gaoling* means 'high ridge', a reference to one of its earlier sources.)

were now in use as glaze materials. This interpretation is also supported by Jiang Qi's remarks, when he writes specifically of a 'glaze earth' being brought from Lingpei.

Analysis suggests that these new glaze earths or glaze stones were less weathered micaceous rocks that contained substantially higher proportions of albite (soda feldspar) than the traditional porcelain stones. Rocks of this type would have been more fusible in the kiln, but harder to crush, and less plastic to use, than the earlier body and glaze materials.

An example of a Jingdezhen *yingqing* porcelain, apparently glazed with glaze stone/glaze ash mixture is given below. Its distinctive feature is a higher proportion of sodium oxide ($Na_2O$) in its glaze analysis than in its porcelain body (Table 17).

This development was followed (apparently in the Yuan dynasty) by the Jingdezhen potters' use of rocks similar to the albite-rich glaze stones as the main ingredients in the porcelain bodies themselves. The lower plasticity and the greater fusibility of these albite-rich rocks were countered by mixing them with an entirely new raw material at Jingdezhen, known as *gaoling*. South Chinese *gaoling* (the origin of our word ' kaolin') is a primary clay, washed out by either the clay miners or the rock crushers from weathered granite, and it is a close relation to our own Cornish china clay. Additions of 10-20% kaolin to high-albite porcelain stones seem to have been typical of Jingdezhen porcelain recipes in the Yuan dynasty, with the high-melting kaolins making ideal additions to these more fusible porcelain stones.

This two-component approach to making porcelain vastly increased the reserves of raw materials available to the Jingdezhen potters, as they no longer had to rely on finding suitably weathered or altered rocks as bodies for their wares. It also allowed porcelain bodies to be adjusted to variations in kiln temperatures – simply by varying the clay to rock ratios in the original body recipes. Chinese potters referred to kaolin as the 'bones' of the porcelain, and the more fusible porcelain stone as its 'flesh'.

One odd characteristic of these new, soda-rich bodies was their tendency to fire to warm rusty colours when left unglazed, probably due to some volatilised soda reacting

Table 17 Jingdezhen *yingqing* ware apparently using glaze stone in its glaze recipe

|  | $SiO_2$ | $Al_2O_3$ | $TiO_2$ | $Fe_2O_3$ | CaO | MgO | $K_2O$ | $Na_2O$ |
|---|---|---|---|---|---|---|---|---|
| *Yingqing* Body | 75.9 | 17.2 | 0.08 | 0.85 | 0.55 | 0.13 | 2.47 | 2.15 |
| *Yingqing* Glaze | 65.8 | 13.8 | 0.06 | 0.8 | 14.15 | 0.6 | 1.55 | 2.74 |

Table 18 Analyses of Yuan Jingdezhen porcelains: the glazes appear to use glaze stone and the bodies are apparently made from porcelain stone/kaolin mixtures

|  | $SiO_2$ | $Al_2O_3$ | $TiO_2$ | $Fe_2O_3$ | CaO | MgO | $K_2O$ | $Na_2O$ | MnO | $P_2O_5$ |
|---|---|---|---|---|---|---|---|---|---|---|
| Glazes |  |  |  |  |  |  |  |  |  |  |
| Yuan B&W 1 | 69.5 | 14.9 | trace | 0.8 | 9.0 | 0.3 | 2.7 | 3.1 | 0.1 | 0.12 |
| Yuan B&W 2 | 70.2 | 14.0 | trace | 0.8 | 8.0 | 0.4 | 2.7 | 3.1 | 0.1 | 0.15 |
| Yuan B&W 3 | 70.3 | 14.5 | trace | 0.8 | 6.5 | 0.4 | 2.8 | 3.1 | 0.1 | 0.16 |
| Bodies |  |  |  |  |  |  |  |  |  |  |
| Yuan B&W 1 | 72.7 | 20.2 | 0.5 | 0.9 | 0.2 | 0.15 | 2.9 | 1.8 | 0.08 | 0.04 |
| Yuan B&W 2 | 72.0 | 20.7 | 0.12 | 0.8 | 0.15 | 0.2 | 2.7 | 2.7 | 0.1 | 0.05 |
| Yuan B&W 3 | 74.6 | 19.5 | –.– | 0.8 | 0.04 | 0.2 | 2.7 | 2.3 | 0.02 | –.– |

At full maturing temperature Chinese porcelains become almost as soft as when they were on the potter's wheel, an effect known as *pyroplasticity*. This x-ray photograph of an early 15th-century Jingdezhen porcelain stem cup shows how the potter has deliberately made the bowl thicker at its lower half to prevent its sinking over its supporting stem. The rim, however, is made thinner, to give an overall illusion of fineness. Courtesy of the Victoria and Albert Museum.

with iron oxides in the porcelain bodies. Rusty or apricot-coloured unglazed bases are typical of 14th-century Jingdezhen porcelain production, but the effect is also seen occasionally in 15th-century wares when Jingdezhen potters have left the bases of their porcelains unglazed.

These unusual soda-rich porcelains were gradually phased out as the 15th century progressed in favour of porcelain bodies closer to pre-14th-century compositions. Even so, the use of kaolin was by now well-established at Jingdezhen, and it seems likely that most late 15th and 16th-century Jingdezhen porcelains contained useful amounts of the material, despite their superficial compositional similarities to the 'pre-kaolin' *yingqing* wares. From the mid 17th century onwards kaolin became increasingly important in Jingdezhen porcelain recipes and, by the early

18th century, 50/50 porcelain stone/kaolin mixtures were commonplace at this kiln site.

The pattern of kaolin usage at Jingdezhen was the subject of a large analytical study at Oxford in 1984 and the main results from this work are summarised by the chart on page 60.

In the West we tend to think of kaolin as vital for porcelain manufacture, but Jingdezhen seems to have been alone amongst southern Chinese kiln sites in its heavy use of the material. At most other southern porcelain centres, kaolin usage was either minor or non-existent, and the bodies consisted largely of porcelain stone. A similar low-kaolin or 'no-kaolin' principle operated at Korean and Japanese porcelain kilns, which began their white porcelain production in the 10th and 16th centuries respectively.

59

Two small *yingqing* ewers, one press-moulded, and the other thrown. 12th century AD. *Yingqing* was essentially a folk porcelain and a vast range of ordinary wares were made from this abundant quartz-mica porcelain material in southern China. H. 6 in., 15cm. British Museum.

Table 19 Analyses of 10th-century Korean and 17th–18th century Japanese porcelains

|  | SiO$_2$ | Al$_2$O$_3$ | TiO$_2$ | Fe$_2$O$_3$ | CaO | MgO | K$_2$O | Na$_2$O | MnO |
|---|---|---|---|---|---|---|---|---|---|
| Korean 1 | 78.1 | 15.0 | 0.1 | 1.6 | 0.3 | –.– | 5.1 | 0.1 | –.– |
| Korean 2 | 72.2 | 17.2 | 0.2 | 1.4 | 0.4 | –.– | 3.8 | 0.2 | 0.03 |
| Japanese | 74.7 | 18.7 | 0.1 | 1.0 | 0.2 | 0.15 | 4.1 | 0.9 | 0.01 |

(Korean porcelains from Sori. The Japanese porcelain is an average of 85 17th and 18th century examples from Arita, Kyushu)

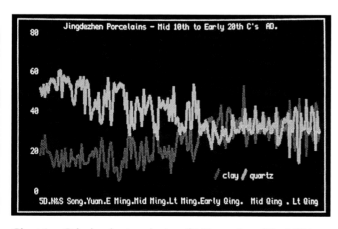

Chart 1 – Calculated mineralogies of 140 samples of fired Chinese porcelains. Clay levels of up to 20% can occur in bodies made entirely from porcelain stone, but the rise in clay levels at Jingdezhen after the Southern Song seems associated with the introduction there of kaolin. This material was used in substantial amounts at Jingdezhen in the early Qing dynasty, but kaolin additions in the later Qing dynasty tend to be more variable.

These early Korean and Japanese porcelains also consisted largely of porcelain stone, and made little use of kaolin as a body ingredient.

## *Shufu glazes*

The first major departure from the transparent *yingqing* style of glaze at Jingdezhen occurred in the early 14th century, when the *shufu* glaze was developed. This rather opaque, sugary-white glaze was made by drastically reducing the amount of glaze ash from about 25–30% in the *yingqing* glaze to about 10% in the *shufu* glaze. This meant that some of the fine silica in the glaze stone remained undissolved in firing, with the unmelted quartz particles producing a white and matt effect. These fine but undissolved quartz crystals also encouraged micro-crystals of lime silicates to grow in the glazes during cooling, which contributed to the stony opacity of the *shufu* glazes.

Table 20 Glazes and bodies of Yuan *shufu* porcelains from Hutian, Jingdezhen

| | $SiO_2$ | $Al_2O_3$ | $TiO_2$ | $Fe_2O_3$ | CaO | MgO | $K_2O$ | $Na_2O$ | MnO |
|---|---|---|---|---|---|---|---|---|---|
| Glazes | | | | | | | | | |
| Hutian *shufu* 1 | 73.3 | 14.6 | tr. | 0.8 | 5.3 | 0.16 | 2.9 | 3.3 | 0.08 |
| Hutian *shufu* 2 | 72.7 | 13.2 | tr. | 0.8 | 4.8 | 0.18 | 3.0 | 3.7 | 0.1 |
| Hutian *shufu* 3 | 72.0 | 15.6 | tr. | 0.85 | 5.5 | 0.2 | 3.0 | 3.5 | 0.1 |
| Bodies | | | | | | | | | |
| Hutian *shufu* 1 | 73.7 | 19.5 | 0.23 | 1.4 | 0.2 | 0.2 | 3.2 | 2.0 | 0.08 |
| Hutian *shufu* 2 | 72.7 | 20.7 | 0.2 | 1.2 | 0.14 | 0.2 | 2.7 | 2.4 | 0.07 |
| Hutian *shufu* 3 | 72.1 | 21.6 | 0.2 | 1.2 | 0.06 | 0.2 | 2.8 | 2.1 | 0.07 |

*Shufu* bowl, thrown and press-moulded. Moulding in relief was most easily managed by direct carving of the mould's surface, as this produced raised ornament on the pressed bowl's form. At Jingdezhen there is a long tradition for the use of unfired moulds of dry clay with porcelain, a practice described by Père d'Entecolles in the early 18th century. Two stages were used in re-pressing thrown forms. First the soft-leatherhard bowls were trued on plain moulds, and they were then applied to patterned moulds set on the potter's wheels. Pressure was applied to backs of the bowls to force the bowl's surface into the moulded designs. They were then turned, but the foot was left solid. After glazing the foot was turned out. These sugary *shufu* glazes were low in 'glaze-ash' (limestone) and consequently rendered matt by some undissolved silica and the growth of lime-silicate microcrystals in cooling. Jingdezhen, early 14th century. D. 5.5 in., 14 cm. Gemeentemuseum, The Hague, OCVO 406–35.

*Shufu* glazes were used on relatively thick porcelains with rather blunt rims and they often show relief decoration achieved by moulding. A number of *shufu* examples bear the moulded characters *shu fu* meaning 'Privy Council'. These characters suggest that *shufu* wares were official Mongol porcelains of some kind, although their exact status in China is still debated.

Body analyses of *shufu* porcelains reveal that they were made from the new albite-rich body stones mixed with added kaolin. Their glazes too exploited high-albite glaze stone materials. Despite these changes the *shufu* bodies are actually less pure than the earlier *yingqing* wares – due largely to the higher titania contents of the *shufu* clays – and it is possible that the semi-opaque *shufu* glazes were developed to disguise this fact. One curious technical feature of low-lime glazes of the *shufu* type is that they interact less with the porcelain bodies, resulting in less distortion of the porcelain shapes at high temperatures. The physical size of Jingdezhen porcelain seems to have increased markedly with the appearance of *shufu*-style wares, and this may have been partly due to the use of these less reactive, low-lime glazes. Whether or not the newly adopted kaolin material played an important part in this change of scale, through improved plasticity of the porcelain bodies, is a disputed point: some data suggest that Jindezhen kaolins and albitic porcelain stones were substantially less plastic materials than the kaolinised porcelain stones they replaced. Nonetheless these large and plain *shufu*-style pieces led in turn to the massive blue-and-white and red-and-white porcelains that were manufactured at Jingdezhen in the 14th and 15th centuries AD, largely for export to the Middle East.

## Underglaze blue

Almost exactly midway between *yingqing* and *shufu* glazes in appearance and composition are the Jingdezhen glazes used with underglaze-blue painting in cobalt ores. These are true lime-alkali glazes and to some extent they were revivals of the glazes used on the old Five Dynasties whitewares. They are less fluid than the *yingqing* glazes, so the painting does not spread in firing, but less opaque than the *shufu* glazes, so the underglaze designs can show clearly through the fired glazes. Recipes for Jingdezhen lime-alkali glazes used for underglaze-blue painting seem to have used varied amounts of glaze ash – between about 10% and 20% – with the remainder being glaze stone.

Jingdezhen blue-and-white folk wares (called *minyao* in China) tended to use the larger amounts of glaze ash, so

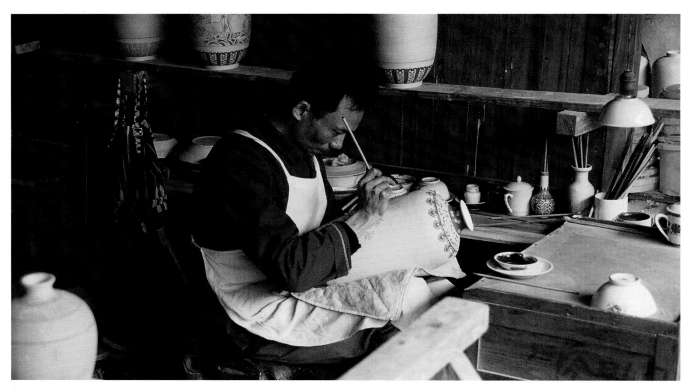

Painting with an underglaze cobalt-blue pigment at Jingdezhen in 1982. Underglaze-blue painting is carried out on the raw porcelain clay, often using tea as a medium. The inside of this particular vase has already been glazed and, when the painting is complete, a raw lime-alkali glaze will be applied to its outside, before firing to about 1280°C in a reducing atmosphere.

Small Jingdezhen plate with underglaze-blue painting, probably from the second quarter of the 14th century. X-ray fluorescence analysis of this very early example of Jingdezhen blue-and-white porcelain showed its pigment to be a high-iron cobalt with a trace of arsenic. D. 5.5 in., 14 cm.
Victoria and Albert Museum, C. 189–1931.

that their glazes matured more easily in the kiln (1220°-50°C) and were consequently cheaper to fire. Higher quality blue-and-white wares used the whiter and more refractory mixtures that were lower in lime, and these superior glazes often matured in the 1270°-1290°C range.

## History of Jingdezhen underglaze blue

The idea for painting on ceramics with a cobalt-blue pigment was not actually a Jingdezhen invention, nor even a Chinese discovery, but a Middle Eastern process developed in Mesopotamia. However, it did see its greatest use at Jingdezhen and, from its beginnings in the late 1320s to the present day, Jingdezhen underglaze-blue painted porcelain has established itself as one of the world's most significant and influential ceramic productions.

Before its appearance at Jingdezhen, underglaze-blue painting had been used sparingly in north China at Gongxian in the late Tang dynasty. The technique had also been tried at Longquan in south China in the Northern Song dynasty – although at both kiln sites blue-and-white production seems to have been short-lived and experimental. However, almost from its beginning, Jingdezhen blue-and-white porcelain established itself as a material of exceptional quality, with enormous potential as a decorative process.

Yuan dynasty underglaze blue painted stem cup, mid-14th century Jingdezhen. The lean form, the lively painting, and the rather thick glaze, are all characteristic of this early stage in Jingdezhen blue and white production. Sotheby's. H. 4.25 in., 10.7 cm.

The most important research towards understanding the beginnings of Jingdezhen blue-and-white porcelain has been carried out by Jingdezhen's leading archaeologist and historian, Professor Liu Xinyuan of the Jingdezhen Institute of Ceramic Archaeology. Since 1984 Professor Liu has been excavating the Imperial porcelain kiln site at Zhushanlu (Pearl Hill Road), near to the centre of present-day Jingdezhen. At this site Liu has found the remains of high-quality blue-and-white porcelains dating from the Mongol occupation of China, that were apparently made to Mongol imperial orders. The status of this ware is indicated particularly by the use of the five-toed, two-horned imperial dragon in the painted, carved and moulded ceramic decorations.

Liu Xinyuan puts the beginnings of this porcelain style to about 1328 and suggests that Jingdezhen blue-and-white began its production as a true imperial ware. Slightly inferior blue-and-white wares of a similar style were also made in the mid-14th century at Jingdezhen apparently for presentation to lesser rulers beyond China – some of the massive 14th-century blue-and-white Chinese dishes in the Topkapi palace in Istanbul seem to date from this very early period. After these august beginnings the production of Jingdezhen blue-and-white ware gradually expanded and, later, included a vast output of folk wares. Nonetheless, blue-and-white porcelains of the very highest quality remained (and still remain) one of Jingdezhen's premier productions.

**The underglaze-blue pigment**

The blue pigment used at Jingdezhen in the 14th and early 15th centuries was a cobalt ore, rich in iron oxide and sometimes containing some arsenic, nickel and copper. A typical balance of iron to cobalt was about 3:1. This cobalt-rich rock is believed to have been imported from the Middle East or Central Asia. Kashan in Persia is usually cited as the main source for 14th and early 15th century Jingdezhen cobalt ores, although alternative and supplementary origins of this material are still being explored.

It is difficult to analyse 14th and early 15th century underglaze-blue pigments directly as many constituents of the blue pigments are also found in the porcelain glazes that surround them. Nonetheless it is possible to establish the

Table 21 Some typical manganese/cobalt and iron/cobalt ratios present in Jingdezhen underglaze-bluewares of successive dynasties

|  | Manganese/cobalt | Iron/cobalt | CoO | FeO | MnO |
|---|---|---|---|---|---|
| Yuan | 0.01:1 | 2.45:1 | 28.9 | 70.8 | 0.3 |
| Yuan | 0.05:1 | 2.7 :1 | 26.6 | 72.0 | 1.3 |
| Yuan | 0.06:1 | 3.0:1 | 24.6 | 73.9 | 1.5 |
| Yuan | 0.5:1 | 41:1 | 2.3 | 96.4 | 1.2 |
| Ming |  |  |  |  |  |
| Xuande | 0.81:1 | 5.8:1 | 13.1 | 76.2 | 10.6 |
| Xuande | 0.7:1 | 2.5:1 | 23.8 | 59.5 | 16.6 |
| Chenghua | 1.82:1 | 1.9:1 | 21.2 | 40.2 | 38.5 |
| Zhengde | 6.1:1 | 1.9:1 | 11.1 | 21.1 | 67.7 |
| Jiajing | 1:1 | 0.82:1 | 35.4 | 29.0 | 35.4 |
| Wanli | 7.9:1 | 1.3:1 | 9.8 | 12.7 | 77.9 |

Table 22 Analyses of native Chinese asbolites, mainly from Zhejiang province

|  | $SiO_2$ | $Al_2O_3$ | $Fe_2O_3$ | $TiO_2$ | CaO | MgO | $K_2O$ | $Na_2O$ | NiO | CoO | CuO | MnO |
|---|---|---|---|---|---|---|---|---|---|---|---|---|
| Asbolite 1 | 28.8 | 36.4 | 3.2 | 0.12 | 0.65 | 0.8 | 0.1 | 0.45 | –.– | 2.8 | 0.7 | 20.5 |
| Asbolite 2 | 28.7 | 35.4 | 2.8 | 0.35 | 0.4 | 0.4 | –.– | 0.3 | –.– | 6.1 | 0.8 | 22.8 |
| Asbolite 3 | 42.5 | 21.0 | 5.2 | –.– | 0.4 | 0.5 | 1.2 | 0.1 | 0.2 | 1.4 | 0.2 | 22.4 |
| Asbolite 4 | 42.5 | 23.7 | 5.3 | –.– | 0.1 | 0.3 | –.– | –.– | –.– | 2.1 | –.– | 24.0 |
| Asbolite 5 | 6.0 | 27.2 | 1.5 | –.– | 0.03 | 0.1 | –.– | –.– | 1.2 | 6.9 | –.– | 49.0 |

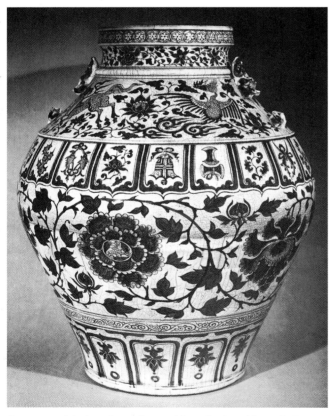

Large porcelain jar of *guan* form with underglaze-blue painting. The pigment used for high-quality Yuan blue and white would have been an imported iron-cobalt ore. Variations in crazing density, seen in the different thrown sections on this jar, suggest that different batches of porcelain clay had been used in its making. Yuan Dynasty, *c.* AD1350. H. 19 in., 48cm.

pigments' ratios of cobalt to iron, and cobalt to manganese, and this was one of the earliest of the non-destructive tests on Chinese ceramics, carried out at Oxford in the 1950s. This, and later work, has shown that high-quality underglaze-blue painting in the Yuan dynasty used iron-cobalt mixtures which gradually gave way, as the 15th century progressed, to manganese-cobalt pigments lower in iron.

In Table 21, the manganese/cobalt and the iron/cobalt ratios have been recalculated to show the likely proportions of colouring oxides in the original pigments. Even so, care is necessary with using these figures for two reasons. First, cobalt-rich rocks often contain some nickel and copper, which are both colouring oxides, but which were not analysed in this particular study. The second point is that the original raw pigments sometimes contained substantial amounts of silica and alumina. Although these are not colouring oxides in themselves, they can still affect the colours produced by cobalt oxide – with high-alumina pigments encouraging cold blues through the creation of cobalt aluminates during firing, and the more siliceous pigments giving 'hotter' (i.e., redder) blues from the formation of cobalt silicates. Analyses of modern manganiferous cobalt rocks (asbolites) used at Jingdezhen show how

Large blue and white wine jar with damaged rim, second half of the 14th century AD. Narrative scenes such as these are common on Ming transitional wares, but extremely rare on 14th-century Jingdezhen porcelains. Large jars in this style were often made in two or more sections and then joined before the final turning stage. Sotheby's. H. 12.2 in., 31 cm.

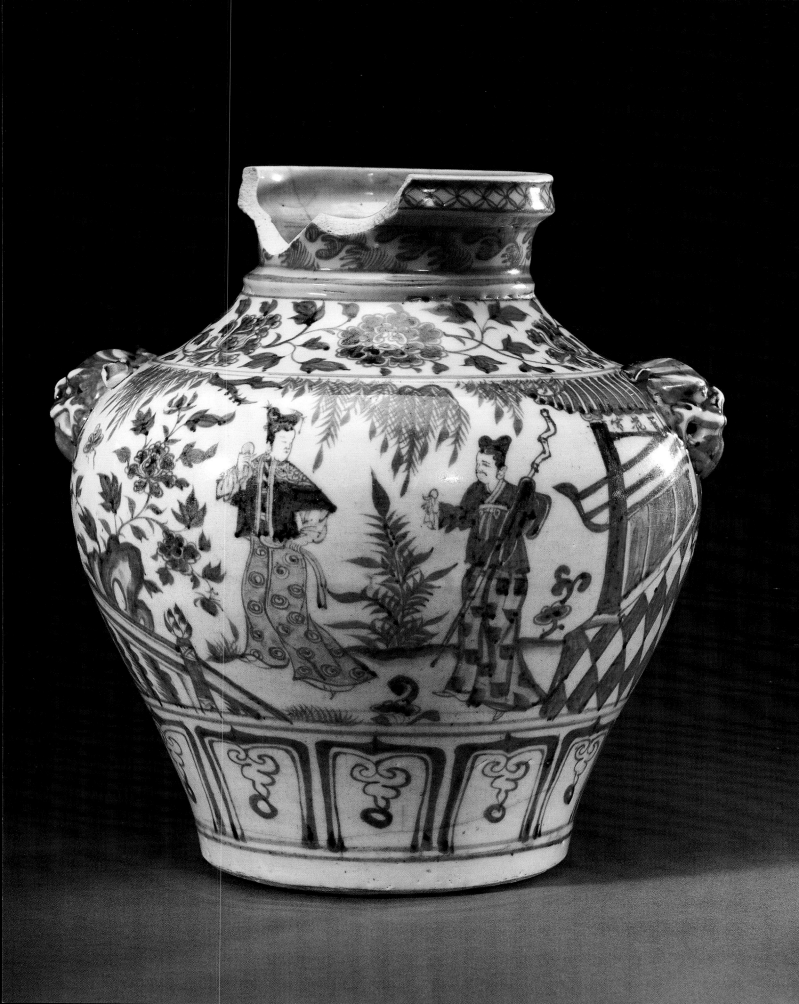

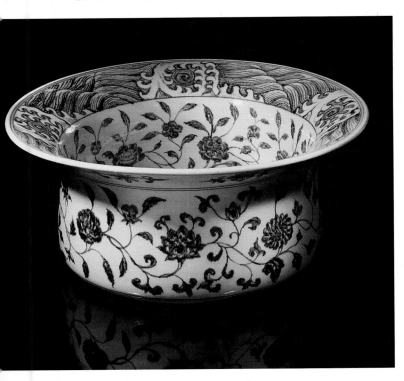

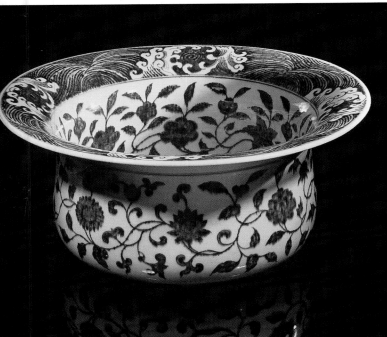

Early Ming blue and white basin and its 18th-century copy. The Ming original (top) is from the Yongle period (1403-1424) and its Qing copy is from the period of Qianlong (1736-1795). The 18th-century Jingdezhen potters have made every effort to produce a close copy of the Yongle basin. To do this they have had to reproduce the 'heaped and piled' effect, that occurs naturally with the high-iron early Ming cobalt-blue pigments, by adding thousands of fine dots to their underglaze-blue painting. (By Qing times the cobalt pigment was high in manganese and would not produce this effect spontaneously). Ming basin D. 13.75 in., 35 cm. ; Qing basin D. 14.25 in., 36 cm. Sotheby's.

complex Chinese cobalt ores can be, as well as revealing how much variation can occur between different examples of the material.

One important difference between these managese-rich pigments, and the iron-rich cobalt ores that preceeded them at Jingdezhen, was the tendency of the iron-rich cobalts to diffuse through the thick porcelain glazes used at the time, and to crystallise out as magnetic iron oxide on the surfaces of the glazes during cooling. This gave the famous 'heaped and piled' effect, so characteristic of 14th and early 15th-century underglaze-blue painting. Jingdezhen potters of the 18th century sometimes copied these qualities with their high-manganese cobalts by applying a myriad of tiny blue dots to their painted designs.

During the 15th century, manganese-cobalt ores from within China gradually replaced the imported materials, but higher iron cobalt ores made a brief reappearance at Jingdezhen in the Jiajing period (1522-1566), when they were used for some particularly fine underglaze-blue work. So valuable was the 'Mohammedan blue' pigment used at this time that Jiajing porcelain painters were obliged to work with their arms through holes in wooden screens, to limit their access to the precious material.

### Underglaze-red wares

In the second half of the 14th century, difficulties with supplies of imported cobalt ores led the Jingdezhen potters to concentrate on underglaze-red effects from arsenical-copper pigments, rather than the traditional underglaze-blue. Underglaze-red is a difficult pigment to fire successfully as the copper tends to spread into the glaze at high temperatures, and also to fire grey rather than red. In order to keep their drawing sharp, Jingdezhen potters developed rather stiffer porcelain glazes than were used on underglaze-blue porcelain, an effect probably managed by reducing the glaze ash contents of their glazes to about 10%. Because of these lower flux levels 14th-century underglaze-red glazes look slightly whiter than their underglaze-blue equivalents and, because of their higher viscosity, the underglaze-red glazes also have an occasional tendency to crawl.

### The 'sweet white' glaze

As we have seen, less glaze ash meant whiter glazes and, in the early 15th century AD, a magnificent plain white porcelain was made at Jingdezhen for imperial use. This was known as 'sweet white' ware (*tianbai* in Chinese). Sweet white glazes consisted almost entirely of glaze stone and contained little or no glaze ash. The sweet white effect can be regarded as the logical conclusion of Jingdezhen potters' experiments with these versatile glaze stone/glaze ash mixtures.

Table 23 Analyses of Jingdezhen Yongle 'sweet white' glazes and bodies

| | $SiO_2$ | $Al_2O_3$ | $TiO_2$ | $Fe_2O_3$ | CaO | MgO | $K_2O$ | $Na_2O$ | MnO | $P_2O_5$ |
|---|---|---|---|---|---|---|---|---|---|---|
| Glazes | | | | | | | | | | |
| Sweet white 1 | 71.2 | 15.2 | 0.10 | 1.2 | 2.36 | 0.6 | 5.3 | 2.7 | 0.09 | 0.16 |
| Sweet white 2 | 72.2 | 16.0 | 0.05 | 0.8 | 2.65 | 0.4 | 5.3 | 2.0 | –.– | –.– |
| Bodies | | | | | | | | | | |
| Sweet white 1 | 72.9 | 22.0 | 0.09 | 0.7 | 0.2 | 0.2 | 2.6 | 0.8 | 0.01 | 0.05 |
| Sweet white 2 | 72.5 | 21.4 | 0.05 | 0.8 | 0.6 | 0.3 | 2.8 | 0.8 | –.– | –.– |

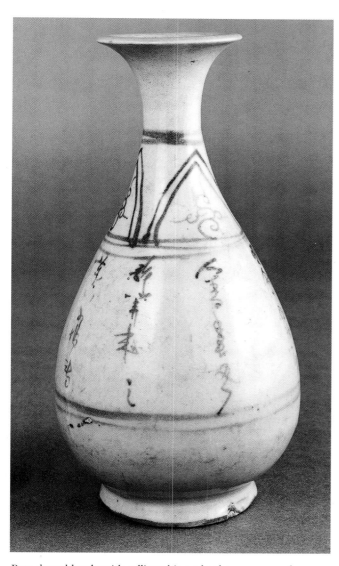

Pear-shaped bottle with calligraphic underglaze copper-red decoration, probably Jingdezhen, first half of the 14th century. The use of underglaze copper-red decoration at Jingdezhen may pre-date underglaze cobalt blue slightly. The first copper pigments used at this kiln site appear to have been copper-iron mixtures, applied under *yingqing*-like glazes. In the later 14th century, copper-arsenic mixtures under whiter and more viscous porcelain glazes were developed. H. 9.75 in., 24.8 cm. British Museum, OA 1975.10–28.2.

The sweet white glaze appeared at a time when Jingdezhen was making some of its finest porcelains, both technically and aesthetically, and also showing signs of its huge potential for mass production. The simple technologies outlined above – based on porcelain stone, kaolin, glaze stone and glaze ash – had proved enormously versatile. Most Jingdezhen wares were raw-glazed and once-fired, and the firing temperatures employed were modest by northern standards. Making was rapid and reliable, with rigid division of labour (itself a Chinese invention) contributing to a hugely efficient production. The succeeding centuries saw this riverside kiln complex grow enormously in size until, by the early 18th century, Jingdezhen was providing all of China, and much of the known world, with porcelain.

**The *zhenyao* kiln**

During the period of its greatest productivity (late 17th to the mid-20th centuries AD), the main Jingdezhen kiln type was the *zhenyao* or 'egg-shaped' kiln – a triumph of brick-laying and firing efficiency that resembled half an egg lying on its side. The chimney of the *zhenyao* kiln was usually as tall as the kiln was long (typically 10-15 metres inside) while the kiln itself used herring-bone brick-laying and a parabolic section that allowed easy construction and repair with only the lightest supporting frame. There was a single large firebox set within the larger end of the kiln, and a tall tapering chimney was built with a 'tear-drop' cross-section to minimise resistance to prevailing winds. The kiln's chimney was built using spiral brick-laying and a fusible mortar to give maximum strength to its single-brick thickness.

Once the kiln was filled with columns of saggars bearing raw porcelains, the kiln-setters built a temporary grate of firebars from refractory bricks over an ash pit in the floor, just inside the wicket (the door of the kiln). They then bricked up the door, leaving a central hole for 'posting in' the short pine logs used as fuel. They also left two holes high in the kiln door (known as the 'eyes' of the kiln) for admitting secondary air. The primary combustion air entered through the central stoking hole, as well as

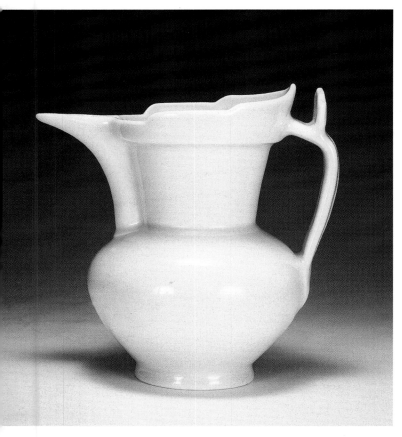

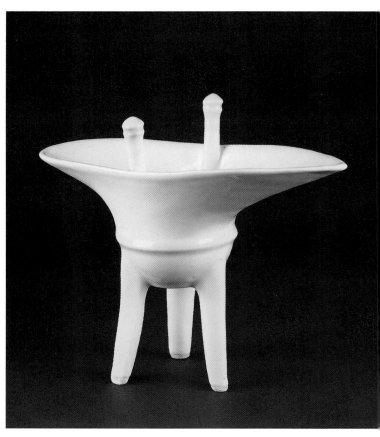

White 'monk's cap' porcelain ewer with a 'sweet white' (*tianbai*) glaze, and a Yongle reign mark, first decade of the 15th century. The Chinese Yongle emperor was an enthusiast for Tibetan buddhism and it has been suggested that similar ewers were made as imperial gifts for Tibetan religious leaders. A number of white monk's cap ewers have been excavated from early Yongle strata at Jingdezhen. H. 7.5 in., 19cm. Sotheby's.

Porcelain *jue* with a *tianbai* glaze, and a form adapted from a Shang bronze wine cup. Ming dynasty, Yongle period, about AD1406. Glazes of this style were used with the finest quality of plain white Yongle porcelain. They are associated with Yongle imperial taste, and wine cups with this archaic form were used in state sacrificial ceremonies. Analysis suggests that Yongle *tianbai* glazes may have consisted almost entirely of glaze stone. H. 5.9 in., 15 cm. Victoria and Albert Museum, 706–1883.

through an arched tunnel below floor level. Water was introduced into the ash pit at the height of the firing to enhance reduction through the creation of water-gas (see p. 162-3 ).

One curiosity of the *zhenyao* design was the great fall-off in heat from the firebox end to the chimney (typically 1320°-1000°C). This huge difference in final maturing temperature was exploited by the Jingdezhen potters who used their flexible glaze and body recipes to match the varying kiln conditions. Bodies richest in kaolin, and glazes lowest in glaze ash, were used for the greatest heat – while lower-firing bodies high in porcelain stone, and glazes rich in glaze ash, were used for the cooler parts.

The very coolest parts of the kiln were reserved for pre-firing saggars and for finishing monochrome porcelains. The latter were usually high-fired whitewares or unglazed bisqued bodies that were being refired with lead oxide – or potassia-fluxed coloured glazes. Bleed holes through the

kiln walls, immediately in front of this back section, ensured that this part of the kiln did not overfire, and also allowed the use of oxidising glazes, within a kiln atmosphere that was generally reducing.

About 70 kilns of this style were still operating at Jingdezhen in the mid-1950s, and a couple of working examples remain in the city today, although coal, electricity and oil-fired kilns, many of Western design, are now the norm. Modern production at Jingdezhen is well in excess of 400 million pieces a year, and the city is China's main provider of porcelain tableware. Jingdezhen is still a major exporter of porcelain, although nowadays its more important markets lie in the Far East, rather than in the West.

## Dehua *(blanc-de-Chine)* porcelains

Jingdezhen was certainly the premier porcelain kiln in China from late Yuan onwards, but an important porcelain

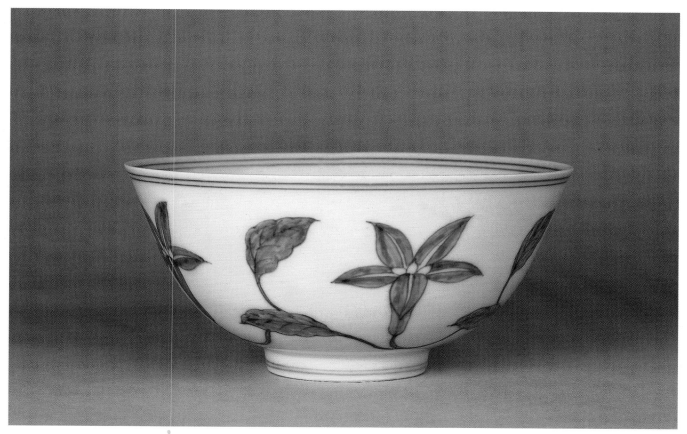

Palace bowl painted with lilies in underglaze cobalt blue, Chenghua period (AD1465–1487). Chenghua underglaze-blue porcelains of this quality are often regarded as the epitome of Chinese blue-and-white porcelain production. The best Chenghua glazes have warmish tones and chemical analysis shows that they were low in lime and above average in alkalis (potassia + soda). Thin glazes with these compositions can re-oxidise slightly at high temperatures and this, combined with less strong reduction in the porcelain kilns, may account for the 'honeyed' tones of the best Chenghua blue and white. D. 6 in., 15cm. Carter Fine Art.

kiln complex also operated some 300 miles to the south east of Jingdezhen, in the coastal province of Fujian, near to the market town of Dehua. Like Jingdezhen, Dehua was built on a plain, surrounded by rocky hills, in a mountainous area of southern Fujian. The Dehua kilns specialised in highly translucent, ivory-coloured porcelains that are known in the West as *blanc-de-Chine*. A small amount of 'country' blue-and-white was also made at Dehua, as well as some unusual overglaze enamelled wares. Recent research has also uncovered evidence for the production of a limited amount of very high quality blue-and-white porcelain in the Dehua area in the late 17th and early 18th centuries, using bodies and glazes that were markedly superior to those of Jingdezhen.

What chiefly distinguishes the products of Dehua from those of Jingdezhen, and from other porcelain kiln sites in south China, is the unusual purity of the local porcelain stone, which was generally used alone, without kaolin additions. The iron oxide contents of Jingdezhen porcelain averaged just below 1% while the iron oxide levels in

Dehua porcelains could be as low as 0.2%. These unusually low proportions of iron allowed the Dehua potters to fire their porcelains in oxidation to about 1280°C, producing a superb ivory-white material.

Scene just outside Dehua town. The rocky valleys, with their fast streams and terraced fields provided sites both for Dehua climbing kilns and the water-powered trip hammers used for crushing the local porcelain stone.

Water wheels at Dehua, Fujian province, used for pulverising porcelain stone in 1995. These undershot water wheels are driven by small leats from the main river, just outside Dehua town. Porcelain stones in this area are among the purest in China.

Small moulded porcelain ewer in double gourd form and with iron-rich spots, perhaps from Fujian province, 14th century AD. Typical of the small ewers and jarlets exported from China in large numbers to the Philippines in the 14th and 15th centuries. This style can also feature spots of underglaze cobalt blue. H. 4.75 in., 12 cm. Victoria and Albert Museum, John Addis gift.

Oxidised porcelains were common in north China (as seen in the famous Ding wares) but the technique was not practised at Jingdezhen to any extent as it gave the wares an unpleasant yellowish cast – as well as spoiling the colours of underglaze-blue pigments. A few examples of oxidised

Jingdezhen porcelain were made in the 18th century, to imitate the classic Ding wares of north China but, in general, Jingdezhen potters took great care to maintain proper reducing conditions within their kilns.

Not only are Dehua porcelains extremely low in iron, but they are also unusually rich in potassium oxide flux, and this made them exceptionally translucent after firing. The potassium oxide contents of Dehua wares could be as high as 7% – which is twice as much potassia as occurs in typical Jingdezhen wares. The Dehua porcelain stones used in the Ming and Qing dynasties seem to have been natural mixtures of potash mica, potash feldspar and quartz with the presence of some unaltered potash feldspar boosting the potassium oxide content of the material.

The great advantage of high-silica, high-potassium porcelains of the Dehua type is that the body-glass they produce in firing is exceptionally viscous (being a mixture of glass and mullite from the breakdown of mica, and glass and leucite from the melting of the potash feldspar). Increasing kiln temperatures tended to dissolve more silica into the body-glass, which in turn raised its viscosity and

Table 24 Dehua porcelain bodies, Song to Qing

| | $SiO_2$ | $Al_2O_3$ | $TiO_2$ | $Fe_2O_3$ | CaO | MgO | $K_2O$ | $Na_2O$ | $P_2O_5$ |
|---|---|---|---|---|---|---|---|---|---|
| Dehua Northern Song | 71.7 | 21.7 | –.– | 0.6 | 0.33 | 0.18 | 5.16 | 0.08 | 0.03 |
| Dehua Northern Song | 77.5 | 17.7 | 0.12 | 0.6 | 0.09 | 0.06 | 4.58 | 0.12 | 0.02 |
| Dehua Southern Song | 81.6 | 14.9 | 0.09 | 0.8 | 0.14 | 0.13 | 2.87 | 0.08 | –.– |
| Dehua Southern Song | 77.8 | 18.5 | 0.03 | 0.4 | 0.17 | 0.17 | 4.45 | 0.10 | 0.03 |
| Dehua Yuan | 76.4 | 17.4 | 0.08 | 0.3 | 0.04 | 0.06 | 5.71 | 0.10 | 0.03 |
| Dehua Ming | 76.7 | 16.7 | 0.10 | 0.3 | 0.15 | 0.08 | 5.94 | 0.13 | 0.03 |
| Dehua Ming | 75.6 | 17.3 | 0.13 | 0.2 | 0.04 | 0.10 | 6.51 | 0.13 | 0.02 |
| Dehua Qing | 75.0 | 18.0 | 0.09 | 0.3 | 0.02 | 0.08 | 6.76 | 0.15 | 0.02 |

delayed any high-temperature collapse of the wares. All these effects made possible the very useful combination of high translucency with good resistance to high-temperature distortion that is typical of the Dehua material.

A further advantage of these unusual porcelain stones was their suitability as glaze ingredients. As at Jingdezhen, the Dehua potters used glaze ash (calcium carbonate) as their main glaze flux, but the high alkali contents of the Dehua porcelain stones made excellent transparent glazes possible with only modest glaze ash additions. Consequently many Dehua glazes are of true alkali-lime composition and have a particularly unctuous brilliance that is rarely seen on Jingdezhen wares (an effect described as 'pig's grease white' in China). Low-calcium glazes also minimised the softening effect that higher lime glazes can sometimes exert on porcelain bodies at high kiln temperatures, and this too helped to limit distortion in the porcelain kilns.

## Development of Dehua porcelains

The Dehua porcelain workshops began operating in the Northern Song dynasty (AD960-1280) when they made thrown, and later moulded, *yingqing* wares. These later came to include a successful line in shallow, moulded boxes with domed lids. Early Dehua *yingqing* looks pale, almost anaemic, when compared to the Jingdezhen material. Some early versions of Dehua glazes were very low in lime (5–7% CaO), and this produced matt-white glazes rich in undissolved silica. These Northern Song 'snow white' glazes from Dehua anticipated the principle of the *shufu* glazes of Jingdezhen by some 300 years. The more transparent Dehua *yingqing* glazes contained 10–12.5% CaO and were closer to the Jingdezhen originals – although compositionally they are just within the lime-alkali class.

Glazes of this general *yingqing* type continued to be made at Dehua throughout the Yuan dynasty but in the Ming even purer and more alkali-rich porcelain stones began to be exploited by the Dehua potters, and the glazes became lower in lime and richer in potassia. This combination of glaze and body resulted in the classic Dehua porcelain material that has continued production into modern times.

Press-moulded covered box with a transparent bluish glaze, Southern Song or Yuan dynasty, perhaps from the Anxi kilns, Fujian province. Fujian *yingqing* glazes tend to be lower in calcium oxide than the Jingdezhen examples, and the Fujian raw materials were also lower in iron. For both reasons Fujian *yingqing* wares are often whiter than their Jingdezhen equivalents. D. 8.75 in., 22.3 cm. Gemeentemuseum, The Hague, OCVO 9–73.

## The Dehua step kiln

As the vast majority of later Dehua porcelain was fired to within the same temperature-range (*c.* 1270±20°C), close control over kiln temperatures was essential in order to develop its ideal translucency. To these ends Dehua potters developed in the 13th century an improved version of the dragon kiln that was divided into wide, rectangular, separate chambers, set one above the other on a series of broad steps. This design eliminated much of the unevenness typical of dragon kilns, and was entirely opposite in concept from the Jingdezhen 'egg-shaped' kilns in which a great range of bodies and glazes were fired simultaneously to a wide spread of temperatures.

At its best, Dehua porcelain can resemble milky glass, or translucent white marble, with a wonderful integration of glaze and clay that gives the illusion of single translucent material. The technical quality of Dehua porcelain was unequalled in China, although it was never adopted as an

Table 25 Analyses of Dehua porcelain glazes – Ming to Qing

| | $SiO_2$ | $Al_2O_3$ | $TiO_2$ | $Fe_2O_3$ | CaO | MgO | $K_2O$ | $Na_2O$ | $P_2O_5$ |
|---|---|---|---|---|---|---|---|---|---|
| Dehua Northern Song | 68.7 | 19.4 | 0.02 | 0.4 | 4.8 | 0.3 | 4.6 | 0.16 | 0.08 |
| Dehua Northern Song | 72.2 | 15.2 | –.– | 0.6 | 6.5 | 0.2 | 4.5 | 0.17 | 0.01 |
| Dehua Southern Song | 69.1 | 14.6 | –.– | 1.1 | 11.6 | 0.6 | 2.4 | 0.1 | 0.01 |
| Dehua Southern Song | 65.0 | 15.8 | –.– | 0.6 | 12.8 | 0.7 | 3.5 | 0.1 | 0.01 |
| Dehua Yuan | 67.0 | 15.2 | –.– | 0.3 | 9.9 | 0.5 | 5.0 | 0.1 | 0.02 |
| Dehua Ming | 69.0 | 15.6 | –.– | 0.6 | 7.0 | 0.4 | 5.4 | 0.2 | 0.08 |
| Dehua Ming | 69.0 | 15.5 | 0.35 | 0.24 | 6.0 | 0.8 | 6.6 | 0.1 | 0.02 |
| Dehua Qing | 68.5 | 16.5 | –.– | 0.3 | 5.1 | 0.7 | 6.8 | 0.2 | 0.4 |

Above: *Yingqing* bowl with applied gilding and a metal-bound rim, Jingdezhen or Fujian, Southern Song dynasty. The metal helps to disguise the unglazed rim and the gilding was probably unfired. The gilding of ceramics became a popular technique in the Song dynasties, but few examples have survived with their gold decoration so complete. Carter Fine Art.

Right: High quality Dehua porcelain figure, early Qing dynasty. Largely because of their high purity, Dehua porcelain-stones were rather non-plastic, and more suitable for press-moulding than for throwing. This may explain the abundance of moulded wares from the Dehua kiln complex, which was particularly famous for its porcelain figurines.

imperial ware. Objects made from this extremely sophisticated ivory-white fabric included wine pots and wine cups, incense burners and censers, altar vases, as well as a famous range of moulded and modelled figures. The continuous use of the same materials and forms, and the lack of painted designs on most Dehua porcelains, have made Ming and Qing Dehua wares very difficult to date, so the study of the development of this important kiln site is still at a rather provisional level.

# FURTHER READING

*BOOKS AND EXHIBITION CATALOGUES*

Robert Tichane, *Ching-te Chen – Views of a Porcelain City*, The New York State Institute for Glaze Research, 1983

(Tichane's book is a complete 'Jingdezhen reader'. Among other texts it contains translations of Georges Vogt, Père d'Entrecolles and Ebelman and Salvetat. There are also Chinese excavation reports from Jingdezhen, and Robert Tichane's own accounts of his visits to the city.)

*PAPERS AND ARTICLES*

Chen Yaocheng, Guo Yanyi and Zhang Zhigang, 'A study of Yuan blue-and-white porcelain', *Scientific and Technical Insights on Ancient Chinese Pottery and Porcelain*, Beijing, 1986, pp 122-8

Guo Yanyi, 'Raw materials for making porcelain and the characteristics of porcelain wares in north and south China in ancient times.' *Archaeometry*, vol. 29, part 1, London, 1987, pp 3-19

Guo Yanyi and Li Guozhen, 'A study of Dehua white porcelains in successive dynasties', *Scientific and Technical Insights on Ancient Chinese Pottery and Porcelain*, Beijing, 1986, pp 141-7

Li Jiazhi and Chen Shiping, 'A study on Yongle white porcelain in Jingdezhen', *Proceedings of 1989 International Symposium on Ancient Ceramics*, (Li Jiazhi and Chen Xianqiu eds), Shanghai, 1989, pp 344-51

Nigel Wood, 'Some implications of recent analyses of Song *yingqing* ware from Jingdezhen', *Scientific and Technical Insights on Ancient Chinese Pottery and Porcelain*, Beijing, 1986, pp 261-4

Zhang Fukang, Feng Shaozhu, Zhang Pushen and Zhang Zhigang, 'Technical studies on Rongxian ware', *Science and Technology of Ancient Ceramics 2 (ISAC '92)*, (Li Jiazhi and Chen Xianqiu eds), Shanghai, 1992, pp 374-9

Porcelain bowl with underglaze-blue decoration, Ming dynasty. Although a country piece, the unusually white body of this bowl suggests that it may have been made in Fujian. D. 5.5 in., 14.5 cm. By courtesy of the Percival David Foundation of Chinese Art.

# Chapter 4
# LONGQUAN, GUAN AND GE

## Longquan

Three giant kiln complexes have dominated the history of porcelain making in southern China over the last thousand years: Jingdezhen, Dehua and Longquan. As described in the last chapter, Jingdezhen and Dehua produced white and translucent wares that would pass all the Western tests for porcelain, but the celadon wares of the Longquan district of southern Zhejiang have bluish, blue-green and olive-green glazes, and dense, opaque, pale-grey bodies that flash to strong rusty-red or cinnamon colours when they are re-oxidised in the kiln.

Simply from their appearance, most potters would describe Longquan celadon wares as fine stonewares. However, when we look further into the technology of Longquan celadon bodies and glazes we find that they are far closer, technically, to the white porcelains made at Jingdezhen and Dehua than to any ordinary stonewares (including celadon wares) made elsewhere in China.

Longquan celadon is a high-alkali, high-silica, material – almost identical to Jingdezhen white porcelain in its analysis, except for a slightly higher content of iron and titanium oxides, and a preponderance of potassia over soda. Longquan celadon glazes are also close relations to the lime-alkali glazes used on Jingdezhen blue-and-white wares, but are again marginally higher in the colouring oxides of iron and titanium and lower in sodium oxide. Because of the thickness of Longquan glazes and bodies, and their higher iron oxide contents, these important underlying similarities are not immediately obvious in the fired wares.

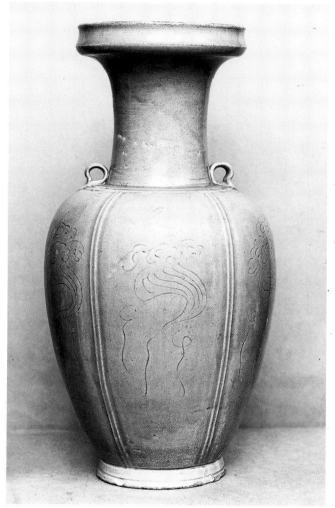

Stoneware vase with grey-green glaze, Yue ware, Shanglinhu or Longquan type, early 10th century. This magnificent Yue ware vessel is typical of the style that influenced the developing Korean celadon industry. The vertical ridges have been formed by drawing a shaped profile through the leatherhard clay. These ridges, and the lightly drawn cloud-scrolls, show clearly through the thin light-green lime-glaze. Wares such as these occur towards the end of the Yue-ware tradition, and just before true porcelain stones began to be exploited for both bodies and glazes in the Longquan area. H. 13.25 in., 33 cm. British Museum, OA 1924.6–16.1.

Longquan bottle with ring handles and a thick celadon glaze, 13th century. Longquan potters often copied contemporary bronze forms, which themselves were often re-workings of much more ancient bronze styles. Multiple-layer application, millions of suspended bubbles and some unmelted glaze-batch material all encouraged the jade-like depths of Longquan glazes. Sotheby's.

Table 26 Comparisons of Jingdezhen and Longquan glazes and bodies

| | $SiO_2$ | $Al_2O_3$ | $TiO_2$ | $Fe_2O_3$ | CaO | MgO | $K_2O$ | $Na_2O$ | MnO | | (KNaO) |
|---|---|---|---|---|---|---|---|---|---|---|---|
| **Jingdezhen glazes** | | | | | | | | | | | |
| Yuan B&W | 69.5 | 14.9 | 0.004 | 0.84 | 8.0 | 0.3 | 2.7 | 3.1 | 0.1 | | (5.8) |
| Hongwu B&W | 68.6 | 14.2 | –.– | 0.8 | 9.9 | 0.2 | 3.7 | 1.8 | 0.1 | | (5.5) |
| Xuande B&W | 69.1 | 14.3 | tr. | 0.8 | 8.4 | 0.4 | 3.7 | 3.3 | 0.06 | | (7.0) |
| Jiajing B&W | 66.9 | 13.2 | –.– | 1.0 | 8.2 | 0.2 | 2.4 | 2.6 | 0.5 | | (5.0) |
| **Longquan glazes** | | | | | | | | | | | |
| S.Song | 66.4 | 14.2 | 0.03 | 1.0 | 11.3 | 1.2 | 4.3 | 1.0 | 0.36 | | (5.3) |
| S.Song | 69.1 | 15.4 | tr. | 0.9 | 8.4 | 0.6 | 4.9 | 0.3 | tr. | | (5.2) |
| Yuan | 67.4 | 16.7 | 0.2 | 1.5 | 6.8 | 0.6 | 5.5 | 1.2 | 0.42 | | (6.7) |
| Ming | 67.6 | 15.0 | tr. | 1.4 | 6.3 | 1.7 | 6.5 | 1.1 | 0.1 | | (6.6) |

| | $SiO_2$ | $Al_2O_3$ | $TiO_2$ | $Fe_2O_3$ | CaO | MgO | $K_2O$ | $Na_2O$ | MnO | $P_2O_5$ | (KNaO) |
|---|---|---|---|---|---|---|---|---|---|---|---|
| **Jingdezhen bodies** | | | | | | | | | | | |
| Yuan B&W | 72.7 | 20.2 | 0.5 | 0.9 | 0.2 | 0.1 | 2.9 | 1.8 | 0.08 | 0.04 | (4.7) |
| Hongwu B&W | 75.3 | 18.2 | –.– | 0.7 | 0.65 | 0.2 | 4.3 | 1.75 | 0.05 | 0.06 | (6.05) |
| Xuande B&W | 73.6 | 20.0 | tr. | 0.9 | 0.5 | 0.53 | 2.9 | 2.0 | tr. | –.– | (4.9) |
| Jiajing B&W | 69.4 | 23.9 | 0.02 | 0.7 | 0.2 | 0.1 | 2.8 | 2.4 | 0.12 | 0.06 | (5.2) |
| **Longquan bodies** | | | | | | | | | | | |
| S.Song | 74.0 | 18.3 | 0.4 | 2.4 | 0.3 | 0.7 | 3.1 | 0.2 | 0.15 | | (3.3) |
| S.Song | 67.8 | 23.9 | 0.2 | 2.1 | tr. | 0.2 | 5.3 | 0.3 | 0.03 | | (5.6) |
| Yuan | 70.8 | 20.1 | 0.16 | 1.6 | 0.2 | 0.7 | 5.5 | 0.8 | 0.07 | | (6.3) |
| Ming | 70.2 | 20.5 | 0.2 | 1.7 | 0.1 | 0.3 | 6.0 | 1.0 | 0.1 | | (7.0) |

(tr. = trace)

These compositional similarities make less surprising the recent discovery at Jingdezhen of a kiln site which produced Yuan and early Ming celadon wares virtually indistinguishable from the Longquan originals. In some early Japanese porcelain sites too (early 17th century) Longquan-like celadon wares were produced in parallel with white porcelains, with both celadons and porcelains being made from very similar volcanic rocks and clays.

## History of Longquan

In many ways Longquan's history echoes that of Jingdezhen. The area around the market town of Longquan, in the Ou river basin, was rich in kilns making Yue-type stonewares in the 9th and 10th centuries. These rather light-bodied wares were often of exceptional quality and recent excavations have shown them to have been fully the equals of the best productions of the northern Zhejiang kilns. However – as happened at Jingdezhen – the subsequent discovery of white-firing, quartz-mica porcelain stones led to the gradual abandonment of the old grey stonewares in favour of the new porcelaneous materials. This seems to have happened rather later than at Jingdezhen, in the early 11th rather than the early 10th century AD.

Where Longquan differed radically from Jingdezhen was in its decision to improve the local greenware tradition, rather than to make true white porcelains. In order to do this the Longquan potters often deliberately adulterated their white porcelain stones with iron-rich clays – creating pale grey porcellaneous bodies that re-oxidised in cooling to warm rusty colours, where the clay bodies were bare of glaze. These adulterated porcelains proved particularly harmonious when used with celadon glazes.

Why the Longquan potters took the greenware road is an interesting question. It is possible that the local porcelain stones were not quite pure enough for white porcelain production (although published analyses of some Longquan porcelain stones seem to suggest otherwise), or it may be that the high reputation that Yue wares still held in the 11th century made the Longquan potters determined to continue the Zhejiang greenware tradition. But, for whatever reason, the new Longquan wares were spectacularly successful, and the Yue ware kilns in north Zhejiang gradually lost most of their markets to these more advanced porcellaneous stonewares, made some 200 miles away in the south of the province.

Why the Yue-ware makers of north Zhejiang did not follow the Longquan potters in their use of porcelain stone is a further mystery. One can only suppose that suitable porcelain stones of the Longquan type were lacking in the districts where the true Yue wares were made

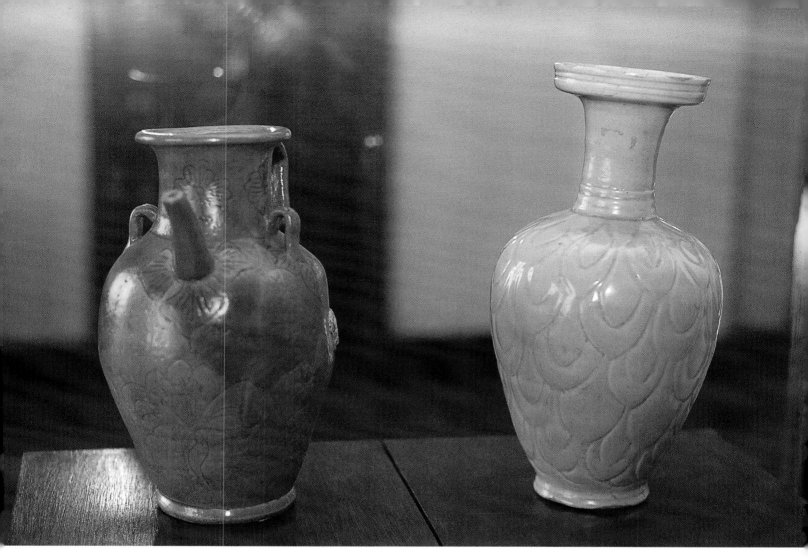

Yue-type stoneware and early white porcelain from Zhejiang province, 10th century AD. White-firing porcelain materials are not uncommon in southern Zhejiang province but, after these early experiments, they tended to be mixed with red clays for making pale grey celadon bodies. Shanghai Museum, China.

(between Shaoxing and Ningbo in north Zhejiang), but even this is arguable as a 12th-century kiln site at Ningbo has just been discovered that made bluish-glazed celadons which were fully equal to the Longquan wares in glaze and body. Perhaps resources of these finer materials were limited, or perhaps the entrenched conservatism of the Yue potters, who had used virtually the same raw materials and recipes for 600 years, eventually led the Yue kiln complex into terminal decline. For whatever reason, the ancient Yue tradition gradually collapsed in the Southern Song dynasty (AD1127-1280), and the main production of greenware in Zhejiang province transferred to the Longquan area.

## The Longquan celadon glaze

The smooth, pale-grey body used for Longquan celadon was a substantial technical achievement, but the real triumph of Longquan ware lay in its glaze – which varied from duck-egg blue, through blue-green to sea-green and

Longquan celadon shard, Southern Song dynasty. The cut section of this fine Longquan celadon ware shard shows the considerable thickness achieved with some Longquan glazes, and the near-porcelain nature of their bodies. Percival David Foundation of Chinese Art study collection, London.

Table 27  Longquan celadon glazes – Five Dynasties to Ming

|  | $SiO_2$ | $Al_2O_3$ | $TiO_2$ | $Fe_2O_3$ | CaO | MgO | $K_2O$ | $Na_2O$ | MnO | $P_2O_5$ |
|---|---|---|---|---|---|---|---|---|---|---|
| Five Dynasties | 59.4 | 16.0 | 0.4 | 1.8 | 16.0 | 2.0 | 3.4 | 0.3 | 0.6 | –.– |
| Northern Song | 63.2 | 16.8 | 0.2 | 1.4 | 13.0 | 1.1 | 3.3 | 0.6 | 0.4 | –.– |
| Southern Song | 68.6 | 14.3 | 0.02 | 0.7 | 10.4 | 0.4 | 5.0 | 0.1 | –.– | 0.14 |
| Yuan | 67.4 | 16.7 | 0.2 | 1.5 | 6.8 | 0.6 | 5.5 | 1.1 | 0.4 | –.– |
| Ming | 67.6 | 15.0 | 0.3 | 1.4 | 6.3 | 1.7 | 6.5 | 1.1 | –.– | –.– |

occasionally almost to olive, with the various colours depending largely on the ratios of titania to iron oxides in the original raw materials. Longquan celadon glazes can be exceptionally thick (four to eight times the thickness of Yue glazes), and their similarities to jade are both striking and deliberate. The reason for the jade-like texture is a mass of bubbles, and a certain amount of unmelted batch material, suspended in the glaze thickness.

The glazes used on Longquan wares were mostly lime-alkali compositions, and the Longquan potters continued with this style of glaze for hundreds of years, although the

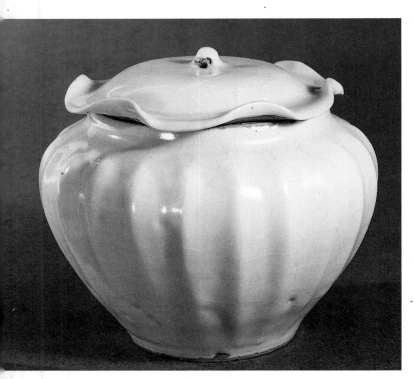

Longquan celadon covered jar of the finest quality, with a bluish celadon glaze, perhaps from the Dayao kilns near Longquan, Southern Song dynasty, 12th century. The lotus-flower carving seen on this jar was managed by first planing the nearly-dry porcellaneous clay to produce a series of vertical flat facets. V-shaped vertical cuts were then added to suggest lotus-petals. H. (with cover) 4.75 in., 12.3 cm. British Museum, OA 1972. 5-17.1.

alkali and titania levels of the glazes tended to rise towards the latter years of the kiln's history, making later Longquan celadon glazes both glassier and greener than the early wares. Longquan potters used porcelain stone and limestone as their main glaze ingredients, in the same way as the Jingdezhen potters, but occasionally supplemented the limestone with small amounts of wood ash, as the Longquan glaze analyses above suggest:

### *Di* and *kinuta* celadons

For sheer quality of glaze and clay, the best Longquan celadons appeared in the late 12th and early 13th centuries AD when the Longquan kilns produced some exceptionally fine bluish-glazed celadon wares for use by large temples, for important burials, and for the appreciation of enlightened collectors. These bluish celadon wares are modest in size and were probably made at the premier Longquan kiln site of Dayao. The best examples are known as *di* ('younger brother') wares in China – apparently a reference to a certain younger brother who operated a celadon kiln in the Dayao area.

In Japan *di* wares are known as *kinuta* celadons after a famous bluish-glazed Longquan vase in a the Bishamon-do collection, Kyoto. This Longquan vase has a shape reminiscent of a paper-beater's mallet – called *kinuta* in Japanese. The bodies of Dayao *di* or *kinuta*-style celadons are very pale grey porcelains, with thick and jade-like bluish celadon glazes applied in as many as four separate layers to develop a fired thickness of about 1 mm. For their particular character of glaze and clay Dayao celadon wares seem to have used porcelain stones and glaze stones that were unusually low in titanium dioxide. These low-titania raw materials encouraged fine iron-blue colours to

Opposite: Longquan celadon moulded octagonal-section jar decorated with the eight Daoist immortals, Yuan dynasty, 14th century. By resisting the decorated panels from the thick celadon glaze it was possible to exploit the harmonious contrast between re-oxidised clay and well-reduced glaze, although on some examples the unglazed panels were gilded. The original model for this form was probably created by using the 'running profile' technique illustrated in the figure on page 15. H. 11 in., 28cm. Sotheby's.

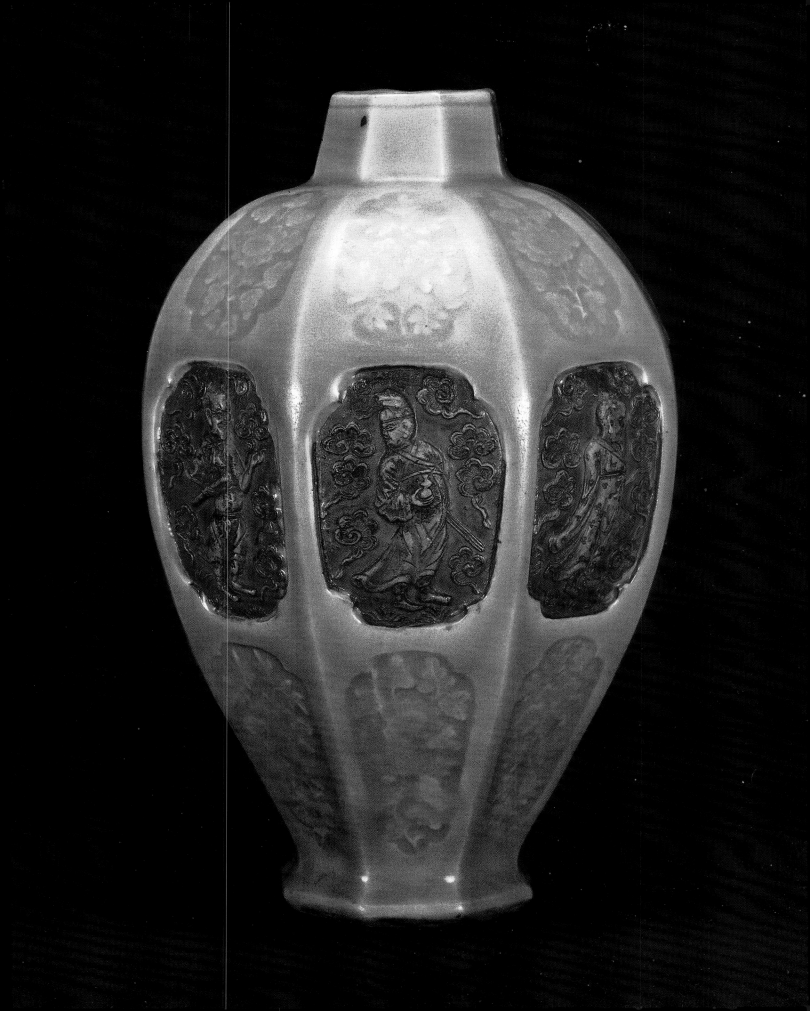

Table 28 Analyses of *di* or *kinuta* celadons – bodies and glazes

| | $SiO_2$ | $Al_2O_3$ | $TiO_2$ | $Fe_2O_3$ | CaO | MgO | $K_2O$ | $Na_2O$ | MnO | $P_2O_5$ | $SO_3$ |
|---|---|---|---|---|---|---|---|---|---|---|---|
| **Glazes** | | | | | | | | | | | |
| Dayao | 67.2 | 14.3 | 0.07 | 1.2 | 10.0 | 0.6 | 4.2 | 0.14 | –.– | 0.2 | 0.02 |
| Dayao | 68.1 | 15.5 | 0.02 | 0.9 | 10.4 | 0.7 | 3.8 | 0.15 | –.– | 0.2 | 0.01 |
| **Bodies** | | | | | | | | | | | |
| Dayao | 67.7 | 23.2 | tr. | 2.4 | tr. | tr. | 5.6 | 1.4 | –.– | –.– | –.– |
| Dayao | 67.1 | 23.4 | tr. | 2.0 | tr. | tr. | 5.9 | 1.5 | –.– | –.– | –.– |

(tr. = trace)

develop in the glazes, and also helped to minimise greyish tones in the porcellaneous bodies themselves.

The remarkable thickness of the Longquan celadon glaze was often managed by raw-glazing the wares with a single coat of glaze, followed by a low biscuit-firing. More coats were then applied to the sintered glaze surface and the wares refired to full heat (1230°–1290°C). These separate coats of glaze are often visible in broken Longquan wares, suggesting that the glazes may have separated slightly before they dried, with the heavier fractions (mainly quartz) sinking towards the bodies. After firing, these accumulated layers of glaze created a more subtle visual quality than a single thick glaze could have supplied.

The reddish re-oxidisation of the exposed Longquan clay complemented the green and blue-green celadon glazes effectively, and this porcellaneous material was also remarkably tough in everyday use. For all these virtues of glaze and body, Longquan celadon became one of the most popular and widely exported of all Chinese ceramics, with millions of large Longquan dishes and bowls finding their way to the Philippines, Japan, East Africa, Egypt and even occasionally to England. The largest of these Longquan dishes (made for the Middle Eastern market) could be as much as a metre in diameter.

The scale of Longquan production at its zenith must have been awesome. In the late 13th century some of the largest dragon kilns in China, more than 100 metres in length, were being used to fire the wares, with hundreds of thousands of celadon-glazed objects comprising a single setting. Major supporting industries must have existed for the management and transport of fuel supplies, the making of saggars and press-moulds (many of them huge), the crushing and washing of porcelain stones, the burning of limestone and the grinding of glazes. Thousands of workers would have been involved in the industry, which culminated in the dispatch of finished wares on rafts down tributaries of the Ou river, on their way to the export ports of Wenzhou and Fuzhou.

Longquan celadon kilns were at their peak in the 13th and 14th centuries. In the 15th and, particularly, the 16th century, the rise of Jingdezhen blue-and-white wares

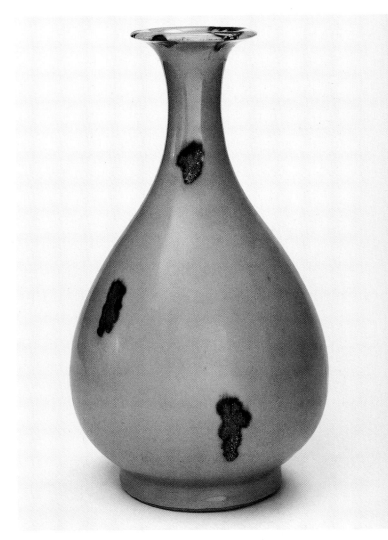

Longquan iron-spotted celadon bottle, 13th or 14th century. Spots of iron-rich pigment were popular additions to greenwares in Zhejiang province in the 4th–5th centuries, and also at the Changsha and Xicun kilns in the 9th–12th centuries. In the Longquan area the method was revived for use with lime-alkali celadon glazes in the late 13th century. Longquan spotted wares occur in many forms, including plates, vases and pouring bowls. So far as one can tell, the iron-rich pigment appears to have been applied beneath the glaze. H. 10.75 in., 27.4 cm. Victoria and Albert Museum.

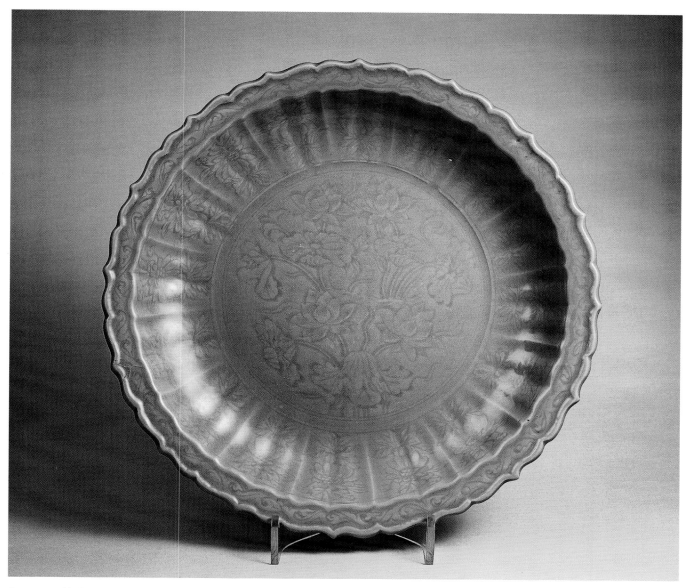

Large moulded Longquan celadon dish, 14th century. The pale olive-green colour, the bracketed rim, and the moulded form, are all typical of later Longquan celadon dishes, often made for the Middle Eastern market. Higher titania levels in these later glazes encouraged yellowish-green tones from the iron oxides they contained. Some examples from this period may be almost a metre across. Carter Fine Art, London.

caused a marked downturn in their markets and, by the 17th and 18th centuries the Longquan kilns were in a severe decline, from which they are only now beginning to recover.

## Guan wares

Despite the undeniable qualities that these fine raw materials provided, Longquan celadons were never adopted as true imperial porcelains. The nearest that the Longquan kilns approached to this ideal was when they began to copy a genuine Southern Song imperial ware known as Guan ware in the late 12th and early 13th centuries AD. Guan wares were stonewares rather than true porcelains, but they

are included in this chapter for their Longquan connections – and also for their apparent use of porcelain stone as a prime glaze ingredient.

Guan wares were certainly very different from mainstream Longquan celadons as they used thin, iron-rich bodies and thick, heavily crackled glazes of the lime-glaze type. The original Guan ware kilns were established by imperial order in north Zhejiang, at the new Southern Song capital of Hangzhou, probably sometime in the second quarter of the 12th century. It is recorded that the first Guan ware kiln was built for the Xiuneisi (Palace Works Department) at the foot of Phoenix Hill in Hangzhou and within the precincts of the palace's rear

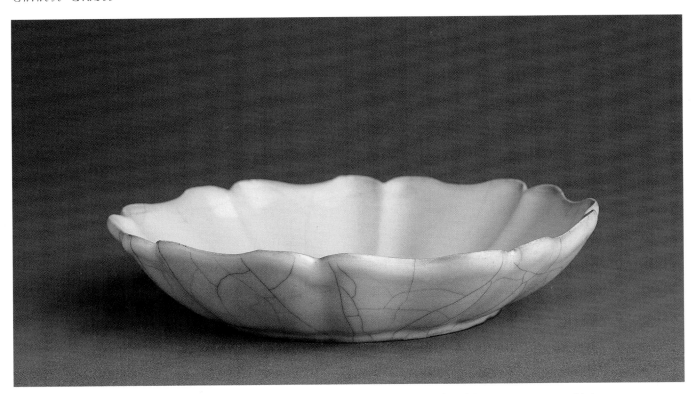

Guan ware dish in eight-lobed form, 12th century. This is one of the most refined examples of Guan ware extant, and it has been suggested that it may represent the first phase of Guan ware production at the Xuneisi kiln at Hangzhou. In similar analysed wares the glaze colour comes from iron in reduction and a very low titania content. The lime glaze is rich in alumina, which encourages a smooth, stony semi-opacity if the glaze is not overfired (e.g. 1240°C). This eight-lobed form also appears in Ru ware, in silverware, and in lacquer. D. 6.6 in., 16.8 cm. By courtesy of the Percival David Foundation of Chinese Art, PDF A46.

Table 29 Hangzhou Guan ware and Longquan Guan wares compared

| | $SiO_2$ | $Al_2O_3$ | $TiO_2$ | $Fe_2O_3$ | CaO | MgO | $K_2O$ | $Na_2O$ | MnO | $P_2O_5$ |
|---|---|---|---|---|---|---|---|---|---|---|
| **Glazes – Hangzhou** | | | | | | | | | | |
| Guan 1 | 65.4 | 14.6 | 0.08 | 0.7 | 13.4 | 0.7 | 4.0 | 0.2 | –.– | 0.4 |
| Guan 2 | 64.8 | 14.5 | –.– | 0.8 | 13.9 | 0.7 | 4.5 | 0.2 | –.– | 0.3 |
| Guan 3 | 65.0 | 16.1 | –.– | 0.9 | 12.5 | 0.7 | 3.5 | 0.3 | –.– | –.– |
| Guan 4 | 65.6 | 16.2 | –.– | 0.8 | 12.1 | 0.9 | 4.5 | 0.3 | 0.2 | –.– |
| **Glazes – Longquan** | | | | | | | | | | |
| Guan 1 | 64.3 | 12.2 | –.– | 1.3 | 16.4 | 0.7 | 4.3 | 0.3 | –.– | –.– |
| Guan 2 | 63.0 | 16.1 | 0.08 | 1.0 | 14.0 | 0.7 | 4.0 | 0.2 | –.– | 0.4 |
| Guan 3 | 66.0 | 14.7 | tr. | 0.8 | 13.4 | 0.2 | 4.8 | 0.3 | 0.01 | –.– |
| Guan 4 | 63.3 | 15.7 | 0.2 | 0.9 | 14.2 | 0.6 | 4.2 | 0.2 | –.– | –.– |

| | $SiO_2$ | $Al_2O_3$ | $TiO_2$ | $Fe_2O_3$ | CaO | MgO | $K_2O$ | $Na_2O$ | MnO | $P_2O_5$ |
|---|---|---|---|---|---|---|---|---|---|---|
| **Bodies – Hangzhou** | | | | | | | | | | |
| Guan 1 | 61.3 | 28.8 | 0.7 | 4.1 | 0.2 | 0.6 | 4.2 | 0.2 | –.– | 0.08 |
| Guan 2 | 66.5 | 23.1 | 1.2 | 3.0 | 0.3 | 0.2 | 3.7 | 0.3 | –.– | –.– |
| Guan 3 | 69.8 | 20.6 | 0.7 | 3.1 | 0.3 | 0.7 | 3.7 | 0.4 | –.– | 0.08 |
| Guan 4 | 70.0 | 21.2 | 1.0 | 3.2 | 0.1 | 0.4 | 2.6 | 0.2 | –.– | 0.09 |
| **Bodies – Longquan** | | | | | | | | | | |
| Guan 1 | 64.2 | 25.2 | 0.8 | 4.5 | 0.2 | 0.6 | 4.0 | 0.1 | –.– | 0.13 |
| Guan 2 | 62.7 | 28.7 | –.– | 3.7 | 0.5 | 0.5 | 4.1 | 0.1 | –.– | –.– |
| Guan 3 | 64.9 | 24.2 | –.– | 3.6 | 0.5 | 0.2 | 4.7 | 0.2 | 0.04 | –.– |
| Guan 4 | 63.3 | 26.1 | –.– | 4.5 | 0.5 | 0.3 | 3.7 | 0.2 | –.– | –.– |

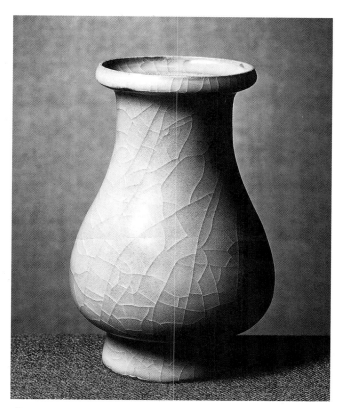

Guan ware vase, grey-green glaze and a dark stoneware body,
AD1150–1179. This thinly thrown vase, with its thick and strongly
crackled icy glaze, is a very fine example of the Guan ware style.
Glaze thicknesses of this order were managed by using a number
of glaze applications, followed by a series of low temperature
firings, before the final firing to full heat. H. 5.1 in., 13 cm.
Victoria and Albert Museum, C102–1967.

courtyard. Very recent reports from China suggest that the
Xiuneisi kiln has at last been located, but it is not known,
at the time of writing, whether the kiln design used for
this earliest Guan ware was of a north Chinese or a south
Chinese type.

It seems that demand for genuine Hangzhou Guan
wares eventually exceeded supply, and that the skills of
the Longquan celadon potters were enlisted to meet these
orders. Finds of locally-made dark-bodied Guan type wares
have been made at the important Longquan kiln sites of
Dayao and Chikou, some 250 miles to the south of
Hangzhou, in the extreme south of Zhejiang province.
Technically, the Longquan potters achieved an excellent
match to Hangzhou Guan ware, and it can take very subtle
statistics to distinguish analyses of Longquan Guan wares
from the Hangzhou originals.

This achievement is all the more impressive when one
realises that fine-quality Guan wares represent one of the
most sophisticated combinations of glaze and clay in the
history of Chinese ceramics.

## History of Guan ware

Guan ware was developed originally as a southern version
of the famous Northern Song Ru ware (described more
fully in Chapter Six). Ru ware was the official court
stoneware of the Northern Song emperor and aesthete,
Huizong. The original Ru was a light-bodied, rather low-
fired stoneware, with an extraordinarily beautiful iron-blue
glaze. These fine Ru glazes were applied to forms that
were plain, austere and largely undecorated, and resembled
the best lacquer wares of the Northern Song period. The
precipitate flight of the Song court to Hangzhou after the
Tartar invasion of north China cut short most Ru ware
production in about AD1127 and it is possible that crafts-
men from the Ru kilns were present in the exodus south,
and were later given the task of restarting production of an
official court stoneware at Hangzhou.

Some good approximations to northern Ru wares
have been excavated recently at a Southern Song kiln site
near Hangzhou called Jiaotanxia (Suburban Altar) – a
place mentioned in Southern Song texts as the major site
for Guan ware production after the closing of the Xiuneisi
kiln. The Jiaotanxia copies of Ru ware that have survived as
shards have thinner glazes and thicker bodies than the
northern originals, although their colours can be remark-
ably Ru-like. Even so, these early Jiaotanxia shards lack the

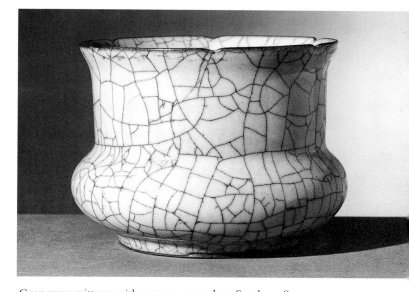

Guan ware spittoon with a cream-grey glaze, Southern Song
dynasty, AD1250–1279. Slight underfiring of the aluminous lime
glazes used for Guan wares was necessary for this smooth and
semi-opaque surface (with slightly more heat and the quality
would have been more like the vase above left). The crazing is a
result of the glaze shrinking more than the body in the last stage
of cooling, and it has been emphasised by the application of a
dark pigment to the craze lines, probably while the vessel was
still hot from the kiln. Victoria and Albert Museum.

subtlety of true Ru wares – possibly due to the faster cooling rates of the southern kilns. It is also likely that the more siliceous and flux-rich bodies, typical of the Hangzhou area of south China, encouraged glassier results from the glazes – compared with the more reserved qualities that the high-alumina, low-flux clays used in north China supplied to the original Ru wares.

Perhaps because of the difficulties encountered in copying Ru wares exactly, the Hangzhou potters eventually took Ru ware as a starting point for an entirely new style of imperial stoneware. These fully developed Guan ('official') wares used darker, more iron-rich clays and extraordinarily thick glazes that often developed multiple crackle systems in cooling. Perhaps most impressive of all was the Guan combination of thick glazes with wafer-thin bodies – achieved by multiple glaze applications and frequent re-firings to soft-biscuit temperatures before the final glaze firing to stoneware heat. The dark iron-rich clays used for true Guan wares enhanced the apparent depth of the crackled glazes and also supplied the famous 'purple rims and iron-feet' as they re-oxidised in cooling. However, not all surviving Guan wares are thin-bodied and reduction-fire. Some rather massively thrown or press-moulded examples are known, as are many fully oxidised Guan wares with creamy or yellow-brown 'rice-coloured' glazes.

The forms of fully developed Guan wares tend to be unusually sophisticated, often showing a consciously 'precious' character, with frequent references to archaic bronze vessel-forms or to lacquer-style wares of deceptively simple design. To some extent, Guan wares lack the tensions, austerity and authority of the original Ru wares, and they were probably rather weak in actual use, due to their heavily crazed glazes and unusually thin bodies. Nonetheless, as the epitome of Southern Song ceramic taste, they are very significant wares in Chinese ceramic history.

## Guan ware bodies

The Ru-like Jiaotanxia shards described above had low-iron, high-silica bodies, much like Yue ware in composition – indeed, the Jiaotanxia site was making Yue-style stonewares before it was taken over for the Guan ware experiments. Surviving examples of these light-bodied southern Ru-type wares are extremely rare in both Western and Eastern collections, and it is the later, dark-bodied Guan wares (also believed mainly to derive from Jiaotanxia) that are the more familiar representatives of the Guan ware style.

These darker Guan ware bodies could have been made by mixing a local iron-rich clay with an impure porcelain stone. Both materials have been found during building work at the Jiaotanxia site, which is now a major museum for Guan ware production. Another possibility is that some dark stonewares used for Guan wares were natural sedimentary clays of an iron-rich type – and not unlike the clays used for some Neolithic earthenwares, such as those made at the Hemudu site near Hangzhou. It is also possible that both approaches may have been used at various times to make the bodies for Hangzhou Guan.

## Iron in reduction-fired stonewares

The iron-oxide levels established for Guan ware clays (3–5%) may not seem unduly high for such dark-firing bodies, but reduction-fired stoneware clays can become very dark with iron-oxide percentages in this general range. By contrast, in oxidised clays, as much as 8–10% iron oxide might be needed to produce equally dark effects – as is evident in the analyses of Jian temmoku bodies and Yixing red stonewares on page 148. This difference seems mainly due to the powerful fluxing effect of FeO in clay bodies, compared to the more refractory character of $Fe_2O_3$. For the same reasons, Guan ware bodies fired in oxidation are noticeably paler in colour than similar wares fired in reduction atmospheres.

Table 30 Comparisons of Ru ware, Hangzhou Guan and Hemudu bodies

| | $SiO_2$ | $Al_2O_3$ | $TiO_2$ | $Fe_2O_3$ | CaO | MgO | $K_2O$ | $Na_2O$ | MnO | $P_2O_5$ | loss |
|---|---|---|---|---|---|---|---|---|---|---|---|
| Ru ware | 64.5 | 28.3 | 1.3 | 2.1 | 1.3 | 0.5 | 1.8 | 0.1 | 0.03 | 0.06 | –.– |
| Guan ware (Hangzhou) | 66.5 | 23.1 | 1.2 | 3.0 | 0.3 | 0.7 | 3.7 | 0.4 | –.– | 0.08 | –.– |
| Iron-rich clay from the Guan kiln-site at Hangzhou | 62.6 | 22.0 | 1.1 | 7.8 | 0.8 | 0.2 | 0.6 | 0.3 | –.– | –.– | 4.6 |
| Stoneware clay from the Guan kiln-site at Hangzhou | 73.6 | 17.0 | 0.9 | 1.0 | 0.13 | 0.2 | 1.8 | 0.2 | <0.01 | –.– | 5.5 |
| Hemudu Neolithic clay | 67.1 | 25.1 | 1.1 | 3.3 | 0.1 | 0.4 | 2.5 | 0.2 | 0.03 | –.– | –.– |

## Guan ware glazes

Reduction-fired Guan ware glazes can vary in colour from a pale iron-blue, through blue-grey to grey-green. In oxidation they may be cream, yellowish brown or light brown. In both oxidation and reduction they can be smooth and stony, of 'mutton fat' richness, or simply glassy and icy. The crackle systems might appear as simple overall crazing, as crazing at different levels within the glaze thickness, or as large major crackle systems, with secondary crazing developing between the larger lines. The reasons for such variation in glaze colour and surface quality seem to owe much to the effects of kiln temperatures and kiln atmospheres on essentially similar glazes, with the glazes becoming 'icier' and more heavily crazed as the firing temperatures increased.

Crazing, in all cases, is due to the glazes' contracting more than the clay bodies they are covering during the last 300°C of cooling – rather as surface mud dries, shrinks and cracks more than the ground beneath. Whether the words 'crackle' or 'crazing' are used to describe these effects is entirely optional – as the potter John Reeve once remarked 'If you like the effect it is crackle. Otherwise it is crazing!'.

The degree to which a glaze will shrink in cooling depends both on the 'expansivities' of the various oxides that it contains, and the levels at which these oxides occur in the glaze. As expansion on heating is matched by contraction on cooling, a 'high expansion' glaze will contract significantly as it cools down. If this shrinkage is greater than that of the clay body beneath, then the glaze will craze during the last stage of cooling. With Guan wares the main reasons for crazing are below-average silica levels in both bodies and glazes as, paradoxically, silica is a prime craze preventer in both clay bodies and in the glazes that cover them.

Guan ware plate with both dark and lighter crackle, 13th–14th century AD. This is the famous 'iron wire and golden thread' effect, where two crazing systems (primary and delayed) have been stained different colours after firing. Oxidised Guan-type wares with these emphasised double crackles are sometimes described as 'Ge wares'. D. 6.5 in., 16.5 cm. By courtesy of the Percival David Foundation; PDF 67.

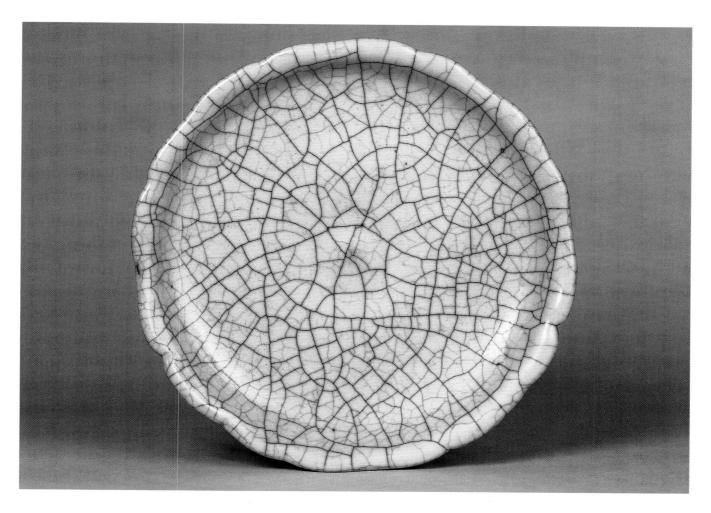

Although most crazing takes place in cooling, the process may continue for days, years, or even centuries, after the wares have been drawn from the kiln, an effect known as 'delayed' or 'secondary' crazing. In some Guan wares the craze-lines were enhanced by treatment with stains and pigments immediately after the firing, while the pots were still hot from the kiln.

### Compositions of Guan ware glazes

Like the Ru glazes that they superseded, Guan glazes are essentially low-titania lime glazes, with their low titania levels encouraging bluish tones from their iron-oxide colourants (typically 1% and 2.5% $FeO+Fe_2O_3$). Also, like Ru wares, Guan glazes are usually above average in alumina, and are often deliberately slightly underfired, with both effects encouraging a smooth, stony semi-opacity to develop during cooling.

Analyses of Guan ware glazes (see Table 29) suggest that their original recipes were probably mixtures of aluminous porcelain stones with wood ashes and/or limestone. Guan glazes from both the Hangzhou and Longquan sites seem to have matured in the 1200°-1250°C range.

### Application of Guan ware glazes

Broken pieces of Guan ware often show unusually thick glazes and thin bodies. At their greatest extremes, the glazes may be as thick as 2.5 mm and the bodies as thin as 1 mm. However, glazes between 0.5-1 mm, and bodies from 1.5-3 mm are perhaps more typical. As at Longquan, the glazing techniques seem to have been a combination of raw glazing, followed by biscuit firing, followed by re-glazing (possibly followed by another biscuit firing and by further re-glazing) – with the whole process concluding with a glaze firing to full stoneware heat.

Electron microprobe studies of both Guan and Longquan glazes often show these separate glaze layers as a series of two, three or four peaks in the calcium contents of the fired glazes as the probe scans from the glaze-body layers to the outer glaze surfaces. Optical microscopy can also show this effect clearly, with each layer concluding with a fine band of semi-dissolved lime.

The reasons for this 'layered' effect are still obscure. Even when glazes are applied in multiple layers there seems no obvious reason why the glaze layers should still be apparent after firing, as all the layers should melt together into an homogeneous whole. One explanation for this compositional layering proposes that a series of glazes, alternating between high-calcia and high-silica compositions, were applied to Guan wares. Another theory (put forward by the author in Shanghai in 1992) is that the same glaze compositions were used throughout for the various layers, but that they tended to unmix themselves slightly on

the pots while they were still wet, with their finer fractions (mostly lime and ash) remaining near the surface, while the coarser quartz grains moved towards the body.

One effect of this layering phenomenon (however achieved) is that the various strata within the Guan glazes often survived the firing – helping to scatter light and sometimes even developing their own separate crazing systems at different levels within the fired glazes. This style of layered crazing enhances the apparent depth of Guan glazes, and is one of the most attractive of all Guan ware qualities. A related effect, also apparently caused by layered glazes, is a tendency for the edges of craze-lines to show fractured fringes that run horizontally into the glaze thickness itself – a phenomenon known as 'fish-scale crazing'. This effect is also seen on some Ru wares and is probably due to cooling stresses set up by differing contractions in the separate glaze layers.

### Stained crackle

Another famous Guan glaze type is where the major crackle is deliberately stained black, and the minor crackle appears a gingery brown. This is known in China as the 'iron wire and golden thread' effect, the 'civil and military' crackle or, more prosaically, the 'big and small' crackle. It seems to rely on the property of delayed or secondary crazing – that is, crazing that slowly develops over the weeks or months after the wares have been drawn from the kiln. The major, primary, crazing happens in cooling and is characterised by large, straight crackle lines that often follow stresses set up in making – a broad ascending anti-clockwise spiral being typical of thrown wares. The secondary crackle shows smaller and looser lines that wander through the glazes, creating networks of fine craze lines within the primary crackle.

To emphasise the primary crackle it is usually best to stain the crazing while it is still open, preferably while the wares are still hot from firing. As the glaze continues cooling the cracks close, trapping any pigment that has been applied. Surplus stain can then be washed away when the wares are cold, leaving the primary crackle permanently fixed as a large network of fine black lines. The secondary crackle may be stained later, but on most Chinese Guan wares the secondary crackle appears to have developed a lighter brown tone simply through use or, occasionally, through burial. In China today charcoal is often used to emphasise crazing. This gives a rather soft effect and the sharp dark lines on true Guan and Ge wares appear more the result of using an intensely black mineral stain, such as black iron oxide.

Study of the range of Guan ware types shows that staining is most commonly used on later (i.e. Yuan dynasty) examples with cream or light brown 'rice-

coloured' glazes. This raises the possibility that the Guan ware potters may have introduced staining as a rescue process – designed to give some quality to accidentally oxidised wares. We know from Jiang Qi's AD1270 accounts of Jingdezhen porcelain making that accidentally oxidised *yingqing* wares were not popular in the 13th century and were sold at a discount. Oxidised Guan wares may also have appeared to be somewhat lacking, compared with the fine blue-green and grey-green reduction-fired examples from the same kilns. Staining of the primary crackle may, initially, have been adopted as a strategy to improve these bland oxidised effects.

## Ge Wares

This issue of staining has some relevance to the problem of Ge ware. Ge is considered historically to have been a distinct and separate kiln from Guan, and Ge was included in the Five Famous Kilns of the Song dynasty as identified by early Ming scholars – that is, Ding, Jun, Ru, Guan and Ge. The difficulty with Ge is that no one knows quite what it looked like, nor where it was made, nor even for whom it was made. The dates for Ge ware are also a matter for discussion.

The earliest description of Ge ware seems to occur in 1428 when it was described as 'similar to Guan ware' – but this is a poor basis on which to make a distinction. There also exist a number of Guan-type wares, once in the imperial collection in Beijing, and now in the Percival David Foundation collection in London, that are traditionally thought to be Ge. These bear inscriptions engraved on their backs on the orders of the Qianlong emperor. Of the 17 engraved pieces, eight are described as Ge and nine as Guan. Unfortunately, there seems no obvious logic in the classification.

In the search for a recognisably different style of Guan ware, which might be classed as Ge, oxidised Southern Song and Yuan Guan-type wares, with stained double crackles, have recently been considered as possible Ge ware candidates. However, the problem with this approach is that all the identifying features of these wares ('rice-coloured glazes', slightly lighter bodies, slight underfiring and a tendency to crawling) can be put down to the effects of oxidation. It seems likely that both 'Ge-like' and 'Guan-like' wares could have issued simultaneously from the same kilns – simply showing the natural variations of atmosphere, temperature and cooling that dragon kilns often provide.

## Longquan Ge

One possible solution to the problem of Ge ware concerns the Guan-type wares made at Longquan. There is a persistent trend in both early and modern Chinese writings on

ceramics to associate Ge ware with the Longquan area of Zhejiang. Apparently one reading of 'Ge' is 'elder brother', and 'Ge-type' and '*di*-type' (younger brother) wares were certainly made and fired together at the Longquan Dayao kilns. It has even been proposed that 'Ge' is simply the Longquan way of pronouncing the Chinese character for 'official' – a character pronounced Guan in Hangzhou. If Ge wares were simply 'Longquan Guan' this would explain why they were virtually indistinguishable from Hangzhou Guan wares – but it would also mean that they were genuinely the products of a quite separate kiln complex.

However, this useful theory is only one of many that have been proposed to resolve the problem of Ge ware. Another idea suggests that 'Ge' is simply a collector's name for Guan ware that became current in the early Ming – an interpretation that denies Ge ware any separate existence at all. Despite two detailed conferences on the subject of Guan and Ge (Shanghai 1992 and London 1993), we are really still no nearer to a proper resolution of this problem – making Ge ware one of the more enduring mysteries of Chinese ceramic history and a fertile field for further work.

## Jingdezhen Guan and Ge

Stained crackle-glazed wares of the Guan and Ge types, apparently inspired by the Song and Yuan originals, were also made at Jingdezhen from the Chenghua reign

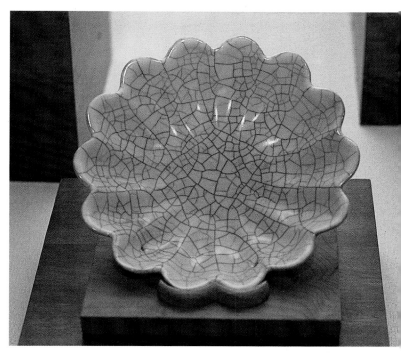

'Ge ware' bowl, Southern Song dynasty. The 'Ge' description is rather vague, but it is sometimes applied to particularly fine Guan-type wares, such as this exceptional bowl in the Palace Museum collection in the Forbidden City, Beijing.

Crackle ware vase from Jingdezhen, Qing dynasty. Wares with crackled glazes achieved 'archaistic' status in China as early as the mid-15th century, when Song and Yuan Guan wares were copied at Jingdezhen at the imperial kilns. Carter Fine Art.

(AD1465–1487) onwards. Deliberately discoloured porcelains were used for the bodies of these 'Jingdezhen Guan' wares, sometimes with iron pigments banded onto their footrings and rims to satisfy the 'purple rims and iron feet' criteria of the Zhejiang originals. A few rare examples have underglaze-blue Chenghua marks, showing that they were porcelains of imperial quality, and incidentally demonstrating the high regard in which Song wares were held in the mid-15th century.

One analysis of a Chenghua copy of Ge ware showed a low-lime glaze that was rich in potash and soda, suggesting that its composition was largely glaze stone. The high-alkali contents of this glaze would have provided the characteristic crackle – rather than the low-silica levels typical of true Guan wares. The body used for this piece suggests either a mixture of a contaminated porcelain stone with ordinary kaolin or, perhaps, the addition of an iron-rich clay to a regular porcelain stone material.

In contrast to the early Ming piece is a later Jingdezhen copy of Ge ware from the Yongzheng period (1723-1735) that used a high alumina, lime-alkali glaze, making it closer in its nature to the Song and Yuan examples. The body too was a true stoneware that contained nearly 5% iron oxides, with a low silica content that encouraged crazing.

Perhaps the least attractive of the Jingdezhen 'crackle' wares are the rather massive late 19th-century porcelains that combine thick, white crackled glazes with underglaze-blue painting or, occasionally, with thick and rather sticky-looking coloured overglaze enamels. In these wares the unglazed porcelain body is often given a dark dressing with an oxide-rich pigment. Glaze stones unusually rich in soda feldspar were used to glaze these wares, which were then fired in the hotter parts of the *zhenyao* kilns.

## The overall principles of south Chinese glazes

The glazes described in this and the previous chapter cover a wide range of fired qualities and maturing temperatures –

Table 31 Analyses of Chenghua Guan-type glaze and body

| Chenghua Guan | $SiO_2$ | $Al_2O_3$ | $TiO_2$ | $Fe_2O_3$ | CaO | MgO | $K_2O$ | $Na_2O$ | MnO | $P_2O_5$ |
|---|---|---|---|---|---|---|---|---|---|---|
| Copy ( glaze ) | 71.3 | 14.2 | -.- | 1.0 | 3.8 | 0.2 | 5.5 | 3.0 | -.- | -.- |
| Body | 72.9 | 19.3 | 0.5 | 2.3 | 0.05 | 0.2 | 2.7 | 1.8 | -.- | 0.07 |

Table 32 Jingdezhen copies of crackled wares

| | $SiO_2$ | $Al_2O_3$ | $TiO_2$ | $Fe_2O_3$ | CaO | MgO | $K_2O$ | $Na_2O$ | MnO | $P_2O_5$ |
|---|---|---|---|---|---|---|---|---|---|---|
| Qing 'Ge' copy | 71.2 | 16.9 | 0.2 | 0.6 | 3.3 | 0.7 | 3.5 | 3.6 | -.- | -.- |
| Qing 'Guan copy | 66.3 | 17.0 | –.– | 1.1 | 10.2 | 0.11 | 0.6 | 3.3 | 1.1 | 0.1 |

Table 33 Late 19th-century Jingdezhen 'crackle' wares

| | $SiO_2$ | $Al_2O_3$ | $TiO_2$ | $Fe_2O_3$ | CaO | MgO | $K_2O$ | $Na_2O$ | Loss |
|---|---|---|---|---|---|---|---|---|---|
| Late 19th century | 72.9 | 15.0 | –.– | 0.6 | 1.5 | 0.15 | 1.7 | 5.4 | 2.7 |
| Late 19th century | 73.7 | 14.1 | –.– | 0.6 | 2.16 | 0.14 | 2.9 | 2.5 | 3.5 |

not to mention a substantial geographical area of China. They include the watery-blue *yingqing* glazes of Jingdezhen, the unctuous and brilliant glazes used on Dehua porcelains, the fine jade-like celadons of Longquan, and the crackled Guan wares of Longquan and Hangzhou. Production of porcelain glazes in south China began more than a 1000 years ago, and they are still manufactured on a huge scale there today.

Nonetheless, despite the timescale, geographical area, and range of glaze compositions involved in the history of porcelain in southern China, there exists a significant unifying logic that draws these glazes together within a single 'south Chinese glaze system'. The essence of this system is an approach to glaze creation that depends on the principle of adding glaze ash (calcium carbonate), and/or wood ash, to a 'porcelain stone' or 'glaze stone' rock.

The lower-firing versions of these glazes tended to use the most glaze ash or wood ash flux in their recipes, while the more refractory examples consisted largely of glaze stone type materials. Some kiln complexes (such as Jingdezhen) managed to exploit the entire range of glaze compositions possible with these mixtures, while others (such as Hangzhou) concentrated on only a small part of the 'system'. So consistent is this south Chinese approach to glaze construction that it is possible to represent the system diagrammatically – with the exploitation of a particular glaze type being represented by a thicker line.

Chart 2 The south Chinese porcelain glaze system

| Glaze type: | High-lime | lime | lime-alkali | alkali-lime | alkali |
|---|---|---|---|---|---|
| Firing temp: | 1200°C | 1230°C | 1250°C | 1270°C | 1310°C |

Jingdezhen (ware-type) *yingqing*, blue-and-white, white, crackle

Dehua (ware-type) *yingqing*, transparent, snow-white

Longquan (ware-type) early celadon, classic celadon, late celadon

Hangzhou (ware-type) various Guan and Ge-type wares

Rongxian (ware type) blue, green & red *yingqing* wares

| Glaze ash wood ash | 30% | 25% | 20% | 15% | 10% | 5% | 0 |
| Porcelain stone or glaze stone | 70% | 75% | 80% | 85% | 90% | 95% | 100% |

It can be seen from Chart 2 that the Jingdezhen potters made the most thorough use of this system – with the *zhenyao* kilns proving especially useful for the manner in which they allowed simultaneous firing of a range of glaze types to a wide spread of kiln temperatures.

# FURTHER READING

*BOOKS*

David Kingery and Pamela Vandiver, *Ceramic Masterpieces – Art, Structure and Technology* (see particularly Chapter Three – 'A Song dynasty celadon jar', pp 69-91), The Free Press, 1986

*PAPERS AND ARTICLES*

Zhou Ren, Zhang Fukang and Zheng Yongfu, 'Technical studies on Longquan celadons of successive dynasties', *Chinese Translation No. 7*, The Oriental Ceramic Society, 1977. (Originally in Chinese in *Kaogu Xuebao*, Vol. 1, 1973, pp 131-56)

Chen Xiangqiu et al., 'A fundamental research on ceramic of Southern Song altar Guan ware and Longquan Ge ware', *Scientific and Technological Insights on Ancient Chinese Pottery and Porcelain*, Science Press, Beijing, 1986, pp 161-75

Rosemary Scott, 'Guan or Ge wares?', *Oriental Art*, Vol 34, no. 2, 1993 pp 12-23

# Chapter 5
# THE PORCELAINS OF NORTH CHINA

The virtual collapse of the old northern porcelain industry in the 14th century, mentioned at the beginning of Chapter Three, has meant that when Chinese porcelain is referred to today it is usually the later and hugely exported southern material that is understood. Even so, north Chinese porcelains were the first true porcelains in the world, and in some ways they were more advanced materials than the southern porcelains that replaced them.

## Origins of northern porcelain

The real origins of these northern porcelains were some 260 million years ago when much of north China was a broad continental plain – a series of shallow seas, estuaries and flood-plains, subject to long cycles of subsidence and uplift. Where land accumulated or emerged it became overgrown with luxuriant carboniferous forests. The soils on which these forests grew were clays, washed from weathered granite highlands hundreds of miles distant. Much of the original rock must have been pure white granite, unusually low in the 'earthy' oxides of iron and titanium. Rivers from the rocky highlands carried the suspended clay material to great deltas where the brackish water and slowing currents caused the fine clay to settle from suspension as estuarine mud. The mudflats became overgrown by mosses, tree ferns, horsetails and primitive pines. The stagnant water preserved the fallen trees and dead vegetation, then huge overlays of silt eventually compressed and transformed the buried woody material into coal. Beneath every seam of coal lies a thinner seam of clay – the original soils on which the ancient forests had flourished. Such clays are known as fireclays in the West, because of their unusual resistance to high temperatures.

These processes occurred repeatedly over vast areas for tens of millions of years, with the result that the present-day coal fields of north China are among the most

Primitive plants, such as tree ferns, covered huge areas of northern China during the coal-building Permo-Carboniferous periods (*c.* 260 million years ago), and muds beneath the swampy carboniferous forests became the stoneware and porcelain clays of north China. At the time that these clays were laid down, north China was a separate land mass (the 'north China block') and closer to the equator than it is today.

extensive in the world. What is remarkable about some of these northern Chinese coal-associated clays is their unusual purity, with many of these Carboniferous clays being secondary (i.e. sedimentary) kaolins. These clays are so low in iron contaminants, and sometimes so rich in fluxes, that they make natural porcelains when fired to high enough kiln temperatures, usually in the 1300°C range. However such pure natural porcelain clays are rare; the great mass of northern fireclays are simply buff and grey-firing stoneware clays of varying quality.

After the Carboniferous and Permian periods two more land-building episodes transformed the landscape of north China. First, deep beds of red sandstone were laid down under arid conditions in many northern provinces. Then,

Mallet-shaped Ding ware bottle, 11th–12th century. Bottles and vases from the Ding kilns are far rarer than bowls and dishes. The excellent plasticity and the fine texture of the Ding porcelain clay can be sensed in this vessel. H. 9.7 in., 24.5 cm. By courtesy of the Percival David Foundation of Chinese Art. PDF 103.

Late Neolithic white tripod ewer (*gui*) Dawenkou culture, *c.* 2800–2500BC, Qianhai, Shandong province. This ewer has been assembled from thrown elements, but hand-built examples also exist. Similar Shandong ewers were made from kaolinitic clays tempered with sand, and they seem to represent the first use of high-firing clays in northern ceramics, albeit still fired at earthenware temperatures. H.9 in., 22.7 cm. Arthur M. Sackler Museum of Art and Archaeology, Peking University, 80ZQM85.8.

relatively recently (over the last 2.4 million years), fine rock-dust from the Inner Mongolian deserts was blown south by prevailing winds. The dust deposits shrouded the face of north China, building to depths exceeding 300 metres in places, and burying the original northern landscape in a deep blanket of fertile loess, covering nearly three-quarters of million square kilometres in its 'primary' beds. The loess lands also include a further quarter of a million square kilometres of reworked secondary deposits, where rivers have collected billions of tonnes of loess from their upper reaches, and deposited the material as fine loessic silts on the northeastern flood plains.

By Neolithic times much of the loess-land of northwest China was a mixture of forest and grassland that supported a varied fauna of elephant, rhino, bear, wolf, wild horse, wild pig and wild dog. Living with, and preying on, these animals were the ancient hunter-gathers of north China – the ancestors of the modern Chinese. Much of the land towards the east tended to be lower-lying, marshy in places, and populated by water buffalo rather than the wild oxen of the west. In what is now Henan province, the Yellow River divided the higher and lower ground and it was in this area some 7000 years ago that semi-sedentary fishermen became some of China's first farmers. This district is regarded as one of the prime 'nuclear areas' of Chinese civilisation, with a long and continuous history that has seen the production of China's finest bronzes and ceramics, and the siting of China's richest and largest cities.

The huge land clearances practised by early man in north China during the late Neolithic and early Bronze Age drove back the primal forest and its wild animals and exposed the loess land for agriculture, particularly for growing fox-tailed millet, wheat and rice. Continuing deforestation eventually destabilised the climate of north China, with drought followed by flood becoming an all too common experience. Infinitely fertile land and a treacherous climate have contributed to the cycles of plenty punctuated by the periods of starvation which have occurred throughout the history of north China.

**Materials for Neolithic ceramics**

The more weathered or reworked 'secondary' loess was occasionally used by early farmers for making coiled pots in the north, but an older and deeper red clay was also popular, being dug from the bottoms of gullies or river-beds, or from where the loess deposits were thinnest. The resulting pots fired red, yellow-buff, black or brown – according to the kiln atmospheres used, and the iron and lime contents of the raw materials. However a few ceramic analyses from late Neolithic sites in Shandong province show occasional use of the more ancient and less accessible fireclay materials. At Neolithic earthenware temperatures (*c.* 1000°C) these would have produced weak and brittle wares, although of an unusually light fired-colour.

*Shang whitewares*

These ancient light-firing, carboniferous clays of north China saw only limited use in late Neolithic ceramics but, during China's early Bronze Age (the Shang dynasty 17th–11th century BC), a true white ceramic was made from this material, and fired to higher kiln temperatures (*c.* 1050°–1200°C) to produce an altogether tougher product. These unglazed Shang whitewares have been excavated at Anyang in north Henan, the religious and political capital of the later Shang dynasty, from about 1300 to 1070BC.

Shang whitewares appear to have been coil-built, and of all Shang ceramics they are the closest in form and decoration to contemporary bronze ritual vessels, with complex small-scale repeat designs cut sharply into the white clay. However, this style of ornament was not used solely for bronze vessels – it was also the 'official' Shang style for decorating jade, bone, ivory and marble, and a recent proposal suggests that Shang whitewares may have been imitations of Shang carved marble vessels.

Whatever their original models, Shang whitewares were important ceramics. Shang society was highly regulated and ritualised and the use of these white-firing clays in a way that echoed important materials must indicate that a special status was invested by the Shang in their white-firing ceramics.

## Compositions of Shang whitewares

It is sometimes said that these rare Shang whitewares would have made true porcelains if fired to suitable porcelain temperatures (1250°–1350°C). With the help of recent work it is now possible to compare Shang whiteware analyses with those of the later northern porcelain bodies.

The analyses in Table 33 suggest that these three examples of Shang whiteware were roughly equivalent to a low grade of Gongxian porcelain made in the Tang dynasty – but were less pure than some better examples of Tang Xing wares and Song Ding wares.

## Later whitewares

A gap of some 1800 years separates Shang whitewares from the first true Chinese porcelains and this was a period that saw very little use of stoneware materials in the north, whether glazed or unglazed. Glazed northern stoneware only begins to become important in north China in the early 6th century AD. By the end of the Sui dynasty (581–618) simple undecorated whitewares were being made at kilns in Henan, Shaanxi and Hebei provinces. They were hard, dense and slightly translucent when thin – in fact, verging on true porcelain. By the mid-8th century AD

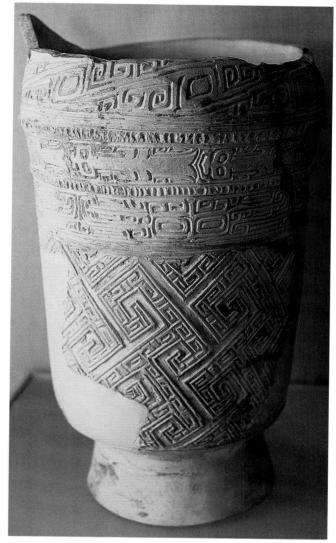

Shang whiteware jar from Anyang, later Shang dynasty 13th century BC. These carved but unglazed stoneware vessels have been found in a number of important tombs at the late Shang capital at Anyang. Shang whitewares vary in purity but the better examples approach northern porcelain in their compositions, although their firing temperatures (*c.* 1150°C) were too low to realise the full potential of the material. Shanghai Museum.

Table 33 Comparison of Shang whitewares with Tang porcelains

|  | $SiO_2$ | $Al_2O_3$ | $TiO_2$ | $Fe_2O_3$ | CaO | MgO | $K_2O$ | $Na_2O$ | MnO | $P_2O_5$ |
|---|---|---|---|---|---|---|---|---|---|---|
| Shang whitewares |  |  |  |  |  |  |  |  |  |  |
| Whiteware 1 | 51.3 | 40.8 | 2.2 | 1.1 | 1.6 | 0.5 | 0.5 | 0.7 | –.– | –.– |
| Whiteware 2 | 57.2 | 35.5 | 0.9 | 1.2 | 0.8 | 0.5 | 2.3 | 1.3 | –.– | –.– |
| Whiteware 3 | 57.7 | 35.2 | 0.9 | 1.6 | 0.8 | 0.6 | 2.2 | 1.0 | –.– | –.– |
| Northern porcelains |  |  |  |  |  |  |  |  |  |  |
| Xing ware | 60.0 | 35.0 | 0.7 | 0.7 | 1.0 | 0.4 | 1.5 | 0.5 | 0.04 | 0.1 |
| Ding ware | 66.0 | 28.0 | 0.8 | 1.0 | 1.0 | 0.7 | 1.8 | 0.5 | –.– | 0.07 |
| Gongxian whiteware | 66.3 | 30.3 | 1.2 | 1.3 | 0.5 | 0.5 | 2.0 | 0.5 | –.– | 0.0 |

true white porcelain was being made at several kiln sites in north China, including Gongxian (Henan province), and the Xing sites at Lingchen in Hebei province.

### The nature of northern porcelain

The world's first porcelains, made in north China in the early 7th century AD, are unfamiliar materials to us in the West. To begin with they were made from secondary clays that rivers had carried as cloudy suspensions hundreds of miles from their rocky origins, and often laid down in mud flats that became overgrown with carboniferous forests. Deposits of such clays, still mined in Henan and Hebei, are quite black in their raw states, only turning white during firing as their organic contaminants burn away.

Our own china clays by contrast are primary kaolins, mined by high-pressure hoses to separate them from the altered granites that produced them, and with which they are still associated. These primary kaolins are brilliant cream-white before firing, but far less plastic than their

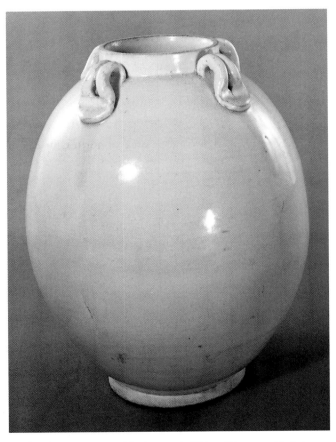

Early white near-porcelain jar, north China (Henan or Hebei province), 7th century AD. This jar has a white slip on a near-white body. Analysis of similar wares suggests that a small amount of extra heat would have transformed the material into porcelain. H. 12 in., 30.5 cm.
British Museum, OA 1968. 4–22.23.

north Chinese equivalent; the large clay particles of the English clays have not been pulverised, sorted and rendered more workable by lengthy river journeys.

A further difference between these early Chinese and modern porcelains is that in the West our porcelains are careful mixtures of china clay, quartz and feldspar – balanced to control glaze fit, whiteness and translucency. So far as we can tell, the early northern porcelains were used largely as found after suitable 'washing' and preparation. Deliberate additions of body fluxes or quartz were probably minimal or absent. In this sense it is probably more accurate to describe Chinese porcelain as having been 'discovered' rather than 'invented'. The almost random and frenetic mixing of likely and unlikely materials, that occurred with much Western experiment in porcelain in the 18th century, was a very different process from the gradual refinement of familiar materials over an enormously long time span, as seems to have happened in China.

### Development of northern porcelain

During their long journey towards tough, white and translucent porcelains, three technical problems in particular would have faced the northern potters: sufficient heat to mature the bodies and produce translucency; control of crazing in the porcelain glazes; and the natural tendency of many northern bodies to fire cream or grey, rather than the pure white of the ideal material.

### Kilns

Pottery fired to stoneware hardness was made at many sites in southern China during the Bronze Age – apparently using updraught kilns, often of square cross section and about one metre across inside. Firing temperatures occasionally reached 1200°–1250°C with the fires burning beneath a perforated floor that supported the wares. Updraught kilns act as their own chimneys and are efficient enough to have still been in use in Staffordshire in the early 20th century for most English earthenware and bone china production. However, the design is rather wasteful of fuel as the kilns tend to overheat at the bottom and to under-fire at the top. Perhaps for these reasons Chinese potters moved away from updraught kilns for most high-fired wares as early as the Warring States period (480–221 BC).

This vital change in kiln layout was managed in China by turning the updraught kiln on its side to produce the cross-draught design. These kilns were usually hollowed from, or built into, clay or loess banks, and are sometimes called 'cave kilns'. A flue at the back of the kiln took the combustion gases to the outside air, while the mouth of the 'cave' acted as both door and firebox, while the cave itself acted as the kiln chamber. By making the fire travel

Early near-porcelain cup, north China, probably Henan province. Sui dynasty, early 7th century AD. H. 3.5 in., 9 cm. British Museum, OA 1967. 12-12.1

The characteristic round kilns of northern China are known locally as *mantou* kilns, after the shape of the steam-baked bread rolls popular in the north. The term 'horse-shoe-shaped kiln' is also used for the same design, referring here to the ground plan rather than to the dome. This kiln type is still seen over most of north China, and occasionally in the south too, where it is still used for firing bricks and tiles, often with coal as the fuel. Dragon kilns, however, seem confined to the south.

The *mantou* design became the northern porcelain kiln *par excellence* and, by the Tang dynasty (AD618–907), firing temperatures between 1280° and 1350°C were common for porcelain-making in China. The higher end of this range is a good white heat, and these temperatures were not matched in the West for firing ceramics until the early 18th century.

### Three northern porcelains of the Tang Dynasty
There is a strong visual similarity between Tang porcelains from north China, and this makes the early northern porcelains rather difficult to tell apart. It is only when shards from the various Tang porcelain sites are compared analytically that some real differences emerge. Three kiln sites in particular have received this detailed examination – those of Gongxian, Xing and Ding.

## *Gongxian porcelain*
Gongxian is a district in the north of Henan province set squarely in the ancient 'nuclear area' of north China, some 200 miles southwest from the ancient Shang capital of Anyang. An approach to Gongxian sees a change from the level and fertile loess lands of the Great Central Plain to the rocky limestone mountains on the edge of town.

Scene near to a Gongxian kiln site, Henan province, north China. A large factory making firebricks is now sited across the river from an early (Sui-Tang) Gongxian kiln site. It is a common experience in north China to see modern industries, such as coal mining, cement works and firebrick factories, exploiting the same sedimentary geologies as were used for early stonewares and porcelains.

horizontally the flame-speed was much reduced, causing the hot gases to linger in the kiln. This made more efficient use of the burning fuel and supplied more energy to the pots in the setting. Higher temperatures were therefore easier to reach, and the kilns used far less fuel in firing – mostly in the form of timber, brushwood, reeds and straw.

During the late Warring States period the cave kiln underwent a further transformation. In the south the design was 'stretched' to make a short tunnel running up a hillside, three to four metres long, and with a slope of about 16°. In the 3rd century BC additional side-stoking holes were added towards the end of the tunnel to boost the heat at the higher levels. As described in Chapter Two, the discovery of this side-stoking principle meant that the kilns could now be made to any length and kilns tens of metres long began to be built up the hillsides of southern China, with the slopes of the kilns becoming shallower as their lengths increased.

In north China the cave kilns eventually became shorter and rounder, and chimneys were added, to give the firemen greater control of the draught. Two chimneys side by side were often used with this design – an odd-looking but very practical feature that persists in China today. These kilns had a horseshoe-shaped ground plan with large fireboxes on the curve of the 'horseshoe' opposite the chimneys. The size of the northern kilns was generally modest – two metres across was a large kiln by northern standards, and most of the later northern kilns kept to this general scale. By contrast, the southern dragon kilns grew to enormous lengths, eventually approaching 140 metres in the Southern Song dynasty.

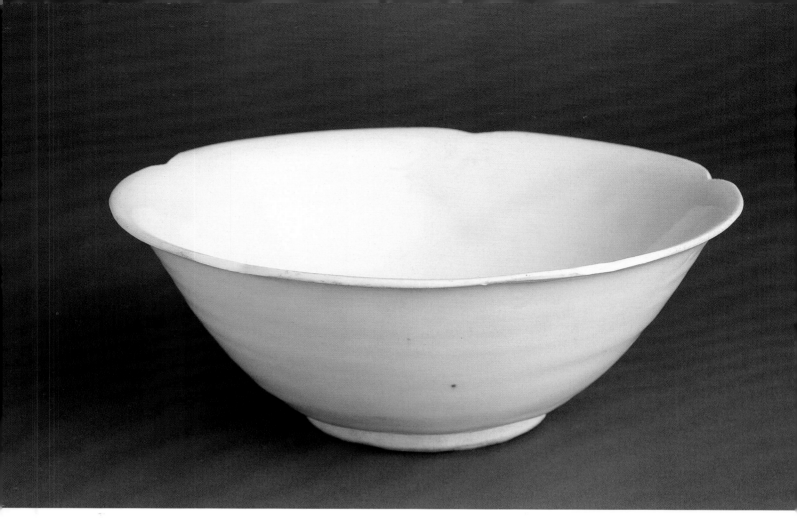

9th-10th century whiteware bowl with white slip inside and the glaze stopping short of the foot outside. D. 7 in., 17.9 cm. By courtesy of the Percival David Foundation of Chinese Art, PDF 106a.

Nowadays Gongxian is a busy and smoky industrial city, scattered with coal mines, cement works and factories producing refractory bricks – all exploiting the rich sedimentary geology of limestone, fireclay and coal. The remains of Tang kilns have been found on the outskirts of Gongxian, in some spectacular rocky valleys on the Huangye and Baiye rivers. The earliest whitewares have been dated to about AD575 – making Gongxian one of China's (and therefore the world's) most ancient porcelain centres.

It is probably significant that Gongxian is near the foothills of a limestone mountain chain that runs north into Hebei province – the Taihang Shan. The loess deposits are thinner here, making the ancient Permo-Carboniferous clays beneath the loess more accessible to the potters. Early whiteware kilns sites tend to follow the foothills of this mountain range, and porcelain kilns hundreds of miles to the north of Gongxian seem to have exploited the same geological system.

Analysis has shown the Gongxian porcelain material to have been an aluminous secondary kaolin, of variable alkali content (2–7% KNaO). This combination of high alumina with occasional high alkali levels suggests that some of the Gongxian clays were natural mixtures of kaolinite and potassic mica, with very little quartz, and with the original mica contents probably varying from about 20–60% by weight. This is an unusual porcelain body, and one that at present seems unique to Gongxian. High mica levels are a feature of most southern porcelains, but the southern raw materials are largely mixtures of mica and quartz, rather than of mica and clay.

As both mica and kaolinite are plastic, Gongxian micaceous porcelains would have been very workable – although perhaps with rather high drying and firing shrinkages. Translucency and resistance to firing distortion would have been good, and the porcelains slightly lower in mica should have had a wide maturing range.

**Gongxian glazes**

Some of the glazes used on Gongxian porcelains were advanced for their time. They were of the lime-alkali type, with a roughly 2:1 balance of calcia and potassia+soda – typically about 7-0% CaO and 3-5% KNaO.

Table 34 Analyses of Gongxian clays, Sui – Tang dynasty

|  | $SiO_2$ | $Al_2O_3$ | $TiO_2$ | $Fe_2O_3$ | CaO | MgO | $K_2O$ | $Na_2O$ | MnO |
|---|---|---|---|---|---|---|---|---|---|
| *Gongxian (lower alkali)* | | | | | | | | | |
| Gongxian 1 | 67.7 | 26.8 | 1.3 | 0.6 | 0.4 | 0.4 | 2.1 | 0.5 | 0.04 |
| Gongxian 2 | 63.0 | 30.3 | 1.2 | 1.3 | 0.5 | 0.5 | 2.0 | 0.5 | 0.06 |
| Gongxian 3 | 66.3 | 28.0 | 1.3 | 1.0 | 0.3 | 0.4 | 2.3 | 0.4 | 0.04 |
| *Gongxian (higher alkali)* | | | | | | | | | |
| Gongxian 4 | 53.4 | 37.1 | 0.8 | 0.6 | 0.5 | 0.4 | 5.0 | 2.1 | 0.04 |
| Gongxian 5 | 52.7 | 37.5 | 0.8 | 0.7 | 0.6 | 0.4 | 5.1 | 2.2 | 0.04 |

Table 35 Gongxian glazes – Sui to Tang

|  | $SiO_2$ | $Al_2O_3$ | $TiO_2$ | $Fe_2O_3$ | CaO | MgO | $K_2O$ | $Na_2O$ | MnO |
|---|---|---|---|---|---|---|---|---|---|
| *Gongxian (lower alkali)* | | | | | | | | | |
| Gongxian 1 glaze | 64.6 | 13.9 | 0.2 | 0.8 | 12.3 | 1.9 | 3.0 | 2.2 | –.– |
| Gongxian 2 glaze | 67.7 | 15.9 | 0.4 | 0.9 | 10.8 | 1.5 | 2.4 | 0.8 | –.– |
| *Gongxian (higher alkali)* | | | | | | | | | |
| Gongxian 4 glaze | 62.5 | 17.0 | –.– | 0.7 | 10.4 | 1.1 | 4.1 | 2.1 | –.– |
| Gongxian 5 glaze | 66.8 | 14.5 | –.– | 0.9 | 9.3 | 1.1 | 4.3 | 1.75 | –.– |

The lime-alkali balance sometimes used at Gongxian gave stable glazes with good resistance to both crystalline dullness and crazing. As we have seen, lime-alkali glazes of the Gongxian type came fully into their own in the Song dynasties (AD960–1280), when they formed the basis of the superbly unctuous Longquan celadons, and also the fine, olive, northern celadons of Yaozhou and Linru. Later still they became the classic glaze type for underglaze-blue painting on southern porcelains, from about the second quarter of the 14th century until the present day.

## Gongxian blue-and-white

Until comparatively recently, Gongxian was regarded simply as a northern kiln site where coloured lead-glazed wares and some white porcelains were known to have been made in the Tang dynasty. Then in 1982, details of its 'Tang blue-and-white' production were published at the first International Conference on Ancient Chinese Pottery and Porcelain (ICACPP) in Shanghai. The shards of Gongxian blue and white illustrated at Shanghai had greyish bodies and greenish-white glazes. They were something of a sensation – Song blue-and-white was rare enough, but Tang blue-and-white was unheard of. However, to Western eyes, although they were certainly painted in underglaze cobalt blue, the bodies were not quite porcelain and the lime glazes were more like pale celadons.

Then at the second ICACPP, at Beijing in 1985, all doubts were removed. Fragments of Gongxian whiteware with clear underglaze blue painting, found in Tang levels at the great southern trading city of Yangzhou, were described. Analysis showed the bodies and glazes to be of typical Gongxian whiteware material and the wares were

Shards of underglaze cobalt blue painted Gongxian whiteware, late Tang dynasty (AD618–907). The slightly yellowish clay is covered with a whiter slip, and the painting is clearly beneath the glaze. The pattern style is Middle Eastern, and the discovery of these shards in the large trading city of Yangzhou may mean that they were destined for export. Yangzhou Ceramics Training Centre, Jiangsu province.

oxidised. The glazes were of the lime and lime-alkali types, and the cobalt pigment was similar to that used in low-fired blue Gongxian lead glazes.

This pigment was unusually pure, being mostly cobalt with small traces of copper, iron and sulphur. This is now thought to have been a cobalt sulphide, possibly linnaeite or cattierite, although its origin is still unknown. It may have been imported from Central Asia, but similar minerals occur in Gansu and Hebei in north China so a source relatively local to Gongxian is not impossible. Since 1985, more examples of Tang blue-and-white have been found

Back of the figure on page 97 showing a typical Tang *bi* shaped foot (the *bi* is a flat jade ring of unknown significance made in China since the Neolithic period).

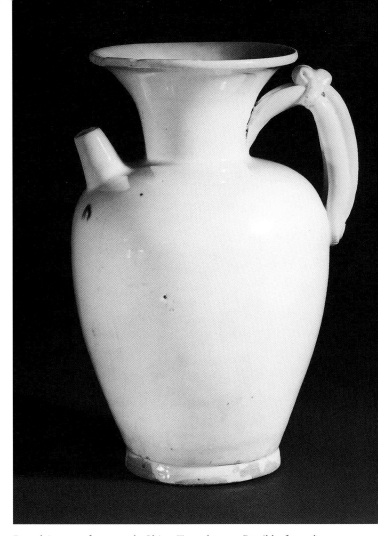

Porcelain ewer from north China, Tang dynasty. Possibly from the Xing kilns in Hebei province, this exceptionally white ewer is a fine example of Tang porcelain. H. 7.5in., 19 cm, OA 1915 4-9 83, British Museum.

in north China, but the Gongxian shards remain the best quality, making this a kiln of prime importance in the history of Chinese ceramics.

The disappearance of underglaze blue painting in north China, so soon after its development at the Gongxian kilns, is almost as much a mystery as its introduction. Did supplies of this unusually pure cobalt ore run out, or did blue-and-white porcelain simply find an indifferent public in the 8th–9th century AD? Whatever the truth, it was another 500 years before this combination of white porcelain and underglaze blue painting became properly established in China, this time in the south of the country and at the great porcelain-producing centre of Jingdezhen.

### Xing ware

It is rare to find a piece of northern porcelain in a Western museum labelled 'Gongxian' as wares from this important kiln site are only now being properly identified. The usual description might be a non-committal 'Northern White-ware', or perhaps 'Xing Ware'. Xing ware is the most famous of Tang porcelains, with a production site recently discovered in Lingchen county, Hebei province, some 350 miles to the north of Gongxian. Xing ware is mentioned in Tang literature as the whitest of northern porcelains and

it was apparently made on a scale that allowed it to be used by 'both rich and poor'.

There is a strong superficial similarity between the porcelains made at Gongxian and Lingchen (Xing), but analysis shows some important differences. First, Xing wares were naturally lower in fluxes, particularly the alkalis, potassia and soda. This meant higher firing temperatures must have been needed to mature the Xing bodies – an impression supported by the Xing glaze analyses themselves, which are notably richer in the 'hard' oxides of silica

Table 36 Analyses of Gongxian blue-and-white materials

| | $SiO_2$ | $Al_2O_3$ | $TiO_2$ | $Fe_2O_3$ | CaO | MgO | $K_2O$ | $Na_2O$ | MnO | $P_2O_5$ |
|---|---|---|---|---|---|---|---|---|---|---|
| Gongxian blue-and-white body | 63.2 | 30.3 | 1.4 | 0.8 | 0.6 | 0.6 | 4.1 | 0.4 | –.– | 0.2 |
| Gongxian blue-and-white glaze | 69.8 | 12.6 | 0.1 | 0.7 | 10.3 | 1.3 | 2.5 | 1.4 | 0.1 | 0.6 |

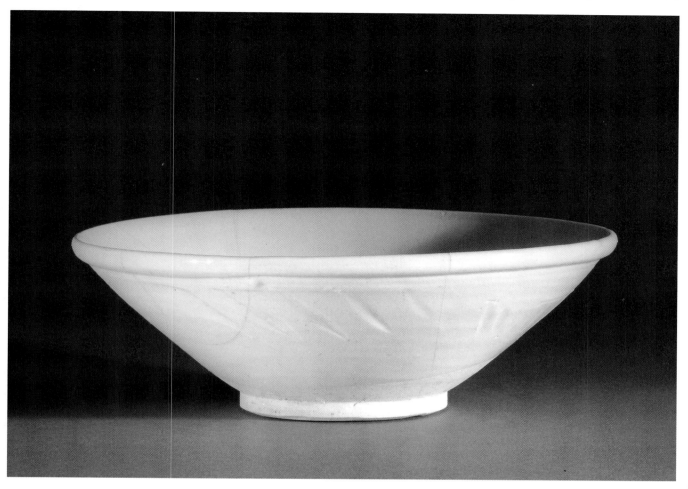

Chinese porcelain bowl, found in Iran, possibly at Nishapur, 10th century AD. In the early 10th-century bowls such as these, with characteristically thickened Tang-style rims, were made at a range of northern kiln sites in Henan and Hebei provinces, as well as at emerging southern porcelain sites, such as Jingdezhen. It can be difficult at this period to distinguish northern from southern examples by sight. (The 'chatter' marks on the bowl's exterior were produced during turning and are evidence of rapid production.) D 7in., 17.8 cm, OA 1970 11-3, British Museum.

and alumina, suggesting firing temperatures that may have reached as high as 1350°C (white-blue heat) in some cases. It is also interesting that in many examples of Xing ware the porcelain body has been dipped in an even whiter clay slip to improve its fired colour. There are also signs that exceptionally pure clays were used in the Xing ware glazes in order to make the glazes much lower in titania (average 0.1% $TiO_2$) than the bodies themselves (average 0.6%) and consequently whiter-firing. Another technique used by Xing potters to produce the 'whitest whiteware' was to use occasionally glazes overloaded with clay – giving 'snow white' alumina-matt effects that were practically opaque. One further difference between Gongxian and Xing wares was the use of a rather stronger reducing atmospheres in the Xing kilns, giving the Xing porcelains a cooler tone than the slightly cream Gongxian wares.

These various techniques all suggest a more compli-cated manufacturing process than at Gongxian, with the

Xing potters carefully controlling raw materials, kiln atmospheres, and their production methods, to make the toughest, whitest and most translucent porcelains possible from local resources.

The Xing kilns made porcelains in typical Tang style – particularly plain bowls, ewers, jars, and lamps in the confident, generous manner of Tang utilitarian ware. More elaborate moulded dishes of foreign influence were also produced. These imitated complex beaten silver designs and showed the pure white porcelain to particular advan-tage. Simpler wares from the Lingchen kilns were exported widely, particularly to the Middle East, where they went, often as secondary cargoes, in ships carrying silk. As a result of this trade, Chinese Xing wares were copied in Iraq in the 8th and 9th centuries, using local dolomitic earthenware clays, and improved versions of the local tin-opacified earthenware glazes.

Table 37 Analyses of Xing bodies and glazes

| | SiO$_2$ | Al$_2$O$_3$ | TiO$_2$ | Fe$_2$O$_3$ | CaO | MgO | K$_2$O | Na$_2$O | MnO | P$_2$O$_5$ |
|---|---|---|---|---|---|---|---|---|---|---|
| *Xing ware bodies* | | | | | | | | | | |
| Xing body 1 | 67.6 | 28.5 | 0.4 | 0.75 | 0.6 | 0.7 | 0.75 | 0.2 | –.– | 0.05 |
| Xing body 2 | 60.0 | 35.1 | 0.7 | 0.7 | 1.0 | 0.4 | 1.5 | 0.5 | 0.04 | 0.11 |
| Xing body 3 | 60.4 | 34.5 | 0.6 | 0.65 | 0.7 | 0.6 | 1.3 | 0.2 | 0.04 | 0.09 |
| Xing body 4 | 64.2 | 28.6 | 0.9 | 0.6 | 0.6 | 0.6 | 1.8 | 0.2 | 0.01 | 0.1 |
| *Xing ware glazes* | | | | | | | | | | |
| Xing glaze 1 | 68.2 | 18.4 | –.– | 0.8 | 7.9 | 2.5 | 1.1 | 0.45 | –.– | –.– |
| Xing glaze 2 | 68.3 | 18.1 | 0.1 | 0.9 | 7.0 | 2.2 | 2.0 | 0.8 | 0.12 | –.– |
| Xing glaze 3 | 65.1 | 16.5 | 0.07 | 0.5 | 11.3 | 2.7 | 1.0 | 0.6 | 0.1 | –.– |
| Xing glaze 4 | 60.0 | 18.5 | 0.15 | 0.55 | 15.5 | 2.0 | 1.1 | 0.4 | 0.06 | –.– |

Table 38 Analyses of feldspathic Xing bodies and glazes from Neiqui county

| | SiO$_2$ | Al$_2$O$_3$ | TiO$_2$ | Fe$_2$O$_3$ | CaO | MgO | K$_2$O | Na$_2$O | MnO | P$_2$O$_5$ |
|---|---|---|---|---|---|---|---|---|---|---|
| *Feldspathic Xing ware bodies* | | | | | | | | | | |
| Feldspathic Xing body 1 | 65.8 | 26.8 | 0.2 | 0.3 | 0.4 | 0.23 | 5.2 | 1.0 | 0.01 | 0.06 |
| Feldspathic Xing body 2 | 62.9 | 26.9 | 0.2 | 0.4 | 0.5 | 0.3 | 7.3 | 1.6 | –.– | 0.01 |
| *Feldspathic Xing ware glazes* | | | | | | | | | | |
| Feldspathic Xing glaze 1 | 71.0 | 16.9 | 0.2 | 0.4 | 2.7 | 0.1 | 6.4 | 1.4 | 0.04 | 0.3 |
| Feldspathic Xing glaze 2 | 69.4 | 13.3 | –.– | 0.6 | 8.4 | 1.3 | 4.7 | 1.4 | 0.1 | 0.3 |

## Feldspathic Xing wares

The general image of Chinese Xing wares, developed by analysis and reasearch in the early 1980s, is outlined above. However, at the third major international conference on ancient Chinese pottery and porcelain, held in Shanghai in 1989, our emerging understandings of Xing ware were challenged by some remarkable finds. These took the form of two shards of unusually white and translucent late Sui Dynasty (AD581–618) Xing wares that had been excavated from Sui/Tang levels at a major Xing ware kiln site in Neiqui county.

These two shards, apparently dating from the earliest stage of porcelain-making in China, and the world, proved to be highly feldspathic and probably made from a mixture of kaolin and potash feldspar in about 3:2 proportions. The glazes on these porcelain fragments were also unusual in being relatively rich in alkalis and low in lime – and not unlike some white glazes used on Jingdezhen porcelains of the early the 15th century AD.

Highly feldspathic porcelains are virtually unknown in Chinese ceramics, and the production of this unusual type of Xing ware seems to have been confined to this early period. What is also interesting about this find is the apparent deliberate blending of refined and crushed raw materials – rather than a simple reliance on naturally flux-rich secondary kaolins, as seems to have been the case with most early northern porcelain bodies.

One possibility, of course, is that the two shards described here were actually stray intrusions from a later date, and were perhaps even made in south China, at a kiln site such as Dehua, However, the compositions above are not quite like Dehua porcelains, and analyses of Xing glazes do indicate that very low titania kaolins were in use at this kiln site from early times, so they may well have been used experimentally in body compositions too. Nonetheless, since this initial report was presented at Shanghai in 1989 no further news of feldspathic Xing ware has appeared – and these two fragments remain exceptions that severely test the 'rules' that have been evolved about the natures of northern porcelains.

## Ding ware

While Xing (Lingchen) is regarded as the greatest of the Tang porcelain kilns, Ding ware became the premier porcelain of the Song dynasties. Ding wares began production some 100 miles north of Lingchen, in Hebei province, in the Tang dynasty. The Ding kiln sites at Beizhen and Nanzhen, near to the town of Jiancicun, initially made stonewares and porcelains in the Xing style, although of slightly lower quality. However, as Xing production declined in the 10th century, the Ding kilns grew in scale and accomplishment until, in the 11th and early 12th centuries, they were making some of the most advanced and successful porcelains that north China had ever seen.

By the Northern Song Dynasty (AD960-1127) Ding kilns were at their zenith and producing a plain and beautiful cream-coloured, oxidised porcelain with austere and refined forms that showed a superb balance of inner and

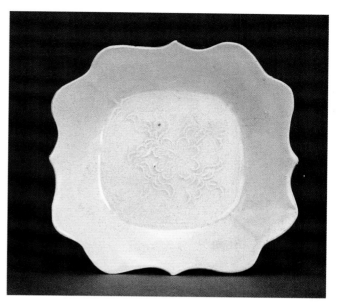

Press-moulded porcelain dish with bracketed sides, Liao dynasty early 10th century. The relief decoration, often used on Liao wares, was probably created by carving the leatherhard clay of the mould before it was fired. W. 3.5 in., 9 cm. Sotheby's.

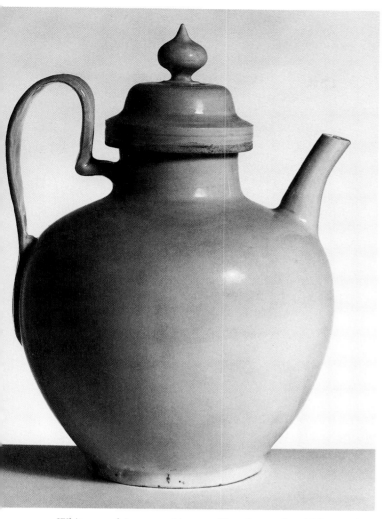

White porcelain ewer with cover, Liao dynasty, late 10th or early 11th century. Although this ewer copies a beaten metal form, the use of throwing gives a special fluency to its shape. Porcelain ewers of this style have been excavated from Liao royal tombs and they were made from clays similar to those used for Xing and Ding wares. H. 7.9 in., 20 cm. Fitzwilliam Museum, Cambridge.

outer space. These were among the first ceramics in China to be approved for palace use. Earlier examples of these fine wares were made by throwing and were decorated by light free-hand engraving of the clay surface. Much of the later Ding ware was made by a combination of throwing and moulding, usually by firmly beating thickly-thrown leatherhard dishes and bowls onto convex pottery moulds. The backs of the bowls, dishes and plates were then turned down to a fine thinness, with their feet sometimes finished with a hand-held profile in a way that anticipated modern jiggering. Engraved moulds were a natural development of this process and were often used to produce complex surface designs in light relief – an ornamental style that seems to have been inspired by contemporary beaten-silver dishes.

This moulding technique was particularly useful for mass-producing dishes and bowls intended for firing on the step-setters used at the Ding kilns – a process that demanded great consistency and precision of form. The setters were made from materials similar to the Ding porcelain bodies themselves and were designed to support a nest of raw-glazed bowls and dishes, set rim downwards on the 'steps' of the setters. As many as seven bowls of decreasing diameter might be fired at one time on a single setter, with only a few millimetres separating the various sizes.

Ring setters of an 'L'-shaped section were also used to support Ding ware bowls but, in this case, bowls of the same diameter could be accommodated. Rings and bowls were stacked alternately, with the bowls set rim down on the ledge of the 'L'. When a stack was complete, the outsides of the ring-setters were lightly brushed with slip to act as a temporary bond during kiln packing. Stacks of setters and bowls were then placed within heavier fireclay saggars and the whole setting was given a single firing to about 1300°C, plus or minus 20°C.

Both types of Ding ware setters could only be used once, as they kept the wares round by shrinking in step with the forms they supported during firing. The heavier saggars that contained the bowls and setters could be used repeatedly. As a result of these setting arrangements, the foot-rings on Ding bowls and dishes became unusually small and light – they no longer had to support the bowls during firing, and these vestigial feet were less likely to sink under their own weight as the porcelain kilns reached their greatest heat.

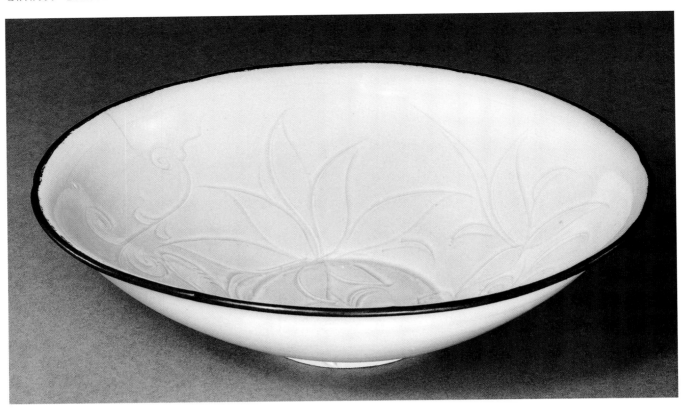

Ding ware bowl, Northern Song dynasty. In both form and decoration this bowl represents a high point in northern porcelain production. The thin bronze band (disguising the unglazed rim) was probably added some hundreds of years after the bowl was made; metal rims contemporary with Ding wares tended to be flatter and broader. D. 9.2 in., 23.5 cm.
British Museum, OA 1947.7–12.59.

Besides these sophisticated setting methods, introduced in the late 12th century, another important advance took place at the Ding kilns – namely, a change of fuel from wood to coal. This was a timely development as a long tradition of agricultural clearance, bronze-founding, iron-casting and stoneware-firing in north China had consumed vast tracts of northern forest. A change from wood-burning to the inexhaustible resources of the northern coal-fields gave a considerable boost to northern high-temperature ceramics in the 10th–11th century – not only at the Hebei porcelain kilns but also at the celadon, blackware and Jun kilns of Shaanxi, Shanxi, Shandong and Henan.

Firing with coal made high temperatures and oxidised firings easier to achieve, but the change also involved some modifications in kiln design and setting practices. The small scale of the *mantou* kilns suited the short flame length of coal, but deep ashpits had to be built beneath the fireboxes to accommodate the masses of cinder and clinker associated with coal firing. The fireboxes themselves, above the firebars, were made smaller to suit the more concentrated fuel and the firebars themselves were often made from solid fireclay cylinders some 3 inches in diameter and up to 1½ feet in length.

Interior wall of a coal-fired stoneware kiln in north China. Unlike wood ash (see figure on page 18) coal ash is a rather refractory material, with a composition not unlike clay. The widespread adoption of coal as a fuel in north China, in the Northern Song dynasty, prompted rapid developments in saggar design. The saggars were needed to protect fine glazes from the gritty coal ash, but they also allowed less scarring of the wares from stacking, and better heat distribution within the kilns.

Coal firing also meant that glazed wares had to be protected by saggars as the fly ash from coal burning is gritty and could easily damage fine glazes, while the action of wood ash on ceramics is generally benevolent. Coal firing became widespread in north China in the 11th and 12th centuries, but was never popular in the south. There was less coal in south China, but the main reason for lack of interest in the fuel must have been the success of the southern style of 'dragon' kiln, which relied on the long flames produced by brushwood or reeds, or by resinous woods such as pine.

## Ding glazes and crazing

Crazing was a recurring problem with early northern porcelains because of their unusually high levels of true clay minerals, particularly kaolinite. The intergrown mixtures of mullite and body-glass that result from the high temperature firing of these clay-rich bodies have very low shrinkages in the last stages of cooling (250°C downwards) – too low to put the glazes in the states of slight compression needed to avoid crazing. This meant that many early northern whitewares crazed badly, which in turn resulted in the wares being much weaker than they should have been, considering the extremely high temperatures to which they had been fired (ceramics with crazed glazes may be only a quarter as strong as their uncrazed equivalents).

With Ding ware the problem seems to have been solved, partly by the thinness of the glazes, but also through control of glaze composition. Ding glazes are unusually rich in the low-contracting oxides of silicon, aluminium and, especially, magnesium. In practice this meant that the final contraction of the Ding glazes in cooling was fractionally less than the bodies – putting the glazes into the state of slight compression needed to keep them uncrazed.

Unusual levels of magnesia can be seen in Ding glazes from the beginning of their manufacture in the Tang – so this may have been a natural feature of the local glaze materials. This use of magnesia as a major glaze-flux actually puts the Ding glazes into a class of their own when compared with nearly all other Chinese porcelain glazes. As well as good craze-resistance the magnesia supplied a special richness to the Ding glazes. This is not quite such an unctuous and sweet effect as in the later southern *blanc-de-Chine* porcelains, but it does supply a certain subdued brilliance to the northern Ding wares.

Like Xing ware glazes, the Ding glazes are far lower in titania than the bodies they cover, suggesting either the use of unusually pure clays in the glaze recipes or, just conceivably, the use of a lime-rich high-alumina mineral, such as lime feldspar (anorthite), in the original recipes. Even so, the strongly oxidising conditions in which Ding wares were fired gave them a cream tone that was less obviously pure than the Xing wares they replaced.

Now that we know so much more about northern porcelains we can better appreciate the high standards of technology that they represent. Some writers have found Ding wares difficult to accept as a true porcelain – their cream colours seems a bit 'off' and their translucency, when present, is rarely obvious. However, from the technical point of view, Ding ware is a very advanced ceramic indeed – unusually high-fired and produced with the most sophisticated making, setting and firing processes in Song China. The southern porcelains that succeeded Ding ware were certainly purer and whiter – but they were less demanding in their manufacture, and rarely approached the austere purity of form and decoration found in the best productions of the Hebei kilns.

Table 39 Analyses of Ding bodies and glazes

| Ding ware bodies | $SiO_2$ | $Al_2O_3$ | $TiO_2$ | $Fe_2O_3$ | CaO | MgO | $K_2O$ | $Na_2O$ | MnO | $P_2O_5$ |
|---|---|---|---|---|---|---|---|---|---|---|
| Tang | 59.8 | 34.5 | 0.4 | 0.7 | 1.1 | 0.9 | 1.25 | 0.7 | 0.03 | –.– |
| Five Dynasties | 61.2 | 32.9 | 0.6 | 0.6 | 3.4 | 0.9 | 1.25 | 0.1 | 0.02 | –.– |
| Northern Song | 62.0 | 31.0 | 0.5 | 0.9 | 2.2 | 1.1 | 1.0 | 0.75 | 0.04 | –.– |
| Jin | 59.2 | 32.7 | 0.75 | 0.7 | 0.8 | 1.1 | 1.7 | 0.3 | 0.01 | –.– |

| Ding ware glazes | $SiO_2$ | $Al_2O_3$ | $TiO_2$ | $Fe_2O_3$ | CaO | MgO | $K_2O$ | $Na_2O$ | MnO | $P_2O_5$ |
|---|---|---|---|---|---|---|---|---|---|---|
| Tang | 73.8 | 17.3 | 0.1 | 0.5 | 2.9 | 2.15 | 1.56 | 1.3 | 0.04 | –.– |
| Five Dynasties | 74.6 | 17.5 | 0.2 | 0.5 | 2.7 | 2.3 | 2.0 | 0.6 | 0.02 | 0.2 |
| Northern Song | 72.1 | 17.5 | 0.2 | 0.75 | 3.9 | 2.3 | 2.0 | 0.5 | 0.03 | 0.3 |
| Jin | 71.2 | 19.7 | 0.45 | 0.6 | 4.45 | 1.6 | 1.6 | 0.3 | –.– | –.– |

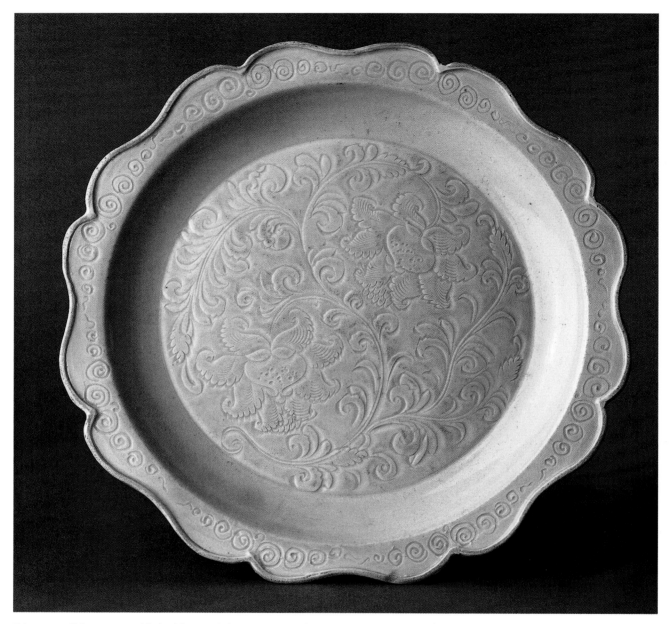

Ding ware dish, press-moulded with carved decoration, Northern Song dynasty, 12th century. D. 10 in., 25.2 cm. Gemeentemuseum, The Hague.

# FURTHER READING

*BOOKS*

Kwang-chih Chang, *The Archaeology of Ancient China*, Yale University Press, 1972

*PAPERS AND ARTICLES*

Chen Yaocheng, Zhang Fukang, Zhang Xiaowei, Jiang Jongyi and Li Dejin, 'A study on Tang blue-and-white wares and sources of the cobalt pigment used,' *Science and Technology of Ancient Ceramics 3 – Proceedings of the International Symposium (ISAC '95)*, chief editor, Guo Jingkun, pp 204-10, Shanghai, 1995

Guo Yanyi, 'Raw materials for making porcelain and the characteristics of porcelain wares in north and south China in ancient times.' *Archaeometry*, vol. 29, part 1, pp 3-19, Oxford, 1989

Li Guozhen and Guo Yanyi, 'An investigation of Ding white porcelain of successive dynasties,' *Scientific and Technological Insights on Ancient Chinese Pottery and Porcelain*, (ed. Shanghai Institute of Ceramics), pp 134-40, Beijing, 1986

Li Jiazhi, Zhang Zhigang, Deng Zequn, Chen Shiping, Zhou Xueqin, Yang Wenxian, Zhang Xiangshen, Wang Yuxi and Chen Ji, 'A study of white Gongxian porcelain of the Sui-Tang period', *Scientific and Technological Insights on Ancient Chinese Pottery and Porcelain*, (ed. Shanghai Institute of Ceramics), pp 129-33, Beijing, 1986

Christine Richards, 'Early northern whitewares of Gongxian, Xing and Ding', *Transactions of the Oriental Ceramic Society 1984-1985*, pp 58-77, London, 1986

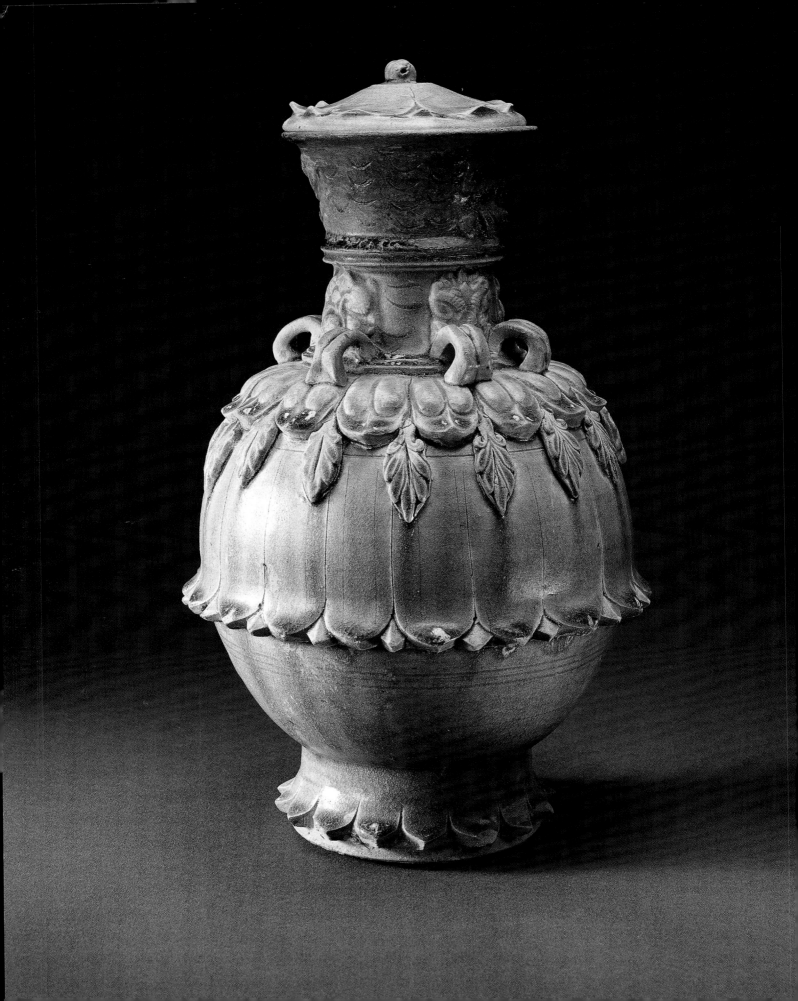

*Chapter 6*

# THE STONEWARES
# OF NORTH CHINA

The stonewares of northern China have a distinctive character of their own that owes much to the geology of China north of the Huai river and the Qinling mountains, and to the early history of the Chinese people. Amongst these northern stonewares are some of the finest ceramics in the history of Chinese art, with the refined Ru wares of the late Northern Song dynasty standing at the peak of this tradition. Other northern stonewares, famous for the qualities of their glazes and forms, are the spectacular bluish Jun wares of Henan province, the fresh-coloured olive-green celadons of Yaozhou and Linru, and the vigorous and dramatic black-and-white slip-painted Cizhou wares from north China's country kilns. Often included within the general Cizhou tradition are the blackwares and brownwares of northern China. These dark-glazed wares are sometimes decorated with iron-rust painting, or by direct carving through their glazes and the various styles of northern blackware are discussed in greater detail in Chapter Seven.

Stoneware in north China reached the height of its development in the Northern Song dynasty (AD960-1127), but the production of its most famous expression, Ru ware, was badly damaged by the Tartar invasion of 1127 that also terminated the dynasty. In the 14th century AD production of northern celadon was further shaken by the Mongol invasion of 1324 – after which the celadon materials coarsened as their luxury markets declined. Jun wares too suffered some loss of material quality over the same period, although the general vigour of the Jun style allowed some striking Jun wares to continue well into the Yuan dynasty – and perhaps even into the early Ming. Cizhou wares and blackwares were essentially country wares, and so were less affected by the social upheavals that followed these northern invasions. Perhaps for this reason, production of north Chinese Cizhou wares continued well into the 20th century, often using clays, glazes, forms and ornament that differed little from those developed in northern China at least 700 years before.

The most refined examples of northern stoneware, however, had a short but glorious history, during which they rapidly overtook their southern models. With the flight of the northern imperial court south in AD1127, the best of these northern wares came to exert a return influence on the ceramics of southern China – most notably through the Ru-inspired wares made at the Guan and Ge ware kilns in Zhejiang province.

## Origins of northern stoneware

Despite these undoubted later successes, the early history of high-temperature ceramics in north China is still one of the most difficult aspects of China's ceramic history to assess properly – largely because early examples of glazed stoneware from north China seem scarcely to exist. The enormously long and steady progress that can be traced in southern stonewares, from the early Bronze Age until about the 10th century AD, seems to have had no parallel in the north, with northern stoneware only really coming to life in the early 6th century AD.

Why there should have been this almost total lack of locally made glazed stoneware in north China, before the late 5th century AD, has never been satisfactorily explained. Indeed, analytical work has only recently raised the subject as an issue as most likely candidates for the description of early northern stoneware have gradually been eliminated from consideration because of their southern-style compositions.

Stoneware vase with applied decoration, 6th century AD. Early examples of northern glazed stoneware include a remarkable group of large vases that are glazed overall and encrusted with a mass of sprigged decoration, combined with carved thrown flanges on the bodies of the vessels. Most examples bear olive-green glazes, which makes this pale-glazed example rather unusual. Sotheby's. H. 17 in., 43 cm.

What makes this subject especially puzzling is that the north was the most advanced area of China during the Bronze Age, both in terms of technology and social organisation. The area had a long experience with high-temperature processes from its advanced bronze-casting industries and, later, from its development of cast-iron in about the 5th century BC. The north also represented a huge potential market for glazed stoneware.

The existence of unglazed Shang whitewares, and the occasional use of similar clays for Neolithic vessels, show that suitably refractory clays were known to the people of north China – so why locally made glazed stoneware should have been so rare as to be virtually non-existent, until about the late 5th century AD, is certainly a mystery. It may be that some answers are to be found in the profound geological and compositional differences that exist between the northern and southern stoneware materials – but whether these provide a total explanation is still difficult to say.

## Southern and northern stonewares compared – northern stoneware clays

Typical northern stonewares are made from true sedimentary clays, often associated with north China's coal fields. These materials consist largely of the refractory clay minerals, kaolinite and halloysite, together with lesser amounts of fine quartz, micas and feldspars. They are alumina-rich materials, and therefore benefited from long firings to temperatures generally higher than those used in the south – typically to between about 1250°C and 1310°C.

The geological history of northern stoneware is outlined in the chapter on northern porcelain, and the two materials are closely related. In compositional terms, northern stonewares shade imperceptibly into northern porcelains, without the significant differences in iron oxide and titania levels that effectively separate the two high-fired materials in southern China.

As mentioned above, these refractory northern stoneware clays saw some minor use in the Neolithic period as light-firing earthenware bodies (including some occasional use as carbonised blackwares) but their poor fired-strength at Neolithic kiln temperatures (*c.* 950°-1000°C) may account for their general unpopularity with Neolithic potters.

## Shang whitewares

Shang whitewares (see Chapter Five) seem to have been the first true stonewares of north China. They were made from similar clays to those used for some Neolithic white earthenwares, but were fired to higher temperatures (*c.* 1150°C) which made some examples thoroughly 'mullitised'. The presence or absence of mullite (an alumina-rich mineral produced from the breakdown of clay at high temperatures) is often used by ceramic technologists as a means for distinguishing hard earthenwares from true stonewares. Mullite crystals are needle-shaped and have a strong re-enforcing effect on ceramic bodies – increasing their fired strength to a marked degree. The development of mullite in Shang whitewares was sufficient to put some examples into the stoneware class.

Shang whitewares, of course, were not glazed in any way, and all the glazed Shang stonewares so far found in north China are still regarded, on fairly convincing compositional grounds, as being ceramic imports from the south.

Apart from these unglazed Shang whitewares, evidence for local stoneware production during north China's Bronze Age is very thin indeed. Professor Feng Xianming mentions a possible site for glazed stoneware production at Fufeng in Shaanxi province in the Western Zhou period (1050-771BC) – but otherwise few examples exist. The main northern ceramic productions at this time were grey and black unglazed earthenwares, and these eventually developed into the grey and red burial earthenwares of the Qin and Han dynasties, produced from the 3rd century BC to the early 3rd century AD. These late Bronze Age earthenwares of north China were made from fusible clays, mostly derived from the northern loess deposits, and would have melted easily if fired to stoneware temperatures.

In south China, by contrast, many of the clays used for Shang dynasty glazed stonewares varied little from those already used for some traditional Neolithic and Bronze Age earthenwares. This suggests that the development of stoneware in southern China was largely the result of a steady rise in kiln temperatures. This resulted in tougher wares, rather than a catastrophic melting of the clays – as would have happened with most northern earthenware materials. Early southern stonewares were also less refractory than true northern stoneware clays, so strong ceramics could have been made from them by firing to the lower stoneware range (e.g. 1150°-1220°C) – temperatures more easily managed in these early kilns. A further boost to southern stoneware development must have been the high-silica and high-flux natures of the raw materials. These converted easily into stoneware glazes with substantial additions of wood ash.

In short, most typical northern earthenware clays would have tended to melt when overfired, and this must have discouraged experiments with superior kiln designs and higher firing temperatures – both vital steps on the road to stoneware. Even when natural stoneware clays were tested in the north, the kiln temperatures needed to mature them fully would have been far beyond the experience of the northern potters. Great efforts would have been expended in the firing of Shang whitewares to 1150°C –

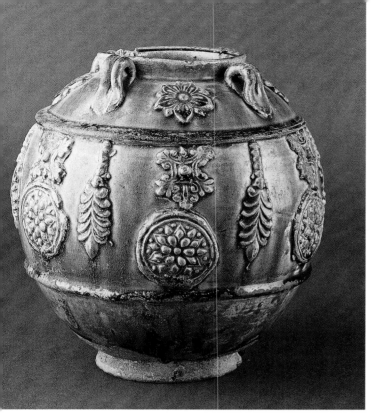

Stoneware jar with sprigged ornament, 6th century AD. Unlike contemporary southern stonewares (e.g. Yue wares), northern high-fired ceramics were often oxidised, giving warmer colours to their lime-glazes. This 'medallion' style of decoration seems to have had its origins in Sasanian Persian ornament. Gemeentemuseum, The Hague. H. 9.8 in., 25 cm

although in terms of strength, the resulting materials would have been little stronger than contemporary northern reduction-fired earthenwares made from common fusible clays.

Perhaps most important of all, northern stoneware clays were the product of ancient geological activity and, in most places, were well buried, often beneath hundreds of feet of loess. By contrast, the landscape of southern China had not been overwhelmed with wind-blown rock-dust. Outcrops of weathered igneous rocks, and silty sediments from these same materials, were enormously abundant, and could easily be processed into useful stoneware clays.

For some or all of these reasons, glazed stonewares, made from local materials, were surprisingly slow to become established in north China. Southern stonewares meanwhile continued their steady advance, both in terms of material quality and expanding markets. By the late 5th century AD, numerous southern glazed stonewares of the Yue type were finding their way to north China and these advanced southern wares must have spurred northern potters to produce equivalent ceramics from their own resources. This process seems to have happened in the late 5th century AD – and only some one hundred years before porcelain itself was developed in north China.

## Northern stonewares of the 6th century AD

When stoneware was at last revived in north China it was in a most interesting way. Typical 6th-century northern stonewares are strong and simple ovoid jars, with four, six or eight large lugs on their shoulders, light buff-coloured bodies, and glassy and finely-crazed glazes stopping some way short of their feet. The high fluidity of these transparent northern stoneware glazes meant that many 6th-century jars were made with two horizontal, raised ridges around their forms – apparently designed to check the flowing glazes, so they did not run down and stick the pots to their supports in the kiln. On the more ambitious wares the ridges were often carved into bold brackets, representing the points of pendant lotus petals; on some plainer jars the ridges were either thumbed up into wavy 'pie crust' lines, or simply left undecorated. Where the fluid glazes thickened in these ridges, they often developed striking optical blue colours, due to liquid-liquid phase-separation occurring during the early stages of cooling.

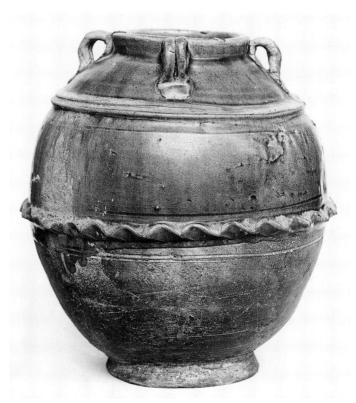

Stoneware jar, northern type, Northern Dynasties or Sui, 6th century AD. The 'thumbed' decoration on this powerful jar also served to prevent the glaze from running down and sticking the vessel to its support in the kiln. That the glaze may have contained considerable wood ash is suggested by its bluish opalescence where it has thickened on the ridges. The overall colour of the glaze is a watery blue-green and there are three spur-marks on the rim. H. 10 in., 25.5 cm. British Museum, OA 1924.12–15.43.

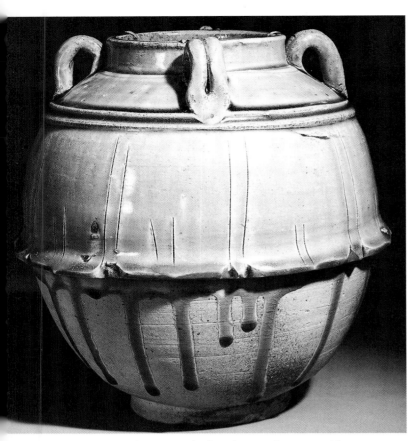

Large oviform jar with olive glaze, northern type, 6th century AD. Once again the horizontal ridges serve to trap the flowing glaze. The cursory decoration represents simplified lotus petals. Clay dots on the rim suggest that another vessel, or perhaps a cover, had been fired on top. H. 10 in., 25.5 cm. Christie's.

In complete contrast to these plain and satisfying northern jar forms, are some truly massive 6th-century covered vases nearly two foot in height, and almost totally encrusted with richly-detailed sprigged ornament. The elements used in these designs derived ultimately from Central Asia and Sasanian Persia, and most of these vessels are entirely covered in dark olive-green stoneware glazes. Because of the novel style of these wares, ceramic historians have described them variously as 'somewhat grotesque' and oddly 'non-Chinese' in spirit. Their applied designs certainly owed much to West Asian ornament, but the ability to pile detail upon detail, while still retaining a freshness of impact, was an established Chinese talent – already well-practised in the decoration of the more spectacular styles of northern bronze.

Northern potters at this time also made their own versions of the chicken-spouted ewers that had long been popular in the south. In the northern versions the ewer design is 'stretched' vertically, and the non-functional chicken-spouts look more like cockerels, often with elaborate and realistic modelling. The hollow tapering handles, typical of the southern ewers, were more usually transformed in the north into dragons with vertically divided bodies, and with their jaws clamped to the rims of the vessels. A few examples of these northern ewers are decorated with the fashionable carved brackets and applied sprigs seen on the 'encrusted' vases. When these dragon handles, applied sprigs, and carved brackets, are all used together the result is a startling combination of form and ornament, seen at its most developed in wares from the Zibo kilns in Shandong province.

### Early northern clays and glazes

Some early northern stonewares used dark olive-green glazes and greyish bodies, but the more typical 6th-century northern material was a pale cream body with a finely-crazed, watery-green, or transparent yellowish, glaze. Analysis shows that these were high-alumina clays and that the glazes were rich in calcia. Judging from their published compositions, and also from their good degree of melt, a firing temperature in excess of about 1220°C seems likely, with both oxidising and reducing atmospheres being used. The wares were fired with wood, without saggars, in early versions of *mantou* kilns – the development of which was essential in achieving sufficient heat to mature the refractory northern clays.

Similar clays and forms to those used for northern stoneware were also employed for some unusual north Chinese lead-glazed wares, which enjoyed a revival in the Northern Qi dynasty (AD550-557). A few of these rare 6th-century lead-glazed wares are decorated with vertical stripes in a hazy copper-green, on a straw-yellow background. Rarer still are a few straw-coloured stonewares with similar copper-green details. These yellow and green glazed stonewares of the 6th century seem to mark the first use of copper colourants on Chinese high-fired ceramics.

### Northern celadon

After these lively beginnings northern 'proto-celadons' seem neither abundant nor particularly distinguished in the Tang Dynasty (AD618-906) – Tang potters in north China

Table 40 Glaze and clay compositions of early 6th century AD northern stoneware

|  | SiO$_2$ | Al$_2$O$_3$ | TiO$_2$ | Fe$_2$O$_3$ | CaO | MgO | K$_2$O | Na$_2$O | MnO | P$_2$O$_5$ |
|---|---|---|---|---|---|---|---|---|---|---|
| Body | 67.3 | 27.0 | 1.1 | 0.6 | 0.5 | 1.8 | 0.2 | –.– | –.– | –.– |
| Glaze | 57.2 | 16.3 | 0.7 | 1.6 | 18.0 | 3.3 | 2.5 | 0.5 | 0.06 | –.– |

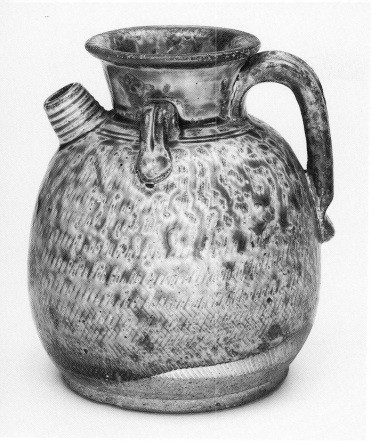

Stoneware ewer with a short spout, a yellowish high-lime glaze, and chattered or rouletted decoration through a white slip, early Tang Dynasty, 7th century AD. The tendency for some high-lime glazes to create a 'patterned' texture during firing has been encouraged by the surface treatment of this ewer. Similar wares were made at kilns in northern Henan and southern Hebei, but use of these amber oxidised lime glazes was gradually abandoned as northern potters gained more experience with reduction-firings in the 10th and 11th centuries. H. 5.75 in., 14.7 cm. Victoria and Albert Museum, C.413.1928.

seem to have been more concerned with developing whitewares, blackwares, porcelains, and lead-glazed *sancai* wares – most of which were fired in oxidation. However, in the late 9th and early 10th-century AD, southern Yue wares were supplying expanding markets in north China. The qualities of Yue wares had already been celebrated by Tang poets, and approved by northern emperors, and their continuing excellence and popularity must at last have spurred north Chinese potters into establishing their own celadon industries. Most of this development occurred in the 10th century AD, at kilns some 80 miles (129 km) to the northwest of Changan (now Xi'an) in the Tongchuan area of Shaanxi province. This district was once known as Yaozhou and these new Shaanxi celadons became known as 'Yaozhou wares' in China.

## Yaozhou wares

The Yaozhou greenware kilns were part of a huge kiln complex at Tongchuan ('Bronze Valley'), a site with a

ceramic tradition reaching back to Neolithic times. The Tongchuan area had been an important production area for Tang blackwares, whitewares and *sancai* earthenwares, mainly supplying the Changan market. Changan was the capital of China in the early and middle Tang, when the population of the city exceeded one million. In the 10th and 11th centuries AD Changan still provided a large, wealthy and discriminating market for locally-made celadon wares – which now included bowls, plates, covered boxes, lamps, incense burners, ewers, vases and stem-cups.

The early 10th century seems to represent Yaozhou's most experimental phase and on show in the Yaozhou Museum in China are some remarkable celadon wares that date from this time, mostly excavated from the Huangbao kiln complex that stretched for some three miles (5 km) along the banks of the River Qishui. These 10th-century wares tend to have pale blue-grey glazes, which are applied variously over patterns painted in white slip, over patterns carved through the white slip, and over carving into the pale stoneware body itself. In some examples the carving can be exceptionally deep and extremely detailed, often operating on more than one plane. Undecorated bluish-glazed Yaozhou wares were also made at this time and at least one piece (a shallow lobed dish of mallow-flower form) could be mistaken at first glance for Henan Ru ware.

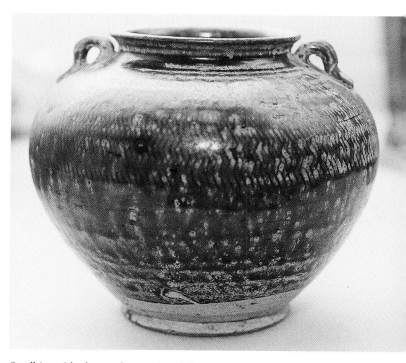

Small jar with chattered or rouletted decoration, and a mottled olive-green lime glaze, Tang Dynasty, north China. This jar uses the same decoration technique as the ewer, but it is fired in reduction. H. 5.1 in., 13 cm. Victoria and Albert Museum, FE.4–1973.

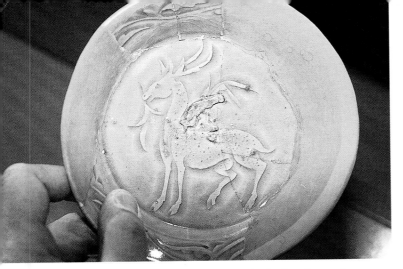

Small plate with carved decoration of a feeding deer and a blue-grey celadon glaze, Huangbao kilns, Yaozhou, 10th century. Recent excavations at the Huangbao kiln site have uncovered an important group of 10th-century Yaozhou wares with bluish glazes. These are similar in colour to Korean celadons, but earlier in their manufacture. These bluish glazes were replaced by the more familiar olive-green Yaozhou celadons in the later 10th century. Yaozhou Kiln Museum, China.

Fragment of a high-quality bluish celadon cup stand, Huangbao kilns, Yaozhou, early 10th century. Similar cup stands were made at the Yue kilns during this period, and the form also appears in China in precious metals and in lacquer. The discovery of Five Dynasties Yaozhou wares of this outstanding quality has raised questions about their possible relationship to Chai ware – a so far unidentified imperial ware of the late Five Dynasties period. Yaozhou Kiln Museum, China.

The bluish glazes used on the Five Dynasties Yaozhou wares are reminiscent of those used on Korean celadon wares of the 11th-12th centuries, and the Yaozhou potters seem to have anticipated a number of Korean celadon techniques.

It has been proposed by some scholars in China that some of these unusually bluish Yaozhou celadons are examples of the semi-legendary Chai ware. Like Ge ware, Chai ware has still to be properly identified, but it is believed to have been a true imperial stoneware that dated from the reign of Chai Shizong (AD954-59) – the last emperor of the Five Dynasties period.

No analyses have yet been published for these interesting bluish-glazed Yaozhou wares, which do not appear to have survived into the mature period for Yaozhou production – the 11th and 12th centuries AD. The change of glaze colour to the more familiar greens and olive-greens, typical of later Yaozhou celadon, seems to have occurred when the potters changed from wood-firing to coal. Even so, it is doubtful whether this change of fuel could have affected the glaze colours so profoundly, and it seems more likely that this colour change represents a move from low-titania to higher-titania glaze compositions.

## Yaozhou green celadons

From the later 10th century onwards Yaozhou potters used more obviously green glazes, coloured with about 1.5-3% iron oxides and about 0.3% titania. Although they probably contained more titania than the Five Dynasties Yaozhou wares, they contained *less* titania than the southern Yue glazes with average about 0.7% $TiO_2$. This difference makes the Yaozhou wares purer and less grey-green in colour. Yaozhou celadons were also lime-alkali glazes, compared with the more primitive lime glazes used by the Yue ware potters.

Yaozhou glazes were relatively thinly applied (compared with the later Longquan celadons), frequently seeded with minute bubbles and sometimes crazed. They were used over finely prepared stoneware clays that often burned to warm brown tones where the body was exposed, or where the

*Opposite:* Yaozhou celadon glazed ewer (handle missing), c. 11th century AD. The deep and dramatic carving seen on this ewer is typical of an early style of northern celadon ware, once known as *dong* ware. Some late Yue wares show similar deep carving but it is not entirely clear whether the style went from south to north or from north to south. H. 8.5 in., 21.3 cm. Carter Fine Art.

Table 41 Yaozhou *nichi* clay

|  | SiO$_2$ | Al$_2$O$_3$ | TiO$_2$ | Fe$_2$O$_3$ | CaO | K$_2$O | Na$_2$O | MnO |
|---|---|---|---|---|---|---|---|---|
| *nichi* clay (fired) | 67.7 | 26.8 | 0.9 | 1.2 | 0.3 | 2.3 | 0.1 | 0.01 |
| Yaozhou body | 70.2 | 24.6 | 1.3 | 1.4 | 0.2 | 2.4 | 0.6 | 0.04 |
| Yaozhou body | 72.2 | 20.3 | 1.2 | 1.7 | 0.4 | 2.6 | 0.8 | 0.1 |
| Yaozhou body | 64.5 | 30.0 | 1.4 | 1.75 | 0.5 | 2.25 | 0.7 | 0.06 |

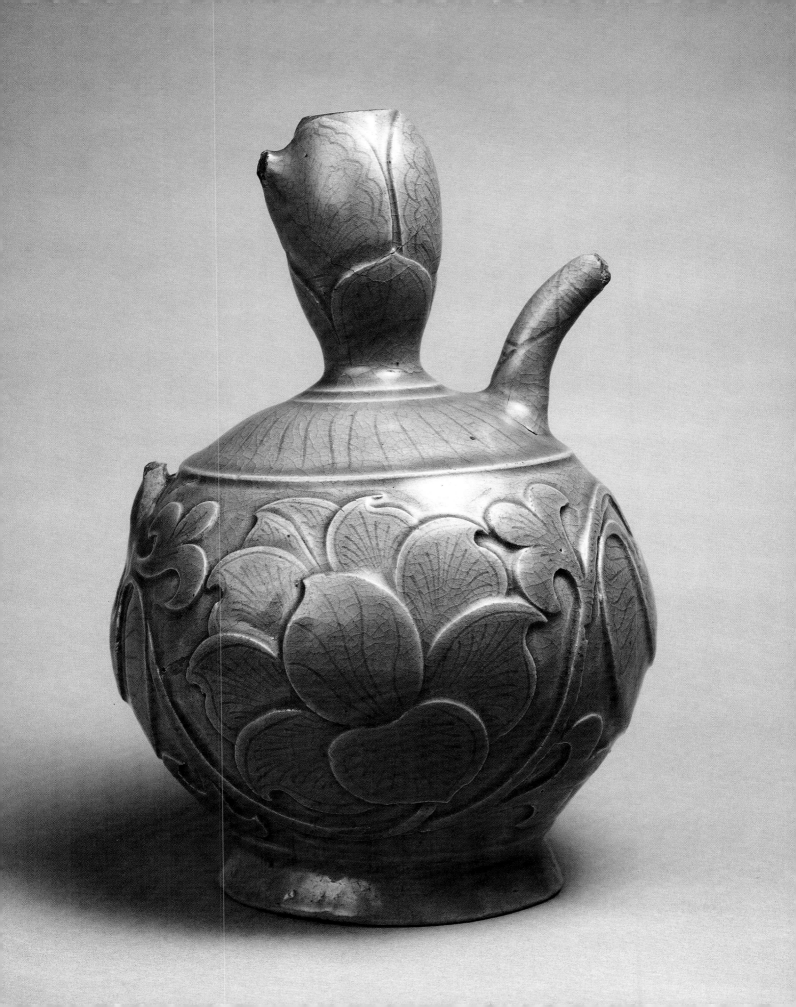

glaze was thin. The appearance of some Yaozhou clays are reminiscent of those used for the later 10th-11th century style of Yue wares made near Longquan. This seems to be because the Yaozhou body materials were often higher in silica and potassia than most stoneware clays in northern China – apparently through the use of a local raw material called *nichi* clay. As a result, the compositions of some Yaozhou clays can fall between the 'classic' southern and northern stoneware types (see Table 41).

### Yaozhou celadon glazes

The transparent celadon glazes used on Yaozhou wares were extremely sensitive to thickness – pooling darkly in the crisply carved or moulded designs, but thinning to a much lighter tones on the carved highlights. A white layer of anorthite crystals tended to develop between glaze and clay at high temperatures and this helped lighten the glazes where they were thin. The shapes of the best Yaozhou celadons are finely conceived and have something of the feeling of metalwork or lacquer. Their forms are more expressive than those used for later southern celadons and their scale is generally smaller – the huge dishes and vases, made in the 14th century for export to the Middle East at the Longquan kilns, seem to have no parallels in Yaozhou production.

The vast majority of Yaozhou celadon wares are fresh green, olive green, or sometimes amber in colour where they have been accidentally oxidised. Oxidised Yaozhou

wares were celebrated in own their time for their similarity to gold – a rather different response to the low regard in which oxidised *yingqing* wares were held.

### Yaozhou kilns

Yaozhou wares were mainly coal-fired in brick-built *mantou* kilns. The kiln chambers were medium sized (2–3 metres internal diameter), of cross-draught design, and with horseshoe-shaped groundplans. They used two chimneys per kiln, built side by side. The wares were set in individual saggars, which were often perforated with a number of small holes – perhaps because the local saggar clays were too vitreous to allow reducing gases to pass through easily. The columns of saggars were raised from the kiln floor on short pillars. The saggars themselves were unusually well made, and all the craftsmanship at this kiln complex seems of a high order. Typical firing temperatures at Huangbao were about 1300°C, and the prevailing kiln atmospheres were reducing.

### Nature of northern celadon glazes

As mentioned above, the glazes used for northern celadon wares were of the lime-alkali rather than the lime-glaze type. Higher firing temperatures and thinner glaze application prevented the jade-like qualities usually associated with lime-alkali compositions – giving instead a fine olive-green transparency, ideal for displaying fine carving and sharply-turned forms to their best advantage. Unlike lime

A demonstration of throwing on a typical north Chinese wheel, Shaanxi province, 1995. Wheels of this style were set turning with a long pole that engaged with small hollows on the flywheel's surface. Throwing continued until the wheel's momentum slowed, when it was given a further spin (this wheel ran anti-clockwise). The ware-boards and water-pot are standing on typical corrugated north Chinese saggars, used in this area since the Jin dynasty. Yaozhou Ware Reproduction Factory, Tongchuan.

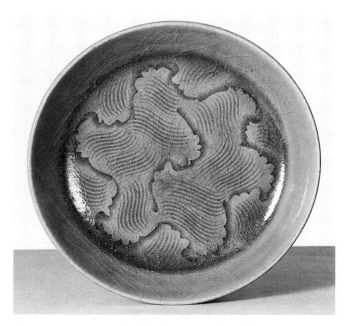

Small carved and combed Yaozhou plate, 11th–12th century AD. The sensitivity of northern celadon glazes to differences in thickness is very evident in this lively example. D. 3.9 in., 10 cm. Victoria and Albert Museum, C.1388–1924.

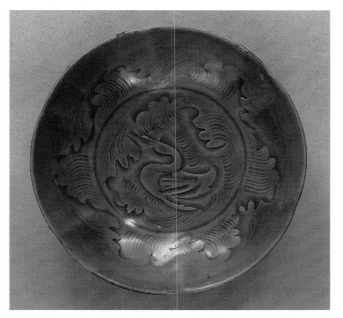

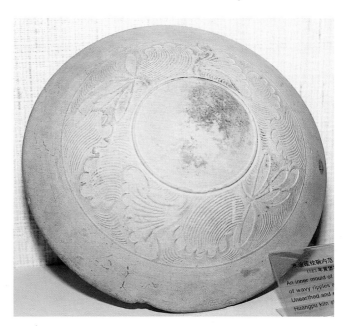

Six-foliate northern celadon bowl with a combed and carved pattern of a duck amongst waves, Yaozhou kilns, 12th–13th century. This was a popular Yaozhou pattern, and the lively carving, the fresh glaze colour, and the surface like much-polished silver, are all typical of the best Yaozhou wares of the Jin dynasty. D. 16.5 cm. Ashmolean Museum, Oxford, X1265.

Stoneware mould for reproducing 'carved' decoration, Yaozhou kilns, Jin dynasty. Moulds such as these would have been pressed from hollow originals that were essentially thick, unglazed stoneware bowls, bearing original carved decoration. Yaozhou Kiln Museum, China.

glazes, lime-alkali glazes can remain quite stable at full heat, so there is little sign of glaze movement in Yaozhou wares, other than a general melting of the glazes into the carved designs.

Analysis also shows that these northern celadon glazes contained about twice as much iron and titanium oxides as the slightly later Longquan celadons of southern China (see table), but less titania than Yue wares. This higher concentration of colouring oxide accounts for their fine olive-green and fresh-green tones. Any tendency to excessive glassiness from the high temperatures used to fire the wares was offset by slow cooling, which resulted in a subtle waxy or silken sheen developing in the transparent glazes, due to microcrystallization of lime-rich minerals before the glazes froze. In some fine Yaozhou wares this produced a surface quality reminiscent of much-polished silver.

**Moulding**

The fully developed Yaozhou carving technique, with dense curly patterns covering most of the form, was a visually effective but very labour-intensive process. With the fall of the Northern Song Dynasty, and the loss of Yaozhou's more discriminating markets, freehand carving was soon replaced by the more economical method of beating leather-hard pre-thrown bowl and plate forms onto sharply-engraved convex stoneware moulds, and then turning the backs of the wares to a regular thinness –

a technique borrowed from the Ding ware potters of Hebei. This made possible the mass production of highly detailed 'carved' patterns, although at the expense of the directness possible with freehand engraving.

Excavation at Yaozhou shows that these stoneware working moulds were themselves pressed from hollow stoneware master moulds – a system that allowed Yaozhou potters to carve their original patterns direct into thick clay 'bowls', with their designs the correct way around. These master moulds were then fired, and a set of working moulds pressed from them. No doubt the definition of the working moulds was improved and retouched before they too were fired to low stoneware temperatures.

### Linru celadons

Another important centre for celadon-making in north China operated at a kiln complex some 200 miles to the east of Yaozhou in Linru county in Henan province, near to the late Tang capital of Luoyang. Linru was a major manufacturing district for northern stonewares, and included blackwares, whitewares and Jun wares amongst its products.

The Linru kilns are believed to have started making celadon wares under the influence of Yaozhou and the kilns were most active after the Tartar invasion of the early 12th century, by which time the re-pressing of thrown wares had become the standard method for decorating northern celadons. In general, Linru glazes are greener, less

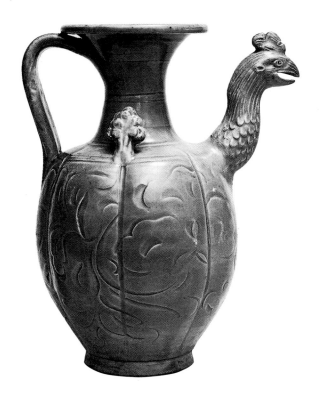

Ewer with a chicken head spout, Yaozhou ware 11th–12th century. Like many Chinese ceramic versions of metal ware, this Yaozhou ewer copies the braces on the neck that were designed to keep the thin metal forms from distorting. The form would have appeared slightly less bizarre when placed in its companion hot-water bowl. H. 8.8 in., 22.3 cm. British Museum, OA 1936.10–12–69.

transparent and less olive than those on Yaozhou wares, and are sometimes known by the name 'mugwort green' in China. Nonetheless, some examples of Linru celadon can be indistinguishable from contemporary Yaozhou wares of premier quality.

## Yue, Yaozhou, Linru and Longquan glazes compared

In order to place these fine northern celadon glazes into context it is useful to compare them with both Yue and Longquan celadon glazes, as they have affinities with both southern types.

In terms of iron oxide levels, northern celadons are closer to Yue glazes than to Longquan celadons but if iron is discounted, Longquan, Yaozhou and Linru glazes are remarkably similar in their overall compositions. Varying titania levels, combined with these iron oxide levels, account for the grey-green colours of Yue, the fresh greens of Yaozhou and Linru, and the jade-like blue-greens of the finest Longquan glazes.

Some subtle differences between Yaozhou and Linru celadons are also apparent in these analyses. The Yaozhou glazes are lower in alkalis (particularly sodium oxide) than those from Linru but also slightly richer in magnesia. The practical effects of these differences would have been to make the Yaozhou glazes appear slightly 'thinner' and more 'glue-like' in quality than the Linru glazes, but less prone to

Table 42 – Yue, Yaozhou, Linru and Longquan glazes compared

| | $SiO_2$ | $Al_2O_3$ | $TiO_2$ | $Fe_2O_3$ | CaO | MgO | $K_2O$ | $Na_2O$ | MnO | $P_2O_5$ |
|---|---|---|---|---|---|---|---|---|---|---|
| Yue | 58.9 | 12.7 | 0.7 | 2.4 | 19.5 | 1.9 | 0.8 | –.– | –.– | –.– |
| Yue | 63.7 | 11.7 | 0.6 | 2.2 | 15.1 | 2.7 | 1.6 | 0.8 | –.– | 1.0 |
| Yue | 57.4 | 12.5 | 0.8 | 1.8 | 20.3 | 2.0 | 1.3 | 0.9 | –.– | 1.5 |
| Yaozhou | 71.6 | 14.4 | 0.4 | 3.8 | 5.6 | 1.5 | 3.0 | 0.5 | –.– | 0.5 |
| Yaozhou | 65.6 | 14.3 | 0.3 | 1.5 | 12.6 | 2.2 | 1.9 | 0.4 | –.– | 0.7 |
| Yaozhou | 67.0 | 15.3 | 0.35 | 2.9 | 9.6 | 1.4 | 2.6 | 0.4 | –.– | 0.8 |
| Yaozhou | 70.0 | 13.6 | 0.11 | 2.0 | 9.5 | 1.3 | 2.7 | 0.3 | –.– | 0.6 |
| Yaozhou | 67.9 | 14.4 | 0.17 | 2.2 | 9.4 | 2.1 | 2.8 | 0.7– | –.– | –.– |
| Yaozhou | 61.4 | 16.3 | 0.41 | 1.9 | 16.0 | 1.5 | 1.7 | 0.2 | 0.07 | 0.8 |
| Linru | 67.0 | 14.7 | 0.3 | 1.6 | 9.2 | 0.8 | 3.6 | 1.7 | –.– | 0.4 |
| Linru | 66.7 | 15.3 | 0.3 | 2.5 | 8.6 | 0.7 | 3.6 | 1.5 | –.– | 0.4 |
| Linru | 67.5 | 15.3 | 0.3 | 2.5 | 7.6 | 1.1 | 3.7 | 1.4 | –.– | 0.6 |
| Linru | 67.6 | 14.5 | 0.2 | 0.4 | 8.5 | 0.7 | 4.2 | 1.6 | –.– | 0.4 |
| Linru | 68.1 | 14.5 | 0.2 | 1.5 | 7.7 | 0.6 | 4.3 | 1.6 | –.– | 0.4 |
| Longquan | 66.1 | 14.4 | 0.1 | 0.2 | 8.4 | 0.6 | 4.9 | 0.3 | –.– | –.– |
| Longquan | 66.3 | 14.4 | 0.1 | 0.5 | 10.0 | 1.2 | 4.5 | 0.4 | 0.5 | 0.75 |
| Longquan | 66.7 | 13.7 | 0.1 | 0.3 | 9.9 | 1.1 | 5.3 | 0.7 | –.– | 0.45 |
| Longquan | 71.0 | 15.5 | 0.2 | 1.0 | 4.8 | 0.6 | 5.4 | 0.5 | 0.15 | 0.8 |
| Longquan | 66.1 | 14.4 | 0.1 | 1.0 | 13.2 | 0.8 | 4.6 | 0.3 | 0.16 | –.– |

(The firing temperatures for the Yue glazes were probably 1200-1230°C; the Yaozhou and Linru glazes matured between about 1280°-1300°C; and the Longquan glazes were fired from about 1230° to 1260°C.)

Yaozhou bowl with its outside carved into overlapping lotus petals, 12th century. Like the Longquan jar on page 78, the Yaozhou potter first facetted the surface intended for decoration, and then added the design-details with a few deft strokes of an angled carving tool. The fine-grained Yaozhou clay, and the more transparent glaze, gave sharper results than those typical of contemporary Longquan celadon bowls, which were often given similar decorative treatments. British Museum.

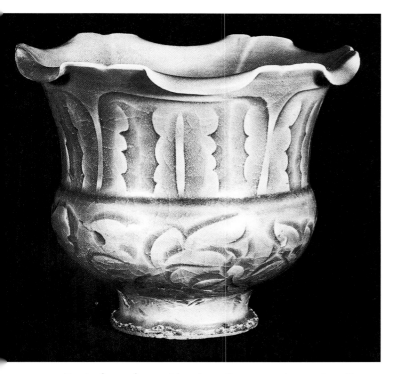

*Zun* in flower form, with a deep olive-green glaze, perhaps from the Yaozhou kilns, Shaanxi province, 11th century. The *zun* form can be traced to early Shang Dynasty glazed stoneware (see the figure on page 17) and variations on its proportions have occupied Chinese potters for millenia. H. 4.25 in., 11 cm; D. 5 in., 12.5 cm. Buffalo Museum of Science.

crazing by reason of their lower alkali and higher magnesia contents – an effect reinforced by the more siliceous Yaozhou clays.

The above analyses, from Yaozhou, Linru and Longquan, represent the highest quality Chinese celadon glazes made from the 11th to 13th centuries AD. Despite the wide geographical spread of the kilns concerned, these glazes are remarkably similar in composition. However, these same analyses can also be used to demonstrate that the original *recipes* used to make northern celadons must have been totally different from those that had evolved for celadon-making in southern China.

## Original compositions of southern and northern celadons

In the case of Longquan celadons it is now generally believed and accepted that their major glaze ingredient was the quartz-mica rock known as 'glaze stone' – and this was probably a very similar material to the pulverised volcanic rock used to make the Longquan celadon bodies themselves. About 12% of crushed and burned limestone, with a lesser amount of wood ash, was added to the glaze-stone to produce the smooth, jade-like lime-alkali glazes that typify Longquan production. This approach seems to have developed naturally from the earlier 'body-clay plus wood-ash' recipes used for the Yue-type stonewares, and already made for centuries in the same districts of Zhejiang.

However, this 'body-clay plus flux' principle cannot be applied successfully to analyses of northern celadon glazes. Yaozhou and Linru bodies both contain about 1.2% $TiO_2$, while their glazes average 0.3% $TiO_2$. As it is practically impossible to remove titania from a stoneware clay, the maximum amount of body clay that could have been used in a typical northern celadon glaze would have been only about 25%.

So, with body clay only possible as a minor glaze ingredient in northern celadons, what were the main raw materials used to make these glazes? Although we still do not know the full answer to this question, it has been suggested for Yaozhou wares that their main glaze ingredient may have been a local fusible rock known as *fuping* stone. This was a sandy calcareous material that was a natural mixture of kaolin, calcite, quartz and feldspar – all useful minerals in stoneware glazes. If *fuping* stone were the basis of Yaozhou celadons, then this would have meant a major

Table 43 Analysis of *fuping* stone

|  | SiO$_2$ | Al$_2$O$_3$ | TiO$_2$ | Fe$_2$O$_3$ | CaO | MgO | K$_2$O | Na$_2$O | MnO | P$_2$O$_5$ |
|---|---|---|---|---|---|---|---|---|---|---|
| *fuping* stone | 65.3 | 12.12 | 0.2 | 1.2 | 6.6 | 3.3 | 2.5 | 1.4 | –.– | –.– |

Table 44 Analyses of Henan raw materials

| | SiO$_2$ | Al$_2$O$_3$ | TiO$_2$ | Fe$_2$O$_3$ | CaO | MgO | K$_2$O | Na$_2$O | MnO | P$_2$O$_5$ | loss |
|---|---|---|---|---|---|---|---|---|---|---|---|
| Shenhou clay | 45.8 | 38.9 | 0.5 | 0.2 | 0.2 | 0.06 | 0.1 | 0.04 | 0.01 | –.– | 14.3 |
| Lilou clay | 61.2 | 20.9 | 1.1 | 5.7 | 0.7 | 0.4 | 1.6 | 0.3 | –.– | –.– | 8.3 |
| Shenhou purple clay | 69.0 | 14.6 | 0.8 | 4.7 | 1.3 | 0.8 | 2.3 | 0.1 | 0.8 | –.– | 6.4 |
| Shenhou feldspar | 63.7 | 18.7 | tr. | 0.1 | 1.0 | 0.06 | 11.8 | 2.5 | 0.004 | –.– | 0.5 |
| Linru 'yellow feldspar' | 79.0 | 11.4 | 0.3 | 0.4 | 0.3 | 0.02 | 9.7 | 0.06 | 0.01 | –.– | 0.6 |
| Wood ash | 20.8 | 4.1 | 0.3 | 1.35 | 34.1 | 3.0 | 3.9 | 0.3 | 0.2 | 1.9 | 30.0 |
| Lintou dolomite | 11.3 | 1.6 | –.– | 1.9 | 29.6 | 14.0 | 0.2 | 0.1 | 0.05 | 0.01 | 38.8 |
| Lintou calcite | –.– | –.– | –.– | 0.01 | 55.1 | 0.6 | 0.004 | 0.02 | –.– | –.– | 44.0 |

Jun ware bowl, north China, 12th century. This bowl is a classic example of the monochrome spirit in north Chinese Song stoneware. H. 6.2 in., 16 cm. Sotheby's.

break with the body-material+flux principle that had operated for more than two millennia for Chinese green-ware glazes.

As is usual with Chinese glazes the extra calcia percentages needed for the glazes could have been supplied by limestone, by wood ash, or by some mixture of the two.

Linru celadon glazes, however, are noticeably richer in soda than the glazes used at Yaozhou – which raises the possibility that a loessic clay may have been used in their recipes. Loess makes up much of the landscape where the Linru kilns are sited and the material is a fusible igneous rock that has been reduced to dust by freezing and thawing, and by the abrasive winds of the Inner Mongolian deserts.

Chinese loess is rich in silica, calcia, magnesia, potassia, soda and iron. It makes a brownish or black glaze when fired to stoneware temperatures, and has probably been used for this purpose at some blackware kilns in north China since at the least the mid-6th century AD. The titania content of loess averages about 0.7% and its iron oxide content is about 5%. Linru celadons could therefore have accommodated about 33% loess in their recipes – with all the benefits associated with an abundant, pre-ground and slightly plastic glaze material. The remaining ingredients could have been a mixture of a quartz-feldspar rock, wood ash and clay.

However, this is only speculation. It may be that loess was not used in the Linru glazes, and that their original recipes were not too different from those employed to make these kinds of glazes today – namely, quartz-feldspar rocks, pure quartz, limestone, clay and wood ash. Modern reproductions of northern stoneware glazes, made recently in northern China, certainly use these raw materials which, in most cases, have been mined or collected near to the Song and Jin Dynasty kiln sites themselves.

To be absolutely sure which glaze raw materials were used by northern celadon potters, detailed mineralogical analysis of unfired celadon glazes, excavated from the original kiln sites, are necessary. Finds of this type have been made in both north and south China, including the huge Tongchuan kiln complex near Xi'an, and at the Guan ware kiln site at Jiaotanxia. Publication of analyses of these raw glaze materials is awaited with interest.

## Jun wares

Broadly contemporary with northern celadons, but with heavier bodies and unusually thick bluish glazes, are the Jun wares of north China. Their main producing kilns were in the Yu and Linru counties of Henan province – although a few Jun ware kilns were also sited in southern Hebei, and a Jun kiln site has been found recently north of the Great Wall in Inner Mongolia. Whether the Yaozhou kilns ever made Jun wares seems doubtful: a Jun shard has been found at the site, but this seems to be a stray intrusion. Yaozhou is certainly not known historically for its Jun ware production.

Jun wares were fired in both coal- and wood-burning kilns, and were set in coarse fireclay saggars, usually with one piece per saggar. The markets for Jun wares were similar to Henan celadons – that is, they were everyday northern wares for the wealthier clases, with a few refined or elaborate examples made for tribute, for temple or palace use, or to special commission. Production began in the late 10th century and may have continued into the early 15th century.

Jun ware bowl stuck in its saggar, Yuan dynasty. Heavy saggars and thick-walled kilns encouraged slow firings for Jun wares, which in turn influenced the qualities of their glazes. Reducing gases pass easily through rather refractory saggars such as these, but with more vitreous saggars, made from finer clays, perforations were sometimes necessary for good reduced effects. Ashmolean Museum, Oxford, X1564.

## Jun ware glazes

The great fascination of Jun ware lies in its glaze, and Jun glazes have long been among the most admired and the least understood of Chinese high-fired effects. The cloudy colours of Jun glazes vary from green-blue, to blue-white, to sky blue, and sometimes almost to lavender. Their curdled and opalescent depths have a mysterious quality that varies with ambient light. These thick Jun glazes are often pitted and pinholed, and sometimes show odd wandering lines within their depths, known as 'earthworm tracks' to Chinese connoisseurs.

Simple brushed patterns with copper-rich pigments were often applied to these bluish Jun glazes. The copper brushwork gave a range of hazy colours against the bluish background glazes, varying from pinkish-red, through purple to green, and occasionally almost to black, depending on the thickness of the pigments used, and on the atmospheres present in the kilns. This combination of diffused copper-red painting and the thick Jun-blue glazes makes Henan Jun wares among the most colourful and dramatic of all northern stonewares.

## The Jun blue effect

During the last 60 years the extraordinary visual qualities of Jun glazes have attracted the attention of leading ceramic scientists and potters from both the East and West. Over this period the blue tones of Jun glazes have been attributed variously to iron phosphate, to colloidal silica, to lime phosphate or suspended carbon, and to mutually insoluble glasses.

It is this last theory – that minute spherules of glass within the Jun glazes were scattering blue light – that has proved correct. In the late 1970s the micro-structure of a Song Jun glaze was photographed using a scanning electron microscope by Dr Robert Tichane in New York State, and published in *Those Celadon Blues* (1978). At high magnification (x 20000), well beyond the resolution of optical microscopy, Jun glazes look rather like caviar or frogspawn, with the light-scattering droplets of glass being plainly visible in the glaze. Technically this effect is known as 'liquid-liquid phase separation' – a 'phase' being simply a state of matter, be it solid, liquid, gas or plasma. The glass droplets in Jun glazes average 0.08 μm and are therefore considerably finer than the wavelength of blue light

Three Henan Jun ware saucer dishes, Jin dynasty. The glass emulsion effects that provide colour in Jun glazes are very sensitive to firing temperatures. These three Jun ware saucer dishes have essentially the same glaze compositions, but they have been fired from about 1250°C to 1300°C. True Jun blue effects develop at the higher end of this range, 'moon-white' glazes at slightly lower temperatures, while badly underfired Jun glazes often show yellowish tones. D. 7 in., 18 cm. Ashmolean Museum, Oxford 1956.1343.

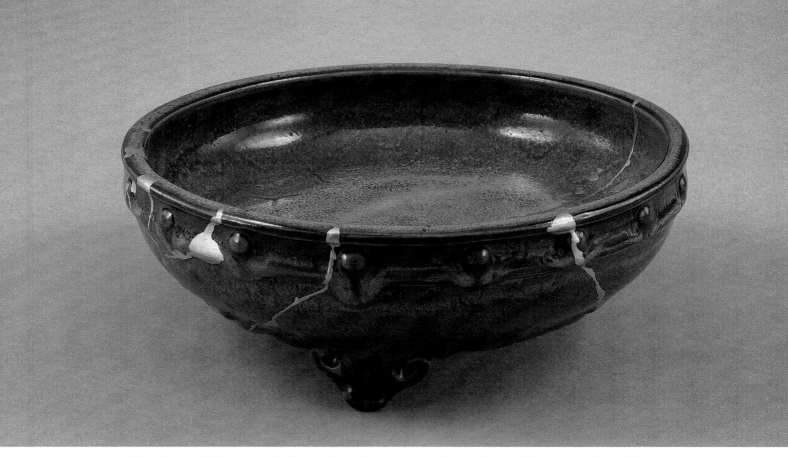

Jun ware bulb bowl with gold lacquer repairs, Yuxian kilns, Henan province, Northern Song or Yuan dynasty. Top-quality moulded bowls with 'nail-head', or 'drum-bossed' decoration have been excavated from the Yuxian kilns. They were reportedly used as narcissi bowls in side halls of the Forbidden City in Beijing. A wash of copper pigment over the outside glaze has caused a copper-red effect to combine with the Jun blue to give a complex purple hue. H. 3 in., 7.5 cm; W. 7.9 in., 20 cm. Ashmolean Museum, X1549.

(0.4-0.5 μm), but through an interference effect known as Rayleigh Scattering they supply a strong bluish cast to the Jun ware glazes.

The blue colours of Jun glazes are therefore optical rather than true pigment effects – rather like the blue of the sky. Similarly, the 'moon white' qualities of slightly underfired Jun glazes are analogous to emulsions like milk, where minute droplets of fat, suspended in water, also scatter white light. In these underfired glazes the separated droplets are larger but, as firing temperatures increase, the droplets that develop in cooling are smaller, changing the glaze colour from white to blue then, with more heat, to blue with a hint of purple. This 'emulsion' phenomenon sets Jun glazes apart from the general run of Chinese glazes, both high-fired and low-fired. With these more ordinary glazes their colours are derived simply from oxide pigments that are in suspension or solution within the thickness of the glaze coating. It is possible to confirm the absence of genuine blue colouring particles, or dissolved blue-colour-ing ions, in Jun glazes by holding a sliver of Jun glaze up the light: the glaze then appears straw-coloured and its blue tone disappears entirely.

## Research on Jun glazes

Until the early 1980s, exactly what was triggering this unmixing of glasses within Jun glazes at high temperatures was still a matter for conjecture, but phosphorous oxides were the prime suspects. Oxides of phosphorus were known to give milky opalescence in glasses, and also to encourage the unmixing of molten rock into immiscible glasses under certain conditions. The circumstantial evidence for a vital role for phosphorous oxides was therefore strong, and it gradually became accepted in both East and West that small amounts of phosphorous oxides were the prime cause of the 'liquid-liquid phase separation' effects in Jun glazes.

However, almost as soon as this idea became established doubts were raised about its validity. For example Dr Nils Sundius (former State Geologist for Sweden) pointed out that the amounts of phosphorous oxides in Jun glazes (about 0.3-0.9%) were far lower than those needed to produce opalescence in glasses (2-3%). In addition to this, an increasing amount of analytical data on Chinese glazes was showing that the phosphorus contents of Henan Juns were by no means exceptional – many Chinese stoneware glazes contained as much (if not more) $P_2O_5$ without

showing any signs of opalescence. With the phosphorus levels in Jun glazes now appearing unremarkable, it was difficult for glaze chemists to see what could be causing the 'Jun effect'.

In addition to these doubts about phosphorus, new and more accurate glaze analyses were showing that Jun glazes and southern celadons were less similar in composition than earlier analyses had seemed to suggest: Jun glazes typically contained about 69–73% silica and just under 10% alumina, while southern celadons of the finest Longquan type contained about 68% silica and 14.5% alumina, with the rest of the glaze oxides being roughly comparable. Could it be that these small but consistent silica and alumina differences were in some way responsible for the unusual bluish cast to these glazes?

The final blow to the 'phosphorus theory' of Jun glazes, and the real solution to the problem, came in a paper presented to the first International Conference on Ancient Chinese Pottery and Porcelain, held in Shanghai in 1982. The paper was written jointly by Professor David Kingery and Dr Pamela Vandiver, then both of the Massachusetts Institute of Technology, USA. This paper solved a number of problems simultaneously, and has since become a key work for the study of Chinese glazes in general.

Jun ware plate with copper-pigment brushwork, Jin dynasty. Copper diffuses easily into glazes during firing, giving characteristically cloudy markings. The main colours on this plate are milky-blue and purple-red, with occasional dots of green where local concentrations of the copper pigment on the glaze surface have re-oxidised. D. 7 in., 18 cm. Victoria and Albert Museum, C.845.1936.

What Kingery and Vandiver were able to show at Shanghai was that, within a range of mixtures of silica, alumina, calcia and potassia (of which Chinese glazes formed just one small part), a compositional area existed where spontaneous unmixing of glasses (liquid-liquid phase separation) occurred during cooling – without any phosphorous oxides being needed to trigger the event. Chinese Jun glazes were just inside, or on the edge of, this 'zone of opalescence' – while Chinese celadon glazes were just beyond it. The compositional differences between average celadons and average Juns were small, but still sufficient to produce totally different fired effects in the two types of glaze – with the Jun glazes showing their bluish opalescent opacity, while the celadons simply showed the typical greenish solution colours provided by iron-titania mixtures in reduction. In short, the small compositional differences between Jun glazes and celadons, particularly in their silica and alumina levels, were responsible for the 'Jun blue effect'.

As for phosphorus, Kingery and Vandiver saw its role in Jun glazes as being restricted to bubble formation, perhaps through the breakdown of the pentoxide to the trioxide at high temperatures, and unrelated to opalizing or opacifying effects: '... opacity was unaffected, but bubble formation was greatly increased when 1% bone ash [a rich source of phosphorus] was added to the formulation.'

However, it is on this last point that some debate continues, and it is interesting to compare Dr Robert Tichane on the same subject (*Those Celadon Blues*, 1978):

'...after more synthesis it was found that the Chün [Jun] is really a high silica opal that is triggered and accentuated by phosphate. A lovely opal blue can be formed by adding more and more silica to a lime-feldspar glaze, but at any stage in the process the opal can be greatly intensified by the addition of 0.5% phosphate ...'.

Tichane appears to have discovered (although not mapped) the 'zone of opalescence' in the silica-alumina-potassia-calcia system, by adding quartz to a lime-feldspar glaze. However, unlike Kingery and Vandiver, Tichane did find that opalescence was enhanced by adding small amounts of phosphate to the glaze. In China (where the Kingery and Vandiver findings have been widely accepted and applied) the idea that phosphorous oxides can extend the conditions under which 'phase separation' can occur is still adhered to. Therefore, although phosphorus is no longer believed to be the prime cause of opalescence, it is still thought by many to enhance the effect, and perhaps even to tip the balance in favour of its production, under some conditions.

**The 'Kingery–Vandiver' system**

Displaying all the possible mixtures of silica, alumina, calcia and potassia in a graphical form is not an easy task. Ideally one needs to construct a transparent tetrahedron (a triangular-based pyramid) with the four oxides studied at the four points of the pyramid. Each edge of the pyramid then represents a mixture of two oxides, each face of the pyramid a mixture of three oxides – and the space inside the pyramid a mixture of all four oxides. Near to one side of this pyramid Kingery and Vandiver described an egg-shaped area that showed spontaneous liquid–liquid phase separation.

For their presentation in Shanghai Kingery and Vandiver illustrated a 'slice' through this pyramid on a plane that corresponded broadly to the silica contents of typical Chinese Jun and celadon glazes. This showed the Jun glazes to be just inside (or on the fringes of) the 'zone of opalescence', while Longquan celadon glazes were just beyond it.

Since this paper was presented a simpler, but still workable, image of glaze compositions that will show spontaneous liquid–liquid phase separation has been proposed by Professor Chen Xianqiu of Shanghai. This is a graph that plots $RO_2$ ($SiO_2+TiO_2$) against $R_2O_3$ ($Al_2O_3+Fe_2O_3+P_2O_3$). All the important Chinese glazes that show liquid–liquid phase separation tend to be found scattered about a line that represents $RO_2$ and $R_2O_3$ in a molecular ratio of 10.7:1 (in real weights this is $RO_2:R_2O_3$ in 6.3:1 proportions). This graph is especially useful for designing glazes from first principles that will display good optical-white and optical-blue colours at stoneware temperatures.

**Ancient Jun-type glazes**

Given the existence of these underlying principles it is probably not surprising that Chinese potters occasionally wandered into this 'zone of opalescence' with their ancient ash-glaze compositions, when the recipes they were using were unusually low in alumina and/or rich in phosphorus. True 'Jun blue' effects have occurred in greenish ash glazes at a number of kiln sites throughout China from the Bronze Age to the present day. In many cases, no opalescence appeared where the glazes were thin, because alumina from the clay body dissolved into the thin glazes and upset the 'ideal' oxide balance. However, where these rather fluid ash glazes had run and thickened, particularly on ledges or in crevices, powerful milky-blue colours could develop during cooling.

In most cases these effects were difficult to produce in the entire glaze because the high-lime recipes on which they were based ran badly if applied too thickly. If the glazes were slightly underfired to avoid running, 'moon white' effects would result, rather than the true Jun blues. Experiments in Shanghai with the 'moon-white' lime glazes of Tongguan and Qionglai have shown that they transform into Jun blues at higher temperatures, but the effect was little used in its day because of the low viscosity of over-fired lime glazes.

Nonetheless, some later southern kilns making opal-blue wares (such as those at Wuzhou and Chuzhou in Zhejiang province) produced lower-lime, and therefore more stable, glazes that showed 'Jun blue' effects. The Wuzhou potters exploited the similarity of their compositions to northern

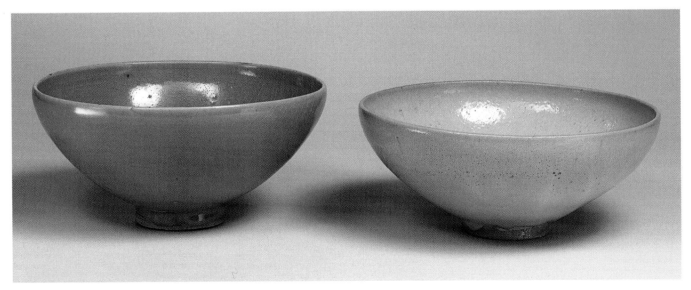

Green Jun and Blue Jun bowls, 12th–13th century. Green Jun wares share forms with the commoner blue versions, but seem to use separate and deliberately different glaze compositions. Green Jun glazes are higher in alumina, and therefore not prone to liquid–liquid phase separation with its associated blue cast. Some examples of Green Jun ware are thought to have been made at the Linru kilns in Henan province. D's. 8.5 in., 21.6 cm; 8.75 in., 22.2 cm. Sotheby's.

Jun glazes and developed their own, rather shiny, versions of the Henan originals. For their 'southern Jun' wares the Wuzhou kilns used some typical Henan forms, such as 'nail-headed' bulb bowls and three-legged incense burners, as well as making ewers and bowls in a more traditionally southern style.

**Further Jun glaze effects**

The qualities seen in true Juns glazes, however, are not solely the result of liquid phase separation effects – they can also show a pronounced milky streakiness, sometimes combined with a white 'sugary' mattness, in addition to their famous opal-blue colours. These extra qualities seem to have been caused by some micro-crystallisation in the glazes of the lime-silicate mineral wollastonite during cooling. Chains of fine wollastonite crystals (vividly described by one Chinese scientist as appearing like 'water-weed in a fast river') tended to grow from the lime-rich droplets in the 'unmixed' glazes during cooling. The growth of wollastonite in Henan Jun glazes was encouraged by the unusually long time that Jun glazes took to cool down – a consequence of the thick walls of the Jun ware kilns, and the heavy fireclay saggars in which the wares were set. South Chinese glazes (like the Wuzhou Juns) cooled rather too fast for these lighter streaks and patches to develop, giving shinier and generally less interesting results.

**'Earthworm tracks' and 'flies' legs'**

A curious and much discussed effect, often seen Jun glazes, are fine meandering lines that appear darker than the glazes that surround them. These lines are reminiscent of earthworm tracks on damp smooth ground, and are probably relics of cracks that occurred in the thick glaze-coat during drying. These cracks seem to have filled with molten material as the glazes started to melt and, as some fractions of a glaze tend to melt before others, this compositional difference is still apparent after firing. A related effect is sometimes seen on very thick Longquan celadon glazes, where drying cracks in the raw glazes survive as fine angled brown lines in the fired glaze-surface – flaws known to Chinese potters as 'flies' legs'.

**Thick glaze application in Jun glazes**

The unusual thickness of Jun glazes, which is such a vital element in their character, was probably necessary for their optical blues to develop. If Jun glazes are too thin they tend to absorb alumina from the clay body at the height of the firing, with the consequent loss of the blue cast to the glaze. For the same reason Jun glazes have a tendency to lose their blue tones where gravity has caused them to run thinner in firing, for instance on the rims of pots and

Jun ware dish with copper oxide brushwork giving purple and green marks on a bluish glaze, Jin Dynasty (AD1115-1234). The slight frosting of white seen on this Jun ware plate may be evidence for slow cooling. D. 7 in., 17.5 cm. Sotheby's.

bowls. This effect can also be seen beneath the feet of many Jun ware dishes and flowerpots, where only a thin wash of glaze has been applied, usually with a brush. The Jun glazes in these areas often show a brownish-green colour.

The easiest way for potters to produce thick glazes is to apply them to rather thick-sectioned biscuit wares. The porous biscuit then rapidly soaks up water from the glaze suspension and gives a substantial glaze coating from dipping or pouring. Biscuit-fired shards have been found at Song Jun kiln sites, and Jun glazes that have been studied in section tend to lack the compositional banding seen in glazes applied in a series of layers. This suggests that the glazes were applied in a single thick coat, which would have been a very difficult feat with raw-glazing.

The sensitivity of the Jun blue to any excess of alumina may also be important in explaining the phenomenon of the 'Green Jun' glaze. This interesting sub-type of Jun ware uses the same forms as regular Juns, but employs fine green glazes that are thicker and slightly more opaque than contemporary northern celadons. Green Juns are thought to have been made in the same districts as some blue Jun wares (such as Linru in Henan province), but their glazes show rather different compositions, being notably higher in alumina and lower in silica. These differences are significant enough to suggest that the Green Jun glaze was a deliberate effect, rather than simply a poorly constructed

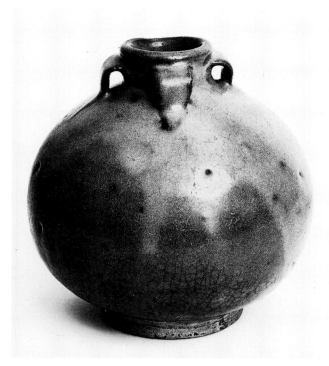

Jun ware bottle with greyish blue glaze, Northern Song dynasty. The small pits in this glaze are probably due to air bubbles that have been displaced from the biscuit ware during glazing, and then trapped in the thick Jun glaze as it dried. Biscuit-fired wares have been found at a number of Jun kiln sites, and biscuit glazing would certainly have helped in providing the substantial glaze thicknesses needed for the best Jun effects. H. 6.7 in., 17 cm. Victoria and Albert Museum, C.67–1931.

Jun blue – particularly as dozens of analyses of true Jun glazes tend to show minimal variation from the 'ideal' composition.

## Composition of Henan Jun wares

When analyses of blue Jun glazes are studied in detail the first impression is of a striking consistency of composition, that varied little from kiln site to kiln site. With glaze effects so dependent on the overall balance of glaze oxides, Jun glazes inevitably had to be kept within very narrow compositional limits. That this was achieved so successfully, and over such a wide area, by the Jun ware potters of northern China is certainly impressive.

As with northern celadons the titania levels of Jun glazes indicate that the Jun clay body could only have been a minor ingredient the Jun glaze recipes. $P_2O_5$ levels in the glazes average about 0.5%, but MnO levels are extraordinarily low (average 0.05% MnO) – which may throw some doubt on the generally accepted view that Jun glazes contained substantial amounts of wood ash. However, almost uniquely, a wood-ash sample from a Henan Song kiln site has been shown to have contained only 0.08% MnO, so it may be that wood ashes that were particularly low in manganese oxides were available to the Jun ware potters.

Beyond this it is difficult to be more specific. A pulverised granite-type rock (such as the Linru 'yellow feldspar' in Table 44), with limestone and/or wood-ash additions, and a small amount of clay, could have produced these analyses – as could a mixture of wood-ash, feldspar and quartz in roughly equal proportions (a popular modern way for achieving Jun blues). Once again analysis of seriously underfired Jun ware wasters or, better still, the

Table 45 Analyses of green and blue Jun ware glazes

|  | $SiO_2$ | $Al_2O_3$ | $TiO_2$ | $Fe_2O_3$ | CaO | MgO | $K_2O$ | $Na_2O$ | MnO | CuO | CoO | $P_2O_5$ |
|---|---|---|---|---|---|---|---|---|---|---|---|---|
| Green Jun | 67.0 | 15.7 | 0.3 | 0.6 | 11.7 | tr. | 2.6 | 1.0 | –.– | –.– | –.– | 0.6 |
| Green Jun | 67.0 | 13.2 | 0.5 | 1.6 | 9.3 | 1.1 | 4.5 | 0.5 | –.– | –.– | –.– | 0.5 |
| *Guantaizhen site, Hebei* | | | | | | | | | | | | |
| Blue Jun Song | 70.7 | 10.1 | 0.4 | 2.0 | 10.3 | 0.9 | 4.7 | 0.3 | 0.07 | 0.01 | 0.05 | 0.4 |
| Blue Jun Song | 72.0 | 9.5 | 0.3 | 1.85 | 9.4 | 0.8 | 4.0 | 0.03 | 0.05 | 0.01 | –.– | –.– |
| Blue Jun Song | 72.4 | 10.5 | 0.3 | 2.0 | 10.0 | 1.1 | 3.8 | 0.4 | –.– | 0.06 | –.– | 0.65 |
| *Liujiagou and Zhaojiawa sites, Henan* | | | | | | | | | | | | |
|  | $SiO_2$ | $Al_2O_3$ | $TiO_2$ | $Fe_2O_3$ | CaO | MgO | $K_2O$ | $Na_2O$ | MnO | CuO | CoO | $P_2O_5$ |
| Blue Jun Song | 70.7 | 9.5 | 0.4 | 1.75 | 10.5 | 0.8 | 3.8 | 0.5 | 0.07 | –.– | –.– | 0.3 |
| Blue Jun Song | 70.5 | 9.9 | 0.3 | 2.1 | 11.0 | 1.2 | 3.8 | 0.5 | –.– | 0.01 | –.– | 0.7 |
| Blue Jun Yuan | 69.1 | 11.0 | 0.2 | 1.8 | 9.8 | 2.4 | 3.3 | 1.1 | –.– | 0.03 | –.– | 0.9 |
| *Linru site, Henan* | | | | | | | | | | | | |
| Blue Jun Song | 68.7 | 9.5 | 0.3 | 1.6 | 13.2 | 1.6 | 2.6 | 0.1 | 0.05 | 0.01 | –.– | 0.8 |
| Blue Jun Song | 70.1 | 10.9 | 0.5 | 2.4 | 9.6 | 1.0 | 4.0 | 0.4 | –.– | 0.01 | 0.013 | 0.3 |
| Blue Jun Song | 72.7 | 9.9 | 0.3 | 1.2 | 8.8 | 1.6 | 3.6 | 0.9 | 0.1 | –.– | –.– | 0.9 |

Shards from various Jun ware kiln sites in north China, dating from the Northern Song to the Yuan dynasties. The kilns represented include Linru, Baofeng, Cizhou and Chifeng Lushan in Inner Mongolia. The unusually pure Jun blue of the Linru shard is typical of this site. By courtesy of Professor Ye Zhemin, Beijing.

Reverse of shards in the above picture. The bare clay at the foot of the Cizhou shard is characteristic of Jun wares produced during the Yuan dynasty.

analysis of actual glaze residues from Jun kiln sites, are needed to provide definitive answers to these problems.

### Significance of Henan Jun wares

As a conclusion to this section on Jun wares it is worth making the point that the fully developed Henan Jun glaze was a high-fired effect unique to China. Most other high-fired glazes discussed in this book (porcelain glazes, celadons, blackware and brownware glazes) have close equivalents in Korean, Thai and Japanese ceramics. The use of thickly-applied stoneware glazes that consistently gave Jun-blue effects, without the use of other glazes beneath, was a Chinese speciality. It relied on viscous, high-silica, lime-alkali compositions that needed to be kept within extremely narrow compositional limits for the blue

colours to appear. In addition to accurate mixing and careful selection of raw materials, Henan Jun glazes also needed unusually long firings and slow cooling for their special characters to develop.

### Ru ware

As an imperial stoneware, commissioned for court use by China's most celebrated emperor-aesthete, Zhao Ji (AD1082-1135), who reigned as the Huizong emperor from 1101-26, Ru ware holds a position unique in Chinese ceramic history. With their austere and elegant forms, subtle bluish-green stoneware glazes, and an almost total lack of ornament, Ru wares are regarded by many as the finest of all Chinese ceramics. Even in their own time these were rare and celebrated productions, and today fewer than 70 examples of this remarkable bluish-green celadon ware can be found in museum and private collections throughout the world.

Ru wares displaced Ding wares as the favoured Chinese imperial ceramics in the early 12th century AD. The cream-coloured Ding wares had enjoyed a long run as official Northern Song porcelains, but eventually lost favour at court – either by reason of their unglazed and metal-bound rims and the 'tear-marks' in their glazes or, perhaps, because they had gradually become less exclusive as production at the Ding kilns expanded in the late 11th century.

### The Ru ware kiln site

Because of the unparalleled status of Ru ware in Chinese ceramic history, the discovery of a Ru ware kiln site in 1986, near to the small village of Qingliangsi, in the Baofeng district of Henan province, was an archaeological event of the highest order – the implications of which are still being absorbed by historians of Chinese ceramics. Before the discovery of the Qingliangsi site, many scholars had assumed that the ruins of the Ru kilns would eventually be found at Kaifeng (the former Northern Song capital) – a site now buried beneath some ten metres of riverine silt. The making of Ru ware within the palace's rear courtyard is recorded in a 12th-century text, and it was thought to be only a matter of time before the ruins of the Ru kilns were uncovered at the Northern Song capital. As for the Qingliangsi kiln complex, this had already been excavated in 1950 and 1977, when some interesting finds of greenwares, blackwares and Song *sancai* wares were made. Two shards of a Ru-like material had been found at Qingliangsi in 1977, but they were assumed at the time to have been imported into the district.

Professor Wang Qingzhen (vice-Director of the Shanghai Museum) described vividly in a lecture in London in 1990 the background to the Qingliangsi discovery. He told how he was shown a misfired Ru ware dish on the last day of a

week-long ceramics conference in Xi'an in 1986. The Ru dish was a brushwasher and its owner, Wang Luxian (a technician in a Henan ceramic factory), had been too diffident to come forward with his find until the last day of the conference. As the brushwasher was an imperfect piece Professor Wang realised at once that it could not have come from a tomb, and was therefore probably a genuine kiln waster. He was amazed to hear that Mr Wang had simply picked up his complete example of Ru ware in a wheat field near to Qingliangsi. Professor Wang recalled his feelings at the time:

> '... I suddenly felt as though I were weightless! This was the site for which my distinguished predecessors had spent their lives in search... I was not even looking for the Ru kiln – but here was its very existence being revealed to me!'

On his return to Shanghai Professor Wang sent two museum staff to Qingliangsi to investigate the site, where they found many more shards, saggars and setting materials, confirming that this was indeed a Ru ware kiln site. After the Shanghai Museum investigation, a dig was organised by local Henan archaeologists with the help of central government cash. A number of misfired examples of Ru ware, but all with classic Ru characteristics, were eventually excavated at Qingliangsi – raising the world total for documented Ru wares from about 60 examples to nearer 70.

## Kaifeng Ru

The discovery of a Ru ware kiln site at Qingliangsi does not automatically mean that accounts of the Kaifeng Ru ware kilns were mistaken, as it is quite possible that a kiln making Ru ware had existed at Kaifeng, particularly towards the end of the Northern Song dynasty (AD960-1127). It has been proposed recently that the Kaifeng kiln was the source of an exceptionally refined style of Ru ware – perhaps using raw materials imported from some 50 miles to the west of the city.

One possible candidate for the description of 'Kaifeng Ru' has been put forward by Regina Krahl, formerly a curator in the Oriental Antiquities department of the British Museum. This is a broken and repaired bowl that has been in the Museum's collection since 1920. This sadly damaged piece shows an exceptionally fine Ru-type glaze with some evidence of 'cicada's wing' crazing, and an unusually refined form. When the bowl was dismantled recently for restoration it was possible to see how thinly the body had been thrown and turned, and how thickly the Ru glaze had been applied – the technology achieved being fully the equal of Southern Song Guan ware. Chemical analysis of the Alexander bowl showed a Ru-

Ru-type ware (the Alexander bowl) Northern Song Dynasty. In some ways the quality of this bowl exceeds even Ru ware. Although its composition shows it to be a northern piece, its true site of manufacture is still unknown. D. 9.5 in., 24.3 cm. British Museum. Presented by the Misses Alexander. OA. 1920 12-11 1.

Broken edge of the British Museum's Alexander bowl, photographed during restoration in 1994. The wafer-thin body and thick glaze show the extent to which Ru-style manufacture had been developed in north China, before the transfer of its technology to the southern Guan kilns in the later 12th century AD. British Museum.

like glaze composition, and the body clay too was of a typical northern type.

The existence of a 'Northern Guan' (i.e. 'northern official') ware is still espoused by many leading scholars of Chinese ceramics, many of whom would regard 'Kaifeng Ru' and 'Northern Guan' as being one and the same material. Even so, an interesting 'revisionist' theory has recently been proposed by Liu Hebing of the Palace Museum, Bejing. Professor Liu believes that the idea for the Kaifeng Ru kilns comes from a mis-reading of the original texts and that the true and only source of Ru ware was Qingliangsi.

## The character of Ru ware

In terms of its body composition, Ru ware is essentially a slightly underfired (1200°-1250°C) stoneware with a high-alumina, low-iron clay of typical north Chinese composition. Ru ware forms were superbly conceived, and then thrown and turned to a reasonable thinness. They were then covered by relatively thick lime glazes (12.5-16.5% CaO) of the low-titania, iron-blue type. Sometimes a hint of lavender-blue developed in Ru ware glazes during firing, possibly due to a trace of copper in the raw materials used, or perhaps due to the use of agate in the glaze. The best Ru wares seem thoroughly reduced, and their iron-blue tones can be unusually pure. Although coal-firing was well-established in Henan in the late 11th/early 12th century, excavations at the Qingliangsi site suggest that the Ru ware potters preferred the more expensive option of wood-firing – perhaps because of the better control that it gave with strongly reducing kiln conditions.

As these analyses show, most Ru ware glazes were essentially lime glazes with above-average levels of alumina. This oxide balance encouraged smooth stony surfaces when underfired, and a tendency to glassiness when overfired. The low titania levels and good reduction encouraged fine bluish tones from the reduced iron.

The Guan glazes that replaced Ru glazes as imperial stonewares in south China were essentially of the same type – but what is perhaps more surprising is the general similarity of Ru glazes to the Shang ash glazes in Table 1. The high titania levels in the Shang glazes, combined with their iron contents, gave grey-green or yellowish-green colours in firing rather than the bluish-green of Ru, but these compositional parallels do demonstrate the essential antiquity of the Ru glaze construction.

As the stoneware bodies used for Ru wares were low in fluxes, and consequently slightly underfired, it was possible for the Ru potters to set their wares on refractory spurs within their saggars, without the forms distorting at high temperatures. This technique allowed an almost total glaze cover to be achieved on most Ru ware pieces. Apart from the high degree of finish that this allowed, it also discouraged the refractory stoneware clays from re-oxidizing beneath the reduced glazes, via the foot-ring area. As Professor Wang remarked in London in 1990: 'If the Ru potters could have levitated their wares in the kiln they would have done so!' The spurs used for Ru ware were small and neat and left a ring of three or five 'sesame seed' scars on the fully-glazed bases. A few Ru wares were fired on unglazed foot-rings, but examples of this type are rare. Where the Ru ware body is exposed, it tends to show a light greyish-brown tone – traditionally described in China as 'the colour of incense ash'.

Ru ware forms were generally undecorated and are reminiscent of the finest lacquer wares of the Northern Song dynasty. It is not impossible that the technique of lacquer itself may have had some influence on the glazing of Ru wares. The idea of a thin substrate as a ground for successive coats of lacquer is not too different from the use of a thin clay body covered by successive layers of glaze. Among the classic Ru ware forms so far found are dishes, bottles, vases, cup-stands, incense burners, basins, covered jars and bulb bowls.

## Origins of Ru ware

Excavation has shown that the Qingliangsi kiln site began life making a range of typical 9th–10th-century stonewares, including blackwares, whitewares, lead-glazed wares and an unusual bluish-glazed celadon ware. Jun wares of an unusual light blue colour were also made at Qingliangsi in the 11th-12th centuries that seem to have been direct descendants of a local 'Tang Jun' style. However, it was the celadon material that was refined and improved, and which was eventually adopted as a true imperial stoneware. Even

Table 46 Compositions of Ru ware glazes

|  | $SiO_2$ | $Al_2O_3$ | $TiO_2$ | $Fe_2O_3$ | CaO | MgO | $K_2O$ | $Na_2O$ | MnO | $P_2O_5$ | CuO |
|---|---|---|---|---|---|---|---|---|---|---|---|
| Ru ware glaze 1 | 58.3 | 15.4 | 0.37 | 2.1 | 14.2 | 2.3 | 4.5 | 0.8 | 0.28 | 0.72 | 0.12 |
| Ru ware glaze 2 | 58.8 | 17.0 | 0.2 | 2.3 | 15.2 | 1.7 | 3.2 | 1.7 | –.– | 0.6 | –.– |
| Ru ware glaze 3 | 58.4 | 15.6 | 0.16 | 2.1 | 16.3 | 1.9 | 3.8 | 0.8 | 0.1 | 0.6 | –.– |
| Alexander bowl★ | 63.6 | 15.6 | 0.1 | 2.3 | 12.4 | 1.9 | 3.1 | 0.9 | –.– | –.– | –.– |

(★This analysis, and the body analysis in Table 47, are by courtesy of The British Museum)

Table 47 Compositions of Ru ware bodies

|  | $SiO_2$ | $Al_2O_3$ | $TiO_2$ | $Fe_2O_3$ | CaO | MgO | $K_2O$ | $Na_2O$ | MnO | $P_2O_5$ |
|---|---|---|---|---|---|---|---|---|---|---|
| Ru ware body 1 | 65.0 | 28.1 | 1.4 | 1.96 | 1.35 | 0.6 | 1.4 | 0.15 | –.– | –.– |
| Ru ware body 2 | 65.3 | 27.7 | 1.2 | 2.3 | 0.5 | 0.4 | 1.8 | 0.2 | –.– | 0.1 |
| Alexander bowl | 62.5 | 31.4 | 1.3 | 1.5 | 0.9 | 0.5 | 1.5 | 0.5 | –.– | –.– |

while the plain and undecorated imperial-quality Ru wares were being made and fired at Qingliangsi, more modest Ru-style wares continued their production, and these often show engraved or stamped designs, beneath their greenish-blue celadon glazes

The stylistic origins of the refined Ru ware forms have long been debated. Longquan celadon was once thought to have been an important influence, but it is now realised that Ru wares actually pre-date the finest celadon wares of the Dayao type and that fine Yue wares and lacquer vessels are the more likely models. The fully-glazed, splayed feet, seen on many Ru pieces, were a typical Yue ware feature, apparently borrowed by the Yue potters from contemporary beaten metal forms.

Korean celadon has also been cited as a possible influence on the Ru ware glaze colour. The dates are correct in this case, but it could be argued that Ru glazes and Koryo celadons are similar in colour simply because they share a common technical feature – an unusually low titania content.

There is also the consideration that, before the perfecting of the bluish-glazed Ru wares, there existed another very mysterious 10th-century north Chinese imperial ware known as 'Chai ware', believed to have been made in Henan province for the emperor Chai Shizong (reigned 954–59), and already mentioned in relation to Yaozhou wares. Chai wares had glazes that early Ming writers described as being the 'colour of the sky after rain' – presumably blue with a faint tinge of green. This very evocative description of glaze colour was later extended to include Ru ware itself. No examples of Chai ware have been identified in modern times and Ming writers record that even shards of Chai ware were so highly prized in

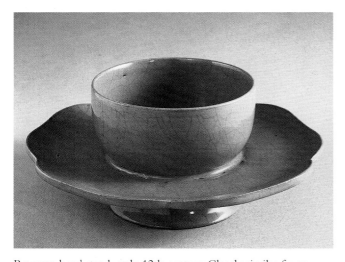

Ru ware bowl stand, early 12th century. Closely similar forms occur in Chinese lacquer and silver during this period. D. 6.6 in., 16.8 cm. British Museum, OA 1971.9-21 1

their day that they were made into expensive belt buckles. Chai ware remains the number one outstanding mystery of Chinese ceramics.

In addition to these possible influences on Ru ware we can now add the recent finds of mid-10th-century bluish-glazed Yaozhou wares. Some examples of Five Dynasties Yaozhou stoneware have glazes and forms that are rather close to the later Ru wares. However, these similarities can also be taken as showing that bluish-glazed celadon wares were made at more than one kiln site in northern China in the 10th century – but that it was the Qingliangsi kiln complex that was selected to develop this style of ware to an imperial standard.

**Bluish celadons**

It is not hard to appreciate how distinguished these bluish celadon colours would have appeared when viewed against the great mass of ordinary grey-green and olive-green stonewares of their time. Also, when Ru wares are set side by side with Jun wares the Jun wares appear somewhat flashy by comparison. The later Longquan celadons also suffer when compared with Ru: one of the most attractive characteristics of Ru ware is the sense of the fine greyish stoneware clay beneath the bluish glaze, as this imparts a mysterious and reserved quality to the glazes. Even the finest Longquan celadons have simpler, harder and more unctuous characters than the classic Ru wares of Henan.

**Crazing on Ru wares**

Most examples of Ru ware glaze are finely crazed, and Ru is sometimes described as the first Chinese classic ware that exploited 'crackled' glazes for their own sake. The high-alumina characteristics of the Ru clays would have made crazing during cooling hard to avoid – so if crazing were appreciated at the time, it would have been as a natural happening rather than as a deliberate effect. In many ways the crazing on Ru ware adds an extra dimension to its glaze quality, particularly when it exhibits the unusual 'fish-scale' form that is seen on some examples.

Fish-scale crazing tends to develop on Ru pieces that have rather thick glazes that have been marginally over-fired. Where it appears the craze lines are fringed by what appear to be fracture zones within the depths of the glazes, but parallel rather than vertical to the glaze surface – giving an odd impression of over-lapping scales. In some cases the craze lines are longer and sparser, but also show these curious 'fractured fringes'. These longer fractured craze lines are compared in China to 'cicada's wings' – a description that is particularly faithful to the faint iridescence of the locally fractured glaze. These unusual crazing effects are also seen occasionally on some of the finest Guan wares.

Detail of the British Museum's 'Alexander Bowl' showing 'cicada's wing' crazing. British Museum, OA 1936. 10-19.1.

The reasons for this odd crazing behaviour have never been explored, but they may be the result of a combination of multiple glaze application, unmixing of some mineral constituents in the glaze while it was still wet on the surface of the wares, and the unusually long firing and cooling cycles employed in north Chinese kilns. All these factors could combine to produce high-and low-expansion layers within the thicknesses of the glazes that shrank at different rates during cooling. Tensions between these layers could have caused horizontal cracks to develop within the glazes that started from the vertical cracks caused by ordinary crazing.

### Raw materials for Ru ware glazes

Ru ware is unusual in having contemporary references to one of its prime glaze ingredients – namely powdered agate. Agate is an extremely hard type of silica rock that often shows a natural banding of yellow, red and opal-white. Support for the tradition that agate was used in Ru ware glazes came from investigations at the Qingliangsi site itself, where veins of red and yellow agate rock are visible, just breaking the surface of the loess. Whether the agate contributed anything to the Ru glaze quality though is more difficult to say: silica is the major oxide in all high temperature glazes, but most of the powdered agate would simply have dissolved in the glaze during firing. However there are some references to 'red specks' being visible in some Ru glazes in strong sunlight, and these may be relicts of crushed, but undissolved, particles of reddish agate rock.

As for the other ingredients in Ru ware glazes – these would have to have been some kind of low-titania igneous rock for the main bulk of the glaze, a clay for extra alumina, and a rich source of calcia to act as the prime glaze flux. To some extent the remarks made about Jun ware glaze materials also apply to Ru. Like Jun glazes, Ru glazes have very low manganous oxide contents, which suggests either a very unusual type of wood ash in their original glaze recipe or perhaps that wood ash was not used at all, and that the main glaze flux was some rocky form of calcium carbonate.

Whatever their source materials, the fired results of the Ru glazes were superb. Ru wares, Guan wares and Korean Koryo celadons all demonstrate the principle that low-titania lime-glazes, coloured by small amounts of iron, and applied to fine grey stoneware clays, are capable of providing one of the most satisfying and expressive combinations of body and glaze in high-fired ceramics.

### The decline of Ru

Kaifeng Ru (if it existed) would almost certainly have ended with the sacking of the Northern Song capital, and Kaifeng potters may well have joined the general exodus south. Evidence at Qingliangsi however suggests that production of a type of Ru ware continued well into the Jin dynasty (1115-1234), but that its quality gradually deteriorated. As we have seen, the making of an imperial Ru-type ware was re-started at Hangzhou in the later 12th century and these 'Southern Ru' wares in turn evolved into the celebrated Guan and Ge wares of the Southern Song.

## Cizhou wares

While Ru wares can be regarded as standing at the very apex of northern stoneware production, the broad base of the pyramid can be represented by Cizhou wares – the most abundant and universal stonewares of northern China. The name Cizhou itself comes from a kiln area in southern Hebei province, famous for this style of north Chinese decorated stoneware.

### Guantaizhen

The most important of the Hebei kiln sites is found at Guantaizhen, some 31 miles (50 km) from the large steel-making city of Handan. The Guantaizhen site is in an austere and wild part of Hebei, approached by a narrow winding road through limestone mountains and gullies. Small family coal mines are scattered through this district, and roadside coke-burning kilns (converting coal for the Handan iron industry) fill the air with dust, fumes, smoke and steam. The kiln site itself occupies a commanding site on an elevated headland, overlooking the Lao River far below, and the extensive wheat fields of a wide loessic plain.

View from the Guantaizhen kilnsite, southern Hebei province. The Guantai kilns operated from the late Tang through to the early Ming dynasty, and were responsible for some of the most imaginative and varied stonewares in China's history – all produced in the myriad Cizhou styles. (Working coal mines can be seen in the distance and the main industry at Guantai today is burning coke for the Handan steel-works, 31 miles (50 km) to the northeast.)

The Guantai kilns began making stoneware in the late Tang dynasty and the Handan Museum has a major collection devoted to this important Cizhou site. Perhaps the most startling aspect of Guantaizhen is the wealth of wares that it produced – some 30 quite distinctive types can be counted in the Handan Museum, all produced in the Northern Song and Jin dynasties alone. These include lead-glazed wares, Jun wares, turquoise wares, enamelled stonewares, wares decorated with chattered slip, white-slipped green-splashed stone-wares, ribbed blackwares and every style of slip-painted stoneware. However, similar wares were also made at kilns in Henan, Shaanxi, Shanxi, and Shandong provinces, and these all tend to be grouped under the general heading of 'Cizhou wares'.

The prime Cizhou wares were essentially slip-decorated country stonewares, fired in neutral-to-oxidising atmospheres. They were often set in large stacks within the kilns, using only minimal separation between the pieces, with unglazed areas on rims, bowl centres, and even shoulders of jars, that allowed an ingenious and economical density of packing.

### The character of Cizhou wares

While Ru wares owed their qualities to austere forms and sublime glazes, Cizhou wares were distinguished by the vigour of their thrown and moulded forms, and by the liveliness of their painted, engraved, stamped and paper-resisted designs. Perhaps the most impressive of all the

Tall stoneware wine jar painted with black slip on an overall white slip coating; dull but clear stoneware glaze. A magnificent example of northern Cizhou ware, Jin dynasty. Shanghai Museum.

Cizhou stoneware were those painted with black slip onto a white slip ground. These can show a breathtaking verve in execution that many consider unmatched in world ceramics. Black and white Cizhou wares also represent the most successful use of brushwork on Chinese ceramics since the demise of fine Neolithic painted wares, some 4000 years before.

### The Cizhou white slip

The principal material needed for the Cizhou style of stoneware was a white slip that would disguise the ordinary buff or grey-firing clays that are typical of northern coal fields. These white slips were essentially the same materials as were used for northern porcelains, that is secondary (i.e. sedimentary) kaolins. The earliest and simplest wares of this type were plain and undecorated stonewares, dipped in white slips to give the illusion of a purer body material – a technique that may even anticipate the production of northern porcelain itself. The

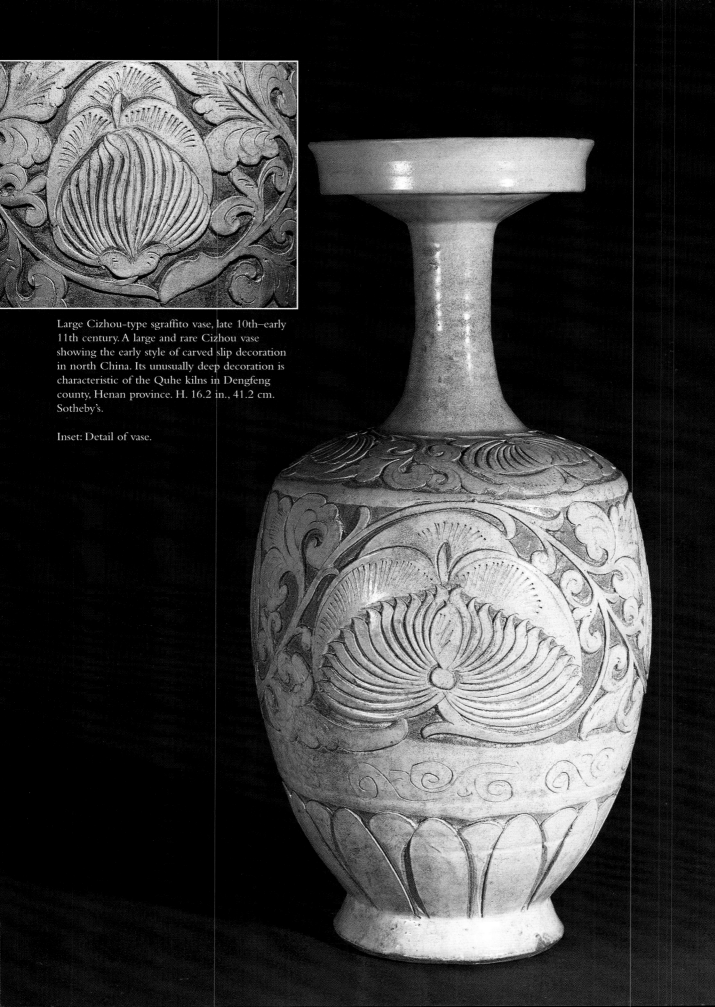

Large Cizhou-type sgraffito vase, late 10th–early 11th century. A large and rare Cizhou vase showing the early style of carved slip decoration in north China. Its unusually deep decoration is characteristic of the Quhe kilns in Dengfeng county, Henan province. H. 16.2 in., 41.2 cm. Sotheby's.

Inset: Detail of vase.

technique of carving through the white slip to show the slightly darker body beneath can be seen on some rare northern stonewares as early as the 6th century AD, but becomes more common at Yaozhou in the early 10th century. Brush-painted designs, using black slip on white, appeared in the late 11th or early 12th century AD.

Because porcelain clays were needed for the Cizhou white slip many kilns that made whitewares in north China also made various styles of Cizhou ware. Perhaps as a result of this relationship the compositions of the Cizhou glazes seem closely related to those used on contemporary northern porcelains. In many cases this resulted in slight underfiring of the Cizhou glazes at their typical firing temperatures of about 1240°-1290°C causing them to be rendered dull by a fine misting of undissolved quartz and also by suspended bubbles in the glazes. In practice this was

Cizhou ware stoneware vase with white and black slips, 12th century AD, north China, Hebei province. The closer spacing of the lower pairs of black slip dots suggests that the patterns were applied with the fingertips. The white slips used on these wares seem related to the clays used for northern porcelain, and the dull but transparent Cizhou glazes also have affinities with northern porcelains. H. 7.9 in., 20 cm.
Victoria and Albert Museum, C.457–1920.

more of an advantage than a handicap: slip decoration shows up well beneath glazes that are transparent but also slightly dull, as no reflections can then detract from the painted or engraved designs. Cizhou glazes were also applied thinly and the effects of underfiring tend to be less obvious in thin glazes.

## Cizhou black and white wares

The intensity and stability of the black slip-painting on north Chinese Cizhou wares is also impressive. As we have seen, high-temperature underglaze and overglaze painting had already been practised at Changsha and Qionglai in the later Tang dynasty, and there is even an extraordinary (and so far unique) large covered jar in the Nanjing Museum that is decorated with detailed underglaze designs of flames and Buddhist images, and which is provisionally dated to the early Six Dynasties period (AD220–589). Nonetheless, in all these southern wares the painted effects are rather blurred, due to the colouring oxides diffusing into the lime-rich glazes at high temperatures. In black and white Cizhou wares the painting remains intensely sharp and black – an effect that was achieved through some rather subtle compositional strategies.

## Technology of northern Cizhou wares

The first of these strategies was to make the Cizhou glazes unusually low in calcium oxide (typically 5-8% CaO) and high in alumina (15-18% $Al_2O_3$). This meant that they were extremely viscous at high temperatures, and this

Country stoneware workshop, Shenhou, Henan province, photographed in 1985. Excavation in north China has shown that many early northern potters operated from workshops dug into loess cliffs, and the cave-like workshops near Shenhou are of this traditional style. Also notable are the big round boards made from fired clay (substantial timber is in short supply in this part of China, while clay and coal are abundant).

effectively controlled diffusion of the underglaze pigments into the molten glazes at the height of the firing. A second vital element for the success of Cizhou black and white painting lay in the nature of the black pigment itself. Mineralogical examination of numerous Cizhou wares has shown the main component of the black colour to be magnetic iron oxide, $Fe_3O_4$ – a mineral that is also known as magnetite or ferroso-ferric oxide. Magnetite is a highly stable compound of the spinel group, and spinels are often used today as the bases for underglaze colours. Red iron oxide (hematite, $Fe_2O_3$) is also present in most examples of Cizhou black slip that have been analysed to date, although in much smaller quantities than the magnetite. No significant amounts of manganese have yet been found in early Cizhou underglaze-black painting, so the intensity of the black colour seems entirely due to iron.

As for the origin of this magnetite, the material can be created from commoner oxides of iron by a neutral glaze firing. However, the number of Cizhou black pigments that have been shown to contain this mineral suggest that substantial amounts of magnetite were probably present in the original black-slip mixtures themselves. The silvery-grey magnetic oxide of iron is a common ore worldwide, and the iron ore reserves of north China are very extensive. It is therefore possible that magnetite could have been used by the Cizhou potters in its natural form, perhaps mixed with white slip, or with a small amount of glaze. The status of the magnetic iron oxide would have been preserved by the generally oxidising-to-neutral firings practised by the Cizhou potters and this, together with the stiff Cizhou glazes, resulted in the unusual clarity and intensity of black pigment, typical of the finest Cizhou wares.

## Raw glazes

The high alumina figures seen in these Cizhou glazes probably derive from mixtures of rather pure secondary kaolins with crushed quartz-feldspar rocks. The clays used

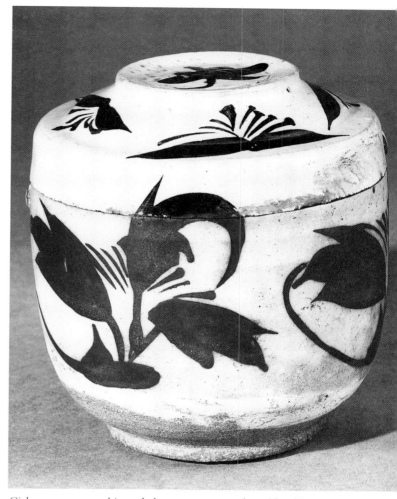

Cizhou ware covered jar, pale brown stoneware clay with white slip coating and black slip painting, 12th–13th century AD. The black and stable pigments used for Cizhou wares seem to have consisted mainly of magnetic iron oxide (ferroso-ferric oxide, $Fe_3O_4$). When used with the typical low-lime Cizhou glazes, and fired in oxidising-to-neutral atmospheres, these pigments remained intensely sharp and clear. Rapid, informal, but highly skilled, making add to the vitality of this small jar, the cover of which doubled as a bowl. H. 5.25 in., 13.5 cm. British Museum.

Table 49 Analyses of Cizhou clays and glazes – Guantai and Pengcheng kilns, Hebei

| | $SiO_2$ | $Al_2O_3$ | $TiO_2$ | $Fe_2O_3$ | CaO | MgO | $K_2O$ | $Na_2O$ | MnO | $P_2O_5$ |
|---|---|---|---|---|---|---|---|---|---|---|
| **Bodies** | | | | | | | | | | |
| N. Song Cizhou | 64.3 | 30.0 | 1.2 | 1.7 | 0.4 | 0.3 | 1.6 | 0.5 | 0.01 | –.– |
| N. Song Cizhou | 64.2 | 29.0 | 1.3 | 2.2 | 0.3 | 0.4 | 2.15 | 0.3 | –.– | –.– |
| Qing Cizhou | 65.1 | 28.1 | 1.5 | 2.2 | 0.6 | 0.4 | 2.3 | 0.3 | 0.04 | –.– |
| **Glazes** | | | | | | | | | | |
| N.Song Cizhou | 62.6 | 18.0 | 0.3 | 0.4 | 4.7 | 1.0 | 3.6 | 2.2 | 0.1 | 0.1 |
| N.Song Cizhou | 72.3 | 16.6 | 0.2 | 0.5 | 4.1 | 0.6 | 3.7 | 2.0 | –.– | 0.15 |
| Qing Cizhou | 71.4 | 16.9 | 0.3 | 0.6 | 2.5 | 0.9 | 3.7 | 2.4 | –.– | 0.12 |
| **Slips** | | | | | | | | | | |
| N.Song Cizhou | 54.2 | 37.3 | 0.9 | 1.0 | 2.7 | 0.2 | 1.8 | 0.8 | –.– | –.– |
| Qing Cizhou | 53.0 | 36.4 | 1.4 | 1.1 | 1.0 | 0.3 | 2.5 | 0.1 | –.– | –.– |

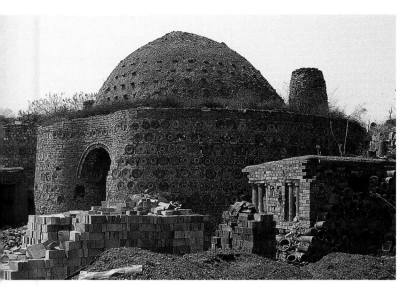

Modern *mantou* kiln at Pengcheng, 25 miles (40 km) southwest of Handan, S. Hebei province. A well-known site for Cizhou wares, in the Yuan and Ming dynasties, Pengcheng now makes refractories for the steel industry. This coal-fired *mantou* kiln is typical of the type used for early Cizhou wares. Without the use of steel banding the lower part of the structure has to be very substantial, even though the high dome sends most of its thrust downwards. The use of old saggars in the walls provides good insulation, and also helps to reduce the kiln's mass. There are two short chimneys (one hidden), side by side, in the traditional *mantou* manner.

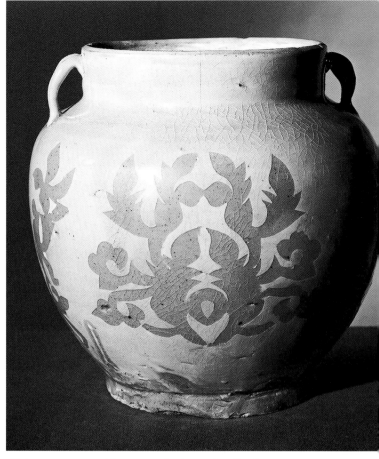

Cizhou ware vase with paper-resist decoration, Jin dynasty. Cut paper shapes have been lain on the damp clay before the whole vase was dipped in white slip. When the slip had hardened sufficiently the paper shapes were peeled away to reveal the stoneware clay beneath. It is likely that the vase was then raw-glazed and once-fired in an oxidising-to-neutral kiln atmosphere, most probably with coal as the fuel.
Victoria and Albert Museum.

would have been chosen for their unusually white-firing (low titania) properties in order to give colourless glazes. This makes the technology of Cizhou glazes very close to that used for northern porcelain, as these glazes too are very low in titania. High-clay slip glazes of this type are ideal for raw glazing onto leatherhard wares as they shrink in step with the bodies beneath, particularly through the last stages of drying.

Lively and often sparing slip decoration, thin clay-rich raw glazes, and unusually dense settings in the kilns, all contributed to speed and economy in production, and the Cizhou sites operated for centuries in China, supplying volumes of kitchen and eating wares to the urban and rural populations of the north. Perhaps the most universal role for Cizhou wares in China was as jars, bottles and bowls for the brewing and drinking of wine, and these wares were widely traded, particularly through the canals and rivers of the northern farmlands.

# FURTHER READING

*BOOKS AND EXHIBITION CATALOGUES*

Penelope Hughes-Stanton and Rose Kerr, *Kiln Sites of Ancient China – Recent Finds of Pottery and Porcelain*, Oriental Ceramic Society, London, 1980

Yutaka Mino, *Freedom of Clay and Brush through Seven Centuries in Northern China: Tz'u-chou type wares 960–1600 AD*, Indianapolis, 1980

Celia Carrington Riely, *Chinese Art from the Cloud Wampler and other Collections in the Everson Museum*, New York, 1969

*Ruyao de Xin Faxian* (New discoveries of a Ru kiln), Beijing, 1991

Shaanxi Travel and Tourism Press, *Yaozhou Kiln*, Xi'an, 1992

Mary Tregear, *Song Ceramics*, Thames and Hudson, London, 1982

William Watson, *Tang and Liao Ceramics*, Thames and Hudson, London, 1984

Yutaka Mino and Katherine R. Tsiang, *Ice and Green Clouds – Traditions of Chinese Celadon*, Indianapolis, 1986

*PAPERS AND ARTICLES*

Chen Yaozheng, Guo Yanyi and Liu Lizhong, 'An investigation of Cizhou black and brown decorated porcelain in successive dynasties', *Oriental Art*, Vol. 34, no. 1, pp 35–41, London, 1988

Regina Krahl, 'The 'Alexander bowl' and the questions of Northern Guan ware', *Orientations*, Vol. 24, No. 11, pp 72–5, 1993

Cizhou ware pillow with cream-white slip and with sgraffito and stamped decoration revealing the reddish-brown stoneware clay beneath. Inscribed 'Everlasting peace in family and state' and '[made].... under the jurisdiction of the Zhao family', and dated equivalent to 1071 AD. The 'fish roe' pattern, often seen on northern Cizhou wares, seems to have been managed by stamping the leatherhard slip with a thin tube. This removed small rings of white slip and revealed the reddish stoneware clay beneath. L 8 in., 21.6 cm, OA 1914 4-13-1, British Museum.

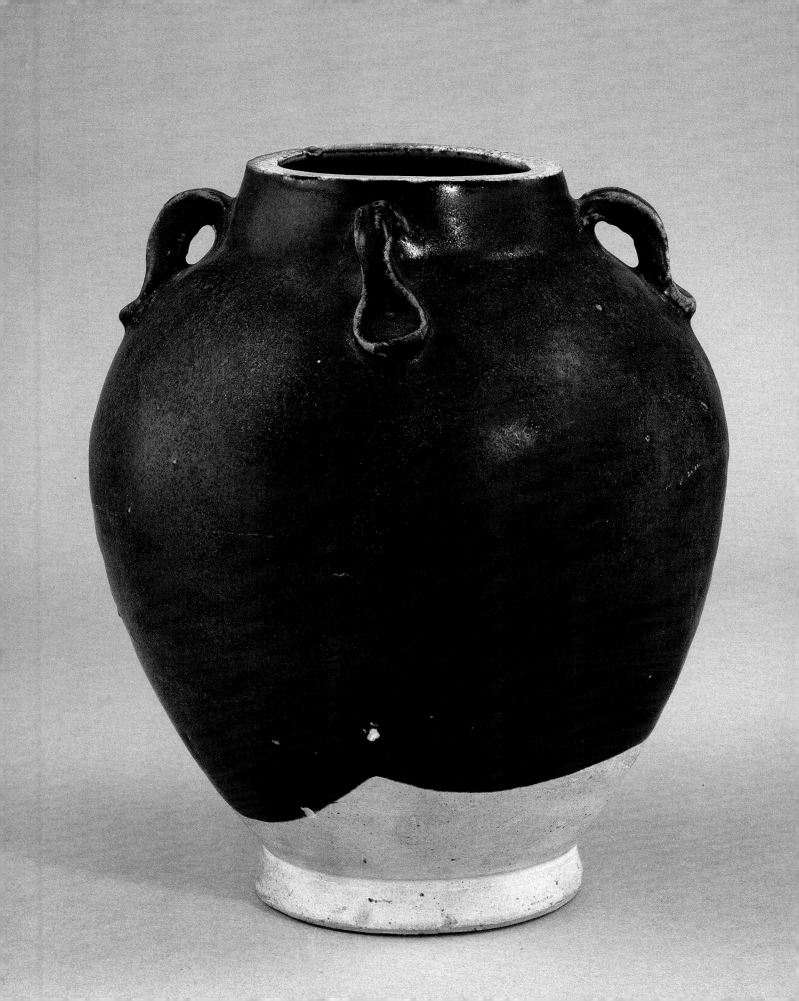

# Chapter 7

# THE BLACKWARES AND BROWNWARES OF CHINA

High-fired blackwares and brownwares are among the most fascinating of all Chinese ceramics. Their iron-rich glazes seem to evoke the very earths of China – and it is not surprising to find that the common clays, river-muds and silts of both north and south China were often the main raw materials used to make them. They are essentially glazes of the Chinese countryside and were applied typically to large storage jars, to wine bottles, vases and rice bowls, and to everyday tea bowls.

One particular style of country tea bowl – from the Jian kilns in the southern province of Fujian – achieved unusual status, both in China and Japan. Early in the Northern Song dynasty (AD960-1127) Jian temmoku bowls were accepted as tribute wares by the Northern Song court, and were approved for imperial use. On the principle of the 'hobbies of the emperor being followed by his subjects', they subsequently became highly fashionable amongst Northern Song society, and in Buddhist monastic communities. As recorded by the Song scholar Su Dongpo, they were also popular with poets of the time for drinking wine. From the Tienmu Buddhist temple near Hangzhou their use spread to Japan in the 12th century, where they were fervently admired by the medieval Japanese – later becoming treasured items in the Japanese Tea Ceremony. In Japan Jian ware tea bowls were given the name 'temmoku' – after the Japanese rendering for the Chinese characters 'Tien mu'. The term *temmoku* is now widely used in both East and West to describe both Chinese blackware glazes and blackwares in general. Much of the appeal of Chinese temmoku lies in its vigorous folk art character, and this earthy spirit has had a profound influence on the work of many 20th-century artist-potters.

Not all Chinese blackwares, however, were folk wares.

Black-brown glazes were occasionally used on some fine Chinese porcelains, such as the ultra-rare 'Black Ding' wares of the Northern Song dynasty, or the sophisticated 'mirror black' monochromes made at Jingdezhen in the 18th and 19th century. In both north and south China, black-glazed porcelains were sometimes embellished with gold. On most examples the gilded patterns have rubbed away, but the original effects of gold on a black ground would have been striking.

## Southern blackwares

The glazes used on the blackwares of south China during the Song dynasties are typified by the oily depths and the subtle brilliance seen in the 'hare's fur' temmokus, made at the Jian kilns in Fujian province. Jian ware glazes are often streaked with fine vertical flow-lines of immiscible rusty-coloured glass, which provide a strong resemblance to animal fur. Another important blackware kiln in southern China was sited at Jizhou, nearly 300 miles to the west of the Jian kilns, where the potters enlivened their dullish black and brown glazes with splashes and trailings of lighter, ash-rich overglazes, as well as employing complex paper- and leaf-resist techniques.

Southern blackware glazes seem to have been unusually sensitive to the effects of glaze application, kiln atmosphere, firing temperatures and cooling rates. At many south Chinese kiln sites a single blackware glaze provided a wealth of varied effects – depending on how thickly the glaze was applied, where it was placed in the kiln, the degree of reduction it received during firing, and its particular rate of cooling. At least a dozen varieties of blackware glaze, of essentially similar composition, are recognised from the Jian kilns alone.

Black glazed jar, Tang dynasty, north China. The dull black glaze and the light-firing stoneware body are typical of ordinary northern blackwares from this period. H. 8 in., 20.3 cm. Ashmolean Museum, Oxford.

## Origins of Chinese blackware glazes

Blackwares are rare among the early stonewares of China: the vast majority of ancient Chinese stoneware glazes are grey-green, yellowish-green or olive-green, and their iron oxide contents tend to fall between about 2–3%. Iron oxide levels in this range are typical of glazes made entirely from wood ash, or from mixtures of wood ashes with stoneware clays – both raw materials being fairly low in iron. True black and brown glaze effects would have needed iron oxide levels from about 5–10%, which in turn would have involved either the use of unusually iron-rich clays, rocks or ashes in the glaze recipes, or the deliberate addition of some concentrated source of iron oxide to existing greenware glazes.

Given the general conservatism of the Chinese greenware tradition it is perhaps not surprising to find that true blackware glazes only feature rarely in the early archaeological record. Greenwares were by far the more important high-fired glaze-type in China until the early 4th century AD, when a limited amount of black-glazed stoneware began to be made in Zhejiang province. Even then these darker wares were not especially popular and it was not really until the Tang dynasty that black glazed stonewares made a significant contribution to Chinese ceramics, with the best of the Tang blackwares being made at kilns in the Yellow River area of northern China.

## *Bronze Age blackware glazes*

Some of the very earliest Chinese blackware glazes, so far found, have been excavated at the villages of Yingtang and Qingjiang in Jiangxi province in south China. They date from the late Shang to the Western Zhou period (*c.*1200–800BC) and differ from the general run of Chinese Bronze Age glazes in their unusually low lime contents. Their potassium oxide contents by contrast proved surprisingly high, and the glazes also showed iron oxide levels in the 5-10% range. It is possible that these glazes were made by mixing iron-rich clays with alkali-rich wood ashes – although the use of pulverised igneous rocks in the original recipes may be another explanation for these high potassium levels.

Occasional examples of brown and black-glazed stoneware occur in China between the Bronze Age examples, described above, and the early 4th century AD, but no important or coherent group emerges until the northern Zhejiang blackwares of the 4th to the 5th centuries AD. These were made at kiln sites such as Deqing and Yuhang in a rice-growing area to the south of the Yangxi river delta. This is an ancient site for greenware production and the Deqing kilns in particular seem to date back to at least the Western Zhou period. True blackwares, however, were not made at Deqing until the early 4th century AD.

The brown-black Deqing glazes were sometimes applied to local versions of the chicken-headed ewers, fashionable in China at this time. Bottles and bowls, and lacquer-shaped 'ear cups' with brown-black glazes, have also survived from this site, as have some dark-glazed incense burners. The Deqing high-iron glazes are variable in quality. On some pieces they have developed a fine and even, dull-surfaced black-brown effect, but on other examples the pots appear as if dipped in dark and murky

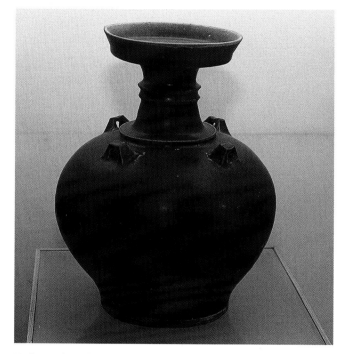

Early southern blackware vase from the Deqing kilns in Zhejiang province, 4th or 5th century AD. This fine example of Deqing blackware has an unusually stable glaze. It also shows the dull surface that is typical of slow-cooled high-lime compositions. H. 9.8 in., 24.9 cm. Shanghai Museum, China.

Table 50 Analyses of Bronze Age blackware glazes from Jiangxi (*c.* 10th century BC)

|  | $SiO_2$ | $Al_2O_3$ | $TiO_2$ | $Fe_2O_3$ | CaO | MgO | $K_2O$ | $Na_2O$ | MnO | $P_2O_5$ |
|---|---|---|---|---|---|---|---|---|---|---|
| Glaze Qingjiang | 68.5 | 12.2 | 1.25 | 9.0 | 0.9 | 1.8 | 5.1 | 0.8 | 0.5 | -.- |
| Glaze Qingjiang | 61.0 | 17.7 | 1.3 | 6.9 | 4.6 | 2.2 | 4.3 | 0.5 | 0.9 | 0.6 |
| Glaze Yingtang | 61.5 | 16.8 | 1.25 | 10.1 | 1.7 | 1.9 | 5.7 | 0.6 | 0.2 | 0.2 |
| Glaze Yingtang | 61.7 | 18.0 | 1.0 | 5.0 | 4.5 | 1.7 | 7.4 | 0.5 | 0.05 | 0.2 |

Table 51 Comparison of Deqing black and green glazes and bodies from the Xiaomashan kiln, Deqing, N. Zhejiang province

| | $SiO_2$ | $Al_2O_3$ | $TiO_2$ | $Fe_2O_3$ | CaO | MgO | $K_2O$ | $Na_2O$ | MnO | $P_2O_5$ |
|---|---|---|---|---|---|---|---|---|---|---|
| *Deqing black* | | | | | | | | | | |
| Glaze DB1 | 55.2 | 12.1 | 0.85 | 7.6 | 19.7 | 1.6 | 1.35 | 0.6 | 0.3 | 0.8 |
| Glaze DB2 | 56.4 | 12.1 | 0.9 | 6.6 | 18.35 | 1.3 | 2.0 | 0.6 | 0.3 | 0.6 |
| Glaze DB3 | 56.9 | 12.0 | 1.2 | 6.6 | 18.55 | 1.4 | 1.9 | 0.6 | 0.3 | 0.6 |
| Body DB1 | 74.3 | 16.8 | 1.0 | 2.8 | 0.3 | 0.4 | 2.4 | 0.9 | 0.02 | –.– |
| *Deqing green* | | | | | | | | | | |
| Glaze DG1 | 60.4 | 12.65 | 0.8 | 2.0 | 18.8 | 1.35 | 1.4 | 0.5 | 0.3 | 0.9 |
| Glaze DG2 | 61.7 | 13.6 | 0.7 | 2.0 | 17.5 | 1.3 | 1.8 | 0.6 | 0.04 | 0.65 |
| Glaze DG3 | 61.1 | 13.5 | 0.8 | 1.9 | 17.9 | 1.3 | 1.7 | 0.6 | 0.1 | 0.7 |
| Body DG1 | 73.4 | 18.0 | 1.1 | 3.1 | 0.5 | 0.55 | 2.4 | 0.8 | 0.03 | –.– |

oil. Nonetheless, despite the mixed success of the technique, iron-rich glazes from kilns of the Deqing type mark an important break with the universal greenware tradition of southern China.

Analyses of the Deqing black glazes show that they were rich in lime (average 19% CaO) and similar to the ordinary green ash glazes of the same date – apart from their higher iron contents (6.5–7.5% iron oxides). Whether this extra iron came from the Deqing potters' using iron-rich clays in their glaze recipes, or whether they had simply added concentrated iron oxide to their existing ash glazes, is still difficult to judge. Iron-rich siliceous silts are common in the paddy fields of northwestern Zhejiang, but reasonably pure iron oxides were also used by northern Zhejiang potters at this time, in the form of carefully placed rusty spots on their grey-green stoneware glazes. The body analyses show that the black and green Deqing wares were made from essentially the same clays, and the glaze analyses suggest fairly modest kiln temperatures, from about 1200° to 1240°C. The pots were wood-fired, without saggars, in the *long* or 'dragon' kilns typical of this part of China.

## High-lime blackware glazes

With the benefit of hindsight we can now see that it would have been technically difficult for the Deqing potters to have made good quality and reliable black glazes from their high-lime recipes, as glazes rich in both iron and lime run badly, look dull, and their colours tend to be poor. Perhaps for these reasons the early blackware kilns of north Zhejiang did not found any important Zhejiang blackware tradition. The province instead became a major producer of Yue-type stonewares, followed in the Song and Yuan dynasties by fine greenish celadons. A few black-glazed wares were made later at the Zhejiang celadon kilns near Longquan, but the real centres for blackware production in succeeding dynasties in south China were established to

the south of Zhejiang in northern Fujian province, and to the west of Zhejiang in Jiangxi province.

## Development of north Chinese blackware glazes

The technical improvements necessary to transform the Deqing-type blackware glazes into the magnificent temmoku glazes of Song China would have been much the same as those that turned Chinese lime glazes into the later lime-alkali glazes – namely a decrease in calcia (to lower high-temperature fluidity and to reduce unattractive crystallinity) and an increase in silica (to stiffen the glazes and to allow thicker application without the glazes' running in firing). Extra alkali would also have improved the general brilliance and richness of the glazes' surfaces.

These changes were not destined to happen at the northwestern Zhejiang kilns themselves, but exactly these improvements in composition can be traced in the next important group of blackware glazes that appeared in China – those used on the stonewares of the northern provinces of Henan, Shanxi, Shaanxi and Shandong. These northern blackware glazes (which seem to have first appeared in the 6th century AD) were not made by modifying existing high-lime glazes, but seem to have come into being fully formed through the simple expedient of using fusible northern clays as their main glaze ingredients. These abundant materials already contained silica, alumina, colouring oxides and fluxes in proportions ideal for blackware glazes.

## Tang blackwares

A few examples of 6th-century northern blackwares are known, but black-glazed stonewares did not become properly established in northern China until the Tang dynasty. Tang blackwares show typically sturdy, noble shapes with simple and austere glazes. They were important productions at a number of northern kilns, and they flourished particularly in the 8th and 9th centuries.

Table 52 Analyses of Tang 'teadust" and blackware glazes

|  | SiO$_2$ | Al$_2$O$_3$ | TiO$_2$ | Fe$_2$O$_3$ | CaO | MgO | K$_2$O | Na$_2$O | MnO | P$_2$O$_5$ |
|---|---|---|---|---|---|---|---|---|---|---|
| Yaozhou tea dust glaze | 62.4 | 13.5 | 0.7 | 5.1 | 10.3 | 3.0 | 2.7 | 1.3 | 0.1 | 0.2 |
| Yaozhou tea dust glaze | 63.8 | 13.6 | 0.7 | 5.1 | 9.1 | 2.6 | 3.0 | 1.2 | 0.1 | 0.2 |
| Yaozhou black glaze | 65.9 | 12.8 | 0.8 | 5.2 | 8.7 | 3.4 | 2.8 | 0.3 | –.– | –.– |

Table 53 Fired analyses of typical north Chinese loess (see also Table 84, p. 197)

|  | SiO$_2$ | Al$_2$O$_3$ | TiO$_2$ | Fe$_2$O$_3$ | CaO | MgO | K$_2$O | Na$_2$O | MnO | P$_2$O$_5$ |
|---|---|---|---|---|---|---|---|---|---|---|
| Xi'an loess | 65.6 | 14.6 | 0.6 | 5.4 | 6.8 | 2.3 | 3.3 | 1.4 | –.– | 0.3 |
| Xi'an loess | 64.8 | 16.1 | 0.9 | 4.6 | 7.1 | 2.2 | 2.4 | 1.5 | –.– | 0.2 |

Analyses of genuine Tang blackware glazes are scarce at present, and the best insight into the subject seems to come from some recently published compositions of Tang 'teadust' glazes – which are surprisingly abundant at Tang blackware kiln sites. It may be that these matt and greenish glazes were a popular style in Tang times, but it seems more likely that they were discarded in large numbers as teadust effects are typical of badly underfired blackware glazes.

For both blackwares and teadust glazes, loessic clays seem the most likely raw materials. These clays are enormously abundant in northern China and they contain about 4-6% of iron oxides, relatively high soda contents (0.7-2%), and a useful mixture of fluxes – namely calcia, magnesia and potassia (see Table 53).

At high temperatures (1250°C and above) many loesses will melt into good black glazes in their own right, but extra fusibility can be encouraged by small additions of wood ash or limestone. When glazes of this type are underfired they often develop fine crystals in cooling, particularly minerals that are various members of the pyroxene family such as augite and fasserite. These give a range of greenish, yellowish and brownish micro-crystalline effects – leading to such Chinese descriptions as 'eel-skin yellow', 'old monk's habit', 'snakeskin green' and 'teadust'. The relatively high magnesium oxide contents of loess encouraged these microcrystals to develop as MgO is an important component of the pyroxene family of minerals.

With greater heat, and a more thorough melt, Tang teadust glazes transform into dull-black and dull-brown colours. With still more heat they begin to show the rich, subtle and glossy glazes seen in the best examples of Tang black-glazed stonewares. For these more mature glaze qualities firing temperatures in the 1260°-1300°C range were probably needed, and the kiln atmospheres used were generally oxidising-to-neutral. The clay bodies used by the Tang blackware potters were usually light-firing stonewares of the clay-rich northern type.

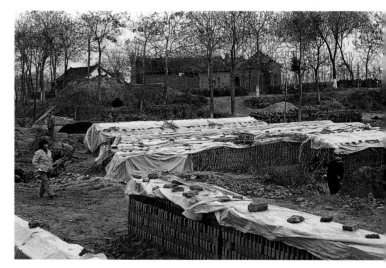

Brickmaking from loess in northern Henan province, 1985. Loess is a fine rock dust, blown south from the Mongolian deserts over the last 2.4 million years. It covers nearly one million square kilometres of northern China in its aeolian and alluvial forms – in some places to hundreds of metres in depth. This highly fertile material became the basis for north China's great agricultural civilisation, but is used here for making grey reduction-fired bricks. Loess bricks and tiles are fired in the 950°–1050°C, range, but the loess also makes a fine blackware glaze at temperatures from about 1270°–1300°C.

Black glazes that have relatively low iron oxide contents (4.5-6.5%) have a tendency to fire to a slightly dull, translucent yellowish-brown when thin – an odd effect reminiscent of old varnish. Probably because of this phenomenon, Tang temmoku glazes were usually applied to a reasonable thickness to ensure that fine and even blacks developed. Tang temmokus were among the first Chinese wares to exploit the possibilities of thick glaze application – a technique that reached its greatest potential in the Song dynasty, with the Jun glazes of north China, and the Longquan celadon and Guan ware glazes of the Zhejiang kilns.

## Yaozhou blackwares of the late Tang and Five Dynasties

Besides their regular production of teadust and plain black glazes, the Yaozhou potters at Huangbao also painted or trailed their black glazes in simple and symmetrical designs directly onto pale-slipped stoneware clays – leaving large areas of the clays unglazed to give a distinctive black-on-pale-buff contrast. A related (and reversed) approach was to paint or trail with rather refractory white glazes, mixed with a resist material. When this glaze-plus-resist mixture was dry, the black glazes were applied over the white painted or trailed designs. The black glazes immediately ran off the white glazes, which later developed in firing as white 'inlaid' patterns within a black background.

## 'Splashed' blackwares

Quite soon after the appearance of the plain Tang blackwares, a dramatic variant was evolved that exploited broad brushings, dippings and pourings of lighter overglazes on the black or brown grounds. These lighter glazes varied from a dry and yellowish-white to a fine, streaky, bluish opalescence, that interacted strongly with the black or brown glazes beneath. Most of these different effects can be put down to firing temperature, with the glossier glazes being the higher fired. Stoneware kilns in Henan province, such as Lushan and Huangdao, are famous for their Tang 'splashed' wares, but excavations have uncovered similar wares at the Yaozhou kilns in Shaanxi province, and even kilns as far south as Rongxian in Guangxi province experimented with this 'splashed temmoku' idea.

The best explanation for these splashed effects seems to be that ash-rich mixtures were applied to the raw blackware glazes before they were fired. Tang potters may have been inspired to experiment with this idea after observing the accidental bluish patches that sometimes developed on their wood-fired blackware glazes – caused either by a localised build-up of fly ash at high temperatures, or by drops of ash-rich slag falling onto the pots from the kiln roofs during firing. Deliberate application of wood ash (or perhaps pulverised ash-slag from the kiln walls) to the black glazes before firing would have been a logical way to recapture and control these 'splashed' glaze qualities.

Ash-decorated Tang blackware are magnificent ceramics, and the technique seems to have led eventually to the

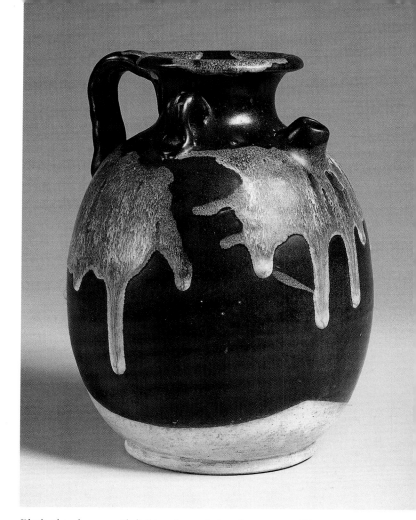

Black-glazed ewer with lighter glaze splashes. It seems possible that this style of ware was inspired by ash-slag dripping from the insides of the wood-fired blackware kilns in the Tang dynasty – although, in this case, the application of the 'splashes' was quite deliberate. It is still hard to establish the exact relationship of these opalescent overglazes to the later Jun ware glazes, often made at related sites in northern China. H. 9.3 in., 23.7 cm. Sotheby's.

development of Henan Jun wares (described in Chapter Six). Perhaps the most famous examples of Tang 'splashed' wares are the large narrow-waisted 'barbarian' drums made at the Henan kilns of Lushan in the late Tang dynasty, a fine example of which is on show in the Shanghai Museum.

The analyses in Table 54 are of five different examples of Tang splashed glazes, and they probably represent various mixtures of the light and dark glazes, sliced from the shards with a fine diamond saw. TJ1 is probably closest to the

Table 54 Analyses of 'splashed' or 'speckled Jun' glazes

|  | SiO$_2$ | Al$_2$O$_3$ | TiO$_2$ | Fe$_2$O$_3$ | CaO | MgO | K$_2$O | Na$_2$O | MnO | P$_2$O$_5$ |
|---|---|---|---|---|---|---|---|---|---|---|
| Glaze TJ1 | 67.4 | 11.3 | 0.4 | 2.2 | 11.4 | 1.0 | 4.2 | 0.3 | 0.1 | 1.85 |
| Glaze TJ2 | 67.1 | 12.4 | 0.8 | 3.9 | 9.2 | 1.9 | 2.5 | 0.7 | 0.1 | 2.0 |
| Glaze TJ4 | 68.6 | 14.1 | 0.95 | 4.8 | 5.7 | 1.8 | 2.7 | 0.6 | 0.1 | 1.0 |
| Glaze TJ5 | 70.0 | 13.6 | 0.7 | 5.1 | 5.4 | 1.7 | 2.5 | 0.75 | 0.1 | 0.01 |

'white' glaze in its composition, and TJ5 to the black. The similarity of TJ5 to the Tang 'teadust' glazes is interesting – as is the compositional similarity of TJ1 to later Henan Jun glazes, of which it may be a direct ancestor.

## Song blackware glazes of north China

During the Tang dynasty the most typical high-fired wares in China were oxidised blackwares and whitewares in the north, and reduction-fired greenwares in the south. The distribution of northern blackware kilns tended to follow the northern loess deposits, as this material supplied unlimited raw material for blackware glazes. The more sophisticated styles of blackware glazes, used in the Song and Jin dynasties in north China, seem to have used essentially the same materials as the Tang glazes although a general increase in firing temperatures, and improved refining of the northern clays, probably accounts for this rise in technical quality.

## Later styles of northern blackware

The old 'splashed' style of Tang blackware went out of fashion in the later 10th century, but the style was eventually replaced by a rather similar approach to decoration that used 'splashes' of iron-rich glazes or pigments on a black glaze ground. Initially the iron-rich painting was pleasantly abstract, giving random rusty markings, or a scattering of large iron-rich spots. In the latter Song, Jin and Yuan dynasties more realistically painted designs in iron-rich slips

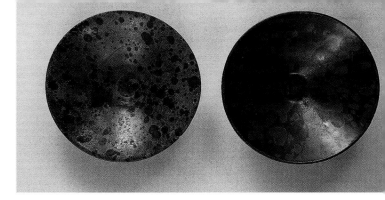

Two shallow bowls made from fine light-coloured stoneware clays, Northern Song to Jin dynasties, perhaps from the Guantai kilns. These two bowls have black glazes splashed with russet on their interiors, and overall russet glazes on their backs. The left-hand bowl is badly underfired, but it gives a good impression of how the rusty glazes were applied to the black glaze background, before the effect was softened by firing. D. 6.1 in., 15.5 cm, H. 2 in., 5 cm. Ashmolean Museum, Oxford, 1956.741.

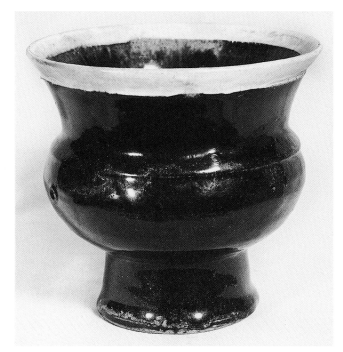

Blackware *zun* with white rim, Northern Song, late 11th–early 12th century, possibly from Yuzhou in Henan province. Deep white rims on blackware vessels are believed to evoke the broad metal rim-bands that were often applied to fine ceramics during this period. To achieve the effect, the black glaze was removed from the rim and replaced with white slip, which was then given a transparent glaze. H. and D. 13.25 cm. Buffalo Museum of Science, N.Y.

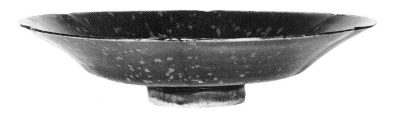

Fine northern blackware bowl with six-lobed rim and slightly indented sides, Northern Song dynasty. The lustrous black glaze on this bowl is flecked with rusty specks. The non-vitrifying northern clays allowed more extreme forms than were possible with southern porcelains – such as this imitation of a lacquer dish, with its wide overhang above its foot. A similar form was used for some contemporary Ding wares, but these were fired rim down. D. 7.75 in., 19.7 cm. Sotheby's.

Table 55 – Analyses of Song blackware glazes from north China

|  | $SiO_2$ | $Al_2O_3$ | $TiO_2$ | $Fe_2O_3$ | CaO | MgO | $K_2O$ | $Na_2O$ | MnO | $P_2O_5$ |
|---|---|---|---|---|---|---|---|---|---|---|
| Song temmoku | 65.8 | 16.3 | 0.95 | 5.7 | 5.6 | 2.4 | 2.3 | 1.0 | 0.07 | –.– |
| Song temmoku | 65.6 | 15.3 | 0.75 | 6.7 | 6.9 | 2.6 | 1.8 | 1.4 | 0.1 | –.– |
| Song temmoku | 65.8 | 14.4 | 0.9 | 6.6 | 6.8 | 2.3 | 2.6 | 0.8 | 0.1 | –.– |
| Song temmoku | 62.9 | 15.1 | 0.6 | 6.6 | 7.6 | 2.8 | 2.4 | 1.1 | 0.1 | 0.3 |

or pigments became popular as were radially-repeating brush-marks on the insides of bowls that echoed the arrangement of chrysanthemum petals.

Later Northern Song and Jin potters also exploited the way that northern black glazes tended to produce dull amber tones, rather than true blacks, where they were applied thinly. Vertical lines of white slip were sometimes trailed onto raw jars and bottles, before they were glazed overall in black. After firing the black glazes appeared almost white over the trailed lines – particularly if the raw glazes had been deliberately rubbed thinner on the raised ribs.

In north China, again during the Jin and Yuan dynasties, black glazes were sometimes combined with areas of white slip covered with clear glazes. Some of the most attractive examples of the technique were plain black

northern bowls with deep white rims – but the method was also used with painted Cizhou-type wares, where black glazes occasionally replaced black slips in the painted designs. The Guantai kilns in southern Hebei were one of many northern kiln complexes to experiment with this idea. A more typical Cizhou approach however was to raw-glaze overall with black or black-brown glazes, which were then cut or carved away to reveal the lighter stoneware bodies beneath. Northern sgraffito blackwares of various types were popular stonewares in the 12th and 13th centuries.

## Later northern blackwares

Despite the existence of some fairly refined examples, northern blackwares were essentially country wares, and they are often included within the general northern

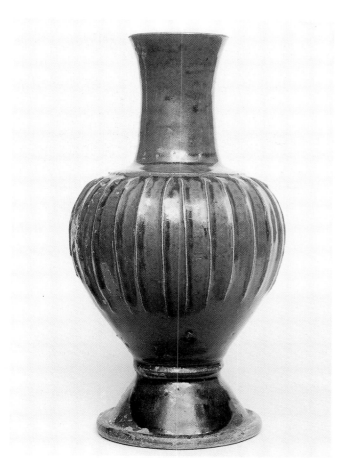

Blackware vase with a tall foot and trailed slip 'fluting', 12th–13th century. At the Guantai kiln site in southern Hebei province trailed slip lines with sharp top edges were used under black glazes. When the stoneware clays were relatively rich in iron (as in this case) the glazes can appear brown – but they become black over the white slip, except on the sharper slip-areas, where they appear almost white. The total fired effect can appear uncannily like carved fluting. H. 7.8 in., 19.5 cm. British Museum.

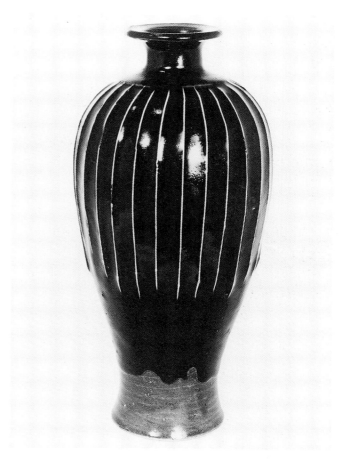

Tall black-glazed vase with ribs of trailed white slip, excavated at Qinghexian, Hebei province, Jin dynasty. Northern blackware glazes contain about 6% of iron oxide, and tend to fire to translucent amber-browns when thin and to rich glossy blacks when thick. When applied very thinly, over white slips, they appear almost white. All three effects have been exploited on this fine northern bottle. H. 7.3 in., 25.7 cm. Sotheby's.

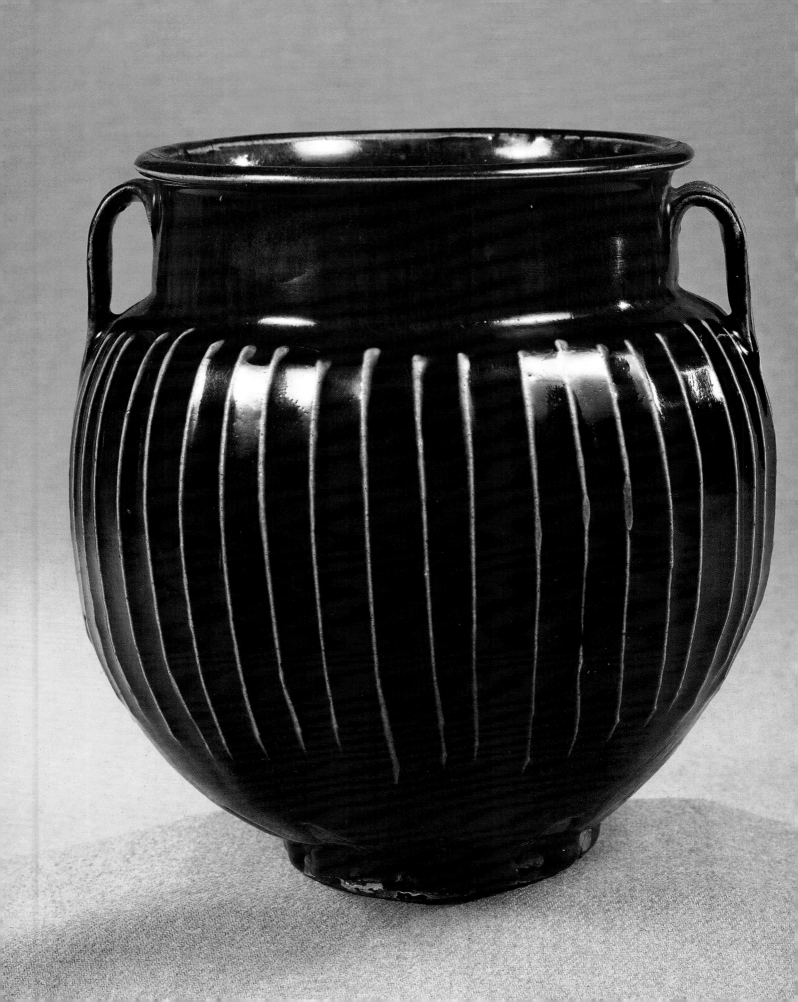

Country blackware kiln site near Shenhou, Henan province, photographed in 1985. The old Song fashion for deep white rims on blackware vessels has survived at this country workshop, where the local loess also provided the main material for the black glazes.

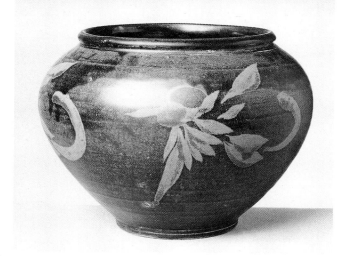

Blackware jar with subdued rusty painting of birds in flight, perhaps from Yu county, Henan province, Jin dynasty. Sometimes described as painted in overglaze iron oxide, it is not impossible that this group of wares was actually painted beneath the glaze with a thin iron-rich slip. In either case, the approach is rather different from decoration with russet glazes – the preferred technique with the 'splashed' style of northern blackware. H. 8.7 in., 22 cm. Victoria and Albert Museum.

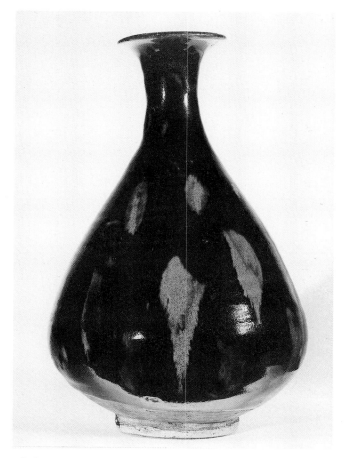

Blackware wine bottle with rusty splashes, Yuan dynasty, 14th century, probably from Henan province. The wide body and short neck suggest a Yuan date for this lively bottle. H. 10.6 in., 26.7 cm. British Museum.

Cizhou tradition. With the Mongol invasion of north China in AD1234, the quality of northern fine wares, such as Yaozhou celadon and Ding ware, which had already been badly damaged by the Tartar invasion of the 1127, dropped further still. At many kilns, such as Yaozhou in Shaanxi, blackwares – which had all but disappeared during the boom years of celadon production – re-emerged as a major ware. From the Yuan dynasty to the present day, the production of black-glazed stoneware of plainer style has survived at a number of country potteries across the loess-lands of northern China.

## South Chinese temmoku wares

Blackwares from northern China were made in a range of fine forms, such as ewers, bottles, jars and vases. Some examples are large, and most show a direct and expressive style of making that puts them among the first rank of Chinese country wares. Blackwares in southern China, by contrast, tend to be modest in scale, with a more limited repertoire of form – with tea bowls of various styles representing the main southern blackware production.

## *Jian temmoku*

Perhaps the most celebrated of the southern teabowl kilns are those that produced the Jian wares of northern Fujian province. This area has a distinguished history for blackware-making that extends from the Five Dynasties period

*Opposite*: Blackware jar with fine trailed slip under an oxidised blackware glaze, Jin dynasty, Henan or Hebei province. To some extent northern blackwares represent a microcosm of north China's geology – with the fusible loessic clays covering the more ancient and refractory kaolinitic materials. Christie's.

Cizhou-style vase, late 12th–early 13th century, probably from the Ciyaobao kilns, Ningxia Huizu Automonous Region. The blackware glaze has been applied raw by dipping or pouring, and then carved to reveal the pale brown stoneware clay beneath. This kiln site in the far northwest of China specialised in cut glaze techniques, without the use of white slip fill-ins. H. 12.3 in., 31 .2 cm. Fogg Art Museum, Harvard, 1977.22.

Cizhou ware jar, Yuan dynasty, 13th–14th century, perhaps from Shanxi province. Pale brown stoneware clay with white slip used to emphasise the carved black glaze design. In some styles of Cizhou ware the bare clay, exposed by carving, was painted with white slip, to give a stronger contrast to the carved pattern. This jar was fired before its carved decoration was complete. H. 14.3 in., 35.5 cm. The George Crofts Collection, Royal Ontario Museum, ROM 918.21. 495.

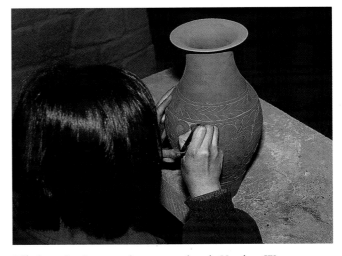

The 'cut-glaze' process demonstrated at the Yaozhou Ware Reproduction Factory, Shaanxi province, north China, in 1995. Blackwares were important Yaozhou productions both before and after celadon wares became the staple of the site. Analysis suggests that Yaozhou blackware glazes were made from local loess, which is also the glaze-material used for this demonstration

to the late 14th centuries AD. Millions of Jian ware tea bowls were made through this period at various mountain kiln sites within a 50 mile radius of Shuji – with Jianyang being a particularly important temmoku centre. This area is some 90 miles to the south of the celadon kilns of Longquan, although it is separated from southern Zhejiang by some very rugged terrain. Visitors to this mountainous area of northern Fujian describe it as one of the most spectacular of all ceramics-producing areas in China.

Before the making of blackwares began in northern Fujian, in the mid 10th century AD, the local potters were producing low-grade stonewares, with pale bodies and light green glazes that have a tendency to flake with burial. Over the last few years archaeologists from the county museum at Fuzhou have explored this district and they

believe that they have found the actual transition from greenwares to blackwares at a kiln site some ten miles from Jianyang where an old dragon kiln, once used for firing Yue-type wares, had been relined and converted to blackware production.

The rather small and shallow tea bowls from this mid-10th century site used darker bodies than the greenish stonewares they replaced, and their black glazes were plainer and duller than later Jian wares. It seems possible that the Jian blackware tradition began when some local potters applied their ancient clay-and-ash glaze-making principles to some local iron-rich clays. From these simple beginnings sprang a blackware industry that came to dominate tea bowl production in China. The Jian kilns eventually inspired countless regional imitations of their local wares – at kilns as widely separated as Yaozhou in Shaanxi, Jingdezhen in Jiangxi and Tushan in Hunan province.

## The Jian ware tea bowl

Seven distinct shapes of Jian temmoku bowl have been identified to date, but the rather conical bowl with a slight indent beneath the rim is the best known and most typical. Jian tea bowls of this type are about 5 inches wide and about 2-3.5 inches high. As a ceramic object this 'classic' Jian tea bowl must be one of the most perfect fusions of glaze, form and body in the history of Chinese ceramics. As a practical bowl for drinking hot green

whipped tea it was also unsurpassed. Its colour complemented green tea effectively, and the thick Jian clay also showed excellent insulating properties when held in the hand. In addition, the slight collaring of the bowl form near to its rim obliged the drinker to take the hot tea in small sips.

The original shape of the Jian tea bowl was subtlely transformed during firing by some movement and thickening of its temmoku glaze as it melted and moved down the bowl at high temperatures – with the glaze pooling in the bowl's well, and sometimes collecting in a thick roll on the outside of the bowl at the limit of pouring. Because of the fluidity of the Jian glaze, the bottom quarters or so of Jian tea bowls were usually left unglazed, with the brown, sandy-looking clays complementing the thick oily brilliance of the glazes above. Jian tea bowls are surprisingly heavy when handled – the fineness of the bowls' rims and the neatness of their turned feet disguised the fact that they were deliberately thrown and turned so that their walls became substantially thicker towards their bases, and their thick temmoku glazes also add substantially to their weight.

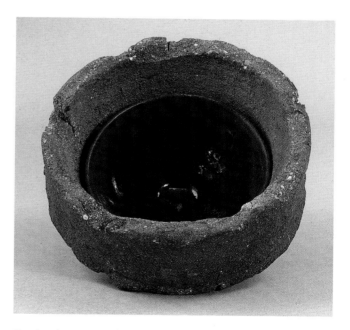

Jian bowl waster, stuck in its saggar, Southern Song dynasty. The rich glossiness, seen with many Jian ware glazes, probably owed a good deal to rapid cooling. In southern dragon kilns cold air was allowed to enter the parts of the kiln that had just been brought to full heat. The white-hot saggars and bowls heated this air, which then produced highly efficient combustion in the fuel added further up the kiln by side stoking. This ingress of cold air cooled the glazes rapidly through the temperature range where microcrystals tend to form (c. 1300°–1000°C). D. of saggar 6.9 in., 17.5 cm, H. 4.9 in., 12.5 cm. Ashmolean Museum Oxford, X 1530.

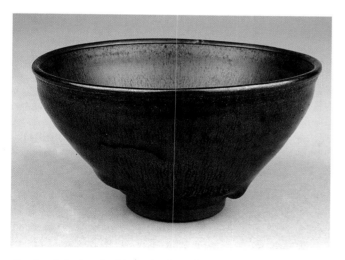

Jian hare's fur bowl with its rim bound in silver, Southern Song dynasty, northern Fujian province. Jian hare's fur glazes occur in many colours and qualities, but in most cases these are due to differences in firing and cooling, rather than to glaze composition. One of the rarest effects is the silvery-grey glaze, caused by a neutral firing atmosphere and the crystallisation of magnetic iron oxide on the glaze's surface during cooling. D. 4.8 in., 12.2 cm. By courtesy of the Percival David Foundation of Chinese Art, PDF 303.

## Glazing and firing

The raw iron-rich clays used for the Jian tea bowls were thickly coated with clay-and-ash glaze mixtures before firing, first by pouring the glaze in and out of the leather-hard bowl, and then by pouring the glaze over the outside of the inverted bowl, while slowly rotating it with the other hand. When dry, each bowl was set in its own saggar on a button of clay. These supporting clay buttons separated easily after firing due to their different rates of contraction from both saggar and bowl.

Tall bungs of saggars were set in the dragon kilns, propped against each other like wood in a stack. The Jian dragon kilns were among the longest in China, with one recently excavated Southern Song example, measuring 150 yards long. The firing temperatures used were generally between 1300° and 1330°C in order to melt the rather refractory and aluminous Jian glazes, while the high iron contents of the local clays dictated that the kiln atmospheres used were mainly oxidising-to-neutral.

These very high iron oxide stoneware clays are similar in composition to the 'purple earths' used from the early Ming dynasty onwards in Jiangsu province for making the famous Yixing unglazed red stoneware teapots – and they were probably not too different from many clays already used for making Neolithic earthenware in southeastern China.

Clays of this type are also similar to our own Etruria marls – red stoneware clays of carboniferous origin that occur near to Ruabon in north Wales, and also in north Staffordshire. Etruria marl was used in the 17th and 18th centuries to copy Yixing wares, and in the 19th and 20th centuries for making engineering bricks and quarry tiles. Various types of Etruria marl are sold today as commercial red clays for modern potters.

## Recipes for Jian glazes

Although dozens of Song Jian glazes have now been analysed, the original recipes used to make them are still unknown. However, the French potter Jean Girel has proposed that the Jian clays themselves could have been their main ingredient. Girel suggests that mixtures of about three parts of Jian ware clay with about two parts of wood ash could account for the published analyses of these glazes – assuming the use of a fairly aluminous wood ash in the original recipes. This would have been a very simple approach for such sophisticated effects but, as the Japanese potter Shoji Hamada once remarked about his own work

Table 56 Jian ware stoneware bodies – Song and Yuan

| | $SiO_2$ | $Al_2O_3$ | $TiO_2$ | $Fe_2O_3$ | CaO | MgO | $K_2O$ | $Na_2O$ | MnO | Loss |
|---|---|---|---|---|---|---|---|---|---|---|
| Song Jian body | 64.8 | 22.2 | 1.6 | 8.8 | 0.04 | 0.5 | 2.2 | 0.07 | 0.08 | 0.4 |
| Song Jian body | 63.3 | 23.1 | 1.1 | 9.6 | 0.2 | 0.4 | 2.5 | 0.06 | 0.09 | 0.6 |
| Song Jian body | 63.1 | 23.2 | 1.6 | 8.2 | 0.1 | 0.5 | 2.7 | 0.06 | 0.12 | 0.6 |

Table 57 Yixing red stonewares, Fujian Neolithic clays and Etruria marls compared

| | $SiO_2$ | $Al_2O_3$ | $TiO_2$ | $Fe_2O_3$ | CaO | MgO | $K_2O$ | $Na_2O$ | MnO |
|---|---|---|---|---|---|---|---|---|---|
| Yixing red stoneware | 62.5 | 25.9 | 1.3 | 7.75 | 0.4 | 0.36 | 1.4 | 0.07 | 0.1 |
| Yixing red stoneware | 60.7 | 23.4 | 1.15 | 9.95 | 0.2 | 0.6 | 2.8 | 0.07 | 0.02 |
| Fujian Neolithic clay | 57.5 | 29.0 | 0.8 | 8.5 | 0.4 | 0.7 | 2.6 | 0.4 | 0.04 |
| Jian temmoku body | 61.9 | 24.8 | 1.4 | 8.3 | 0.2 | 0.5 | 2.6 | 0.06 | 0.07 |
| N. Staffs. Etruria marl | 64.4 | 22.0 | 0.3 | 9.4 | 0.7 | 0.2 | 1.0 | 1.8 | –.– |

Table 58 Jian ware glazes and local raw materials

| | $SiO_2$ | $Al_2O_3$ | $TiO_2$ | $Fe_2O_3$ | CaO | MgO | $K_2O$ | $Na_2O$ | MnO | $P_2O_5$ | Loss |
|---|---|---|---|---|---|---|---|---|---|---|---|
| Song Jian glaze | 62.2 | 17.8 | 0.6 | 5.35 | 6.5 | 0.7 | 3.0 | 0.1 | 0.7 | 1.2 | –.– |
| Song Jian glaze | 61.1 | 18.1 | 0.6 | 5.3 | 7.4 | 1.9 | 3.0 | 0.1 | 0.7 | 1.2 | –.– |
| Song Jian glaze | 61.2 | 19.3 | 0.7 | 6.3 | 5.8 | 1.7 | 2.8 | 0.1 | 0.6 | 1.1 | –.– |
| 'Glaze stone' | 63.1 | 18.1 | 1.1 | 6.0 | 0.4 | 2.2 | 1.6 | 0.36 | 0.07 | –.– | 6.4 |
| Pine ash | 26.4 | 7.5 | 0.7 | 2.5 | 34.3 | 6.3 | 8.8 | 0.8 | 3.4 | –.– | 14.9 |
| Red clay | 48.2 | 25.0 | 1.4 | 11.9 | 0.04 | 0.5 | 2.1 | 0.08 | 0.21 | –.– | 10.4 |
| Mixed ash | 11.0 | 2.9 | –.– | 0.8 | 40.5 | 5.7 | 2.1 | 0.1 | 2.8 | 1.9 | 32.2 |

– 'my recipes may be simple, but my materials are very complicated!'. Body-clay and wood ash are certainly the preferred materials today for the excellent modern revivals of Jian temmoku wares that are produced in Fujian, although these present-day recipes also include a local iron-rich rock known as 'glaze stone', that is similar in composition to the Jian body-clay.

### The hare's fur effect

One of the most striking features of the Jian ware glaze is its fur-like streakiness. The mechanisms responsible for these effects have now been thoroughly studied by Chinese chemists with the whole process involving a series of quite separate stages as the glazes melted, matured, and then cooled:

• Once the Jian glaze had thoroughly melted, crystals of lime feldspar tended to separate from the molten glaze-matrix, particularly at the glaze-body interface. This left the remaining glaze lower in calcia and alumina and higher in iron oxide.

• A high-iron fraction then spontaneously separated from the remaining glaze in the form of iron-rich droplets. These droplets then coalesced to form a thin iron-rich layer within the molten glaze. The remaining glaze contained less iron in solution, but was still almost black in colour.

• Bubbles rising through the maturing glaze carried some of the iron-rich layer to the glaze-surface, where the material appeared as iron-rich spots within the blackish glaze. These spots of high-iron glass soon ran down the sides of the bowls under the influence of gravity, giving fine, brown, glassy streaks against a black glaze background.

• Dissolved iron oxides in these streaks, on the surface of the glaze, gradually crystallised out at high temperatures (and in cooling) to give various iron-rich minerals. If the kiln atmospheres were mainly reducing, greyish streaks of ferrous oxide would appear. If reducing-to-neutral, silvery streaks of magnetic iron oxide were formed. If fully oxidising, ferric oxide supplied foxy-red or yellowish-brown streaks within the blacker glazes. Combinations of these three crystalline states of iron oxide can also co-exist on a single Jian ware bowl.

• Where the glazes ran thinner (at the rims of the bowls), the colours were usually matt-brown or a dark matt-grey – again due to the crystallisation of iron-rich minerals. This tended to make the rims of Jian tea bowls slightly rough, and on some Jian tea bowls narrow bands of silver have been applied to disguise the effect.

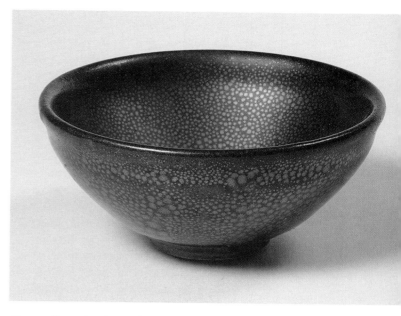

Henan oil spot bowl, Northern Song dynasty. Oil spot effects were achieved in north China by the application of an iron-rich slip beneath a conventional northern blackware glaze. As the glaze bubbled and boiled during its maturation, concentrations of iron oxide were carried to the glaze surface. During cooling these crystallised as magnetic iron oxide, which has a silvery hue. It is possible that the iron-rich slips were themselves rich in magnetite, and related to those used for black-and-white Cizhou-style wares. D. 3.5 in., 9 cm. By courtesy of the Percival David Foundation of Chinese Art, PDF 301.

Jian tea bowls that have been subjected to reduction-firing tend to show unusually dark bodies that often exhibit signs of over-firing, such as fine overall bloating. However, the glazes on these reduction-fired bowls can be exceptionally rich and glossy, with fine bluish-black colours, shot through with grey or silver streaks.

### Oil spot tea bowls

Bowls with streaky 'hare's fur' glazes are by far the commonest type of Jian temmoku ware, but it happened occasionally that kiln temperatures began to fall while the glazes were still boiling, thereby fixing the iron-rich spots before they could run down into streaks. Occasionally these spots crystallised as magnetite, giving silvery spots on a black background – the celebrated 'oil spot' effect. Bowls with true oil spot glazes from the Jian kilns are extremely scarce and much sought by collectors. Interestingly, the effect was copied in north China (a major market for Jian wares) in the Song and Jin dynasties – using a more reliable technique that involved the application of an iron-rich (and perhaps magnetite-based) slip beneath an ordinary black temmoku glaze. The success of this approach has meant that northern oil spot temmokus are less uncommon than the Jian originals.

## *Partridge feather temmokus*

'Partridge feather' glazes are mentioned in a 10th century Chinese text as being a speciality of the Jian kilns, but there has long been a debate as to what the term 'partridge feather' actually referred. Did it mean the fine markings on the back of the partridge, which were not unlike some 'hare's fur' glazes? Or was it a reference to the feathers on the breast of the partridge, that often show fairly large light-coloured spots?

The problem was resolved in 1990 when excavations at Jianyang uncovered a nearly complete shard of a Jian-type bowl with 66 carefully placed spots of white glaze on a black background. The foot of the bowl bore a carved *gong yu* mark – suggesting that it was originally intended for tribute. This then was the true Jian partridge feather glaze, with a design resembling the spotted breast of a partridge.

The effect of these icy white spots on a dark ground also makes sense of a Northern Song poet's description of a Jian bowl, as having markings that appear 'like melting snow on dark water' – a description that would be hard to better for this particular piece. Local potters in Fujian are already copying the Northern Song 'partridge spot' effect with some success. Where the white spots are thinner on these pieces they can appear almost yellow, due to some interaction with the iron-rich glazes beneath. A few Jian bowls with large rusty spots are also known – although in this case they seem to be southern versions of a popular northern style.

Another speciality (and rarity) of Jian temmoku production in the Song dynasty are the 'white temmoku' tea bowls that have glazes with greyish-white streaked surfaces. For a black glaze to fire white is certainly odd, but the effect seems less extraordinary when kiln wasters from the Jian sites are examined, as these often show grey-white or beige-white surfaces when they have been underfired. The cause of these white surfaces though is still a mystery – particularly as this colour appears so different from the greenish-brown 'tea-dust' effects typical of underfired

A shard of 'white Jian ware', Southern Song dynasty. 'White' Jian temmokus are really greyish and appear to use thin and highly siliceous white overglazes on top of the standard Jian blackware compositions. By courtesy of Professor Guo Yanyi, Shanghai Institute of Ceramics.

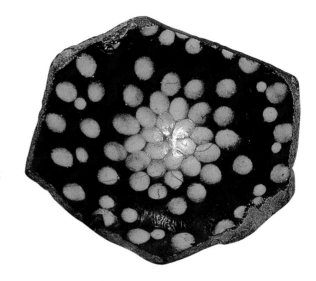

A shard of 'partridge spot' Jian ware temmoku. In this ultra-rare style of Jian ware, spots of a siliceous white porcelain glaze were applied to the raw temmoku glaze before firing. Very few complete examples are known. By courtesy of Professor Guo Yanyi, Shanghai Institute of Ceramics.

Table 59 Analyses of Jian 'partridge feather' glazes and their bodies

|  | SiO$_2$ | Al$_2$O$_3$ | TiO$_2$ | Fe$_2$O$_3$ | CaO | MgO | K$_2$O | Na$_2$O | MnO | P$_2$O$_5$ |
|---|---|---|---|---|---|---|---|---|---|---|
| Dark background glaze | 62.6 | 20.7 | 0.6 | 5.3 | 5.63 | 1.9 | 2.6 | 0.0 | 0.5 | –.– |
| White spots | 70.4 | 14.8 | –.– | 0.9 | 8.7 | 0.5 | 4.1 | 0.5 | –.– | –.– |

Table 60 Analyses of Jian 'white temmoku': dark base-glaze and white streaks

|  | SiO$_2$ | Al$_2$O$_3$ | TiO$_2$ | Fe$_2$O$_3$ | CaO | MgO | K$_2$O | Na$_2$O | MnO | P$_2$O$_5$ |
|---|---|---|---|---|---|---|---|---|---|---|
| Dark background glaze | 63.3 | 18.3 | 0.7 | 6.6 | 4.8 | 1.6 | 3.2 | 0.1 | 0.8 | 0.6 |
| White streaks | 78.9 | 12.3 | 0.65 | 1.4 | 1.3 | 0.2 | 4.8 | 0.1 | 0.1 | 0.2 |

northern blackware glazes and which are of rather similar chemical composition.

These pale colours in very underfired Jian temmoku glazes may be another example of glazes spontaneously unmixing while they are still wet on the wares – causing the ash components, which are rich in lime and magnesia, to remain near the surface, and eventually to produce pale lime-rich minerals in cooling.

True 'white temmoku' bowls, however, were not obviously underfired and in the one example that has been examined to date this white layer has been shown to be high in silica, and low in lime and iron – closer in fact to the composition of the white glaze used in the partridge spot temmokus. True Jian white temmokus may therefore have used a thin wash of a high-silica, porcelain-stone based glaze over the standard black glaze, to achieve these unusual qualities of grey-white streaks against a darker ground.

## Colour-changeable Jian wares

Jian temmoku bowls that change colour as they are moved in the light have also been recorded and valued since Song times. The effect seems related to lustre and, like lustre, appears to be a light-interference phenomenon, caused either by a thin semi-transparent layer on the surface of the bowl, or by local changes in the refractive indices of the glazes.

It has been suggested by China's leading researcher on Jian temmoku wares, Professor Chen Xianqui of Shanghai, that the celebrated 'colour changeable' Jian wares, recorded

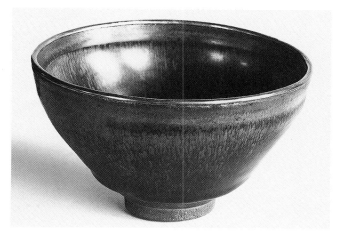

'Hare's fur' teabowl from the Jian kilns with a silver-bound rim, 12th-13th C. AD. Bowls in this style were fired in huge quantities for hundreds of years in the dragon kilns of northern Fujian. The 'hare's fur' effect is caused by the bubbling and boiling of the glaze during firing. This disturbed higher- and lower-iron layers that had developed within the glaze earlier in the firing, bringing specks of iron-rich glass to the surface, which then ran down as streaks through the effects of gravity. D 5.2 in. 13 cm. British Museum, OA 1947.7-12.142

by a writer of the Southern Song, may actually refer to the famous spotted 'yohen' temmoku bowls, of which only four examples are known in the world. This small group of Jian tea bowls is remarkable for the large and small iridescent spots on their inside surfaces, and their Japanese name, yohen, suggests a changing and glittering brilliance. All four yohen bowls are Japanese National Treasures and Important Cultural Objects. Three are held in museum collections in Tokyo, Osaka and Kyoto, while the fourth is in a private collection in Kamakura. The best example is the Seikado Library, in Tokyo, and the inside surface of this bowl displays constellations of spots on a black ground that show a lustrous change from yellow, to green, to blue, according to how the light catches the glaze. These iridescent spots are ringed by semi-opaque fringes that are bluish-white.

Numerous theories have been proposed to explain the yohen phenomena but the extreme rarity of these bowls means that ideas have to be developed from speculation and observation, rather than from direct destructive analysis. Unlike wares of equivalent rarity (Black Ding, Ru, and Xuande copper-red) no shards are known of the fully developed yohen effect, so it may be awhile before the physics and chemistries of these extraordinary glazes are properly examined and understood.

## Jizhou temmokus

Second only to Jian as an important temmoku centre in southern China was the kiln complex at Jizhou which operated some 275 miles to the west of Jian in Jiangxi province. Like Jian, the Jizhou kilns had a vast output of tea bowls which ranged from the sketchily made to the well-finished and finely decorated. However, while the Jian-ware makers relied largely on the countless transformations that were possible from a single glaze composition, the Jizhou potters preferred to enhance their brown or black stoneware glazes with applications of lighter, yellowish buff overglazes in a manner that brings to mind the earlier Tang splashed blackwares of northern China.

In combining these light and dark glazes the Jizhou potters developed a wealth of decorative techniques that included paper resist, sgraffito, random splashing, and lively abstract glaze-trailing. The Jizhou blackware glazes were applied raw to the wares, which were once-fired to fairly low stoneware temperatures, generally in oxidising-to-neutral atmospheres.

### The Jizhou body

Superficially the Jizhou body seems a dull material, particularly when compared with the warm and earthy Jian temmoku clays. The Jizhou bodies vary from a putty-grey-white to a light biscuit colour, and it has been proposed that the fully glazed sides and rather skimpy feet

that typify Jizhou bowls may have been evolved to disguise these rather pale clays.

From the technical point of view however, the Jizhou clays show some interesting compositions with potassium oxide levels higher even than those found in typical Jingdezhen porcelains. The iron and titanium oxide impurities in the Jizhou clays probably prevented any true translucency from developing during firing, but these high flux contents did allow a tough and vitreous ceramic material to develop at moderate stoneware temperatures (1220°-1290°C). The fired density of the Jizhou clays probably accounts for the unusual weight of many Jizhou bowls. These bodies seem to have been prepared from impure quartz-mica porcelain-stones and, even after preparation, often contain some fairly large grains of quartz.

## Jizhou glazes

Typical Jizhou wares have matt, brown-black glazes, variously dipped, splashed or trailed with dryish cream-coloured overglazes. Other Jizhou wares show greater integration of their glazes, with smoother surfaces and curdled and streaky mottling. Where the two glazes have merged and melted during firing they sometimes develop a curious mouldy quality, reminiscent of old tortoiseshell. Other Jizhou bowls are far glossier in their surfaces, with shiny black-brown grounds embellished with transparent golden-yellow splashes and streaks – a fine effect that is known in China as the 'tiger's-fur glaze'.

Although these various glaze qualities seem to indicate that a range of recipes were in use at Jizhou, chemical analysis again shows that they are due more to the effects of kiln temperatures and atmospheres on essentially similar compositions. The Jizhou kilns were of the traditional 'dragon' design – highly efficient in terms of fuel economy, but rather uneven in firing.

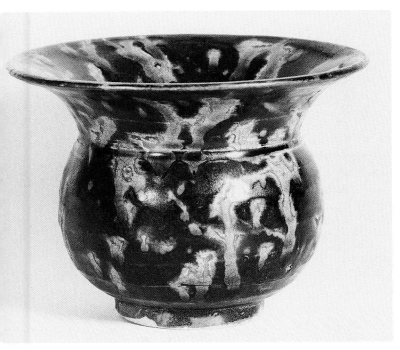

Vessel with flaring rim and tortoiseshell glaze, probably Yuan dynasty. By dabbing and dribbling ash-rich glazes onto the raw Jizhou black-brown glazes, 'tortoiseshell' or 'tiger's fur' effects could be produced in firing. The amber colours come from local dilution of the iron content of the darker glaze, and the milkiness, evident in some areas, is probably due to high phosphorus contents in the plant ashes used in the overglazes. D. (top) 5.2 in., 13.25 cm. H. 4 in., 10 cm. Buffalo Museum of Science, N.Y.

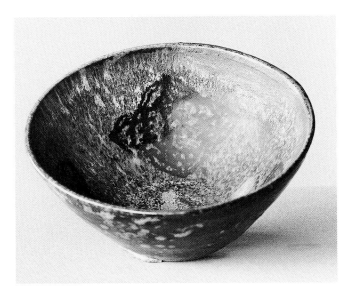

Jizhou tea-bowl with cut-paper resist decoration, Southern Song dynasty. Cut paper shapes were sometimes used with northern Cizhou slipwares, and the technique was adapted for glaze resist at the Jizhou kilns. In this method, the symmetrical paper forms (cut from folded paper) were lain onto the damp black glazes, before the lighter overglazes were applied. When dry the paper shapes were peeled away, together with the overglazes on their surfaces, to reveal the darker glazes beneath. D. 4 in., 10 cm. Victoria and Albert Museum.

Table 61 Jizhou ware clay bodies

| | SiO$_2$ | Al$_2$O$_3$ | TiO$_2$ | Fe$_2$O$_3$ | CaO | MgO | K$_2$O | Na$_2$O | MnO | P$_2$O$_5$ |
|---|---|---|---|---|---|---|---|---|---|---|
| Jizhou clay body | 61.8 | 27.8 | 1.1 | 0.9 | 0.1 | 0.3 | 5.8 | 0.4 | 0.01 | 0.2 |
| Jizhou clay body | 62.0 | 27.4 | 1.1 | 1.6 | 0.01 | 0.3 | 6.4 | 0.3 | –.– | 0.2 |

The discovery of relatively high magnesia levels (2-4% MgO) in most Jizhou temmokus and their overglazes may help to explain their unusual sensitivity to heat. Magnesia becomes a powerful flux above about 1260°C, when it gives rich and glossy surfaces to glazes. Below about 1260°C magnesia behaves more as an anti-flux, and has a dulling effect on glazes. The striking variations in gloss, apparent when a group of Jizhou tea bowls are examined together, probably owe a good deal to this phenomenon.

Another influence on glaze melt would have been kiln atmosphere. Iron oxide is a powerful flux in reduction and this means that reduction-fired Jizhou wares would have been much shinier than their oxidised equivalents. In general, though, the kiln atmospheres at Jizhou were oxidising to neutral, and the wares were fired below the 1260°C 'horizon', making the great mass of Jizhou wares subdued in their surface qualities although still displaying an austerely attractive character.

## Jizhou blackware glazes and their lighter overglazes

The dark Jizhou glazes contain about 6% of iron oxides, together with about 1% manganous oxide (MnO). Analysis of excavated batches of unused Jizhou blackware glazes that have survived from Song times suggests that they were made from mixtures of body clay, plant ash and an iron-manganese ore called iron-lazulite. Jizhou glazes were of the iron-rich lime-alkali type, with unusually high phosphorus levels (1.5-3.1%), perhaps through the use of palm-leaf ash in the glaze recipes. These high $P_2O_5$ levels may well have encouraged the milky opalescence typical of many Jizhou glazes.

The lighter Jizhou overglazes are more of a problem. They have been analysed but, like the 'speckle Jun' glazes described above, only after careful removal of the glazes from excavated shards. The analyses below therefore represent indeterminate mixtures of the lighter overglazes and the darker temmoku glazes beneath.

A number of writers have proposed that these lighter Jizhou overglazes were made from recipes rich in high-silica ashes, giving compositions similar to traditional Japanese *nuka* glazes, which they superficially resemble. Analysis though seems to tell a different story, suggesting that the Jizhou overglazes were richer in calcia and magnesia, and lower in silica, than the temmoku glazes beneath. This type of composition encouraged white diopside (CaO.MgO.SiO$_2$) crystals to grow in the glazes during cooling and it is this mineral, rather than undissolved silica, that gives the glazes their dry-looking and semi-opaque surfaces when underfired.

However, with increasing heat, both the calcia and the magnesia in the overglazes work effectively as fluxes, producing areas of yellowish-milky opalescence and then, with still more heat, dissolving and diluting the temmokus beneath to create rich transparent ambers. In the best examples of Jizhou temmoku ware, the milky opalescence combines with the transparent amber to create a dramatic curdled streakiness. The main ingredients in these Jizhou overglazes were probably wood ashes of some low-silica type.

## Jizhou decorative techniques

Jizhou temmoku wares were often embellished with designs of birds, flowers, insects or Chinese characters set within panels. The designs are repeated within the bowls and seem to have been achieved by laying cut-paper patterns onto the damp, raw, temmoku glazes, then re-glazing with the ash-rich overglazes. When nearly dry the paper shapes were carefully picked off and peeled away (together with any overglazes on their surfaces) to reveal the complex cut-paper designs as dark patterns on a lighter ground. In firing these images lost some definition, but gained in richness through the high-temperature reactions between the glazes. Similar patterns can occur as gilding on some Jizhou bowls (probably achieved with paper-cut gold leaf), so some of these lighter overglazes may be hinting at more expensive gilded effects.

Table 62 Brown-black Jizhou glazes

| | SiO$_2$ | Al$_2$O$_3$ | TiO$_2$ | Fe$_2$O$_3$ | CaO | MgO | K$_2$O | Na$_2$O | MnO | P$_2$O$_5$ |
|---|---|---|---|---|---|---|---|---|---|---|
| Brown-black glaze | 60.3 | 13.8 | 0.5 | 5.5 | 9.0 | 3.2 | 3.2 | 0.25 | 0.8 | 1.8 |
| Brown-black glaze | 59.3 | 14.3 | 0.7 | 5.4 | 9.2 | 2.8 | 4.7 | 0.3 | 1.1 | 1.7 |
| 'Splashed' black glaze | 58.4 | 14.3 | 0.5 | 7.7 | 7.5 | 2.9 | 5.0 | 0.4 | 0.8 | 2.0 |

Table 63 Analysis of Jizhou light overglazes

| | SiO$_2$ | Al$_2$O$_3$ | TiO$_2$ | Fe$_2$O$_3$ | CaO | MgO | K$_2$O | Na$_2$O | MnO | P$_2$O$_5$ |
|---|---|---|---|---|---|---|---|---|---|---|
| Jizhou light yellow glaze | 56.8 | 14.6 | 0.7 | 4.9 | 12.5 | 2.7 | 4.2 | 0.3 | 1.1 | 1.8 |

In a less formal style of Jizhou bowl, the same pale over-glazes were often splashed and trailed on top of the dark glazes in a lively 'abstract expressionist' style. Sometimes these lighter glazes remained dry and opaque after firing, and in slight relief, but, with enough heat, they could dissolve the iron-rich glazes beneath, giving golden-yellow loops, streaks and splashes on a dark and glossy ground.

## Jizhou leaf temmoku

One of the most interesting (and sought after) Jizhou effects is seen in the Jizhou 'leaf temmoku' bowls where the image of a natural leaf, complete with all its veins, and often in sharp outline, is preserved inside the bowl as a lighter image on a black-brown ground. There seems little doubt that an actual leaf was laid inside the raw temmoku bowls when the glaze was still wet, and the bowls were then dried and fired in the usual way. Whether the leaf was first dipped in some material (such as the Jizhou overglaze) to improve its definition is not known. It has also been suggested that the leaf may have been 'pre-rotted' before it was applied, so that only its lacy skeleton remained. Again this is not certain, but it would certainly have lessened the tendency of the leaf to curl up as it dried during the early stages of the firing.

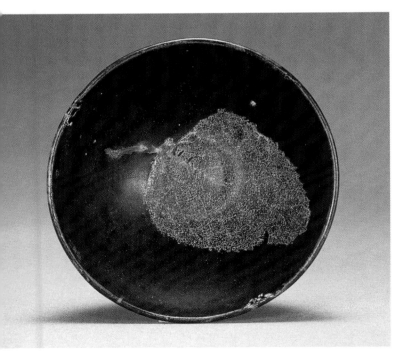

Jizhou leaf bowl, Southern Song dynasty. In this technique the leaf is left *in situ* after being laid onto the wet black glaze. The leaf burns away in firing, but a combination of thinner glaze and the oxides in the leaf's ash (particularly those of calcium, magnesium and phosphorus) reproduce the leaf's form accurately in the black stoneware glaze. D. 4.4 in., 11.1 cm. Sotheby's.

Some of the colour differences apparent in these bowls must be due to the way that low-iron temmoku glazes appear much lighter where they are thinner, for example where a leaf has displaced some of the raw temmoku glaze. There is also the consideration that most leaves are rich in both glaze fluxes and in phosphorous oxides, so the ashes that they produced in firing could well have turned the temmokus locally to a lighter colour.

The success of the technique may also have owed something to the type of leaf used, as plant ashes can vary substantially in their chemistries. In Shanghai in 1992, the Korean potter Lee Kyung Hee proposed that the most typical 'Jizhou leaf' came from the Pipal or 'Bo' tree – a rare and enormously long-lived tree that grows in India, Sri Lanka, China and Korea. This is the tree under which the Lord Buddha is traditionally said to have received enlightenment, and Buddhist monks in Korea still make beads from the seeds of the Pipal fruit. If Dr Lee is correct, the leaf in the Jizhou bowl may have once carried its own Buddhist message to its user.

### Body materials in Chinese glazes

The likelihood that Jian and Jizhou glazes both made substantial use of their local body clays in their original glaze recipes makes them very much part of a south Chinese approach to glaze construction that dates back to the early Bronze Age. Just how different north Chinese stoneware and porcelain glazes are in their approaches to glaze design is shown in the following chart, that relates glaze composition to body materials:

Chart 3 Likely usage of body materials in northern and southern Chinese glazes

| Ware | Body material important in glaze | Body material little used in glaze |
|---|---|---|
| *North Chinese ceramics* | | |
| Ding ware | | ○ |
| Xing ware | | ○ |
| Yaozhou ware | | ○ |
| Ru ware | | ○ |
| Jun ware | | ○ |
| Northern blackware | | ○ |
| Cizhou ware | | ○ |
| | | |
| *South Chinese ceramics* | | |
| Yue and Yue-type wares | ○ | |
| Changsha wares | ○ | |
| Early Jingdezhen porcelains | ○ | |
| Dehua porcelains | ○ | |
| Longquan celadon | ○ | |
| Guan ware | | ○ |
| Jizhou blackwares | ○ | |
| Jian wares | ○ | |

## Blackware glazes on porcelain

All the blackwares discussed so far have been applied to stonewares, but some the finest Chinese blackware effects appear on porcelains. Perhaps the rarest of these are the 'Black Ding wares' of Hebei province described in their own time (the Northern Song dynasty) as being as 'rare as black swans'. Today they are rarer still with perhaps less than a dozen examples in the West and Japan, while China has only shards of this ware, excavated from the Ding kiln site at Quyangxian.

Unlike contemporary white Ding wares these shallow black bowls were fired on their feet, probably because the fluidity of their shiny black glazes would have stuck them to their setters if the *fushao* (upside-down) firing method had been used. Some examples of Black Ding ware held in Japan and the USA show traces of gilding – apparently through the application of 'papercut' gold leaf. There is a tradition in China that this style of gilding was fired on, after an initial application with garlic oil, but replication of the process has proved elusive.

One Chinese shard of Black Ding ware has been analysed, and its glaze was shown to have a typical loess-like composition. An original firing temperature to about 1280°-90°C seems likely, in the oxidising atmosphere typical of the coal-burning Ding ware kilns.

Less rare, but equally famous, are the 'persimmon coloured' or 'purple Ding' glazes. These have fine russet colours, reminiscent of Northern Song brown lacquer, and their forms tend to follow Northern Song and Jin lacquer style. Their rusty colours derive from high alumina and silica contents in the glazes, combined with their low flux levels, particularly calcia. This probably encouraged the crystallisation of iron-rich minerals during cooling. Similar lower flux iron-rich glazes may have been used to supply

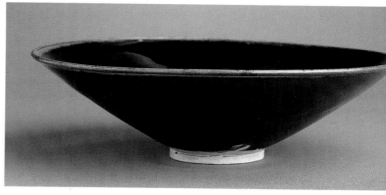

Black Ding ware bowl, 11th–12th century. Like 'Red Dehua', Black Ding is a great rarity from a kiln complex that specialised in white or cream-coloured porcelains. The glazes appear to have been made from loess, in the usual northern manner, but the cream-white porcelain clay gives the glaze a lacquer-like gloss and depth. On this example the rim is finished with a thin copper-alloy band, but the amber colour of the glaze in this area can still be seen where it is thin. (Unlike white Ding wares, the bowl was fired on its foot.) Some examples of Black Ding ware show traces of gilding, but they are not evident on this example. D. 7.3 in., 18.5 cm. By courtesy of the Percival David Foundation of Chinese Art, PDF 300.

the rusty elements used on Northern Song 'iron-splashed' blackwares, already described on page 142.

Judging from the analyses above, both the Black Ding and the russet-coloured glazes, could have been made from local loessic materials.

Plain rusty-brown or bronze-coloured glazes of this type were copied as far south as the Rongxian kilns (near Guilin) in the Northern Song dynasty, and also at the Jingdezhen kilns in the Yuan dynasty. The Jingdezhen kilns, in fact, have always had a certain reputation for blackwares and for high-iron glazes in general. This tradition saw a major revival in the Qing dynasty when an important range of high-iron porcelain glazes were developed, particularly in the first half of the 18th century.

Table 64 Analyses of 'Black Ding' glaze

|  | $SiO_2$ | $Al_2O_3$ | $TiO_2$ | $Fe_2O_3$ | CaO | MgO | $K_2O$ | $Na_2O$ |
|---|---|---|---|---|---|---|---|---|
| Black Ding glaze | 63.5 | 16.7 | 0.7 | 5.3 | 7.5 | 2.9 | 2.2 | 0.7 |

Table 65 Analyses of russet-coloured Ding glazes

|  | $SiO_2$ | $Al_2O_3$ | $TiO_2$ | $Fe_2O_3$ | CaO | MgO | $K_2O$ | $Na_2O$ | MnO |
|---|---|---|---|---|---|---|---|---|---|
| Russet-coloured glaze | 64.8 | 19.4 | 1.0 | 5.7 | 2.8 | 2.3 | 2.0 | 2.0 | 0.04 |
| Russet-coloured glaze | 69.1 | 17.6 | 1.1 | 6.3 | 1.5 | 1.7 | 2.7 | 1.8 | 0.1 |
| Russet-coloured glaze | 68.0 | 16.4 | 0.8 | 2.3 | 3.5 | 2.1 | 2.6 | 1.1 | 0.1 |



The obvious exception to this principle is Guan ware, and this may be further evidence for a northern influence on Guan glaze technology.

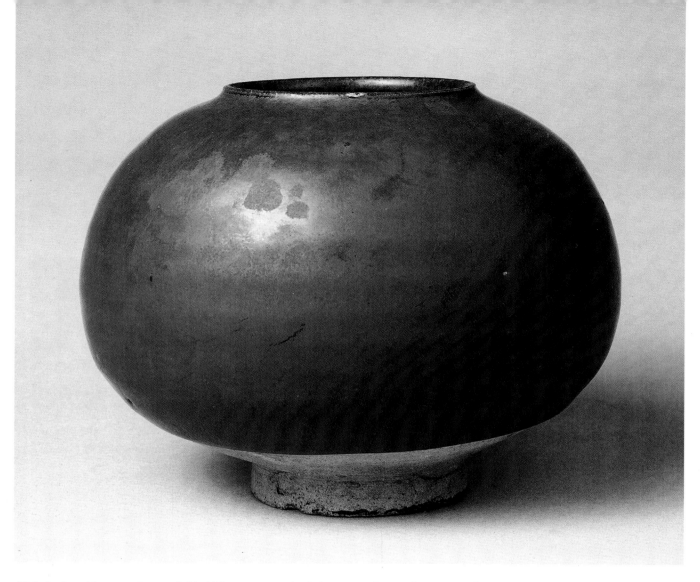

Globular jar with russet glaze, probably 12th century AD. Analysis suggests that northern russet glazes were less fusible than the closely related blackware glazes, and therefore more likely to form iron-rich microcrystals during cooling. D 5 in., 12.5 cm. Carter Fine Art.

### High-iron porcelain glazes of the Jingdezhen kilns

Of the wealth of Jingdezhen high-iron porcelain glazes made in the Qing dynasty (1644-1911), the 'mirror-black' is probably the most familiar. This differs from the Black Ding glaze in being coloured by iron, cobalt and manganese oxides – rather than by iron alone. The highish manganese content (about 3%) of the Jingdezhen mirror black glaze contributed to its lustrous brilliance, and its cobalt content prevented the glaze from appearing too brown after firing. Its original recipe was described by Georges Vogt in his famous essay on Jingdezhen porcelain practice, first published in 1900. Vogt describes the original Chinese glaze as a mixture of siliceous red clay, glaze ash (calcium carbonate), and a low grade of Chinese cobalt. Its maturing temperature was about 1230°C, and the wares were raw-fired in a cooler part of a big *zhenyao* kiln. Similar glazes were in use at Jingdezhen as late as the 1950s and the glaze has recently been revived at Jingdezhen as part of the *San yang kai tai* effects, described on page 184.

### The gold-bronze or dead-leaf glaze

Also analysed by Vogt was the *tze-kin* or *kou-tong* glaze – a long-running Jingdezhen favourite that had a surface like burnished bronze. Similar glazes, but with slightly duller surfaces, were used in the 14th century at Jingdezhen for glazing stemcups. Jingdezhen bronze-coloured glazes were particularly popular in the 17th-18th century when they were used on a style of Jingdezhen porcelain that combined the bronze-coloured glaze with blue-and-white underglaze painting – a style known in the West as Batavian ware.

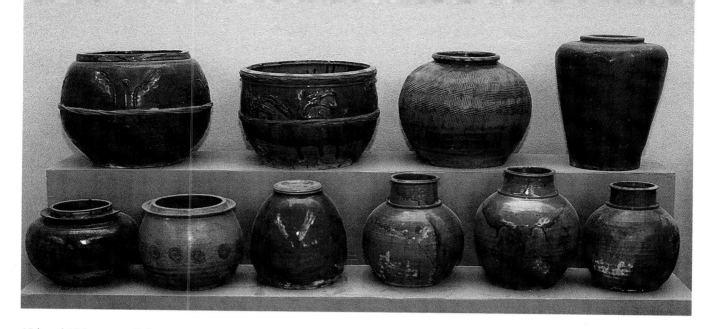

19th and 20th-century Fujian country-style jars, Quanzhou Museum, Fujian, China.
High-firing southern brownware glazes tend to be high in lime, fast-cooled and rather glossy.
China's recent folk wares are rather neglected and this is a fine display in a Chinese museum.

Georges Vogt revived this bronze glaze successfully at Sèvres in the late 19th century, which may explain how it became such a popular glaze on French porcelain coffee wares. Vogt found from original notes on Jingdezhen porcelain practice that the Chinese glaze was a mixture of glaze stone, 'glaze ash' and a siliceous red clay – the same clay in fact as was used in the mirror black recipe.

Two other late Jingdezhen high-iron porcelain glazes of note are the 'iron rust glaze' and the 'teadust' glaze – the former being a rusty-red and the latter a speckled green. Both glazes were used on rather formal moulded and thrown vases, but neither type has yet been analysed chemically. Similar results to the 'iron red' can be had by adding about 16% red iron oxide to an ordinary porcelain glaze, firing in reduction to about 1280°C, oxidising strongly, and then cooling fairly slowly. Oddly enough, the greenish teadust glaze may have been a close relation to the iron red, as the recipe above gives a strongly crystalline green when fired to a slightly lower temperature (say 1240°C), and also cooled fairly slowly.

Since Vogt's pioneering work in the 1880s, Jingdezhen high-iron glazes of the Qing dynasty have been rather neglected by modern investigators, and glazes such as the high temperature coral red, the teadust glaze, and the iron-red, still await proper chemical investigation in order to complete a full survey of Chinese high-temperature, iron-rich compositions.

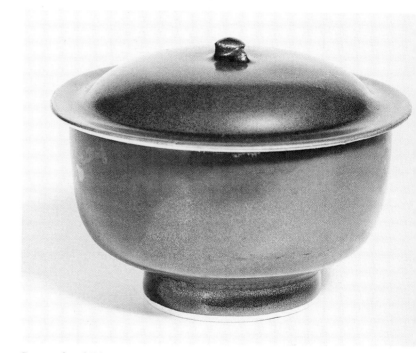

Russet glazed Ding ware covered bowl, Northern Song or Jin dynasty. D. 4 in., 10 cm. H. 3.1 in., 8 cm. Buffalo Museum of Science, N.Y.

Table 66 Analyses of Jingdezhen mirror black glazes

|  | $SiO_2$ | $Al_2O_3$ | $TiO_2$ | $Fe_2O_3$ | CaO | MgO | $(K_2O+Na_2O)$ | MnO | CoO |
|---|---|---|---|---|---|---|---|---|---|
| 1882 mirror black | 61.9 | 11.4 | tr. | 9.1 | 10.6 | 0.1 | (4.2) | 3.0 | 0.4 |
| 1950s mirror black | 61.5 | 13.0 | 0.23 | 6.5 | 13.0 | 1.5 | (4.1) |  | 0.3 | –.– |

Table 67 Analysis of the Jingdezhen golden bronze glaze

|  | $SiO_2$ | $Al_2O_3$ | $TiO_2$ | $Fe_2O_3$ | CaO | MgO | $K_2O$ | $Na_2O$ |
|---|---|---|---|---|---|---|---|---|
| 1882 Jingdezhen bronze glaze | 66.7 | 16.7 | 0.4 | 3.75 | 7.35 | 0.5 | 3.1 | 1.5 |

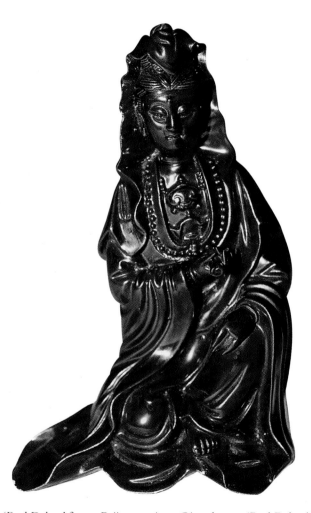

'Red Dehua' figure, Fujian province, Qing dynasty. 'Red Dehua' is rare variation on the usual ivory-white style of Dehua porcelain glaze, and the colour looks much like polished hardwood. These glazes have yet to be studied analytically, but it is possible that they are the standard Dehua porcelain glazes with added iron.

# FURTHER READING

## *BOOKS AND EXHIBITION CATALOGUES*

Robert D. Mowry, *Hare's Fur, Tortoiseshell and Partridge Feathers – Chinese Brown and Black Glazed Ceramics, 400-1400*, Harvard University Art Museum, 1996

## *PAPERS AND ARTICLES*

Chen Xianqiu, Chen Shiping, Huang Ruifu, Zhou Xuelin and Ruan Meling, 'A scientific study on Jian temmoku wares in the Song Dynasty', *Scientific and Technological Insights on Ancient Chinese Pottery and Porcelain*, (ed. Shanghai Institute of Ceramics) pp 227-35, Science Press, Beijing, 1986

Chen Xianqiu, Huang Ruifu, Jiang Lingzhang, Yu Ling and Ruan Meiling, 'The Structural nature of Jianyang hare's fur temmoku imitations', *Scientific and Technological Insights on Ancient Chinese Pottery and Porcelain*, (ed. Shanghai Institute of Ceramics) pp 236-40, Science Press, Beijing, 1986

Jean Girel, 'Fourrure de lièvre – a propos d'un bol Jian des Collections Baur', *Collections Baur – 47*, Geneva, 1988

Kazuo Yamasaki, 'Scientific studies on the special temmoku bowls, *yohen* and oil spot', *Scientific and Technological Insights on Ancient Chinese Pottery and Porcelain*, (ed. Shanghai Institute of Ceramics), pp 245-8, Science Press, Beijing, 1986

# Chapter 8

# IRON IN CHINESE GLAZES

Virtually all the Chinese glazes discussed so far have relied on iron for their colours, and it is probably true to say that no ceramic tradition in the world has made greater nor more imaginative use of iron oxides in the colouring of its clays and glazes than has that of China. In some ways the whole early history of Chinese ceramics can be regarded as a systematic exploration of all the colouring potentials of iron oxides – in bodies and glazes, in low-fired and high-fired wares, and in both oxidising and reducing atmospheres. By the late 12th century AD Chinese potters had used oxides of iron to provide, red, yellow, amber, green, blue, brown, black and even silver colours in ceramic glazes – not as crude spectrum colours but as tones and qualities in close harmony with our everyday unconscious awareness of iron as the prime colourant of the inorganic world.

How iron came to hold this central position in Chinese ceramic technology can now be seen as an inevitable consequence of the Chinese potters' approach to the collection of raw materials, which has always been marked by a direct and highly creative use of local rocks and clays, and of the ashes of plants and trees that grow upon them.

### Distribution of iron in the Earth's crust

Iron oxides are by far the most common colouring oxides in the earth's crust and nearly 7% of the earth's uppermost layer is estimated as iron in its various states of oxidation. Apart from a sprinkling of iron meteorites, very little uncombined elemental metallic iron exists naturally in the Earth's crust – any iron that is not united with oxygen tends to be combined with sulphur, water or carbon dioxide, or tied up in complex iron-rich minerals such as black micas and olivine. This abundance of iron compounds has had a profound effect on the colours that surround us: ordinary rocks, clays, earths and sands all owe their colours to the iron minerals they contain and, in the man-made world, bricks, tiles, concrete and even glass are either lightly or strongly coloured by these same iron compounds.

It might be assumed from the above that any ceramic tradition in the world must inevitably make extensive use of iron – simply because the oxide is so difficult to avoid in ceramic raw materials. However, this widespread use of iron oxide as a glaze colourant in Chinese ceramics is actually in marked contrast to another major ceramic tradition of the Old World – that of the Middle East. In Islamic ceramics in particular, the oxides of copper, cobalt, manganese and tin played far more important roles as glaze colourants than iron. Islamic glazes are essentially glasses, and were deliberately made from low-iron raw materials, while their clay bodies often consisted largely of quartz (a low-iron mineral), with lesser amounts of glass and white clay (also low in iron). In Islamic ceramics the use of iron oxides as glaze and body colourants was very much the exception rather than the rule.

### Titanium dioxide

The only other ceramic colouring oxide that is at all significant in the higher crustal rocks is titanium dioxide ($TiO_2$, 'titania'), which averages about 0.75% by weight. Titania is therefore another important presence in most

Test bar showing the influence of titanium dioxide on a lime-alkali glaze containing about 1% of iron oxide, and fired to about 1260°C in reduction. With iron alone the glaze shows a bluish tone but this is soon modified to green by the addition of titanium dioxide. The titania increments in this test are in 0.1% steps, left to right – and as little as 0.2% $TiO_2$ has an obviously yellowing effect on the glaze colour.

ceramic raw materials used for Chinese stonewares. When titania combines with iron oxide it has a powerful yellowing effect on iron solution colours, particularly on Chinese celadon glazes when small amounts of titania (usually about 0.2 to 0.5%) change the natural bluish tones of reduced iron oxide towards the range of cool greens, grey-greens, green-brown and olive-green glazes that were produced for centuries at the stoneware kilns of northern and southern China. It was not until the potters of south China discovered titania-free raw materials (porcelain stones) in the 10th century AD that reduction-fired glazes of the watery-blue *yingqing* type became widely used in Chinese ceramics.

### The origin of iron in the earth's crust

The iron that plays such a vital role in Chinese ceramics, particularly in Chinese glazes, had its origins in the explosion of a nameless star, early in the history of our universe. Spectrographic study of starlight has shown that all the common elements are being continuously created by thermonuclear reactions within the hearts of stars and that the order in which these elements are created follows a definite sequence in a star's life. Iron is almost the last element to appear and its presence indicates that the star is in a state of rapid decline that must end in explosion, extinction or inward collapse. If the star is large enough, it will eventually explode and billions of cubic miles of 'star dust' will be strewn through space.

It is believed that a small part of just such a cloud of stellar debris accumulated to produce the planet Earth. As the dusts, gases and ices condensed their temperatures rose until the whole proto-planet became molten. Much of the abundant iron that was present sank by gravity towards the Earth's centre – rather as the heavy metal collects at the bottom of a blast furnace. A great deal of our planet therefore consists of iron, particularly at the Earth's core which is believed to be largely iron and nickel, and still at an incandescent heat of perhaps 4000°C – but in a solid state due to the enormous gravitational pressures from the rocks above.

This separation process, when the Earth was new, drained much of the iron from its surface although enough remained for iron compounds to make a substantial part of the Earth's crust, and of the rocks, clays and shales that are present in its topmost layer.

The abundance of iron oxides in Chinese ceramics can therefore be partly explained by the origins of the Earth itself, and partly by the traditionally direct approach of Chinese potters in choosing their raw materials. However, the remarkable range of glaze colours that are possible from iron oxides in ceramic glazes are the result of the essential chemistry of iron itself, particularly the various ways in which the metal can combine with oxygen.

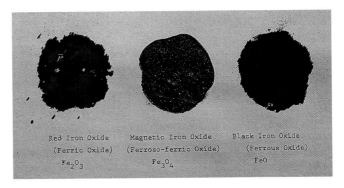

Red Iron Oxide (Ferric Oxide) $Fe_2O_3$     Magnetic Iron Oxide (Ferroso-ferric Oxide) $Fe_3O_4$     Black Iron Oxide (Ferrous Oxide) $FeO$

The three oxides of iron in their crystalline forms: red, magnetic and black. Iron in these states can exist in clay bodies, where they help to determine the fired colours of clays. In some cases crystalline iron oxides will also form (or survive) in glazes, once again appearing in these three oxide colours.

### States of iron oxide

Iron can combine with oxygen in three ways – as red iron oxide ($Fe_2O_3$), as the silvery-grey magnetic iron oxide ($Fe_3O_4$), and as black iron oxide ($FeO$). These are the three natural colours of pure iron oxide crystals and these various oxides are often present in ceramic raw materials and in fired clays. Sometimes one or other oxide state will dominate (giving red, metallic blue-black, or grey clays respectively) but the fired colour of a clay body can often represent indeterminate mixtures of all three. At higher kiln temperatures (1100°C+), iron oxide tends to combine with alumina in the clay body to produce a yellowish mineral, and the reddish or pinkish tones, typical of oxidised low-fired ceramics, fade away to be replaced by browns, buffs, creams and muddy yellows.

### Iron oxides in solution

Iron oxides in clays tend to survive or develop as their crystalline forms, but when the same oxides are present in glazes the minute iron oxide crystals gradually dissolve into the glassy matrix of the molten glaze. Once in solution iron oxides provide a further range of ceramic colours that are quite distinct from the colours of the iron minerals themselves. For example, when ferric oxide (red iron oxide) is dissolved in a glaze or glass it will give ivory to straw tones from about 0.5–2.0% by weight, then yellows at 2–3%, on to amber (3–4%), then amber-brown (4–5%), then eventually to black (about 6–8%). Dissolved ferrous oxide (black iron oxide) by contrast will always give cold colours, starting with cool, icy-blue glazes (0.5–1.0%), darkening to a bluish bottle green (2–4%), then eventually to a shiny black (4–8%), but to a black of noticeably colder hue than that supplied by ferric oxide.

As these oxides dissolve, free iron atoms enter into the glazes' glassy structures, as positively charged atoms that are known as *ions*. Red iron oxide (ferric oxide) gives $Fe^{3+}$

Test bar, showing the effect of adding red iron oxide ($Fe_2O_3$) in 1% increments to a high-lead glaze. In these quantities ferric oxide dissolves in the molten glaze to give $Fe^{3+}$ ions. These colour the glaze from straw to dark brown, with various shades of yellow and amber appearing at about 3–4% $Fe_2O_3$. Fired to 1060°C in oxidation.

Test bars showing lime-alkali glazes with increasing iron oxide contents, fired in both oxidation and reduction. In this case the iron oxide increments are in 2% steps. Besides the obviously warm colours in oxidation and cool colours in reduction, the reduction-fired bar also shows a reddish effect at 16% iron. This is due to the re-oxidation of fine iron oxide crystals on the glaze surface during cooling – where an over-saturation of iron oxide in the glaze has caused them to grow. This iron-red effect in reduction was exploited in the Jingdezhen 'iron rust glazes' of the Qing dynasty. (The glaze recipe used was 85 Cornish stone, 15 whiting, and the firing temperature was 1270°C.)

Close up of the iron-red glaze above, showing the ferric oxide crystals.

ions and black iron oxide (ferrous oxide) gives $Fe^{2+}$ ions. Strictly speaking $Fe^{2+}$ ions are colourless in glazes and it seems that the characteristic cold colours from iron oxide in reduction-fired glazes are actually mixtures of $Fe^{2+}$ ions with smaller amounts of $Fe^{3+}$ ions. Nonetheless, glazes containing $Fe^{2+}$ ions alone are very rarely achieved in

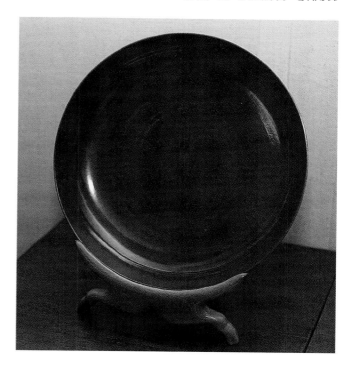

Low-firing yellow and red monochrome glazes on porcelain, early 16th century AD, Jingdezhen kilns. Both the yellow and red glazes are high in lead and coloured with ferric oxide. They were fired to about 1000° and 800°C respectively – after application to already-fired transparent porcelain glazes. The yellow glaze contains about 3% ferric oxide which has dissolved totally in the lead glaze to give $Fe^{3+}$ ions in the lead-rich glass. In the red glaze (which contains about 20% ferric oxide) most of the iron has either not dissolved, or has re-crystallised in cooling, giving the matt and opaque red colour.

ordinary pottery kilns so this colourless effect is hardly ever seen. Magnetic iron oxide (ferroso-ferric oxide) does not seem to dissolve in glazes in the same way as the two other oxides of iron; this oxide remains either in its crystalline state, or gradually breaks down to give mixtures of $Fe^{3+}$ and $Fe^{2+}$ ions.

### Glazes overloaded with iron oxide

The amount of iron oxide that any glaze can dissolve is limited and, once this limit is reached (about 7–10% in typical Chinese glazes) excess iron oxide tends to crystallise at the glaze surface as it cools. The oxides then become susceptible to the prevailing kiln atmospheres – giving red (ferric oxide), silvery-grey (ferroso-ferric oxide) or grey-black colours (ferrous oxide), or sometimes combinations of all three. These fine iron oxide crystals grow on the glaze surface, often extending downwards, through the glaze thickness itself, rendering the glaze opaque and its surface slightly matt.

### Transformation of iron oxides through reduction

It is quite possible to change the colours that a particular iron oxide will give in a clay or a glaze during firing by the processes known as oxidation and reduction, and these can greatly extend the colour potentials of particular clay-glaze combinations. Oxidation tends to be the natural state of a burning kiln, while some manipulation of the kiln is needed by the potter or fireman in order to develop a good reducing atmosphere.

### Reduction firing

Reduction during firing is relatively easy to achieve, and must have happened naturally in most developing ceramic traditions. By cutting down the amount of air entering the fireboxes of the kiln, or by over-stoking the firebox with

A further influence on iron colours in glazes is the degree of reduction that they have received during firing. In this test the same celadon glaze has been fired in oxidation (right), a neutral atmosphere (centre), and in good reduction (left). However, it is surprisingly difficult to make blue celadons fire green with this approach, as may be seen with the *yingqing* shards on page 55. (All tests were fired to 1260°C.)

fuel, inefficient burning occurs and 'reducing' gases begin pouring through the kiln chamber. These are mainly carbon monoxide (CO) with lesser amounts of hydrogen ($H_2$). Both are 'oxygen hungry' gases that will actively convert to the more stable compounds of carbon dioxide ($CO_2$) and water ($H_2O$). To achieve this transformation the reducing gases 'steal' oxygen from where they can – including from iron in its most oxidised (red or ferric) state in clays and in glazes. The oxygen-depleted ferric oxide is thus transformed into its less oxygen-rich black or ferrous condition.

In chemical terms the red iron oxide with its greater amount of oxygen ($Fe_2O_3$) is known as the 'higher' oxide, while black iron oxide, with its lesser amount of oxygen (FeO) is known as the 'lower' oxide – hence the term 'reduction' to describe this conversion. In pottery kilns reduction of iron oxide tends to stop at the black, ferrous, state, although full reduction to elemental metallic iron (Fe) was practised regularly by the Chinese in making cast iron in blast furnaces, as early as the 5th century BC.

The colour implications of this simple process were profound. A single iron-bearing clay could be made to fire red, brown or grey according to the degree of reduction it received and the proportions of ferric to ferrous oxide that resulted from the firing. An added bonus was that ferrous (black iron) oxide works as a flux above about 900°C, and simple earthenware clays subjected to reduction could be made much tougher than their oxidised equivalents, fired to the same temperatures.

Most unglazed Chinese bricks and tiles are grey, due to their deliberate firing and cooling in reduction and this has been the preferred technique for firing bricks and tiles in China for more than 2000 years. Chinese texts show that, from at least Han times, many brick kilns used water-assisted reduction, and kilns for firing grey bricks can still be seen in the Chinese countryside, surmounted by huge pottery jars containing water.

### Water gas reduction

This curious reduction process involved introducing small amounts of water into the kiln chamber or the kiln firebox. Where water-assisted reduction is used in the West the water is dripped intermittently onto the burning fuel. The water then combines with any red-hot carbon, producing carbon monoxide and hydrogen – a process expressed by the following equation:

$$H_2O + C = CO + H_2$$

The resulting carbon monoxide-hydrogen mixture is known chemically as 'water gas'.

In China the more usual approach seems to be to allow water to trickle down channels on the insides of the kiln walls. At the same time as the water is introduced, the

Interior of a Chinese kiln used for the reduction firing of loessic bricks through the water-gas effect. In this process water is trickled down the inside walls of the kiln while it is at full heat, after closing the flues somewhat to generate smoke. Steam reacts with red-hot carbon particles in the smoke to give hydrogen and carbon monoxide. Both gases reduce red iron oxide to black, and turn the bricks grey. The yellowish colour of the raw loess comes from hydrated (water containing) iron minerals in the clay. These break down to red iron oxide at about 500°C. Henan province, North China.

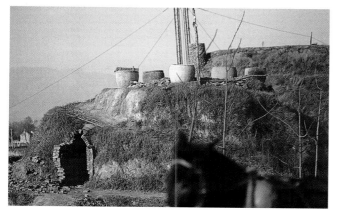

Exterior of a Chinese brick-kiln designed for water-gas reduction. Note the five large water jars on the kiln's roof. Hydrogen reduction (as it is sometimes called) can be highly explosive, and needs some care in its use. Henan province, north China.

amount of air burning the fuel is drastically reduced, causing black smoke (fine carbon) to fill the kiln chamber. The water then flashes to steam on the red-hot kiln walls and reacts with the incandescent carbon particles in the kiln's atmosphere to produce a water gas mixture. Once generated, the strongly-reducing water gas turns the red bricks grey, and also burns actively in the kiln chamber, providing extra heat for the firing and replacing some of the energy used to turn the water to steam. Water-assisted reduction is also used at Jingdezhen in the few wood-burning kilns that survive in the city, although in this case the water is introduced at the front of the kiln, directly into the kiln's firebox. How extensively these water-reduction processes were used throughout history at other Chinese kilns, where reduction-firing was practised, is still rather difficult to assess.

Short section of China's Great Wall showing reduction-fired bricks made from loess. With clays (unlike glazes) reduction has to be sustained during early cooling, otherwise the bricks tend to re-oxidise to the yellowish-grey colours, seen in some examples here.

## Reduction in glazes

One essential difference between reduction in clay bodies and in glazes is the way that clay bodies can be reduced or oxidised at any stage during the firing, but glazes must be subjected to reduction before they melt. Once iron-coloured glazes become glassy they are largely impervious to reducing gases or to re-oxidation if they are already reduced. This last phenomenon is of considerable practical use to potters as it means that the inefficient (and therefore expensive) burning process of reduction can be suspended once the glazes are properly melted. Also, reduction need not be continued through cooling, when the kiln atmosphere tends to clear naturally to an oxidising state. The only conditions under which melted glazes might re-oxidise is when they are very thinly applied, or when an excess of iron has caused iron oxide crystals to develop on the glaze surface during cooling.

With clays however the effects are different, and reduction may often be reversed by high-temperature re-oxidation. This means that it is quite possible for unglazed areas of a pot to re-oxidise to the warm earthy colours of

ferric oxide while the glaze on the same piece (and the clay protected by the molten glaze) retains the cold blue, green or grey colours typical of iron in its lower oxidation state. The depth to which a clay will re-oxidise depends largely on how vitrified it has become during firing. With dense glassy clays, such as southern stonewares and porcelains, some re-oxidation may occur, but it is often only 'skin deep', with only the uppermost layer of the clay changing colour. A good example of this is seen in the vitreous Longquan celadon bodies, where the reddish re-oxidation is entirely superficial, and the hard greyish porcellaneous stoneware beneath can be easily revealed by mild abrasion. With more open and less vitreous bodies (the clays used for Yuan dynasty Jun wares for example) the clays re-oxidise easily, and to some depth.

This combination of warm, superficially re-oxidised clays, and cool well-reduced glazes, is one of the happiest effects in Chinese ceramics. It is seen in the 'purple rims and iron feet' of Guan wares and in the warm, earthy, unglazed clays that contrast with the curdled and clouded blueness of Jun wares. It is also familiar in the slightly orange clays and icy-blue glazes of many *yingqing* porcelains, and it appears too in the archaic, semi-glazed 'proto-porcelain' of north Zhejiang and Jiangsu provinces, where unglazed, reddish or purple-brown clays harmonise with the dark olive-green ash glazes that cover the upper halves of the wares.

## Oxidised and reduced glazes occurring together

If only part of a pot has caught the reducing flame it is quite possible for oxidised and reduced zones to occur on the same glaze; it is also possible for reduction-fired saturated-iron glazes to re-oxidise on cooling, in the same way as clays. A good example of this latter effect is seen in the 18th-century 'rust red' monochrome glazes of Jingdezhen. The surfaces of these 'overloaded iron' glazes re-oxidise on cooling to a rusty mass of ferric oxide crystals, while the ordinary porcelain glazes used inside the vessels, and applied inside their foot-rings, retain the cool bluish tone of reduced iron.

## Reduction of Chinese lead glazes

An important exception to glazes that can be successfully reduced are those that are rich in lead oxide. If lead glazes are accidentally reduced while they are still melting, they tend to turn black, and to boil and blister, with the effect being caused by the way that lead oxide (PbO) is easily reduced to lead metal (Pb). This results in bubbles and blisters forming in the glazes, while precipitated lead turns the glaze grey-black.

In China lead glazes are largely low-firing compositions used for architectural and burial wares, and for onglaze enamels applied to stonewares and porcelains. Chinese lead glazes coloured with iron are therefore almost always oxidised, and are consequently warm in tone and display a fine range of yellows, ambers, browns and reds. In some cases, however, Chinese lead glazes coloured with iron can show greenish colours, not unlike dark celadons. In these examples it tends to be the iron-rich *clays* beneath the glazes that have become reduced at a very early stage in the firing or, more usually, have not had time to oxidise from their naturally reduced states. Rapidly melting lead glazes tend to seal in the reduced clay – supplying a greenish cast to the nearly-transparent lead glazes above – although the glazes themselves are oxidised.

## Examples of iron-oxide colours in Chinese glazes

All the colour possibilities from iron oxide described above have been exploited by Chinese potters and they provide the wealth of iron colours for which Chinese ceramics are so universally admired. In the order that these colours are found in the spectrum, their use in Chinese ceramics has been broadly as follows:

**RED** As described later, in Chapter Ten, the first use of the crystalline iron-red effects in Chinese glazes occurred in north China on the rare 'glass-paste' decorated earthenwares of the late 3rd century BC. However, the principle then seems to have been lost in China until the late 12th century AD. At this time potters in north China rediscovered the fact that high-lead glazes overloaded with ferric oxide (8% plus) give warm iron-red enamels as the excess of iron oxide allowed much of it to survive in its red crystalline state. From the later 12th century to the present day, the iron-red enamel has been used continuously in China, particularly as an outlining colour in overglaze enamels.

In the 18th century a similar approach was used to make iron-red porcelain glazes, which were overloaded with iron oxide to provide 'rust-red' monochromes. These glazes were fired in reduction, but the excess iron crystallised out during cooling, when it re-oxidised on the surface of the glaze as a dense mass of red, ferric oxide crystals. This high-temperature glaze was more subdued than the low temperature red.

**ORANGE** Also in the 18th century it was discovered that by replacing some of the lead oxide in the traditional red porcelain enamel recipe by potassium nitrate an orange tone was possible, similar in colour to red lacquer. These glazes are known as 'coral reds' and their orange tones were often improved by applying them over iron-yellow enamels. High temperature orange-reds were also made at Jingdezhen in the 18th century. These have not yet been analysed, but their appearance suggests a similar approach

to that used in Japanese Shino glaze – that is, the use of a highly feldspathic low-lime porcelain glaze with a small (i.e < 2.0%) iron oxide content. Thin application, reduction firing and oxidised cooling are all necessary for the high-temperature version of the iron-based orange-red colour to develop.

**YELLOW** Amber-yellow glazes, made from ferric oxide dissolved in a lead-baria base, feature on the rare 'glass-paste' jars mentioned above. Iron yellow lead glazes were also used on the famous Tang earthenware burial figures and pottery of the 7th to 9th centuries AD. However the purest use of the effect is seen in the famous 'imperial yellow' monochrome. This was an all-over iron-yellow enamel containing about 3.5% ferric oxide in a lead silicate base. The white porcelain body or glaze beneath the enamel enhanced the luminosity of this transparent colour.

**GREEN** Iron in moderate reduction ($Fe^{2+}$ with $Fe^{3+}$) combined with traces of titania provides the wealth of high-temperature stoneware and porcelain glazes known as 'celadons'. These glazes have been the backbone of Chinese ceramics for some 3000 years, and no two celadon greens seem exactly alike in colour or quality. The amounts of iron oxide in Chinese celadon glazes vary from about 0.5 to 2.5% by weight. Opaque crystalline greens are also seen in some Chinese teadust effects, but in this case the colour seems due to the growth of pyroxene crystals in the cooling glazes.

**BLUE** A preponderance of ferrous oxide in solution, in the absence of titania, will give cool bluish colours from about 0.5 to 1.5%. Examples of such iron-blue Chinese glazes are the *yingqing* (shadow-blue) porcelain glazes of the 10th to the 14th centuries, and the refined Longquan celadons of the *kinuta* type. The Jun glazes of north China are also blue, but the colour here seems to be an optical effect that overpowers the natural iron-titanium greens that might be expected from the glazes' colourant percentages.

**BLACK** Blackware glazes were much later in their establishment in China than greenware glazes, as the ancient high-ash greenware recipes gave murky and crystalline results when the iron oxide levels exceeded about 3%. However, by making their black stoneware glazes from the fusible clays of the Great Central Plain Chinese potters of the 6th century AD began a successful blackware style that was later imitated throughout China with many fascinating local variations. Most Chinese blackware glazes contain about 6% iron oxides, and they were usually fired in oxidation to between 1250° and 1320°C.

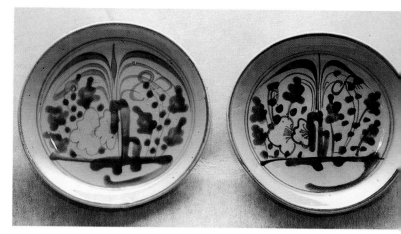

Country porcelain plates from Fujian province ('Minan ware'), Qing dynasty, fired in reduction (left) and in oxidation (right). Pure cobalt oxide is rather insensitive to kiln atmosphere and gives blues under most conditions. However the cobalt ores used for most Chinese underglaze-blue wares were rich either in iron oxides (early wares) or in manganese oxides (later wares). Both types of impure cobalt pigment fire grey-brown in oxidation, so reduction firing has been essential with most Chinese underglaze-blue. A further reason for this practice was the rather high iron contents of Chinese porcelain materials (typically 0.5 to 1% iron oxides), which tend to give straw-colours in oxidised kilns.

### Traces of iron in Chinese glazes

All the above are definite colours from iron oxides and in most cases they rely on the substantial presence of iron in the glaze raw materials. However, almost as important to the appearance of Chinese ceramics are the slight traces of iron that are present in porcelain glazes. In oxidation these provide the cream colours of Ding wares, and the ivory-white tones of the southern Dehua porcelains. By contrast, the faintly bluish-white colours typical of Jingdezhen wares are evidence of thorough and deliberate reduction during firing, often assisted by water-gas effects.

## FURTHER READING

*BOOKS*

John Ayres. Margaret Medley and Nigel Wood, *Iron in the Fire*, Oriental Ceramic Society, London, 1988

A. L. Hetherington, *Chinese Ceramic Glazes*, Cambridge, 1937

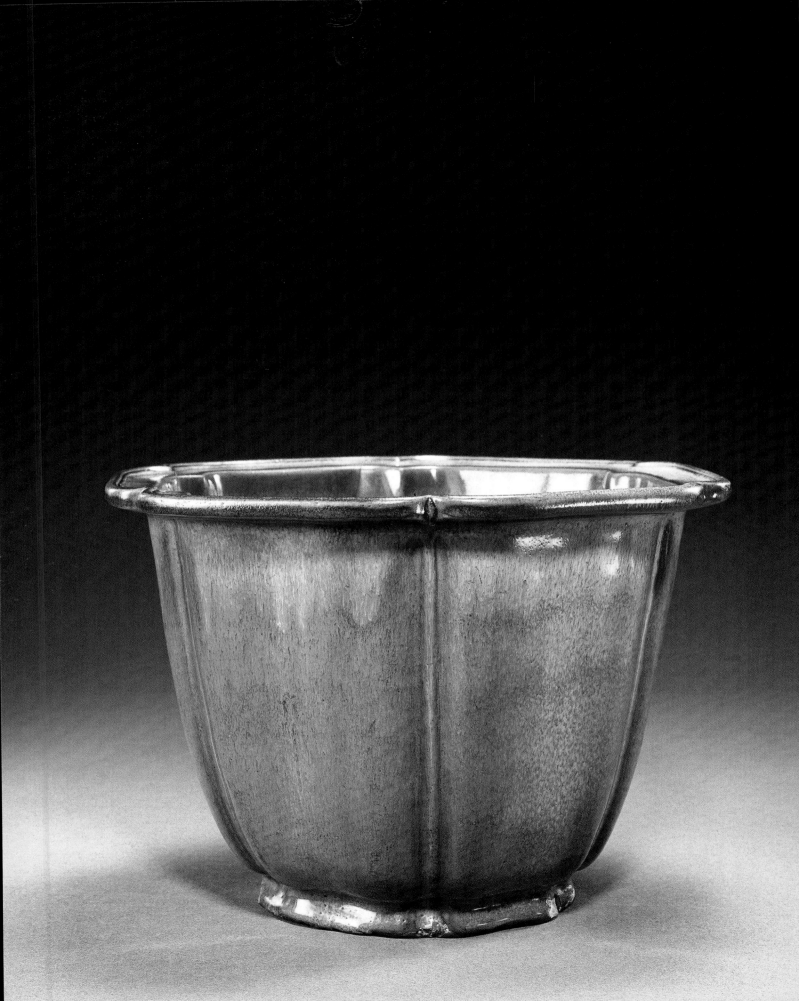

# Chapter 9

# COPPER IN CHINESE GLAZES

Copper is second only to iron in its importance as a colourant in Chinese glazes, where it provides a spectacular range of emerald-greens and turquoise-blues in oxidised glazes, and rich and vibrant copper-reds in high-temperature glazes fired in reduction. However, where copper differs significantly from iron is in the way that it was added by Chinese potters to their various base glazes as a deliberate colourant, and in a concentrated state. Iron, by contrast, was usually present naturally in Chinese raw materials in a finely distributed form, and mostly at levels high enough to colour the glazes without further deliberate additions.

As copper is invariably added to Chinese glazes as an extra ingredient, the sources of copper in Chinese glazes have been the subject of a good deal of research. Most examples of early Chinese glazes coloured with copper have now been analysed and in most cases the copper has been found associated with lesser amounts of tin oxide. In oxidised glazes these low levels of tin would have had little effect, but where tin oxide occurred in reduction-fired copper-containing glazes the material may well have helped to produce the finest copper-red colours.

## Copper-tin compounds

The source of tin in Chinese copper-containing glazes has not yet been established. It is possible for copper and tin to occur together in natural ores, such as the triple sulphide of tin copper and iron, stannite ($CuSnFeS_4$) – but stannite is a rare mineral and unlikely to have been an important source of copper over the many centuries and extensive areas that copper-coloured glazes have been made in China. A more likely source for the copper and tin discovered in many of these early glazes seems to be oxidised bronze – which in China was usually a copper-tin or a copper-lead-tin alloy.

Tin has now been found together with copper in Han green lead glazes, in the copper-red brushwork on Song and Yuan Jun ware glazes, and in Liao high-fired green-splashed wares. Tin has also been found associated with copper in Tongguan copper-green stoneware glazes, in most purple and turquoise Chinese alkaline glazes (*fahua* glazes), and also in the copper-green lead glazes made at the Jizhou kilns in Jiangxi province in the Song dynasty. Small amounts of tin oxide also appear in early 15th-century copper-red glazes from Jingdezhen.

In addition to all this analytical work we also have two useful written references to the sources of copper in Chinese glazes, dating from 1722 and 1900 respectively. The first (by Père d'Entrecolles) describes the creation of copper oxides from flicking water onto near molten copper metal, then lifting away the oxide scale thus formed with iron tweezers. The material was then ground to a powder, together with an unspecified 'red stone' material, some urine and some porcelain glaze. A small amount of this concentrated copper pigment was then added to a transparent Jingdezhen porcelain glaze to produce the Kangxi monochrome copper-red. In the second reference (by Georges Vogt, Technical Director of the Sèvres National Factory in the late 19th century) copper oxides were identified in a prepared copper-rich powder collected by Consul F. Sherzer at Jingdezhen in November 1882. Mixed intimately, in about equal parts with the copper oxides, was an iron-containing material, probably a siliceous red clay.

From the practical point of view both copper and bronze are fairly easy to oxidise if raised to orange heat and then quenched with water. This produces abundant scales of metal oxides. However, one problem with this process is that the oxides produced may be difficult to grind to a fine powder, apparently because of their flaky

Moulded Jun ware flowerpot bearing the incised numerical character *san* (three) on its base, Northern Song dynasty (960–1127). A thin wash of copper pigment on the glaze's outside surface has produced a spectacular fuschia colour on one side of the vessel during firing. H. 7.5 in 19 cm.; D. 10.6 in. 27 cm. Sotheby's.

nature, and perhaps due also to the presence of some un-oxidised copper or bronze metal. It seems possible that, in both cases described above, a harder and grittier material has been added to the copper oxides to make them easier to grind.

It is interesting to note, in passing, that in Japan a much slower technique for preparing copper pigments for ceramics was often preferred – that is, the oxidising of copper-rich scrap metal, filings or turnings by the action of water, brine or vinegar. Washing and drying the oxidised material gave a fine green powder rich in copper carbonate as well as some residual traces of soluble copper salts. This material needed little grinding and mixed easily with the glaze batches. During firing the copper carbonate ($CuCO_3$) broke down to give extremely fine cupric oxide (CuO) at about 500°C.

A particular advantage of using copper-rich metals (whichever oxidising technique was used) would have been the widespread availability of copper and its alloys in areas where natural copper ores were either rare or non-existent.

## Colour in copper-bearing glazes

The colours produced by copper and its oxides in ceramic glazes are pure and strong and can vary from black, through green and turquoise, to brick-red, to cherry red, and then from pinkish red to purple. To understand how such a wealth of colour can be provided by a single pigment it is useful to recognise the five forms that copper and copper oxide can assume in glazes – two in the oxidised, and three in the reduced state:

## Oxidised forms of copper

*Cupric Oxide, black copper oxide, (CuO), in an undissolved (i.e. crystalline) state.* This appears when a glaze is overloaded with cupric oxide (usually at least 4% CuO, and frequently much more), to the extent that some cupric oxide remains undissolved in the glaze matrix, and/or re-crystallises on cooling. Cupric oxide by itself is a slightly metallic-looking, grey-black mineral and is not a particularly attractive ceramic effect, although it was used occasionally to make some rare 'black' Tang *sancai* lead glazes by overloading lead silicate base glazes with cupric oxide.

*Cupric oxide, black copper oxide, (CuO), dissolved in a glass or glaze.* This is one of the most useful, ancient and widespread colourants in world ceramics, where it has provided turquoise-blue and emerald-green transparent colours for thousands of years. A typical cupric oxide concentration in a transparent glaze would be about 2-3% CuO. Technically copper in this state is known as '$Cu^{2+}$ ions', as the copper and oxygen atoms in CuO separate when in glass-solution, while still being electrostatically bonded. (To make a CuO molecule a single copper atom 'donates' two electrons, which are negatively charged, to a single oxygen atom, hence the CuO formula. The loss of two negative electrons makes the copper atom positively charged, hence the $Cu^{2+}$ notation.) In transparent lead glazes, in lime glazes, and in lime-alkali glazes, $Cu^{2+}$ ions give transparent green colours. Where the main glaze fluxes are potassium and/or sodium oxides the solution-colour provided by $Cu^{2+}$ ions is a fine turquoise-blue. In these solution colours, the copper colourant dissolves totally in the molten glaze, and no particles of crystalline copper oxide can be found in the glaze after firing.

## Reduced forms of copper and copper oxide

*Red copper oxide, cuprous oxide, cuprite ($Cu_2O$).* This is a reddish-brown mineral that is unstable in air, where it slowly converts to CuO. Trapped in a solidified glass or glaze, the crystalline mineral will not re-oxidise, and can supply good, bright, brick-red colours to opaque glasses – if the cuprite crystals are large enough. Smaller cuprite crystals have been reported as supplying *yellow* colours to glasses. Re-crystallised cuprite was first used to make red glass in the Middle East. Cuprite crystals can also occur in small amounts in some Chinese copper-red glazes.

*Cuprous oxide ($Cu_2O$) in solution.* This state is written $Cu^+$: two Cu atoms combine with one oxygen atom to give $Cu_2O$. Each of the two copper atoms donates a single electron [–] to the same oxygen atom, leaving each copper atom with a single positive charge, hence $Cu^+$. In small amounts $Cu^+$ is nearly colourless in a glass or glaze, but in greater amounts it is weakly yellow. $Cu^+$ ions are rather easily reduced to atoms of metallic copper (Cu).

*Copper metal (Cu).* This is the ultimate reduced form of copper and a prime source of colour in copper-red glazes. Copper cannot exist in a solid state in glazes at high temperatures (its melting point is 1083°C), but it can solidify below this temperature as the glaze cools down. Copper atoms may also form in cooling from the further reduction (usually 'in-glaze') of $Cu^+$ ions, and these copper atoms clump together to produce small crystals of copper metal. If the cooling is not too slow the particles of copper remain extremely small (typically 20–50 nm) and can give an intensely red colour to a transparent glaze in both transmitted and reflected light. Copper of this fineness is colloidal – that is, on the borderline between suspension and solution. Slightly coarser copper may cause 'dichroism' giving blue in transmitted, but red in reflected light. Copper-reds tend to spoil if the clumps of copper atoms grow too large, giving 'livery' or 'muddy' copper-red colours.

Copper in its oxidised state is seen in its most characteristic form in Chinese low-fired glazes, where it provides fine green and turquoise colours, and these are discussed in greater detail in the sections on Chinese low-temperature glazes. Chinese high-temperature glazes mainly used copper in its reduced form – most notably in the magnificent copper-red glazes that represent some the greatest achievements of Chinese glaze technology.

## Chinese copper-red effects

Chinese copper-red glazes have seen a long evolution that began about 1000 years ago. They reached their most successful expression in the early 15th century AD when Jingdezhen porcelains with copper-red glazes were used in China in imperial rites – perhaps the most prestigious role for any ceramics in China's history. Early Ming copper-red porcelain glazes of this type are known by the name *xianhong* meaning 'fresh red' in Chinese. The ability to make these superb *xianhong* glazes was lost in the later Ming dynasty, and then revived with some success in the early 18th century.

## *Historical background*

Although early Ming copper-red glazes have become the most celebrated examples of the copper-red phenomenon, the use of copper to provide bright red colours in a silicate melt is actually a Middle Eastern discovery and probably Mesopotamian – taking place at least 3,000 years before the glaze's first appearance in China. The technique became well developed in Egyptian red glass of the mid-second millennium BC.

Ancient Middle Eastern copper-red glasses are distinguished by the large amounts of copper used to produce their colours (*c.* 5–11%), and by their near-opacity. By contrast Chinese copper-red glazes tended to be translucent, high-firing compositions (*c.* 1200°–1320°C), with a copper content rarely exceeding 1%. Perhaps most important of all the red colour in the Chinese glazes was provided largely by a thin scattering of pure, colloidal, copper metal (Cu) crystals that developed in the middle of the glaze thickness during cooling – rather than by the dense mass of large cuprite crystals ($Cu_2O$) usually found in Egyptian red glasses.

However, even the presence of copper metal itself to give a red glass is not an entirely Chinese phenomenon: it seems likely that at least some Egyptian reds, and some later Roman red glasses, were coloured by both colloidal copper and cuprite. Unusually for Chinese ceramics therefore, the Chinese copper-red effect seems to have been an independent Chinese development of a much older Middle Eastern technical tradition.

## *Changsha copper reds*

The first deliberate use of the copper-red effect in Chinese ceramics seems to have occurred at the Tongguan kilns, near to Changsha in Hunan province, in the 9th or early 10th century AD. In some ways the beginnings of copper-red effects at Tongguan may seem surprising because these kilns specialised in wares fired in oxidising to neutral atmospheres. It seems that the Tongguan copper-reds evolved from the copper-bearing Tongguan green and blue-green glazes – two of the standard Tongguan stoneware effects. On some pieces the actual change from green to red can be clearly seen where a reducing flame has caught part of a vessel.

Despite this preference for oxidising atmospheres, the use of wood-burning dragon kilns at Tongguan would have made some occasional accidental reduction of the copper-green glazes quite likely. Some self-reduction from the exceptionally high ash levels (with their associated residual carbon) in the Tongguan glazes may also have occurred. There is also the possibility that the 0.5% or so of tin oxide in the Tongguan green glazes may have contributed some reducing effect. The mechanism for this is curious: after slight reduction, dissolved stannous oxide ($Sn^{2+}$) tends to re-oxidise in cooling to stannic oxide ($SnO_2$), 'stealing' oxygen from such charge-changeable materials as dissolved cuprous oxide ($CU^+$) and thus further reducing the $Cu^+$ ions to colloidal copper metal (Cu). Colloidal copper is a prime source of the copper-red effect. Dissolved ferrous oxide ($Fe^{2+}$) is also thought to act on dissolved cuprous oxide in a similar way.

Bearing these various factors in mind, the accidental creation of some sort of copper-red glaze from misfired Tongguan copper-greens would have been hard to avoid.

## Tongguan copper-red glazes

Three types of Tongguan copper-red ware have been found so far: red decoration with semi-transparent glazes; red and green decoration together (also with transparent glazes); and a true copper-red monochrome. The first and last types were illustrated in an unpublished poster-paper at the Second ICACPP in Beijing in 1985. The Tongguan monochrome copper-red piece was the top half of a Tang ewer. The paper's author (Zhou Sirong) wrote of this piece: 'The glaze is fine and smooth, uniform and neat, bright and glossy in quality'. This large portion of a red monochrome ewer confirms that the Tongguan copper-red was not simply a red pigment, nor just a red glaze used as a red pigment, but it could also exist as a true monochrome copper-red glaze in its own right. However, no other examples of Tongguan copper-red monochromes are known at present.

The second version of the Tongguan red (red and green together) is perhaps the most puzzling of all. Here

the effect is obviously deliberate and well controlled, as the pattern of stripes follows red-green-red alternately. But how oxidised and reduced versions of copper-coloured glazes can exist on the same article is certainly mysterious, although a number of explanations seem possible:

*1. The composition of the red glaze could have been higher melting than the green glaze.* A glaze will not reduce satisfactorily if it is already melted so, if reduction did not begin until the green glaze had melted, but started before the red glaze began to melt, both oxidised and reduced effects could have been achieved on the same article – with both glazes

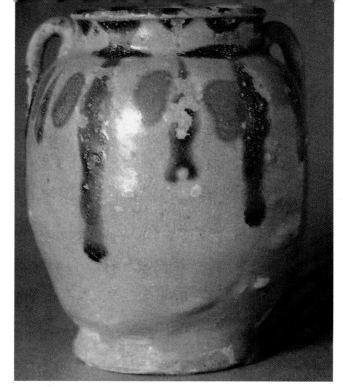

Stoneware jar decorated with red and green stoneware glazes, Tongguan kilns, Changsha, Hunan province, 9th century. This small jar is one of the most intriguing examples of early copper-red decorated stoneware to have survived. A number of possibilities suggest themselves as to how oxidised and reduced copper glazes could appear side by side on the same piece, but mild reduction in the kiln, combined with rather low copper contents in the red glazes, and much higher copper levels in the green glazes, may be one answer. H. 3.75 in., 9.5 cm. By courtesy of the Cernuschi Museum, Paris.

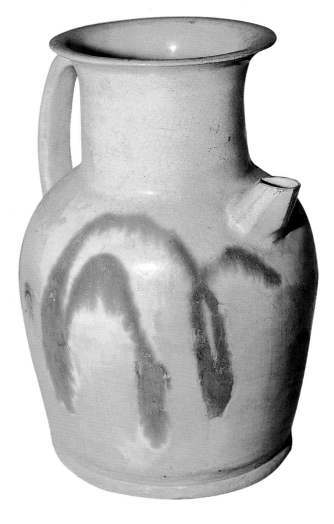

Tongguan (Changsha) ewer, 10th century AD, with a white stoneware glaze with trails of copper-green glaze on top. The high phosphorus oxide, and low alumina totals, in some Changsha ash glazes can induce a milky opalescence in cooling. These semi-opaque glazes made good grounds for decoration with copper-green lime-glazes. The green glazes were often opacified by the same effects, and can show almost turquoise tones if overfired.

ultimately firing to the same temperature. This is quite a common effect in modern Western ceramics where glazes of very different compositions, but with similar maturing temperatures, are used on the same piece. A variation on this approach would have been to make the red glaze *lower* melting than the green, reducing and melting the red glaze first, then re-oxidising the green glaze just before it too melted. This would also have resulted in oxidised and reduced copper glazes on the same article.

*2. The red glaze could have contained a 'local reducing agent'.* This could have made the reduction largely inglaze, and independent of the prevailing kiln atmospheres. A high concentration of carbon (possibly from the use of half-burned wood ash in the glaze recipe), and a neutral firing, could have achieved this result, and any tin oxide in the red glaze would have helped the effect. (Inglaze reduction of copper-red glazes, using fine silicon carbide powder and an oxidising kiln, is a process occasionally used by modern potters.)

*3. The jar could have been fired totally in oxidation, but without the copper-red stripes. These could then have been added to the fired vessel and the whole piece refired, this time in reduction.*

The already fired and melted glaze would not reduce but the unfired raw, red glaze would.

*The red glaze could have contained considerably less copper than the green glaze.* Good copper-reds are most easily achieved in low-copper glazes (i.e. less than 0.5% copper oxide). Too much copper can actually result in copper-green rather than copper-red effects if the reduction is rather light, as seems to have been the case in the Tongguan kilns.

On balance, methods 1, 2 and 4 seem the more likely, although combinations of these effects are also possible. But whichever technique was used the alternate red and green striped Changsha wares are the best evidence that we have to date that the Changsha copper-red could be both a deliberate and a well-controlled process.

### Copper red effects in north China
The second important phase in the history of copper-red effects in China occurs in the Jun wares of north China, and these spectacular opalescent-blue stoneware glazes are discussed in greater detail in Chapter Six. As Henan Jun wares evolved, copper washes were used more freely until, on some examples, the whole glaze surface became suffused with red. Some later Jun wares can be true copper-red monochromes, of a distinctly *flambé* type.

### Origins of copper-painting on Jun wares
The use of copper colourants on northern stonewares seems to have started in the mid-6th century AD, when some northern stonewares with watery-yellow lime glazes were enhanced with touches of copper-green colour. These wares strongly resemble some lead-glazed wares of the same date. Following these experiments, high temperature copper-greens were little used on northern wares until the 9th-12th centuries AD, when copper-green splashes appear on some white-slipped Cizhou-style stonewares. White-slipped stoneware shards with copper-green splashes have been found at the Shandong kiln of Zibo, at the Jiaocheng kilns of Shanxi province, the Yaozhou kilns in Shaanxi province and at the Guantai kilns in Hebei.

A rare variation of this early copper-splashed ware is in the reserve collection of the Ashmolean Museum, Oxford, where the splashes are copper-red, rather than copper-green. This interesting piece (a whiteware bowl of Tang form) raises a number of questions. In particular there is the problem of whether this is a misfired version of a green splashed bowl, or a deliberate and developed copper-red style, and there are also problems of provenance and date. Professor Feng Xianming of the Palace Museum, Beijing has suggested a late Tang dating for this bowl with a probable origin at the Shanxi kiln of Jiaocheng, where a few red-splashed shards have been found.

Two northern white-slipped stoneware bowls with clear glazes overall. Both bowls have been decorated with dabs of copper-containing stoneware glaze, but one has been oxidised and the other reduced. The red-spotted bowl is the earlier, and has been dated to the 10th century AD, with a possible origin in the Jiaocheng kilns in Shanxi province, where similar red-spotted wares have been found. White-slipped stonewares, with splashes of copper-green glaze, were already in use in China at this time, so the red versions may be accidentally reduced examples of the green-on-white effects. D. of red-splashed bowl, 5.4 in., 13.7 cm. Ashmolean Museum, Oxford, 1956.1038.

There are therefore many good precedents for the use of copper-green 'splashes' on northern high-fired glazes – and in some cases copper-red colours must have occurred on these wares through accidental reduction. For Henan Jun wares there are also the stylistic precedents of Tang splashed blackwares, and these dramatic splashed and streaked ceramics may have been important in the development of the Jun wares themselves. In both wares the apparently casual brush marks are placed with great subtlety, and add greatly to the impact and vitality of the forms. In the copper-decorated Jun wares the haziness of the semi-volatilised copper and the sweeping brushmarks applied to the glazes give living expression to the Chinese concept of *qi*, which sees all matter and life forming and reforming, driven onwards by an all-pervading energy.

In fact, virtually all the colour-states possible with copper and its oxides may be seen on some Jun wares. Radiating out from where the brush leaves the thickest layer of copper pigment the various colour-states run as follows:

**Black** where the pigment was too thick to dissolve into the glaze beneath, and has re-oxidised on cooling to crystalline cupric oxide (CuO); **green** where it was concentrated enough to re-oxidise superficially, but still dilute enough to remain in glaze solution and stain the glaze ($Cu^{2+}$); **brick red** where it formed cuprite crystals ($Cu_2O$), and **pinkish-red** where pure colloidal copper metal absorbs some transmitted light, letting through light in the red wavelength range (Cu).

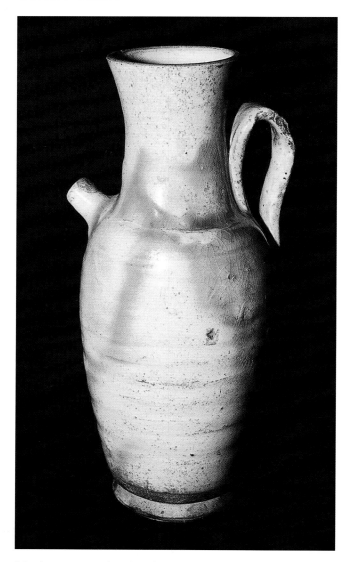

Northern ewer with a dip of white slip covered in clear, then copper-green, stoneware glazes, Henan province, 10th century AD. This northern vessel uses slip to provide a white ground for the copper-green glaze decoration, rather than the semi-opaque white glazes, often used at Changsha. In both northern and southern glazes the copper-green areas also contain tin oxide, suggesting that the green glaze colourants may have been made from oxidised bronze. H. 8.3 in., 21 cm. Victoria and Albert Museum, 223–1912.

The last, and most typical colour on copper-painted Jun wares (**purple-red**) is believed to be a mixture of copper-red, iron-blue and opalescence. Scientists investigating the technology of Jun ware have found that the copper pigment was painted on top of the raw Jun glaze, before the wares were given a high-temperature firing in the 1250°–1300°C range. The copper pigments used often contained substantial amounts of tin oxide, which may have helped in the development of the copper-red colours.

All this work suggests that the wealth of colour seen with the use of copper on Jun wares was achieved by paint-

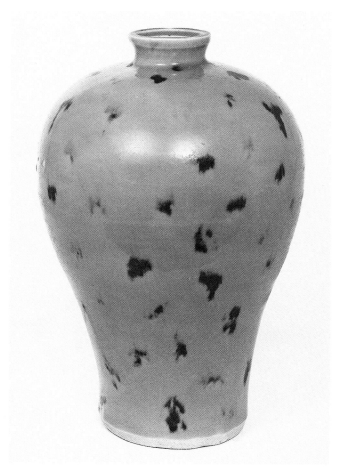

Longquan celadon *meiping* vase with dots of underglaze copper-red pigment, Yuan dynasty, 14th century. A few examples of spotted Longquan celadon exist that are decorated with underglaze copper, rather than with iron oxide pigments. H. 6.9 in., 17.5 cm. Sotheby's.

ing a copper-tin pigment (perhaps derived from oxidised bronze) onto an unfired Jun glaze, firing in reduction, and then cooling in oxidation (the natural state of a cooling kiln). When the various oxide forms of copper were combined with the complex bluish opalescence and rich microstructures of northern Jun glazes, the results were both subtle and spectacular. In some ways though this use of copper was a rather simple approach, and perhaps less original in its technology than the Tongguan wares, with their copper-red monochromes and alternating red-green-red decoration.

### Copper and post-Tang southern wares

Compared with the successes of the northern Jun kilns, examples of copper-red glazes and pigments in the Song dynasty in south China seem few and far between. As described in Chapter Three there was a minor use of copper-red at the Northern Song kiln of Rongxian, Guangxi province, but no complete examples of the

Table 68 Analyses of Song Jun ware glazes coloured with copper

| | $SiO_2$ | $Al_2O_3$ | $TiO_2$ | $Fe_2O_3$ | CaO | MgO | $K_2O$ | $Na_2O$ | $P_2O_5$ | CuO | $SnO_2$ |
|---|---|---|---|---|---|---|---|---|---|---|---|
| Henan Song Jun | 70.4 | 9.6 | 0.4 | 2.5 | 9.6 | 0.8 | 4.8 | 0.7 | 0.6 | 0.4 | 0.4 |
| Henan Song Jun | 70.6 | 9.5 | 0.36 | 2.1 | 9.7 | 1.0 | 3.8 | 0.7 | 0.6 | 0.13 | 0.5 |

Rongxian red are known to have survived. Copper-red spots were also used occasionally on some Yuan Longquan celadon wares, but even at the southern Jun ware kiln of Wuzhou (Zhejiang province), where local imitations of Henan Jun wares were manufactured, the Henan influence does not seem to have extended to any over-painting with copper pigments. It was not really until the Yuan dynasty (1279-1368AD), at the porcelain kiln complex near Jingdezhen, Jiangxi province, that copper-red technology was again taken up in earnest and developed in southern China – apparently in the early 14th century.

## Underglaze copper-red at Jingdezhen

Unlike the Jun kilns, where copper was painted on the surfaces of the opal-blue glazes in broad swathes, copper compounds were used at Jingdezhen for detailed underglaze red painting. The arrival of copper-painting at Jingdezhen may slightly predate the introduction there of underglaze cobalt-blue, and in some early examples both copper and cobalt painting can occur together on the same piece. From these pioneering experiments in the early 14th century the use of copper-red effects at Jingdezhen gradually became more sophisticated, but the material was always difficult to control, as it still is today.

### Jingdezhen copper-red painting

One of the earliest complete examples of Jiangxi underglaze-painted porcelain comes from a tomb that was closed in 1319. This covered jar has been described variously as painted with underglaze native-cobalt blue, and as a possible example of underglaze iron-brown. Other writers have described the same piece as decorated with both copper-red and cobalt-blue. These different opinions are a measure of how difficult it may be to tell slightly misfired and impure examples of underglaze copper, cobalt and iron pigments apart by sight – although when non-destructive tests such as air-path x-ray fluorescence analysis are applied it is easy to tell the difference between these various pigments.

A particularly early example of underglaze-red, this time used alone on porcelain, was brought up from the Sinan wreck, now dated to AD1323. No blue and white porcelain was found on the wreck of this Chinese junk, which sank off Sinan in Korea *en route* to Japan.

Although copper-red decoration appears on a number of very early Jingdezhen underglaze-painted wares, problems with the stability of the red colour soon led to cobalt blue becoming established as Jingdezhen's prime underglaze pigment. It is probably significant that when Jingdezhen's leading archaeologists (Liu Xinyuan and Bai Kun) excavated the important Yuan porcelain site of Hutian at Jingdezhen in 1979 they found only two underglaze-red pieces. They suggest that most 'Yuan style' underglaze-red may actually date from the slightly later period of the reign of the Ming Hongwu emperor (AD1368-98). The popularity of underglaze copper-red in the Hongwu reign has often been ascribed to supplies of imported cobalt ores being interrupted by military conflict, and the Jingdezhen potters having to make do with their second-best pigment – although some scholars maintain that there was a definite preference for underglaze red wares during this period.

### Copper as a underglaze porcelain pigment

One of the problems in achieving a good underglaze-red from copper was the need for a copper colloid to develop in the glaze for the best red colour to appear. For this to happen the glaze had to be thick, of the right composition,

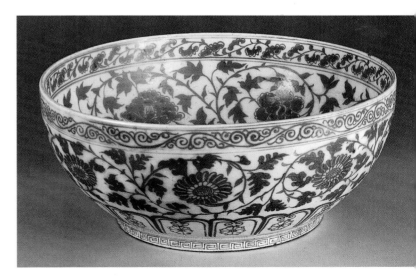

Large porcelain bowl with underglaze copper-red decoration of chrysanthemums, Jingdezhen, Hongwu period (late 14th century). Problems with supplies of imported cobalt-blue pigment led to numerous underglaze copper-red wares being made at Jingdezhen in the later 14th century. The main underglaze-red material used during the Hongwu period seems to have been copper with traces of arsenic, perhaps a copper-sulphur-arsenic ore.

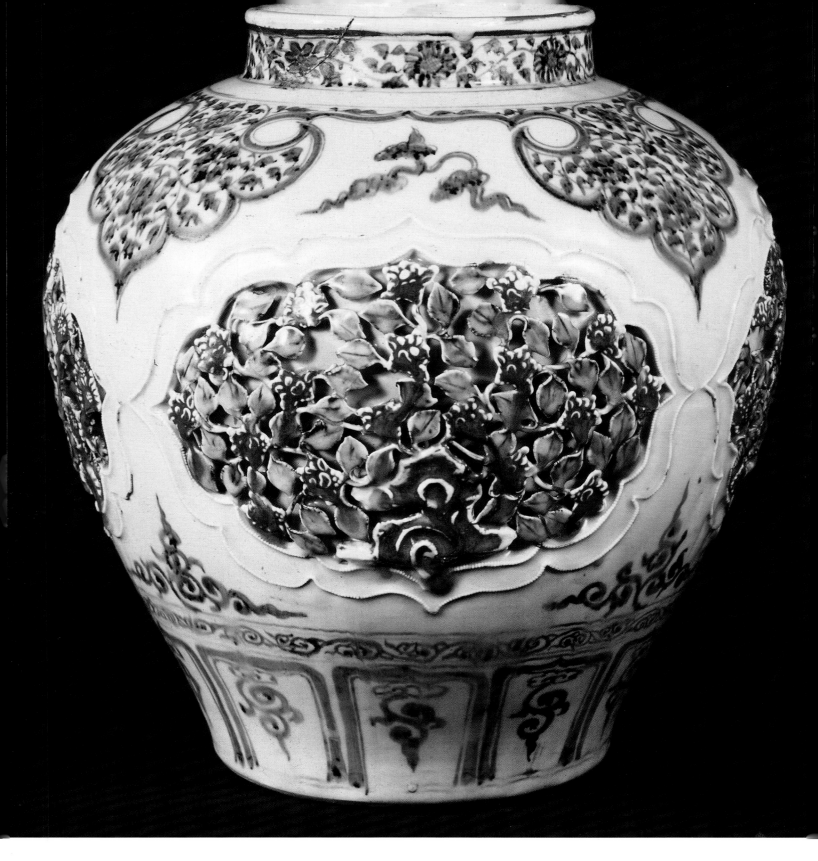

and fired to the right temperature. Kiln atmospheres and cooling rates also had to be ideal. Cobalt is far easier to use than copper as it simply stains the glaze blue with great reliability. Another difficulty with copper was its solubility, which often rendered the underglaze painting hazy as the copper spread into the surrounding glaze.

When underglaze copper-red was introduced to Jingdezhen, the *yingqing* glaze was still in use, having seen continuous employment in the district since the late 10th century AD. This late version of the *yingqing* glaze may well have been used for some of the earliest Jingdezhen underglaze copper-red wares, made in the second quarter of the 14th century. The rather fluid nature of the glaze often allowed a good colour to be achieved with the underglaze-red painting, but the same fluidity also tended to encourage diffusion of the copper during firing, making definition of the painting rather poor. One example of a Yuan-style underglaze copper-red shard was analysed in 1992 at the Victoria and Albert Museum, London, and the pigment was found to have been copper, mixed with a substantial amount of iron. The presence of the iron would have increased the fusibility of the pigment, and therefore its tendency to spread within the glaze. Perhaps because of the fluidity of these *yingqing*-style glazes, and the poor definition of early attempts at copper painting, potters making underglaze-red wares in the later 14th century at Jingdezhen seem to have changed to low-calcia glazes of the *shufu* type. Painted definition was certainly improved, but fine copper-red colours seem to have been harder to achieve.

As to the type of pigment used for these post-Yuan underglaze-red wares at Jingdezhen in the 14th century, this problem has been studied by Dr Robert Tichane in New York State in 1985, and at the Victoria and Albert Museum in London in 1992.

Robert Tichane examined the glaze body interface on a 14th-century underglaze-red porcelain shard by destructive x-ray analysis and found there a black material, rich in copper and sulphur and containing a trace of arsenic. Above this material, in the middle of the glaze thickness, could be seen a hazy red cloud, presumably colloidal copper metal, and the cause of the red colour. Tichane writes: 'Thus, the Chinese, rather than using copper oxide or copper metal, were using copper sulphide as a colorant in this 14th century specimen'.

Four further examples of Hongwu underglaze-red were studied at the Victoria and Albert Museum in 1992. These again proved to be copper-arsenic mixtures, but

the non-destructive technique used was unsuitable for identifying the light element sulphur. It may be that these underglaze copper pigments were also copper-arsenic-sulphides, but other possibilities that have been proposed include the use of hydrated copper-arsenic minerals, such as olivenite, or oxidised arsenical-copper metals.

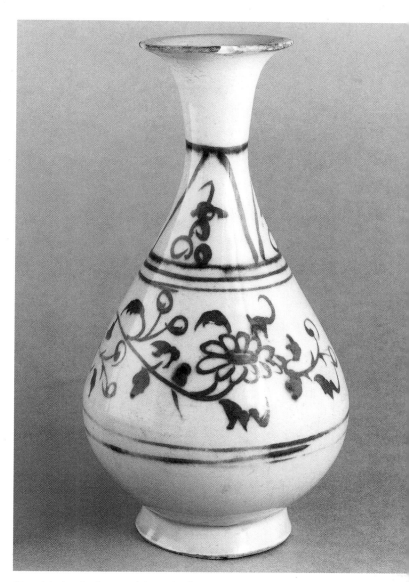

Porcelain bottle decorated in underglaze copper-red, Yuan dynasty, Jingdezhen. Early Jingdezhen underglaze copper-red wares, made for the export market, often have a lively and informal style, such as this mid-14th-century wine bottle. Less painted detail was attempted with copper than with cobalt at this time, which adds to the freshness of the design. H. 9.2 in., 23.3 cm. British Museum, OA 1961.2–16.3.

*Opposite:* Large Jingdezhen wine jar painted with both underglaze red and underglaze blue, mid-14th century. The beaded panel edges and pierced double walls are survivals of earlier *shufu* and *yingqing* styles, while the combination of underglaze copper-red and underglaze cobalt-blue is a feature of some early Jingdezhen underglaze-painted wares. Copper-red pigments from this early period often show good colours but a poor stability in firing. H. 13.1 in., 33 cm. Christie's.

## Jingdezhen copper-red monochromes

A few shards of what seem to have been the very first Jingdezhen copper-red monochrome porcelain glazes have been dated to the late Yuan dynasty (AD1279–1368) – although complete examples of this ware are so far only known from the Hongwu dynasty (1368–1398). None of these pioneering Jingdezhen monochrome reds managed to achieve the pure cherry-reds of the early 15th century, and their colours vary from an orangey red to a muddy grey-pink.

Hongwu copper-reds often have a waxen sheen, and they tend to be semi-opaque. These qualities tend to obscure the relief and engraved designs often used beneath the glazes. They probably contain a certain amount of unmelted glaze material, and a dense mass of bubbles, suspended in the glaze thicknesses. Hongwu copper-red colours sometimes extend over the edges of the porcelains, with less evidence of the white rims that became such a characteristic feature of most later Chinese copper-red monochromes.

Monochrome copper-red dish, probably Hongwu period, Jingdezhen. Early Jingdezhen monochrome reds often show moulded and/or engraved decoration. By the Xuande period (AD1426–1435), totally plain monochrome-red wares were the preferred copper-red style in China. Palace Museum, Beijing.

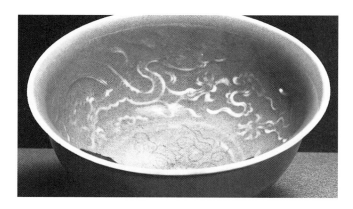

Small monochrome copper-red bowl, Hongwu period (late 14th century), Jingdezhen. Early experiments with monochrome copper-red wares at Jingdezhen resulted in rather poor copper-red colours. X-ray fluorescence analysis of this particular bowl suggests that the problem may have come from the use of too much copper in the glaze recipe, and not quite enough flux. D. 3.8 in., 9.8 cm. Victoria and Albert Museum, C. 138–1963.

Surviving examples of Hongwu (late 14th century) copper-red glazed porcelains are rare. There is a stem cup and a sauce-pot in the Palace Museum, Beijing, but otherwise the pieces are mainly small saucer dishes and bowls, with fine relief moulding and light engraving inside and no glaze at all beneath their feet. This latter feature, although initially strange to see in high-quality porcelain, is quite common in Yuan, Hongwu and some 15th-century wares, and is a natural consequence of Jingdezhen raw-glazing practice, which left turning of the inside of the foot to the last stage of the making process. In the fine 15th-century wares the reign-mark would have been painted inside the foot-ring after turning, and some clear glaze brushed or poured over the cobalt-painted characters. As a final detail the edges of the foot-ring would have been chamfered, removing any stray glaze in the process.

The composition of the Hongwu reds is not yet known in detail, but it seems likely that they were adapted from existing Jingdezhen recipes, of which three were in general use in the 14th century: the transparent, bluish, *yingqing* glaze; the translucent glaze used over underglaze-blue and underglaze-red painting, and the semi-opaque, and rather sugary, *shufu* glaze – a variation of which was also used for the Hongwu underglaze-reds. The main differences between these glazes lay in their calcium oxide contents. These were high for *yingqing* glazes (average 14% CaO), moderate for the glazes used with underglaze-blue pigment (average 9% CaO), and low for the semi-opaque *shufu* and underglaze-red glazes (average 5.5% CaO):

Table 69 Analyses of typical 14th-century Jingdezhen porcelain glazes

|  | $SiO_2$ | $Al_2O_3$ | $TiO_2$ | $Fe_2O_3$ | CaO | MgO | $K_2O$ | $Na_2O$ | MnO | $P_2O_5$ |
|---|---|---|---|---|---|---|---|---|---|---|
| *Yingqing* glaze | 65.8 | 13.8 | 0.06 | 0.8 | 14.1 | 0.6 | 1.5 | 2.7 | 0.1 | 0.05 |
| 'Blue & white' glaze | 69.5 | 14.9 | 0.04 | 0.8 | 8.9 | 0.3 | 2.7 | 3.1 | 0.1 | –.– |
| *Shufu* glaze | 72.0 | 15.6 | –.– | 0.85 | 5.6 | 0.3 | 3.0 | 3.5 | 0.1 | –.– |

Hongwu lid being analysed by air-path energy dispersive x-ray fluorescence spectroscopy (airpath EDXRF). This non-destructive technique is useful for analysing ceramic pigments, as it is very sensitive to heavy elements. The pinkish-red painting on this lid proved to be a copper-arsenic mixture. By courtesy of Jo Darrah, Scientific Research Department, Victoria and Albert Museum.

All three glaze types were made by mixing 'porcelain stone' or 'glaze-stone' with 'glaze-ash' (calcium carbonate).

By the end of the 14th century (the Hongwu period) the *yingqing* glaze was no longer fashionable, and the two main Jingdezhen glaze types were the underglaze-blue variety and the *shufu* glaze. Recent EDXRF analysis of a single Hongwu bowl suggests that a glaze composition somewhere between the underglaze-blue type and the *shufu* type may have been the basis of the Hongwu monochrome red.

## Improving the Hongwu red

The early 15th-century reign of Yongle (AD1403–1424) saw a spectacular improvement in the colour of Jingdezhen copper-red glaze, and a movement away from rather lean Hongwu dishes and stem-cups towards the fuller style of 'classical' Ming wares. Moulded relief was still used occasionally but simple undecorated forms became more fashionable. These plainer Yongle shapes set the style for Chinese copper-red monochromes in succeeding centuries

EDXRF analysis, carried out in 1992 at the Victoria and Albert Museum, suggests that there may have been three ways in which the Hongwu monochrome-reds were improved, to achieve the pure cherry-red colours of the early 15th century:

• First the calcium content of the glaze seems to have been increased slightly, bringing the monochrome red glaze nearer to the kind of composition used for Yongle underglaze-blue wares. This made the glaze slightly more fluid at high temperatures, allowing many more trapped bubbles to escape during firing, and dissolving some of the batch material suspended in the glaze – both of which had tended to veil the copper-red colour.

• The second, and equally important, improvement was to reduce substantially the amount of copper used in the original glaze recipe. This also had the effect of creating a much purer copper-red colour as copper-red glazes tend to look muddy if their copper contents are too high.

• A third difference seems to have been that the Jingdezhen potters changed from using oxidised copper metal to oxidised bronze as a colourant for their monochrome copper-reds in the early 15th century. The minute traces of lead, tin and antimony introduced by the use of oxidised bronze, probably encouraged the in-glaze reduction of $Cu^+$ ions to colloidal copper metal during cooling, and this too may have helped the finest copper-red colours to develop.

Monochrome-red porcelain stem cups, Ming Dynasty, Yongle period (1403–1424). Jingdezhen monochrome copper-red glazes were perfected in the early 15th century and reached their zenith in the Yongle (1403–1425) and Xuande (1426–1435) periods. Stem cups such as these, with red *xianhong* glazes, were used in imperial rites and are consequently some of the highest-status wares in China's ceramic history. H. 4.25 in., 10.7 cm. Victoria and Albert Museum, 168–05.

Table 70 Analyses of Yongle (AD1403-1425) copper-red and 'blue-and-white' glazes

| | SiO$_2$ | Al$_2$O$_3$ | TiO$_2$ | Fe$_2$O$_3$ | CaO | MgO | K$_2$O | Na$_2$O | P$_2$O$_5$ | CuO |
|---|---|---|---|---|---|---|---|---|---|---|
| Yongle copper-red glaze | 70.9 | 14.0 | 0.05 | 0.98 | 6.4 | 0.4 | 4.4 | 2.6 | 0.1 | 0.3 |
| Yongle blue & white glaze | 70.7 | 14.1 | –.– | 0.9 | 6.8 | 1.3 | 3.1 | 2.7 | 0.07 | –.– |

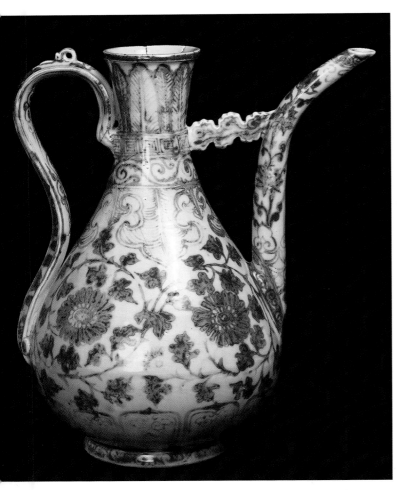

Large porcelain ewer decorated in underglaze copper-red, Hongwu period, late 14th century. Made in the style of Islamic metalwork this fine and elaborate ewer shows the curiously flinty greys and pinks that were often produced by underglaze copper pigments at Jingdezhen in the later 14th century. H. 14.5 in., 37 cm. Victoria and Albert Museum, C857–1936.

## Xuande copper-red

When we come to examine Xuande (AD1426-1435) copper-red porcelains from Jingdezhen we are at the very peak of Chinese copper-red porcelain production. Not only are Xuande copper-red wares outstanding for the qualities of their glazes and bodies but, as imperial ritual porcelains, they enjoyed the highest status of all ceramics in China itself. The forms used for Xuande copper-reds, known at present, include dishes, bowls, water pots, bulb bowls, covered jars, stem-cups, various wine-ewers and *meiping* vases.

### Technology of Xuande copper-reds

Study of the technology of Xuande copper-red glazes and bodies has benefited enormously from excavation of the reject heaps of the old imperial Ming kilns at Jingdezhen. This rare opportunity to study Xuande copper-reds in depth is the indirect result of the laying of gas and water pipes in Zhushanlu (Pearl Hill Road), Jingdezhen in 1983-4. Workers' trenches broke into rubbish heaps in the back garden of the Ming imperial porcelain workshop and thousands of porcelain fragments were exposed, including ten tonnes of material from the Xuande and Yongle periods. Amongst this mass of broken porcelain were copper-red shards bearing the six-character mark of the Xuande emperor (reigned 1426-35). A number of broken pieces of Xuande copper-red porcelain have now been studied analytically, together with copper-red fragments from the 16th, 17th and 18th centuries. In addition to this work, a number of Xuande copper-red vessels have been rebuilt from fragments, including a *meiping* vase, complete with cover, nearly 15.75 inches (40 cm) high.

The first technical reports on Xuande copper-red glazes and bodies were presented to the second ICACPP, held in Beijing in November 1985. Two papers dealing

Jingdezhen copper-red bowl of the finest quality, Xuande mark and period (1426-35). 15th century Jingdezhen copper-red glazes used similar lime-alkali base-glazes to those employed for Jingdezhen underglaze-blue wares, and for imperial quality copies of Longquan celadon glazes. Less than half a percent of copper oxide provided an intense red colour in reduction. D. 7.4 in. 18.8 cm. By courtesy of the Percival David Foundation of Chinese Art. PDF A529.

Table 71 Analyses of Xuande and Yongle Jingdezhen porcelain glazes

| | $SiO_2$ | $Al_2O_3$ | $TiO_2$ | $Fe_2O_3$ | CaO | MgO | $K_2O$ | $Na_2O$ | MnO | CuO★ | $P_2O_5$ |
|---|---|---|---|---|---|---|---|---|---|---|---|
| Xuande copper-red | 69.7 | 13.9 | 0.08 | 0.7 | 7.7 | 0.2 | 4.85 | 2.4 | 0.1 | 0.3 | 0.08 |
| Xuande blue & white | 69.1 | 14.3 | –.– | 0.8 | 8.4 | 0.4 | 3.7 | 3.3 | 0.06 | –.– | –.– |
| Xuande celadon | 69.3 | 14.4 | –.– | 1.4 | 7.5 | 1.1 | 3.9 | 1.9 | –.– | –.– | –.– |
| Yongle blue & white | 70.7 | 14.1 | –.– | 0.9 | 6.8 | 1.3 | 3.1 | 2.76 | 0.07 | –.– | –.– |

★Copper in Chinese analyses of copper-red glazes is conventionally reported as CuO, although it is probably present as mixtures of CuO, $Cu_2O$ and Cu.

with the subject of Ming and Qing copper-reds were delivered, and also displayed as poster-papers. In their compositions Xuande copper-red glazes proved to be very similar to the standard Xuande 'blue-and-white' porcelain glazes, but with a slight excess of potassium oxide and a small amount of added copper. The Shanghai scientist, Professor Zhang Fukang, later estimated that up to half the copper may have vapourised in the firing, which would have meant that the original copper oxide additions were between about 0.4 and 0.6%. Another important finding from the 1985 paper was the presence of both cuprite and copper metal in the Xuande glazes examined, at particle sizes of 10–20 nm and 25–45 nm respectively.

Just how versatile this Xuande lime-alkali glaze could be is shown by its simultaneous use in the Xuande period for blue-and-white, copper-red and celadon-green wares (Table 71).

The Xuande glazes above were almost certainly based on glaze stone/glaze ash mixtures in about 9:1 proportions. When fired to the usual blue-and-white Jingdezhen temperatures (1250°–1280°C), these glazes would still have been quite viscous. Such viscosity is ideal for celadons, which rely on masses of trapped bubbles and some undissolved glaze batch material for their jade-like quality, and also for covering blue-and-white painting, where the high-temperature solubility of the cobalt pigment has to be controlled.

In the Xuande *xianhong* glazes the stiffness of the base glaze resulted in well-behaved copper-reds that did not run in firing, producing a very narrow white-rim at the top of the copper-red wares, and virtually no movement of glaze at the foot. The millions of bubbles trapped in the *xianhong* red glazes also supplied a slightly curdled quality to the fired glaze, as well as the characteristic Xuande 'orange-peel' surface, where traces of minute bubbles remain that have burst at high temperature. However the very viscosity of the Xuande red glazes would have made production of the brightest copper-reds difficult, as mobility of the copper during firing is important for the effect, and any suspended material in the glaze tends to veil its colour. It may be that the very best Xuande copper-reds came from slight overfiring. A small 'colour' kiln has been discovered at Jingdezhen for firing some early Ming copper-red glazes and it is possible that this was built to fire the *xianhong* glazes to higher-than-average temperatures (e.g. 1300°C+).

## Silhouette wares

The development of these fine Xuande copper-red glazes led to further experiments at Jingdezhen with white-on-red and red-on-white silhouette effects – a style that had already seen mixed success with Jingdezhen underglaze-red porcelains. However the Xuande silhouette wares seem to have used copper-red glazes rather than copper-red pigments, which gave more reliable results. This style enjoyed a revival in the Zhengde period (1502–1521).

How these two-colour wares were made in practice is not fully understood. A combination of paper-resist, followed by painting the copper-red glaze into the resisted area, once the plain glaze had been applied and the paper removed, seems logical, although super-imposition of the red glaze on the 'white' glaze might also have worked, perhaps using paper stencils to apply the copper-red shapes. There is also the possibility that the red glaze was 'sandwiched' between clear glazes. The greater thickness of the red glaze, noticeable on number of these silhouette wares, suggests its use under, over, or between the porcelain glazes, but this extra thickness may simply be due to the fact that copper-red glazes need to be applied thicker than porcelain glazes in order to maximise their colours.

When successful these silhouette wares can be of superb quality, especially the original Xuande examples. However, the small numbers that have survived, often with their copper-red areas misfired, suggest that the technique may not have been an easy one.

## Qing copper-reds

The reasons for the decline of the *xianhong* glaze at Jingdezhen during the late 15th, 16th and early 17th centuries remain obscure. Depletion of a key raw material has been suggested, but general frustration with this fickle colour seems an equally likely cause. One example from the Wanli period (1573–1620) has been investigated, but the colour was poor and the glaze was crazed.

It was not really until the reign of the Kangxi emperor (1662-1722) that Jingdezhen potters made determined efforts to revive the classic copper-red porcelains of the early 15th century. In this aim they succeeded well, while at the same time developing three new types of copper-red effects – the 'Langyao' glaze, the peachbloom glaze and the *flambé* glaze – the last being known in China as the 'Jun red'.

### The Qing 'sacrificial red' glaze

Qing copies of Xuande *xianhong* porcelains far outnumber the Ming originals. With their imitation Xuande marks and their fine copper-red colours they can sometimes be difficult to distinguish from genuine 15th-century wares. However the Qing red glazes tend to have a slightly 'washed out' colour when compared with the purity of the early 15th-century reds, and the Qing glazes are usually thinner than the genuine early Ming examples. They are often known in China as *jihong* (sacrificial red) glazes because of the ritual significance of the Xuande originals.

That there were also important compositional differences between Ming and Qing copper-red porcelains, in both glazes and bodies, was demonstrated in 1985 in two papers at the Beijing conference. The subject was explored in greater depth by Professor Zhang Fukang in Shanghai in 1989, and expanded by him at a seminar in Paris in 1991. The essential features of these differences were further confirmed by Dr Ian Freestone at the British Museum research laboratory, also in 1991.

All this detailed analytical work has shown that Qing copies of the early 15th century *xianhong* glazes were richer in calcia, higher in alumina, and lower in silica and alkalis than the early Ming originals. Higher calcia and lower silica contents meant more fusible glazes, but this greater fusibility was offset to some extent by the higher alumina and lower alkali levels in the Qing glazes. Although chemically somewhat different these two glaze types gave broadly similar effects when coloured with copper.

While sometimes hard to detect by eye, these differences show up well with non-destructive tests, such as airpath Energy Dispersive X-Ray Fluorescence Spectroscopy (EDXRF), and this can be a useful technique for distinguishing Ming *xianhong* wares from high-quality Qing re-creations. Besides these compositional differences the longer firings used at Jingdezhen in the late 17th and early 18th centuries tended to give a slightly glassier appearance to Qing copies of *xianhong* glazes – although shininess is not a totally reliable guide to a Qing piece as true Xuande copper-reds can also be somewhat glassy if they have been overfired.

On the subject of Qing reds, it is interesting to read Père d'Entrecolles' accounts of Jingdezhen copper-red production. The French Jesuit missionary-scientist, Father Francois Xavier d'Entrecolles (1664-1741), was an eye-witness to Jingdezhen porcelain manufacture in the early 18th century. In his two letters on Jingdezhen porcelain-making (1712 and 1722) d'Entrecolles gives valuable information on the source of copper for these glazes, on their original raw materials and recipes, and where in the kiln they were fired (away from the fiercest heat, either behind the first three rows of saggars, or a foot and a half above the kiln floor). The technique for producing copper oxide, recorded by d'Entrecolles, involved oxidising copper metal, and was described at the beginning of this chapter. Non-destructive analysis of two Qing red glazes in 1992 showed the copper colourant to be plain copper in one Kangxi example, and copper with a trace of zinc in a Qianlong piece.

Table 71 Analysis of a Wanli copper-red

|  | $SiO_2$ | $Al_2O_3$ | $TiO_2$ | $Fe_2O_3$ | CaO | MgO | $K_2O$ | $Na_2O$ | MnO | CuO | $P_2O_5$ |
|---|---|---|---|---|---|---|---|---|---|---|---|
| Wanli copper-red glaze | 68.5 | 13.9 | 0.1 | 0.8 | 10.3 | 0.2 | 3.5 | 2.7 | 0.05 | 0.16 | 0.07 |

Table 72 Xuande and Qing copper-red glazes compared

|  | $SiO_2$ | $Al_2O_3$ | $TiO_2$ | $Fe_2O_3$ | CaO | MgO | $K_2O$ | $Na_2O$ | MnO | CuO | $P_2O_5$ |
|---|---|---|---|---|---|---|---|---|---|---|---|
| Xuande | 69.7 | 13.9 | 0.08 | 0.7 | 7.7 | 0.2 | 4.85 | 2.4 | 0.1 | 0.3 | 0.08 |
| Xuande | 69.1 | 14.3 | tr. | 0.8 | 8.4 | 0.4 | 3.7 | 3.3 | 0.06 | 0.28 | –.– |
| Kangxi | 63.3 | 16.1 | 0.05 | 1.2 | 13.2 | 0.2 | 2.6 | 3.2 | 0.1 | 0.4 | 0.09 |
| Qianlong | 63.1 | 16.4 | 0.01 | 1.2 | 13.4 | 0.9 | 2.9 | 2.2 | 0.1 | 0.1 | –.– |

Copper-red glazed porcelain bowl, Jingdezhen kilns, Kangxi period *c.* 1700. Revivals of the 15th century monochrome copper-red style at Jingdezhen in the Kangxi period often used base-glazes that were higher in calcia than the early Ming originals. This tended to give more fluid red glazes, with deeper white rims than the 15th century examples. D. 9.7 in. 24.2 cm. By courtesy of the Percival David Foundation of Chinese Art. PDF 513

Cross-section of Ming monochrome-red glaze. For some reason good copper-red colours are inhibited both by contact with the clay body and with the kiln's atmosphere: they therefore develop best in the centre of thick glazes. This phenomenon may help to explain the white rims that are seen on many copper-red monochrome wares. In these cases gravity has thinned the glazes, causing the two colourless zones to meet, with the consequent loss of the red glaze effect. By courtesy of Professor Zhang Fukang, Shanghai Institute of Ceramics.

## The Jingdezhen Langyao *glaze*

The deliberately close copies of early 15th-century copper-red wares, produced at Jingdezhen in the late 17th and early 18th centuries, were made more in homage to early Ming ceremonial wares, and as a demonstration of Jingdezhen virtuosity, than with any particular intention to deceive. Very similar glazes to these *xianhong* copies were also used in the Kangxi period on more 'contemporary' forms, and these are usually known in China as *Langyao* (Lang ware) reds. To whom or to what *Lang* refers to has long been a matter for debate, but scholarship now tends towards Lang Tinji – supervisor of the Jingdezhen imperial kilns between 1705 and 1712.

*Langyao* reds tend to be thicker, redder and glassier than the Kangxi *xianhong* copies, with deeper white rims where the glaze has run down in firing – aptly described in Chinese reports as the 'lampwick' effect. Compositionally they differ little from the Kangxi copies of early Ming reds, although they were probably applied thicker and fired somewhat higher.

### White rims on copper-red wares

The reason for the white rims, so characteristic of Chinese copper red wares, seems to be that copper-red glazes need to be greater than a certain thickness for their red colours to develop. Contact of the glaze with the clay body, and with the kiln atmosphere at the glaze surface, both seem to inhibit the development of the colloidal copper responsible for the copper-red colour. Therefore, if the glaze has run too thin in firing, through the effects of gravity, these

two 'bleached' layers can meet – leaving no room for the colloidal copper to precipitate in cooling and for the red colour to appear. The copper contents of Chinese copper-reds glazes are too low to colour the glazes by solution effects (particularly in reduction), so where the glazes are thin they can seem virtually transparent. Low copper contents also help the white-rim effect, and this may explain why white rims are less obvious on the higher-copper Hongwu red wares.

Stem cup with white glaze and copper-red fish, Jingdezhen ware, Xuande period and bearing a Xuande mark. These rare silhouetted red-and-white wares probably used copper-red glazes rather than underglaze red pigments for their effects. The red glazes may have been applied with the help of paper stencils. D. 4 in. 10.1 cm. Victoria and Albert Museum, London. C.64-1935

Peachbloom glazed water pot with applied metal rim, Qing dynasty, Kangxi (AD1662–1722) mark and Kangxi period. It seems likely that the Qing peachbloom effect was managed by spraying a copper-lime pigment between two clear glazes. Spraying in the early 18th century, at Jingdezhen made use of a short, wide bamboo tube with silk stretched over one end. This was dipped in glaze or pigment, and then blown sharply at the open end. This resulted in a fine, but short-lived, spray of glaze. H. 2.75 in., 7 cm. Victoria and Albert Museum, C357–10.

## The Qing peach-bloom glaze

A major Kangxi innovation at Jingdezhen was the 'apple red' or 'peach-bloom' glaze – also known as the 'beauty's blush', 'baby's face', 'bean red' or 'drunken beauty' glaze in China. This copper-based glaze shows blushes of red, occasionally dotted with fine green spots, on a pinkish-red ground. The glaze sometimes gives the impression of delicate blushing skin, sometimes of ripening fruit. The peach-bloom glaze was used on small porcelain wares of exceptional quality, made in a limited range of forms 'for the scholar's table'.

There is a tendency to treat the peach-bloom glaze as a single glaze, but it is possible that the peach-bloom effect was achieved by using a copper-lime pigment sandwiched between clear glazes, with the pigment itself probably applied by spraying. The reasoning behind this alternative theory runs as follows: In the 1950s, during the Sino-Soviet accorde, Russian ceramic chemists studied Jingdezhen ceramic practice and raw materials which, at that time, had changed little since the 19th century. In the 1950s a peach-bloom glaze was still being made at Jingdezhen, and the Russian scientist G.L. Efremov recorded the 'sandwich'

technique outlined above. The composition of this copper-lime pigment, used for modern peach-bloom glazes, was analysed by Efremov (see Table 73). It proved to be very similar to a prepared copper-rich material, collected at Jingdezhen by Sherzer in 1882, and analysed by Georges Vogt at Sèvres for his 1900 paper on Jingdezhen porcelain production.

Sherzer's material was used at Jingdezhen, not for making peach-bloom glazes, but as an underglaze copper-red pigment – and copper-lime mixtures are still used at Jingdezhen for this purpose.

The logic behind these unusual copper-lime under-glaze-red mixtures seems to be that copper-red painting develops more effectively beneath more fluid glazes – but more fluid glazes also cause the copper brushwork to diffuse during firing, thereby losing definition. By adding a flux to the copper pigment a stiff porcelain glaze can be rendered more fluid in the narrowly defined area of the painting itself (thereby improving its colour), but the stiff glaze surrounding the painting can still prevent the pigment from spreading further into the glaze during firing. Some limited analyses of these pigments suggests that

Table 73 Analyses of Jingdezhen copper-lime pigments

|  | SiO$_2$ | Al$_2$O$_3$ | Fe$_2$O$_3$ | CaO | MgO | K$_2$O | Na$_2$O | CuO |
|---|---|---|---|---|---|---|---|---|
| Jingdezhen 'peach-bloom' pigment *c.* 1956 | 19.0 | 1.1 | 1.1 | 46.0 | 0.7 | 0.3 | 2.1 | 29.3 |
| Jingdezhen underglaze-red pigment *c.* 1882 | 17.4 | 0.5 | 4.8 | 49.8 | 0.6 | 0.6 | 0.7 | 20.8 |

Table 74 Analysis of a Qing peach-bloom glaze

|  | SiO$_2$ | Al$_2$O$_3$ | Fe$_2$O$_3$ | TiO$_2$ | CaO | MgO | K$_2$O | Na$_2$O | CuO | P$_2$O$_5$ |
|---|---|---|---|---|---|---|---|---|---|---|
| Qing peach-bloom glaze | 60.5 | 13.9 | 1.2 | 0.05 | 17.1 | 0.4 | 1.7 | 1.6 | 2.4 | 0.8 |

the copper-arsenic-lime underglaze-reds were used by Jingdezhen potters in the early Qing, but that they were then replaced by bronze-lime pigments as the dynasty progressed.

Through this subtle approach the quality of the Qing underglaze-red was much improved, with the Qing pigment showing a purer red that occasionally breaks to a watery green. This latter effect could be well controlled, and was occasionally used to heighten details in underglaze-red painting. When applied to large areas, the Qing underglaze red appears much like a peach-bloom glaze. All these clues suggest that the Kangxi peach-bloom glaze may well have been a clear glaze with a copper-lime pigment beneath it. Some support for the above theory comes from analysis of a complete Qing peach-bloom glaze, with the glaze appearing unusually rich in both lime and copper (see Table 74).

Using the technique outlined above, some of the pigment would have remained trapped and undissolved in the glaze thickness, scattering and reflecting light, and making the glaze appear slightly opaque, although still with a smooth surface. Copper that dissolved into the glaze from the pigment would have supplied the copper-red colour. Differences in pigment thickness, resulting from spraying, may well have produced copper- and flux-rich areas that soaked through the overglazes. These thicker patches sometimes re-oxidised as greenish spots. On some examples, where a good deal of pigment has diffused through to the surface, the glaze itself seems to have superficially re-oxidised, to give areas of translucent copper-green.

Vase with underglaze copper-red decoration, Qing dynasty, Kangxi mark and period (AD1662–1722). The pigment on this vase appears to be oxidised leaded bronze with a small addition of lime. H. 8.8 in., 22.5 cm. Victoria and Albert Museum, FE37–80.

## *Jingdezhen 'Jun red' glaze*

The 'Jun red' was another Qing innovation and the term is still used by Jingdezhen potters to describe their standard shiny-red monochrome porcelain glazes. These glazes seem far removed from the rich and complex copper-red qualities seen in Henan Jun wares, but the name appears to be a survival from the early 18th century when Jingdezhen potters were commissioned by the court in Beijing to copy the qualities of Song Jun ware glazes.

The Jingdezhen Juns, made from about 1727 onwards, were high-temperature copper-red glazes modified with lead oxide. Whereas the original Henan and Hebei Jun glazes were made from single glaze recipes, with occasional over-washes of a copper-rich pigment, the Jingdezhen potters used three quite different compositions for their Jun ware copies: one for the blue insides, one for the red outsides, and a third for the brownish-green glazes applied within the root-rings of the wares.

The results of these experiments were extraordinarily glossy *flambé* blues and reds that showed signs of liquid-liquid phase separation during cooling. Their curdled surfaces also suggest that strong boiling and bubbling of the glazes may have occurred at high temperatures – before the glazes smoothed over at the height of the firing. These *flambé* glazes often became so fluid at high temperature that their bases needed extensive grinding after firing, where the molten glazes had overrun their feet.

In the mid-18th and 19th centuries these lead-containing 'Jingdezhen Juns' were adapted to become the standard Jingdezhen monochrome-red porcelain glazes, and the Langyao and *xianhong* copies of the early Qing were gradually abandoned. In some ways this marks a persistent theme in the history of copper-red glazes at Jingdezhen – with increasingly fluid glazes gradually being adopted in the search for still more brilliant copper-red effects.

### The late 19th-century Jingdezhen copper red

The original glaze raw materials, prepared glaze suspensions, and fired examples, of this late Qing style of copper-red glaze were all collected in China by the French government agent F. Sherzer in 1882, and shipped back to the Sèvres National Factory near Paris for analysis. The late 19th-century Jingdezhen copper-red proved to have consisted of four pulverised Chinese glasses, combined with the standard Jingdezhen porcelain glaze. Two of these glasses were rich in lead, but at least three-quarters of this lead oxide volatilised in the high kiln temperature used to fire the wares (1280°–1300°C). The fact that the lead was pre-fritted (that is already incorporated into a high-lead glass) probably made it less susceptible to reduction, which can be highly damaging to lead-containing glazes. Georges Vogt (who analysed the glazes) reproduced the copper-red effect at Sèvres successfully in the late 19th century.

## *The 'san-yang kai-tai' effect*

One of the more unusual copper-red wares, developed in the 18th century at Jingdezhen, was a combination of the shiny blood-red glaze with large areas of the Qing mirror-black. These wares were made in the Yongzheng and Qianlong periods of the Qing dynasty (1723–1795), when Jingdezhen potters were specialising in curious and dramatic effects. The red and black porcelains were known as *'sang-yang kai-tai'* wares – with the name referring to the change from winter to spring, when darkness is dispersed by the sun.

The red and black glazes used on *'sang-yang kai-tai'* wares were applied to large solid-looking porcelain vases, and the final effect was somewhat lurid. A technical difficulty with these glazes lay in achieving equal degrees of brilliance from the red and black glazes – without the glazes running off the vessels during firing. No analyses of the original *'sang-yang kai-tai'* glazes have yet been made, although the 1882 Qing red above, and its contemporary mirror black glaze on page 158, were probably close relations to the glazes used. The *'sang-yang kai-tai'* technique has recently been revived successfully at Jingdezhen, using modern recipes that are fired in reduction, apparently to temperatures approaching 1320°C. Two analyses are given for the red, and two for the black glazes, with successfull results claimed within the ranges in Table 76.

However, judging simply from these published analyses, the iron oxide contents suggested for the black glazes seem rather low – while the firing temperature proposed (1320°C) seems much higher than one would expect with lime-glaze compositions.

Table 75  Late 19th-century Qing copper-red glaze before and after firing

|  | $SiO_2$ | $Al_2O_3$ | $Fe_2O_3$ | CaO | MgO | $K_2O$ | $Na_2O$ | CuO | PbO |
|---|---|---|---|---|---|---|---|---|---|
| 1882 glaze, before firing | 61.5 | 4.4 | 0.85 | 7.4 | 1.7 | 5.9 | 2.89 | 0.6 | 12.7 |
| 1882 glaze, after firing | 70.2 | 6.5 | 0.9 | 8.0 | 1.65 | 4.8 | 2.7 | 0.5 | 3.9 |

Table 76 Modern Jingdezhen *'sang-yang kai-tai'* glazes

|  | SiO$_2$ | Al$_2$O$_3$ | Fe$_2$O$_3$ | CaO | MgO | K$_2$O | Na$_2$O | CuO | CoO |
|---|---|---|---|---|---|---|---|---|---|
| Red 1 | 62.4 | 10.9 | 0.2 | 22.0 | 0.2 | 2.7 | 1.6 | ★ | –.– |
| Red 2 | 64.0 | 12.7 | 0.15 | 17.5 | 0.2 | 3.7 | 1.6 | ★ | –.– |
| Black 1 | 63.7 | 13.2 | 2.3 | 15.2 | 0.2 | 3.6 | 1.7 | –.– | 0.05 |
| Black 2 | 64.8 | 14.6 | 3.6 | 12.0 | 0.2 | 3.1 | 1.5 | –.– | 0.12 |

★ not supplied

## Summary

Thanks to the great volume of work that has been carried out on Chinese copper-red glazes over the last few years, much of which is summarised above, we now have a far clearer image of how the classic copper-red monochrome glaze was developed in China. Until about 1727 Chinese copper-reds were simply the standard stoneware or porcelain glazes of their time to which potters had added small amounts of copper-rich materials to achieve monochrome-red effects. These base glazes were representative of the enormously long, and quite logical, developments with simple glaze materials that had characterised the history of south Chinese ceramics over the previous 3000 years.

In the 1720s however, an entirely novel approach to ceramic technology was adopted at Jingdezhen, when the old 'organic evolution' was replaced by a quite deliberate and systematic programme of testing of new raw materials in order to achieve unusual effects. A special feature of this work was the use of opaque coloured glasses in glaze recipes. In low-fired glazes this resulted in the famous *famille rose* palette of onglaze enamels that are described in Chapter Twelve. It also lead to such famous 18th-century low-temperature effects as the 'Robin's Egg Blue', and various opaque acid-greens and cold lemon yellows.

In the field of high-fired ceramics, new glazes were created at Jingdezhen to copy materials as various as patinated metals, precious and semi-precious stone, certain types of lacquer, and even different types of wood. Some of the most successful of these new porcelain glazes, developed during this highly experimental phase, were the streaky blue, purple and red glazes designed initially to imitate Henan Jun wares. These too relied on various Chinese glasses, mixed with conventional porcelain glazes, for their particular qualities. From these glass-rich compositions Jingdezhen potters managed to develop still more vibrant and glossy copper-red monochrome glazes.

These rather over-fluxed copper-reds, characteristic of the later Qing dynasty, were often applied to large vases of heavy appearance, many of which show signs of grinding on their bases where over-run glaze has had to be removed after firing. Very similar glazes are still made at Jingdezhen, where they are fired in one of the last wood-burning 'egg-shaped' kilns still operating in the city.

However, now that the real nature of the early Ming copper-red glaze has been demonstrated so effectively, through the analysis at Beijing and Shanghai of the Pearl Hill Road finds, Jingdezhen scientists are looking again at these compositionally simple, but aesthetically unsurpassed copper-red glazes. As a result of this work it may not be too long before the story of copper-red glazes in China takes a further turn – with the experimental re-introduction at Jingdezhen of these early 15th-century compositions.

# FURTHER READING

*BOOKS AND EXHIBITION CATALOGUES*

Robert Tichane, *Reds, Reds Copper Reds*, The New York State Institute for Glaze Research, 1985

Herbert H. Sanders, *Glazes for Special Effects*, Watson-Guptill, New York, 1974

*Chinese Copper Red Wares*, (ed. Rosemary Scott), Percival David Foundation of Chinese Art, Occasional Monographs No 4, London University, 1991

*PAPERS AND ARTICLES*

Georges Vogt, 'Recherches sur les porcelaines Chinoises.' *Bulletin de la Societe d'Encouragemnet pour l'Industrie Nationale* (also translated and republished in Robert Tichane's *Ching-te-Chen – Views of a Porcelain City*, New York State Institute for Glaze Research, 1983, pp 186-313)

Nigel Wood, 'Investigations into Jingdezhen copper-red wares', *The Porcelains of Jingdezhen*, Colloquies on Art and Archaeology in Asia, no. 16, Percival David Foundation of Chinese Art, London University, pp 47-68, London, 1993

Yang Wenxian and Wang Yuxi, 'A study on ancient Jun ware and modern copper red glaze from the chemical composition.' *Scientific and Technological Insights on Ancient Chinese Pottery and Porcelain* (ed. Shanghai Institute of Ceramics), Science Press, Beijing, China, 1986, pp. 204-10

Zhang Fukang, 'Technical studies of Changsha ceramics', *Archeomaterials 2*, 1987, pp 83-92

Zhang Fukang and Zhang Pusheng, 'Analysis of Ming and Qing sacrificial red glazes,' *Proceedings of 1989 International Symposium on Ancient Ceramics*, (ed. Li Jiazhi and Chen Xianqiu), pp 267-71

Ian Freestone, 'Composition and microstructure of early opaque red glass'. In *Early Vitreous Materials* (M. Bimson and I.C. Freestone, eds). London: British Museum Occasional Paper 56, pp 173-191

Feng Xianming, 'Red glazed and underglaze-red porcelain of the Yuan dynasty.' *Orientations*, July 1985, pp 44-48

G.L. Efremov, 'Art porcelain in the Chinese People's Republic.' *Stecklo i Keramika* (1956), 13, pp 28-30

Francois Xavier d'Entrecolles (1712 and 1722) – Letters from Jingdezhen to Père d'Orry. (Translated and republished in Robert Tichane's *Ching-te-Chen – Views of a Porcelain City*, New York State Institute for Glaze Research, 1983, pp 49–128)

H.A. Seger, 'Japanese porcelain, its decoration and the Seger porcelain. The red and flammed cuprous oxide glazes.' *The Collected Writings of H.A. Seger*, The Chemical Publishing House, USA, 1902. Vol.2, pp 708-758

*Opposite:* Porcelain stem cup with monochrome copper-red glaze, early Ming dynasty, Yongle period (1403–24). XRF analysis of the colourants in this glaze revealed copper, iron, zinc, lead and antimony in a balance that matched a Chinese bronze of this period – which suggests that oxidised bronze may have been used as the glaze colourant. The base glaze itself seemed similar to under-glaze blue glazes of the same period. H. 4 in., 10 cm. Victoria and Albert Museum, C168-1905.

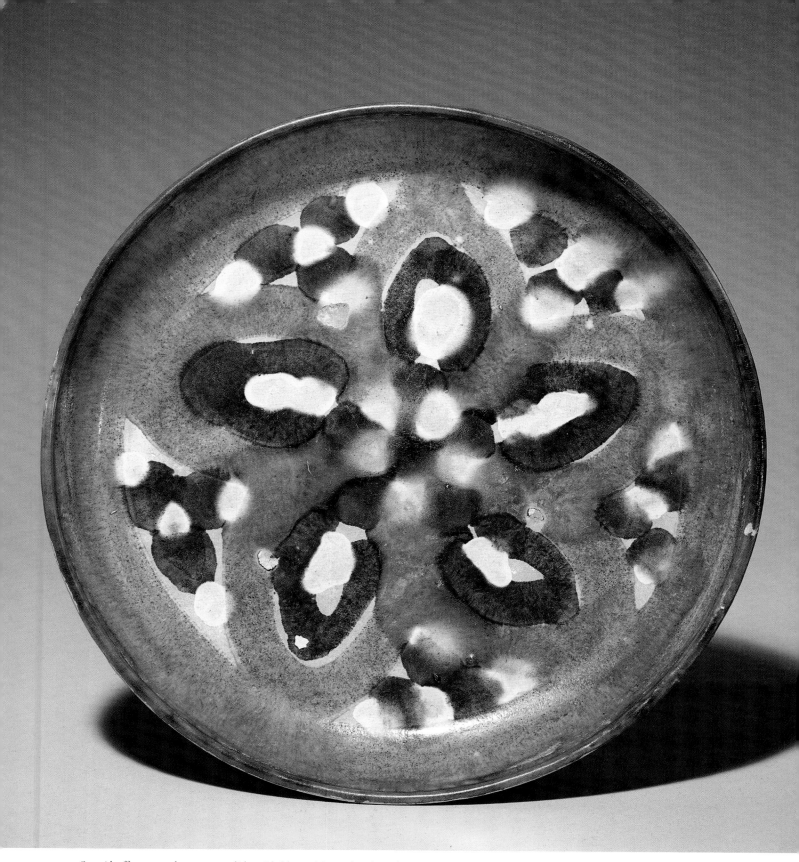

*Sancai* buff-pottery deep saucer-dish, with blue, white and amber glazes, Tang dynasty, first half of the 8th century. The technique used to glaze this dish seems simply to have been dabs of coloured glaze, applied with a brush direct to the unslipped biscuitware. Tang potters often used three-point clay spurs to separate their wares in firing, and these were almost identical in form to those used by the English ceramic industry today. Scars from one of these three-pointed supports can be seen on this dish. D. 9.4 ins., 23.8 cm. Christie's.

# Chapter 10

# CHINESE
# LOW-FIRED GLAZES

High-fired glazes have been used for the great majority of Chinese ceramics, with the magnificent monochrome stoneware glazes of Song China representing the peak of this tradition. But in parallel with these high-fired glazes runs a more colourful glaze technology that exploits the brilliant surfaces and polychrome effects that are possible with low-temperature firings. Low-fired glazes were used first in China for burial and architectural ceramics, but glazes of a similar type were later adapted and developed by Chinese potters to provide coloured overglaze enamels for stonewares and porcelains.

Chinese earthenware glazes therefore include the spectacular 'splashed' coloured lead glazes used on Tang funerary wares, the red, yellow, green and blue low-fired monochromes used on Jingdezhen porcelains, and the brilliant turquoise and purple-blue alkaline glazes, used in both north and south China on tiles, tomb figures and *fahua* wares. Chinese overglaze enamels are essentially lead-rich earthenware glazes, fired to low-earthenware temperatures (*c.* 700°–800°C) to exploit the range and intensity of colour possible with low-fired compositions.

The general level of Chinese ceramic technology is actually so high that its low-fired glaze tradition is also one of the most important and varied in the world. The majority of Chinese low-fired glazes are lead glazes, but China also has its own style of alkaline glaze, mainly fluxed with potassium oxide. Recent research in China has also uncovered a rare use of a boracic earthenware glaze, made at a kiln site near Beijing as early as the 11th century AD.

Apart from tin-opacified glazes, no important category of earthenware glaze is missing from the story of low-fired glazes in China and, in some cases, most notably Tang *sancai* glazes and Jingdezhen lead-based monochromes, Chinese potters seem to have achieved definitive quality from certain of these glaze types. Even so, and despite these considerable later successes, low-fired glazes were actually rather slow to become established in China – probably appearing at least 1000 years after the first Chinese

high-fired glazes were developed, and perhaps 3000 years after low-fired glazes were first made in ancient Egypt.

## The beginnings of earthenware glazes in China

The earliest Chinese low-fired glazes so far found seem to have been those used on some rare Warring States (475–221BC) earthenware jars decorated with relief rosettes of dotted glaze. Of the few examples that have survived (only four are known) all are made from gritty red clays coated outside with a white ground. The glazes are applied in regular dotted and striped patterns, where they stand out in low relief. In some areas as many as four different colours have been super-imposed – a peculiar, and so far unique, approach to glaze decoration in Chinese ceramics.

These 'glazes' are traditionally described as being fused or sintered glasses, but they are so degraded by weathering or burial that their original natures have been hard to assess. They have long represented an intriguing puzzle in Chinese ceramics, and it is only very recently that an example has been examined scientifically – with results that have proved as interesting as the pieces are rare.

## Warring States pottery jars with 'glass paste' decoration

Of the four examples of Warring States 'glass paste' decorated earthenware known to exist, one is in the collection of the British Museum, London; two more are in the USA; and one is in the National Museum in Tokyo. All four jars are essentially the same in form and style, although the British Museum example lacks a cover. The British Museum vessel was studied scientifically in 1994 and the results of this work were presented in Shanghai in 1995.

Analysis of the British Museum jar showed that the different coloured areas on the outside of the vessel (including the white ground) were all lead or lead-baria compositions. Because the glazes did not melt completely in the kiln it was possible for the potters to apply them

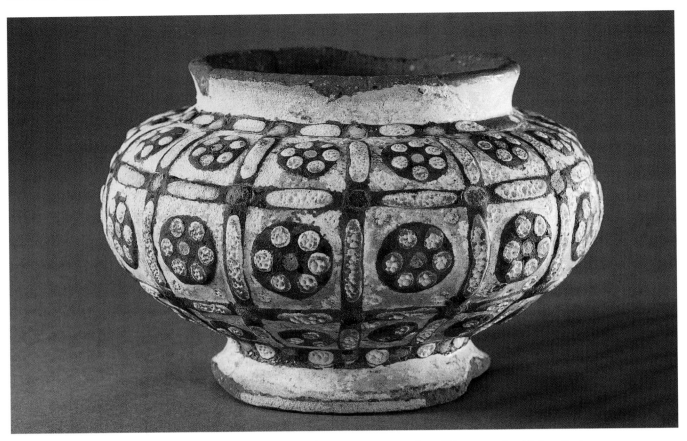

Pottery jar with highly weathered glazes, Warring States period. This is one of the earliest Chinese vessels with low-fired glazes to have survived, and is one of only four examples known with this style of decoration. These vessels seem to make use of similar glaze technologies to the bead on page 191, but with the glazes applied to ordinary clays. The original glaze colours would have been red, yellow and blue, on a white glaze ground, and would have looked much like the glazes on the Warring States bead. Their firing temperature seems to have been about 1000°–1050°C. H. 3.75 in., 9.5 cm. British Museum, OA 1968.4–22. 18.

in as many as four successive layers, without the combined masses of glaze running off the wares as they fused.

Close examination of less weathered areas of the British Museum piece showed that the original glaze colours were white, red, yellow and blue. The white ground was either opacified by undissolved quartz or perhaps by barium disilicate the usual opacifier in very early white Chinese glass. The vertical and horizontal bands and stripes were coloured red, from undissolved ferric oxide, while the yellow stripes and discs were iron yellows, produced by ferric oxide dissolved in the glaze. The blue dots proved the most remarkable of all as they owed their colour to particles of 'Chinese blue' – a synthetic copper-barium-silicate mineral, invented by the Chinese, and hitherto only known as an early Chinese paint pigment. Chinese blue has the composition $BaO.CuO.4SiO_2$.

Whether the Chinese blue was produced by the interaction of copper, barium and silica, as part of the firing process, or whether it was deliberately added to the glaze materials before firing, as a ready-made blue 'ceramic stain', is still not certain, but either way it was an unusually advanced, and powerfully coloured, ceramic effect. Nevertheless, despite the success of the technique, and the strength of the blue colour, this technology was not developed further in China, and the use of this brilliant barium-blue on Chinese ceramics seems restricted to this very early period.

Taken together these results represent a number of important 'firsts' in Chinese ceramics, including: the first use of low-temperature glazes in China; the first example of the Chinese low-temperature iron-red glaze; the first use of the low-temperature iron yellow glaze in China; the earliest known use of copper as a colourant in Chinese ceramics; the first (and apparently last) use of the 'barium blue' effect in historical Chinese ceramics; and the first employment of low-temperature polychrome glaze effects in China.

As for the style of these small jars, they seem influenced both by bronze vessels, and also by early Chinese glass. Their shape is close to that of a bronze *pou* (jar) form, while

Large glazed bead with stonepaste body and red, blue and yellow glazes on a white ground. Warring States period of the Eastern Zhou dynasty, probably late 3rd century BC. Two types of bead were made in China during the later Bronze Age, and both styles copied imported Western glass 'eye-beads'. The first were all glass, but in the second group true glazes were applied to vitreous near-ceramic bodies. Analysis of this bead (of the second type) suggests that its body was made from vitrified wood ash, while the low-fired glazes were complex mixtures of soda feldspar, quartz, and lead and barium minerals. These glazes appear to have been used unfritted and are not totally fused. The blue glaze is coloured with Chinese blue (see page 190), while the red and yellow colours derive from iron. It seems likely that this unusual technology was adapted to produce the glazed jar on page 190. L. 0.8 in., 2 cm. Collection of the author.

their dotted rosette patterns are common on Warring States glass 'eye-beads', as well as appearing on some very rare Warring States Chinese glass vessels. So far as is known the British Museum 'glass-paste' pottery jar is thought to come from Xunxian in Henan province and all four examples were excavated by Japanese archaeologists in the 1920s.

## Early Chinese high-lead glazes

The 'glazes' used on the Warring States jars described above were relatively low in lead (perhaps averaging only about 20% PbO), but there is another famous lidded jar, very similar in form to these 'glass-paste' vessels, that is in on show in the Nelson Atkins Museum of Art in Kansas City. This lidded jar is completely covered in what appears to be a greenish-yellow high-lead glaze, and this is generally held to be the oldest completely glazed earthenware vessel so far found in China. Even so, despite these important developments in the late Warring States period, it was not until the early first century BC that lead glazes began to see wide use in north China, although still only

on burial wares – with most everyday northern ceramics continuing as unglazed grey earthenwares.

### The novelty of high-lead glazes

That the Chinese began their low-fired glaze tradition with lead glazes (rather than with alkaline glazes) is an interesting phenomenon in itself. Alkaline earthenware glazes, fluxed by sodium oxide, had existed for nearly 3000 years in the Middle East by the time lead glazes were first made in China, but whether the principles of high-lead compositions were pioneered by Chinese or by Roman potters, who may have influenced whom, or if indeed any influence took place, are still live issues.

### The nature of high lead glazes

The ancient alkaline glazes of the Middle East occasionally contained small quantities of lead oxide as a secondary flux, but high-lead glazes that contained virtually no potash or soda at all were an entirely new development in world ceramics. Among the many advantages of these new compositions were their smooth, brilliant, but generally viscous, melts, and their excellent response to colouring oxides, which produced strong colours with rich and warm tones. The low thermal expansion and good elasticity of lead glazes meant that, unlike alkaline glazes, they did not need special high-expansion earthenware bodies in order to stop them flaking from the wares after firing. A further advantage of high-lead glazes was that they could be made direct from crushed raw materials that did not usually need fritting (that is pre-melting with silica) to decrease the solubility of their fluxes.

The fired appearance of high-lead glazes is particularly rich because of the high refractive index of lead oxide glass. The high atomic weight of lead oxide also increases the brilliance of the glaze, and a well-fired high-lead glaze can reflect twice as much light as an alkaline glaze. On the debit side lead glazes were made from very toxic raw materials that were potentially dangerous to the potters. The public was also at some risk from lead-rich glazes: if the glazes were wrongly designed it was not difficult for lead to be leached out from the fired glazes after firing by ordinary food acids, with potentially fatal results.

### Han lead glazes

Three main types of lead glaze were used on Han funerary wares: a transparent glaze (appearing light orange-brown over the reddish earthenware clay), a darker toffee-brown glaze coloured with iron oxide, and various copper-greens – often called 'cucumber-rind greens' in China. All three colours were reminiscent of bronze in its various states of patination and early Han lead-glazed vessels often followed the shapes of Han bronzes.

In addition to these colours, many Han lead glazes in museums show a silvery iridescence, due to the weathering and lamination of the outer glaze surface during burial under wet or corrosive conditions. This happens particularly to the Han copper green glazes due to the destabilising effects of copper on lead-rich glasses or glazes. In extreme cases, the glaze structure breaks down into flaky layers that show a curious silvery iridescence similar to mica. The effect was obviously unintentional, but in its milder form it adds interest and grandeur to many Han burial wares, particularly those made to imitate bronze forms.

This tendency for copper oxide to encourage the breakdown of high-lead glazes would have made most green Han lead glazes dangerous to use with food and drink – and a fatal dose of lead oxide could easily have been supplied by a single green-glazed Han bowl. Whether or not this explains the restriction of lead glazes in China to mortuary wares at this time is hard to say. White lead (lead carbonate) was used in China as a cosmetic in the Warring States period, and the Romans (who certainly knew of lead glazes, but also made little use of them on domestic wares) used white lead to sweeten wine. This all suggests that knowledge of the dangers of lead compounds in the ancient world was still less than complete.

### Han lead glazes of detail

In order to tackle the many questions raised by the origins and use of lead glazes in China, a programme was set up in 1989 to analyses some Han lead-glazed wares in the collection of the Victoria and Albert (V & A) Museum in London. The glazes and bodies of Han earthenware were examined using a number of techniques, including electron microscopy (to study the glaze structures, and to analyse their compositions), Airpath Energy Dispersive X-ray Fluorescence Analysis (where the examples were too well-preserved to take micro-samples), and Differential Thermal Analysis (to study the clay minerals in the raw earths still clinging to some pieces). Two examples of Han lead-glazed ware were examined in this way, with particular attention being paid to the way that the glazes had deteriorated with burial. The results of this work were presented in Shanghai in 1989.

### The V&A work

The first Han lead glaze studied from the V&A's collection came from a small Eastern Han covered jar with a bluish-green, slightly iridescent glaze. A minute glaze fragment was taken from an unweathered area of the glaze surface, and this micro-sample gave the result in Table 77.

This green glaze proved to be a fairly advanced lead-alumino-silicate composition containing about 2% of calcia. Its composition looked forward to the types of green high-lead glaze used on Tang, Liao and Song north Chinese *sancai* wares, as well as on some north Chinese Ming architectural ceramics. This glaze therefore seems a true technological ancestor of the 'classic' type of Chinese copper-green, high-lead glaze (Table 78).

These glazes are all very similar in composition and are also very near in their oxide balances to the lead oxide-silica-alumina eutectic: PbO 61.2%; $SiO_2$ 31.7%; $Al_2O_3$ 7.1%. This mixture begins to melt at 650°C, and supplies good lead glazes in the 900°–1000°C range. These glazes are further examples of a simple eutectic mixture providing the chemical 'bones' for a major Chinese glaze tradition.

Table 77    Eastern Han green lead glaze 1

| | PbO | $SiO_2$ | $Al_2O_3$ | $Fe_2O_3$ | $TiO_2$ | CaO | MgO | $K_2O$ | $Na_2O$ | BaO | CuO | $SnO_2$ | Cl |
|---|---|---|---|---|---|---|---|---|---|---|---|---|---|
| E. Han green lead glaze | 59.7 | 29.5 | 3.7 | 1.3 | 0.2 | 1.9 | 0.5 | 0.9 | 0.2 | 0.2 | 1.2 | 0.2 | 2.2 |

Table 78    Typical Chinese copper-green high-lead glazes

| | PbO | $SiO_2$ | $Al_2O_3$ | $Fe_2O_3$ | CuO | CaO | MgO | $K_2O$ | $Na_2O$ | BaO | $SnO_2$ |
|---|---|---|---|---|---|---|---|---|---|---|---|
| Han Green | 59.7 | 29.5 | 3.7 | 1.3 | 1.2 | 1.9 | 0.5 | 0.9 | 0.2 | 0.2 | 0.2 |
| Tang green | 55.6 | 33.6 | 5.8 | –.– | 2.0 | 1.0 | 0.5 | –.– | 3.0 | –.– | –.– |
| Tang green | 53.6 | 32.4 | 6.7 | 0.3 | 0.6 | 1.2 | 0.7 | 0.4 | 0.2 | –.– | –.– |
| Liao green | 57.2 | 33.3 | 3.4 | 1.5 | 2.1 | 0.9 | 1.4 | –.– | –.– | –.– | –.– |
| Liao green | 56.7 | 33.2 | 4.1 | 0.5 | 1.9 | 0.9 | 0.3 | 1.0 | –.– | –.– | –.– |
| Song green | 54.8 | 32.2 | 4.8 | 1.1 | 2.8 | 2.5 | 0.6 | –.– | –.– | –.– | –.– |
| Ming green | 60.0 | 30.3 | 5.2 | 0.17 | 3.4 | 0.4 | 0.1 | 0.2 | –.– | –.– | –.– |
| **Eutectic mixture** | **61.2** (M.P. 650°C) | **31.7** | **7.1** | | | | | | | | |

Small green lead-glazed jar, Eastern Han dynasty (AD25–220).
This jar was microsampled for the analysis in Table 77.
Victoria and Albert Museum, C99–1930.

As for the Han lead glaze's original recipe, the above analysis could have been achieved by mixing a raw lead compound (white lead, red lead, litharge or galena) with a fine sandy loess in roughly 3:2 proportions – although it is not impossible that raw lead compounds alone were applied to the wares, with the lead oxide dissolving the clay's surface during firing to make a glaze. The green colour was probably made by adding a small amount of a copper-tin compound to the glaze, and the most likely source for this copper-rich material would have been oxidised bronze.

The more weathered areas of the same glaze proved to be much lower in lead and copper oxides, and higher in silica, alumina, sulphur and chlorine compounds, probably from contact with burial earth, organic materials and ground salts. More than two-thirds of the lead oxide originally present in the unaltered glaze had been leached away during burial.

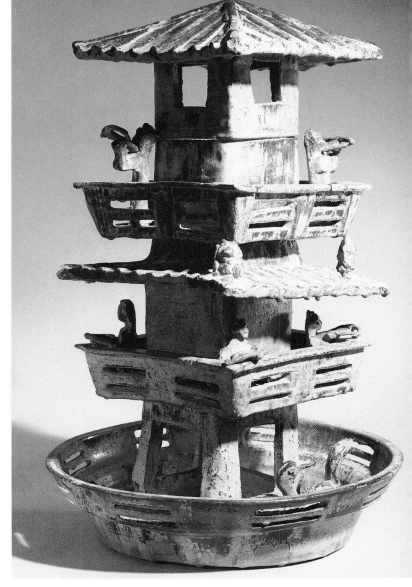

Large glazed earthenware model of a lookout tower, covered with a copper-green lead glaze, now somewhat weathered, from north China, Eastern Han dynasty. Many Han lead-glazed wares show milkiness, or silvery iridescence, due to the weathering and lamination of their glazes. Copper tends to de-stabilise lead glazes, so the effect is more evident in the green-glazed, rather than the brown-glazed, examples. H. 23 in., 58.5 cm. Christie's.

Table 79 Weathered areas of glaze 1

|  | PbO | $SiO_2$ | $Al_2O_3$ | $Fe_2O_3$ | CuO | CaO | MgO | $K_2O$ | $Na_2O$ | S | Cl | $SnO_2$ |
|---|---|---|---|---|---|---|---|---|---|---|---|---|
| Weathered area glaze 1 | 16.2 | 49.4 | 8.3 | .9 | .7 | 1.6 | 0.7 | 3.9 | –.– | 5.7 | .6 | –.– |

Table 80 Eastern Han green lead glaze 2

|  | PbO | $SiO_2$ | $Al_2O_3$ | $Fe_2O_3$ | $TiO_2$ | CaO | MgO | $K_2O$ | $Na_2O$ | BaO | $SnO_2$ | S | CuO |
|---|---|---|---|---|---|---|---|---|---|---|---|---|---|
| E. Han lead glaze 2 | 43.5 | 33.4 | 3.9 | 2.0 | 0.6 | 2.0 | 0.7 | 0.5 | 0.4 | 7.7 | 1.2 | 0.6 | 3.0 |

**Han lead glaze 2**

The second Han lead glaze examined for the study came from a small thrown vessel with a thrown lid, three short legs and two short handles. It was made to copy a Han bronze Ding. Microprobe analysis of its dark green glaze gave the composition in Table 80.

This also proved to be a high-lead glaze, coloured with copper and iron oxides, and with a small amount of tin oxide. However, the barium oxide content of this glaze (7.7% BaO) appeared most unusual at the time, as no examples of such high baria levels had appeared previously amongst analyses of either Han or post-Han lead glazes – making this one of the earliest lead-baria ceramic glazes yet discovered. Nonetheless, as we have seen, lead-baria compositions are quite common among Chinese high-lead *glasses*, particularly from the 3rd century BC to the 3rd century AD, and they have also been found on the British Museum's Warring States 'glass paste' vessel described above. This suggests that the Warring States jar may represent some kind of a bridge between early Chinese glass and early Chinese low-fired glaze technologies (see Table 81).

In the Han dynasties glass was treated rather as a semi-precious stone, and was often carved, using jade-working techniques, from 'cast' glass blocks. 'Cast glass' is not actually poured, but is made from crushed glass cullet that is packed into a mould, fired to about 700°C to fuse the cullet, and then given a lengthy cooling to anneal it.

Han grave goods were essentially cheap copies of vessels originally made in bronze and lacquer, so it may be that even glass cullet was too expensive a material to use for glazing purposes. Even so, the derivation of Chinese high-lead glazes from earlier experiences with high-lead glass does seem a definite possibility. It is possible that a tradition arose for using similar raw materials for both glass and glaze – without necessarily using the crushed glass itself as a major glaze raw material.

The source of the baria in both Han glazes and glasses is also a problem. The most obvious explanation might be that it was a natural impurity in the lead ore used to make the glass or glaze – and it is certainly true that some galena (lead-rich sulphide) rocks contain appreciable amounts of barium minerals. However, it is also true (as described

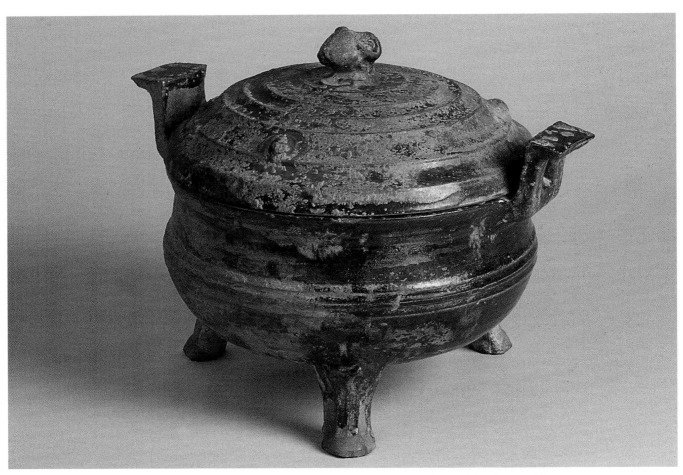

Three-legged covered jar of *ding* form, with dark green earthenware glaze, Eastern Han dynasty. The glaze on this vessel was shown to contain barium as well as lead oxide (see Table 80). Victoria and Albert Museum, C244–1909.

Table 81 Warring States glass analysis and Han lead-baria glass analysis

| | PbO | SiO$_2$ | Al$_2$O$_3$ | Fe$_2$O$_3$ | CuO | CaO | MgO | K$_2$O | Na$_2$O | BaO | MnO$_2$ |
|---|---|---|---|---|---|---|---|---|---|---|---|
| Warring States glass | 44.7 | 36.6 | 0.46 | 0.15 | –.– | 2.1 | 0.2 | 0.1 | 3.7 | 10.1 | 0.02 |
| Western Han glass | 42.4 | 38.8 | 1.28 | 0.17 | 0.08 | 0.7 | 0.14 | 0.2 | 3.3 | 10.7 | 0.05 |

Table 82 Analysis of weathered areas on the Han lead-baria glaze

| | PbO | SiO$_2$ | Al$_2$O$_3$ | Fe$_2$O$_3$ | TiO$_2$ | CuO | CaO | MgO | K$_2$O | Na$_2$O | BaO | SnO$_2$ |
|---|---|---|---|---|---|---|---|---|---|---|---|---|
| Weathered area Glaze 2 | 18.3 | 28.7 | 4.2 | 3.1 | 0.6 | 0.07 | 0.4 | 0.65 | 1.4 | 1.6 | 1.7 | –.– |

Table 83 Heavy metal release from reconstructed Han lead glazes, parts per million

| | Lead | Barium |
|---|---|---|
| Glaze #1a (no copper, but with 1% Fe$_2$O$_3$) | –.– | –.– |
| (as #1a with 1.5% CuO and 0.2% SnO$_2$) | 42 | 0.0 |
| Glaze #2a (no copper, but with 2% Fe$_2$O$_3$) | 1.5 | <1.0ppm |
| Glaze #2 (as #2a with 3% CuO and 1.% SnO$_2$) | 120 | 15 |

above) that the Han Chinese knew of barium minerals as pure substances, as they were used from at least the 3rd century BC to make blue and purple paint pigments by fusing barium-copper-silicate mixtures to about 1000°–1100°C.

The barium oxide discovered in the Han lead glaze was therefore not necessarily an unrecognised impurity in a lead-rich ore: it could equally well have been a deliberate and quite separate addition to the glaze. The whole question of the relationship of Chinese lead glazes to Chinese glasses is still a difficult and important subject, especially as Chinese high-lead glazes may prove to be the earliest examples of this glaze type in the world.

In the weathered areas of the Han lead-baria glaze lead and copper were again the major losses, but four-fifths of the original barium oxide had also been removed by the leaching process. Barium is known to be subject to heavy-metal leaching in glazes, but the mechanisms for this are less well understood than with lead.

*Han lead glazes and toxicity*
To establish just how poisonous these Han lead glazes originally were, glazes 1 and 2 were rebuilt with English materials, fired to about 1000°C, and then sent to the British Ceramic Research Association in Stoke-on-Trent for heavy-metal release tests. The glaze samples were prepared both with and without copper oxide and tin oxide, but all with iron oxide. The glazes were applied to a clay body designed to copy north Chinese loess (three parts of dry Potclays Red clay to two parts of Cornish stone). The results from these heavy-metal release tests are in Table 83.

These results show clearly how poisonous these Han green lead glazes could have been in their fired states and the very active way that the copper oxide colourant has increased this toxicity. Barium is also a heavy metal poison and is almost as toxic in its effects as lead. As with lead, the release of barium from the fired glaze seems to have been encouraged by additions of copper.

**EDXRF analysis**
A further question, explored by this V&A study, was whether the lead-baria glaze that had been discovered was a rare exception or whether other Han lead-baria glazed wares existed in the museum's collection. Six more examples of Han lead glazes were therefore analysed by the non-destructive method of 'air path' Energy Dispersive X-Ray Fluorescence Spectroscopy. This technique does not give a full oxide analysis for a glaze, but it can still show clearly which major and minor elements are present in the compositions.

Of the six examples studied, one more Han lead-glazed vessel showed substantial levels of barium – suggesting that lead-baria glazes were in the minority in the Han dynasties, but were not especially rare. The results also showed that all the green Han lead glazes analysed for the study contained tin as well as copper.

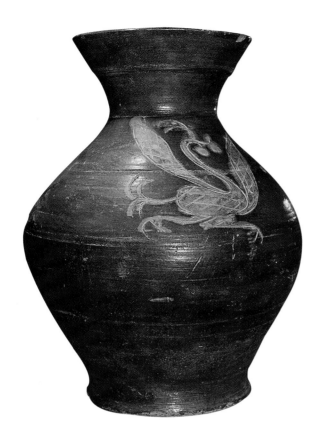

Lead-glazed jar with a sgraffito design of a bird in green, against a brown-glaze background, Eastern Han dynasty. Two-coloured Han wares are rare, and those with sgraffito designs are rarer still. The green glaze has weathered more than the brown. Hong Kong antique shop, 1995.

### Body composition of the Ding shaped vessel

A final step in this research programme was to establish the kind of raw materials that had been used by Chinese potters for making Han lead-glazed earthenwares. To these ends the Ding-shaped vessel with the lead-baria glaze was chosen for microsampling and analysis.

The Ding vessel proved to have been made from a loessic clay, closely related in composition and microstructure to some large, hollow Han tomb beams, also in the V&A's collection, and also analysed for this particular study. These results confirmed a long-held suspicion that loessic clays were the main raw materials used for making Han lead-glazed wares, and also for the large beam-shaped bricks, some more than a metre in length, that are found in many Han tombs in north China.

### *Loessic clays*

Loessic clays had already enjoyed a long production history in China by the time they were used for making Han

burial vessels and Han tomb bricks. They were the raw materials preferred for many Neolithic hand-built earthenwares, for Shang and Zhou bronze-casting moulds, and also for the great mass of ordinary architectural ceramics (pipes, bricks, tiles and beams) made throughout northern China from the Shang dynasty through to the Han. Loess is still used extensively as a raw material for brick and tile production in northern China, where the material is simply stripped from field surfaces for brickmaking – a technique that is only possible because the high fertility of loess can extend downwards for a 100 metres or more.

Perhaps the most spectacular use of loess in China's history was to make the terracotta army of Qin Shihuang, now partially uncovered and on view at Lishan Hill near Xi'an. Vast stretches of the China's Great Wall were also made from beaten loess, sometime faced with grey, reduction-fired bricks manufactured from the same material.

In most of these early wares the loessic clays were fired and cooled in reducing atmospheres, which gave the clays an ashy-grey colour, and also improved their fired strength through the fluxing effect of ferrous oxide. However reduction firing would have damaged the lead glazes used on Han mortuary earthenwares as lead oxide is easily reduced to lead metal, causing the glazes to blacken and blister as the PbO breaks down to metallic lead. For this reason Han potters deliberately oxidised their lead-glaze kilns, and this has produced the pale reddish-orange clays typical of Han lead-glazed earthenwares. Most unglazed and painted Han mortuary wares, however, continued to be fired and cooled in reducing atmospheres, and are consequently grey.

The Great Wall of China, north of Beijing. Much of the China's Great Wall is built from reduction-fired loess bricks, often laid against a rammed-loess substructure. Han lead-glazed wares were also made from loess, but they were oxidised rather than reduced.

Table 84 Analyses of loess-based north Chinese ceramics and Chinese loess

|  | SiO$_2$ | Al$_2$O$_3$ | TiO$_2$ | Fe$_2$O$_3$ | CaO | MgO | K$_2$O | Na$_2$O | MnO | P$_2$O$_5$ |
|---|---|---|---|---|---|---|---|---|---|---|
| Body of Ding-shaped Han vessel | 66.2 | 17.9 | 0.7 | 5.9 | 1.6 | 2.3 | 3.2 | 1.8 | –.– | 0.3 |
| Unglazed hollow Han tomb lintel | 68.1 | 17.2 | 0.5 | 4.6 | 1.2 | 1.8 | 2.7 | 1.5 | –.– | 0.1 |
| Loess found within lintel | 71.7 | 12.8 | 0.5 | 4.0 | 5.0 | 1.5 | 2.3 | 2.3 | –.– | 0.4 |
| Qin terracotta warrior, Lishan | 66.3 | 16.6 | 0.7 | 6.1 | 2.0 | 2.3 | 3.3 | 1.5 | –.– | –.– |
| Qin terracotta horse, Lishan | 63.2 | 15.9 | 0.7 | 6.1 | 2.6 | 2.1 | 2.9 | 2.0 | –.– | –.– |
| Han funerary jar | 65.8 | 15.8 | 1.0 | 5.2 | 2.1 | 2.1 | 3.3 | 1.6 | –.– | –.– |
| Neolithic pot, Banpo | 67.7 | 16.6 | 1.0 | 5.2 | 2.0 | 2.0 | 2.3 | 1.5 | –.– | 0.2 |
| Shang earthenware pipe | 66.5 | 16.9 | 0.8 | 6.5 | 2.8 | 2.0 | 3.0 | 1.3 | 0.1 | –.– |
| Loess (fired) Xi'an, Shaanxi | 64.6 | 17.6 | 0.7 | 5.2 | 4.4 | 2.4 | 2.6 | 2.3 | –.– | –.– |
| Loess (fired) Wonquanxien, Shaanxi | 63.9 | 16.9 | 0.8 | 5.3 | 5.9 | 2.3 | 2.9 | 1.6 | –.– | 0.16 |

The ease with which these fine-textured, low-shrinking clays could be worked, dried and fired must have contributed to the special vitality of Han burial earthenwares, which retain all the freshness of their original making. Fairly large-scale objects with ambitious forms, and many joints and additions, presented no problems to the Han potters who pressed, moulded, threw and slabbed this abundant raw material with all the confidence of a familiar and reliable medium.

This use of loessic clays for making substantial architectural units may reflect an increasing shortage of heavy timber in north China, which had suffered extensive forest clearances to create farming land from late Neolithic times onwards. Bronze and iron casting had also made heavy inroads into northern woodland – not to mention the grandiose building projects of Chinese emperors such as Qin Shihuang.

A combination of the natural versatility of the loessic raw material with the simplicity of low-temperature firings must have encouraged the extraordinary range and variety of later Han mortuary earthenware. These objects provide as rich an insight into the everyday life of Han China as the wooden and clay objects from ancient Egyptian tombs. However, while Egyptian design is rather stiff, the Han tomb objects are bursting with vitality and constantly surprising with the effectiveness of their distortions and stylisations, and the novelty of their subject matter. Even some of the simplest and most roughly executed moulded animals from Han China are small masterpieces of sculptural design and actually inspired such great modern artists as Henri Gaudier-Brzeska. The larger Han tomb models, representing houses, well-heads, farms, barns and temples have an architectural presence of considerable power.

This combination of lively invention with the potent spirit of Han art gives great richness to Han mortuary wares. The later Tang burial earthenwares, although fine in themselves, were less concerned with the practicalities of farming life and contemporary architecture – recording instead the splendours of Tang high society and international trade, together with exotic influences from beyond the Tang empire.

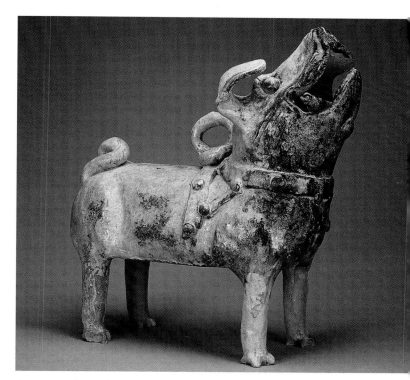

Pottery model of dog with a harness and a heavily weathered copper-green glaze, Eastern Han dynasty. Carter Fine Art.

### *Han earthenware decoration*

Much Han burial ware was decorated with paint, rather than with true glaze, while on some pieces both fired and unfired colours were used together. Among the colours applied to Han burial wares were the remarkable 'Chinese blue' and 'Chinese purple' paint pigments from the copper-barium-silicates, already mentioned in connection with the Warring States 'glass paste' vessels. The purple, pigment ($CuO.BaO.2SiO_2$), being more soluble than the blue, now often appears as a pale-lilac to white. Other colours were probably similar to those that had been used in earlier centuries to paint the terracotta warriors themselves, namely a white from bone ash, a green from malachite, a red from vermilion, and a black from carbon (lamp black). These pigments were often suspended in thin lacquer- or glue-based media to create the painting mixtures. Detailed decoration was more easily achieved with paint then with glaze and numerous large Han jars survive that are entirely covered by complex, rhythmic, painted designs in red, green, purple, blue and black. These are probably made in imitation of painted lacquer, which in Han China enjoyed a status far superior to bronze.

### Han two-coloured wares

Detailed polychrome patterns, however, were not possible with lead glazes at this stage in their development – although some simple effects were managed by painting brown and green lead glazes side by side on large jars, and with the edges of their coloured designs just in contact so that they melted together in the firing, with the definition of the green areas occasionally improved by rouletting or by sgraffito. There are also a few examples of the green glazes being trailed or brushed in repeating patterns onto a brown glaze background. Two-colour Han pieces are exceptionally rare, but they seem to anticipate some of the main decorative techniques developed later for Tang *sancai* earthenwares.

### *Post-Han earthenware*

Despite some 300 years of successful production, Chinese low-fired glazes suffered an eclipse in the chaotic centuries that followed the collapse of the Han empire. Between the early 3rd century AD and the mid 6th century AD, the use of burial earthenwares continued in north China, but glazes were used far less often; these burial wares were either left undecorated, or were painted with cold colours. Chinese lead-glazed wares were probably at their lowest ebb in the 4th to the mid-5th centuries AD.

However, by the latter half of the 5th century more stable conditions had returned to north China and lead-glazed wares began to revive – as represented by the rich store of green and brown lead-glazed figures discovered in the tomb of Sima Jinlong (a descendant of the Han royal family) dated to AD484, and found in the northern province of Shanxi. In south China, where lead glazing was always rare, improved stoneware technology saw increasing amounts of greenish, ash-glazed stonewares included in southern burials.

### Tang lead-glazed earhenwares

China has undergone many cycles of advance and decline, but the Tang dynasty (AD618–907) represents one the most glorious episodes in its entire history. Between the early 7th century AD and the late 9th century China became the greatest nation on earth – a prosperous, confident and outward-looking super-power, open to, and indeed fascinated by, influences beyond its boundaries and supporting large foreign communities (particularly Arab traders) in its cities. A powerful ruling class emerged, and the families of the rich, the noble, and of high officials, vied to stage the most spectacular funerals. The grave goods were paraded through the great metropolitan centres of north China and displayed on staging near the tombs before burial, before they were placed in special niches within the tombs themselves. The practice reached its height in the late 7th and early 8th centuries AD, when the finest and most ambitious ceramic burial wares were made.

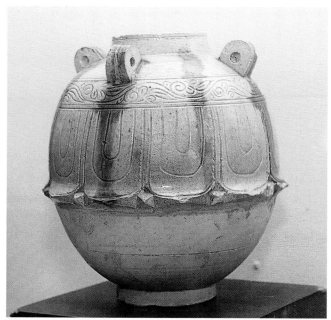

Light-bodied earthenware jar with a light yellow lead glaze and copper-green vertical stripes. This Northern Qi dynasty (AD550–577) lead-glazed jar marks an important change from the old loessic bodies, used hitherto for northern lead-glazed earthenwares, to whiter-firing clays that were essentially under-fired stonewares or porcelains. The light-firing clay and the designs in coloured glazes anticipate the two main techniques of the Tang *sancai* industry. H. 9.8 in., 25 cm.

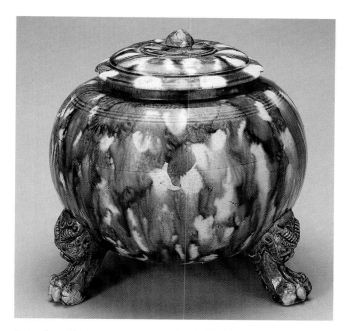

Tripod jar (*fu*), Tang *sancai* ware. First half of the 8th century AD. The classic *sancai* colours of straw-white, amber and warm green have been used to decorate this jar, which is made from low-fired stoneware or porcelain clay. Low biscuit firings were often used for Tang *sancai* wares (*c.* 1050°–1150°C), and the lead glazes matured at about 1000°C. It is not easy to tell whether an overall clear lead glaze has been applied first to this particular jar: the surface may simply have been built up from a patchwork of colourless- and coloured-glaze brushmarks. H. 6.3 in., 16.2 cm. Carter Fine Art.

When railways were built across north China in the 1920s thousands of glazed Tang tomb ceramics wares were uncovered. Many were shipped to Western museums where they give a spectacular (if somewhat one-sided) view of Tang ceramic art.

## Tang sancai wares

Tang lead-glazed earthenwares are known in China as *sancai* wares – *san* meaning three, *cai* meaning colours. Much of this ware uses straw-white, amber and green glazes, but the Tang dynasty also saw the introduction of a cobalt-blue lead glaze in the second half of the 7th century. There are also grey-black and brown-black Tang *sancai* glazes – apparently achieved by overloading the lead-rich base glazes with copper oxide and iron oxide respectively. Turquoise glazes also occur on a few rare pieces of Tang *sancai*. This brings the total of Tang earthenware glazes to at least six – making '*sancai*' a curious name for this ware. However, a modern Chinese handbook on Tang *sancai* explains its origins thus:

'Tang *sancai* is a modern name. In 1928, when the Longhai Railway was being built, some glazed camels and horses were excavated from tombs. They were

bright in colour and lifelike in manner. Since the relics discovered were glazed in amber, green and white they were given the name Tang San Cai – Tang Dynasty Tri-Colored Glazed Ware. By the time objects glazed in yellow, blue, black, brown and other colours were discovered the name had already stuck. People have continued to use it without change ever since.'

The wealth of influences that made Tang China one of the most remarkable civilisations in world history are plain to see in the Tang burial wares. In their scale, range of form, brilliance of colour and dramatic decoration, they exceed anything attempted by the makers of Tang high-fired ceramics. The *sancai* potters borrowed shapes from India, Persia, Mesopotamia and central Asia, as well as exploiting China's rich repertoire of utilitarian forms. Objects copied included those made originally in gold, silver, bronze, lacquer, wood, glass, horn and stone. Little attempt was made to imitate the character of the materials themselves – the forms tend to be impartially decorated with dotted, splashed, streaked and marbled coloured lead glazes, often using strong, geometric patterns derived from imported textiles. Perhaps most splendid of all are the Tang sculptural

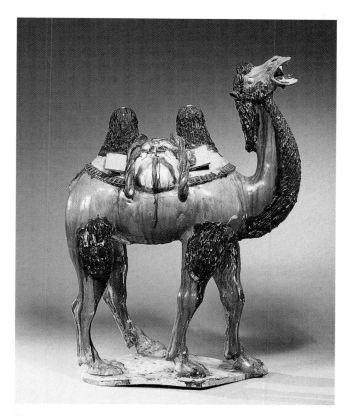

Large Bactrian camel with *sancai* glazes, Tang Dynasty. Much of China's trade with the West in the Tang dynasty used camels, and the animals must have been familiar sights in the northern cities. In this case the *sancai* glazes have been used semi-naturistically. H. 28.5 in., 72.4 cm. Sotheby's.

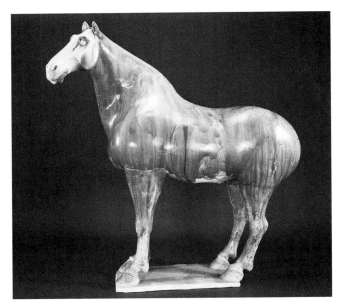

Large pottery horse with white slip on a buff body and an iron-containing amber lead glaze. From the tomb of Liu Tingxun (died AD 728). H. 30 in., 76 cm. British Museum, 1936, 10–12 226.

ceramics, especially the large horses and camels – usually glazed semi-naturalistically in creams, ambers and browns, but also with improbable and dramatic glaze combinations, such as blue with white spots, or white glazes with green splashes.

Apart from this greatly expanded subject matter, the most important difference between Tang and Han lead-glazed earthenware lay in the earthenware body itself. Tang potters abandoned the old reddish loessic clays that had been the mainstay of northern earthenware production since Neolithic times, adopting instead the white and buff-firing secondary kaolins and fireclays associated with north China's coalfields. These clays had already proved their usefulness in the rapid development of Chinese high-fired wares in the 6th century AD. Mortuary ware kilns sprang up at existing Tang stoneware and porcelain kiln sites, such as Tongchuan in Shaanxi, Neiqui county in Hebei and Gongxian in Henan. The local stonewares and porcelains were underfired to provide earthenware bodies for the *sancai* burial wares, and the huge quantities discovered suggest that funerary ceramics were a substantial business in the late 7th and early 8th centuries AD.

When the traditional northern lead glazes were applied to the new white bodies, the clear lead-glazes fired straw-

coloured or light yellow, the iron-rich glazes a fine amber or chestnut brown, and the copper glazes showed rich and warm copper-greens. Initial experiments with these new clays seem to have started as early as the Northern Qi dynasty (AD550–577) and a fine Northern Qi white bodied jar, decorated with a yellow lead glaze with green stripes, was excavated in Henan province and is now on show in the Palace Museum, Beijing. This important piece comes from a tomb that was closed in AD576 and it seems to be a true precursor of the Tang *sancai* style.

## The beginnings of Tang sancai

Despite the existence of some advanced glazed earthenwares from the late 6th century, such as the Northern Qi jar described above, the fully developed *sancai* style cannot be traced back much further than the reign of the notorious empress Wu (reigned AD690-704), and the best Tang *sancai* wares were made for a surprisingly short period, perhaps for only about 75 years in all.

Coloured lead glazes are found on some Tang burial wares made earlier than this reign, but they tend to be used either alone, or in combination with cold painting, rather in the Han manner. A few streaked lead-glazed wares have been found in a tomb dated to AD664, that have something of the *sancai* spirit, without yet showing its developed style.

Tomb guardian and Buddha defender at the Juxian temple cave, near Luoyang, Henan province, late 7th century AD. The building of this temple, with its giant 17 m high Buddha, was financed by the empress Wu. These dramatic limestone figures, carved in the cliff-face to the Buddha's left, are amongst the greatest of Tang rock carvings, and their style is echoed in some Tang *sancai* figures.

Table 85 Analyses of Tang *sancai* bodies

|  | SiO$_2$ | Al$_2$O$_3$ | TiO$_2$ | Fe$_2$O$_3$ | CaO | MgO | K$_2$O | Na$_2$O |
|---|---|---|---|---|---|---|---|---|
| Henan *sancai* body | 63.8 | 29.8 | 0.9 | 1.4 | 1.6 | 0.6 | 0.7 | 1.2 |
| Shaanxi *sancai* body | 65.9 | 27.8 | 1.2 | 1.15 | 1.5 | 0.55 | 1.3 | 0.5 |

Guardian figure in Tang *sancai* ware, early 8th century. Large tomb guardians such as these were hollow and made from numerous press-moulded sections, joined together with sticky clay whilst in the leatherhard state. They were then slipped with white clay, biscuit-fired and glazed. Shanghai Museum.

Some of the very finest Tang *sancai* wares have been excavated from the tomb of the princess Yongtai, near Xi'an. Chinese histories record that the 19 year old princess was either forced to hang herself, or was flogged to death, on the orders of her grandmother, the empress Wu, in revenge for some mis-reported remarks. The princess was pardoned, posthumously, in AD705, and given a spectacular funeral. Her tomb near Xi'an was excavated in 1964 and, besides its fine *sancai* wares, contains some of the best examples of tomb painting to have survived from this period.

The analyses on page 202 shows that Tang *sancai* glazes were based on the same lead oxide-silica-alumina eutectic mixture as some Han lead glazes. This low-firing 'ideal' mixture begins to melt at 650°C and gives good quality lead glazes up to about 1000°C – providing a useful transparent base for the various *sancai* colours. The alumina contents of these glazes would have allowed fair amounts of clay to have been used in the original recipes (about 15-50%, depending on the types of clay used). These clay contents would have been useful when applying glazes to

Detail of figure, showing resisted glaze areas.

biscuit-ware or to raw clay, as well as helping to suspend the heavy lead compounds in the glaze mixtures. The alumina levels in Tang lead glazes also contributed to the slightly dull richness that is part of the *sancai* quality, while at the same time enhancing glaze viscosity during firing. Tang *sancai* glazes are usually minutely crazed, which further softens their fired appearance. This fine crazing is due to the very low contraction of the *sancai* bodies during their last stages of cooling.

**Modern *sancai***

It is interesting that Tang potters based their *sancai* lead glazes on this particular eutectic mixture, as there is an even simpler lead oxide 'eutectic' that would also have served. This is a mixture of 84.7% lead oxide and 15.3% silica, with an initial melting point of 690°C. However glazes of this higher lead type may well have been avoided by Tang potters because of their lack of clay content, and the rather harsh and over-glossy effects that they produce. Nonetheless, there are some modern Chinese *sancai* imitations that make use of the higher-lead 'eutectic' – such as a modern Shaanxi *sancai* 'white' glaze which contains 84.1% lead oxide, 14.23% silica and 1.2% alumina. Modern Shaanxi *sancai* wares are biscuit-fired to 1050°C, then given a glaze firing to 850°C. They are far shinier than the Tang originals.

**Colour in Tang *sancai* glazes**

The ten analyses listed above also show the typical colouring oxide percentages found in Tang *sancai* glazes, that is: amber 2-5% $Fe_2O_3$, green 1-4% CuO, and blue about 1.0% $Fe_2O_3$, plus about 1.0% CoO. This particular 'white' (transparent) glaze contains about 2.0% $Fe_2O_3$, which provides a warm straw colour, although most clear *sancai*

## Chemistry of Tang *sancai* glazes

Table 86 Analyses of Tang *sancai* glazes

| Glaze | Excavation site | PbO | SiO$_2$ | Al$_2$O$_3$ | Fe$_2$O$_3$ | CaO | MgO | K$_2$O | Na$_2$O | CuO | CoO |
|---|---|---|---|---|---|---|---|---|---|---|---|
| 1 Yellow-orange | Shaanxi | 50.5 | 30.5 | 6.9 | 4.9 | 1.2 | 2.1 | 0.2 | –.– | –.– | –.– |
| 2 Yellow-orange | Shaanxi | 54.6 | 28.6 | 8.0 | 4.1 | 1.6 | 0.4 | 0.7 | 0.4 | –.– | –.– |
| 3 Yellow-orange | Gongxian | 59.6 | 29.3 | 5.7 | 2.3 | 1.6 | 0.5 | 1.0 | 0.5 | –.– | –.– |
| 4 Green | Fostat | 55.6 | 33.6 | 5.8 | n.t. | 1.0 | 0.5 | –.– | 0.3 | 2.0 | –.– |
| 5 Green | Gongxian | 50.0 | 30.6 | 6.5 | 0.5 | 0.9 | 0.2 | 0.3 | 0.3 | 3.8 | –.– |
| 6 Green | Mantai | 55.4 | 32.6 | 6.7 | –.– | 0.8 | 0.6 | 0.3 | 0.5 | 3.2 | –.– |
| 7 Green | Samarra | 57.0 | 36.0 | 4.2 | 1.1 | –.– | –.– | –.– | –.– | 1.1 | –.– |
| 8 White | Shaanxi | 52.6 | 31.9 | 5.8 | 2.1 | 2.2 | 1.3 | 0.5 | 0.1 | –. | –.–– |
| 9 Blue | Gongxian | 42.1 | 34.4 | n.t. | 1.1 | 2.3 | 0.5 | 0.2 | 0.1 | –.– | 1.2 |
| 10 Blue | Gongxian | 45.0 | n.t. | n.t. | 1.0 | 0.8 | 0.4 | 0.3 | 0.2 | 0.4 | 1.0 |
| PbO–SiO$_2$–Al$_2$O$_3$ eutectic mixture | | 61.2 | 31.7 | 7.1 | | | | | | | |

n.t. = not tested

glazes probably contained less iron than this example. Glaze 7 (a green glaze) contains iron oxide as well as copper oxide, which gives the green a warmer tone. Three of the glaze analyses above are from Chinese *sancai* wares found in the Middle East (Glazes 4, 6 and 7), while the remainder are from wares excavated in China. This suggests that there were no essential differences between *sancai*

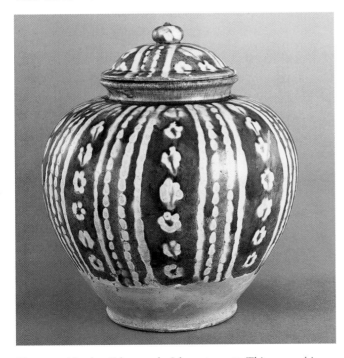

Tang *sancai* jar, late 7th or early 8th century AD. This covered jar shows the influence of Central Asian textile patterns, often adapted for use on Chinese *sancai* wares. The resist material may have been wax (in which case it would have burned away in firing), or a more solid resist-substance, such as clay, which would have been removed once the coloured glazes had been applied and dried. H. 20.5 cm. British Museum, OA 1946.7–15.1.

glazes made for export and those used on burial earthenwares within China itself.

When considering how close these analyses might be to the original glazes, it is worth noting that some lead oxide was probably lost during firing through volatilisation. There is also the consideration that these coloured glazes were often applied over transparent base glazes, which tended to dilute the colouring oxide percentages. The original overglazes were probably richer in colouring oxides to allow for this effect.

### *Sancai* glaze types

So far as one can tell, the great majority of *sancai* techniques seem to have involved coloured glazes, rather than over- or under-painting with pure metal oxides – and three different concentrations of colouring oxides appear to have been used by the *sancai* potters:

*Glazes with 'oversaturated' oxide contents.* These give very dark brown-black and grey-black glazes, with dull micro-crystalline surfaces. They are overloaded with either iron or (more rarely) copper oxides, which are present in the undissolved or re-crystallised state after firing. These are the rarest of the *sancai* types and they have yet to be analysed. In the case of copper oxide in lead glazes, over-saturation begins at about 5% – and with iron oxide at about 8%.

*Glazes with medium-to-high colouring-oxide contents.* These are the commonest *sancai* type and they were often applied over transparent lead glazes. These clear underglazes would have diluted the strong colours of the overglazes to provide the typical *sancai* colours. Where these concentrated overglazes (by accident or design) were used too thickly, or directly onto the clay bodies, oversaturated effects sometimes occurred.

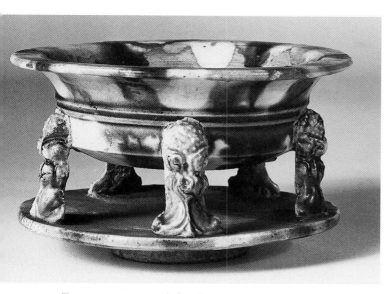

Tang *sancai* censer with five feet, 8th century AD.
Royal Ontario Museum, ROM 920.10.91.

*Glazes with lower colouring-oxide contents*. These glazes were intended to be applied direct to the raw or biscuited clays, without the colourless glazes beneath. They were often used on the monochrome style of *sancai* wares.

## Firing temperatures

The lead oxide eutectic mixture, on which most Tang *sancai* glazes depend, starts to melt at 650°C, but the glaze firings for most Tang *sancai* wares have been variously estimated as being 'below 900°C' and 'about 950°C'. Most Tang *sancai* glazes therefore seem to have been slightly overfired to encourage the dramatic (but usually well controlled) running and merging of the lead-rich glazes that is very much part of the *sancai* style. When the above analyses are reconstructed, a firing temperature of about 1000°C seems to work best – although it must be remembered that reconstructed *sancai* glazes should never be used on domestic wares as they can easily poison food, with the *sancai* copper-greens being particularly deadly.

In terms of their original Chinese recipes, glazes 2 and 3 could have been made from mixtures of about three parts raw lead (litharge, galena, red or white lead) with about two parts loess. This recipe accounts well for all the major and minor oxides present, as well as for the iron oxide colourants – although this is only a guess as to how these amber glazes may have been made. The alkali and iron oxide contents of the other *sancai* glazes are much lower than in glazes 2 and 3, and this tends to rule out the use of substantial amounts of loess in the original glaze recipes. White clays, such as the clays used for the *sancai* bodies themselves, may well have provided the alumina and some of the silica in these glazes without introducing too much alkali or iron oxide. Powdered quartz probably

supplied the silica balance. The kilns used for Tang *sancai* wares were wood-burning and of the *mantou* style. The wares were open-fired, using quite advanced kiln furniture, such as three-pointed spurs and kiln props and kiln shelves.

Apart from their relative purity, the above analyses show that there was nothing especially novel about *sancai* glaze chemistry as similar oxide compositions had already been used in the Han dynasty (see Table 77). The particular character of Tang *sancai* came from the application of the coloured glazes to buff or white, underfired stoneware clays, and from the striking patterns and resist processes that were typical of the developed *sancai* style.

## *Sancai* kiln sites

The two main centres for *sancai* production in Tang China that have been properly studied are the Huangbao kilns in Shaanxi province and the Gongxian kilns in Henan province. These two important kiln complexes are at least 300 miles apart, and they seem to have supplied the great Tang cities of Changan (now Xi'an) and Luoyang respectively. Analysis shows that both kiln areas used remarkably similar clays and glazes – that is, underfired stonewares for the bodies and lead-alumina-silica mixtures for the glazes. Such close matches between clays and glazes from such widely separated kiln sites happen surprisingly often in Chinese ceramics. In the case of the bodies this is often the result of consistent geological features that run for hundreds of miles. The similarities between *sancai* glaze compositions from Huangbao and Gongxian suggest either some communication between the two kiln areas concerning successful *sancai* recipes or perhaps parallel developments from earlier lead-glazing traditions. In style there seems little difference between the two kilns, although use of the cobalt-blue glaze was more extensive at Gongxian.

## Decorative techniques in Chinese *sancai* wares

When we come to examine the decorative techniques used with Tang *sancai* we meet some of the most original uses of coloured glazes in the whole history of Chinese ceramics. Tang textiles are thought to have influenced many of the patterns used by the *sancai* potters, but the verve and drama, apparent in the way these patterns were applied, puts the Tang *sancai* wares into a class of their own. The remarkable originality of the *sancai* style has been credited in part to the 'aristocratic exoticism' of High Tang taste, and this free and almost expressionistic spirit can also be seen in some Tang paintings. High-fired Tang wares display this spirit to a much lesser degree. The best Tang stonewares and porcelains were essentially sober and high-quality utilitarian wares with strong and simple forms, and not intended to provide striking displays of colour, wealth and style.

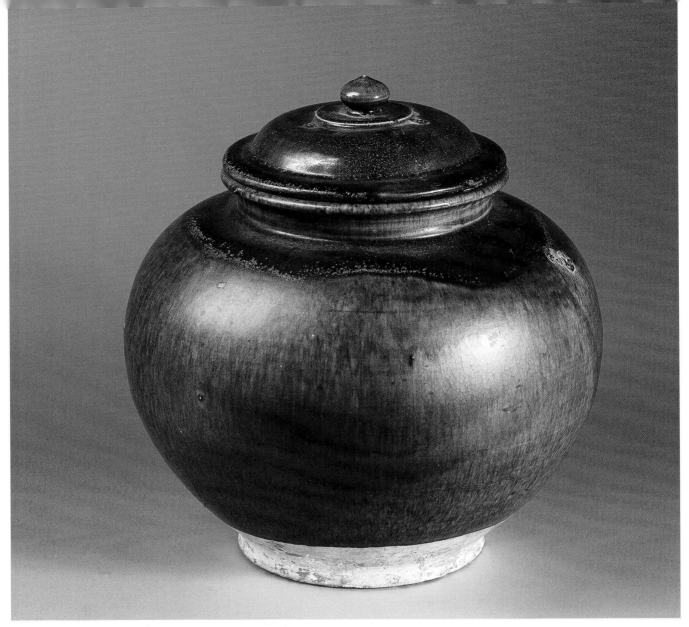

Plain blue-glazed Tang earthenware pot with cover, early 8th century. Cobalt pigments need to be exceptionally pure in order give good blue tones in high lead glazes. In this case the cobalt seems to be mixed, probably naturally, with iron oxide, and forms a true black where thick. H. 9 in., 23 cm. Gemeentemuseum, The Hague. OCVO 22–54.

## Glaze application

Study of *sancai* wares themselves suggests that pouring, dipping and brushing were all used to apply the glazes, with each technique supplying its particular surface quality. The commonest *sancai* application method was to paint coloured glazes on top of clear glazes. Less often the various glazes were painted side by side, and built up into an elaborate patchwork of coloured design. On some examples, though, the glazes appear to have been applied by trailing, perhaps by using a fine spouted vessel. Diagonal glaze trailing was a particularly effective technique as it encouraged vertical streaks of coloured glaze to run down from the diagonal lines during firing. The copper-green glazes, being the most fluid of the *sancai* compositions during firing, were often used in this way. Monochrome lead glazes were often poured or dipped, but seem occasionally to have been brushed – giving dynamic variations to plain forms through small differences in glaze thickness.

## The resist process

Perhaps the most original *sancai* technique was the resist process. This involved applying patches of resist medium to a thin clear glaze before firing, then overglazing by painting, pouring or dipping with the coloured *sancai* glazes. It was once assumed that wax or grease were the usual resist media in Tang *sancai* wares – in which case the overglazes would have simply run off the resisted areas during application, and the resist medium would have burned away in the glaze firing.

However some examples of Tang *sancai* show dusty patches in the resisted areas that look like traces of white clay. It seems possible, in these cases, that the *sancai* potters may have borrowed the textile technique of using a clay and flour paste mixture as a resist medium. This would have been applied on top of the clear glaze and allowed to dry before the coloured glazes were brushed on. The small details of set resist could then have been picked off, taking small areas of the coloured overglazes with them. In using this method some of the clear underglaze would have come away with the resist material, and it is noticeable that the centres of the resisted areas on many Tang *sancai* wares are dull and almost bald of glaze, which may support the idea that some kind of kaolin-resist process had been used. This is still supposition but, however achieved, the dappled glazes and slightly uneven surfaces that resulted from *sancai* resist-glazing techniques are characteristics of some of the finest and most ambitious examples of these wares.

### Firing temperatures for *sancai* bodies

While there is general agreement about the firing temperatures used for Tang Chinese *sancai* glazes (*c.* 900°–950°C), some very different firing temperatures have been proposed for the bodies themselves. These tend to fall into two groups: *c.* 950°–1050°C, and 1100°–1200°C.

The first temperature range is low enough for the wares to have been raw-glazed and once-fired. However, raw glazing is not suggested in any Chinese reports, and a certain amount of biscuited *sancai* ware has been found at Tang kiln sites. Even so, these may have been destined for export and it is not impossible that some Tang *sancai* wares were once-fired. Biscuit firings to roughly the same temperatures as the glaze firings may also have been practised, particularly with large and complex pieces.

The second range of firing temperatures proposed (1100°–1200°C) suggests a hard biscuit firing to toughen the body, followed by a lower firing to mature the glazes. The use of a hard biscuit firing seems associated particularly with the Tang *sancai* wares made for export, presumably to render them strong enough to survive their long trade-journeys, and eventual domestic use.

The best evidence for high biscuit firing is seen in some Chinese *sancai* wares excavated at Samarra in Iraq that date to late in the Tang dynasty (late 9th, early 10th century). Tang *sancai* shards from Samarra have the same body compositions as the Tang whitewares found with them. Both whitewares and 'earthenwares' seem to have been fired to 1100°–1200°C, but the *sancai* wares were left unglazed in the high temperature firing. The hard biscuit was then glazed, and given a second firing to about

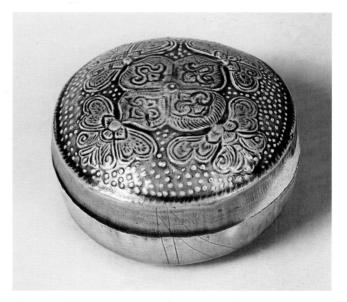

Press-moulded copper-green lead glazed dishes of this type are sometimes attributed to the Tongguan kilns of the late Tang dynasty. They may be a southern development of the northern *sancai* style. D. 5.6 in. 14.2 cm. Carter Fine Art.

Opinions differ on the source of these covered boxes; some are attributed to Henan province in the north, others to the Tongguan kilns. The close compositional similiarities between northern and southern copper-green lead glazes in China in the late Tang dynasty can make northern and southern green lead glazes difficult to tell apart. (The central pattern on the box's cover seems to represent the quatrafoil sepals of the persimmon fruit – a popular pattern on northern *sancai* wares.) H. 2.6 in. 6.5 cm. Carter Fine Art.

Liao *sancai* beast, perhaps a tiger, 11th century AD. This lively animal is unusual in being freely modelled from solid clay, rather than press-moulded into porous biscuit-fired clay moulds, like the earlier Tang *sancai* figurines. The lead glazes are iron-brown and copper green. Liao *sancai* greens, with these warm olive tones, often contain iron as well as copper oxides, but their essential compositions are close to the Tang *sancai* originals. L 4 in., 10 cm. Carter Fine Art.

900°–1000°C to mature their glazes. This 'hard-biscuit – low-glost' idea anticipated the Jingdezhen 'enamels on *bisque*' process by at least 400 years. Much of the whiteware and *sancai* ware found at Samarra is thought to have been made in Gongxian, in Henan province, with the *sancai* wares in particular being tailored to Mesopotamian taste.

**Everyday use of Tang *sancai***

The existence of Chinese *sancai* wares, made for export to Iraq, as well as to other countries such as Japan and Egypt, has raised the question of whether Tang *sancai* wares were ever used as luxury wares by those living in China. This is a much discussed problem, but it now seems possible that Tang *sancai* wares saw some limited use in China as exotic everyday wares. However, by the late 9th century, the days of Chinese *sancai* itself were numbered: the Tang empire collapsed in AD906, elaborate burials ceased, and lead glazing in China suffered another eclipse. It was fortunate for the future of lead glazing in China that many of the Tang *sancai* techniques were adopted and developed by potters north of the Great Wall in the 10th century AD – in the newly-formed empire of the Khitan tribesmen, who styled themselves the Liao.

*Liao Wares*

The Liao was a northern dynasty, with Beijing as its capital. It lasted from AD907 to 1125. The dynasty was founded by the Khitan tribes of Manchuria, who were semi-pastoral nomads with designs on the old Tang empire, which was now breaking up under the turmoil of the Five Dynasties and Ten Kingdoms period (AD907–960).

In an expansionist foray south in AD945 the Khitans seized and occupied parts of Hebei province where many important whiteware kilns were sited, kidnapping many craftsman from the Xing and Ding kilns in the process. In AD946 they pushed further south, to the very heart of north China – Zhengzhou and Kaifeng in Henan province. Somewhat overstretched, they then retreated to Beijing and concentrated on developing their empire to the east and to the west. By AD947 the Liao controlled vast stretches of far northern China, including present day Liaoning province and Inner Mongolia, with the lands around the Great Wall as their southern border. The Liao empire lasted until AD1125, when it was destroyed by the Jurchen Tartars who had their tribal origins near present-day Vladivostok. Two years later the Tartars invaded north China itself, capturing both the current and retired emperors in Kaifeng in AD1127, establishing their own Jin ('Golden') dynasty – again with Beijing as the capital. The Jin dynasty lasted until AD1234, when it in turn was obliterated by the re-invasion of north China by Genghis Khan's third son Ogödai and his Mongol horsemen.

The Liao made lively ceramics in a vigorous style that owed much to the Tang spirit in design. The Liao potters specialised in lean and dramatic forms, often with flaring tops. One popular Liao shape consisted of thrown ceramic bottles with their rims squeezed together in imitation of the traditional Khitan leather flasks. This design had already featured among Tang *sancai* exotica, but was now used by the Liao as a ceramic form on home territory.

The Liao also produced high quality thrown and moulded white porcelains, some of which were made at the important Longquanwucun kilns, some 17 miles north of Beijing. But of particular interest to this chapter are the Liao lead-glazed earthenwares as these were everyday wares and not especially made tomb goods. This has presented ceramic historians with the problem of deciding whether this was a new departure, or a Liao development of an existing Chinese tradition. Recent work on the Tang *sancai* wares found in Iraq seems to suggests the latter.

The Chinese ceramics found in Samarra are thought to have been made quite late in the Tang – in the 9th, or even the very early 10th, centuries AD (Tang Dynasty, AD6 18-907). If relatively high-fired wares, glazed with lead glazes, and intended for everyday use, were being made in China in very late Tang times it is not hard to imagine the technique spreading to the new Liao empire, perhaps via the skills of captured Hebei or Henan potters.

With this likely Chinese influence in mind it may be significant that the Liao lead glazes that have been analysed

are very close in composition to the lead glazes used on Tang *sancai* wares. As with Tang *sancai* wares, the Liao lead-glaze analyses fall in the general area of the 650°C lead oxide-silica-alumina eutectic mixture.

A few minor differences can be seen between the Tang and the Liao lead glazes in the ways that their colouring oxides are used. Glaze 1 is unusual in being coloured by a nickel-cobalt mineral, rather than the iron- or manganese-cobalts usually seen in Chinese ceramics (this must be a very rare shard as complete Liao wares with blue lead glazes are most unusual). The Liao green glazes tend to be richer in iron oxide, and lower in copper oxide, than their Tang *sancai* equivalents. The Liao amber glazes, however, are very close to the Tang originals in composition, and indeed look just like them. A hard biscuit firing to about 1120°C has been proposed for Liao earthenware and, as with the Tang wares, their body materials were essentially underfired stonewares. The Liao glazes probably matured at temperatures approaching 1000°C.

Most of the earlier Liao lead-glazed wares featured plain monochrome glazes, rich, deep and glossy in character and often used over impressed or lightly carved decoration. Most were thrown, and tall bottles were a popular form. White slip was usually applied to the darker stoneware clays to show these coloured glazes to good effect. Later in the Liao dynasty (apparently after the mid-11th century AD) a true *sancai* style developed, using amber, clear and green glazes over buff bodies, again covered with white slip. Intense cream-white areas were achieved where the thin, clear glazes covered the white ground, and this generous use of white is a particularly attractive feature of the Liao *sancai* style. A certain amount of Liao *sancai* was made in the shapes of contemporary silver dishes, with the rich repoussé detail copied by press-moulding.

In another group of Liao lead-glazed wares, related to the *sancai* pieces, the coloured glazes were applied direct to light-firing bodies decorated by freehand drawing in the leatherhard clay. The green, amber and straw glazes deepened in the designs as they melted, enhancing the sharp lines with hazy colour. In some examples the decoration is naïve and carefully filled in with coloured glazes, but in some other wares the drawing is almost Korean in its wildness and the different glazes are very freely applied. The Tartar conquest of the Liao was a particularly bloody affair and the reckless and dramatic spirit of these late Liao wares may reflect conditions of extreme privation or danger in the lives of the potters.

## Liao boric-oxide glazes

All the low-fired glazes, so far described in this chapter, have been of the high-lead or lead-baria type, and of broadly similar composition. But an important exception to this rule has been recently discovered at the kiln area of Longquanwucun, some 17 miles north of Beijing. Two Liao Longquanwucun shards with curious dark-green earthenware glazes were analysed in 1989 and shown to contain boric oxide as their major glaze flux. Their lead oxide contents were negligible, making these the earliest boric oxide-fluxed glazes so far found anywhere in the world.

Boric oxide is an odd glaze material as it serves simultaneously as a flux, a glass former and a glaze stabiliser. In large quantities it causes crazing, in smaller amounts it reduces crazing. Its refractive index is lower than lead oxide's so boric oxide glazes tend to lack the richness of their lead equivalents. Their response to colouring oxides is midway between that of alkaline glazes and lead glazes – for instance when copper oxide is used in boric oxide glazes it gives a greenish-blue colour, rather than the turquoise-blue typical of high-alkali glazes, or the strong emerald greens that can be achieved in glazes that are rich in lead.

These glaze analyses are difficult to interpret – both in terms of their chemistries and their original recipes. There is no obvious eutectic basis to the above glazes, as there so often is in Chinese ceramics – and it is also hard to tell which natural raw materials have been used to make the glazes. The most abundant boron-rich mineral found in Liaoning province today is ascherite – a magnesium borate – but this is too high in magnesium to have been used in the above recipes.

Table 87 Analyses of Liao lead glazes

| | PbO | SiO$_2$ | Al$_2$O$_3$ | Fe$_2$O$_3$ | TiO$_2$ | CaO | MgO | K$_2$O | Na$_2$O | MnO | NiO | CuO | CoO |
|---|---|---|---|---|---|---|---|---|---|---|---|---|---|
| Blue | 43.3 | 42.5 | 10.3 | 0.4 | 0.1 | 0.9 | 0.1 | –.– | 0.5 | 0.01 | 0.41 | 0.06 | 0.1 |
| Green | 57.2 | 33.3 | 3.4 | 1.5 | 0.05 | 0.9 | 0.1 | 0.5 | 0.2 | 0.01 | 0.14 | 2.1 | –.– |
| Amber | 53.7 | 33.0 | 6.6 | 3.5 | 0.05 | 1.0 | 0.1 | 0.7 | 0.4 | 0.01 | 0.1 | 0.06 | –.– |
| Green | 46.0 | 35.9 | 7.4 | 0.7 | 0.01 | 0.5 | 0.1 | 0.5 | 0.2 | 0.01 | 0.02 | 1.4 | –.– |
| Amber | 52.7 | 33.5 | 7.1 | 4.0 | 0.04 | 1.1 | 0.1 | 0.4 | 0.3 | 0.02 | 0.07 | 0.2 | –.– |
| Green | 50.2 | 34.6 | 8.2 | 1.3 | –.– | 1.0 | 0.2 | 1.1 | 1.1 | 0.03 | –.– | 1.8 | –.– |
| Green | 56.7 | 33.2 | 4.1 | 0.5 | –.– | 0.9 | 0.3 | 1.0 | 0.8 | 0.03 | –.– | 1.9 | –.– |
| Eutectic mixture | 61.2 | 31.7 | 7.1 | | | | | | | | | | |

Press-moulded saucer dish with eight lobes. Low-fired stoneware clay with green, yellow and clear lead glazes over a thin white slip, perhaps from the Shangjing kilns, middle to late Liao dynasty (Liao AD 916–1125). The generous use of white with amber and green glazes is a characteristic of Liao *sancai* wares. D. 5.2 in., 13.2 cm. Carter Fine Art.

Table 87 Liao boracic earthenware glazes and bodies from Longquanwucun

| | SiO$_2$ | Al$_2$O$_3$ | Fe$_2$O$_3$ | CaO | MgO | K$_2$O | Na$_2$O | PbO | B$_2$O$_3$ | CuO | MnO | P$_2$O$_5$ |
|---|---|---|---|---|---|---|---|---|---|---|---|---|
| Liao boracic glaze 1 | 58.1 | 9.3 | 0.8 | 4.6 | 0.6 | 3.1 | 5.1 | 1.3 | 10.3 | 6.4 | 0.04 | –.– |
| Liao boracic glaze 2 | 54.7 | 5.5 | 0.6 | 6.2 | 2.0 | 1.5 | 10.5 | 0.4 | 12.8 | 6.3 | –.– | 0.2 |
| Boracic-glaze body 1 | 57.1 | 32.9 | 1.6 | 0.6 | 0.2 | 1.7 | 4.0 | –.– | –.– | –.– | 0.01 | 0.1 |
| Boracic glaze body 2 | 58.6 | 32.2 | 1.6 | 0.5 | 0.2 | 1.9 | 3.1 | –.– | –.– | –.– | –.– | 0.2 |

At first sight the most promising candidate, as a source of boric oxide in these glazes, appears to be ulexite (Na$_2$O.2CaO.5B$_2$O$_3$.16H$_2$O), a material rich in boric oxide, soda and calcia – the three main fluxes in the above analyses. It is actually possible to copy Glaze 1 with a mixture of a typical ulexite material, feldspar and quartz (e.g. Gerstley borate from America 28.5, feldspar 46.5, quartz 18.5 and copper oxide 5.5). Unfortunately these raw materials will not 'fit' Glaze 2 as this glaze is too rich in sodium oxide and too low in alumina. However a mixture of Gerstley borate 32, soda ash 14, quartz 37, china clay 11 and copper oxide 5 will 'rebuild' Glaze 2 – as will mixtures of raw borax 35, soda ash 9.5, quartz 31, clay 9 and copper oxide 6. In short, Glaze 2 can only be made using soluble raw materials, which suggests that some of the original Liao boric oxide glazes may have been fritted.

Another curious feature of these glazes is the high percentages of cupric oxide (average 6% CuO) that have been used to provide the dark green-blue colours. This is about three times the amount of copper that is usual in Liao green lead glazes.

Despite the importance of these glazes in the history of world ceramics, and their rarity in China itself, their appearance was actually rather ordinary and boric oxide glazes do not seem to have been developed further at this time. The Chinese researchers who studied the glazes suggest that the huge demand for glazed tiles for temples and palaces in Beijing may have stimulated experiment with new earthenware compositions, and they propose borax as the most probable source of B$_2$O$_3$.

The Liao empire was actually a forcing house of ceramic ideas. The Liao inherited (or maybe seized) the cream of late Tang ceramic technology and were unrestrained by the many rules and conditions that governed the 'correct' use of ceramics in China. They had a vigorous and inventive style of their own and retained wide contacts with the outside world at a time when China had become more inward-looking. They used these exotic influences to great effect in their own work and, above all, they were exceptional potters.

While keeping the Liao at bay the Chinese had high regard for their ceramics. Liao forms and decorative techniques were gradually absorbed into the consciousness of Song potters, where they helped to form the remarkable character of Song ceramics.

## *Song* sancai

One of the most obvious practical influences of Liao ceramic techniques on Chinese craftsmen was the re-appearance in China of lead-glazed wares for everyday use. The cobalt-blue glaze had now all but disappeared from the *sancai* palette, but the three basic *sancai* colours of straw, amber and green had survived. The elaborate resist and 'mosaic' techniques of the old *sancai* style were dropped by the Song potters in favour of the late Liao fashion for filling in sgraffito patterns on light-firing clays or slips with coloured glazes. Song *sancai* is rather controlled in style and lacks the drama of the Tang and Liao originals, but the technique still resulted in some exceptional objects, particularly the ceramic pillows made at the Cizhou kilns of northern China. Analyses of these Song Cizhou lead glazes are scarce, but the one that is available is very similar to a Liao original.

As with Tang and Liao *sancai*, the Song and Jin Cizhou glazes were applied to light-coloured, underfired stonewares, then glaze-fired to about 1000°C. In addition to the standard yellows, greens and ambers, Song *sancai* can also show an occasional use of turquoise blue, dark iron-red, and what may be an iron-manganese purplish-brown.

## *Southern lead glazes*

All the low-fired glazes discussed so far have been made in north China, where lead glazes saw their earliest and most rapid development. However a few Song lead glazes were also produced in the south, most notably at Jizhou in Jiangxi province, and Qionglai in Sichuan province. Once again it is the green lead glazes that were most popular, and a couple of these southern *sancai* glazes have been analysed. They have proved to be much like those used in the north China and, like the northern glazes themselves, were applied to underfired stoneware clays, rather than to true earthenware bodies.

The tin oxide content of the Jizhou glaze is particularly high. It may represent the use of high-tin scrap bronze in the glaze recipe (such as old mirrors) or, just possibly, a copper-tin sulphide ore (copper-tin pyrites).

Table 88 Analyses of Song and Liao *sancai* green glazes

|  | PbO | SiO$_2$ | Al$_2$O$_3$ | Fe$_2$O$_3$ | CaO | MgO | K$_2$O | Na$_2$O | CuO |
|---|---|---|---|---|---|---|---|---|---|
| Song sancai green glaze | 54.8 | 32.2 | 4.8 | 1.1 | 2.2 | 0.5 | 0.6 | 0.3 | 2.8 |
| Liao sancai green glaze | 57.2 | 33.3 | 3.4 | 1.5 | 0.9 | 0.1 | 0.5 | 0.2 | 2.1 |

Table 89 Analyses of lead glazes from south China

|  | PbO | SiO$_2$ | Al$_2$O$_3$ | Fe$_2$O$_3$ | CaO | MgO | K$_2$O | Na$_2$O | CuO | P$_2$O$_5$ | SnO$_2$ |
|---|---|---|---|---|---|---|---|---|---|---|---|
| Qionglai | 68.8 | 29.0 | 5.6 | 0.7 | 0.6 | 0.3 | 0.6 | 0.2 | 1.5 | 0.1 | –.– |
| Qionglai | 60.2 | 36.2 | 10.0 | 1.1 | 0.4 | 0.5 | 0.6 | 0.3 | –.– | 0.04 | –.– |
| Jizhou | 47.0 | 36.6 | 5.4 | 0.8 | 2.8 | 0.6 | 1.4 | 0.2 | 2.3 | –.– | 2.4 |

Pottery flask and pottery phoenix-headed ewer with brown and green lead glazes, Liao dynasty (916-1126). The use of lead glazes on domestic wares is a typical Liao fashion and the compositions of Liao lead glazes are very similar to those used on Tang *sancai* wares. Sotheby's.

Lead-glazed Song and Jin *sancai*-style wares were not made in great numbers, and lead glazes at this time probably saw wider use in architectural ceramics, although few examples have survived. The 11th and 12th centuries were really the heyday of high-fired glazes in China, and their superior strength and subtlety tended to put lead glazes in the shade. However, just as traditional lead glazes appeared to be on the wane in China a new use was found for them – to provide brightly-coloured painted decoration on high-fired ceramics. This remarkable discovery, apparently made in the late 12th century AD, marked the beginning of the great Chinese onglaze enamel tradition, which still flourishes today. These lead-rich, onglaze enamels were first applied to some white-slipped and glazed stonewares in north China, but were later adopted by the great porcelain kiln complexes of southern China.

However, before discussing Chinese onglaze enamels in detail, it is worth exploring the subject of China's unusual alkaline glazes. These are mainly turquoise-blue in colour and they were first developed in China in response to imports of Middle Eastern glazed earthenwares in the Tang dynasty. They embody a uniquely Chinese approach to alkaline glaze construction and they saw employment on some striking and original ceramics.

# FURTHER READING

*PAPERS AND ARTICLES*

Li Guozhen, Chen Naihong, Qui Fengjuan and Zeng Fenqin, 'A study of Tang *sancai*', *Scientific and Technological Insights on Ancient Chinese Pottery and Porcelain*, Science Press, Beijing, 1986, pp 77–81

Li Zhiyan and Zhang Fukang, 'On the technical aspects of Tang *sancai*', *Scientific and Technological Insights on Ancient Chinese Pottery and Porcelain*, Science Press, Beijing, 1986, pp 69–76

Jessica Rawson, Michael Tite and Michael Hughes, 'The export of Tang *sancai* wares: some recent research', *Transactions of the Oriental Ceramic Society, 1987-1988*, London, 1989, pp 39–61

Nigel Wood, Anne Broderick, Rose Kerr and John Watt, 'An examination of some Han dynasty lead glazed wares', *Proceedings of the 1992 International Symposium on Ancient Ceramics*, Shanghai, 1992, pp 129–42

Nigel Wood and Ian Freestone, 'A preliminary examination of a Warring States pottery jar with so-called "glass paste" decoration', *Science and Technology of Ancient Ceramics 3; Proceedings of the International Symposium (ISAC'95)* (chief editor, Guo Jinkun), Shanghai, 1995, pp 12–17

# Chapter 11

# CHINESE
# ALKALINE GLAZES

Two widely differing approaches to making earthenware glazes have marked the development of ceramics in the old world. In northern Europe and in northern China high-lead compositions became the norm, but in the Islamic world (mainly the Middle East) alkaline glazes, fluxed with sodium oxide, were the dominant earthenware type. In the history of Islamic ceramics high-fired glazes hardly feature at all and high-lead glazes are in a definite minority.

Islamic glazes consist mainly of pulverised soda-lime glass frits, usually mixed with small amounts of gum or earthenware clay. These glazes were often coloured with cupric oxide (CuO), which dissolved in the glazes during firing to give turquoise-blue and turquoise-green effects. Alkaline copper-blue glazes can evoke the qualities of deep cool water, and such colours have always had great appeal to the Middle Eastern world.

## Islamic glazes in China

Recent archaeological work in China has shown that the Tang Chinese were aware of the fine turquoise-blue and turquoise-green glazes that Islamic potters were achieving with their highly alkaline compositions, and Middle Eastern turquoise-glazed earthenwares have been found in late Tang levels at the great trading and cultural centre of Yangzhou, Jiangsu province, where the Grand Canal meets the Yangzi river.

Yangzhou was an important trade crossroads in Tang China and huge quantities of Chinese stonewares and silks were shipped down to the Yangzi to Yangzhou, on their way for export to the Middle East. These exports from China took a 5000 mile sea-route that often used Sri Lanka as a staging post. Imports from the Middle East were organised by the large Arab community in Yangzhou and the alkaline-glazed earthenwares found in the city seem to have been part of this thriving two-way trade. Turquoise-

glazed shards have also been found in China as far inland as Guilin in the far southern province of Guangxi, and these too seem to have been of Middle Eastern origin.

## Nature of Middle Eastern glazes found in China

Islamic alkaline-glazed ceramics of the types found in China used sodium oxide rather than lead oxide as their main glaze flux – a technology that was already some 4000 years old by the time these wares reached China. They were usually coloured with about 1.5-3.5% of cupric oxide, which gave a fine range of turquoise-blues and turquoise-greens. By contrast, copper oxide in typical Chinese high-lead glazes supplied the distinctive emerald-greens and grass-greens that are so familiar in Han and Tang lead-glazed earthenwares.

Because of China's thriving contact with the Middle East in Tang times, it is tempting to see some Middle Eastern influence in the unusual opaque turquoise-green stoneware glazes made at Changsha and Qionglai in the late 9th and early 10th centuries AD – particularly as these Chinese ceramics often show patterns that are reminiscent of the broad and simple trailed and brushed designs used on some contemporary Mesopotamian earthenwares. The Chinese bluish-green stoneware glazes were made by adding about 3% copper oxide to the traditional off-white 'glass emulsion' ash glazes used at Changsha and Qionglai. When overfired, these lime-rich stoneware glazes occasionally developed into translucent turquoise blue-greens, as their optical-blue tones modified their copper-green colours. Nonetheless, most Chinese glazes of this type are noticeably more green than blue, and chemical analysis shows clearly that some very profound differences existed between the technologies used for the Chinese and Islamic wares – differences that are well illustrated by analyses made in Shanghai of the Yangzhou finds themselves.

Turquoise-glazed jar, 8th–9th century AD, probably from Iraq. This is typical of the Middle Eastern glazed earthenware jars imported to China by Arab traders during the Tang dynasty. Shards of this style of ware have been excavated from Tang levels in Yangzhou, where the Grand Canal meets the Yangzi river. H. 14.4 in., 37 cm. British Museum, 1912 5–201.

Table 90 Analyses of turquoise-green Middle Eastern glazes found at Yangzhou in late Tang levels

|  | PbO | $SiO_2$ | $Al_2O_3$ | $Fe_2O_3$ | $TiO_2$ | CaO | MgO | $K_2O$ | $Na_2O$ | CuO | $P_2O_5$ | $SnO_2$ |
|---|---|---|---|---|---|---|---|---|---|---|---|---|
| Glaze no. 1 | 1.1 | 65.3 | 5.0 | 1.0 | 0.16 | 5.5 | 1.8 | 2.9 | 10.8 | 3.6 | 0.2 | 1.4 |
| Glaze no. 2 | –.– | 67.0 | 5.2 | 1.3 | 0.16 | 6.4 | 2.5 | 3.8 | 7.7 | 2.5 | 0.1 | 1.3 |
| Glaze no. 3 | –.– | 67.3 | 4.6 | 1.5 | 0.18 | 6.2 | 2.4 | 4.1 | 8.4 | 1.7 | 0.2 | 0.25 |
| Body no. 1 | –.– | 50.0 | 13.9 | 6.6 | 0.4 | 17.2 | 6.2 | 1.4 | 2.1 | –.– | 0.2 | –.– |
| Body no. 2 | –.– | 50.0 | 13.1 | 6.3 | 0.5 | 16.5 | 6.3 | 1.3 | 1.9 | –.– | 0.7 | –.– |
| Body no. 3 | –.– | 50.0 | 13.3 | 6.6 | 0.3 | 17.6 | 7.0 | 1.5 | 2.1 | –.– | –.– | –.– |

The lead oxide contents of these Middle Eastern glazes are low or non-existent with sodium oxide, supplemented with lesser amounts of potassia, providing their main flux contents. However, if sodium oxide is used alone as a prime glaze flux the resulting glaze may still be soluble after firing. The calcia and magnesia contents of the above analyses were probably there to counter this effect – an approach already used successfully for millennia in the Middle East for stabilising glass.

Islamic glasses and Islamic glazes are actually very close to one another in their compositions, and most Middle Eastern glazes seem to have been made from simple glass frits, ground to a fine dust, mixed with small amounts of clay and gum, and then suspended in water for dipping, pouring or brushing onto the wares. The compositions of the glazes above suggest that they were made from mixtures of glassy frits with small amounts of body clay, in roughly 4:1 proportions.

It is noticeable that the silica levels in the Islamic glazes (average 67%) are far higher than those found in typical Tang lead glazes (average 33%), and this seems to be because the soda/potassia-silica eutectics that operate as the chemical 'bones' of these glazes are themselves unusually silica-rich. Modern glaze recipes, recreated from these analyses, tend to mature between about 1060° and 1100°C – higher than any Chinese lead glazes so far discussed (average 900°-1000°C).

What also separated Chinese and Islamic earthenwares at this time were the true earthenware clays used by the Islamic potters. Middle Eastern calcareous or dolomitic bodies begin to melt above 1170°C but can provide good buff-firing earthenwares in the 1000°-1100°C range. Although these clays are quite high in iron (average 6.5% $Fe_2O_3$) the substantial amounts of calcia and magnesia that they contain tend to bleach out the natural ferric oxide reds, and also induce a very slight shrinkage in the fired bodies during cooling. This helped to control crazing in these high-alkali compositions. This was a valuable effect as alkaline glazes applied to ordinary clays tend to craze heavily, and can even flake off the wares after firing.

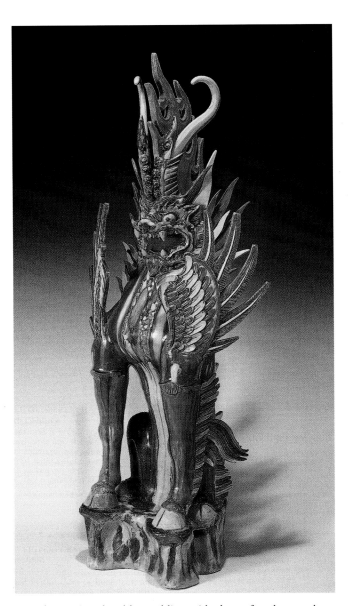

Very large winged and horned lion with cloven feet decorated with *sancai* glazes including turquoise blue, early 8th century AD. This seems to be an example of the earliest use of the high-alkali turquoise blue earthenware glaze on Chinese ceramics, although a similar colour had already appeared in Han glass. H. 37 in., 118 cm. Sotheby's.

## Origins of Chinese earthenware turquoise glazes

It is possible that some Qionglai and Tongguan turquoise-greens were used to produce stoneware versions of Mesopotamian earthenware effects, but there is also evidence that true turquoise-coloured *earthenware* glazes were made in China as early as the Tang dynasty (see figure opposite). Rather later in date there is also a fine early Jin dynasty bottle with a turquoise glaze, presented recently to the Victoria and Albert museum in London (see page 227). These are all unusual pieces but, by the time we reach the later Jin dynasty of north China (AD1115-1234) turquoise-glazed earthenwares in China are not too rare. From this time to the present day, low-fired alkaline glazes have provided a persistent theme in Chinese ceramic production. As Chinese experience with these alkaline earthenware glazes gradually developed, their colour range was expanded with blue-black, purple-blue and aubergine glazes being added to the traditional turquoise blue colours in the 14th century AD.

### The nature of Chinese high-alkali earthenware glazes

When Chinese potters eventually developed their own style of alkaline glazes they did so with approaches that were radically different from those adopted in the Middle East – suggesting that the Chinese alkaline effects were achieved without any detailed knowledge of western glaze-making practices. The main Chinese innovation was the use of potassium oxide as the prime glaze flux, rather than the sodium oxide preferred by the Islamic potters. The Chinese also applied their alkaline glazes to relatively high-fired bisqued stonewares and porcelains, rather than to the calcareous earthenwares and siliceous fritware bodies used in the Middle East.

### Potassium oxide an earthenware glaze flux

The use of potassium oxide ($K_2O$) as the main alkaline glaze flux seems to have been an entirely Chinese innovation and, as with Chinese lead glazes, the technique may well have been pioneered by Chinese glass makers. In addition to the unusual lead-baria glasses, discussed in Chapter Ten, Chinese glass makers also made some limited use of high-potassia glass compositions as early as the Han dynasty.

We cannot be sure exactly which raw materials were used to supply potassia in all Chinese earthenware glazes

and glasses, but the traditional source for potassium oxide in Chinese glass and glaze is saltpetre (potassium nitrate, $KNO_3$). Saltpetre is usually found as a crystalline surface encrustation at sites of ancient organic decomposition. Alternatively, the efflorescence of saltpetre can be encouraged by burying organic remains over a period of months in lime-rich soils and watering regularly.

Saltpetre was also made in China by leaching soil in which nitrogen from urine had combined with mineral potassium. Saltpetre has been used in China for making black gunpowder from at least the 7th century AD, when its production became a state monopoly. It was also used by the Song Chinese in rocket, poison-smoke and flame-thrower attacks on Ogödai Khan's Mongols in the 13th century AD.

One of the curiosities of the ways that Chinese potters used the material is that saltpetre was often used totally unfritted, although it is essentially a soluble material: the saltpetre was simply mixed with quartz and water (and sometimes with lead oxides or carbonates) to make low-temperature glazes. The great French ceramic chemist Georges Vogt was amazed by this approach, and in 1900 he wrote the following, after analysing a late 19th century raw turquoise glaze used at Jingdezhen:

> 'The simplicity with which the Chinese prepare this turquoise … is truly remarkable. Nothing in its composition needs to be melted, or to be fritted. The only preparation needed is to grind together the saltpetre, the quartz and the copper powder in suitable proportions and it is ready to be used on porcelain vases.'

Cizhou-type covered box with alkaline-lead turquoise glazes over black-painted white slip on low-fired stoneware clay, north China, 14th century. D. 17 cm. British Museum, 1936, 10–12, 271.

Table 91 Han blue glass fluxed with potassium oxide

|  | PbO | SiO₂ | Al₂O₃ | Fe₂O₃ | TiO₂ | CaO | MgO | K₂O | Na₂O | CuO |
|---|---|---|---|---|---|---|---|---|---|---|
| Han blue glass | 0.7 | 70.8 | 2.7 | 1.26 | 0.2 | 5.3 | 0.8 | 14.3 | 0.9 | 2.6 |

Soluble materials can be troublesome in glazes as they can migrate into the clay bodies during glazing, and can also crystallise onto the glaze-surface as it dries. However the solubility of saltpetre decreases markedly in cold water, for example at 5°C 100cc of water will only dissolve 17g of saltpetre, while at 18°C it will dissolve 30g. This very useful property of limited solubility in cold water may well have been exploited by Chinese potters.

The awareness of saltpetre as a distinct compound in China is also very ancient. A flame test for identifying saltpetre in the field was described in China as early as the 3rd century AD, and the capacity for saltpetre to melt quartz (its fundamental role in glasses and glazes) was accurately described in AD1150 by the Chinese chemist Sheng Xuanci: '… if you heat a piece of white quartz, then put a drop of saltpetre on it, it will sink in …'. However, to reproduce this effect, the quartz needs to be taken to at least an orange-red heat.

In terms of glaze technology potassium oxide is a slightly superior alkaline glaze flux to sodium oxide. Potassia-fluxed glazes are harder, marginally less likely to craze, and also less liable to volatilise in the kiln, than soda-fluxed glazes. They are also less likely to be soluble after firing, and they do not necessarily need stabilising with calcia. The unusual capacity of saltpetre to work as a glaze raw material without fritting also made Chinese high-potassia glazes far easier to prepare that their high-soda Islamic equivalents.

### Uses of alkaline glazes in China

Apart from the Tang and early Jin examples described above, early alkaline glazes in China are probably best known for their use over black underglaze painting in the Cizhou manner. Turquoise-glazed wares made in the Cizhou style (particularly in the form of *meiping* bottles and bulb-bowls) were produced at various northern kiln sites in the late 13th and 14th centuries, including the important Guantai site in Hebei.

In the mid-14th century AD, at Jingdezhen in south China, turquoise glazes saw their most prestigious use ever on Chinese ceramics when they were applied to some very early south Chinese imperial porcelains. Shards of Jingdezhen porcelain with turquoise alkaline glazes on hard-fired porcelain bodies, were excavated recently at Jingdezhen and described in London in 1992. Some examples showed signs of gilding which, combined with turquoise-blue, would have presented a rich and splendid effect. Liu Xinyuan (Jingdezhen's leading historian) dates these rare imperial Mongol porcelains to the 1330s and sees in them a strong Middle Eastern influence – perhaps even from Islamic turquoise wares decorated with silver lustre, which has a notably golden hue.

Following this 14th-century experience with alkaline glazes, the Jingdezhen potters of the 15th century used turquoise-blue overglaze enamels, both as low-fired monochrome glazes on porcelain, and as an extra colour in combination with lead-based overglaze enamels. Turquoise blue glazes, fluxed with saltpetre, continued as a minor theme at Jingdezhen throughout the succeeding centuries, and glazes exploiting this unusual potassia-based technology are still manufactured at Jingdezhen today.

### *Cizhou polychrome alkaline glazes*

While turquoise-glazed porcelains of true imperial quality were being made in south China in the mid-14th century AD, rather more rustic ceramics, enhanced with alkaline glazes, were being manufactured in the north. In the 14th century the style was expanded to include an inky blue-black as an extra alkaline-glaze colourant. These new blue-black alkaline glazes were used in combination with turquoise-blues and lead-rich amber-yellow glazes to 'colour in' some vigorous slip-painted designs, produced in the Cizhou manner.

Cizhou-style jar with alkaline-lead earthenware glazes, north China, 14th–15th century. These low-fired glazes have been applied over black-painted white slip onto low-fired stoneware clay. Of particular interest in this vessel is the use of a high-manganese cobalt in the purple-black glaze. Although the alkali and lead contents of these glazes are about equal, their colour response is generally alkaline (see Table 92). H. 11.2 in., 28.5 cm. Victoria and Albert Museum, C52–1915.

Table 92 Northern Cizhou-style alkaline glazes

| | PbO | SiO$_2$ | Al$_2$O$_3$ | Fe$_2$O$_3$ | TiO$_2$ | CaO | MgO | K$_2$O | Na$_2$O | CuO | CoO | MnO | SnO$_2$ |
|---|---|---|---|---|---|---|---|---|---|---|---|---|---|
| Blue-black | 11.2 | 64.1 | 1.6 | 0.7 | 0.1 | 0.6 | 1.2 | 13.1 | 1.9 | 0.4 | 0.15 | 4.4 | –.– |
| Blue-black | 14.8 | 61.7 | 1.8 | 0.7 | 0.1 | 1.2 | 1.2 | 10.7 | 1.8 | 0.5 | 0.2 | 4.9 | 0.2 |
| Dark green | 11.6 | 66.3 | 0.5 | 0.5 | –.– | 1.2 | 1.0 | 9.4 | 3.3 | 4.9 | –.– | 0.1 | 0.3 |

(Glaze analyses from a 14th–15th-century Cizhou-style jar in the Victoria and Albert Museum with underglaze painting beneath blue-black, turquoise-blue and amber glazes; glazed dark green inside)

These low-firing compositions (probably maturing at about 1000°C) were applied direct to white-slipped soft-fired stonewares. These glazes were sometimes unstable, with a tendency to flake away after firing – although this problem may have had as much to do with a lack of flux in the underlying slips as to difficulties with the glazes themselves. Green earthenware glazes were sometimes applied inside these unusual Cizhou-style wares – setting a fashion for green inner glazes for alkaline-glazed ceramics that survived in China for many centuries. Analysis shows the compositions of these early northern alkaline glazes to be as in Table 92.

These three analyses are quite different from any Chinese low-fired glazes described so far in this book. They also differ markedly from the glazes on the Islamic wares excavated in Yangzhou. They are essentially lead oxide-potassia silicates – coloured in the first two cases by cobalt and manganese oxides and, in the third glaze, by copper oxide with a trace of iron. These analyses are interesting in two ways: they are the earliest alkali-rich, low-firing Chinese glazes for which we have full oxide compositions, and they are also the first low-fired glazes coloured by cobalt oxide made in north China since the Tang *sancai* glazes of the 7th–8th centuries.

## Use of cobalt in early alkaline glazes

All cobalt-coloured Chinese glazes of the high-alkali type, analysed to date, have contained substantial amounts of manganous oxide (MnO). This suggests that asbolite (manganese-cobalt ore, or 'wad') was the usual cobalt-bearing colourant for early Chinese alkaline glazes. It used to be thought that all 14th and early 15th century cobalt-blue effects in Chinese ceramics were achieved with imported iron-cobalt rocks – the so-called 'Persian cobalts'. Although this idea still seems to hold true for high-quality underglaze-blue porcelains, some recent analyses of Jingdezhen folk porcelains of the late 14th and early 15th centuries have shown some use of manganese-cobalt pigments. These were apparently native Chinese raw materials, such as those already used for some extremely rare blue-and-white porcelains made in the Northern Song dynasty in the Longquan area of Zhejiang province – and Zhejiang

itself later became an important source of high-manganese-cobalt ores for the Jingdezhen porcelain industry. Manganese-cobalt ores were therefore popular pigments for low-quality porcelains in south China in the 14th century, and it seems that the cobalt ores used for the north Chinese alkaline-glazed wares were of this same general type, although whether the cobalt ores used for colouring these northern alkaline glazes actually came from south China is still difficult to say.

## Chinese *fahua* wares

In the 14th and 15th centuries (still in north China) the turquoise, purple-black, amber and green glazes were joined by two new colours – aubergine-purple and an intense purple-blue. The aubergine glaze seems to have been a diluted version of the earlier blue-black glaze, and it was made by using less manganese-cobalt ore in the recipe. The purple-blue seems to have been made by combining copper oxide with Chinese cobalt. The purple colour produced by this mixture was the result of a complex 'cocktail' of cobalt, manganese, copper and iron ions in an alkali-lead base glaze. These two new colours expanded the Chinese alkaline glaze palette, and made it appropriate for an entirely new purpose – the production

White-slipped *fahua*-style bowl with trailed-slip and alkali-lead earthenware glazes over a low-fired stoneware clay. From north China, probably Shanxi province, 15th–16th century AD. Victoria and Albert Museum, C51– 1911.

of ceramics that bring to mind the appearance of *cloisonné* enamelling on metal.

## *Chinese* cloisonné

*Cloisonné* is a technology for fusing coloured glasses onto base metals. It had been imported to China from Byzantium, perhaps as early as the Tang dynasty. In China *cloisonné* is known as *falan* ware, which identifies it as a foreign process. The *cloisonné* technique, adopted by Chinese craftsmen, made use of beaten or spun bronze, brass or copper forms covered with low 'fences' made from thinly beaten metal strips. In the early Chinese *cloisonné* wares the thin strips were attached to the vessels' surfaces with a high-melting silver-based solder, where they supplied the outlines for the *cloisonné* designs. The separate cells of the designs (known as *cloisons*) were then filled with crushed coloured glasses mixed with gum and fired to sufficient heat (*c.* 600°C) to cause the glass grains to fuse together and to bond to the metal beneath. A series of successive glass applications and firings were used until the separate cells were slightly over-filled with fused glass. The surface could then be cut back by polishing with increasingly fine abrasives until the top edges of the metal *cloisons* were exposed. On the best pieces, these exposed edges, and any other areas of visible metal, were finished by gilding. By the 15th and 16th centuries AD *cloisonné* technology in China had become very sophisticated, and included some truly massive examples.

The ceramic versions of Chinese *cloisonné* wares, first made in north China, were much broader in spirit than the metal originals. The metal *cloisons* were imitated with trailed slip, and the separate cells filled with coloured glazes. The two main glaze colours employed were those that featured regularly in early Chinese *cloisonné* itself – namely a copper turquoise-blue and a dark cobalt-blue. As with the Cizhou-style wares, green glazes were often used inside these pottery vessels, as well as for some outside details. However, for some reason, the opaque reds and yellows that were also typical of early Chinese *cloisonné* wares, were not used in the new ceramic.

These unusual and dramatic alkaline-glazed earthenwares are known in China as *fahua* wares – a term sometimes translated as 'designs within boundaries'. In most examples of northern *fahua* ware white slips entirely cover the buff or brown, soft-fired stoneware clays, to provide a white ground for the coloured glazes, and kiln sites in Shanxi province have now been identified as major producing centres for these northern *fahua* wares.

### Southern *fahua* ware

The *fahua* style spread to south China in the mid-15th century, where the technique was used on porcelain bisque,

White-slipped *fahua*-style bottle with trailed slip and alkali-lead earthenware glazes over low-fired stoneware clay, from north China, probably Shanxi province. Both this bottle and the bowl on page 217 show similar glaze compositions to the Cizhou jar – that is a roughly equal balance of lead oxide with the alkalis. 16th century AD. H. 7.5 in., 19 cm. Ashmolean Museum, Oxford, X 1965.

but in this case the use of white porcelain bodies made overall white slips redundant. Some large and magnificent porcelain *fahua* objects were produced in the south, such as barrel-shaped garden seats and large *guan*-shaped wine jars, often with elaborately pierced double walls. These are usually dated to the late 15th and early 16th centuries. South Chinese *fahua* wares were hard-fired porcelains, and the coloured glazes were applied direct to the vitrified bodies, both inside and out, often using green or yellow lead-rich glazes inside the vessels in the northern manner. It is generally assumed that most southern *fahua* porcelains were made at Jingdezhen, but so far only an experimental *fahua*-style shard, using green and yellow enamel glazes, has been excavated from a 15th century level at the imperial kilns.

## Compositions of *fahua* ware glazes

Chinese *fahua* glazes from both north and south China were analysed at Oxford in 1989 for a large study that explored the relationship of Chinese *fahua* wares to Chinese *cloisonné*. This work uncovered a rather complex picture as might be expected from ceramics made at kilns throughout China, and over more than four centuries of varied production.

The first *fahua* object examined for the Oxford study was a small bottle dated to the 16th century. Analysis of its turquoise and aubergine glazes gave the results in Table 93.

These alkali-lead glazes are very similar to those used on the Cizhou-style jar already described, but in this case the piece is made in a true *fahua* manner. The aubergine glaze has a similar colouring oxide balance to the Cizhou blue-black glazes, but is slightly lower in manganese and cobalt oxides.

The next object studied was a small *fahua* ware bowl of a similar style and date, with a body material that also seems to have been an underfired stoneware clay.

The dark green glaze has been produced by raising the lead oxide content at the expense of the potassium and sodium oxides – which encouraged a more emerald green. The turquoise glaze however is low in both lead oxide and copper oxide, and relatively rich in alkalis – all of which provide a fine turquoise-blue. The greener turquoise, in the third glaze, was made by using slightly less alkali, rather more copper oxide, and substantially more alumina.

In terms of their glaze compositions, these three vessels make a consistent group, although it is probably risky to assume that they come from the same kiln complex.

## Other northern *fahua* glaze-types

Apart from the alkali-lead glazes, described above, another type of *fahua*-style glaze emerged from the Oxford work – one that was unusually rich in calcium oxide. These glazes were found on a fine 15th–16th century *fahua* jar in the Victoria and Albert Museum's collection. The qualities and colours of these glazes were subtly different from those used on the three vessels described above. Where the glazes were thin they showed a pale, watery and finely-crazed effect but, where thick, their colours were strong and bright, and the glazes semi-opaque. Chemical analysis gave the results in Table 95.

A Ming *fahua*-style oviform jar trailed white slip decoration on white-slip ground, low-fired stoneware clay with alkali-lead glaze, north China, 15th–16th century. H. 5.9 in., 15 cm. Christie's.

Table 93 Northern fahua wares – 16th century bottle in the Ashmolean Museum, Oxford

|  | PbO | SiO$_2$ | Al$_2$O$_3$ | Fe$_2$O$_3$ | TiO$_2$ | CaO | MgO | K$_2$O | Na$_2$O | CuO | CoO | MnO | SnO$_2$ |
|---|---|---|---|---|---|---|---|---|---|---|---|---|---|
| Turquoise glaze | 16.2 | 63.5 | 0.6 | 0.3 | –.– | 0.6 | 1.3 | 7.2 | 5.7 | 4.5 | –.– | –.– | 0.2 |
| Aubergine glaze | 17.1 | 58.9 | 1.6 | 0.9 | –.– | 0.5 | 0.4 | 8.4 | 6.9 | 0.7 | 0.1 | 3.4 | –.– |

Table 94 Northern fahua ware glazes – 16th-century bowl, Victoria and Albert Museum

|  | PbO | SiO$_2$ | Al$_2$O$_3$ | Fe$_2$O$_3$ | TiO$_2$ | CaO | MgO | K$_2$O | Na$_2$O | CuO | CoO | MnO | SnO$_2$ |
|---|---|---|---|---|---|---|---|---|---|---|---|---|---|
| Dark green | 43.4 | 43.9 | 0.2 | 0.5 | –.– | 1.3 | 0.6 | 3.7 | 1.5 | 5.1 | –.– | 0.1 | 0.4 |
| Turquoise blue | 17.5 | 60.4 | 0.9 | 0.5 | –.– | 0.9 | 0.8 | 13.0 | 3.4 | 1.5 | –.– | 2.0 | 0.1 |
| Turquoise green | 13.6 | 62.9 | 5.8 | 0.6 | 0.1 | 0.5 | 0.5 | 11.8 | 0.8 | 3.4 | –.– | –.– | 0.1 |

Censer form, north China, 14th–15th century. Some recent analyses have shown that this unusual style of northern alkaline-glazed ware used a fairly high-firing lead glaze, containing about 77% silica and 16% lead oxide, for the white background, together with a range of lead-alkali glazes for the coloured decoration. It is not known at present which kiln produced these wares, but the style is northern. Victoria and Albert Museum, London, C.49-1935

These particular glazes proved to be remarkably similar to some true *cloisonné* enamels, used on an early 16th-century metal incense burner, and also in the Victoria and Albert Museum's collection:

It seems likely that, in this case, that the same types of crushed glasses employed for *cloisonné* enamelling on metal had been used for ceramic glazes. If this were the case, it would be a rare and early overlap of ceramic and metal enamel technologies. The maturing temperatures for these glazes were probably 900°-1000°C, but for the *cloisonné* enamels perhaps only about 600°C – just sufficient to fuse and smooth the grains of crushed enamel-glass without buckling the metal forms beneath.

### *Fahua* glazes used for southern porcelains

Southern *fahua* glazes, used on porcelain bisque, had much in common with the northern originals. Potassium oxide was again their main glaze flux, and their purple-blue colours were also achieved with complex mixtures of copper, iron, cobalt and manganese oxides – probably derived from Chinese cobalt/copper oxide mixtures. However, in their major oxide compositions, south Chinese *fahua* glazes proved to be much lower in lead than the northern glazes, and rather closer to the eutectic mixtures that operate within the alkali-silica, and alkali-alumina-silica systems (see Table 97).

Table 95 15th–16th century Fahua glazes

| | PbO | SiO$_2$ | Al$_2$O$_3$ | Fe$_2$O$_3$ | TiO$_2$ | CaO | MgO | K$_2$O | Na$_2$O | CuO | CoO | MnO | SnO$_2$ |
|---|---|---|---|---|---|---|---|---|---|---|---|---|---|
| Transparent turquoise blue | 32.5 | 51.1 | 0.9 | 0.2 | –.– | 5.0 | 0.3 | 7.4 | 1.0 | 2.2 | –.– | –.– | –.– |
| Transparent | 30.0 | 54.1 | 0.7 | 0.2 | –.– | 6.1 | –.– | 8.4 | 0.9 | –.– | –.– | 0.1 | –.– |
| Pale mauve | 30.1 | 54.1 | 0.7 | 0.1 | –.– | 6.5 | –.– | 8.5 | 0.9 | –.– | –.– | –.– | –.– |
| Translucent yellow | 36.2 | 48.2 | 1.6 | 2.5 | –.– | 3.1 | –.– | 6.2 | 1.5 | –.– | –.– | –.– | 1.8 |

Table 96 – *Cloisonné* enamels on a 15th/16th-century incense burner

|  | PbO | SiO$_2$ | Al$_2$O$_3$ | Fe$_2$O$_3$ | TiO$_2$ | CaO | MgO | K$_2$O | Na$_2$O | CuO | CoO | MnO | SnO$_2$ |
|---|---|---|---|---|---|---|---|---|---|---|---|---|---|
| Transparent enamel | 29.5 | 47.5 | 0.3 | 0.3 | 0.1 | 6.0 | –.– | 12.7 | 0.6 | –.– | –.– | –.– | –.– |
| Turquoise enamel | 29.0 | 49.0 | 0.3 | 0.2 | –.– | 6.0 | –.– | 12.6 | 1.0 | 2.6 | –.– | –.– | 0.1 |

Table 97 Compositions of south Chinese *fahua* glazes – used on 16th-century porcelains

|  | PbO | SiO$_2$ | Al$_2$O$_3$ | Fe$_2$O$_3$ | TiO$_2$ | CaO | MgO | K$_2$O | Na$_2$O | CuO | CoO | MnO | SnO$_2$ |
|---|---|---|---|---|---|---|---|---|---|---|---|---|---|
| *Meiping vase* | | | | | | | | | | | | | |
| Purple-blue | 0.7 | 73.2 | 3.1 | 0.7 | –.– | 0.7 | –.– | 12.3 | 1.5 | 2.4 | 0.6 | 5.7 | 0.4 |
| Turquoise blue | 1.1 | 76.3 | 1.1 | 0.4 | –.– | 0.9 | 0.2 | 13.2 | 2.7 | 4.0 | –.– | –.– | 0.5 |
| Transparent turquoise | 1.1 | 70.0 | 1.1 | 2.1 | –.– | 0.9 | 0.1 | 15.2 | 3.3 | 5.2 | –.– | –.– | 0.1 |

*Cloisonné* incense burner, 15th–16th century AD. The enamel compositions on this piece are very similar to those used on the *fahua* jar (right). Victoria and Albert Museum.

*Fahua*-style jar with relief decoration, white slip and alkali-lime-lead oxide earthenware glazes; all applied to a low-fired stoneware clay. From north China, 15th–16th century. This style of *fahua* ware shows an unusual set of alkaline glazes that are watery where thin, and opaque and strongly-coloured where thick. Their chemical compositions are unusually rich in calcia, and they seem similar to those used for *cloisonné* enamels on metal (see Tables 96 and 97). Victoria and Albert Museum, C118–1938.

The compositional similarities between these south Chinese high-alkali glazes (used on prefired porcelains), and these theoretical high-alkali eutectic mixtures, are striking. Table 98 shows clearly how different these high-silica 'alkali eutectics' are from the classic 'lead eutectics' that provided the compositional bases for most of the Chinese lead glazes described in the previous chapter.

### Late Jingdezhen *fahua* wares

The last type of south Chinese *fahua* porcelain vessel, analysed for the Oxford study, was a *meiping* vase of a much later date, and probably made in tribute to the early Ming *fahua* style. It is of exceptional quality, and seems to date from the 18th century or later. Analysis of its purple-blue glaze revealed a composition nearer to the northern style of *fahua* glaze than to the *fahua* glazes used on Ming Jingdezhen porcelains.

Table 98 Eutectic mixtures with potassia, soda and lead oxide

| Eutectic in system | Melting Point | SiO$_2$ | Al$_2$O$_3$ | K$_2$O | Na$_2$O | PbO |
|---|---|---|---|---|---|---|
| Potassia-silica | 880°C | 82.5 | | 17.5 | | |
| Soda-silica | 830°C | 81.6 | | | 18.4 | |
| Potassia-alumina-silica | 870°C | 77.5 | 5.2 | 17.3 | | |
| Soda-alumina-silica | 800°C | 77.1 | 5.1 | | 17.8 | |
| Lead oxide-alumina-silica | 650°C | 31.7 | 7.1 | | | 61.2 |

Table 99 Late Qing Jingdezhen *fahua* glaze

| | PbO | SiO$_2$ | Al$_2$O$_3$ | Fe$_2$O$_3$ | TiO$_2$ | CaO | MgO | K$_2$O | Na$_2$O | CuO | CoO | MnO | SnO$_2$ |
|---|---|---|---|---|---|---|---|---|---|---|---|---|---|
| Purple-blue | 15.3 | 59.7 | 1.4 | 0.4 | –.– | 0.3 | 0.3 | 11.1 | 4.0 | 4.8 | 0.5 | 3.4 | 0.5 |

Porcelain *meiping*, with designs in trailed slip, probably from Jingdezhen, 16th century AD. Low-fired alkali-lead glazes applied to high-fired porcelain *bisque*. H. 11 in., 28 cm. Victoria and Albert Museum, 690 1893.

Porcelain *meiping*, with designs in trailed slip, probably from Jingdezhen, Qing dynasty. Low-fired alkali-lead glazes applied to high-fired porcelain *bisque*. H. 11 in., 28.5 cm. Victoria and Albert Museum, C1472–1910.

## The *fahua* principle

Compositionally, the great majority of *fahua* glazes can be regarded as mixtures of the high-potassia eutectics and the high-lead eutectics, and coloured variously with copper-tin pigments, with Chinese cobalt, and with blends of both colourants.

However truly alkaline glazes, based on saltpetre and quartz, rich in potassia and entirely free from lead oxide, were also made at Jingdezhen in the late Qing dynasty, and a prepared example of this type of glaze was collected from a porcelain workshop in Jingdezhen by the French Consul F. Sherzer in the autumn of 1882. The liquid glaze was sent to France in a sealed bottle, where it was analysed by Georges Vogt at Sèvres. Vogt's analysis showed that the glaze contained about 41.5 saltpetre, 50 quartz, and about 8.5 'copper powder' (a mixture of copper oxide with an iron-rich clay). This discovery prompted Vogt's admiring and surprised remarks concerning the Chinese use of salt-petre in unfritted glazes, already quoted above. Vogt found the compositions of the glaze to be as in Table 100.

Georges Vogt assessed the firing temperature of the 1882 Jingdezhen turquoise glaze as about 950°C. Its body material (also collected by Sherzer) proved to be a single porcelain stone of the kaolinised type, making it essentially the same type of rock as had been used for the Five Dynasties whitewares at Jingdezhen nearly 1000 years earlier. The highly siliceous nature of this porcelain stone probably helped to control crazing in the turquoise glaze, although crazing in such alkali-rich compositions would have been difficult to eliminate entirely.

Unusually for Jingdezhen porcelain, the 'turquoise body' was given a biscuit-firing prior to glaze application, probably because the glaze contained no plastic constituents, so would have been very difficult to apply to the raw clay. It was also important to fire the porcelain first to a relatively high temperature as the melting point of the glaze was too low for much strength to develop in this highly siliceous porcelain material. The final firing of the 1882 Jingdezhen turquoise porcelain took place in the cool part of the big Jingdezhen *zhenyao* kiln – in an area close to the chimney, where the kiln temperatures were cooler and the strongly reducing conditions nearest to the fire mouth gave way to atmospheres that were generally oxidising to neutral.

## Other late Chinese alkaline glazes

One of the prime uses for Chinese alkaline glazes throughout their history has been for glazing bricks, roof tiles, ridge tiles and roof finials, and many north Chinese tileworks seem to have made alkaline-glazed vessels and small temple figures as a sideline to their regular architectural productions. In north China it seems likely that a good deal of this architectural ware used glazes virtually identical to those used on the *fahua* pieces. However, in south China, higher-firing and more weather-resistant alkaline compositions were often used for glazing bricks and tiles. These tougher glazes were based on crushed glasses, mixed with small amounts of clay, rather than on the more traditional approach of combining saltpetre, quartz and various lead-rich compounds. This technique of mixing crushed glasses with clays resulted in Chinese alkaline glazes that were closer in their nature to the traditional alkaline glazes of the Middle East – particularly as the crushed glasses used in the Chinese recipes tended to be of the universal soda-lime

Porcelain jar from south China engraved onto the raw clay and then given a high-temperature bisque firing. Finished with applied alkali-lead glazes outside and a yellow lead glaze inside. 16th century AD. H 5.3 in., 13.5 cm. Victoria and Albert Museum, C130–1911.

Table 100 Late Qing Jingdezhen turquoise-blue glaze and body (1882)

|  | PbO | SiO$_2$ | Al$_2$O$_3$ | Fe$_2$O$_3$ | TiO$_2$ | CaO | MgO | K$_2$O | Na$_2$O | CuO |
|---|---|---|---|---|---|---|---|---|---|---|
| 1882 Turquoise-glazed body | –.– | 76.0 | 18.0 | 1.0 | –.– | 0.2 | 0.2 | 4.1 | 0.4 | –.– |
| 1882 Turquoise glaze | 0.1 | 61.3 | 2.3 | –.– | –.– | 0.3 | 0.3 | 26.3 | 0.4 | 9.0 |

Table 101 Chinese alkaline glazes based on soda-lime glasses

| | $PbO$ | $SiO_2$ | $Al_2O_3$ | $Fe_2O_3$ | $TiO_2$ | $CaO$ | $MgO$ | $K_2O$ | $Na_2O$ | $CuO$ | $ZnO$ |
|---|---|---|---|---|---|---|---|---|---|---|---|
| 'Blue tile glaze' S. China | 1.5 | 69.6 | 4.5 | 0.7 | 0.1 | 11.3 | 1.4 | 0.7 | 9.9 | 1.0 | –.– |
| Shiwan 'Cucumber green' | –.– | 72.0 | 1.3 | 0.7 | –.– | 12.7 | 0.8 | 1.55 | 7.2 | 2.3 | 1.1 |
| Shiwan 'Onion green' | –.– | 62.5 | 4.4 | 1.0 | –.– | 16.8 | 2.7 | 2.7 | 2.7 | 2.0 | 0.5 |

type. Three examples of these glass-based compositions are given below. The first is described simply as a 'blue-glazed ridge tile' from the Qing dynasty (no provenance, but with a southern-style body composition). The second and third analyses are typical of the greenish-blue glazes made at Shiwan, near Canton (Guangzhou) since the late Ming dynasty. These blue-green glazes were used for garden pots, bricks, roof tiles and kitchen wares, and similar glazes are still manufactured on a huge scale in Shiwan, where they are used for wares as various as glazed litter bins and ceramic lamp posts. The maturing temperature for the first glaze is given as about 1140°C, and the Shiwan glazes were probably fired to comparably low stoneware temperatures.

An illustrated account of Shiwan pottery production, written in 1937, showed how the various glasses used by the Shiwan factories were crushed by women stepping on and off the ends of long beam hammers, which were set see-saw fashion to crush broken glass in iron mortars. At another factory the glass was pulverised by women standing on large flat stones with convex undersides. These stones were rocked back and forth over a layer of broken glass on a hard stone floor, until the glass was reduced to a fine dust. The powdered glass was then mixed with mud from the local Pearl River, which supplied extra silica, alumina and lime to stabilise the glazes in firing. The Pearl River mud also assisted in the initial suspension of the glaze, and in its application to the raw wares.

The green colours were supplied by copper, usually in the form of powdered brass – which probably accounts for the small zinc oxide percentages that tend to occur in these glazes. The high silica and low alumina contents of the Shiwan green-blue compositions often predisposed the glazes to liquid-liquid phase separation during cooling, sometimes resulting in milky-opaque areas developing that could be almost turquoise in tone.

In addition to being used on their own, Shiwan blue-green glazes were sometimes splashed on top of milky opal-white glazes, giving a green-on-white contrast reminiscent of the two colours of a spring onion. As well as these attractive greens, green-blues and whites, the Shiwan potters' glaze repertoire also included a wealth of rich and complex effects similar to, but subtly different from, those used on Jun, Guan, Ge, copper-red and celadon wares. These Shiwan copies of earlier classic Chinese glaze effects

Shiwan hexagonal press-moulded jar, 19th century. The fine 'Canton green' was a lower-firing oxidised stoneware glaze made from ground glass mixed with mud from the Pearl River. The green colour came from the addition of oxidised brass (a copper-zinc alloy) to the base glaze. Glazes of this type often show milky areas that make the glaze appear more bluish in places. This is probably a result of liquid-liquid phase separation, triggered by the glazes' low alumina levels. H. 5.9 in., 15 cm. Author's collection.

are mostly stoneware compositions, modified with lead oxide. They were fired in both oxidising and reducing conditions, and sometimes in the large dragon kilns that still operate in the city. The 'pomegranate red' of Shiwan is a famous example of this interesting group. The composition of this rich copper-red glaze has yet to be established, but it may not be too different from the Shiwan green.

## Yixing glazes

A few analyses do exist, however, of traditional low-firing stoneware glazes from the Yixing kilns in Jiangsu province. These can be similar in appearance to some Shiwan glazes, particularly in the case of the Yixing 'pseudo Jun' examples. The Yixing glazes are not strictly alkaline glazes, but are included here for their Shiwan parallels. Yixing is best

Yixing teapot with a robin's egg glaze, late 18th or early 19th century. The town of Yixing (on the shores of Lake Tai) has an enormously long history for stoneware-production, reaching back to the Shang dynasty. However, it is best known for its unglazed red stoneware teapots, which were first celebrated in the mid-Ming dynasty. Low-stoneware and earthenware glazes were a later development at Yixing, and included this fine local version of the robin's egg blue. 4.5 in. 11.5 cm. Sotheby's.

known for its unglazed red teapots, but the kiln complex also has a long history (reaching back to the Shang dynasty) for making glazed stonewares. The more modern Yixing glazed wares (made from the late Ming to the present day) used a wealth of low-stoneware effects and a number of these were analysed for a 1933 Industrial Handbook for Jiangsu province (see Table 102).

The high MnO figures, seen in some of these glazes, are curious and may be the result of the MgO and MnO figures becoming transposed during typesetting – although reconstruction of these glazes may prove otherwise. The zinc oxide levels are more familiar in Western glazes of the 'Bristol' type, and this makes it hard to say whether these particular glaze compositions are of Western or

Table 102  Low-stoneware glazes from Yixing

| | $PbO$ | $SiO_2$ | $Al_2O_3$ | $Fe_2O_3$ | $CaO$ | $MgO$ | $KNaO$ | $MnO$ | $CuO$ | $ZnO$ | $CoO$ | $As_2O_3$ |
|---|---|---|---|---|---|---|---|---|---|---|---|---|
| White | –.– | 53.6 | 11.6 | 1.5 | 4.4 | –.– | 6.0 | 5.7 | –.– | 14.9 | –.– | –.– |
| *Junyu* | 7.1 | 55.8 | 11.3 | 3.7 | 6.6 | –.– | 5.15 | 7.0 | 1.2 | –.– | –.– | –.– |
| Red | –.– | 54.0 | 10.6 | 10.4 | 19.7 | 1.2 | 3.2 | 0.7 | –.– | –.– | –.– | –.– |
| Green | 0.7 | 51.3 | 10.9 | 5.9 | 2.8 | –.– | 4.8 | 1.0 | 0.7 | 21.6 | –.– | –.– |
| *Huagang* | –.– | 51.0 | 12.3 | 4.8 | 14.5 | –.– | 4.0 | 6.7 | 0.5 | 4.5 | –.– | –.– |
| *Yu* blue | 42.5 | 36.1 | 2.4 | 1.6 | 3.1 | 0.5 | 4.9 | –.– | –.– | –.– | 5.1 | 3.4 |

Chinese origin. The Yixing raw materials mentioned in the Handbook include 'kiln sweat' (glassy slag from the kiln walls and ceilings), ground glass, lime, wood ash and various fusible and refractory clays. The main colourants were 'copper dust' and 'black glaze stuff'. In the 1930s the *long* kilns at Yixing were fired mainly with wood and reeds, but occasionally small amounts of coal were used as a supplementary fuel. It is reported that an average-sized Yixing *long* kiln took about 24 hours to fire and about 24 hours to cool, which is a typical firing cycle for medium-sized dragon kilns of about 20 metres in length.

Shiwan pomegranite red, Qing dynasty. The copper-red is another Shiwan speciality. Its composition is not known in detail, but it may be similar to the Shiwan green glaze. Its dark colour suggests that its copper content is higher than typical Jingdezhen copper-reds.

# FURTHER READING

## *PAPERS AND ARTICLES*

Bureau of Foreign Trade, *China Industrial Handbooks – Kiangsu*, (see Chapter 44, 'Pottery', pp 779-807), Shanghai, 1933

Julian Henderson, Nigel Wood and Mary Tregear, 'The technology of sixteenth and seventeenth century Chinese *cloisonné* enamels', Archaeometry, 31 (2), pp 133-46, Oxford, 1989

Joseph Needham, Ho Ping-Yü, Lu Gwei-Djen and Wang Ling, *Science and Civilisation in China*, Vol. 5 'Chemistry and Chemical Technology', Cambridge, 1986

Georges Vogt, 'Recherches sur les porcelaines Chinoises', *Bulletin de la Societé d'Encouragement pour l'Industrie National*, April 1900, pp 530-612. (Translated and republished in *Ching-te-Chen – Views of a Porcelain City* by Robert Tichane, pp 186-313, New York State, 1983)

Nigel Wood, Julian Henderson and Mary Tregear 'An examination of Chinese *fahua* glazes,' *Proceedings of the International Symposium on Ancient Ceramics*, (ISAC '89), pp 172-82, Shanghai, 1989

*Opposite:* Turquoise-glazed bottle, with a sgraffito design engraved through a white slip to a light reddish-brown clay, Cizhou-style ware, 12th or 13th century, north China. This early example of northern alkaline-glazed earthenware is unusual, both in its engraved white slip pattern and its reddish clay body. The form though is typical of the period, and was often used at the Guantai kilns in southern Hebei, where later examples of turquoise-glazed wares have been found. H. 8.3 in., 21 cm. Victoria and Albert Museum, FE.33–1994.

'Robin's egg blue' vase, low-fired glaze on porcelain, Yongzheng period (1723–1735). British Robin's eggs have brown freckles, so this Western name may refer to the eggs of the American Robin. Non-quantitative analysis of on example showed it to be lead-based glaze, coloured with copper, and opacified with arsenic. The fine red patterning, often seen on glazes of this type, may have been applied by spraying iron-red enamels onto the fired glazes, and then re-firing. Some unusual porcelains with mottled low-fired glazes have been found in Xuande levels at Jingdezhen, so it is possible that the Robin's Egg Blue was a Qing revival of this rare Ming type. H. 12.4 ins., 31.5 cm. Sotheby's.

# Chapter 12

# CHINESE OVERGLAZE ENAMELS

Chinese overglaze glaze enamels are low-fired earthenware glazes that are strongly coloured with oxides of metals such as iron, copper, cobalt and manganese. Most examples consist mainly of lead oxide (as much as three-quarters of the glaze's weight) with the difference being mainly silica, usually supplied by powdered quartz. The raw enamels are painted onto already fired stoneware and porcelain glazes or bodies, then given a quick oxidised firing to about 700°-800°C to mature them. This temperature allows fast and economical firing, maximises the power of the colouring oxides, and is just high enough to melt the enamels and to create some interface between them and the high-fired materials beneath.

Glazed porcelains or stonewares are decorated with the raw enamels, and then set in small enamel kilns that are sometimes made from iron. The newly enamelled wares are generally piled one upon the other in tall stacks. At firing temperatures higher than about 800°C there is some risk that enamelled wares might sinter together slightly, where high-fired bodies and high-fired glazes are in contact — another reason for the low maturing temperatures preferred for firing Far Eastern enamels. The actual areas where the raw enamels are painted, of course, must not touch anything in the setting, and the forms, the enamel decorations, and the setting methods employed, were all developed with this problem in mind.

## Metal and ceramic enamels

There is an understandable confusion over the term 'enamel' when applied to ceramics. Are these overglaze enamels the same as metal enamels in composition? And where do glass enamels fit in? In the case of China the answer seems to be that metal enamels and ceramic enamels generally remained quite separate technologies until the third decade of the 18th century. In the 1720s however it is possible that Chinese metal enamels began to have a strong influence on ceramic enamel composition, perhaps *via* the imperial workshops set up in the Forbidden City in

Beijing by the Kangxi emperor. From this time onwards there has been a considerable overlap between the two traditions, although a few colours remained that were peculiar to metal or to ceramics respectively. In the Middle East glass and ceramic technologies have always been closely connected, and Persian ceramic enamels may well have developed from experience gained through the enamelling of glass. Glass enamels however were little used in China until the 18th century AD.

So far as one can tell Chinese and Persian potters seem to have discovered the principle of overglaze enamels independently and at about the same time, in the late 12th to early 13th century AD — although, as we have seen, a technique similar to 'enamels on bisque' had already been practised by the Chinese for *sancai* export wares in the late 9th to early 10th centuries AD. At present the earliest example of a dated Chinese overglaze-enamelled object bears an ink inscription equivalent to AD1201.

The Persian and Chinese approaches to using overglaze enamels were quite different: Persian potters used enamels primarily to produce luxury wares in which the Persian style of miniature painting was transformed into glaze by detailed 'illumination' with a wide overglaze-enamel palette. The Persian potters painted their enamels with considerable skill onto glazed fritware 'porcelain', and the firing temperatures of these enamels may not have been too different from the tin glazes beneath. By contrast, the Chinese approach was much broader in spirit, with low-firing red, green and yellow enamels being freely applied to white-slipped, glazed stonewares at a number of northern kiln sites.

To many people's eyes these Cizhou enamelled stonewares are not only the earliest, but also the liveliest of all Chinese enamelled wares — indeed some critics would place them in the first rank of Song ceramics. At least half a dozen northern stoneware kilns have been shown to have produced enamelled stonewares, most of which are in the form of small bowls, dishes and bottles, decorated with

Small oxidised stoneware dish with white slip, clear stoneware glaze, and low temperature overglaze enamels in red, yellow and green, north China, early 13th century AD. Designs of fish and water-plants were popular images on early northern enamelled wares, which were probably fired to about 800°C in the enamel kilns. The red, being a suspension, rather than a solution, colour tends to be used for the outline drawing, while the more transparent colours are used to complete the design. The diluting effects of the yellow and green enamels on the red have been used to advantage in the banded borders. D. 6.8 in., 17.2 cm.

The north Chinese Cizhou potters may well have developed their overglaze enamels from existing low-fired lead-glaze recipes, which had already seen some 1500 years of production by the time they were 'borrowed' for the enamelled wares. It is probably significant that the main northern kilns that developed polychrome enamelling on Chinese stoneware were those that had already made Cizhou wares with overall green lead glazes, applied to high-fired wares, in the 12th century AD.

In terms of chemical composition it is only the red and green Cizhou onglaze enamels that have been analysed thoroughly – with the red enamel in particular showing some unusual and innovative features (see Table 103).

When fired successfully the iron-red enamel of the Cizhou kilns can show a fresh cinnabar-red colour, that can be superior to the red enamels used later on southern porcelains. The Cizhou red was a major innovation – in fact it was the first new lead-based colour to be developed in China since the *sancai* cobalt-blue of the 7th century, although as we have seen, a primitive type of iron-red earthenware glaze was made in China's distant past, the late Warring States period, and applied to some rare 'glass-paste' decorated pottery vessels and beads.

In the Cizhou red enamel, analysed above, ferric oxide is present at about 8%, but it remains largely undissolved in the lead-rich glaze. The red enamel therefore relies for its colour on the principle of adding more red iron oxide to a lead glaze than the glaze can dissolve, leaving some of the ferric oxide suspended in the glaze matrix, where it provides an attractive, slightly matt, bright brick-red colour. In addition to this high iron oxide content, the iron-red enamel also shows a high alumina level (11%) and an unusual calcia level (3.0%). However, it is hard to say whether these oxides were present in the original enamel mix, or whether they merely represent some of the underlying stoneware glaze. (It is very difficult to analyse thin overglaze enamels without some of the high-temperature underglaze appearing in the composition.)

During the enamel firing itself, strict oxidation was essential, as any trace of the lower oxide of iron (FeO) (produced by reduction) could spoil the red colour. For the same reason the iron oxide used in the original glaze recipe needs to be of the highest purity. A very curious

boldly drawn flowers, birds, fish and animals, although some enamelled figurines are also known. The enamel painting is carried out in the vigorous northern slip-painting style, but using red, green and yellow overglaze enamels, rather than the usual black and white Cizhou materials. The main designs are sketched in red, then filled in with green and, sometimes, yellow. The yellow enamels are often used at the tips of leaves – adding a touch of realism to the stylised designs. Occasionally the yellow and green are used intentionally on top of the enamel-red brushwork, which is then locally dissolved by the added colours during firing.

Table 103 Analyses of Chinese Cizhou overglaze enamels – Jin dynasty

| | PbO | SiO$_2$ | Al$_2$O$_3$ | Fe$_2$O$_3$ | TiO$_2$ | CaO | MgO | K$_2$O | Na$_2$O | CuO | P$_2$O$_5$ | SnO$_2$ |
|---|---|---|---|---|---|---|---|---|---|---|---|---|
| Green Cizhou enamel | 65.9 | 24.5 | 3.2 | 0.2 | 0.06 | 0.9 | 0.2 | 0.25 | 0.4 | 3.5 | –.– | –.– |
| Song green glass | 66.8 | 27.9 | 0.3 | 0.2 | –.– | 0.2 | 0.04 | 0.53 | 0.13 | –.– | –.– | –.– |
| Red Cizhou enamel | 20 | 52 | 11.5 | 8.0 | 0.1 | 3.5 | 0.9 | 2.5 | 0.9 | 0.04 | 0.2 | 0.3 |

feature of iron-red enamels is that their red fired colours become progressively brighter the longer they have been ground before use – perhaps because this process encourages total oxidation of the ferric oxide during firing.

Later examples of Chinese iron-red enamels contain 20-30% ferric oxide to oversaturate the glaze, but the Cizhou enamel above has only the minimum ferric oxide necessary to achieve the effect. This may explain why the Cizhou reds tend to be brighter in colour and less opaque than many of the later Chinese overglaze reds.

Once developed the iron-red became the one of the most important and widely used of Chinese enamel colours, to the extent that the enamelling studios later established at Jingdezhen were known to the potters as the 'red shops'. The main use for the iron-red was as an outlining colour in combination with other coloured enamels. Its value for this role depend on the fact that it was a suspension rather than a solution effect. It was therefore stable and semi-opaque, and capable of retaining the finest painted detail in the firing.

### The Cizhou green and yellow enamels
The green Cizhou enamel analysis above is slightly higher in lead oxide, and lower in silica and alumina, than any Tang, Liao or Song *sancai* glaze so far analysed, and therefore probably lower-firing. Otherwise, it is a typical Chinese copper-green lead glaze. It is quite similar to some examples of Han green lead glazes (see Table 77)

Enamelled stoneware bowl and cover. White slip and clear glaze on oxidised stoneware, 13th century, north China. The bowl may have been damp when it was enamelled, or the enamel firing may have been too fast – both effects could have caused small portions of glaze and slip to fly off the bowl in the early stages of the enamel firing. The fine colour of the red enamel is typical of Chinese Cizhou-type wares and may be due to comparatively low levels of iron oxide in the enamel recipe, compared with later versions of the same colour. H. 3.75 in., 9.5 cm. Victoria and Albert Museum, C.345 & A–1921.

although it may also be compared to an example of contemporary Song green glass, found in Anhui province and recently analysed at Shanghai (see Table 103). This latter analysis suggests that crushed glass, perhaps mixed with a small amount of clay, cannot be entirely ruled out as a possible raw material in Cizhou enamel recipes – although recipes made from raw lead compounds and silica are perhaps more likely.

Yellow Cizhou enamels have yet to be tested, but it would be surprising if they did not owe their colours to ferric oxide in solution (i.e. $Fe^{3+}$ ions in a lead-rich glass) – most probably in the 3-4% range that supplies the rich amber-yellow colours to various *sancai* glazes. There are number of puzzling references to Cizhou yellow enamels being coloured by antimony oxide, but no analyses have been cited to support this idea. The Cizhou yellow enamels have a tendency to misfire and look rather turbid (a characteristic of antimony-yellows) but this has also been a recurrent problem with Chinese and Japanese iron-yellow enamels throughout their history.

### Cizhou black enamels
Cizhou wares are often described as being enamelled in 'red, yellow, green and black' but close inspection of early Cizhou 'black' enamels almost always shows them to be beneath the glaze, and actually a high-fired effect of painted black slip on white slip ground beneath a high-temperature glaze. Nonetheless, black slip can appear uncannily similar to an opaque onglaze black enamel, particularly where it appears slightly matt and crystalline on the glaze surface, where the dark slip has reacted with the high temperature glaze above. Where the black painting is definitely on top of the glaze it may be later restoration (using paint), a genuine contemporary addition using ink, or perhaps a much later piece altogether.

### Turquoise Cizhou enamels
Occasional examples of later Cizhou overglaze decorated wares (14th–15th centuries) feature details in turquoise enamels. These colours must have derived from the northern Cizhou experience with potassia-rich turquoise glazes, discussed in the previous chapter.

### Chinese enamelled porcelain
Despite the decorative potential of the technique very few examples of enamel decoration on good quality northern porcelains have been found, and early northern enamelling was essentially a stoneware process. No doubt overglaze enamelling in the north was considered a 'folk' technique and out of keeping with the rather austere and aristocratic style of northern porcelain, with its emphasis on strong and simple forms, usually borrowed from beaten silver or from gold.

It is in south China that we see the first proper use of enamels on glazed porcelain, but even here the technique was slow to become established. A few pieces of 14th century enamelled porcelain in the *shufu* material are known. These are decorated with red, green and, occasionally, turquoise, enamels in the rapid 'boneless' (no outlines) style typical of the mass-produced blue-and-white export wares found in the Philippines. The genuineness of these pieces has sometimes been questioned, but we also have the rather second-hand evidence of Vietnamese porcelain of the 15th century, which copied 14th century Chinese porcelain styles fairly closely. Some early Vietnamese porcelains are also decorated with sketchy designs in red and green enamels, and these are similar in style to the enamelled *shufu* wares.

Jingdezhen polychrome overglaze enamels may therefore have started life in the 14th century as a 'cheap and cheerful' enhancement to low-quality export porcelains, albeit of rather limited production. But despite these modest beginnings, the succeeding century saw Jingdezhen overglaze enamels raised to the highest possible status for ceramics in China – when they were used on porcelains intended for the imperial household. These 15th century enamelled imperial porcelains have always enjoyed a special place in China's ceramic history, and they remain some of the best regarded, and most sought after, of all Chinese ceramics. This movement towards a more elevated role for overglaze enamels at Jingdezhen may well have started in the late 14th century, as a single dish, finely decorated with overglaze red dragons, has been found recently in a Hongwu (1368-1398) stratum at the early Ming capital of Nanjing.

### 15th–century Jingdezhen enamelled porcelains

When we come to examine the 15th century wares themselves we are on much firmer ground historically as the waste heaps of the Ming imperial kilns have been excavated recently at Jingdezhen, and many broken pieces reassembled. The reject porcelains had each been dealt a blow with a sharp instrument and were still in fairly large pieces. They had been smashed at the final inspection stage for various shortcomings, one of the more unusual being the accidental drawing of six toes on a five-toed imperial dragon. Before these finds were made, the great museums of the world could only boast a handful of 15th-century enamelled porcelains apiece. There are now many tonnes of broken 15th-century wares available for study by Chinese archaeologists, with the well-stratified levels at Zhushan Road giving a clear image of how early Ming styles and techniques developed. Also, amongst the mass of shards that have been excavated, have been found some totally novel porcelains that have no surviving parallels as complete wares, either within China or without.

Imperial quality Ming *doucai* jar, underglaze-blue painting with coloured overglaze enamels, Jingdezhen kilns, Chenghua period (AD1465–1487). Made from Jingdezhen's finest materials and using the district's best craftsmen, *doucai* wares have long been regarded as exceptional productions. The red, yellow and green enamel compositions seem to be very refined examples of traditional enamel recipes. The innovative brown enamel may be coloured by manganese, with a small natural cobalt impurity. This jar is a particularly fine example of *doucai* ware and is similar to another *doucai* jar, in the Palace Museum in Taiwan, which still has its flat-topped cover. D. 5.1 in., 13 cm, H. 2.9 in., 7.4 cm. By courtesy of the Percival David Foundation of Chinese Art, PDF 797.

### Yongle (1402–425) enamelled wares

Most Yongle imperial porcelain was deliberately austere – often consisting of undecorated white-glazed wares, and using forms that were classically 'Chinese', when compared with the stylistic excesses of the Yuan and Hongwu periods, with their strong West Asian influences. Although the vast majority of ordinary surviving Yongle porcelain (outside the Zhushan excavation) is blue and white, 95% of the Yongle porcelains found at Zhushan Road were undecorated whitewares – apparently the favoured imperial style. Overglaze enamelled wares make up only a minute proportion of the Yongle imperial porcelains that have been excavated, but their very existence is of great significance.

The main overglaze enamel of the Yongle reign was the iron-red, probably introduced as a reliable substitute for the troublesome underglaze-red from copper. But, besides the iron-red pieces, the Zhushan Road excavations also produced occasional finds of white Yongle porcelains enamelled in green and red and, in one rare case, high-fired brown combined with overglaze green. The yellow enamel was also used at Jingdezhen in the Yongle period, but so far it is only known in the on-*bisque* version.

## Definition with overglaze enamels

The iron-red, as a semi-opaque colour, shows up clearly and with good contrast, and its sharp definition was well exploited by the Yongle potters. However, with the Yongle transparent enamels (which at this time were confined to yellow and green) there was some difficulty with their general lack of contrast – with the yellow enamel being particularly hard to see against the white porcelain ground. This had not been such a problem with the old Cizhou enamels, which were usually thickly applied and rather cloudy, and which often used iron-red outlines to emphasise the more transparent colours. At Jingdezhen the high purity of the 15th-century porcelain, and the thinness of the transparent enamels themselves, meant that a whole series of decorative techniques had to be devised to sharpen the impact of enamel-painted designs.

The first method adopted by the Yongle potters was a light engraving of the raw porcelain body before glazing. This caused the lead-based enamels to pool and darken in the engraved lines, giving some form and outline to the transparent colours. Sometimes the engraved porcelains were covered with high temperature transparent glazes before enamelling, sometimes they were simply given a high-temperature biscuit firing and the enamels were applied direct to the hard porcelain body. This latter technique gave clearer results as the enamels pooled in the carving itself, without any intervening high-temperature glaze to soften the effect. This 'enamels on the bisque' process also tended to give slightly darker tones to the enamels as the unglazed, re-oxidised body was less white than fully glazed porcelain. The Yongle white glaze itself was of exceptional quality: it consisted almost entirely of glaze stone, and was consequently slightly opacified by undissolved silica.

The idea for light engraving of the porcelain body, in order the enhance the definition of the enamels, seems to date from the 14th century, when the Jingdezhen potters faced a similar problem with their troublesome underglaze red pigments based on copper. Light engraving was sometimes used then to supply some definition to the copper pigments as they diffused and spread in the firing.

## *Doucai* wares of the Xuande (1426–1435) and the Chenghua (1465–1487) reigns

The definition of the early Ming enamel colours was further improved in the Xuande and Chenghua periods by an entirely novel approach – the use of coloured enamels to fill in high-fired, underglaze-blue designs. In this technique fully glazed and fired underglaze blue-and-white wares had the outlines of their blue drawing carefully filled in with coloured enamels, with occasional touches of solid blue being left to give an extra colour in the finished

Transporting Jingdezhen wares in the 1980s. Jingdezhen is still China's main ceramics producing town, with debris from the 15th-century imperial factories lying just beneath its streets.

decoration. The wares were then refired to enamel temperatures. This style is known as the *doucai* technique – *doucai* being variously (and rather confusingly) translated as 'clashing' or 'dovetailing' colours. It is a true polychrome effect, combining red, yellow, green, brown and aubergine overglaze enamels with underglaze blue. Some secondary colours are also seen in *doucai* wares, such a sage-green, achieved by painting the transparent yellow enamel over the underglaze-blue.

The *doucai* technique is particularly associated with small toy-like porcelain objects, made from the finest porcelain materials, and using the highest standards of craftsmanship. The style is delicate and rather feminine. Most *doucai* pieces are small bowls, dishes and stem cups, but *doucai* incense burners and covered jars were also made.

Until the Zhushan Road excavations the *doucai* technique had been associated with the reign of the Chenghua emperor (reign 1465-1487) and, in particular, with the influence of the emperor's consort, Wan Guifei. However, closer reading of history has shown Wan Guifei to have been a mercilessly cruel woman, with a taste for armour and fast horses, and an unlikely patron for fine porcelain. The appearance of many *doucai*-style pieces, in the Xuande levels of the Zhushan excavation, has now shown that the development of *doucai* porcelain actually took place in the earlier reign of the Xuande emperor, and one complete Xuande bowl, made in a prototype *doucai* style, has survived at the Sa'gya Monastery in Tibet.

Besides this 'painting by numbers' principle the experimental Xuande *doucai* technique also saw the introduction of a totally new enamel colour – a transparent brown with a slightly purple tinge. Unfortunately, the almost legendary

value of 15th-century *doucai* wares has so far prevented any analysis of *doucai* enamels being attempted but, judging from its colour, the *doucai* brown seems to have been based on manganese, perhaps with a small cobalt impurity. So famous were these wares that they were imitated almost perfectly in the early Qing dynasty, and these Qing copies are still being confused with the 15th-century originals.

### Turquoise enamels

The 15th century also saw some further experiments with the turquoise enamel, which had already seen use on mid-14th-century Jingdezhen imperial porcelains, and on a few *shufu*-style enamelled wares. Turquoise appears occasionally at Jingdezhen as a monochrome overglaze colour but, in the Chenghua reign, it was also used applied successfully to high-fired, underglaze-blue porcelains. In this technique the

underglaze blue appears almost black where it is covered by the turquoise enamel – producing an odd and striking effect reminiscent of Persian silhouette wares. These turquoise and blue-black wares are rare and the style was not pursued. Besides these special cases the turquoise enamel was gradually introduced at Jingdezhen as a useful supplementary colour to the 15th-century porcelain decorator's palette.

Visitors to the Zhushan Road excavations have been told that the turquoise enamel was potassia-rich and made with saltpetre. This information fits in well with what we know of Chinese alkaline glazes, such as those used on Chinese *fahua* wares although, surprisingly, shards of true *fahua* wares have yet to be found at any Jingdezhen kiln site. The nearest approach to a *fahua* object, discovered at the imperial kiln site excavations was a plain Chenghua bulb-bowl, glazed turquoise on the outside and green

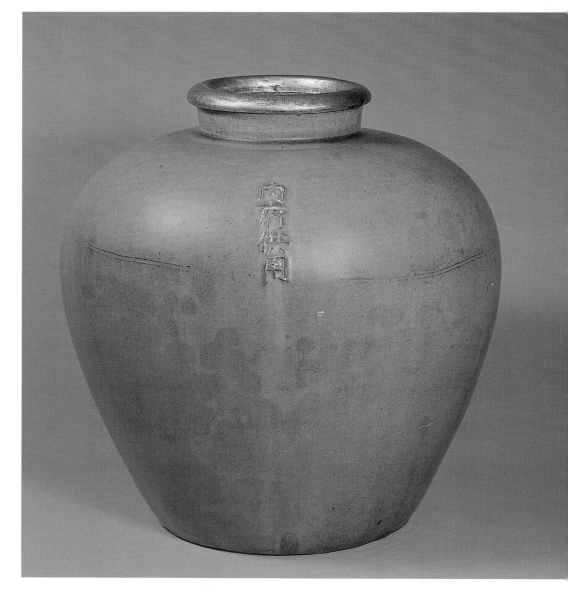

Turquoise-glazed jar with its rim finished in gilded copper, 15th century, probably from south China. Low-fired alkaline glaze coloured with copper and applied to high-fired porcelain. This fine jar was once in the imperial collection in Beijing, and the characters on its shoulder record that it was made for use in an Inner Palace. The combination of the turquoise glaze with gold became an imperial style at Jingdezhen as early as the mid-14th century, perhaps through the influence of Islamic lustreware. H. 13.2 in., 33.5 cm, W. 12.5 in., 31.6 cm. Percival David Foundation of Chinese Art, PDF 518.

inside. This is a typical *fahua* colour combination, although the piece lacked the usual *fahua* slip-trailed designs. A red and green dragon-dish, with trailed *fahua*-type slip decoration has also been found in a middle-Chenghua strata at Jingdezhen. In this case the technique was pure *fahua*, although the colours were wrong. Nonetheless, it is not hard to imagine that both colours and processes were successfully combined at Jingdezhen sometime in the late 15th century.

## The under-enamel black

Some Chenghua enamelled porcelains show a 'black' enamel effect – achieved by using a dark pigment beneath the transparent green enamel. A small Chenghua duck-shaped incense burner, excavated at Zhushan Road, shows large black-enamelled areas produced by this method. The final effect is identical to Qing dynasty *famille noire* porcelain, which used the same 'green-on-black' technique – some two centuries later than the Chenghua experiments.

According to the leading archaeologist of the Jingdezhen finds, Liu Xinyuan, the black under-enamel pigment was the standard Chenghua, high-temperature, underglaze-blue pigment which, by this time, was an iron-manganese-cobalt mixture. The cobalt pigment would have been painted on top of the fired glaze, and then covered with the green enamel, where it was 'fixed' by the melting of the overglaze green. The oxidised firing and the lead-rich enamel composition produced a black colour from the impure cobalt – rather than the typical blue tone that it would have supplied if used beneath a regular porcelain glaze fired in reduction.

Once developed, the use of the under-enamel black proved a useful extra technique in the enameller's repertoire – and it was later used extensively at Jingdezhen to provide thin black outlines for overglaze enamel painting. This proved a more versatile method for supplying definition to the porcelain enamels than the underglaze blue used for the *doucai* wares, as the painted designs for the porcelains did not have to be fixed at such an early stage in their manufacture. The black pigment did not contain any flux so it usually needed to be slightly overlapped by the coloured enamels, otherwise it would eventually rub away after firing. In this respect the black pigment differed subtly from the iron-red enamel, which was also used for outlining, but which contained its own lead oxide flux. The iron-red was always painted just beyond the enamel limits as it was easily dissolved by the transparent colours.

The aubergine enamel and the black pigment became important additions to the Jingdezhen enamellers' range of effects and we know from an eye-witness account (Père d'Entrecolles' letters of 1712 and 1722) that low-grade Chinese cobalt was still in use in overglaze enamel recipes at Jingdezhen in the early 18th century – both for making under-enamel black pigments, and as the prime colourant for aubergine enamels. Georges Vogt's paper of 1900 shows that manganese-cobalt ores continued to be used for these purposes at Jingdezhen in the late 19th century – further evidence for the remarkable conservatism and continuity that operated within the Jingdezhen porcelain-making tradition.

## The ultimate origins of late 15th-century Jingdezhen enamels

The end of the Chenghua period (1487) is a useful date at which to pause and take stock of the development of low-fired glazes in China thus far, as the accumulated knowledge of some 1700 years of low-fired glaze technology in China became focused in the enamelled porcelains of the Chenghua era. Most of these Chenghua enamels had their origins in north China, with some of the Jingdezhen enamel colours representing a remarkably long pedigree:

**Copper green** – Possibly Warring States glazed pottery beads (north China).

**Iron Yellow** – Warring States 'glass paste' decorated beads and pottery vessels (north China).

**Iron red** – Warring States 'glass paste' wares but, more conventionally, in the late 12th century, as an onglaze Cizhou stoneware enamel (north China).

**Copper turquoise** – Still unknown, perhaps Han glass.

**Manganese-cobalt aubergine** – Northern alkaline-glazed earthenware (14th–15th century).

**Manganese-iron-copper-cobalt under-enamel black** – Mid 15th-century Jingdezhen.

**Gilding** – 11th-12th century, north China (occasionally used on some northern porcelains, such as the rare black Ding wares).

The techniques developed in China to enhance the definition of overglaze enamels may also be summarised at this stage. In chronological order they seem to be:

**Outlining in red enamel** – Late 12th century north China.

**Outlining of enamels with trailed clay slip** – *Fahua* wares, north China, 14th-15th century.

**Engraving in raw body, with enamels applied direct to high-fired porcelain biscuit** – Gongxian kilns, late 9th century.

**Engraving in raw body, covered by high-temperature glaze, then enamel** – Early 15th century, Yongle reign, Jingdezhen.

**Using enamels in silhouette effects with large areas of high-temperature colour** – early 15th century, Jingdezhen.

**Using enamels in silhouette effects with other enamel colours** – early 15th century, Jingdezhen.

**Enamels painted within high-fired underglaze-blue outlines (*doucai* style)** – Xuande period, Jingdezhen.

**Outlining in under-enamel black pigments on top of high-fired porcelain glazes** – Chenghua period, Jingdezhen.

Thus, by the end of the Chenghua period Jingdezhen potters were able to use six overglaze colours (red, yellow, green, turquoise, aubergine and 'black') plus gilding and underglaze blue, besides a number of useful processes for increasing contrast and definition. The combined use of the full range of overglaze enamelling effects in the late 15th century lead to a new style of overglaze enamelling, known as the *wucai* (five-colour) style. Curiously, as with '*sancai*', the term '*wucai*' tends to under-estimate the number of colours involved. In addition to this wide palette, at least eight different ways of emphasising the enamel colours had been developed or adapted by 1487. The decorative potential of Jingdezhen overglaze enamelling technology was now enormous, and the scene was set for the great expansion of overglaze enamel production that occurred at Jingdezhen in the 16th century AD.

## 16th-century Jingdezhen enamelled wares

The important finds of 15th century enamelled wares at Zhushan Road actually represent a relatively limited output that made use of the highest quality raw materials and craftsmanship. Fifteenth-century enamelled porcelains were mainly imperial wares; overglaze colours were little used by the private and folk kilns – which concentrated on wares painted with underglaze blue. Complete and surviving examples of 15th-century enamelled porcelains are consequently extremely rare, although excellent copies continued to be made at Jingdezhen, right up to modern times.

By the third decade of the 16th century, however, overglaze enamelling was becoming a truly popular style and, as the Jiajing reign (1522-1566) progressed, a prodigious production was established. Dozens of private kilns were now using overglaze enamel techniques, and whatever was lost in terms of refinement of concept and attention to detail was more than offset by spectacular invention and breadth of treatment. Variety in overglaze enamelling reached its peak towards the latter part of the Jiajing period when porcelains of unprecedented complexity, scale and colour were made. Giant *wucai* enamelled fish bowls a

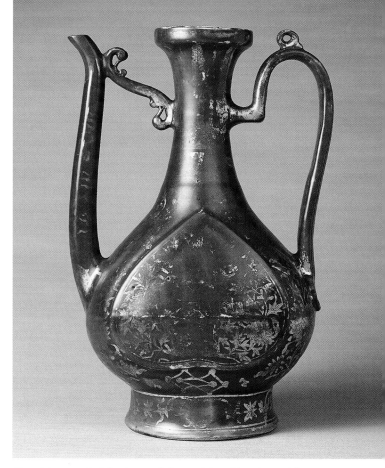

Porcelain ewer in Islamic metal form, plain white glaze with overall iron-red enamel and gilded decoration, 16th century AD. The reign of the Jiajing emperor is noted for its elaborate and colourful enamelled porcelains. This sumptuous combination of iron-red with gilding is known as the *kinrande* style in Japan. Carter Fine Art.

metre or more in diameter were produced, as well as huge dragon dishes decorated in underglaze blue and overglaze iron-yellow. Numerous low-fired monochrome glazes were manufactured including green, blue, yellow, red and turquoise. Gilding was used extensively, and every known underglaze and overglaze technique was practised and combined with a much expanded repertoire of form and ornament. To 16th-century Chinese connoisseurs and collectors contemporary wares must have seemed the height of opulence and vulgarity, when compared with the refined wares of the 15th century. From the standpoint of history though, the 16th century in China produced some stunning enamelled porcelains.

Nonetheless, despite this explosion of production and trade, close examination of 16th-century enamelled wares shows that enamel technology remained much the same – amounting to the imaginative reworking of the seven colours and eight techniques of the 15th century. There was though one important exception, and this was the development, and limited use, in the Jiajing period (1522–1566), of an overglaze enamel blue.

Tang blue-glazed figure of a courtier. Earthenware with a cobalt blue lead glaze, early 8th century. Carter Fine Art.

## *Chinese low-temperature cobalt blues*

Low-temperature glazes, coloured blue with cobalt oxide, have a history in China that reaches back to the second half of the 7th century AD, when they were first used on some Tang *sancai* wares. But from the end of the Tang dynasty to the development of blue-black alkaline glazes in the 14th century low-fired cobalt blues were virtually unknown in China. The reasons for this long gap seem to have owed more to technology than taste – particularly to the problems that Chinese potters faced in finding suitably pure sources of cobalt oxide.

### Sources of Chinese cobalt

Most cobalt-rich rocks, used throughout the history of Chinese ceramics, have been heavily contaminated with other colouring oxide impurities, particularly those of iron and manganese. In high temperature reduction-fired glazes this was not a problem as pure cobalt gives harsh results in porcelain glazes, and the large amounts of iron and/or manganese compounds in these pigments were essential in achieving fine underglaze-blue colours. In oxidised lead-rich glazes though, these same impure cobalt-rich rocks gave aubergine colours when used as solution colourants – or dense blacks when they were used as under-enamel

pigments. It seems possible that the 15th-century Jingdezhen aubergine enamel and the 15th-century Jingdezhen under-enamel black, were both fortuitous by-products of unsuccessful experiments to make low-fired overglaze blues from the traditional sources of cobalt.

Analysis has shown that the success of the Tang *sancai* blue came from the use of an unusual cobalt pigment that, at its most impure, contained about equal amounts of iron and cobalt oxides. As cobalt oxide has at least ten times the colouring power of iron oxide this was a powerfully pure material, and one that gave a fine blue in the oxidised high-lead *sancai* glazes.

In the Yuan dynasty (when imports of cobalt to China revived) underglaze-blue pigments contained two to four times as much iron oxide as cobalt. This was now too much iron for a good blue in a lead-rich glaze, but still entirely adequate for underglaze painting with reduction-fired porcelain. In the 15th century levels of manganous oxide in underglaze-blue pigments gradually increased at Jingdezhen, at the expense of iron, as Chinese sources of cobalt were exploited and mixed with the imported material. Even so, although the relative amounts of iron and manganese oxides changed, the actual levels of cobalt oxide in the underglaze pigments remained much the same, and were still too low to give worthwhile blues in lead-rich glazes.

### *Fahua* purple-blues

It is possible to achieve some kind of low-temperature blue with manganese-iron-cobalt mixtures if an alkali-rich, low-temperature glaze is used instead of a high-lead base – and if copper oxide is added to boost the blue tone with its turquoise colour. This was a technique exploited by the *fahua* potters who successfully made intense, low-temperature, purple-blue glazes, from the late 14th century onwards. A typical colourant mixture for a *fahua* purple-blue was 0.4% CoO, 3.3% MnO, 3.8% CuO and $Fe_2O_3$ 1.1% – apparently achieved by mixing copper oxides with Chinese cobalt-rich rock. Unfortunately this approach only works with high-alkali glazes. With lead-rich glazes the copper oxide gives green rather than turquoise, and this green component destroys the purple-blue colour.

One analysis of a cobalt pigment used for Jiajing underglaze blue has shown at least 34% CoO, (with 37% FeO and 28% MnO). This is the highest cobalt oxide content established for a cobalt pigment used for Chinese ceramics since the Tang dynasty *sancai* wares. The use of this cobalt-rich rock in the reign of the Jiajing emperor may explain why a low-temperature, lead-based blue could at last be produced at Jingdezhen, where it was used in both low-fired, blue monochrome glazes on porcelain, and in true overglaze blue enamels. After the Jiajing period cobalt levels in underglaze-blue pigments again declined, and

overglaze blue enamels did not reappear at Jingdezhen until the end of the 17th century.

## Later Ming porcelain

The creative impetus behind Jingdezhen porcelain began to run out of steam in the Wanli period (AD1573-1619), and much Wanli porcelain is rather run-of-the-mill, with crowded designs and poor materials, although some good reworkings of earlier Ming designs were still being made. The Ming dynasty itself began to fall apart at the end of the Wanli era, due to near civil war in the south and Manchu incursions in the north. Because of these troubles porcelain orders to Jingdezhen from the court in Beijing were suspended in the mid-17th century. Curiously, this break in imperial patronage had a liberating effect on the Jingdezhen potters as the main kilns felt free to experiment and to develop new markets. The years from the 1630s to the 1670s are known as the Transitional Period – a time that saw some superb landscape and narrative decorated porcelains being manufactured at Jingdezhen.

Transitional porcelains often feature tall, clean and novel shapes, with thick bodies and smooth, milky-white glazes. The crowded patterns used on Wanli porcelain were soon replaced by more imaginative designs, with the white spaces between the painting being used to fine effect. Partly because of the thickness of Transitional glazes the underglaze blue showed an unusually pure and soft tone – an effect once likened to 'violets in milk'. Enamelled versions of this style were also made, with the underglaze-blue landscape and figure scenes 'coloured in' with overglaze enamels, using copper-green as the dominant colour, and large areas of underglaze blue left as an integral part of the design.

Large 'Swatow ware' dish with overglaze enamels. Decorated with four identical Chinese characters and the traditional 'split pagoda' pattern. The characters have been translated as: 'Jade hall full of nobility and wealth'. Swatow is the name of a port from which many Fujian-made porcelains were exported, especially in the later Ming dynasty. The kilns proper were further inland, particularly in the Pinghe area, and also to the south in Guangdong province. The use of turquoise overglaze enamels is a characteristic of Swatow wares, probably using lead-alkali enamel bases, coloured with copper. D. 15 in., 38 cm. By courtesy of the Percival David Foundation of Chinese Art.

*Opposite:* Large Kangxi *famille noire* baluster vase and cover. The black enamel effect was achieved at Jingdezhen by applying a copper-green lead-based enamel over an unfired coating of impure Chinese cobalt. During enamel firing the two combined to give an intensely black effect, with a hint of green. The technique was first used at Jingdezhen in the mid 15th century, but it then disappears until the late 17th century. H. 16.4 in., 41.6 cm. Sotheby's.

Wine ewer, decorated with underglaze blue and overglaze enamels, Jingdezhen kilns, Tianqi period. The penultimate reign of the Ming dynasty, the Tianqi period (AD1621–1627) was responsible for some of Jingdezhen's most original wares, often made to Japanese order. This is an unusually fine example from the period. H. 5.6 in., 14.2 cm. By courtesy of the Percival David Foundation of Chinese Art.

## The Qing dynasty (1644–1912)

The beginning of the Qing dynasty (1644) found Jingdezhen in a run-down condition after years of political turmoil. Civil war flared again in the 1670s and in 1674 Jingdezhen was virtually destroyed by fire. But by the 1680s stability had returned, the imperial kilns were rebuilt and porcelain production re-organised. The re-organisation of Jingdezhen is marked by some magnificent porcelains, many based on the ideas of the Transitional period, but reworked and refined into a new Qing 'official' style. Green enamels still tend to dominate in these Kangxi (1662-1722) designs, a style dubbed *famille verte* by French collectors. These later Kangxi porcelains (from the 1680s onwards) combine vigorous design, with fine materials and confident execution.

## Qing enamels

When we reach the first decades of the 18th century we are once more on firmer ground, as we not only have some good analyses of Qing enamels from the period, but also some first-hand accounts of Jingdezhen enamel recipes and materials. The latter information was supplied by the French Jesuit, Père d'Entrecolles, who was a missionary at Jingdezhen in the early 18th century, and who wrote two famous letters on Chinese porcelain production to his Superior in Paris in 1712 and 1722.

## Père d'Entrecolles

Father Francois Xavier d'Entrecolles (1664–1741), was obviously hand-picked for his mission to Jingdezhen. Besides his deep knowledge of Chinese languages and customs he was an eagle-eyed observer of practical technology. He arrived at Jingdezhen at a time when the secret of true porcelain was still unknown in Europe, and fortunes in gold were being paid to China by France, Saxony, Britain and the Netherlands to purchase Kangxi wares. Père d'Entrecolles must have been aware of the great need in Europe to understand the nature of this extraordinary Chinese ceramic material, and eventually to imitate it with European raw materials. There was also the more immediate need for France to discover if any trade could be established with Jingdezhen to offset the huge amounts of cash being spent on the Chinese wares.

D'Entrecolles two letters (dated September 1712 and January 1722) address both problems, although with little hope on the latter, other than an idea that European cobalt might make an item of trade. On the subject of porcelain-making, however, these letters are a priceless record of the techniques and recipes used at Jingdezhen at one of the high points of its history. D'Entrecolles' first letter provides a vivid description of Jingdezhen, its layout, its history and the lives of its potters, together with a general account of porcelain manufacture in the later Kangxi period.

*Famille rose* and *famille verte* enamels compared. In the early 1720s the colours and qualities of Jingdezhen porcelain enamels began to change in a number of important ways. Most obviously an opaque white enamel (containing lead arsenate) and an opaque yellow enamel (containing lead stannate) were introduced, together with a translucent pink enamel that contained colloidal gold. These opaque and translucent colours were often combined with traditional transparent Jingdezhen enamels to create a painting style reminiscent of oil-painting. hinese *cloisonné* wares and European metal and ceramic enamels have been suggested as possible sources for these new colours. (top: detail of late 18th C *famille* rose plate; below: detail of Kangxi famille verte enamelled plate c. AD1700. Author's collection).

The second letter is more detailed in its practical descriptions and includes careful accounts of making methods, processing of raw materials, recipes, kiln setting and kiln firing techniques. The writing throughout is concise, lucid and not without quiet humour. The letters were devoured by European potters, including Josiah Wedgwood, who may well have based his ideas of mass production and division of labour on d'Entrecolles' accounts of how the Jingdezhen workshops were organised.

The high quality of Père d'Entrecolles observations continue to be confirmed by modern scientific studies of Qing porcelains – with one good example being his account of the Kangxi overglaze blue, a colour that re-appeared on Jingdezhen porcelain in the late 17th century.

Père d'Entrecolles records numerous recipes for early 18th-century Jingdezhen enamels, most of which were composed of three parts of white lead (lead carbonate) to one part of quartz, with small additions of colouring oxides for the various colours. However d'Entrecolles did note that the Kangxi overglaze blue differed from most

Table 104 Analyses of Kangxi overglaze enamels

| | PbO | SiO$_2$ | Al$_2$O$_3$ | Fe$_2$O$_3$ | TiO$_2$ | CaO | MgO | K$_2$O | Na$_2$O | CuO | CoO | MnO | Cl |
|---|---|---|---|---|---|---|---|---|---|---|---|---|---|
| Blue | 47.8 | 42.1 | 0.4 | 0.3 | –.– | 0.9 | 0.04 | 6.2 | 0.45 | 0.15 | 0.2 | –.– | 1.6 |
| Bright green | 62.7 | 31.5 | 1.0 | 1.0 | –.– | 0.4 | 0.05 | 0.1 | 0.06 | 3.1 | –.– | –.– | –.– |
| Dark green | 58.7 | 32.3 | 1.0 | 0.3 | 0.01 | 0.6 | 0.1 | 0.3 | 0.4 | 6.0 | –.– | –.– | 0.4 |
| Olive green | 66.2 | 29.0 | 0.6 | 1.2 | 0.02 | 0.14 | 0.02 | 0.2 | 0.1 | 2.1 | –.– | –.– | –.– |
| Coral red | 41.4 | 24.0 | 5.0 | 22.7 | –.– | 2.4 | 0.1 | 0.25 | 0.3 | 0.13 | –.– | –.– | –.– |
| Light purple grey | 69.5 | 29.0 | 0.8 | 0.05 | –.– | 0.04 | –.– | 0.2 | 0.1 | 0.1 | –.– | 0.2 | –.– |

enamels in being made from a pulverised blue glass that was also used at the time as a glass enamel on metal. Jingdezhen potters crushed and washed this blue glass (which came originally from Beijing or Canton), and mixed it with gum or fish-glue to make the Kangxi overglaze-blue enamel. Père d'Entrecolles puts the introduction of the Jingdezhen overglaze blue at about AD1700 – and mentions that it appeared at Jingdezhen at about the same time as fired-on gilding.

Analyses carried out on Kangxi overglaze enamels by Professor David Kingery and Dr Pamela Vandiver, at the Massachusetts Institute of Technology in 1983–4, confirmed that the Kangxi overglaze blue did indeed have a different compositional base from the general run of Jingdezhen enamels, with their analyses showing that the blue had a potassia/lead-oxide/silica basis rather than the simple lead oxide/silica mixture of its contemporaries (see Table 104).

The discovery of a significant amount of chlorine in the Kangxi enamel blue may also explain the slight iridescent halo that often surrounds the colour. This iridescence is visible when Kangxi porcelain is held at certain angles to the light, and is often regarded as a mark of genuineness in wares of this date. Chlorine is a volatile and reactive element and could well have encouraged some vaporisation of the molten blue enamel during firing, with some of this material condensing back as a thin iridescent film around the blue enamel painting during firing. The MIT analysis also shows the relative purity of the enamel's cobalt colourant which, as we have seen, was a necessary condition for a successful high-lead overglaze blue.

Apart from this unusual blue, the porcelain enamels in use at Jingdezhen at the time of d'Entrecolles' ministry were essentially those developed in the mid-15th century with most of these colours deriving from still earlier Chinese technical traditions. However, at about the time that Père d'Entrecolles was leaving Jingdezhen to take up a new post in Beijing (1723), a radical change overtook Jingdezhen enamel technology, when the old transparent enamels began to be replaced by an entirely new opaque porcelain enamel palette. This change occurred just too late to be recorded by d'Entrecolles, but was part of a highly experimental phase in the history of Jingdezhen porcelain that has already been touched upon in the chapter concerning copper reds. These new opaque

Large 'goldfish bowl' showing scenes of porcelain manufacture including an egg-shaped kiln, painted in *famille rose* overglaze enamels (interior decorated with carp and plants), *c.* 1735. H 16 in., 40.5 cm. Gemeentmuseum, The Hague.

Table 105 Analyses of Yongzheng (1723-735) Jingdezhen enamels

| | PbO | SiO$_2$ | Al$_2$O$_3$ | Fe$_2$O$_3$ | CaO | MgO | K$_2$O | Na$_2$O | As$_2$O$_5$ | Au | CoO | SnO$_2$ | MnO$_2$ | Sb$_2$O$_3$ |
|---|---|---|---|---|---|---|---|---|---|---|---|---|---|---|
| Blue-green | 45.5 | 38.4 | 0.8 | 0.2 | 0.1 | 0.05 | 8.2 | 0.65 | 0.85 | –.– | –.– | –.– | –.– | –.– |
| White | 43.2 | 43.3 | 1.0 | 0.1 | 0.1 | 0.1 | 5.7 | 2.5 | 4.3 | –.– | –.– | 0.1 | 0.03 | –.– |
| Yellow | 57.5 | 35.2 | 0.3 | 0.2 | 0.1 | 0.1 | 2.7 | 1.4 | –.– | –.– | –.– | 1.5 | 0.01 | –.– |
| Red | 11.75 | 24.3 | 8.5 | 30.3 | 1.6 | 0.3 | 0.1 | 0.2 | –.– | –.– | –.– | –.– | 0.1 | –.– |
| Rose | 47.3 | 45.1 | 0.6 | 0.15 | 0.3 | 0.1 | 2.1 | 2.75 | –.– | 0.1 | –.– | 0.22 | 0.02 | . |
| Blue | 38.4 | 45.2 | 0.7 | 0.5 | 0.1 | 0.1 | 5.8 | 2.7 | –.– | –.– | 0.3 | –.– | 0.2 | –.– |

enamels gradually displaced the more transparent Kangxi *famille verte* palette and established the more opaque style of Jingdezhen porcelain enamelling, that is still current in China today.

The compositions of these new opaque porcelain enamel colours (largely micro-sampled from Jingdezhen wares of the 1730s) were also studied by David Kingery and Pamela Vandiver during the MIT study of 1983-84.

The work at MIT revealed three novel features. The first was that many of the lead-rich enamels now contained potassia – a change already heralded by the Kangxi blue. The second was that micro-crystalline colourants, such as lead-arsenate white and lead-stannate yellow, were now employed to provide opaque whites and opaque yellows, respectively, in Jingdezhen enamel recipes. The third was that minute amounts of colloidal gold were used to make a translucent pink enamel with a lead oxide-potassia-silica base. The widespread adoption of this pink enamel at Jingdezhen led Western collectors to apply the name *famille rose* to the new style of Chinese overglaze-enamel painting.

These three new colours (opaque white, opaque yellow, and translucent pink) transformed the appearance of Jingdezhen porcelain. By using the colours separately, and also by intermixing them with each other, and with the

existing transparent Jingdezhen colours, an extensive range of opaque, transparent and translucent effects became available to the porcelain enamellers. For example, the pink enamel painted on top of the opaque white gave an opaque pink; the transparent copper-green with the opaque white gave an opaque emerald-green; opaque yellow with the old copper-green provided an acid yellow-green; the existing manganese-cobalt aubergine mixed with the new gold-pink gave a translucent purple, and so on.

This new palette, with its range of transparent, translucent and opaque colours, encouraged a style of porcelain enamelling that was far closer to oil painting than to the watercolour qualities typical of earlier Jingdezhen work. These new bright opaque overglaze colours were also well-suited to the rather over-sweet and mildly decadent character of mid-and late 18th-century Jingdezhen porcelain.

### *The origin of the* **famille rose** *palette*

The source of these new Jingdezhen opaque colours has been much discussed over the last century, and two schools of thought have arisen on their possible origins. One view sees Europe as their source, with Western missionaries in Beijing providing the necessary European connection. The other view holds that new opaque colours could well have been borrowed from the current Chinese *cloisonné* technology.

One problem with disentangling this subject has been the tendency to treat the pink, the yellow and the white enamels as sharing a common source. A gold-pink porcelain enamel was certainly in use in Europe in about 1718 at the new Meissen factory in Saxony, a few years before the colour first appeared in China. However, recent analyses have shown that an opaque lead-arsenate white and an opaque lead-stannate yellow were used in China for making *cloisonné* enamels in the late 17th century – and this suggests that the yellow and white enamels could well have been adapted from existing Chinese *cloisonné* experience. If a metal enamel source is accepted for the Kangxi blue (as now seems likely) a precedent for using metal enamels on Jingdezhen porcelain already existed.

Late Kangxi (AD1662–1722) imperial ruby-ground *famille rose* bowl, possibly enamelled in workshops in the Forbidden City using experimental enamel colours. D. 4.8 in., 12.3 cm. Sotheby's.

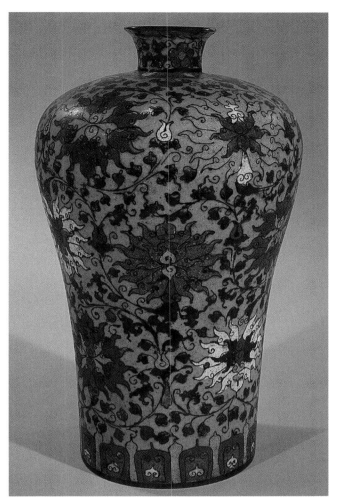

Chinese *cloisonné* bottle, second quarter of the 17th century. Metal-enamel coloured glasses, rendered white with lead arsenate and yellow with lead stannate, were in use in China at this time. They may have crossed into porcelain-enamel production at the enamelling workshops, established within the Forbidden City by the Kangxi emperor. Ashmolean Museum, Oxford.

Enamelling workshops for both porcelain decorating and *cloisonné*-making were established in the Forbidden City by the Kangxi emperor in the early 18th century, and these could well have provided the necessary contact point between metal enamelling and porcelain enamelling traditions. Experience with these new colours may well have spread from Beijing to Jingdezhen itself, where the new overglaze enamel palette was gradually adopted in the 1720s. Until this time ceramic and *cloisonné* enamels in China had followed quite separate paths – apart from the very interesting overlap seen in some rare types of northern *fahua* ware, and described on page 220. The early 18th century name for these new porcelain colours in the Forbidden City palace records is *falancai* meaning '*cloisonné* colours'. This may be a further clue to their origins, or it may simply be an analogous description.

One of the most interesting uses for this new palette occurred just at the end of the Kangxi emperor's reign, in the early 1720s, when a number of small Jingdezhen bowls were decorated in Beijing with elaborately stylised plant and fruit designs with red, blue, green, pink or yellow enamel grounds. These luxury imperial wares now enjoy a status among porcelain collectors approaching that of the *doucai* wares of the 15th century. Like *doucai* wares these late Kangxi porcelains were much imitated in later centuries and, again like *doucai* wares, rigorous modern scholarship has whittled genuine examples down to a limited number of undisputed examples in the world's museums and collections.

However, to return to the source of the *famille rose* palette – opinion now seems now to be verging towards a Chinese *cloisonné* origin for the arsenic-white and the lead-tin-yellow of the *famille rose* palette, and a European source for the gold-pink. Even so, it must be stressed that these ideas are still based on only a handful of analyses. We need to know more, for instance, not only about early 18th-century European metal, majolica and porcelain enamels (which may well have included lead-tin yellows and arsenic-whites in their number), but also about the various coloured glasses used in the Middle East and India. It is recorded that Persian craftsmen were making gold-red glass as early as the 10th century AD, which makes a Middle Eastern source for gold-red glass technology far from impossible, especially as the Chinese technique for making pink overglaze enamels often used gold alone (as in the Persian method) rather than the gold-tin mixtures used in Europe.

### Later Jingdezhen porcelain enamels

As Chinese porcelain enamel technology moves into the 20th century another factor complicates the picture, and that is the use in China of ready-made imported overglaze enamels from Stoke-on-Trent in England and also from various industrial sources in Germany. These late Jingdezhen enamels often contain boric oxide in their compositions, as borax was a popular flux in late 19th/early 20th-century Western enamel recipes. Nowadays the use of Western enamels is far less common at Jingdezhen, where most modern enamels are prepared from Chinese raw materials.

### Jingdezhen low-fired monochrome glazes

Closely related to overglaze enamels in China are the low-fired coloured glazes, applied overall to porcelains in order to develop pure and bright monochrome (single-colour) effects. This approach to glazing has produced some of the most splendid of all Chinese porcelains, which are very much in the mainstream of Chinese taste.

Strictly speaking, the very earliest examples of low-fired Chinese monochrome porcelains would have been the black, rust, green and turquoise versions of north China's

Ding wares, the latter two of which were made by adding copper oxide to low-fired lead glazes and to low-fired alkaline glazes, respectively. Nonetheless, it was at Jingdezhen in the early Ming Dynasty that strongly coloured monochrome-glazed porcelains became significant productions in China, particularly when these glazes were applied to wares intended for imperial ritual use.

High temperature 'sacrificial red' and 'sacrificial blue' glazes were both made in China, but the third primary colour, yellow, was managed through the use of dissolved iron oxide ($Fe^{3+}$) in a lower firing high-lead glaze. One example, from the Hongzhi period (AD1488–1505) has been analysed in Shanghai, and shown to be a near relation to the ordinary Jingdezhen overglaze yellow enamel.

This warm, translucent yellow glaze is often called imperial yellow in the West, but in China is better known as 'chicken-fat yellow' or as the 'tender yellow' glaze. These fine monochrome glazes were applied to plain glazed porcelains, and also to high-fired porcelain bisque. On the bisque material the yellow provided a darker, but generally richer, glaze quality.

### Firing temperatures for Jingdezhen monochrome glazes

Unlike ordinary enamelled porcelains, which were fired to about 750°–800°C in small updraught kilns, most Jingdezhen low-temperature monochrome-glazed wares seem to have been set in the cooler parts of the big cross-draught

Green monochrome glazed porcelain *guan* shaped jar, apple-green overglaze enamel, Transitional period. H. 12 in., 28 cm, Carter Fine Art.

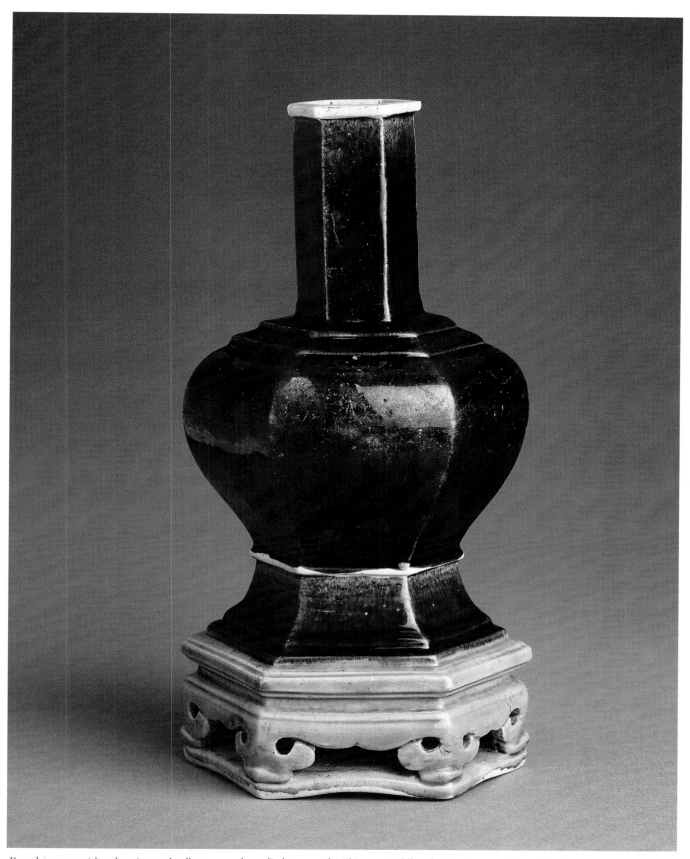

Porcelain vase with aubergine and yellow enamels applied to porcelain bisque, Middle of Ming dynasty. Carter Fine Art.

Table 106 Jingdezhen monochrome yellow

| | PbO | SiO$_2$ | Al$_2$O$_3$ | Fe$_2$O$_3$ | CaO | MgO | K$_2$O | Na$_2$O | CuO | MnO |
|---|---|---|---|---|---|---|---|---|---|---|
| Hongzhi monochrome yellow | 45.0 | 42.9 | 4.5 | 3.6 | 1.2 | 0.1 | 1.3 | 0.7 | 0.05 | 0.03 |

Jingdezhen porcelain kilns – probably reaching temperatures between about 950° and 1100°C. For this reason their compositions were often slightly harder (i.e. richer in silica and alumina) than the regular enamel colours.

## Compositions of Jingdezhen low-fired monochrome glazes

Consul F. Sherzer collected some useful recipes for Jingdezhen monochrome glazes in the 1880s, but what are missing at the moment from the analytical record are full oxide analyses of 18th-century Jingdezhen monochromes, particularly from the most experimental phase of monochrome glaze production, the reign of the Yongzheng emperor (1723–35).

Nonetheless, despite this lack of hard numbers, we do have a valuable non-quantitative survey of late Jingdezhen monochrome glazes, made by the physicist Professor E.T. Hall, when he was Director of the Research Laboratory for Archaeology and the History of Art at Oxford University. For this study of monochrome glazes Professor Hall used the method of airpath x-ray spectroscopy – a non-destructive and qualitative analytical technique that Hall had developed and used at Oxford from the 1950s onwards.

## The Oxford results

E.T Hall presented his results in Shanghai in 1982, and the low-fired aspects of this study are given below:

Table 107 Airpath XRF analyses of low-fired Jingdezhen monochrome glazes

| Glaze colour | Main colourant | Lead | Other colourants present |
|---|---|---|---|
| Blue turquoise | Cu | – | |
| Deep purple | Mn | – | Co, Cu |
| Apple green | Cu | ++ | |
| Opaque turquoise | Cu | ++ | As |
| Robin's egg | Cu | ++ | As |
| Dark blue | Co | ++ | |
| Aubergine | Mn | ++ | Co |
| Rose | Au | | ++ |
| Lemon yellow | Sb | ++ | |
| Lime green | Sb,Cu | ++ | |

(Note: Au = gold, As = arsenic, Sb = antimony)

To take the leadless glazes first, the turquoise-blue is probably similar to the Jingdezhen leadless alkaline glazes, described on p. 223, while the deep purple glaze shows the characteristic mix of manganese, copper and cobalt, pioneered with alkaline glazes in north China in the 14th century (see Chapter Eleven). Of the lead-rich glazes, the apple-green derives from the familiar use of Cu$^{2+}$ ions in a high-lead base, and is a late example of one of the oldest and most popular low-fired glaze effects in China.

The opaque turquoise and the 'robin's egg blue' glaze, though, are quite novel in Chinese monochrome glaze history, and rely on lead arsenate opacification – one of the essential principles of the *famille rose* palette. Also recognisable from the Jingdezhen *famille rose* experience is the translucent rose colour from colloidal gold, although in this case the rose enamel is applied overall as a single colour.

Perhaps the greatest surprises from these results are the last two glazes – a lemon yellow from antimony (or, more accurately, from lead antimonate, Pb$_3$(SbO$_4$)$_2$), and a lime green from a lead-antimonate/Cu$^{2+}$ mixture. These are some of the very few cases where antimony has been positively identified in Chinese glazes, and the antimony-yellow occurs in a situation where one might have expected the lead-tin yellow from the *famille rose* palette. Basic antimonate of lead is an ancient Middle Eastern and, later, European, source of a bright yellow pigment in glass, glaze and oil paint but, despite having some of the largest antimony deposits in the world, China has made very little use of the element in its history – least of all in its ceramic technology. Its appearance in the late Qing dynasty at Jingdezhen seems to mark one of the very last modifications to the traditional Chinese low-fired glaze palette and, in this case, it seems safe to assume some Japanese or even Western influence on its introduction.

Porcelain dish with monochrome overglaze yellow enamel, Xuande period (AD1426–1435). Monochrome glazed porcelains, used in Imperial rites in China, were mainly the three primaries (red, yellow and blue) and white. Copper-red, cobalt-blue and *tianbai* white porcelain glazes were all possible at high temperatures, but yellow was a more difficult effect and needed the use of a higher-firing iron-yellow overglaze enamel in order to achieve a good colour. These tended to be slightly higher-firing (*c.* 1000°C) than the usual iron-yellow overglaze enamels. D. 7.8 in., 20 cm. Sotheby's.

# FURTHER READING

## BOOKS AND EXHIBITION CATALOGUES

Urban Council of Hong Kong and Jingdezhen Museum of Ceramic History, *Imperial Porcelains of the Yongle and Xuande Periods Excavated from the Site of the Ming Imperial Factory at Jingdezhen*, Hong Kong, 1989

## PAPERS AND ARTICLES

Francois Xavier d'Entrecolles (1712 and 1722), Letters from Jingdezhen to Père d'Orry. (Translated and republished in Robert Tichane's *Ching-te-Chen – Views of a Porcelain City*, pp 49–128, New York State Institute for Glaze Research, 1983)

Edward Hall and Mark Pollard, 'Analysis of Chinese monochrome glazes by X-Ray fluoresence spectroscopy', *Scientific and Technological Insights on Ancient Chinese Potttery and Porcelain*, pp 382-6, Beijing, 1986

Julian Henderson, Mary Tregear and Nigel Wood, 'Ceramics and glass – two case studies in related uses', *Ceramics and Civilization*, Vol. 4, pp 315–46, Pittsburgh, 1990

David Kingery and Pamela Vandiver, 'The eighteenth century change in technology and style from the *famille verte* to the *famille rose* style', *Ceramics and Civilization*, Vol. 2 – 'Technology and Style', pp 363-81, Columbus, 1985

Georges Vogt, 'Recherches sur les porcelaines Chinoises', *Bulletin de la Societé d'Encouragement pour l'Industrie National,* April 1900, pp 530–612. (Translated and republished in *Ching-te-Chen – Views of a Porcelain City* by Robert Tichane, pp 186-313, New York State, 1983)

# Chapter 13
# RECONSTRUCTION
# OF CHINESE GLAZES

As the rest of this book shows, behind every aesthetic aspect of Chinese glazes lies a technical fact – and this is the incentive for tackling the strings of figures that are the chemical expressions of these fascinating glazes. These analyses can take us directly to those narrow, but extremely fertile areas of glaze chemistry that have provided Chinese and Korean potters with their finest glazes for many hundreds of years. These analyses also allow us to recreate these glazes, while at the same time providing many useful insights into the fundamental principles of glaze construction.

The technical soundness that these analyses also represent has long been appreciated by Western potters and in the late 19th century many European porcelain factories began to redesign their glazes and bodies to bring them closer in composition to the best Far Eastern wares. If there has been any flaw with Western work along these lines it has been the tendency to copy the Far Eastern clays and glazes with only the purest Western raw materials. The result, in some cases, has been that only the technical virtues have survived, while the true characters of the originals have been rationalised out of existence.

Because of the risk of losing all the natural variety provided by the 'impurities' always present in Chinese glazes, some way has to be found for retaining these lesser oxides when recreating the glazes with Western raw materials. Not only do we need to understand the parts played by all the minor elements that are present in the Chinese glazes, but also how to introduce these oxides into our recreated glazes in the same amounts as they occur in the original compositions. This demands a method of glaze calculation that is subtle as well as accurate. Unfortunately, these are not the strongest points of the usual method of glaze calculation – the Seger (or 'molecular') technique that was invented by the German ceramic chemist Hermann August Seger (1839–93) in the late 19th century.

There is however another method for expressing, comparing and calculating glazes that uses no molecular weights, but which works directly with the real weights of the oxides shown in the analyses, and with the oxides that are present in the raw materials used to create them. This is known as the Percentage Method and it tends to be simpler, more accurate and more flexible than the Seger system. It is also easier to understand how glazes 'work' if they are expressed in the percentage style, rather than by Seger formulae.

As this book shows, the use of 'oxides by percent weight' is the standard method for reporting glazes in archaeological and technical papers, so a calculation technique that can work with 'real weight' analyses can save a good deal of time. However, rather than accepting these reservations about the Seger method on trust, it is still useful to know why the technique is less suitable for this kind of work, as the Seger system is still the most popular method for calculating glazes – and is used worldwide for this purpose by craft potters and by the ceramic industry. Some of the reasons for the limited usefulness of the technique with Chinese glazes can be found by studying the logic behind the Seger system.

## The Percentage Method versus the Seger (molecular) technique

The Seger method of glaze calculation probably owes its creation to the important discoveries concerning chemical compounds that were made during the late 19th century. These showed that chemical compounds represent combinations of atoms in whole numbers and in fixed proportions. No obvious logic appeared when these proportions were expressed as *real* weights (masses), but when the *atomic* weights of atoms were used to explain the constitution of molecules and compounds, chemistry unfolded as a model

Large stoneware teapot by the author. The body of the pot was indented in three places while still on the wheel. The glaze is a slightly underfired feldspathic temmoku with two bands of diluted iron oxide brushed on the glaze. Reduction fired to 1260°C. Largest diameter: 11.8 in., 30 cm.

Stoneware oval dish by the author. The dish was first glazed overall with a dark stoneware glaze (see recipe for dish below right), which was then swiftly decorated with a rubber comb. A Jun glaze (Glaze 9) was then poured in and out before the first glaze had dried. Reduction fired to 1270°C. L. 12.8 in., 32.5 cm.

of logic, harmony and order. This fact must have made the idea of representing *glazes* as molecular formulae very attractive as it allowed glazes to be brought within this newly-developed and all-embracing chemical system.

Encouragement for the development of the Seger system must also have come from the fact that most raw materials used in 19th century Western whiteware factories were so pure that they could be represented as *minerals* (which are definite chemical compounds) rather than as *rocks*, which are complex mixtures of minerals. Thus the feldspars, whitings, marbles, china clays, flints and quartz, used in huge quantities by these factories, were generally so free from contamination by other minerals that they could be represented by their ideal chemical formulae. Feldspars could be treated as pure albite ($Na_2O.Al_2O_3.6SiO_2$) or orthoclase ($K_2O.Al_2O_3.6SiO_2$); whiting, limestone and marbles as calcium carbonate ($CaCO_3$); and quartz and flint as pure silica ($SiO_2$).

However, one flaw with this 'molecularisation' of ceramic science was that glazes are actually non-crystalline materials (glasses) and are not found in the neat molecular proportions that characterise natural minerals. Nonetheless, glaze compositions can be manipulated mathematically to make a 'formula', and this formula can be arranged to take the same style as, for example, orthoclase feldspar. A glaze that contains the following oxides in real percentage weights: 67 $SiO_2$, 13 $Al_2O_3$, 12.5 CaO, 6.0 $K_2O$ and 1.3 MgO, can therefore become, for the purpose of calculation by the Seger method, the following 'Seger Formula':

$K_2O$ 0.2
CaO 0.7 $Al_2O_3$ 0.4 $SiO_2$ 3.5
MgO 0.1

(A cone 7-9 porcelain glaze)

The Seger Formula for the stoneware glaze can be seen here as somewhat many-headed, with three oxides sharing the place occupied by the '1.0 $K_2O$' in the feldspar's

formula. The idea for setting all the fluxes together, and then making them add up to one, is to make it easier to compare the ratios of alumina ($Al_2O_3$) to silica ($SiO_2$) in different glazes – when expressed in the Seger style.

Having brought a percentage list of oxides-by-weight to this state (a fairly complicated procedure) it is relatively easy to work out the 'parts' of complete molecules (representing pure raw materials) that will 'fit' this formula. Thus 0.2 parts of potash feldspar will provide the 0.2 $K_2O$, 0.2 parts of $Al_2O_3$, and 1.2 parts of $SiO_2$ (that is, a whole molecule of potash feldspar divided by 5). These numbers are then subtracted from the original glaze formula, and the remaining glaze is gradually accounted for with different raw-materials-as-minerals, by following the same approach.

When this process is complete, the potter is faced by a list of decimal parts of complete molecules of different minerals (or of different raw materials). This list – although accurately reflecting the Seger formula for the glaze – cannot be used as it stands but must be converted from *molecular* proportions to *real* proportions by weight in order to create a usable recipe. This is managed by multiplying each decimal part of the 'ingredient-as-molecular' by the

Oval dish by the author. A slip containing 7% iron oxide has been trailed inside this dish and also dipped onto its rim. The dish has then been slip-glazed with a very dark green glaze (feldspar 55, fusible red clay 35, whiting 15 and red iron oxide 5). Once-fired to 1260°C in reduction, porcellaneous stoneware clay. L. 9.5 in., 24 cm.

*formula weight* peculiar to that mineral or raw material. The formula weight is the sum total of all the atomic weights of all the atoms in each 'raw material as molecule'.

All this sounds complicated but it is roughly the equivalent of having all the goods in the shops marked in francs. To achieve an idea of what we have spent we then have to convert from francs to pounds – just as we have to convert from molecular to real weights to achieve a usable recipe.

Expressed in this way the Seger method raises the obvious question: Why not have the prices in pounds in the first case? Or, more exactly: Why turn these glazes into molecular formulae rather than calculate directly with the oxides-by-weight in the glazes, and the oxides-by-weight in the raw materials? It is, in fact, quite practical to use this latter method, and this is the calculation technique adopted for this book. The percentage method is particularly useful for dealing with Chinese glazes as the materials used to make these glazes were not pure minerals, and the best results come from using naturally complex raw materials to recreate them. If the Seger technique is used with Chinese glazes, and with naturally complex raw materials, it becomes a complicated and unwieldy process – and a process that demands about twice as much calculation as the percentage method.

Another serious drawback to the Seger method is that the translation from a list of oxides-by-weight to the Seger formula can obscure the highly revealing patterns of the percentage expression. This changes such easily understandable (and important) figures as 1.0% $Fe_2O_3$, or 0.5% $P_2O_5$ to, for instance, 0.04 $Fe_2O_3$ (mol.) and 0.01 $P_2O_5$ (mol.). Also, because it expresses the silica and alumina contents of the glazes in terms of a ratio, the 'Seger formula' obscures a particularly useful fact provided by a percentage analysis – that is the exact percentage by weight of silica in a fired glaze. For example, the 'formulae' for the potash feldspar and the stoneware glaze just given above suggest that the feldspar, with 6.0 $SiO_2$, contains substantially more silica than the stoneware glaze with 3.5 $SiO_2$. In fact, in real weights, the potash feldspar contains less silica (at only 64.8%) than the stoneware glaze at 67%.

## Tsuneshi Ishii's experiments

Another illustration of the tendency of the Seger system to give false impressions of silica contents is seen when the following ideal glazes, developed by the Japanese chemist Tsuneshi Ishii in the 1920s, are presented in both the Seger and the percentages styles (Table 108).

In his search for 'ideal' celadon glazes, of the Kinuta type, Tsuneshi Ishii tested hundreds of compositions, using systematic substitutions within the Seger system. However, when his six best glazes are presented in the Seger style surprisingly little logic emerges – while in the percentage style these same glazes show a strong 'family likeness' in their silica and alumina figures. As most Chinese glazes represent similar substitutions of the alkaline earths (CaO+MgO) by the alkalis ($K_2O+Na_2O$) in their essential compositions, it follows that it should be easier to understand the structures of Chinese glazes through their percentage expressions rather than through their Seger formulae.

## *Calculations by the Percentage Method*

Most of the analyses of Chinese glazes in this book can be recreated with the usual pottery raw materials. The calculations work directly with the analyses of the original glazes, and with the analyses of the various raw materials obtainable from the materials suppliers. We use the fired analyses of the original glazes, and the unfired or raw analyses of the raw materials. There are only a few principles involved in this process, and the use of a pocket calculator speeds the work considerably. Most glaze calculations by the percentage method make use of two simple calculation procedures. Once these are learned, many fine glazes become accessible, and the only limitations are how we decide to use them.

### *Problem one*
*If a glaze contains 12% CaO, and whiting contains 56% CaO in its analysis, how much whiting will provide 12% CaO?*

The answer is found by dividing the amount of CaO in the whiting (56) into the amount of CaO in the analysis (12), and then multiplying the answer by 100:

$$(12 \div 56) \times 100 = 21.43$$

Table 108 Tsuneshi Ishii's ideal celadon glazes

| Code | Silica (mol) | % | Alumina (mol) | % | Potassia(mol) | % | Calcia(mol) | % |
|---|---|---|---|---|---|---|---|---|
| E /34 | (5.7) | 71.0 | (0.6) | 12.7 | (0.6) | 11.7 | (0.4) | 4.6 |
| F 3/4 | (5.5) | 72.3 | (0.5) | 11.2 | (0.5) | 10.3 | (0.5) | 6.1 |
| F 7/8 | (5.0) | 70.4 | (0.5) | 12.0 | (0.5) | 11.0 | (0.5) | 6.6 |
| G 7 | (4.5) | 69.8 | (0.45) | 11.8 | (0.4) | 9.7 | (0.6) | 8.7 |
| H 13/14 | (4.7) | 71.3 | (0.45) | 11.6 | (0.3) | 7.1 | (0.7) | 9.9 |
| H 18/19 | (4.6) | 70.0 | (0.5) | 12.9 | (0.3) | 7.1 | (0.7) | 9.9 |

This means that 21.43 parts of whiting in real weights will give 12 parts of CaO – again in real weights.

This is the main calculation method using the percentage system, and it is repeated with every oxide in the glaze analysis until no more amounts of oxides are left to be found, and the recipe is complete.

Problem 2 explains how to deal with the other oxides brought into a glaze when a raw material that contains more than one oxide in its analysis is used. These associated oxides all play their parts in satisfying the glaze analysis, and we need to know the exact amounts in which they have been introduced, so that we can then subtract them from the original glaze analysis, together with the main oxide supplied by the method shown above. This method involves 'percentages of percentages' and is simpler than it sounds.

### Percentages of percentages

This type of calculation is best approached by understanding the close links between decimals and percentages; for instance, 0.5 of a number is the same as 50% of it, 0.25 the same as 25% of it; or 0.176 of a number is the same as 17.6% of it. Therefore, if we need to know, say, 21.43% of 56 we multiply 56 by 0.2143, which gives the answer 12.0.

Armed with both methods of calculation we can now solve the following problem:

#### Problem two

*If a glaze needs 12% CaO, and wollastonite contains 47% CaO and 51% SiO$_2$, how much wollastonite will supply 12% CaO, and how much SiO$_2$ will the wollastonite bring into the glaze with it?*

The answers are found by dividing the amount of CaO in wollastonite (47%) into the CaO needed in the glaze (12%), and then multiplying the answer by 100:

$(12.0 \div 47)$ x 100 = 25.53
(parts of wollastonite needed in glaze)

To find how much silica is brought into the glaze by the 25.53 parts of wollastonite, multiply the amount of the silica in wollastonite (51%) by 0.2553 (we know this to be the same as 25.53% of 51% SiO$_2$):

$51.0$ x $0.2553$ = 13% SiO$_2$

These two calculations tell us that 25.53 parts of wollastonite will supply 12.0% of CaO and 13% of SiO$_2$ to a glaze.

(All this may seem complicated but a certain amount of practice with a calculator will show that it takes far longer to explain these calculations than to actually work them out.)

Casserole dish by the author, porcellaneous stoneware clay. The glaze was made from two parts of dry body-clay to one part of whiting (calcium carbonate) – essentially the south Chinese approach to glaze making. Once-fired to 1250°C in reduction. D. 11 in., 28 cm.

These two techniques are really all that are needed for most glaze calculations by the percentage method: the rest of the work is simple subtraction. The most valuable aspect of the technique is that the amounts of raw materials found are the amounts that can be used in actual glaze recipes. No molecular weights or molecular formulae are used at all – we are dealing simply with the real weights of the oxides in the glazes, and with the real weights of the oxides in the raw materials.

### Order of oxides found in glaze calculation

By now the reader may be wondering how we make sure that we do not go 'over the top' with the associated oxides when using a complex material. This is simply a matter of practice and increasing familiarity with the analyses of the raw materials and the analyses of the glazes. The main safeguard against overdoing a particular oxide is the order that has been evolved for finding the oxides in a glaze. This order tends to bring the more complicated materials in first, and usually ends with a simple 'topping up' of pure oxide materials such as flint (SiO$_2$) and red iron oxide (Fe$_2$O$_3$).

The order that gives the greatest protection against overdoing any particular oxide is:

the alkalis - alumina - magnesia - phosphorous - lime - silica - iron

| K$_2$O + Na$_2$O | Al$_2$O$_3$ | MgO | P$_2$O$_5$ | CaO | SiO$_2$ | Fe$_2$O$_3$ |
|---|---|---|---|---|---|---|

When calculating an actual glaze we would start by finding the potash + soda combined – probably by using a feldspar or Cornish stone – and then find the remaining alumina with some type of clay. If there were magnesia in the glaze we might use dolomite or talc; the calcia might come from

whiting or wollastonite; and any few per cent of silica still needed could be supplied by flint or quartz. Finally, any remaining iron needed in the glaze could be supplied by pure iron oxide.

## Calculation of a glaze from a percentage analysis
Everything explained so far can be seen as an actual example of glaze calculation by the percentage method. For example we might begin with the 1170°C silica-alumina-lime eutectic, using Treviscoe China clay, whiting and flint to satisfy the following analysis:

|  | $SiO_2$ | $Al_2O_3$ | CaO |
|---|---|---|---|
| 1170°C silica-alumina-lime eutectic | 67.0 | 14.75 | 23.25 |

The analyses of the three raw materials are as follows:

|  | $SiO_2$ | $Al_2O_3$ | CaO | $K_2O+Na_2O$ | loss |
|---|---|---|---|---|---|
| Treviscoe kaolin | 48.3 | 36.9 |  | 2.6 | 11.1 |
| Whiting |  |  | 56.0 |  | 44.0 |
| Flint | 100 |  |  |  |  |

As there are no alkalis in the glaze we begin with the alumina – dividing the amount of alumina in the clay into the amount needed in the glaze, then multiplying by 100: (14.75 ÷ 36.9) x 100 = 40.0. Therefore, 40 parts of kaolin are needed in the glaze. We now make the mental

Flat rectangular stoneware dish with paper-resist decoration. The basic form was extruded and then a wooden board, slightly smaller than the slab, was pressed into the shape to leave the rim. The slab was then pressed over a shallow plaster hump-mould to make it slightly hollow and four feet were added. After biscuit firing the dish was glazed overall with Glaze 1. While the glaze was still damp, dampened cut-paper shapes were laid on to it, and then it was quickly re-dipped in Glaze 8. When nearly dry, the paper shapes were removed and a few details added with an iron-cobalt pigment (97 yellow ochre, 3 cobalt carbonate). The dish was fired in reduction to 1270°C. L. 13.75 in., 35 cm.

adjustment that tells that if we multiply all the other oxides in the kaolin analysis (see above) by 0.4 we will discover how much silica and alkalis have been brought into the glaze with the 14.75% $Al_2O_3$.

Silica in raw kaolin: 48.3 multiplied by 0.4 = 19.3% $SiO_2$
Alkalis in raw kaolin: 2.6 multiplied by 0.4 = 1.04% $(K_2O + Na_2O)$

We now know that 40 parts of kaolin have given us 19.3% $SiO_2$, 14.74% $Al_2O_3$ and 1.04% $K_2O + Na_2O$. All these oxides can be subtracted from the original glaze to discover what is left to be found:

|  | $SiO_2$ | $Al_2O_3$ | CaO | $(K_2O+Na_2O)$ |
|---|---|---|---|---|
| Glaze | 62.0 | 14.75 | 23.25 |  |
| Kaolin 40 parts: | 19.3 | 14.75 |  | 1.04 |
| Still to be found: | 42.7 | X | 23.25 |  |

The next oxide on the list is calcia. We divide the amount of calcium oxide (CaO) in whiting (56.0) into the amount needed in the glaze (23.5) and then multiply the answer by 100: (23.5 ÷ 56) x 100 = 42 (parts of whiting). This takes care of the CaO. All that remains is the 42.7% $SiO_2$ and this is easily provided by pure flint or quartz (42.7 parts). The recipe is therefore: kaolin 40, whiting 42, flint 42.7.

This recipe has given us the 1170°C silica-alumina-lime eutectic mixture, although there are two points that need some explanation. First, we have 1% too much $K_2O+Na_2O$. This is unavoidable as all clays contain some alkalis, and this 1% KNaO should make little difference to the glaze. Second, the recipe, although calculated from a percentage analysis, does not add up to 100. This does not matter if the relative proportions of the ingredients are correct (which they are). It is the result of using raw materials that have 'losses on ignition' – in this case 11.11% water from the clay and 44% $CO_2$ from the whiting.

The important point is that the recipe provides 100% of oxides in the right proportions, and of the right types, to make the glaze. To bring the recipe to a percentage state all the ingredients should be added (40 + 42 + 42.7 = 124.7) and then each individual quantity should be divided by this total, and then multiplied by 100. This gives the true percentage recipe as follows:

Kaolin 32.1    Flint 34.2    Whiting 33.7

Such a glaze would be rather too high in clay to use on biscuit ware, but should work well on dry clay as a raw glaze. The firing temperature would have to be about 1210°–1250°C.

Although it has taken a fair amount of space to explain how to create this glaze there are few actual calculations

| | SiO$_2$ | Al$_2$O$_3$ | TiO$_2$ | Fe$_2$O$_3$ | CaO | MgO | K$_2$O | Na$_2$O | (KNaO) |
|---|---|---|---|---|---|---|---|---|---|
| Song celadon | 66.3 | 14.28 | 0.03 | 1.0 | 11.3 | 1.2 | 4.3 | 1.0 | (5.3) |
| **Raw Materials** | | | | | | | | | |
| Cornish stone | 72.0 | 15.6 | | | 2.2 | 0.2 | 4.4 | 4.0 | (8.4) |
| Wollastonite | 51.0 | | | | 47.0 | | | | |
| Treviscoe kaolin | 48.3 | 36.9 | 0.04 | 0.75 | | | 2.5 | 0.1 | (2.6) |
| Dolomite | | | | | 31.2 | 19.8 | | | |
| Pure (synthetic) iron oxide | | | | 100 | | | | | |
| Flint | 100 | | | | | | | | |

involved, and these are all very simple. One more example of this type of calculation by the percentage method should be enough to deal with most of the problems likely to be encountered when using the technique.

## Calculation of a typical Chinese glaze using the percentage method

The next calculation involves the recreation of a Chinese Southern Song celadon glaze using Cornish stone, wollastonite, Treviscoe kaolin, dolomite, flint, and pure iron oxide, to provide the oxides found by analysis to be present in the Chinese glaze. The procedures are the same as those used for the eutectic glaze, but as the Chinese glaze contains a greater variety of oxides, the process takes longer.

The Chinese glaze is a Zhejiang celadon of the Dayao type and shows the typical 2.1 balance of lime to alkalis, typical celadon silica and alumina figures, and an especially low titanium figure that should allow a good bluish tone from the 1% of iron oxide in the glaze analysis. Because of the very low TiO$_2$ figure, china clay rather than ball clay should be used in the 'recreation'. The use of wollastonite rather than whiting encourages a jade-like character from the glaze, and allows the glaze to be reduced fairly heavily in an oil-fired kiln without suffering from the effects of 'smoke-staining'.

The calculation uses the order of oxides previously described (that is: alkalis, alumina, magnesia, lime, silica and iron). The amount of each raw material needed is found by dividing the quantity of oxide found in that material *into* the quantity of the particular oxide needed in the glaze and then multiplying the answer by 100. The associated oxides are found by the 'percentages of percentages' method already described. After each material has been introduced, the oxides that it brings to the glaze are subtracted from those still to be found and the process is continued until no more oxides are needed and the glaze is complete.

Each new row (representing a new material) is underlined and subtracted from the row above it. The glaze can be double-checked when complete by adding all the underlined figures beneath the separate oxides – and these totals should match the intended glaze. The completed glaze is as on page 255, and the recipe (which is usable as it stands) is on the left.

The only discrepancies are that there is too little titanium dioxide (the amounts involved are too low to be important, even for titania), and 0.3% too much alkali, but this too is of marginal importance. However, where clays that are particularly high in alkalis are used, an even more accurate method of percentage calculation can be employed that allows for this (see page 255).

The stages that have been followed in creating this glaze are as follows:

1. Divide the K$_2$O+Na$_2$O (potash + soda) in the Cornish stone into the K$_2$O + Na$_2$O in the celadon, then multiply by 100 to give 63.2 (parts of Cornish stone). Multiply all the oxides in 100% Cornish stone by 0.632. **Subtract from the line above**.

2. Divide all the Al$_2$O$_3$ in the kaolin into Al$_2$O$_3$ still to be found, then multiply by 100 to give 11.9 (parts of kaolin). Multiply all the oxides in 100% kaolin by 0.119. **Subtract from line above**.

3. Divide all the MgO in the dolomite into the amount of MgO still to be found, then multiply by 100. Multiply the oxides in dolomite by 0.053. **Subtract from line above**.

4. Divide the CaO in wollastonite into the CaO still to be found, then multiply by 100. Multiply all the oxides in wollastonite by 0.176. **Subtract from line above**.

5. Supply the remaining SiO$_2$ with pure flint (6.05 parts). **Subtract from line above**.

6. Supply the remaining Fe$_2$O$_3$ with pure iron oxide (1.0 part). **Subtract from line above**. This is the last oxide needed and the glaze is now complete.

7. Add all underlined oxides together to check the glaze. It should match the top line almost exactly.

## Simultaneous calculation

The kind of calculation just described will be suitable for nine out of ten glazes, but should two materials be needed in a glaze that both contain appreciable amounts of alkalis

| | SiO$_2$ | Al$_2$O$_3$ | TiO$_2$ | Fe$_2$O$_3$ | CaO | MgO | (KNaO) |
|---|---|---|---|---|---|---|---|
| **Blue Celadon (% by Wt)** | **66.33** | **14.28** | **0.03** | **1.0** | **11.34** | **1.17** | **5.29** |
| Cornish stone 63.2 parts | 45.53 | 9.87 | | | 1.4 | 0.11 | 5.29 |
| *To be found:* | *20.8* | *4.41* | *0.03* | *1.0* | *9.94* | *1.06* | *X* |
| Kaolin 11.9 parts | 5.77 | 4.41 | 0.005 | | | | 0.3 |
| *To be found:* | *15.03* | | *0.025* | *1.0* | *9.94* | *1.06* | *X* |
| Dolomite 33 parts | | | | | 1.66 | 1.06 | |
| *To be found:* | *15.03* | | *0.025* | *1.0* | *8.28* | *X* | |
| Wollastonite 17.6 parts | 8.98 | | | | 8.28 | | |
| *To be found:* | *6.05* | | | *1.0* | | | |
| Flint 6.05 parts | 6.05 | | | | | | |
| *To be found* | *X* | | *0.025* | | | | |
| Red iron oxide 1.0 part | | | | 1.0 | | | |
| *To be found:* | | | | *X* | | | |
| Total of under-lined oxides | 66.33 | 14.28 | 0.005 | 1.0 | 11.34 | 1.17 | 5.59 |
| **Intended glaze:** | **66.33** | **14.28** | **0.03** | **1.0** | **11.34** | **1.17** | **5.29** |

and alumina, some method must be used to find the one combination of the two materials that fits the demands of the intended glaze. Say, for example, that we wish to use red earthenware clay with Cornish stone to make a temmoku glaze based on Albany slip, and that we find that we have the analyses below for the Albany slip, the Cornish stone and the common red clay.

To find the one combination of Cornish stone and Fremington clay that will give 16.67 Al$_2$O$_3$ and 4.38 K$_2$O+Na$_2$O we set out the problems as a pair of simultaneous equations, with the amount of stone needed being 'a' and the amount of clay needed being 'b':

Equation (1)
a x (alumina in stone) + b x (alumina in clay) = alumina in glaze

Equation (2)
a x (alkalis in stone) + b x (alkalis in clay) = alkalis in glaze

In real numbers the two equations are as follows:

Equation (1)   15.62a + 18.17b = 16.67
Equation (2)   8.3a + 3.68b = 4.38

To solve the equations we divide all the numbers in equation (1) by 15.62, and all the numbers in equation (2) by 8.3:

Equation (1) now becomes: a + 1.16b = 1.06
Equation (2) now becomes: a + 0.44b = 0.52

We can now eliminate 'a' by subtracting (2) from (1) to give: 0.72b = 0.54.

It is now easy to find 'b' for it must be 0.54 divided by 0.72 – which is 0.75. We already know that when an oxide is multiplied by 0.75 it means that the actual amount of the raw material needed in the recipe is 75%, so with 'b' representing the clay we know that the recipe needs 75 parts of dry Fremington Clay.

Now that we have found the value for 'b' we can substitute this figure in one of the equations to find 'a'. For example, equation (1), in its second stage, now becomes: 'a' + (1.16 x 0.75) = 1.06, which in turn becomes 'a' + 0.87 = 1.06. By subtracting 0.87 from 1.06 we find that 'a' equals: 0.19. We now know that the recipe needs 19 parts of Cornish stone and have established the two most important ingredients in the imitation Albany slip recipe: 75 parts Fremington clay, 19 parts Cornish stone.

These two materials are now put into a table (see page 256) and any other oxides still needed for the glaze are calculated in the usual way:

| | SiO$_2$ | Al$_2$O$_3$ | TiO$_2$ | Fe$_2$O$_3$ | CaO | MgO | (K$_2$O+Na$_2$O) |
|---|---|---|---|---|---|---|---|
| Albany slip | 62.75 | 16.67 | 0.77 | 5.53 | 6.48 | 3.25 | 4.38 |
| Cornish stone | 72.04 | 15.62 | | | 2.01 | 0.18 | 8.37 |
| Fremington clay | 52.66 | 18.17 | 1.02 | 6.22 | 4.69 | 3.42 | 3.68 |

(Note: analyses of intended glazes ((Albany slip in this case)) should be in the fired state, and the analyses of the raw materials used to recreate them ((e.g. Cornish stone and clay)) should be in their 'raw' ((unfired)) states.)

| | SiO$_2$ | Al$_2$O$_3$ | TiO$_2$ | Fe$_2$O$_3$ | CaO | MgO | K$_2$O+Na$_2$O |
|---|---|---|---|---|---|---|---|
| **Albany slip:** | **62.75** | **16.67** | **0.77** | **5.53** | **6.48** | **3.25** | **4.38** |
| Fremington clay 75 parts | 39.5 | 13.62 | 0.76 | 4.66 | 3.5 | 2.56 | 2.76 |
| *To be found:* | *23.25* | *3.05* | *X* | *0.87* | *2.98* | *0.69* | *1.62* |
| Cornish stone 19 parts | 13.36 | 2.96 | | | 0.38 | | 1.59 |
| To be found: | 9.57 | X | | 0.87 | 2.6 | 0.69 | X |
| Dolomite 3.4 parts | | | | | 1.6 | 0.69 | |
| *To be found:* | | *9.57* | | *0.87* | *1.0* | *X* | |
| Whiting 1.8 parts | | | | | 1.0 | | |
| *To be found:* | *9.57* | | | *0.87* | | | |
| Flint 9.57 parts | 9.57 | | | | | | |
| *To be found:* | *X* | | | *0.87* | | | |
| Red iron 0.9 parts | | | | 0.87 | | | |
| (glaze complete) | | | | X | | | |
| **Underlined oxides total** | **62.75** | **16.58** | **0.76** | **5.56** | **6.48** | **3.25** | **4.35** |

We can see that the simultaneous equations have worked well, if not quite to the hundredth part of the oxides. This glaze is obviously a raw glaze like the original Albany slip. The high magnesia content of this glaze (3.25% MgO) would make it much glossier if fired above 1260°C.

Using two materials at once in a glaze requires a certain confidence that the resulting simultaneous blend will not go 'over the top' in oxides such as silica and iron oxide, but this is only a matter of practice and experience. Eventually one comes to recognise which raw materials are most suited for which glazes. For example, low-alumina clays are particularly useful for designing raw glazes that need high clay contents, as they allow this without providing too much alumina.

The last two types of calculation, employing the percentage method, are used to bring any glaze recipe (where analyses of the materials used are known), and any 'Seger formula' published for a glaze, into percentage form. Thus, if we wish to understand a glaze better, or to copy it with different materials, we must know how to express that glaze as percentage oxides by weight.

## From a glaze recipe to a percentage analysis

The technique used for this is simply the 'percentages of percentages' method already explained. For example, a famous stoneware and porcelain glazes used for many years in Stoke-on-Trent has the recipe 85 Cornish stone and 15 whiting. Why is this such a successful glaze? The first step to understanding the answer is to find the analyses of Cornish stone and whiting (Table a).

To find 85% of all the oxides in Cornish stone we multiply each by 0.85. To find how much CaO is provided by 15% of whiting we multiply 56 (the CaO content of whiting) by 0.15 (Table b).

Table a

| | SiO$_2$ | Al$_2$O$_3$ | Fe$_2$O$_3$ | CaO | MgO | K$_2$O | Na$_2$O | loss |
|---|---|---|---|---|---|---|---|---|
| Purple Cornish stone | 72.1 | 15.96 | 0.24 | 2.54 | 0.13 | 3.34 | 2.6 | 1.96 |
| Whiting | | | | 56.0 | | | | 44.0 |

Table b

| | SiO$_2$ | Al$_2$O$_3$ | Fe$_2$O$_3$ | CaO | MgO | K$_2$O | Na$_2$O | (K$_2$O+Na$_2$O) | Total |
|---|---|---|---|---|---|---|---|---|---|
| 85 Purple stone | 61.285 | 13.56 | 0.2 | 2.16 | 0.11 | 2.84 | 2.21 | (5.05) | |
| 15 Whiting | | | | 8.4 | | | | | |
| Oxide total | 61.285 | 13.56 | 0.2 | 10.56 | 0.11 | 2.84 | 2.21 | (5.05) | 90.76 |

Table c

| | SiO$_2$ | Al$_2$O$_3$ | Fe$_2$O$_3$ | CaO | MgO | | (K$_2$O+Na$_2$O) | Total |
|---|---|---|---|---|---|---|---|---|
| 85/15 glaze (%) | 67.52 | 14.94 | 0.22 | 11.6 | 0.12 | | 5.56 | 99.99 |

Because of the losses in firing associated with both Cornish stone and whiting, the total of oxides is only 90.76. To bring them to the 100% that makes it possible to compare this glaze with other glazes, we divide them all separately by 90.76, then multiply each result by 100. (Table c).

We can see at once from this that the '85/15' recipe is yet another example of the 'ideal' oriental porcelain and celadon glaze, with all that this implies in terms of quality of surface and long maturing range. Its best firing temperature is probably Cone 8 to 9.

### Seger formula to percentage analysis

The final problem in this section on calculation concerns glazes expressed in the Seger formula style that we would like to change to percentage form. The technique for changing a Seger formula for a glaze into a percentage analysis is as follows:

1. Put all the oxides into the order preferred for the percentage method that is: $SiO_2$, $Al_2O_3$, $Fe_2O_3$, $TiO_2$, CaO, MgO, $K_2O$, $Na_2O$, $P_2O_5$, MnO.

2. Multiply each oxide by its molecular weight – this brings all the oxides in the list to their real weights.

3. Although the list is now in real weights they still need to become percentage weights. This is managed by adding all the real weights together, dividing the total into that found for each oxide in '2' and then multiplying the results by 100.

A practical example of the procedure might arise as follows:

### Seger cones as glazes

We might read in a book the interesting fact that Seger cones make first-class glazes at about 100°C higher that the temperatures they are designed to indicate. This is particularly true of Seger Cone 4, the composition of which is often used in the West for making porcelain glazes for the temperature range 1230°-1300°C. Some of the literature concerning both Chinese and Western glazes makes the point that the 'cone 4 type of whiteware glazes' has a composition and appearance similar to the best Chinese glazes. Why is this? Well, the answer should be found by turning the Seger formula for cone 4 into a percentage analysis, and then comparing this analysis with the glazes already studied. The first step is to find the 'formula' for Seger cone 4:

Seger cone 4:

$$0.7 \ CaO$$
$$0.3 \ K_2O \qquad 0.4 \ Al_2O_3 \qquad 4.0 \ SiO_2$$

The three steps for changing a 'formula' into a percentage analysis are now taken:

*Step 1* (Mol. Wts)

| | | | | | |
|---|---|---|---|---|---|
| $SiO_2$ | x | 4.0 | 60.1 | = | 240.4 |
| $Al_2O_3$ | x | 0.5 | 101.9 | = | 50.95 |
| $K_2O$ | x | 0.3 | 94.2 | = | 28.2 |
| CaO | x | 0.7 | 56.1 | = | 39.27 |

*Step 2.* Real Wts. total: 358.88

*Step 3*
(all oxides are now divided by 358.88 and then multiplied by 100)

| | |
|---|---|
| $SiO_2$ | 67 |
| $Al_2O_3$ | 14.2 |
| $K_2O$ | 7.8 |
| CaO | 11.0 |

This gives the percentage analysis of Seger cone 4 as:

$SiO_2$ 67 $Al_2O_3$ 14.2 CaO 11.0 $K_2O$ 7.8

At first sight this glaze appears to be exactly the 'ideal' or 'lime-alkali' celadon/porcelain glaze mentioned so often in this section. However, a second look at the analysis shows it to be considerably higher in alkalis (at 7.8%) than most of the celadons and the porcelain glazes discussed so far. It is actually moving from the 'lime-alkali' class to the 'feldspathic' class as its theoretical recipe suggests:

feldspar 41.5 flint 27. kaolin 13.0 whiting 8.0
(Seger cone 4 glaze)

It is worth adding, as a conclusion to this section on calculation, that glazes created by the percentage method rarely need any adjustments to bring them closer to their desired qualities – so long as the analyses of the raw materials are reliable and the original glaze analyses are accurate. Any problems with glazes made by this method tend to be physical rather than chemical – for example, too much clay in a recipe may make a glaze crawl although its fired quality might otherwise be good. Some materials too might need extra grinding (for instance calcined clays, local clays and, often, dolomite) but, after a certain amount of practice, it should be possible to create glazes similar to those listed in the recipe section of the book. However, before describing these reconstructed glazes in detail, it is worth examining an alternative to calculation for the development of glazes of the Far Eastern type.

## Simple blending of raw materials

Glaze calculation is a powerful technique and it is a quick and accurate way to construct fine glazes. Nonetheless, it is not the only approach that is possible, and similar glazes can be achieved by the simple blending of likely raw materials – rather in the way that the original Chinese potters would have worked. As this book shows many magnificent Chinese glazes were made from some extremely simple combinations of local rocks, clays and ashes.

For the practical testing of raw materials for glazes, two blending processes are particularly useful – line blends and

Table 109 Typical proportions used in a line blend – 10% increments

| Material A | 100 | 90 | 80 | 70 | 60 | 50 | 40 | 30 | 20 | 10 | 0 | |
|---|---|---|---|---|---|---|---|---|---|---|---|---|
| | 0 | 10 | 20 | 30 | 40 | 50 | 60 | 70 | 80 | 90 | 100 | Material B |

triaxial blends. In the first method two materials are tested separately, and in a range of mixtures between them. A typical line blend will advance in 5% or 10% steps, as one material replaces the other in a series of mixtures (Table 109).

The second technique – the triaxial blend – is more ambitious. This time *three* materials are combined in fixed proportions and the number of separate mixtures needed might total 45 (see page 261), 55, or even more. A complete triaxial blend provides a powerful image of the interactions of ceramic raw materials, but it represents a substantial investment in time and effort.

### A practical technique for the rapid blending of glaze materials

It is quite feasible to weigh out, mix with water, and then sieve, any number of separate recipes that represent the various stages of line blends or triaxial mixtures. Although this can be a very time-consuming process, particularly for triaxial blends, it does allow any fired results to be adopted immediately as a new dry-weight recipes. However, because of the slowness of the approach potters have long made use of various blending techniques that work with liquid and already-sieved mixtures of the two or three raw materials that they are investigating. These different materials are then blended by volume in the liquid state (using teaspoons or plastic graduated syringes), stirred together, and then applied to test tiles for firing in the kiln. The advantage of this method is that the weighing out and sieving are confined to the individual raw materials – and the rest of the work is managed simply by mixing-by-volume and then by stirring

Although wet-blending can be a quick and easy way to test material mixtures, a serious drawback to the method is that different raw materials need different amounts of water to bring them to the same glaze state: 100g of dry clay, for example, may take 100g (100cc) of water to make a good glaze suspension, while 100g of feldspar may take only 50cc of water before the suspension becomes too thin. This is because the sub-microscopic and platy clay particles have a much greater surface area that needs to be covered by water than the relatively coarse and blocky feldspar crystals. If the clay and feldspar glaze slips are then blended by volume, there will be much less clay in any clay-feldspar mixtures than the volumetric recipes appear to suggest, and this in turn makes it very difficult to convert from fired results to usable dry-weight recipes.

### Liquid blending using 'customised syringes'

One solution to this problem is to use 10 ml (10cc) plastic syringes to measure the various liquid suspensions needed, but with the existing calibrations on the syringes replaced with paper labels that give the correct proportions for the particular materials used. For example, the calibrations would be further apart with clays and closer together with feldspars. Of course, for such a technique to work properly the calibrations must be designed so that they are correct for the different raw materials used, but this can be managed with surprising accuracy through the use of the following technique:

1. Mix 250g of the dry raw material with water to bring it to an ideal glaze slip state.

2. Sieve the mixture (e.g. twice through an 80s mesh sieve) and pour it into a plastic measuring cylinder. Note the volume that it occupies.

3. For every 100cc of volume measure 1 inch down the fan-shaped diagram on page 259 (for example 280cc would mean 2.8 inches down the chart).

4. Place the edge of a piece of backed sticky paper against this line and mark the ten spaces needed for a scale.

Small raw-glazed porcelain vases with fused-silver details by Chün Hseuh-Liao. Made from Valentine's white porcelain, the vessels were glazed using 60% dry porcelain body and 40% wollastonite, to give a *yingqing*-like composition. The silver was applied by pressing silver wire into the leatherhard clay. During firing the silver fused, ran, and formed a bead near the foot. 1250°C. H. 2.6 in., 6.5 cm. Royal College of Art, London.

**Lines for calibrating 'customised syringes'**

Use of chart: weigh 250 g of dry glaze material. Add enough water to make a good glaze suspension, then sieve twice through an 80 sieve. Pour all of the mixture into a graduated cylinder and record the volume. For every 100 cc of liquid glaze, measure one inch down the chart from the apex of the fan (e.g. feldspar might give a result of 225 cc, so measure 2.25 in. down from the top). Draw a line parallel with top line at this level. This is the new scale for this particular material. Copy this scale to adhesive paper and place this over the original scale on the plastic syringe.

5. Remove the paper backing and stick the new 'customised' scale over the existing marks on the syringe. This is the scale appropriate for this raw material, using the 'blending-by-volume' technique.

## Adding colouring oxides

When different raw materials are combined by wet-volume methods some compensation is necessary for their different water contents. However, when mixtures of the same glazes, but with various colouring oxides added, are made no compensations are needed. In this case, the original 1ml divisions on the syringes may be used.

A typical example of the testing of additions of colouring oxides to a colourless base glaze might be to add the maximum amount of iron oxide to be investigated to half the prepared liquid glaze (e.g. made originally from 200g of dry materials), and then to leave the other half of the mixture uncoloured. The coloured glaze is then resieved and liquid blends made of the two glaze suspensions. If the simple scale shown in Table 110 were used, 10% of added iron oxide would give roughly 1% increments.

Triaxial blends will also work well with this technique, perhaps using two colouring oxides (e.g. iron oxide and titanium dioxide) in the bottom two corners, and leaving the top of the triaxial as the uncoloured glaze. The resulting blend will not only show the interaction of the iron oxide with the titanium dioxide, but the glaze colours will also appear paler as they move towards the apex of the blend, due to the diluting effect of the colourless glaze.

45 tile triaxial blend using iron and copper oxides in a high-lead glaze. By leaving the third corner of the triaxial as the uncoloured base-glaze a diluting factor can be built into the test. (Note: the high lead glazes containing copper are very poisonous and these recipes should not be used on domestic wares.) Test by Richard Slade.

Table 110  A forty-five tile triaxial blend

**A**

Tile1
A=8
B=0
C=0

Percentage eqivalents: -
1=12.5
2=25.0
3=37.5
3=37.5
4=50.0
5=62.5
6=75.0
7=87.5
8=100

e.g. Tile 9
converts to:

9
A=62.5
B=12.5
C=25.0

| 2 | 3 |
|---|---|
| A=7 | A=7 |
| B=1 | B=0 |
| C=0 | C=1 |

| 4 | 5 | 6 |
|---|---|---|
| A=6 | A=6 | A=6 |
| B=2 | B=1 | B=0 |
| C=0 | C=1 | C=2 |

| 7 | 8 | 9 | 10 |
|---|---|---|---|
| A=5 | A=5 | A=5 | A=5 |
| B=3 | B=2 | B=1 | B=0 |
| C=0 | C=1 | C=2 | C=3 |

| 11 | 12 | 13 | 14 | 15 |
|---|---|---|---|---|
| A=4 | A=4 | A=4 | A=4 | A=0 |
| B=4 | B=3 | B=2 | B=1 | B=0 |
| C=0 | C=1 | C=2 | C=3 | C=4 |

| 16 | 17 | 18 | 19 | 20 | 21 |
|---|---|---|---|---|---|
| A=3 | A=3 | A=3 | A=3 | A=3 | A=3 |
| B=5 | B=4 | B=3 | B=2 | B=1 | B=0 |
| C=0 | C=1 | C=2 | C=3 | C=4 | C=5 |

| 22 | 23 | 24 | 25 | 26 | 27 | 28 |
|---|---|---|---|---|---|---|
| A=2 | A=2 | A=2 | A=2 | A=2 | A=2 | A=2 |
| B=6 | B=5 | B=4 | B=3 | B=2 | B=1 | B=0 |
| C=0 | C=1 | C=2 | C=3 | C=4 | C=5 | C=6 |

| 29 | 30 | 31 | 32 | 33 | 34 | 35 | 36 |
|---|---|---|---|---|---|---|---|
| A=1 | A=1 | A=1 | A=1 | A=1 | A=1 | A=1 | A=1 |
| B=7 | B=6 | B=5 | B=4 | B=3 | B=2 | B=1 | B=0 |
| C=0 | C=1 | C=2 | C=3 | C=4 | C=5 | C=6 | C=7 |

| 37 | 38 | 39 | 40 | 41 | 42 | 43 | 44 | 45 |
|---|---|---|---|---|---|---|---|---|
| A=0 | A=0 | A=0 | A=0 | A=0 | A=0 | A=0 | A=0 | A=0 |
| B=8 | B=7 | B=6 | B=5 | B=4 | B=3 | B=2 | B=1 | B=0 |
| C=0 | C=1 | C=2 | C=3 | C=4 | C=5 | C=6 | C=7 | C=8 |

**B**

**C**

# FURTHER READING

*BOOKS*

Nigel Wood, *Oriental Glazes*, Pitman Publishing, 1978

Ian Currie, *Stoneware Glazes – a Systematic Approach*, Bootstrap Press, Queensland, 1986

Hermann Seger, *Collected Writings*, (ed. A. Bleininger), Easton PA, 1902

*ARTICLES AND PAPERS*

Nigel Wood, 'An alternative method of glaze calculation', *Pottery Quarterly*, No. 30, 1973, pp 123-34

Tsuneshi Ishii, 'Experiments on the Kinuta Blue celadon glazes', and 'Experiments on the Tenriuji Yellow celadon glaze', both in *Transactions of the British Ceramic Society*, Wedgwood Bicentenary Memorial Number, 1930

# Chapter 14
# GLAZE
# RECIPES

The glazes in this chapter have been arrived at by the methods of calculation described in Chapter Thirteen. They are based mainly on analyses of genuine Chinese glazes and have given good results even when firing conditions have been less than perfect. Although this is not primarily a recipe book, these few glazes illustrate many practical points that arise when theory is turned into practice. At the same time, however, they should prove to be useful glazes in their own right.

Glaze 1. Porcelain glaze, 1240°-1290°C, oxidation or reduction

| Potash feldspar | 25 |
|---|---|
| Wollastonite | 27 |
| China clay | 12.5 |
| Hyplas 71 ball clay | 12.5 |
| Flint | 20 |
| Talc | 3 |

| $SiO_2$ | $Al_2O_3$ | $TiO_2$ | $Fe_2O_3$ | CaO | MgO | $K_2O$ | $Na_2O$ | KNaO |
|---|---|---|---|---|---|---|---|---|
| 68.7 | 12.2 | 0.2 | 0.3 | 13.7 | 1.1 | 3.0 | 0.7 | (3.7) |

This glaze is of a type suitable for raw-glazing unfired, dry pots, as well as those that have already been biscuit-fired. On porcelain and porcellaneous bodies it gives results that are very close to traditional Chinese porcelain glazes, particularly those glazes that were used on the less refined (but more interesting) blue-and-white porcelains, such as ginger jars and plates, painted with landscape patterns that were turned out by the million at Jingdezhen from the 15th century onwards, and at numerous Fujian kilns in the 19th and 20th centuries. Much of the character of this glaze comes from the use of wollastonite, rather than whiting, in the glaze recipe, and the presence of a small amount of ball clay provides the trace of iron that also gives life to the Chinese originals.

The 1% or so of magnesium oxide, provided by the talc in the recipe, improves the lustre and richness of the glaze above about 1250°C. It is also important that the ball clay used in the recipe is of the high-silica type (see analysis of Hyplas 71). If an ordinary aluminous ball clay has to be substituted for this clay, about 7% clay and 5% quartz or flint should be used instead.

This glaze has a lime percentage marginally higher than that typical of celadons, and the slight dullness produced when more than about 12% CaO is used in the lower temperature range can be prevented by following the Chinese practice of cooling the kiln fairly quickly from its finishing temperature to about 1000°C. This lessens the tendency of the lime to crystallise and does not harm the ware so long as the kiln is clammed-up and allowed to cool at its own speed once 1000°C is reached.

This porcelain glaze ranges in character from a fine opaque white at 1230°C to a glossy, transparent, faintly bluish glaze just below 1300°C. This particular recipe allows the glaze to be applied fairly heavily and one of its best qualities appears when it is applied thickly and fired in reduction to about 1250°C.

Glaze 2. Pale green celadon, 1240°–1280°C in good reduction

| Potash feldspar | 30.5 |
|---|---|
| Wollastonite | 22.5 |
| Flint or quartz | 16.0 |
| Talc | 12.5 |
| Hyplas 71 ball clay | 15.5 |
| Red iron oxide (synthetic) | 0.5 |

| $SiO_2$ | $Al_2O_3$ | $TiO_2$ | $Fe_2O_3$ | CaO | MgO | $K_2O$ | $Na_2O$ | KNaO |
|---|---|---|---|---|---|---|---|---|
| 67.5 | 14.4 | 0.2 | 0.8 | 11.5 | 1.1 | 3.6 | 0.9 | (4.5) |

This recipe gives a good pale green celadon with a fine surface quality and a fresh colour. It has been designed to be used on dry, raw clay, as well as on biscuit ware. It looks best when thickly applied and fired to just below 1250°C in fairly heavy reduction. It can be re-oxidised at top heat without losing its colour and this high temperature re-oxidation can supply good warm colours to the clays, if they are of the right type. When the glaze is cooled fast to 1000°C it is more likely to show a 'fat' or 'waxy' quality where opacity is balanced by a soft surface glossiness. The small amount of magnesia from the talc re-inforces this effect.

This pale green celadon is at its best when used on porcelain, or on the special 'grey porcelain' bodies made from siliceous ball clays and nepheline syenite and described in

more detail on p. 267. As might be expected from its analysis this recipe will also make an excellent porcelain glaze if the 0.5% iron oxide is left out. The 'synthetic' red iron oxide, referred to in the recipe, is of a particularly pure and fine type and it is useful where exact amounts of iron are important. Some cheaper grades of iron oxide seem to vary in strength (they probably contain some silica or clay) and this makes it harder to gauge exactly how much to use. As the 'synthetic' iron is a rather expensive material, the cheaper grades can be used in high-iron glazes, such as temmokus and Kakis where iron contents are not quite critical. It will be noticed that while only 0.5% iron is used in the recipe there is 0.8% ferric oxide in the fired glaze. This is because some iron oxide is also present in the other glaze materials.

Glaze 3. 'Northern' celadon, 1230°–1260°C, in good reduction

| | |
|---|---|
| Cornish stone | 56 |
| Wollastonite | 20 |
| SMD ball clay | 20 |
| Talc | 3.5 |
| Red iron oxide (synthetic) | 1.5 |

| $SiO_2$ | $Al_2O_3$ | $TiO_2$ | $Fe_2O_3$ | CaO | MgO | $K_2O+Na_2O$ |
|---|---|---|---|---|---|---|
| 67.1 | 13.2 | 0.3 | 1.9 | 11.2 | 1.3 | 5.0 |

This is a fine, glossy, olive-green glaze which, like the genuine Chinese northern celadons, reveals carving, engraving and combing in the clay with great clarity. Its maturing temperature is slightly lower than that of the pale green celadon, and it shows its best character between about 1230° and 1250°C. The remarks about firing and cooling, suggested for Glaze 2, also apply to this glaze – and it can also be applied to both dry and biscuited clays. Celadons are, of course, classic reduction glazes, but the types that are higher in iron also show most attractive straw-yellow and amber colours in oxidation.

Glaze 4. Temmoku, 1260°–1300°C oxidised - 'Northern' temmoku. Reduced – 'hare's fur' temmoku.

| | |
|---|---|
| Cornish stone | 42.5 |
| BBV ball clay | 15.0 |
| Molochite (dust)★ | 13.0 |
| Dolomite | 15.5 |
| Flint or quartz | 17.0 |
| Red iron oxide | 4.5 |
| Rutile | 0.5 |

| $SiO_2$ | $Al_2O_3$ | $TiO_2$ | $Fe_2O_3$ | CaO | MgO | $K_2O$ | $Na_2O$ |
|---|---|---|---|---|---|---|---|
| 62.5 | 16.55 | 0.8 | 5.5 | 6.45 | 3.52 | 2.6 | 1.96 |

★Molochite is a calcined china clay from English China Clays Ltd. The finest dust grade should be used but, if this is unavailable, 15% of raw china clay can be substituted. The calcined clay has been used to reduce the drying shrinkage of the glaze.

Although this glaze was created originally in an attempt to imitate a typical northern temmoku, somewhat surprisingly, in a 1280°C reduction firing, the recipe produced a fine hare's fur temmoku of the Jian type.

Thinly applied, on light-coloured bodies, this glaze will also show the typical tendency of northern temmoku glazes to fire transparent yellowish-browns – particularly in oxidised firings. Where the glaze is especially thin (for instance, on sharp edges), it is almost white, which is rather surprising as the same glaze is quite black when thick. Some clues to this phenomenon are found in microscopic work with cross-sections of northern temmokus, which shows them to be made up of three distinct layers within the glaze: a white layer of lime-feldspar crystals next to the clay, then a thicker layer of dark iron crystals and, finally, a layer of transparent glass. It may be that the layer of iron crystals can only form if the glaze is thick enough, and this would explain the very noticeable differences in colour and quality that thickness provides in glazes of this type. (Feldspathic temmokus are quite different in their behaviour, and tend to show the famous 'black breaking to rust' effect when used thinly.)

### The 'hare's fur' reaction

Because the 'hare's fur' effect seems to be encouraged by boiling and bubbling of the glaze as it melts, it is probably better, in this case, to use carbonates, such as whiting and dolomite in temmoku recipes, rather than their less reactive equivalents – wollastonite and talc. If the firing temperature has not been high enough to bring the magnesia in the glaze into the reaction, the resulting glaze tends to be a dull brown with a matt surface. The quality of this glaze changes abruptly at the right temperature (apparently about 1260°C), for it happens occasionally that a pot is taken from the kiln with one side showing a fine glossy black glaze, while the other side is still changing from its dull state. As this glaze has a tendency to run slightly if applied thickly and fired fully, it should not be taken too near to the foot of the pot in glazing. A firing temperature between about 1280° and 1300°C seems to give the best results.

Glaze 5. Raw 'Albany slip', 1360°–1300°C, oxidation or reduction

| | |
|---|---|
| Hyplas 71 ball clay | 61.5 |
| Potash feldspar | 17.5 |
| Dolomite | 15 |
| Red iron oxide | 4.5 |
| Wollastonite | 2 |

| $SiO_2$ | $Al_2O_3$ | $TiO_2$ | $Fe_2O_3$ | CaO | MgO | $K_2O$ | $Na_2O$ |
|---|---|---|---|---|---|---|---|
| 62.0 | 17.2 | 1.2 | 5.5 | 6.4 | 3.6 | 3.8 | 0.7 |

This is a slip glaze of the type that can be applied to pots that are still shrinking after being made, i.e. the leatherhard state. The glaze can also be used on raw, dry pots, and even on biscuited pots if it is not used too thickly. It is actually better used thinly for it seems to have remarkable 'covering power' and shows its best character as a thin coat on a fine clay body.

In reduction, at the temperatures suggested, this recipe gives a fine smooth, glossy glaze with a dark bronze colour, and with something of bronze's natural variety of tone and lustre. The glaze is very similar to the famous 'dead leaf' glaze used on Chinese porcelain from the Song dynasty to the present day, and it is on porcelain and porcellaneous bodies that it is seen at its best.

The same remarks about the dangers of dullness from underfiring apply to this raw 'Albany slip', which is definitely at its best in reduction. The stronger the reduction used, the more opaque, lustrous and rich in tone the glaze will appear. In oxidation when applied thinly, it shows the same brownish semi-transparency as Glaze 4.

Glaze 6. Mirror-black glaze, 1220°-1250°C in oxidation or reduction

| Flint or quartz | 20.5 |
|---|---|
| Wollastonite | 18.5 |
| Potash feldspar | 19.0 |
| China clay | 14.7 |
| Hyplas 71 ball clay | 14.7 |
| Iron oxide | 9.0 |
| Manganese dioxide | 3.2 |
| Cobalt carbonate | 0.5 |

| $SiO_2$ | $Al_2O_3$ | $TiO_2$ | $Fe_2O_3$ | CaO | MgO | $K_2O+Na_2O$ | MnO | CoO |
|---|---|---|---|---|---|---|---|---|
| 62.1 | 12.4 | 0.3 | 9.5 | 9.1 | 0.1 | 3.0 | 2.7 | 0.3 |

This type of glaze became popular in China in the early 18th century, but glazes with a mirror black appearance were in use in north China as early as the Northern Song dynasty. This particular recipe was reconstructed from the analysis of the late Qing Jingdezhen mirror black glaze on page 158. As described in Chapter Seven, the 18th and 19th century recipes for mirror blacks made use of second-grade cobalt pigments that were essentially manganese ores containing small amount of cobalt as natural impurities – hence the large amount of manganese dioxide in the reconstructed recipe.

This reconstructed glaze gives a fine mirror-black effect from 1220°C upwards in both oxidising and reducing atmospheres, but tends to run if fired higher than about 1250°C. The glaze is best at a medium thickness, but if it used thinly on a light body it can vary from golden-brown to black in a manner reminiscent of tortoiseshell – an attractive quality in its own right. If it is used too thickly it tends to become dull and crystalline and is not so good. The clay proportion in this glaze (equal parts of china clay and a siliceous ball clay) has been used because this quantity and mixture of clays have been found to give good results in dipping. They also prevent settling and solidification of the glaze when not in use, and they allow raw glazing on dry ware without the flaking and crawling that can result from using glazes too low in clay.

Glaze 7. Chinese blue stoneware glaze, 1250°-1310°C, best fired in reduction, but can be also be used in oxidation. Also suitable as an overglaze

| Potash feldspar | 30.5 |
|---|---|
| Wollastonite | 15.0 |
| Flint or quartz | 20.0 |
| China clay | 15.5 |
| Hyplas 71 ball clay | 12.5 |
| Red iron oxide (syn.) | 0.5 |
| Cobalt oxide | 0.4 |
| Manganese dioxide | 1.5 |

| $SiO_2$ | $Al_2O_3$ | $TiO_2$ | $Fe_2O_3$ | CaO | MgO | $K_2O+Na_2O$ | MnO | CoO |
|---|---|---|---|---|---|---|---|---|
| 69.07 | 14.2 | 0.24 | 0.73 | 7.6 | 1.6 | 5.52 | 1.6 | 0.3 |

This glaze is included because it is difficult to make a stoneware glaze coloured with cobalt that is not too garish, and the good blue tone that this glaze displays is the result of the original glaze being coloured with impure Chinese cobalt (a natural mixture of iron, manganese and cobalt oxides). This mixture is reproduced in the above recipe. The colour of this glaze (a medium blue) can be changed to a darker and richer blue by increasing the iron oxide in the recipe to 1.0%. The fact that this glaze is a of typical celadon type, but coloured with small amounts of manganese and cobalt, as well as the usual iron oxide, enhances its fired qualities.

Once again the clay content allows the glaze to be applied both to biscuit ware and to dry clay, and it should be applied to a reasonable thickness (if it is too thin the colour looks somewhat 'washed out'). The hotter the glaze is fired (within the limits suggested) the better its appearance. Good reduction gives the best results as the green tone from the reduced iron is an important component of the glaze's colour.

The disadvantage of using glazes coloured with cobalt oxide is that they need to be ball-milled thoroughly to disperse the cobalt, which will otherwise appear as definite flecks in the finished glaze. Also care is needed to wash out very thoroughly the ball mill, pebbles, and any sieves that may have been used in mixing, or every subsequent glaze prepared will show blue flecks after firing. If no ball mill is available, it is probably better to use both cobalt carbonate and manganese carbonate (instead of the oxides) as, being finer, they disperse more thoroughly in the glaze batch.

Glaze 8. Mashiko Kaki, 1240°-1310°C, oxidation or reduction

| Cornish stone | 54.5 |
|---|---|
| Hyplas 71 ball clay | 10 |
| Molochite | 12.5 |
| Flint or quartz | 9 |
| Wollastonite | 5.5 |
| Talc | 6 |
| Red iron oxide | 6 |

| $SiO_2$ | $Al_2O_3$ | $TiO_2$ | $Fe_2O_3$ | CaO | MgO | $K_2O$ | $Na_2O$ | $(K_2O+Na_2O)$ |
|---|---|---|---|---|---|---|---|---|
| 68.4 | 14.3 | 0.36 | 6.54 | 3.7 | 2.0 | 2.3 | 2.25 | (4.55) |

This is a traditional Japanese (rather that a Chinese) glaze but it has been included in this section because it is so exceptionally versatile, both as a highly attractive overglaze and as a basis for making good temmokus. It is a glaze that has been used to great effect by the potters Bernard Leach and Shoji Hamada – particularly as an overglaze and in combination with various methods of resist.

A good Kaki glaze used over another (usually more fluid) glaze gives a fascinating variety and richness of colour and texture, within the range of natural colours and tones typical of stoneware glazes, that cannot be obtained by other methods. The above glaze seems to show all the good characteristics of the Japanese original.

By itself the Kaki glaze is a smooth rusty-brown glaze with a slight gloss, but it is at its best when used over slightly more fluid glazes such as celadons, temmokus or porcelain glazes. The extra flux supplied by the underglazes seems to bring the Kaki glaze to life, making it appear a rich foxy-red colour where it is thick, dissolving into a brown-black, dusted with rust, where it is thinner. When thinner still, and used over a porcelain glaze, it looks like a greenish-brown celadon, but a celadon that transforms itself into a Kaki glaze wherever (by accident or design) it is applied more thickly. Thus, this one overglaze can produce colours ranging from green, through dark-brown to rust simply by varying its thickness. When these natural variations are combined with some form of resist (wax, paper, or even leaves), the possibilities are even greater.

The Kaki glaze is also useful for trailing over other glazes, rather in the manner of slipware, and looks well over the darker olive-celadons, porcelain glazes and temmokus. It can also be used (with some discretion) over the blue glaze, although one of the best results comes from reversing this arrangement and trailing the blue glaze over the Kaki (itself used to cover another glaze).

Because the Mashiko glaze is originally prepared from a crushed rock, the above recipe has been designed with only enough clay to stop it settling, with the remainder of the clay being supplied by Molochite (calcined china clay). As Molochite is slightly coarser that most ceramic raw materials the glaze benefits from ball milling.

Used as a basis for temmokus, the Kaki glaze gives a most interesting series of glazes with additions of ordinary wood ash from about 1-15%. Those glazes lowest in ash will soon change to fine glossy black temmokus, and eventually to clear, glassy amber or green glazes with increasing ash. These latter glazes are often seen on Japanese country pottery.

A particularly effective use of the Kaki glaze is had by trailing it on top of the Kaki/ash temmokus – a technique often used by Shoji Hamada.

Glaze 9. Jun glaze 1280°-1300°C, reduction

| Potash feldspar | 45 |
|---|---|
| Quartz | 29 |
| Whiting | 11 |
| China clay | 5 |
| Dolomite | 6.5 |
| Red iron oxide | 1.5 |
| Bone ash | 2.0 |

| $SiO_2$ | $Al_2O_3$ | $TiO_2$ | $Fe_2O_3$ | CaO | MgO | $K_2O$ | $Na_2O$ | $P_2O_5$ |
|---|---|---|---|---|---|---|---|---|
| 68.2 | 10.8 | –.– | 1.8 | 10.3 | 1.6 | 5.1 | 1.3 | 0.9 |

Like all Jun glazes, this recipe should be applied to a good thickness for the best optical blue colours to develop, and the low clay content of the glaze helps in the application process. Slow cooling prevents too glassy a surface developing, and brushwork on the dry glaze surface with a dilute copper carbonate pigment before firing can result in the spectacular and diffused copper-red effects seen in the Song, Jin and Yuan originals.

## Analyses of materials used in glazes and bodies in this chapter

These analyses are for materials used in the above recipes. Different suppliers use different sources for the raw materials they sell, but they usually publish analyses for their own particular feldspars, talcs, etc., in their catalogues, and it is these analyses that should be used in any calculations.

**Clays**

| | $SiO_2$ | $Al_2O_3$ | $TiO_2$ | $Fe_2O_3$ | CaO | MgO | $K_2O$ | $Na_2O$ |
|---|---|---|---|---|---|---|---|---|
| Hyplas 71 ball clay (ECC) | 71 | 19 | 1.5 | 0.6 | 0.1 | 0.14 | (KNaO | 2.3) |
| Hymod SMD ball clay (ECC) | 66 | 22 | 1.6 | 1.0 | 0.1 | 0.5 | (KNaO | 2.5) |
| AT ball clay (ECC) | 52 | 30 | 1.0 | 2.6 | 0.2 | 0.6 | (KNaO | 3.5) |
| Grolleg China clay (ECC) | 48 | 37 | 0.02 | 0.75 | 0.06 | 0.3 | 1.85 | 0.1 |
| Molochite ECC) | 54.5 | 42 | 0.07 | 1.1 | 0.06 | 0.31 | 2.0 | 0.1 |

**Feldspars etc.**

| | $SiO_2$ | $Al_2O_3$ | $TiO_2$ | $Fe_2O_3$ | CaO | MgO | $K_2O$ | $Na_2O$ |
|---|---|---|---|---|---|---|---|---|
| Potash feldspar | 68.8 | 17.7 | | 0.2 | 0.3 | 0.1 | 10.4 | 2.5 |
| Cornish stone (synthetic) | 74.4 | 15.2 | | 0.1 | 2.1 | 0.1 | 3.9 | 4.1 |
| Nepheline syenite (North Cape) | 56.3 | 24.9 | | 0.1 | 1.2 | 0.0 | 9.1 | 7.0 |

**Others**

| | $SiO_2$ | $Al_2O_3$ | $TiO_2$ | $Fe_2O_3$ | CaO | MgO | $K_2O$ | $Na_2O$ |
|---|---|---|---|---|---|---|---|---|
| Talc | 51.8 | 7.1 | 0.2 | 1.7 | 0.2 | 34.5 | | |
| Dolomite | 1.2 | 0.5 | | 0.05 | 31.4 | 20.7 | 0.05 | 0.1 |
| Wollastonite | 51.0 | | | | 49 | | | |
| Whiting | | | | | 54.0 | | | |
| Flint | 100 | | | | | | | |

## *Reconstruction of Chinese clays*

### Southern celadon clays

It is possible to copy southern celadon clays by adding iron oxide or ochre to a white feldspathic porcelain body, and this approach was used by Bernard Leach for the 'porcellaneous stoneware' he once made at his St. Ives pottery. This is a rather expensive way of making a 'grey porcelain', but it is probably the only way of making a porcelain that is at the same time high in iron oxide (about 2% is ideal) and low in titania – an important features of genuine Zhejiang celadon bodies. However, if one can accept the more pronounced greyness that titania brings to porcelain clays, cheaper, simpler and much more plastic bodies can be made by adding potash feldspar, Cornish stone or nepheline syenite to high-silica ball clays, using a general recipe of 90-80 parts ball clay to 10-20 parts of feldspar, stone, or nepheline syenite. The porcellaneous stonewares that result from these types of blends tend to be very close in their oxide analyses to south Chinese celadon clays – except for a small amount of extra titanium dioxide.

### Siliceous ball clay 'porcelains'

Clays of this type show very good technical qualities, with reasonable plasticity, low shrinkage, good glaze fit, and a tendency to re-oxidise to the same warm iron-tones seen with genuine Chinese porcelain and celadon clays. Ball clay porcelains can be very vitreous and tough after firings as low as 1220°C, and can usually be fired safely to 1280°C, which was probably the upper limit for most southern celadon clays. Although these ball clay porcelains can contain at least as much flux, and are fired nearly as high as white Chinese porcelains, they show no signs of translucency. This, however, is also a feature of the Chinese originals. Like the original Chinese bodies, these clays can often be raw-glazed when quite dry, if a good interval is left between glazing the insides and the outsides of the wares. Some shapes, however, such as wide bowls and dishes, should not be raw-glazed, as they tend to crack with this treatment.

When creating recipes for this type of body, ball clays that contain the most silica and least potash+soda should be mixed with the highest quantities of mineral flux (up to about 20% of the total). Siliceous clays that contain less silica are better used with about 10% of feldspar, stone or nepheline syenite. (To qualify as siliceous a ball clay should contain more than about 65% $SiO_2$ in the unfired clay analysis). Because siliceous ball clays are unhealthy materials, good precautions should be taken to avoid inhaling the clay dust, which contains a high proportion of very fine silica in the danger range of about two to four microns.

### 'Northern' stoneware bodies

It might be assumed that clays of this type should be easier to copy than southern celadon bodies, because they seem to be nearer to the 'ordinary' stonewares that most potters use. However, it is surprisingly hard to find stoneware clays that are both as fine in texture and as low in fluxes as typical Chinese clays – particularly as almost all fire clays have to be disqualified because of their high iron and copper pyrites contents. Pure ball clay bodies are not the complete answer either, because their shrinkages in drying and firing are unacceptably high. Some success can be had with bodies made by adding ball-milled fireclays to dry ball clays in the right proportions to make a plastic clay (the ball milling disperses the iron evenly throughout the fireclay). This can give bodies with the colour and character of northern stonewares, but the range between the two major body faults of crazing and shattering seem rather narrow in this kind of mixture – perhaps because the clays are so low in fluxes. From the evidence of their analyses, many American clays seem much nearer to Chinese stonewares than English clays, so it may be easier to make this style of stoneware in the USA than it is in the UK.

### White Chinese porcelains

An account of the factors involved in the imitation of Chinese porcelains with Western materials really needs a book to do justice to the subject, for much of the history of Western ceramics from the early 18th century onwards has been concerned with this problem. Even so, it was not until the late 19th century that hard porcelains began to be calculated directly from the ideal oxide proportions of Chinese and Japanese porcelains, while true micaceous hard-paste porcelains seem only to have been made experimentally in the West at Sèvres in the 1880s and in Stoke-on-Trent in the early years of this century. Both research projects produced fascinating papers, and the work of Georges Vogt at Sèvres, particularly, resulted in the most comprehensive and detailed account of the technology of Chinese porcelain production ever written. The Sèvres and the Staffordshire porcelains were designed to mature at the typical firing temperatures for 19th-century Chinese porcelain of about 1280°C, but neither body became established commercially.

Modern hard-paste porcelains are made from mixtures of potash feldspar, quartz and china clay, and the only mica they contain is about 5-8% from the china clay. Many modern porcelains have been designed to be as near as possible to Far Eastern porcelains in their analyses, and bodies of this type can be calculated from the analyses of Chinese porcelains in this book, using the same method as described for glazes. The 'simultaneous' method of calculation that

takes the flux in the china clays into account gives the most accurate results but, because these recipes do not have the advantage of a high content of fine mica, they can result in recipes that are impractically low in clay.

## Using mica in porcelains and glazes

Potassium mica is really the 'forgotten mineral' in Western whiteware manufacture, and the subject of mica in porcelains and glazes is only just beginning to be explored again by Western potters, although there are certain problems involved with its use that should be mentioned. First, the crystal structure of mica makes it very resistant to grinding, and it is therefore difficult to obtain mica fine enough to use in porcelain bodies. Also, mica is a possible health hazard, and, like most silicate dusts, it is the finest grades that need the most care in use. To these problems can be added the fact that mica is three to four times the price of feldspar and it is difficult to buy mica in quantities of less than one tonne. In short, the difficulties in using pure mica in ceramics are considerable and it is probably better to look for natural micaceous clays and rocks that are similar to those used in the Far East. One example of such a rock is hard white Cornish stone – a material that is still used in the Staffordshire pottery industry as a body ingredient in fine bone china.

## *Glazes calculated from the Tables*

Some of the glaze recipes mentioned at the start of this chapter use raw materials that may not be available to all potters. For this reason the glaze recipes in the following section are based on common and universal ingredients, such as potash feldspar, china clay and quartz. These recipes were calculated from typical analyses of these raw materials – essentially those that are shown in page 266.

Not every analysis in this book converts readily to a usable recipe with common materials (particularly the high-potassia alkaline glazes in Chapter Eleven), but the great majority can be rebuilt in this way – making the following mixtures useful starting points for further experiments with most of the major Chinese glaze types.

In order to save space, short codes have been used to represent the various raw materials in the recipes, and these are as follows:

| | |
|---|---|
| Potash feldspar = PF | Bone ash = BA |
| Soda feldspar = SF | Manganese dioxide = MD |
| China clay = CC | Titanium dioxide = TD |
| Quartz = QU | Copper carbonate = CuC |
| Whiting = WH | Cobalt carbonate = CoC |
| Dolomite =DO | Tin oxide = TO |
| Red iron oxide = RIO | Lead Bisilicate = LBS |
| Zinc oxide = ZO | Ground glass = GG |
| Alumina hydrate = AH | |

## Chapter One

Table 1 – Shang stoneware glazes

| PF | CC | QU | WH | DO | RIO | BA | MD | TD |
|---|---|---|---|---|---|---|---|---|
| 26.5 | 19.5 | 18.5 | 19 | 11 | 2 | 3.5 | 0.3 | 1 |
| 31.0 | 18.0 | 21.5 | 15 | 11 | – | 3.0 | 0.3 | 0.6 |
| 15.5 | 31.5 | 28.5 | 11.5 | 9 | 4 | – | 0.4 | 0.8 |
| 39.0 | 18.0 | 17.0 | 15.5 | 8.5 | 1.5 | – | 0.4 | 0.5 |

Table 2 – Wood ashes

| PF | CC | QU | WH | DO | RIO | BA | MD | TD |
|---|---|---|---|---|---|---|---|---|
| 44.0 | 10.0 | – | 20.5 | 16.0 | 2.8 | 4.5 | 4.3 | – |
| 48.5 | 6.0 | 15.5 | 8.5 | 17.0 | 2.5 | – | 2.0 | 0.9 |
| 20.0 | 12.5 | 22.0 | 35.5 | 8.0 | 2.0 | – | 0.1 | 0.5 |
| 49.5 | 17.0 | 17.0 | 3.5 | 10.0 | 5.5 | 4.0 | 2.5 | – |

Table 3 – Western Zhou glazes

| PF | CC | QU | WH | DO | RIO | BA | MD | TD |
|---|---|---|---|---|---|---|---|---|
| 22.0 | 15.0 | 18.0 | 25.0 | 14.0 | 1.0 | 4.0 | 0.7 | 0.4 |
| 26.0 | 35.5 | 12.0 | 16.0 | 8.5 | 1.7 | – | 0.4 | 0.6 |
| 16.0 | 21.0 | 30.0 | 16.0 | 13.0 | 1.0 | 2.5 | 0.5 | 0.5 |

Table 4 – Han Protoporcelain

| PF | CC | QU | WH | DO | RIO | BA | MD | TD |
|---|---|---|---|---|---|---|---|---|
| 17.5 | 24.0 | 27.0 | 20.0 | 7.5 | 1.0 | 2.5 | 0.3 | 0.6 |
| 23.0 | 18.5 | 25.5 | 21.5 | 7.5 | 1.75 | 2.0 | 0.4 | 0.5 |
| 17.0 | 24.0 | 32.0 | 17.0 | 6.5 | 2.0 | 1.5 | 0.5 | 0.5 |
| 15.0 | 21.0 | 30.0 | 22.5 | 8.0 | 1.0 | 2.0 | 0.4 | 0.5 |

## Chapter Two

Table 7 –  Southern lime glazes

| PF | CC | QU | WH | DO | RIO | BA | MD | TD |
|---|---|---|---|---|---|---|---|---|
| 16.0 | 22.0 | 27.0 | 22.0 | 9.5 | 1.0 | 2.0 | 1.0 | 0.5 |
| 10.0 | 21.0 | 36.0 | 20.5 | 8.5 | 1.5 | 2.5 | 0.3 | 0.8 |
| 17.5 | 24.0 | 27.0 | 20.0 | 7.5 | 1.0 | 2.5 | 0.3 | 0.6 |
| – | – | – | – | – | – | – | – | – |

Table 8 – Yue glazes

| PF | CC | QU | WH | DO | RIO | BA | MD | TD |
|---|---|---|---|---|---|---|---|---|
| 13.0 | 21.0 | 33.0 | 15.0 | 12.5 | 2.5 | 3.5 | 0.5 | 0.6 |
| 16.0 | 22.0 | 27.0 | 22.0 | 9.5 | 1.5 | 2.0 | 1.0 | 0.5 |
| 13.0 | 21.0 | 29.0 | 20.5 | 12.0 | 1.5 | 3.0 | 0.4 | 0.6 |

Table 8b – Koryo celadons

| PF | CC | QU | WH | DO | RIO | BA | MD |
|---|---|---|---|---|---|---|---|
| 22.0 | 17.0 | 25.5 | 16.5 | 17.0 | 1.6 | 0.4 | 0.3 |
| 20.5 | 21.0 | 24.5 | 23.6 | 7.2 | 1.0 | 2.0 | 0.4 |
| 29.5 | 18.0 | 22.5 | 16.5 | 11.0 | 1.0 | 1.5 | 0.5 |

Table 9 – Yellow Shouzhou glazes

| PF | CC | QU | WH | DO | RIO | BA | MD | TD |
|---|---|---|---|---|---|---|---|---|
| 15.0 | 25.5 | 30.5 | 15.0 | 8.0 | 3.0 | 3.0 | 0.2 | 0.15 |
| 20.5 | 22.0 | 26.5 | 13.5 | 12.0 | 2.5 | 2.5 | 0.3 | 0.7 |
| 16.0 | 27.0 | 27.0 | 10.0 | 14.0 | 2.5 | 2.0 | 0.5 | 0.7 |

Table 10 – Tongguan glazes

| TO | CuC | PF | CC | QU | WH | DO | RIO | BA | MD | TD |
|---|---|---|---|---|---|---|---|---|---|---|
| 0.6 | 3.5 | 15.0 | 14.5 | 36.0 | 12.0 | 14.5 | 0.6 | 6.5 | 0.8 | 0.7 |
| 0.6 | 3.5 | 13.0 | 14.5 | 36.0 | 18.5 | 11.5 | 0.7 | 5.0 | 0.8 | 0.5 |
| – | – | 11.0 | 22.0 | 31.0 | 18.5 | 10.0 | 4.5 | – | 3.5 | 0.8 |
| – | – | 13.0 | 22.5 | 35.5 | 15.5 | 9.5 | 1.0 | 3.0 | 0.5 | 0.8 |
| – | – | 16.0 | 11.0 | 34.0 | 17.5 | 11.5 | 1.0 | 5.0 | 0.5 | 0.5 |
| – | – | 12.0 | 13.5 | 35.5 | 18.0 | 11.0 | 1.5 | 3.5 | 0.5 | 0.7 |

Table 11 – Qionglai glazes

| -   | PF   | CC   | QU   | WH   | DO   | RIO | BA  | MD  | TD  |
|-----|------|------|------|------|------|-----|-----|-----|-----|
| -   | 11.0 | 17.5 | 33.0 | 13.0 | 18.0 | 2.0 | 4.0 | 0.5 | 0.6 |
| CC  | 10.5 | 19.0 | 35.0 | 10.0 | 18.5 | 2.5 | 5.0 | 0.5 | 0.6 |
| 2.0 | 10.5 | 17.0 | 34.5 | 13.5 | 17.0 | 2.0 | 3.0 | 0.5 | 0.6 |

## Chapter Three

Table 12 – 5 Dynasties glaze

| PF   | CC   | QU   | WH   | DO  | RIO |
|------|------|------|------|-----|-----|
| 17.0 | 28.0 | 36.0 | 14.0 | 5.0 | 0.5 |

Table 14 – *Yingqing* glazes

| Cuc | PF   | CC   | QU   | WH   | DO  | RIO | BA  | MD  |
|-----|------|------|------|------|-----|-----|-----|-----|
| -   | 22   | 21   | 31   | 19.5 | 6.0 | 0.7 | –   | 0.3 |
| 3.5 | 24   | 20.5 | 34   | 16.5 | 8.0 | 1.0 | 2.5 | 0.5 |
| 0.8 | 26.5 | 20.5 | 28.5 | 13.0 | 8.5 | 1.0 | 1.0 | –   |

Table 15 – Rongxian glazes

| CuC | PF   | CC   | QU   | WH   | DO  | RIO | BA  | MD  |
|-----|------|------|------|------|-----|-----|-----|-----|
| -   | 22.0 | 21.0 | 31.0 | 19.5 | 6.0 | 0.7 | –   | 0.3 |
| 3.5 | 24.0 | 20.5 | 24.0 | 16.5 | 8.0 | 1.0 | 2.5 | 0.5 |
| 0.8 | 26.5 | 20.5 | 28.5 | 13.0 | 8.5 | 1.0 | 1.0 | –   |

Table 16 – Glaze ash

| CC  | QU  | WH   | DO  |
|-----|-----|------|-----|
| 2.5 | 2.0 | 92.0 | 3.5 |

Table 17 – *Yingqing glaze*

| PF   | CC   | QU   | WH   | DO  | RIO |
|------|------|------|------|-----|-----|
| 28.0 | 19.0 | 30.0 | 20.5 | 2.5 | 0.6 |

Table 18 – Yuan B&W glazes

| PF   | CC   | QU   | WH   | DO  | RIO | BA  |
|------|------|------|------|-----|-----|-----|
| 28.0 | 19.0 | 30.0 | 20.5 | 2.5 | 0.6 | –   |
| 40.6 | 15.0 | 30.0 | 11.5 | –   | 0.6 | 0.5 |
| 42.0 | 16.0 | 30.0 | 9.0  | –   | 0.6 | 0.4 |

Table 20 – *Shufu* glazes

| PF   | CC   | QU   | WH  | RIO |
|------|------|------|-----|-----|
| 44.0 | 15.5 | 31.0 | 8.5 | 0.6 |
| 50.5 | 10.5 | 31.5 | 8.0 | 0.6 |
| 46.0 | 17.0 | 28.0 | 9.0 | 0.6 |

Table 22 – Asbolite pigments

| CoC | PF  | CC   | QU   | DO  | RIO | MD   | AH   | CC  |
|-----|-----|------|------|-----|-----|------|------|-----|
| 3.7 | 3.0 | –    | 22.0 | 3.0 | 3.0 | 21.0 | 44.5 | 0.8 |
| 8.0 | 1.5 | –    | 22.0 | –   | 2.0 | 22.5 | 42.0 | 0.9 |
| 2.0 | 6.0 | 48.0 | 13.0 | –   | 4.5 | 25.0 | –    | 2.0 |

Table 23 – Sweet white glazes

| PF   | CC   | QU   | WH  | DO  | RIO | BA  |
|------|------|------|-----|-----|-----|-----|
| 60.0 | 11.0 | 23.0 | 2.0 | 3.0 | 0.8 | 0.4 |
| 53.5 | 15.5 | 25.5 | 3.0 | –   | 0.6 | –   |

Table 25 – Dehua glazes

| PF   | CC   | QU   | WH   | DO  | RIO | BA  | TD  |
|------|------|------|------|-----|-----|-----|-----|
| -    | -    | -    | -    | -   | -   | -   | -   |
| -    | -    | -    | -    | -   | -   | -   | -   |
| 15.0 | 27.0 | 38.0 | 17.0 | 2.5 | 0.8 | –   | –   |
| 23.0 | 26.0 | 30.0 | 18.0 | 3.0 | 0.4 | –   | –   |
| 35.0 | 20.0 | 28.0 | 14.5 | –   | –   | –   | –   |
| 39.0 | 20.0 | 28.0 | 10.0 | –   | 0.4 | –   | –   |
| 48.0 | 16.0 | 24.5 | 8.0  | 3.5 | –   | –   | 0.3 |
| 50.5 | 18.0 | 22.0 | 5.5  | 3.0 | –   | 1.0 | –   |

## Chapter Four

Table 26 – Jingdezhen glazes

| PF   | CC   | QU   | WH   | RIO | MD  |
|------|------|------|------|-----|-----|
| -    | -    | -    | -    | -   | -   |
| -    | -    | -    | -    | -   | -   |
| 49.0 | 12.0 | 24.0 | 12.5 | 0.6 | -   |
| 36.5 | 16.5 | 32.0 | 14.0 | 0.8 | 0.6 |

Table 26 – Longquan glazes – i

| PF   | CC   | QU   | WH   | DO  | RIO  | MD  | TD  |
|------|------|------|------|-----|------|-----|-----|
| 35.5 | 16.5 | 27.0 | 15.0 | 5.0 | 0.75 | 0.4 | –   |
| 35.5 | 20.5 | 29.0 | 12.0 | 3.0 | 0.7  | –   | –   |
| 46.5 | 18.5 | 21.0 | 9.5  | 3.0 | 1.0  | 0.5 | 0.2 |
| 54.0 | 11.5 | 20.0 | 6.0  | 7.5 | 1.0  | 0.1 | –   |

Table 27 – Longquan glazes – ii

| PF   | CC   | QU   | WH   | DO  | RIO | BA  | MD  | TD  |
|------|------|------|------|-----|-----|-----|-----|-----|
| 22.5 | 25.0 | 23.0 | 19.5 | 8.0 | 1.4 | –   | 0.6 | 0.3 |
| 24.5 | 27.0 | 25.5 | 17.5 | 4.5 | 1.0 | –   | 0.4 | 0.1 |
| 34.5 | 18.0 | 30.0 | 15.0 | –   | 0.5 | 0.3 | –   | –   |
| 46.0 | 19.0 | 22.0 | 9.5  | 2.5 | 1.2 | –   | 0.4 | 0.2 |
| 54.0 | 11.5 | 20.0 | 6.0  | 7.5 | 1.0 | –   | –   | –   |

Table 28 – Dayao glazes

| PF   | CC   | QU   | WH   | DO  | RIO | BA  |
|------|------|------|------|-----|-----|-----|
| 29.5 | 20.5 | 32.0 | 14.0 | 2.5 | 1.0 | 0.5 |
| 25.5 | 24.0 | 32.0 | 14.0 | 3.0 | 0.7 | 0.5 |

Table 29 – Hangzhou Guan glazes

| PF   | CC   | QU   | WH   | DO  | RIO | BA  | MD  |
|------|------|------|------|-----|-----|-----|-----|
| 27.0 | 21.0 | 29.0 | 18.5 | 3.0 | 0.5 | 1.0 | –   |
| 30.5 | 18.5 | 27.0 | 19.0 | 3.0 | 0.5 | 0.7 | –   |
| 24.0 | 25.5 | 28.5 | 18.0 | 3.0 | 0.6 | –   | –   |
| 31.0 | 22.0 | 25.0 | 16.5 | 4.0 | 0.5 | –   | 0.2 |

Table 29 – Longquan Guan glazes

| PF   | CC   | QU   | WH   | DO  | RIO | BA  | TD   |
|------|------|------|------|-----|-----|-----|------|
| 30.0 | 13.5 | 28.5 | 23.5 | 3.0 | 1.0 | –   | –    |
| 26.5 | 24.0 | 25.0 | 19.0 | 3.0 | 0.7 | 0.8 | –    |
| 33.5 | 18.0 | 26.5 | 21.0 | –   | 0.5 | –   | –    |
| 28.0 | 22.5 | 25.0 | 20.5 | –   | 0.6 | –   | 0.15 |

Table 31 – Ming & Qing Ge glazes

| PF   | CC   | QU   | WH   | DO  | RIO  |
|------|------|------|------|-----|------|
| 63.5 | 6.5  | 22.0 | 6.5  | –   | 0.8  |
| 28.3 | 26.0 | 27.0 | 14.5 | 2.5 | 0.75 |

Table 33 – Lt. 19th C. Crackle glazes

| PF   | CC   | QU   | WH  | RIO |
|------|------|------|-----|-----|
| 54.0 | 14.0 | 29.0 | 2.5 | 0.4 |
| 40.5 | 18.0 | 37.0 | 3.5 | 0.4 |

## Chapter Five

Table 35 – Gongxian glazes

| PF   | CC   | QU   | WH   | DO  | RIO | TD  |
|------|------|------|------|-----|-----|-----|
| 35.0 | 16.0 | 26.0 | 14.5 | 8.0 | 0.6 | 0.2 |
| 20.0 | 27.0 | 33.0 | 13.0 | 6.5 | 0.6 | 0.3 |
| 42.0 | 21.0 | 18.0 | 14.0 | 5.0 | 0.5 | –   |
| 42.0 | 15.5 | 25.0 | 12.0 | 5.0 | 0.7 | –   |

Table 36 – Gongxian B&W glaze

| PF | CC | QU | WH | DO | RIO | BA |
|---|---|---|---|---|---|---|
| 26.0 | 17.5 | 37.0 | 12.0 | 5.5 | 0.5 | 1.5 |

Table 37 – Xing glazes

| PF | CC | QU | WH | DO | RIO | MD | TD |
|---|---|---|---|---|---|---|---|
| 8.0 | 38.5 | 36.5 | 6.0 | 11.0 | 0.5 | – | – |
| 17.0 | 34.0 | 33.0 | 6.0 | 9.5 | 0.6 | 0.1 | – |
| 8.5 | 33.5 | 35.5 | 11.0 | 11.5 | 0.3 | 0.1 | – |
| 7.0 | 37.5 | 28.4 | 19.0 | 8.0 | 0.3 | 0.1 | 0.1 |

Table 38 – Feldspathic Xing glazes

| PF | CC | QU | WH | DO | RIO | BA | MD |
|---|---|---|---|---|---|---|---|
| – | – | – | – | – | – | – | – |
| 43.0 | 12.0 | 29.0 | 10.0 | 5.5 | 0.4 | 0.7 | 0.1 |

Table 39 – Ding glazes

| PF | CC | QU | WH | DO | RIO | BA | TD |
|---|---|---|---|---|---|---|---|
| 18.0 | 33.0 | 40.0 | – | 9.0 | 0.3 | – | – |
| 16.0 | 34.0 | 41.0 | – | 9.0 | 0.3 | 0.4 | – |
| 15.5 | 35.0 | 39.5 | – | 10.0 | – | 0.7 | 0.7 |
| 10.0 | 42.0 | 38.8 | 3.0 | 7.0 | 0.4 | – | 0.4 |

**Chapter Six**

Table 40 – 6th C. AD glaze

| PF | CC | QU | WH | DO | RIO | MD | TD |
|---|---|---|---|---|---|---|---|
| 17.0 | 27.0 | 22.5 | 19.0 | 13.0 | 1.0 | 0.1 | 0.6 |

Table 42 – Yue glazes

| PF | CC | QU | WH | DO | RIO | BA | TD |
|---|---|---|---|---|---|---|---|
| 3.5 | 26.5 | 35.5 | 25.0 | 8.0 | 2.0 | – | – |
| 15.0 | 19.5 | 36.0 | 15.0 | 11.0 | 1.8 | 2.0 | 0.5 |
| 13.0 | 22.0 | 30.0 | 23.0 | 8.0 | 1.5 | 3.1 | 0.7 |

Table 42 – Yaozhou glazes

| PF | CC | QU | WH | DO | RIO | BA | TD |
|---|---|---|---|---|---|---|---|
| 23.0 | 23.5 | 38.5 | 4.0 | 6.0 | 3.5 | 1.0 | 0.3 |
| 14.0 | 26.1 | 35.5 | 13.0 | 9.0 | 1.0 | 1.5 | 0.25 |
| 19.5 | 28.0 | 35.0 | 14.0 | – | 2.5 | 2.0 | 0.3 |
| 19.0 | 23.0 | 39.0 | 10.5 | 5.5 | 1.7 | 1.3 | – |
| 22.5 | 23.0 | 34.0 | 10.0 | 9.0 | 1.8 | – | 0.1 |
| 10.0 | 31.0 | 30.5 | 19.0 | 6.0 | 1.5 | 1.8 | 0.3 |

Table 42 – Linru glazes

| PF | CC | QU | WH | DO | RIO | BA | TD |
|---|---|---|---|---|---|---|---|
| 36.5 | 18.5 | 28.0 | 12.0 | 3.5 | 1.3 | 1.0 | 0.2 |
| 35.0 | 20.5 | 27.5 | 11.0 | 3.0 | 2.0 | 1.0 | 0.25 |
| 35.0 | 20.5 | 28.5 | 8.0 | 5.0 | 2.0 | 1.3 | 0.25 |
| – | – | – | – | – | – | – | – |
| 41.5 | 16.0 | 28.0 | 10.0 | 3.0 | 1.25 | 1.0 | – |
| – | – | – | – | – | – | – | – |

Table 42 – Longquan glazes

| PF | CC | QU | WH | DO | RIO | BA | MD | TD |
|---|---|---|---|---|---|---|---|---|
| 37.0 | 19.0 | 29.0 | 12.5 | 3.0 | – | – | – | 0.1 |
| 33.3 | 19.0 | 28.5 | 11.5 | 5.0 | 0.4 | 1.7 | 0.6 | 0.1 |
| 42.0 | 13.5 | 26.0 | 12.5 | 5.0 | 0.2 | 1.0 | – | 0.1 |
| – | – | – | – | – | – | – | – | – |
| – | – | – | – | – | – | – | – | – |

Table 45 – Jun glazes

Green Jun glazes

| PF | CC | QU | WH | DO | RIO | BA | TD |
|---|---|---|---|---|---|---|---|
| 23.0 | 26.0 | 32.0 | 17.0 | – | 0.4 | 1.5 | 0.25 |

Guantaizhen glazes

| PF | CC | QU | WH | DO | RIO | BA | TD |
|---|---|---|---|---|---|---|---|
| 35.0 | 8.0 | 37.0 | 13.5 | 4.0 | 1.7 | 1.0 | 0.3 |
| 28.5 | 10.0 | 43.0 | 13.5 | 3.5 | 1.6 | – | 0.3 |
| – | – | – | – | – | – | – | – |

Liujiagou & Zhaojiawa glazes

| PF | CC | QU | WH | DO | RIO | BA | TD |
|---|---|---|---|---|---|---|---|
| 30.5 | 9.0 | 40.5 | 14.5 | 3.5 | 1.5 | 0.7 | 0.35 |
| 30.0 | 10.0 | 39.0 | 13.0 | 5.0 | 1.8 | 1.5 | 0.25 |
| 30.0 | 12.0 | 36.0 | 8.0 | 10.5 | 1.5 | 2.0 | 0.2 |

Linru glazes

| PF | CC | QU | WH | DO | RIO | BA | TD |
|---|---|---|---|---|---|---|---|
| 18.0 | 14.0 | 43.0 | 15.5 | 7.0 | 1.3 | 2.0 | 0.25 |
| 30.5 | 12.0 | 38.0 | 12.5 | 4.5 | 2.0 | 1.0 | 0.4 |
| 31.5 | 9.0 | 41.0 | 8.5 | 7.0 | 1.0 | 2.0 | 0.3 |

Table 46 – Ru glazes

| PF | CC | QU | WH | DO | RIO | BA | MD | TD |
|---|---|---|---|---|---|---|---|---|
| 34.5 | 19.0 | 18.0 | 15.0 | 9.5 | 1.7 | 1.5 | 0.3 | 0.3 |
| 31.0 | 23.5 | 18.0 | 18.0 | 7.0 | 1.8 | 1.2 | – | 0.1 |
| 29.0 | 21.5 | 20.0 | 19.0 | 8.0 | 1.6 | 1.0 | 0.1 | 0.1 |
| 25.3 | 23.5 | 27.0 | 14.5 | 8.0 | 1.8 | – | – | – |

Table 49 – Cizhou glazes

| PF | CC | QU | WH | DO | BA |
|---|---|---|---|---|---|
| 43.0 | 27.0 | 20.0 | 5.0 | 5.0 | – |
| 40.0 | 22.0 | 30.0 | 5.0 | 3.0 | 0.3 |

**Chapter Seven**

Table 50 – Bronze Age glazes

| PF | CC | QU | WH | DO | RIO | BA | MD | TD |
|---|---|---|---|---|---|---|---|---|
| 44.0 | 11.0 | 31.5 | – | 7.0 | 9.0 | – | 0.6 | 1.2 |
| 32.5 | 27.5 | 21.1 | 0.5 | 10.0 | 6.0 | 1.4 | 1.0 | 1.2 |
| 45.0 | 21.0 | 18.0 | – | 7.5 | 9.5 | 0.5 | 0.2 | 1.2 |
| 56.0 | 18.0 | 11.0 | 2.5 | 7.5 | 4.5 | 0.5 | – | 1.0 |

Table 51 – Deqing black glazes

| PF | CC | QU | WH | DO | RIO | BA | MD | TD |
|---|---|---|---|---|---|---|---|---|
| 11.0 | 21.5 | 29.0 | 24.0 | 6.5 | 6.5 | 1.6 | 0.3 | 0.7 |
| 16.0 | 20.0 | 28.0 | 24.0 | 5.5 | 5.5 | 1.5 | 0.3 | 0.8 |
| 15.0 | 20.0 | 29.0 | 24.0 | 6.0 | 5.5 | 1.2 | 0.3 | 1.0 |

Table 51 – Deqing green glazes

| PF | CC | QU | WH | DO | RIO | BA | MD | TD |
|---|---|---|---|---|---|---|---|---|
| 11.0 | 23.0 | 33.0 | 23.5 | 5.5 | 1.6 | 2.0 | 0.3 | 0.7 |
| 14.0 | 24.0 | 32.0 | 22.0 | 5.5 | 1.6 | 1.5 | – | 0.6 |
| 13.5 | 24.0 | 32.0 | 22.5 | 5.5 | 1.5 | 1.5 | 0.1 | 0.7 |

Table 52 – Tang teadust glazes

| PF | CC | QU | WH | DO | RIO | BA | TD |
|---|---|---|---|---|---|---|---|
| 31.0 | 12.5 | 34.0 | 12.0 | 4.5 | 2.0 | 4.0 | 0.4 |
| 21.0 | 20.0 | 37.0 | 6.0 | 8.5 | 3.4 | 4.4 | 0.7 |
| 22.0 | 24.0 | 37.0 | 2.5 | 8.0 | 4.5 | 2.5 | 0.9 |

Table 53 – Loess

| PF | CC | QU | WH | DO | RIO | BA | TD |
|---|---|---|---|---|---|---|---|
| 32.0 | 20.0 | 28.5 | 4.5 | 7.0 | 5.0 | 0.7 | 0.5 |
| 25.5 | 26.0 | 29.0 | 5.5 | 9.5 | 4.0 | 0.4 | 0.8 |

Table 54 – Splashed Jun glazes

| PF | CC | QU | WH | DO | RIO | BA | MD | TD |
|---|---|---|---|---|---|---|---|---|
| 31.0 | 12.5 | 34.0 | 12.0 | 4.5 | 2.0 | 4.0 | 0.1 | 0.35 |
| 21.0 | 19.5 | 37.0 | 6.0 | 8.5 | 3.4 | 4.5 | - | 0.7 |
| 22.0 | 24.0 | 37.0 | 2.5 | 8.0 | 4.5 | 2.5 | - | 0.9 |
| 21.5 | 23.0 | 39.0 | 4.5 | 7.5 | 4.5 | - | - | 0.6 |

Table 55 – Song temmoku glazes

| PF | CC | QU | WH | DO | RIO | TD |
|---|---|---|---|---|---|---|
| - | - | - | - | - | - | - |
| 21.0 | 29.0 | 32.0 | 3.0 | 10.5 | 5.0 | 0.8 |
| 20.0 | 26.0 | 32.0 | 4.5 | 11.0 | 6.0 | 0.8 |
| 22.5 | 25.0 | 29.5 | 4.5 | 12.0 | 6.0 | 0.7 |

Table 58 – Jian temmoku glazes

| PF | CC | QU | WH | DO | RIO | BA | MD | TD |
|---|---|---|---|---|---|---|---|---|
| 20.0 | 34.0 | 28.5 | 6.0 | 3.0 | 5.0 | 2.5 | 1.0- | 0.5 |
| 18.0 | 37.5 | 26.0 | 2.5 | 7.5 | 5.5 | 2.5 | 1.0 | 0.6 |
| - | - | - | - | - | - | - | - | - |

Table 59 – Jian `partridge feather` glazes

| PF | CC | QU | WH | DO | RIO | MD | TD |
|---|---|---|---|---|---|---|---|
| 15.0 | 41.5 | 26.5 | 4.0 | 8.0 | 4.5 | 0.5 | 0.5 |
| 31.0 | 21.0 | 33.0 | 12.5 | - | 0.7 | - | - |

Table 60 – Jian `white temmoku' glazes

| PF | CC | QU | WH | DO | RIO | BA | MD | TD |
|---|---|---|---|---|---|---|---|---|
| 21.0 | 34.0 | 28.0 | 2.5 | 7.0 | 6.0 | 1.5 | 1.0 | 0.6 |
| 36.5 | 15.0 | 45.5 | 1.5 | 1.5 | 1.2 | 0.5 | - | 0.6 |

Table 62 – Black-brown Jizhou glazes

| PF | CC | QU | WH | DO | RIO | BA | MD | TD |
|---|---|---|---|---|---|---|---|---|
| 23.0 | 22.0 | 29.0 | - | 14.0 | 5.0 | 4.0 | 0.1 | 0.5 |
| 34.0 | 18.0 | 22.0 | 4.0 | 12.0 | 5.0 | 4.0 | 1.0 | 0.6 |
| 37.5 | 17.0 | 20.0 | 0.5 | 13.0 | 7.0 | 4.5 | 1.0 | 0.5 |

Table 63 – Jizhou light overglaze

| PF | CC | QU | WH | DO | RIO | BA | MD | TD |
|---|---|---|---|---|---|---|---|---|
| 29.5 | 20.0 | 20.5 | 9.5 | 11.5 | 4.0 | 4.0 | 1.0 | 0.6 |

Table 64 – Black Ding glaze

| PF | CC | QU | WH | DO | RIO | TD |
|---|---|---|---|---|---|---|
| 18.0 | 30.5 | 30.0 | 5.0 | 12.5 | 4.5 | 0.6 |

Table 65 – Russet Ding glazes

| PF | CC | QU | WH | DO | RIO | TD |
|---|---|---|---|---|---|---|
| 26.0 | 34.5 | 25.5 | - | 10.0 | 5.0 | 1.0 |
| 30.5 | 28.5 | 30.0 | - | 7.0 | 5.5 | 1.0 |
| 25.0 | 29.0 | 34.0 | 0.5 | 9.5 | 2.0 | 0.75 |

Table 66 – Mirror black glaze

| COC | PF | CC | QU | WH | DO | RIO | MD | TD |
|---|---|---|---|---|---|---|---|---|
| 0.6 | 28.0 | 13.5 | 29.5 | 17.0 | - | 8.0 | 3.5 | - |
| - | 27.0 | 17.5 | 27.5 | 16.5 | 6.5 | 5.5 | - | 0.2 |

Table 67 – Bronze glaze

| PF | CC | QU | WH | RIO | TD |
|---|---|---|---|---|---|
| 31.0 | 25.5 | 28.0 | 10.5 | 3.0 | 0.4 |

## Chapter Nine

Table 68 – Song Jun reds

| TO | CuC | PF | CC | QU | WH | DO | RIO | BA | TD |
|---|---|---|---|---|---|---|---|---|---|
| 0.5 | 0.5 | 39.0 | 5.1 | 35.5 | 12.5 | 3.5 | 2.0 | 1.5 | 0.4 |
| 0.5 | 0.2 | 32.0 | 8.5 | 39.5 | 12.0 | 4.5 | 2.0 | 1.5 | 0.3 |

Table 69 – 14th C porcelain glazes

| PF | CC | QU | WH | DO | RIO |
|---|---|---|---|---|---|
| 27.5 | 19.0 | 30.0 | 20.5 | 2.5 | 0.6 |
| - | - | - | - | - | - |
| - | - | - | - | - | - |

Table 70 – Yongle red & white glazes

| CuC | PF | CC | QU | WH | DO | RIO | BA |
|---|---|---|---|---|---|---|---|
| 0.4 | 50.0 | 11.0 | 27.0 | 9.0 | - | 0.8 | 0.2 |
| - | 40.5 | 15.0 | 30.0 | 7.5 | 6.0 | 0.7 | - |

Table 71 – Xuande red, celadon and white glazes

| CuC | PF | CC | QU | WH | BA |
|---|---|---|---|---|---|
| 0.4 | 52.0 | 10.0 | 25.0 | 12.5 | 0.5 |
| - | 49.0 | 12.0 | 24.5 | 12.5 | 0.6 |
| - | 40.5 | 16.0 | 28.5 | 9.5 | 1.0 |
| - | 41.0 | 15.0 | 30.0 | 8.0 | 0.7 |

Table 72 – Wanli copper red

| CuC | PF | CC | QU | WH | RIO |
|---|---|---|---|---|---|
| 0.2 | 43.0 | 13.5 | 26.5 | 16.0 | 0.6 |

Table 73 – Xuande and Qing copper-red glazes

| CuC | PF | CC | QU | WH | DO | RIO | BA |
|---|---|---|---|---|---|---|---|
| 0.4 | 52.0 | 10.0 | 25.0 | 12.5 | - | 0.5 | 0.2 |
| 0.3 | 49.0 | 12.0 | 24.5 | 12.5 | - | 0.6 | - |
| 0.5 | 38.5 | 19.5 | 20.5 | 20.0 | - | 0.9 | 0.2 |
| 0.2 | 33.0 | 22.0 | 22.0 | 18.5 | 4.0 | 0.9 | - |

Table 74 – Copper-lime pigments

| CuC | PF | QU | WH | DO | RIO |
|---|---|---|---|---|---|
| 28.0 | 13.0 | 6.0 | 54.5 | 2.5 | 0.75 |
| 20.5 | 7.5 | 8.5 | 61.0 | 2.0 | 3.5 |

Table 76 – Late 19th C. copper-red glaze

| CuC | PF | CC | QU | WH | RIO | LBS |
|---|---|---|---|---|---|---|
| 0.8 | 20.5 | 22.0 | 28.0 | 25.0 | 0.9 | 19.0 |

Table 77 – *san-yang kai-tai* glazes

| COC | PF | CC | QU | WH | RIO |
|---|---|---|---|---|---|
| - | 27.5 | 11.5 | 28.5 | 33.0 | - |
| - | 35.0 | 13.0 | 25.5 | 27.0 | - |
| 0.1 | 35.0 | 14.0 | 25.0 | 23.5 | 2.0 |
| 0.2 | -30.5 | 20.0 | 28.0 | 19.0 | 3.0 |

(Recipes for Chinese high-lead glazes and overglaze enamels are not included because of their high toxicity when fired)

## Chapter Eleven

Table 102 – Shiwan glazes

| GG | CuC | LBS | CC | QU | WH | DO | RIO | ZO |
|---|---|---|---|---|---|---|---|---|
| 60.0 | 1.5 | 2.0 | 9.0 | 15.0 | 6.0 | 6.0 | 0.5 | - |
| 50.0 | 3.0 | - | 2.0 | 29.0 | 11.0 | 3.5 | - | 1.0 |
| 30.0 | 2.5 | - | 9.5 | 30.0 | 16.0 | 12.0 | 1.0 | 0.5 |

Table 103 – Yixing glazes

| PF | CC | QU | WH | RIO | MD | ZO |
|---|---|---|---|---|---|---|
| 44.5 | 9.0 | 17.0 | 7.0 | 1.5 | 7.0 | 14.5 |

## Practical points

When preparing these glazes, it is usually best to ball mill them thoroughly in the wet state for about 90 minutes (normal materials should not be milled longer than this as extended grinding times encourage crawling of the glazes during firing). Reference to the text should show whether the original glazes were oxidised or reduced, and should also give some idea of the glazes' original firing temperatures.

As with all new recipes, it is useful to test the glazes at three or four different thickness, as many of the famous qualities of Chinese glazes depended to a large extent on how thickly they were applied. Clay bodies are important too, as the same glaze can look quite different on different clays, and reference to the text should again provide information on the original materials used. In many cases, suitable clay bodies can be calculated from their original analyses, using the same calculation techniques that have been described for glazes – particularly the 'simultaneous' calculations that consider alumina and the alkalis in the clays at the same time.

By following the techniques outlined, many of the finest glazes in China's history become accessible – with the added bonus that experimentation with these glazes can add further levels of understanding and appreciation to the Chinese originals.

# CHRONOLOGY

### NEOLITHIC CULTURES

| | |
|---|---|
| Cishan–Peiligang | c. 6500–5000 BC |
| Central Yangshao | c. 5000–3000 BC |
| Gansu Yangshao | c. 3000–1500 BC |
| Hemudu | c. 5000–3000 BC |
| Daxi | c. 5000–3000 BC |
| Majiabang | c. 5500–3000 BC |
| Dawenkou | c. 4300–2400 BC |
| Songze | c. 4000–2500 BC |
| Hongshan | c. 3800–2700 BC |
| Liangzhu | c. 3300–2250 BC |
| Longshan | c. 3000–1700 BC |
| Qijia | c. 2250–1900 BC |

### EARLY DYNASTIES (BRONZE AGE CHINA)

| | |
|---|---|
| Xia | c. 2000–1500 BC |
| Shang | c. 1500–1050 BC |
| Western Zhou | c. 1050–771 BC |
| Eastern Zhou | 771–221 BC |
| Spring and Autumn period | 771–481 BC |
| Warring States period | 480–221 BC |

### IMPERIAL CHINA

| | |
|---|---|
| Qin | 221–207 BC |
| **Han** | **206 BC–AD 220** |
| Western Han | 206 BC– AD 9 |
| Xin | AD 9–25 |
| Eastern Han | AD 25–220 |

| **Three Kingdoms** | **221–280** | |
|---|---|---|
| Shu (Han) | 221–263 | |
| Wei | 220–265 | |
| Wu | 222–280 | |

### Southern Dynasties south China 265–589(Six Dynasties)

| | | |
|---|---|---|
| Western Jin | 265–316 | |
| Eastern Jin | 317–420 | |
| Liu Song | 420–479 | |
| Southern Qi | 479–502 | |
| Liang | 502–557 | |
| Chen | 557–589 | |
| Sui | 581–618 | (north & south China) |
| Tang | 618–906 | (north & south China) |
| Liao | 907–1125 | (far north China) |
| Five Dynasties | 907–960 | |

| **Song** | **960–1279** | |
|---|---|---|
| Northern Song | 960–1126 | (north & south China) |
| Southern Song | 1127–1279 | (south China) |
| Jin | 1115–1234 | (north China) |
| Yuan | 1279–1368 | (north & south China) |
| Ming | 1368–1644 | |
| Qing | 1644–1911 | |

### Northern Dynasties north China 386–581

| | |
|---|---|
| Northern Wei | 386–53 |
| Eastern Wei | 534–550 |
| Western Wei | 535–557 |
| Northern Qi | 550–577 |
| Northern Zhou | 557–581 |

### MING EMPERORS

| | |
|---|---|
| Hongwu | 1368–98 |
| Jianwen | 1399–1402 |
| Yongle | 1403–25 |
| Xuande | 1426–35 |
| Zhengtong | 1436–49 |
| Jingtai | 1450–57 |
| Tianshun | 1457–64 |
| Chenghua | 1465–87 |
| Hongzhi | 1488–1505 |
| Zhengde | 1506–21 |
| Jiajing | 1522–66 |
| Longqing | 1567–72 |
| Wanli | 1573–1620 |
| Tianqi | 1621–27 |
| Chongzhen | 1628–44 |

### QING EMPERORS

| | |
|---|---|
| Shunzhi | 1644–61 |
| Kangxi | 1662–1722 |
| Yongzhen | 1723–35 |
| Jiaqing | 1796–1820 |
| Daoguang | 1821–50 |
| Xianfeng | 1851–61 |
| Tongzhi | 1862–74 |
| Guangxu | 1875–1908 |
| Xuantong | 1909–11 |

### REPUBLICAN CHINA

| | |
|---|---|
| Republic | 1912– 49 |
| People's Republic | 1949– |

*Note: Chronologies of Chinese dynasties can vary from source to source. The above is essentially that used in The British Museum Book of Chinese Art, (1992) but with the addition of the Xia dynasty, and the Ming and Qing emperors.*

# INDEX